1000 Years of Swiss Art

1000 Years of

Swiss Art

Edited by Heinz Horat

Hudson Hills Press, New York

Editor
Heinz Horat, Zug

Graphic Concept and Layout
Bühler + Stolzenburg, Basel

Manuscript Editor
Eileen Walliser-Schwarzbart, Riehen

Translations
BMP Translation Services, Basel
Mavis Guinard, Buchillon
Ann E. Keep, Venthône
Suzanne Leu, Basel
Catherine Schelbert, Bettwil
Eileen Walliser-Schwarzbart, Riehen

Production
Wiese Publishing, Basel

Printing
Birkhäuser+GBC, Reinach/Basel

First Edition
Copyright © 1992 by Pro Helvetia, Zurich

Published in the United States by Hudson Hills Press, Inc.,
Suite 1308, 230 Fifth Avenue, New York, NY 10001-7704.
Editor and Publisher
Paul Anbinder

Distributed in the United States, its territories and possessions, Canada,
Mexico, and Central and South America by National Book Network, Inc.
Distributed in the United Kingdom and Eire by Shaunagh Heneage Distribution.
Distributed in Japan by Yohan (Western Publications Distribution Agency).

This publication was made possible by financial contributions from the
Arts Council of Switzerland Pro Helvetia, the Coordinating Committee for the
Presence of Switzerland Abroad, and Arthur Andersen & Co., SC,
(Guy Barbier, George Bunge, John Demas, Marshall Faillace, Ron Flores,
Paul Hoeve, Beat Schnider, Walter Tenz, Paul Von Holzen).

Library of Congress Cataloguing-in Publication Data

1000 years of Swiss art / edited by Heinz Horat. – 1st ed.
p. cm.
Includes bibliographical references and index.
ISBN 1-55595-079-5
1. Art, Swiss. 2. Art, Medieval-Switzerland. 3. Art, Modern-Switzerland.
I. Horat, Heinz. II. Title. III. Title: One thousand years of Swiss art. IV. Title:
Swiss art.
N7143.A15 1992 92-25409
709'.494-dc20 CIP

Printed and bound in Switzerland.

Table of Contents

Foreword

Swiss, in character and real habit –
the political boundaries are of no moment.
John Ruskin, *Praeterita* (35.113), 1833.

In 1515 Hans Holbein the Younger leaves his native Augsburg for Basel, where he acquires citizenship in 1520. In 1521 he produces what is probably his most impressive painting, the body of Christ in the tomb. A few years later he goes to England, returning to Basel several times and ultimately dying in London, where he is buried at St. Andrew's Cemetery. On 14 August 1867 the epileptic Russian novelist Feodor Mikhailovich Dostoevsky, who is spending a year in Switzerland, sees the picture of the Dead Christ at the Basel Kunstmuseum. His wife reports that he is enormously impressed by the work. In 1868 he publishes *The Idiot*, which he wrote in Switzerland. The protagonist of the novel, Prince Lev Nikolaevich Myshkin, is in Switzerland for his health, undergoing one of the rest cures for which the country is famous. He sees Holbein's picture of the Dead Christ at the Basel Museum. Returning to St. Petersburg, he encounters a copy of the original he saw in Basel at the home of his antagonist Rogoshin. "I saw this picture when I was abroad and cannot forget it," he says. When Rogoshin murders Nastasja Filippovna, his bride and Myshkin's mistress, the prince will ultimately find her in this same house, laid out like Holbein's Dead Christ.

This little historical vignette is typical of the cultural situation of Switzerland – not only in Dostoevsky's time, but down the centuries and across the country's shifting geographical and political identities. The small country in the heart of Europe that we know as "Switzerland" has only existed in its present form since the nineteenth century. A federalistic state from the very start, it is characterized by a strong polycentric strain rooted in the distant past. As a result of its size and its political and social structures, genuinely "national" works of art are a rare occurrence. There have nonetheless been numerous high-quality works produced here in all periods of art history, works fitting in quite naturally with the architectonic and artistic trends of Europe's major cultural centers and often generated directly – or at least influenced substantially – by them.

International mobility and extensive economic development in the small country of "Switzerland" as a whole and in its various cultural regions have led to an astonishingly diverse range of artistic enterprises. The topographical advantages of an alpine state that incorporates both south and north, the tasks assumed by that state in the realm of European traffic and transport, its internationally recognized contributions in a variety of scientific fields, its introduction of innovative methods of industrial production – all of these factors have been instrumental in fostering lively reciprocal relations transcending (historically often negligible) national frontiers. These international links, evolving in the course of history from alliances in war to shared religious affiliations and trade relations, have always involved cultural exchange; and this has had a positive effect not only on Swiss art and architecture, but on the international scene as well. In all periods of art history, Swiss territory has functioned as a platform for exchanges between south and north, east and west, with the Alps serving as an impulse rather than an obstacle. "Transit" is not just a modern term connected with European integration. It was as valid for the early Middle Ages as it is today. "Transit art" may sound like a catch phrase, but as a concept it comes very close to the Swiss understanding of culture, and it applies as strongly to the past as to the future.

It is pointless to ponder whether "Swiss art" means art by Swiss artists or art in Switzerland, or whether the term has any validity at all. "Swiss art" owes a debt to artists from all over the world. Under the influence of international trends, the art produced within Switzerland's borders has developed in ever new combinations and permutations, and has found regional forms of expressions; but thanks to reciprocal relations it has also been exported to other countries.

If the political situation in 1914 induced the Alsatian Hans Arp to move from Paris to Switzerland because it was a sanctuary from war, and if he then succeeded in exerting a substantial influence on the development of contemporary art from that refuge, he is unquestionably a typical representative of the Swiss art scene. Throughout history, Switzerland has been a place for artists to withdraw to in times of trouble. As an island of comparative peace, Switzerland was isolated during both world wars. Here immigrant artists like Arp could unite in 1917 to form a group that would respond to the self-destruction raging abroad by creating the dada movement as a new artistic order. Only in neutral Switzerland could the legacy of De Stijl and the Bauhaus be carried on and advanced during World War II. It is thanks to Richard Paul Lohse and Max Bill that the "Concrete Art" exhibition was mounted in Basel in 1944, an exhibition that would go down in the annals of art history as an extraordinary event in a Europe at war.

Oskar Kokoschka came to Switzerland at the invitation of his Austrian compatriot Adolf Loos. The latter had just built the Villa Karma in Clarens for an Austrian client while his own wife was being treated for tuberculosis in Les Avants. In 1953 Kokoschka ultimately settled in Villeneuve on the Lake of Geneva. In 1917 Ernst Ludwig Kirchner chose Davos as the place to seek help for a nervous disorder and remained there until his death in 1938.

If, on the other hand, Abel Faidy, a Vaudois architect trained in Germany and England, emigrated to the United States in 1914 and was celebrated as the designer of "Jazz Age Furniture," he represents another equally typical phenomenon in Swiss art: the artist as art exporter. He shares this feature with many others, among them the baroque architects Francesco Borromini and Carlo Maderno in Rome, the Grisons architects in the German Empire after the Thirty Years' War, the painters Hans Holbein the Younger and Henry Fuseli in London, Charles Gleyre, Le Corbusier, and Alberto Giacometti in Paris, or Johannes Itten in Germany. Swiss art as an export article cannot be relegated to history: it is timelier than ever before, as much in demand and as sought after as only cheese, chocolate, and watches have been up to now.

The present book, designed for an international reader-ship, offers verbal and pictorial evidence of the "bound-less" reciprocal relations so essential to Switzerland as an artistic nerve center. Swiss art historians who live and teach at home and abroad have written essays on individual aspects of their special fields with a view to providing pieces for the larger mosaic of "Swiss art." Grouped chronologically from the early Middle Ages to the present day, these texts, all of them published here for the first time, offer insight into the art-historical research being pursued in Switzerland; they also focus selectively on the center or centers of artistic production in our country. Each section has an introduction presenting works particularly characteristic of the artistic position of Switzerland in an international context. They represent regional forms of expression and principal European currents in the various eras, artistic groups, and contemporary trends, or simply numerous individual artistic fates that have, for one reason or another, been linked with Switzerland.

Heinz Horat

The Middle Ages

The Benedictine monastery of St. John in Müstair, Grisons, was founded by the Bishop of Chur in the late eighth century. Originally a Benedictine abbey, it became a women's convent around 1100, which it remains today. Being situated at the southeastern edge of Chur-Rhaetia, close to the Via Claudia Augusta, the Verona-Augsburg transit route, the abbey is likely to have possessed considerable political prominence in Charlemagne's time. But the border location manifested itself artistically as well. Whereas the Carolingian architecture is largely the product of northern influence, the frescoes, plasterwork, and furniture for the monastery were created by artists from the south. During the Carolingian construction and furnishing period, the abbey community consisted of some thirty-three monks. Originally built as a strategic outpost of the expanding Frankish Empire and a hospice in inclement terrain, the monastery owes the preservation of its medieval substance to its remoteness and poverty. The most important surviving Carolingian monastery, it contains the richest extant Carolingian cycle of frescoes. It has been placed on the "Unesco register of humanity's major cultural monuments."

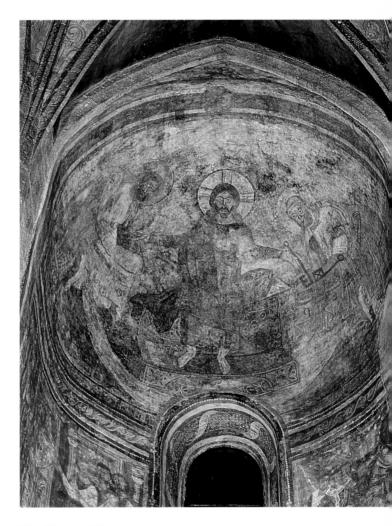

"Traditio legis." Christ presenting the keys to Peter and the book to Paul. Detail from a Carolingian fresco in the north apse of the convent church of Müstair, Grisons, c. 810.

11

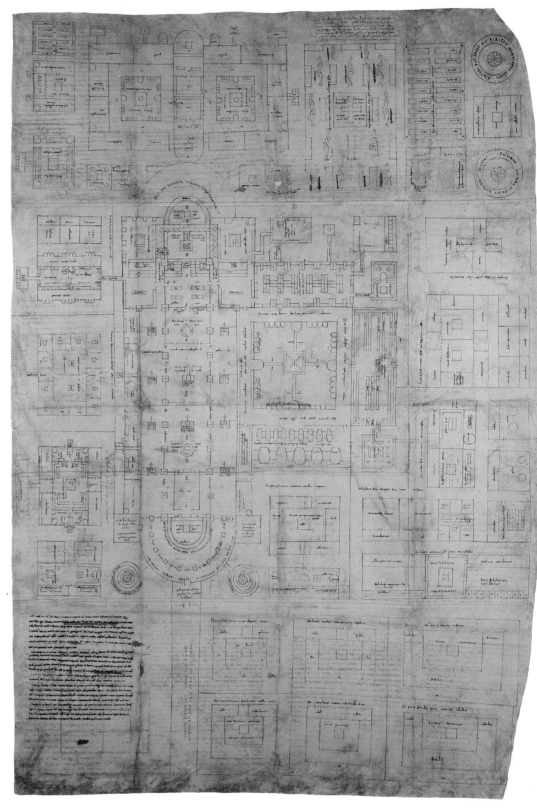

The ground plan of the monastery of St. Gallen is the most important written document pertaining to Carolingian architectural history. Intended for the abbot of St. Gallen, who was about to embark on structural alterations to the monastery, it was produced by draftsmen and copyists from St. Gallen's sister abbey on the island of Reichenau around the year 830. For the abbey library of St. Gallen, where the monastery plan is preserved, see p. 145.

Around 285/286 the Roman soldiers of the Theban Legion died at Agaunum, the present St. Maurice, as martyrs for their Christian faith. One of the officers who fell, Candidus, is still venerated in St. Maurice with a reliquiary in the shape of a physical relic. The "caput sancti Candidi" evokes the bodily presence of the saint in his reliquiary. The inscription on the front reads: "Candidus exempto dum sic mucrone litatur / spiritus astra petit, pro nece vita datur." (As Candidus falls victim to the drawn sword, his spirit rises to the stars: for death he receives life.) The small figure representing the soul of the martyr being carried to heaven by an angel relates the head falling beneath the sword with the artistically recreated head to be venerated. The visible layer of silver foil conceals an outstanding contemporaneous sculpture, a life-sized head carved out of wood. The abbey of St. Maurice, founded at the grave of the Theban Martyrs in 515, continues to keep alive the memory of the deeds that followed in the wake of the Diocletian persecution of Christians. It contains one of the world's most important church treasuries.

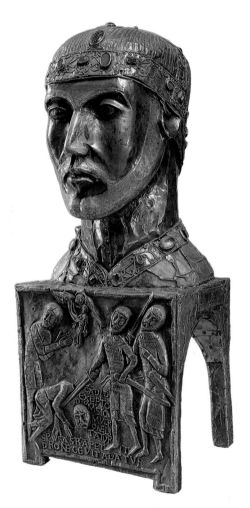

Head of Candidus, in the abbey treasury of St. Maurice, c. 1150, silver gilt over a wooden core, filigree and cabochons, height 57.5 cm.

The Romanesque painted ceiling of the parish church of St. Martin in Zillis, created in the first half of the twelfth century, numbers among the most important surviving artworks of its time. Executed acording to Carolingian and Ottonian prototypes from the Lake of Constance region, its subject matter is characteristic of a church located on a pilgrims' road, here the Germany-Chur-Splügen/San Bernardino-Italy route. The wooden ceiling is bordered by a sea frieze populated by a variety of creatures. Its 153 generously painted, easily readable panels relate the history of salvation and the life of patron saint Martin. Particular emphasis is placed on the Journey of the Magi to Bethlehem: they, too, were pilgrims, and, with the angels with trumpets, they will accompany the travelers who have interrupted their dangerous journey to stop at the church.

Jesus the Boy Bringing the Clay Birds to Life.

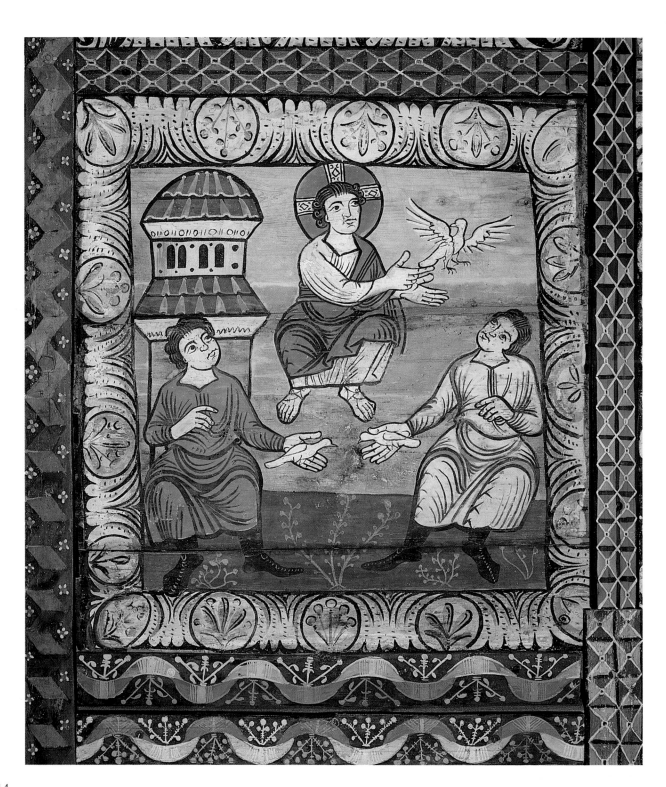

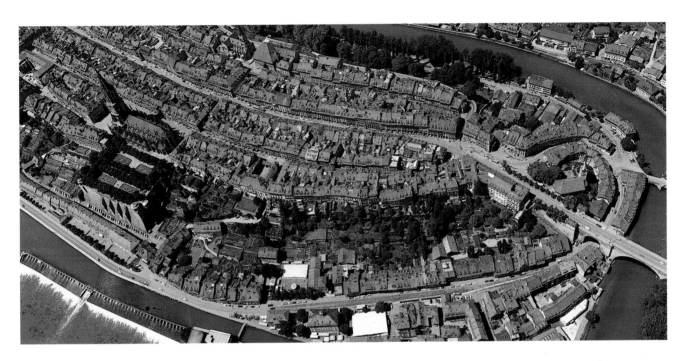

The Old Town of Bern from the northwest, aerial photo, 1975.

The city of Bern was founded by Duke Berchtold V of Zähringen on the Aare Peninsula in 1191 and continued to expand into the late baroque era. It is probably one of the most striking examples of late medieval city development in Europe today and, as such, has been included in the "Unesco register of humanity's major cultural monuments."

"When the long nights steal in, summoning the howling winds that stray over the earth, I see the city before me again, as it was the morning I first set eyes upon it, spread out along the river that rises on the nearby icy peaks, flowing round it, deep and soundless beneath the houses, forming a strange bend open only toward the west and so defining the shape of the city. That day the mountains lay far in the distance, in the haze, like fluffy clouds behind the hills, from where they could not threaten man. The city was of wondrous beauty, and in the twilight the light often penetrated the walls like molten gold; and yet I think back on it with dread, for its luster shattered as I approached it,

and as it enveloped me I was plunged into a sea of fear. It was blanketed by a poisonous fog that corroded the seeds of life and forced me to gasp for breath, stricken with an agonizing feeling, as if I had penetrated a region strangers were not allowed to trespass, where every step violated a secret law. I wandered around, driven by oppressive dreams, pursued by the city that torments those who have come from afar to find refuge there. I sensed that it was self-sufficient, for it was perfect and without mercy. It had stood unchanged since time immemorial, and no house had disappeared or been added. The buildings were unalterable and not subject to time, and the lanes were not crooked as in other old cities, they were straight and well-aligned, according to fixed plans. They seemed to lead into eternity, and yet they did not offer freedom, for the low arcades forced the people to stoop as they moved about among the buildings, invisible to the city and thus tolerable to it."

Friedrich Dürrenmatt, *The City*, 1947.

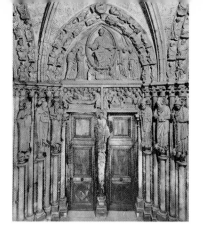

The "Painted Portal" on the south side of Notre-Dame Cathedral in Lausanne was created c. 1216-1220.
A projecting openwork baldachin, it serves not only as a porch but also as an architectonically ideal site for Marian worship, for its iconography is dedicated wholly to the Virgin Mary, Mother of God and intermediary between the Old and New Testaments. On the tympanum, she is receiving the crown from the enthroned Christ, the latter assisted by angels. The archivolts show the Elders of the Apocalypse, with the Lamb of God at the apex. Two reliefs on the lintel depict the Dormition and Assumption of the Virgin. Intermediary figures on columns set off the salvational theme: on the central pillar, the Archangel Michael as "Ianitor paradisi," gatekeeper to the heavenly Jerusalem. On the left embrasure: Moses, John the Baptist, and Simeon, representing the Old Law; on the right: Peter, Paul, and John the Evangelist, standing for the New Testament. Sculptors from one of the largest French construction sites created these figures in the knowledge that they were to be painted immediately after completion, and it is the original polychromy that makes the "Painted Portal" an extraordinary work of Gothic art.

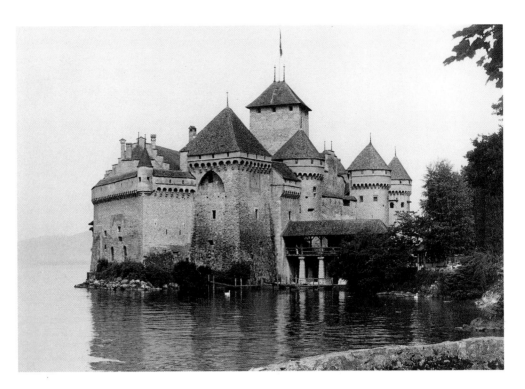

The Castle of Chillon, strategically located on a rocky spur in the Lake of Geneva and on the road across the Great St. Bernhard to Italy, is one of Europe's most famous castles. Built on a generous scale in the eleventh to thirteenth centuries by the Counts of Savoy, its fortifications were continually strengthened. With the Bernese conquest in 1536, it became a bailiff's castle for the new rulers. Lord Byron saw the castle as ruins in 1816 and placed his "Prisoner of Chillon" in the poem of the same name (VI) in the dungeon of the seven pillars:

Lake Leman lies by Chillon's walls:
A thousand feet in depth below
Its massy waters meet and flow;
Thus much the fathom-line was sent
From Chillon's snow-white battlement,
Which round about the wave inthrals:
A double dungeon wall and wave
Have made – and like a living grave.
Below the surface of the lake
The dark vault lies wherein we lay,
We heard it ripple night and day;
Sounding o'er our heads it knocked;
And I have felt the winter's spray
Wash through the bars when winds were high
And wanton in the happy sky;
And then the very rock hath rock'd
And I have felt it shake, unshock'd,
Because I could have smiled to see
The death that would have set me free.

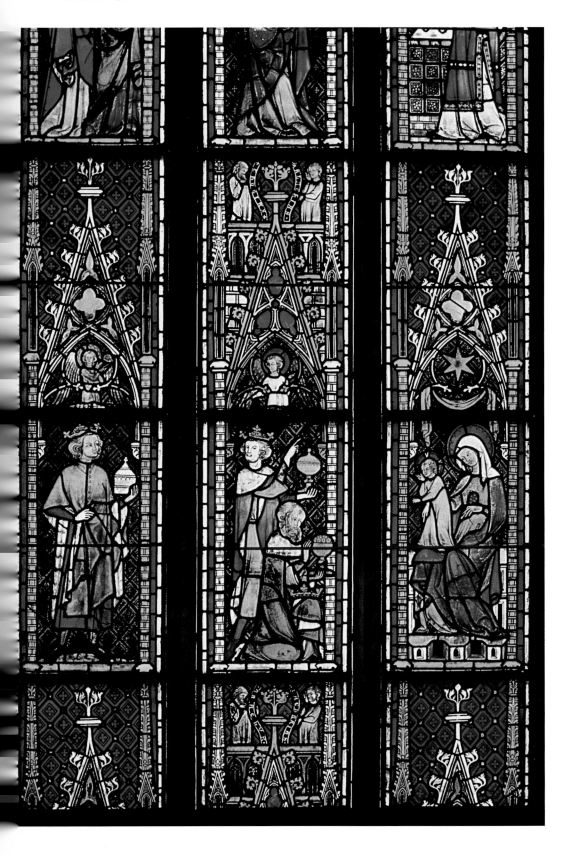

Königsfelden, not far from the Habsburgs' home fortress, is one of the major monuments to the House of Habsburg. It was here that Johann von Schwaben murdered his uncle, the German king Albrecht I, on 1 May 1308. Albrecht's wife founded a double convent on the site of this infamous act, the Franciscans establishing their community there in 1311 and the Poor Clares in 1312. Subsequently Queen Agnes, daughter of the murdered ruler, assumed responsibility for the welfare of the convent, which she fitted out lavishly. The plan of the church was typical of fourteenth-century mendicants' churches in the Franciscan Province of Upper Germany. The stained-glass windows in the choir, produced between 1325 and 1340, have largely been preserved and are of extraordinary quality. They were commissioned from a leading stained-glass workshop in the Habsburg Empire – presumably working in the Upper Rhine region, most likely Strasbourg, with help from glass painters from Constance. Thanks to its outstanding artistic quality and courtly-classical formal idiom, the cycle is both a masterpiece of contemporary stained glass and an exceedingly progressive artistic creation.

Rudolf Schnyder

The Writing Tablets of Charlemagne: Two Ivory Diptychs in the Abbey Library of St. Gallen

Between 1971 and 1977 the ivory covers of illuminated manuscripts in the St. Gallen abbey library were subjected to examination in the Schweizerisches Landesmuseum. The findings were published in a volume which appeared in 1984, entitled *Die Elfenbein-Einbände der Stiftsbibliothek St. Gallen* (The Ivory Book-Covers in the Abbey Library of St. Gallen), by Johannes Duft, a former librarian of the abbey, and the present writer.[1] One of the conclusions reached was that the two ivory tablets on the covers of the Evangelium longum (Codex 53) (figs. 1-4) and Codex 60 (figs. 5, 6) were writing diptychs that had once belonged personally to the emperor Charlemagne. This discovery was chosen as the theme of an exhibition, "The Writing Tablets of Charlemagne," that was first put on at the Schweizerisches Landesmuseum in 1985 and later toured St. Gallen (1986), Chur, and Zug (1988).[2] In each city the display was enriched by objects from the locality illustrative of the historical background to these Carolingian works. The arguments in favor of the tablets' attribution were set out visually at this exhibition but have not yet been published. The present article is designed to fill the gap.

The ivory tablets in question have long been known to scholars and have been the subject of controversy for over a century. Ekkehart, the St. Gallen monk and chronicler, states in chapter twenty-two of his history of the monastery, probably written soon after 1030, that the mitered abbot Salomo (bishop of Constance 890, † 919/920) presented to the abbey *duas tabulas*

eburneas, i.e., two ivory tablets from the treasure of Hatto (bishop of Mainz 891, † 913), which "are of a size one sees very seldom elsewhere, as if the elephant armed with such tusks was a giant among those of his kind. But they were former wax tablets for writing, which Emperor Charles (the Great)… used to place by his bedside when he went to sleep. One of them is splendidly decorated with pictures, the other was of exquisite smoothness, and it was this polished one that Salomo gave to our Tuotilo to be carved. To this end he had our Sintram write a gospel measuring the appropriate length and width, and then had this volume, with its luxurious tablets, embellished with Hatto's gold and precious stones."[3]

The two tablets mentioned here were at first taken to be separate ones, and this led to them be identified with the ivories on the *Evangelium longum.* But since it was impossible to identify clearly the work of two different artists in these two tablets, doubt was cast on the written source's authenticity. Finally the two plaques, along with the ivories on Codex 60, were ascribed to Tuotilo's workshop in St. Gallen, and the tale that they had originated in Hatto's treasure and had once been in Charlemagne's possession was no longer taken seriously. Not until after recent studies was it realized that in this passage Ekkehart had in mind not two separate tablets but two writing diptychs, and that he was referring to the two pairs of tablets that have been preserved in St. Gallen until the present day. The diptych "splendidly decorated with pictures" is identical with the tablets on Codex 60 (figs. 5, 6); the diptych "of exquisite smoothness" (figs. 3, 4) was carved by Tuotilo soon after 894 for the *Evangelium longum* it still adorns today.

The Smooth Writing Tablets

The two pairs of tablets in St. Gallen were originally writing diptychs from late antiquity. The pair that was originally smooth and that Tuotilo carved in relief (figs. 3, 4) is, as Ekkehart tells us, quite unusually large. Its plaques, measuring 320 x 155 mm, are among the broadest that have come down to us. Their edges have been cut back both above and below, and it can be calculated that before they reached St. Gallen or were worked there, the plaques were originally about 400 mm long. It follows that the only comparable piece handed down from antiquity is the diptych of Apion, the largest of all, measuring 410 x 150 mm, which is dated 539 and is housed in the treasure of Orvieto cathedral.[4] Such giant tablets are characteristic of the latest period in which consular diptychs were still granted. In Rome this practice came to an end in 534, and in Constantinople in 541. Such a time-frame is also suggested by the workmanship of our specimen, the width of the margin left on the inner sides in the remains of the frame around the incised writing area, and the construction of its former shaft hinge, with its three alternating sections embedded in slots and sunk into a fold (fig. 4).

In the *Notitia dignitatum,* the Roman political handbook, smooth writing tablets, ornamented solely by cross strips of gold, are prescribed for officials of subordinate rank.[5] Remains of an ornamented specimen were found in the grave of King Childeric I (482), discovered near Tournai in 1653.[6] Because such plain pieces were the first ones, and were worked on later, few of them have survived.

What is so remarkable about the smooth writing tablet which the abbey of St. Gallen received from Hatto's treasure is that it remained uncarved for so long. Adolph Goldschmidt, who compiled the great corpus of medieval ivories, considers large plaques characteristic of the earliest Carolingian schools of carving, which undoubtedly had still more antique writing tablets to work on than was later the case. In this respect our diptych is untypical.[7] Undoubtedly the reason why no one touched it until around 900 was that it was so enormous. It must have been held in high regard and admired for the qualities it still possesses today: as an exceptionally rare piece, it was thought to be worthy of the most powerful of rulers and thus fit to be preserved in the most important treasure.

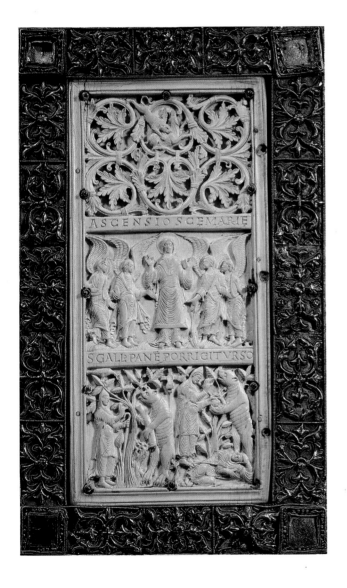 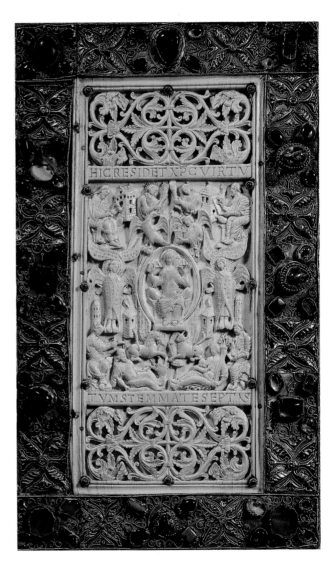

figs. 1-2: Front and back covers of the binding of Codex 53 at the abbey library of St. Gallen. The ivory tablets "of exquisite smoothness" that once belonged to Charlemagne were carved in St. Gallen by Tuotilo after 894. The gold frame of the back cover is also by Tuotilo, whereas the gold strips on the front covers date from the second half of the tenth century.

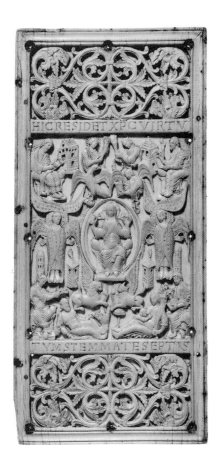

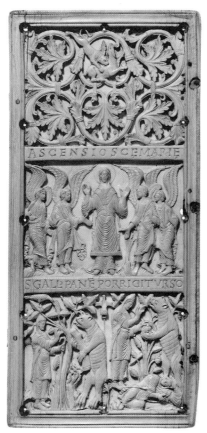

fig. 3: The ivory diptych on Codex 53, outer sides.

The St. Gallen tradition, based on Ekkehart, that this giant tablet once belonged to Charlemagne therefore harmonizes well with the nature of the object.

The Carved Diptych

The pair of tablets that had already been carved before they reached St. Gallen (figs. 5, 6) are somewhat smaller than the pair we have been discussing. The plaques measure "only" 270 x 103 mm and have an almost symmetrical shape. The delicate workmanship suggests that this is an early-fifth-century diptych which was later reworked. Originally it had two hinges embedded in facing slots. Later this arrangement was replaced by hinges which fitted not into the existing slots but into new open bearings gouged out above them (fig. 6). This renovation of the hinges must have been carried out at the same time as the diptych acquired its relief decoration, which was already on it when it was presented to St. Gallen abbey.

The smaller pair of tablets is certainly among the largest Carolingian carved ivory tablets that have come down to us. This fact alone links them – if we follow Adolph Goldschmidt here – to the carving schools that existed in Charlemagne's lifetime. Yet it is hard to find any other tablet directly comparable to them. They seem to have been the only tablets to have been carved, not to serve as the cover of a sacred book, but to be put to further use as writing tablets. On such tablets it is rare for the composition of the relief decoration on the two plaques to differ strikingly instead of matching.

One tablet (fig. 5a) is covered evenly all over with a rosette decoration. Each rosette has twelve blossoms, arranged in two rows of six, each flower being accompanied by four palmettes. The palmettes are set diagonally to the blossoms and are joined to them by pinnules (fig. 8). The tips of the leaves touch to form an elegant latticework extending across the surface, while the petals, whose lobes curl forward, unfurl freely into the intervening space.

The second tablet (fig. 5b) is decorated with wavy tendrils growing organically as a tree on the base line. On

fig. 4: The ivory diptych on
Codex 53, inner sides,
with marks from the former
hinge construction.

either side of the central axis, it juts out sideways to form six loops, in a reflected image. The result is an evenly arranged latticework pattern that fits exactly into the given framework, like the rosettes in the other tablet. The loops are filled alternately with a delicately articulated cinquefoil leaf and with scenes of animals in combat. The scenes in the middle face inwards while those above and below face outward. The topmost animal scene portrays a big bear attacking a bull (fig. 7); in the center a lion is ripping a hind, and at the bottom a spotted panther is grappling with a gazelle. The stalks of the tendrils, bound together in the middle, broaden out in sections to form funnel-shaped elements, from which they bifurcate and then turn into a principal leaf curling forward, a stem with winged palmettes, and springs with little heart-shaped leaves.

Common to both tablets is the division into twelve panels and the delicate high relief, which stands out clearly from the recessed background. In each case the carved area is enclosed within a simple, flat channel and two scratched lines. These common features make it quite clear that, despite their different ornamental motifs, the two plaques belong together. The foliage, with the detail of the principal leaves and petals brought out by double lines, is evidence that in both pieces the same artist was at work.

Style

Adolph Goldschmidt was the first to call the tablets "Carolingian" instead of "antique" or "Roman," as hitherto.[8] He substantiated his opinion with the remark: "The leafy palmettes show resemblance to those of carvings in the Ada group." By this he meant that the wealth of forms on the plaques testified to the artistic creativity found in the orbit of Charlemagne's court. Among the works which Goldschmidt assigned to this school are three small square ivory tablets, one of which represents a bust of Christ in a medallion and the others symbols of the Evangelists Matthew and John.[9] Today they are housed respectively in Ravenna and London, but they must have once belonged together. This is clear, to look no further, from the deco-

ration on the frame, where we find exactly the same palmettes as on our tablet (fig. 9). Filling the corners of the frame in the former work is the same kind of leaf – with five lobes and on the sides two half-leaves with three lobes and the tip curling outward – that occurs grouped diagonally around the blossoms of our rosettes. The same motif may be found on the sides of the frame, except that in this case the central leaf curls forward in the same way as our petals. Recent research has led to abandonment of the view that these works, which bear closest resemblance to Charlemagne's tablets, belong to the orbit of the Ada group. Instead scholars point to their affinities with our tablet, which they date c.900 and locate in St. Gallen on account of the similarities between its relief carvings and those of Tuotilo on the *Evangelium longum*.[10] These similarities can now be explained by the fact that when Tuotilo created this masterpiece he had our tablets as a model to go by.

It is indeed the case that, if one looks around for palmettes readily comparable with those on our tablets, one is most likely to find them in works from Charlemagne's time. For there is a great distinction between that age and the following decades as regards decorative inventory: artists made different use of clearly delineated lobed leaves or half-leaves with tips curling forward – rolling either inward or outward – and a fine ribbing of double lines. The closest parallel to our palmettes – not only in their compositional structure but even down to the smallest details – is found in the principal monument that Charlemagne erected to commemorate his reign, the Palatine Chapel in Aachen, notably in the first of the so-called "classicistic" bronze screens.[11] In the relief of its elegant little capitals, we once again come across, quite plainly, our three-part ribbed palmette with the five-lobed middle leaf – its tip curled slightly forward and marked by a notch – and the three-lobed half-leaves with the tips rolling out on either side (fig. 11). On the base of the capital, one is surprised to see delicate leaves with buds. Also befitting the ornamental repertoire we are familiar with are the

volutes above the palmette and the shape of the rosette right on top. Over and above these similarities, the thick bars at either end of the screen, which have channels with sharply defined lines, closely resemble the frame of our diptych. These ample analogies prompt the inevitable conclusion that our tablets are closely related to these screens, which they surpass in the precision of their design and carving.

Iconography

As a writing diptych, our tablets must have once been designed for someone's personal use. We can gain some more information about that individual's identity from the ornamental relief. As already mentioned, each plaque has its own, very different motif: in one case a carpet of rosettes and in the other a tendrillar tree with animals in combat. Hence the chief motifs that are combined to form the iconography of the ruler are a rosette, animals in combat, and a tree.

The closest parallels to the use of the rosette as a ruling sovereign's attribute occur in the Near East.[12] It is found on the garment of the Sassanian king in the grotto of Taqi Bustan near Kermanshah (Iran), at the gateway to Asia. Another example occurs in the firmament surrounding the enthroned ruler, made of almandine (ruby) and rock crystal, on the bowl of Khusraw I (or Solomon). This object was probably taken as booty by the Byzantine emperor Heraclius after he seized Ctesiphon and defeated the Sassanians, and then passed on to the Merovingian king Dagobert in 627/628; it is today among the treasures of the Bibliothèque Nationale in Paris. A third example is to be found on the cloth bearing the name of the Umayyad caliph Marvan, dated around 750. It forms the central medallion on the lion socle of the statue of this ruler that stands above the entrance gate to the great audience chamber and bathing hall in the Umayyad palace of Khirbat al-Mafjar.[13] In this hall it decorates a large floor mosaic, identifying the position of the ruler's seat in a way that would be obvious to everyone. Here the rosette, an ancient symbol of the sun, stands for the splendor that radiates from the royal power: the ruler appears as an embodiment of light.

In another floor mosaic in this very palace, Khirbat al-Mafjar, we find a scene of fighting animals that is relevant in our context. In a richly furnished room adjacent to the great audience chamber, the prince's emplacement is indicated by a mighty tree bearing fruit; in its shadow we see on the left a lion striking a gazelle, and on the right gazelles grazing peacefully. This calls to mind the first verses of Psalm 1:

Happy are those who reject the advice of evil men,
Who do not follow the example of sinners
Or join those who have no use for God.
Instead, they find joy in obeying the Law of the Lord,
And they study it day and night.
They are like trees that grow beside a stream,
That bear fruit at the right time,
And whose leaves do not dry up.
They succeed in everything they do.

An analogous passage occurs in the Koran (Sura 14, 25 f.):

Do you not see how Allah inspires the parable of a
good word? (He is) like a healthy tree with solid
roots and branches that rise up to heaven. He brings
forth fruit each time according to his Lord's
commandment.

The tree, a symbol of a man who heeds the Law of the Lord and keeps to it, is at the same time an image of the wise judge and righteous ruler who ensures that the evildoers to his left are put down and the good men to his right protected. "God has made your sword to be the judge between the beasts of prey and the gazelles," wrote Muhammad ben Wasif shortly after 865, in a panegyric of Yakub as-Saffar.[14] Our images of animals in combat clearly represent the dispensing of justice and thus the ruler passing judgment. They follow a literary model, for in chapter seven of the Book of Daniel the prophet has a vi-

fig. 5: The ivory diptych
"splendidly decorated with pic-
tures" for Charlemagne around
800, on Codex 60 at the abbey
library of St. Gallen.

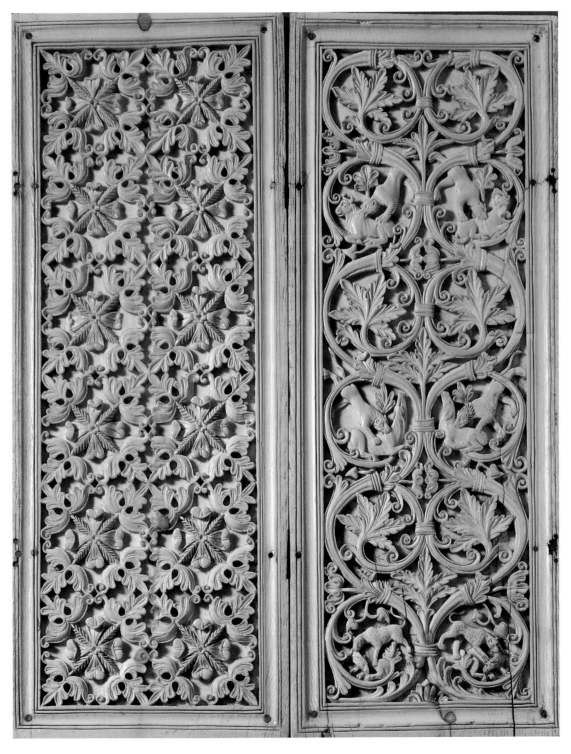

fig. 6: The ivory diptych on Codex 60, inner sides, with marks from the former hinge and lock constructions.

sion of a lion, bear, and leopard (panther) – an allusion to three great kingdoms and powerful rulers.

Looking at our diptych in the light of this knowledge, one perceives that, in relation to the delicate plates on the hinge that held the tablets together at the rear, the ornamental one is on the right and the one with scenes of animals in combat is on the left. This reproduces exactly the relationship depicted in the floor mosaic at Khirbat al-Mafjar, except that in lieu of the tree – an image of the ruler – we have the king himself. Beneath his right hand is the ornamented tablet, where peace reigns, while beneath his left hand the scene is one of violence.

All this leads to the conclusion that our diptych must have been made especially for a ruler. Bearing in mind its stylistic features and chronological dating, that ruler can have been none other than Charlemagne.

History

Since the tablets were insignia of office, as is shown by the composition and meaning of their relief carvings, this raises the questions where they were carved and on what occasion they were presented to the emperor. As mentioned above, the relief carving has its closest analogies in the little ivory tablets in Ravenna and London showing Christ and symbols of the Evangelists. These are thought to have been made in northern Italy.[15] The workshop of bronze craftsmen at Aachen also originated from the Lombardy region.[16] It is clear that, before it moved to Aachen, there were artists in Italy, in any case in Rome, who were able to make such large pieces, for we know that Pope Hadrian I (✝ 795) had bronze doors cast for the atrium of St. Peter's.[17] In this region more than anywhere else, the traditions of antiquity were still alive. Italy maintained ties with Byzantium and with Near Eastern lands now Islamicized but still powerfully marked by their Greek heritage. In this region people will still have remembered the old Roman custom whereby a new consul, on acceding to office on the first day of the new year, presented an ivory diptych to his peers, the ruler, and his consort.[18] This suggests that our diptych too may have been presented to Charlemagne at an official's installation. Since the work in question was made in Italy around 800, we may deduce that this occasion was Charlemagne's own investiture and coronation as Holy Roman Emperor at Christmas/New Year 800/801.

If the emperor received our diptych as part of his coronation ceremony in Rome, its presentation will have been a highly symbolic act. This is clear from the symbolic content of the tablets, to look no further. The form of the reliefs was based on those of antiquity and most closely resembles the screens in Aachen, in which an ancient Roman motif is reproduced almost literally in a classical acanthus scroll. But its six square elements, placed one above the other, are joined on to the screens that Wolfgang Braunfels has termed "Frankish."[19] On the tablet with scenes of animals in combat, the uppermost complete field of the tendrillar tree has the same typical cinquefoil leaf that occurs in the ornament on the border of those bronzes (fig. 10). Apart from this, the five-pointed leaves of our tablet seem to be serrated, with fine ribbing, thus giving a richer impression. The sculptural working of the foliage and especially the lifelike modeling of the animals' bodies - the lions' heads, although tiny, are strikingly like the one on the "Wolf's Door" in Aachen[20] – show that our diptych was more greatly indebted to antiquity and closer to the earliest "classicistic" screens. Borne in the hands of the

fig. 7: Detail of the Animals in Combat tablet in fig. 5.

fig. 8: Detail of the ornamental tablet in fig. 5.

emperor, this is a masterpiece of Carolingian art, created at the moment when the imperial court at Aachen was on the verge of turning towards classicism.

Charlemagne's Writing Tablets

Einhard tells us that, on Charlemagne's return from his coronation in Rome, the emperor thought a great deal about the duties his new high office imposed upon him. In chapter twenty-five he relates the anecdote that when the emperor was advanced in years and suffering from sleeplessness, he used to practice writing and was in the habit of putting his writing tablets under his pillow so that they would always be ready to use. In other words, we are told, expressly and vividly, that the emperor always had his official writing paraphernalia with him. Einhard calls them *tabulas* and *codicellos*, using words whose sense exactly matches our tablets. The large uncarved ones could not have been described by any other term than *tabulas*; however, *codicilli* were not "booklets," the usual translation, but rather should be understood, according to the sense of the Latin, as documents – in particular imperial decrees of appointment – in the form of an ivory diptych with relief carving,[21] such as we have here.

The image of the emperor conveyed by this work is the same as that given by his contemporaries, of a gentle but strict ruler. Dungal portrayed him "governing the Roman empire in the fullness of virtue, preparing peace by exercising power."[22] We see him in the same way as Notker did, inspecting schools like Christ at the Last Judgment (Matt. 25:33), dividing the sheep to his right from the goats on his left – that is to say, gathering the assiduous and successful pupils on his right and bestowing praise on them, but ordering the lazy and unsatisfactory ones to stand on his left and scolding them.[23]

From Charlemagne to St. Gallen

Our analysis of the two ivory diptychs that reached St. Gallen from Hatto's treasure leads to the deduction that Ekkehart's statement identifying them as the writing tablets of Charlemagne mentioned by Einhard is plausible.

But how did these tablets reach Archbishop Hatto of Mainz? On this point Johannes Duft observes:

The fact that such valuable pieces, along with others which had belonged to Charlemagne, should have reached Mainz is clear from chapter thirty-three of Einhard, where he records, although in very summary form, the provisions of the emperor's will. This stated that pious bequests should go to twenty-one metropolitan cities of the Empire, among which Mainz was expressly mentioned, each of them to be handed over to its archbishop; one third of these gifts was to remain in the archbishop's own church, while two thirds were to be distributed among the suffragan bishops.[24]

Charlemagne also ordered one twelfth of his property to be given to his sons and daughters. To this twelfth were to be added "such other vessels and commodities... and domestic objects of value... as shall be found in the camera and vestiarium at the moment of death."[25]

It follows that the tablets, too, may have passed to members of the imperial family – most probably to Charlemagne's son, who succeeded him to the throne – and then have been bequeathed by the latter. It is noteworthy that, at the synod of St. Macra at Nîmes in 881, the assembled French bishops made use of Einhard's information about Charlemagne keeping his writing tablets to hand, in order to give King Louis III a stern warning to abandon his autocratic ways. The great Charles, they said, had always had three of his wisest counselors beside him, "and at the head of his bed he had writing tablets and a stylus, and whenever, by day or by night, he thought of something that might serve the well-being of the church or be of advantage in strengthening the Empire, he noted it down on these very tablets and then discussed it with the counselors whom he had about him."[26]

Under Charles III, Louis's brother and successor, Charlemagne's entire realm was again briefly reunited. Then, under Arnulf, in favor of whom Charles III had to abdicate in 887, Hatto rose to become the king's close

fig. 9: Corner palmettes from the ivory tablet with the symbol of John at the Victoria and Albert Museum, London (cf. note 7, no. 34).

fig. 10: Palmette ornaments from the second "Frankish" bronze screen in the Palatine Chapel in Aachen (cf. note 11, fig. 1).

fig. 11: Capital and palmette ornaments from the first "classicistic" bronze screen in the Palatine Chapel in Aachen (cf. note 11, fig. 12).

friend and adviser. His ascendancy took place at a time when the objects inherited by Charlemagne's family had been gathered together before being finally dispersed. For Hatto, described by Ekkehart as a man who knew how to acquire costly and interesting objects, the moment must have seemed ripe to secure some important pieces from this legacy.

The Tradition of the Tablets in St. Gallen

In St. Gallen the tablets of the large, smooth diptych were handed over to Tuotilo, who carved them for the *Evangelium longum*. These carvings still embellish its cover (figs. 1, 2). But what happened to the second pair of tablets, which was already decorated with reliefs, once they had been handed over to the abbey of St. Gallen?

Today they enclose Codex 60, a Latin Gospel according to St. John in Irish script from about 800.[27] But this binding was not put on until early in the nineteenth century – prior to 1827, when the manuscript acquired its present binding. Previously the tablets were bound to another volume. This is clear from a catalogue compiled in 1759 by P. (Pater=father) Pius Kolb, according to which the St. John Gospel had no ivory binding at that date. Another item of evidence is the fact that the smooth writing areas on the inside of the tablets have been roughened by cross-hatching, the lines of which are irregular. This shows that the plaques were once glued on to a support. Furthermore, in the corners of the plaques there are holes that have been filled in, which suggests that the plaques were formerly fastened on to something – no doubt the cover of a book. Now as early as 872-883, when a list of books was drawn up at the behest of Abbot Hartmut, there is mention of a lectionary with the remark "elephanto et auro paratum." This manuscript was still extant in St. Gallen in the sixteenth century, when Vadian mentioned it as "the epistle of St. Paul or lectionary, bound in ivory and decorated with gold and silver clasps"; he says explicitly that it "can still be seen in St. Gallen." Today there is no such volume there; but it is thought that the codex in question is identical with a lectionary from St. Gallen that has been in the Pierpont Morgan Library, New York, since 1905 as Manuscript No. 91.[28] This manuscript is very closely akin to the *Evangelium longum;* the second scribal hand employed on it is that of Sintram, who also wrote the *Evangelium longum.* Thus this codex may very well have been the volume that had the carved diptych as its cover. This would of course mean that the list of books compiled at Abbot Hartmut's behest was drawn up after the ivories had come to St. Gallen and had been bound to the codex, i.e., not earlier than 894. Since Hartmut died shortly afterwards, after 895, the list may have been made to commemorate his services to the library.[29]

Today Codex Morgan No. 91 has a modern binding. If its earlier cover was once embellished with our ivory tablets, then the manuscript was not, like the *Evangelium longum,* cut to fit the measurements of the diptych. Rather, it must have been either in progress or complete at the time when the plaques, which were somewhat too long for it, were fitted on. The only evidence that the tablets were once really bound to the codex comes from a paper flyleaf, whose watermark bears the arms of Abbot Beda Angehrn (1767-1796); apparently at that time the binding was renewed in connection with the great reorganization of the abbey library. This paper flyleaf shows traces of having been glued, pressed, and folded. The measurements of these traces correspond in striking fashion with those of the writing area on the inside of the tablets. This reinforces us in the conviction that the ivories indeed belonged to this codex.[30] They must have been removed from its covers before the manuscript left St. Gallen around 1800, and then, shortly afterwards, have been bound on to the Irish St. John Gospel, the present day Codex 60.

Translated from the German by Ann E. Keep

Notes

1 Johannes Duft and Rudolf Schnyder, *Die Elfenbein-Einbände der Stiftsbibliothek St. Gallen* (Beuron, 1984).

2 Schweizerisches Landesmuseum, *Jahresberichte* 94, (1985), p. 9; 95 (1986), pp. 14 f.; 97 (1988), p. 53.

3 Duft and Schnyder, op. cit, p. 22.

4 Richard Delbrueck, *Die Consulardiptychen und verwandte Denkmäler* (Berlin and Leipzig, 1929), p. 150, n. 33.

5 Ibid., pp. 4 f., 10.

6 Ibid., p. 9.

7 Adolph Goldschmidt, *Die Elfenbeinskulpturen aus der Zeit der karolingischen und sächsischen Kaiser, VIII-IX Jahrhundert,* vol. 1 (Berlin, 1914; reprint ed., Berlin, 1969), pp. 4, 6.

8 Ibid., pp. 61, 81, no. 164.

9 Ibid., pp. 20 f., nos. 32-34.

10 Hans Belting, "Probleme der Kunstgeschichte Italiens im Frühmittelalter," *Frühmittelalterliche Studien,* vol. 1 (Berlin, 1967), pp. 118 f.

11 Wolfgang Braunfels, "Karls des Grossen Bronzewerkstatt," *Karl der Grosse,* vol. 3 (Düsseldorf, 1965), pp. 190 f.,

12 Richard Ettinghausen, *From Byzantium to Sasanian Iran and the Islamic World,* The L. A. Mayer Memorial Studies in Islamic Art and Architecture, vol. 3 (Leiden, 1972), pp. 36-39, 44 f.

13 Janine Sourdel and Berthold Spuhler, *Die Kunst des Islam,* Propyläen Kunstgeschichte, vol IV (Berlin, 1973), pp. 177-182.

14 Gilbert Lazard, *Les premiers poètes persans* (Paris, 1964), p. 54.

15 Hermann Fillitz, "Die Elfenbeinschnitzereien zur Zeit Karls des Grossen," *Aachener Kunstblätter* 32 (Aachen, 1966), pp. 40 ff.; Marguerite Menz-von der Mühll, "Die St. Galler Elfenbeine um 900," *Frühmittelalterliche Studien,* vol. 15 (Berlin and New York, 1981), p. 421.

16 Braunfels, op. cit., p. 199.

17 Ibid., p. 169, A6.

18 Delbrueck, op. cit., p. 6.

19 Braunfels, op. cit., pp. 171 ff.

20 Ibid., pp. 195 f., fig. 25.

21 Delbrueck, op. cit., p. 3.

22 Wolfram von den Steinen, "Karl und der Dichter," *Karl der Grosse,* vol. 2 (Düsseldorf, 1965), p. 86.

23 Notker der Stammler, *Taten Kaiser Karls des Grossen,* ed. Hans F. Haefele, Monumenta Germaniae Historica, Scriptores, vol. 12 (Berlin, 1962), p. 4.

24 Duft and Schnyder, op. cit., p. 24.

25 Percy Ernst Schramm and Florentine Mütherich, *Denkmale der deutschen Könige und Kaiser* (Munich, 1962), pp. 22, 90 f.

26 W(ilhelm) Wattenbach, *Das Schriftswesen im Mittelalter,* 3rd ed.(Leipzig, 1896; reprint ed., Graz, 1958), pp. 65 f.; Migne, P.L. 125, 1084 c8.

27 Duft and Schnyder, op. cit., pp. 29 f.

28 Meta Harrsen, *Central European Manuscripts in the Pierpont Morgan Library* (New York, 1958), p. 11.

29 Paul Lehmann considers that the list of books compiled at Abbot Hartmut's behest must have been prepared prior to 884, because Ratpert, who completed his Casus in that year, used it. For arguments to the contrary, see Duft and Schnyder, op. cit., p. 31.

30 The flyleaves have traces of folding along the lower and upper edges, the space between them measuring 252 mm (the inside length of the tablets is 249 mm and the depth 1-1.5 mm). They also have a line made by pressure, which runs parallel to the outer side of the flyleaf, 15 mm from it, and this has a counter-trace 85 mm away (the width of the writing areas of the tablets is 83-86 mm). One can also clearly see the places where clasps were glued on, which are at approximately the same height as the slots cut in the tablets and are of corresponding width. The diagonal hatching on the writing areas, roughening the surface, is evidence that the tablets were indeed once glued on to a support, probably of paper.

I am grateful to the Research Foundation of Zurich University for enabling me to undertake a personal inspection of manuscript M 91 in the Pierpont Morgan Library, New York.

Mittelalterliche Bibliothekskataloge Deutschlands und der Schweiz, vol. I, Munich, 1918), p. 85,

Picture credits

figs. 1, 2, 5: P. C. Merkle, Beuron

figs. 3, 4, 7, 8: Schweizerisches Landesmuseum, Zurich

Peter Hoegger

The Fourteenth-Century Gradual of Wettingen

The High Gothic gradual which we are placing at the center of our considerations was named after the Cistercian monastery of Wettingen in Aargau; it has, however, no connection with the monastery, nor with the Cistercian order in the wider sense. To judge from the text and the iconography, the manuscript was created for a monastery of the Augustinian hermits. At some time unknown, perhaps during the Reformation, perhaps during the Thirty Years' War, it found its way as a piece of "art-historical jetsam" to Wettingen, where it remained until the sacking of the Aargau monasteries in 1841. Since then it has been in the cantonal library in Aarau (MS Wett Fm 1-3).

Of the six folios which originally made up the gradual, only three remain. Each volume measures about 24 x 16 inches and has five single-column lines of text and five four-line staves on each page. Volume I contains the winter and volume II the summer part of the so-called Proprium de Tempore (anthems for the festivals of our Lord); volume III contains the sanctoral (anthems for saints' days). All three volumes are richly supplied with illuminated initials: at the start of the text for weekday anthems there are red and blue letters with pearl and bud filigree decoration; before the anthems for ordinary Sundays there are red and blue initials wound round with filigree work filled in with buds and cross-hatching; in volume I this is enlivened by tendrils of outlined leaves, and in all volumes accompanied by extremely delicate, fire-work-like fleuronné decoration (fig. 34). This initial illumination is more extensive at the beginning of the Christmas week anthems

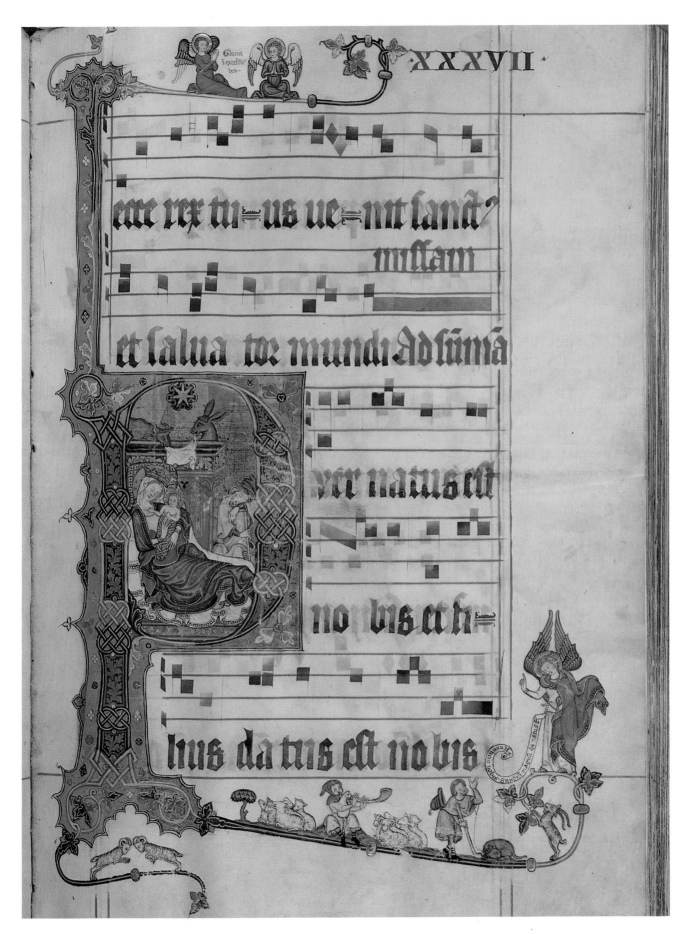

Color plate I: Aarau, Cantonal Library, Ms. Wett Fm 1 (Wettinger Gradual, vol. I) fol. 27. Initial P with Birth of Christ and Message to the Shepherds.

(in volume I) and in a few Mass anthems (in volume III), where letters appear in gold with various opaque watercolors, especially when introducing the festivals of the church and the main saints' days. In these there are magnificent initials of staff and woven work on square or vertical rectangular gold cushions about half the width of the text area. They include Christmas, Epiphany, and Palm Sunday illustrations (in volume I) (figs. 4, 7, 10; color plate I), Resurrection, Ascension, Pentecost, Trinity, Corpus Christi, Consecration of Churches (in volume II) (figs. 2, 14, 16, 17, 19), Presentation in the Temple, Annunciation, Death of Mary, the Madonna and Child with St. Anne, and All Saints (in volume III) (figs. 21, 23; color plates II, III). An initial I for the feast of St. Augustine, which was originally in fourth place in volume III, was stolen before the last world war. Each letter-cushion leads, on the left-hand side of the page, into a gold bar covered with long leafy stalks which at top and bottom send out towards the right-hand side tendrils bearing amusing depictions of figures or birds (figs. 1, 2; color plates I, II).

The Wettinger Gradual throws up a series of questions concerning the history of tradition, paleography, liturgy, and the history of art. Hitherto, research has managed to shed light only on a minority of these.[1] Art historians have concerned themselves in most detail with the script. The technically and artistically outstanding pictorial initials were published and dealt with in a monograph by Marie Mollwo in 1944, and this earned them their deserved recognition in later literature.[2] In recent decades, however, the illuminations have increasingly become the stepchild of art research, with deeper study falling behind.[3] It seems to us that now is the time to take up once more the study of illuminated initials in the gradual, even if the present fluid state of research into Gothic illumination means we are not in a position to expect thoroughly conclusive results.

The Two Masters of the Gradual and their Workshop in Cologne

Marie Mollwo's painstaking stylistic analysis has shown that two book illuminators principally worked on the gold and pictorial initials, and on the filigree letters. The stylistically "older" of the two worked on the first volume, the other, stylistically the "younger," produced the second and third volumes of the gradual.[4] The older master shows a feeling for finely tuned depiction of mood (figs. 4, 7, 10). Robust, warm-hearted figures in heavy robes lend a childlike, direct flavor to his scenes. With a sure feeling for shape he builds letters and figures into a convincing whole. At the same time, particularly in the Christmas scene, he places at the service of the compositions a variegated chromatic rhythm covering the whole gold background (color plate I). His colors – vermilion, subdued blue, verdigris, and carmine red predominate on his palette – are laid on opaquely with broad strips of shadow, while essentially not departing from the pencil sketch. He enjoys emphasizing contours and edges of garments with sharp accompanying lines, so that now and again, for example on Mary's robe in the Epiphany picture, they seem to take on a melodious, undulating movement. The illuminator of the gradual's first volume comes across in all his pictures as an artist who exploits drawing and coloring as largely independent, but mutually enhancing, means of expression.

The younger master reveals himself to be fundamentally different (figs. 14, 16, 17, 19, 21, 23; color plates II, III). His pictures are characterized by violent changes of mood and impulsive reactions on the part of the figures. Seriousness, grief, and terror show on their features; gestures and postures are expressively exaggerated, without the varied combinations of facial and dynamic motifs being able to conceal that they are limited to only a few standard types.[5] The painting technique matches the tense, sometimes dramatic, pictorial scenes. While the older master practices careful and binding preliminary drawing, under the younger one's illustrations lie light pencil sketches; optional suggestions sometimes undergo heavy alter-

Color plate II: Aarau, Cantonal
Library, Ms. Wett Fm 3
(Wettinger Gradual, vol. III) fol.
23v. Initial V with Annunciation
of the Virgin.

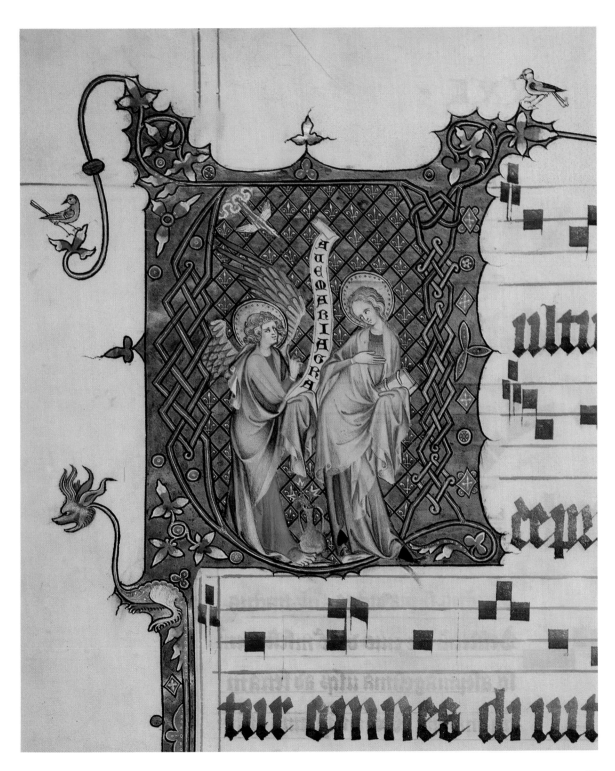

ations during conversion to color pictures. The colors, which are enriched with grey, yellowish pink, and lilac, experience innumerable gradations from enhancing white to saturated dark tones (color plates II, III). Applied sketchily with a nervous brush, they produce, on the one hand, intense light and shade effects, and, on the other, a vibrating overall impression. The young master succeeds much less well than his predecessor in fitting the figures into the field of the letters (figs. 2, 21), and the painter's obvious weaknesses show in a certain compositional awkwardness (fig. 14), as well as in a stereotyped repetition of individual pictorial components.

As the period of origin of the gradual, the years around 1330-1335 have always and unanimously been suggested.[6] On the question of provenience, researchers have been less in agreement. H. Swarzenski and other authors following him have favored the Swiss and Upper Rhine areas;[7] Marie Mollwo and Ellen J. Beer have proposed the Lower Rhine, in particular Cologne.[8] It is true that backgrounds of leafy tendrils and the occasional bust medallions in the filigree letters of volume I are firmly anchored in Cologne illumination (fig. 34). Further evidence for Cologne is that the hand of the older master of the gradual can be clearly recognized in the miniatures of a Willehalm manuscript commissioned by the Hessian landgrave in 1334 and now in Kassel (figs. 3, 6, 36, 38). It must have been produced, if not in the nobleman's own residence in Marburg, then most probably in the nearby Rhine city.[9] Of course, these arguments connect only the decoration of the first volume and the work of the older master with Cologne. Nothing particularly native to Cologne is observable in the work of the younger master. Yet there is no doubt that the younger master worked in the same place as his colleague – either beside him or immediately after him. This is evidenced by the page layouts as a whole (figs. 1, 2) and many of the decorative details, which are clearly derived from the older master's compositions and sometimes give an impression of weary quotation (observe the absolutely straight lines around the strips and cush-

ions, and their pedantically placed lozenge and circle motifs) (fig. 23).[10]

In the case of the Wettinger Gradual, the search for contemporary stylistic affinities would seem less significant than the question of stylistic precursors. It has been noted and stressed from an early date that strongly northwest European features are operative in the style of both the older and the younger master. Marie Mollwo attempted to demonstrate in the older master influences of late-thirteenth-century Parisian illumination, in particular the high achievements of the "style Honoré," while for the younger master she assumed the same workshop origin as for the Parisian illuminator Jean Pucelle (known to have been active about 1320-1334).[11] Ellen J. Beer puts forward as further possible sources certain northeastern French book-illuminating centers, such as Amiens, which were developing before and during the "style Honoré" period, and which both played a part in developing that style and pointed in quite different directions.[12]

The Older Master of the Gradual and Book-Illumination in England

Apart from Parisian and French provincial illumination, there is a third possible source for the style of the gradual, which has never been considered seriously: English book illumination at the end of the thirteenth century and the beginning of the fourteenth.[13] Yet essential principles of the older master's compositional style, as well as some individual decorative elements, are quite clearly prefigured here. The Tenison Psalter, written in London before 1284 – a late example of the "Court Style" of the period shortly before the emergence of East Anglian illumination – turns out to be a key work for understanding the style of the gradual (Brit. Mus., Add. 24686) (fig. 25).[14] Its well-known Beatus page exhibits the wide edging and compact linking of the margin decoration to the cushion of the initial that also appear on the Christmas page in volume I of the gradual (color plate I) and on the first illuminated page of the Willehalm MS (fig. 3). By contrast, such a union of

margin decoration and initial area cannot be found in the Honoré circle's work (e.g., the Gratian of 1288 in Tours Municipal Library, 558), or in earlier or later Parisian works. In these, the marginal decoration is delicate and connected to the cushion – mostly by fine linking elements, sometimes in the form of imaginatively drawn fabulous creatures (fig. 28).[15] Clear similarities of conception between the psalter and the older master's compositions are also shown by the Bible scenes, the amusing vignettes and shields placed on the beams and tendrils in both works (figs. 25, 3; color plate I),[16] the trellis-work in the bodies of the letters which appear in both places,[17] the common decorative detail in the lobed "cabbage leaves" viewed from the side (figs. 4, 10),[18] and the vine leaves linked together by a circular tendril (figs. 25, 7).[19] Finally the margin decoration must be mentioned: in most of the psalter's folios and in the work of the master of the gradual, it consists similarly of a rigid strip on the left with lively tendrils sprouting from it (figs. 27, 1, 3, 7). The older master's unusual outlines, drawn in the shape of a denticulated wheel round the spirals of tendrils (fig. 10), do not, it is true, have an exact predecessor in the Tenison Psalter; but in the foliage arranged radially around the spirals, an early, embryonic form of them can be recognized (fig. 25).[20]

Around the turn of the fourteenth century and briefly thereafter, the features of the Tenison Psalter saw a direct continuation in East Anglian works of illumination. While the East Anglian manuscripts leave the Tenison far behind with respect to richness of form and exuberance of page design, in some respects they retain the latter's generous form, as seen, for example, in the Ormesby Psalter, with its compactly linked letter-cushions and marginal strips (Oxford, Bodl. Libr., Douce 366).[21]

Besides the described foliage (fig. 30), the trellis knots (fig. 11), vignettes, and shields, further vegetable elements appear which can clearly be seen as forerunners of the style of the older master of the gradual: the trefoils as a filling for the spandrels (figs. 11, 4, 10) and the curious vine or oak leaf whose foremost point ends in a stalk (figs. 30, 7).[22]

As far as can be judged at present, hardly any of the many motifs mentioned is native to Paris; only for the circumscribed mise-en-page, with its firm left-hand bar sending out shoots top and bottom, is there a distant relative as early as the third quarter of the thirteenth century and more or less convincingly similar examples in the 1280s.[23] This situation rules out a Parisian origin for the older master of the gradual, not only because the Tenison Psalter shows an analogous page layout (fig. 27), but also because the union of marginal strip and letter field already mentioned, which is found on the Beatus page of the psalter (fig. 25) and can be identified in the master of the gradual's work (figs. 1, 3, 4, 7, 10), is totally atypical of Paris. In the fourteenth century, not Paris, but England presents those page designs that are nearest to the Tenison Psalter and the gradual, and stand chronologically and typologically between these two monuments. Examples are to be found in the presumably Middle English Grey-Fitzpayn Book of Hours (Cambridge, Fitzw. Mus., 242) and a group of manuscripts related to it (fig. 26).[24]

The tone of the decorative style in the gradual and the Willehalm manuscript, so obviously foreign to the Honoré circle, is also apparent in the nature of the gold ground and its treatment. Every illuminated initial by the older master of the gradual is consistently backed by a homogeneous gold ground, which occupies the whole area of the cushion and extends seamlessly into the left-hand decorative strip and into the furthest sections of the tendrils (color plate I). This integral gold ground decisively strengthens the unity of the margin and the letter area. It is in pronounced contrast to the grounds of the initials and decorative strips in Parisian illumination, which without exception change from gold to blue and red; yet it is similar at least to the general practice in England.[25] In England the unified gold ground can also be found, although only rarely, and hardly as extended over letter cushion and margin as in the initial illuminations of the master of the gradual. Very early and eloquent examples may be seen in the Salvin Book of Hours from the diocese of Lincoln (Brit.

Mus., Add. 48985; after 1262), in which the initial V under Pentecost appears in a gold cushion and with a polychrome bar.[26] The Beatus page of the Tenison Psalter, on the other hand, shows a diamond-patterned frame on a gold ground, with colored spandrels around the gold center of the rectangular letter area contrasting with a unified gold ground effect (fig. 25). Finally, in the Ormesby Psalter there is an initial Q with round letter area, the two right-hand spandrels gilded, and the two left-hand spandrels colored (around 1300) (fig. 11).[27] In the gradual's Epiphany picture, and even more strikingly in the Palm Sunday picture, the gold ground is ornamented with fine rows of dots lining the inner edges of the cushion and the letter, and with informally scattered dot-rosettes (figs. 7, 10). This type of dotted ornamentation was used in English illumination from the early thirteenth century;[28] it is particularly frequent in East Anglian miniatures, as can be seen from the Ormesby Psalter, the Tickhill Psalter (New York, Publ. Libr., Spencer 26), and the Stowe Breviary (Brit. Mus., Stowe 12) (figs. 11, 12, cf. 26).[29] In Paris the row of dots along the edges never occurs, and if rosettes are used as a motif, then not in the haphazard manner of England and of the gradual, but integrated into a strict rectangle or a diamond-patterned frame.[30]

Northeastern France and the Decorative Style of the Older Master of the Gradual

In so far as our comparisons permit of a judgment, a Parisian origin for the older master of the gradual cannot be assumed; his "English" motifs are too evident, his similarities to Honoré and his followers too limited to unconvincing generalities. Whether his stylistic affinities to London courtly art and East Anglia should lead us simply to suppose an English origin, however, remains questionable. Beside the rugged, capricious, and often literally overflowing textual ornament in the East Anglian manuscripts, the orderly, clearly-edged miniatures of the gradual and Willehalm appear almost austere, as if their author had valued neat clarity above any creative fantasy (com-

pare fig. 30 with figs. 1, 7). It is hard to imagine the master of the gradual as a direct descendant of an early-four-teenth-century English workshop; one would instead be induced to conclude that he was not in contact directly with the island's art, but indirectly, through an artistic region on the continent that had itself been influenced by England.

Since Count Vitzthum's researches we know that Ghent and Bruges, French Flanders, Artois and Picardy, and other areas in northeastern France were such regions.[31] The nature and degree of English impact in these regions were very varied; the western elements of style are always mixed with indigenous, including southern, Parisian elements. In our context, two localities are particularly significant: Amiens-Corbie and Cambrai. The Psalterium-Horarium of Yolande de Soissons (New York, Pierp. Morg. Libr., M 729), which is supposed to have been illuminated between 1280 and 1285 in Amiens, is on the same level of style in the layout of its pages as the approximately contemporary Tenison Psalter (figs. 32, 25). The initial cushion firmly connected with the margin strip, the vignettes, and the woven rosettes give this away, as do the leaves, with their denticulated outline standing out radially from the spiraling tendrils.[32] And, like the psalter, the Horarium resembles the illuminated initials of the gradual, indeed it shows even more similarities, for example, in the way its tendrils fork into the page corners in two opposing spirals (compare the tendril joints on the Christmas page, color plate I) or in the frequent zigzag friezes packed with trefoils and tubers at the edges of the pictures (figs. 4, 8, 9, 10, 32).[33] Trellis-work as part of the body of the letter is limited in the Horarium to the Beatus B at the start of the psalter text; possibly this is a not entirely coincidental parallel with the fact that the master of the gradual also designed only his first initial (Christmas) with trellis-work.[34]

Not every detail that we have indicated as prefiguring the gradual in the decorative style of English manuscripts is also to be found in the Yolande manuscript. Where the

cabbage leaf is recognizable as such (for example, fol. 123), it appears in a very undeveloped form little different from the misunderstood vegetable shape customarily used in Parisian book illumination.[35] In other Amiens manuscripts, however, the cabbage leaf is unmistakable, as is the nearby spandrel-filling trefoil: in the Psalter Lat. 10435 in the Bibliothèque Nationale in Paris (around 1290) (fig. 31) and in the missal from Corbie D 157 in Amiens (around 1300) (fig. 35).[36] Both of these are monuments which also demonstrate that at the time northeastern France was in no sense behind the Tenison Psalter in the superb use of trellis-work initials, indeed even surpassing it.[37]

The quest for continental examples of the integral gold ground motif leads from Amiens to French Flanders. From the area around Arras-Lille-Tournai, the Marquette Bible, written about 1270 and formerly in the Ludwig Collection in Aachen, may be cited; in it the gold ground of the letter areas spreads into every corner of the remarkably zigzag marginal strip.[38] Even more important are several codices that can be localized in Cambrai: a psalter in Baltimore (Walters Art Gallery, W 45) and a two-volume breviary in Cambrai itself (Bibl. Mun., 102-103), both dating from the final decade of the thirteenth century;[39] lastly there is a Horarium, also in Cambrai (Bibl. Mun., 87), which may have been produced in 1312 (figs. 39-41).[40] It is true that in none of these manuscripts can the effect of a gold ground lying behind an entire miniature painting be detected to the same degree as in the initials of the gradual, but the common features are abundantly clear. Just as striking in the Cambrai items is the existence of a whole range of other motifs typical for the style of the first master of the gradual and to be found only in part in the English and Amiens manuscripts. To name but a few: the cabbage leaf (even its dotted veins are there!), the leaf stalk branching out from and covering the tendril stem, the contrarotating pair of spiral tendrils, the dotted edges to the gold ground. Especially deserving of attention are the strips and tendrils framing the script area: the psalter and the breviary show their relationship to the Tenison and Ormesby Psalters in their four-sided framing of the script (figs. 25, 30); the Horarium, on the other hand, in which any right-hand edging is lacking altogether, and in which the script area is bounded above and below by lively outstretched tendrils, points forward to the design found in the gradual.[41]

With the manuscripts mentioned above, Amiens and Cambrai are closer to the style of the older master of the gradual than any other known and comparable monuments. With regard both to the overall page layout and to the individual motifs, there are many things that can be considered close predecessors of the illuminated initials in the first volume of the gradual. Nevertheless, no predecessor that would lead straight to the gradual as regards motifs has emerged from our study of the northeast French works. For in none of them does the style of miniature painting show the simple construction wholly dominated by the gold ground and the moderate overall aspect, avoiding all extravagance, that characterize the three illuminated initials in the first volume of the gradual. One final piece in the history of the gradual's stylistic origins remains obscure. For this reason the possibility of further stylistic influences, as yet not clearly recognizable, must be reckoned with. Considering the dominant character of the gold ground, one should examine whether the area of Lake Constance, and not only northeastern France, might be an important stylistic source area. In view of the fact that in the English manuscripts the gold ground is never employed to the same degree and as consistently as in the gradual, and also that in the Cambrai manuscripts it does not cover such large areas as in the gradual, works such as the late-thirteenth-century Nuremberg gradual (German. Nationalmus., 21897) or the well-known gradual from St. Katharinenthal, dating from the first decade of the fourteenth century (Landesmuseum Zurich) gain significance as possible conveyers of ideas (fig. 42).[42] Certainly nowhere else in western Europe at that time did the golden background for initials gain such prevalence as in upper Germany, and there, in the scriptoria of Breisgau and Alsace, it had a substantial tradition.[43]

Northeastern France and the Figure Style of the Older Master of the Gradual

After focusing our attention exclusively on the page design and the decorative style of the older master, it is time to take the style of the figures into consideration. Although this style is very distinctive and unified in its nature, it cannot be traced to its origins as a whole, but only when divided into several components. However, once more the track leads to northeast France. Indications are to be had first from a comparison with the already mentioned missal D 157 in the Amiens Library, which was illuminated for the monastery of Corbie, probably about 1300.[44] All essential features of the garments worn by the figures in the gradual and in the Willehalm can also be traced in the initial figures of this Amiens manuscript: the broadly brushed depths of shadow and the misty white highlights; the massive folds and the decorated flow of the edges highlighted in white (figs. 37, 38, 4, 7, 10). Most surprising are the parallels that appear not only in individual motifs but in entire garments, as with the clothing worn by Queen Arabel (on folio 15 of the Willehalm) and Queen Bathildis (on folio 29 of the missal) (figs. 35, 36). In the most significant work in our group of Amiens manuscripts, the Psalterium-Horarium of Yolande de Soissons dating from around 1280, the garments, modeled in light and dark, are often also marked by sharply drawn folds, a not inconsiderable difference to the soft representation of garments in the gradual; on the other hand, the portrayal of the faces is entirely comparable, as can be seen from the scenes of the healing of the blind man and the entry into Jerusalem (figs. 8, 9). The high foreheads, the pupils looking in amazement from the corners of the eyes, and the thick tresses of hair over the ears and on the shoulders all reappear in the figures of the older master of the gradual. Despite occasional differences due to different artists' hands and the periods at which they were created, the scenes in the Horarium and in the gradual are played by figures portrayed in an exceedingly similar, childlike and warmhearted mood.[45]

As a criterion for comparison, this "mood of the picture" radiated by the actors is perhaps more enlightening than any other characteristic of the figure style. Consequently mention should be made at this point of a cycle of miniatures that, although of a very individual nature as a whole, nevertheless bears a relationship to the work of the master of the gradual by reason of the pure spontaneity of its figures; furthermore, in several striking details it displays surprising similarity to the latter. This is the picture codex Nouv. acq. fr. 16251 in the Bibliothèque Nationale in Paris, with scenes from the life of Christ and the holy martyrs.[46] The work was probably executed around 1280 in the diocese of Cambrai. In many of its figures – for example, the angel and Mary in the Annunciation (fig. 5) – the identical facial type and sensitive gestures we have seen in the gradual and the Willehalm (figs. 7, 10, 6) can be observed; in addition, all figures show the familiar heavily-robed form, even though their stances and movements appear considerably more varied and robust than in the work of the master of the gradual. Ellen J. Beer has emphatically drawn attention to the art-historical significance of this codex. In it she sees the representative of a northeastern French concept of style that not only essentially affected later continental illumination (Lorraine, the Upper Rhine, Lake Constance) but also shows a relationship to contemporary Anglo-French Apocalypse manuscripts, a fact explicable only by contact with English precursors.[47] Thus for the gradual's figure style, as for its decorative style, indirect English stimuli must be presumed behind the direct northeastern French influences.

Paris as Probable Home of the Younger Master of the Gradual

As far as the illuminations of the younger master in the second and third volumes of the gradual are concerned, the prime consideration is what we mentioned at the outset. In the basic features of his page design as well as in many a detail, he shows himself to be a true successor to his older colleague. Rather than go into detailed descrip-

tive comparisons, one can convince oneself of this fact better and faster by direct observation, for example, by comparing the pictures of Palm Sunday and the Resurrection (figs. 1, 2). Not infrequently the obedient dependence of the younger master on the older one's model has something clumsy or forced about the composition, for example, the awkwardly sturdy zigzag junction above the picture of the Trinity (fig. 16) and the constrained tendril growing from it. The frequent repetition of motifs, such as the vignette with hare and hound – which recurs nine times – or the stereotypically positioned bird on the branch, are the result of his dependency on his model.

On a few occasions the younger master surprises one with details lacking in the older master's pictures. As with so many motifs of the older master, parallels for some of these cases can be seen in northeastern France. The already mentioned Amiens manuscript Lat. 10435 and a medical treatise by Roger of Salerno (Brit. Mus., Sloane 1977; around 1300) (figs 29, 31) will serve as evidence for the use of the bizarre long-haired masculine masks and the large loop of tendril in the initial illumination for the feast of Consecration of Churches (fig. 19).[48] The characteristic placing of the leg and feet of Simeon in the Presentation scene (fig. 21) is rooted in the still older provincial French tradition, to which, among other things, the Psalter of Gérard de Damville from Saint Omer belongs (New York, Pierp. Morg. Libr., M 72).[49] Godparent to all these motifs was English illumination, to which attention can be drawn here only in passing.[50] It would be helpful to know how the elements of Anglo-French style found their way into the younger master's initial illumination. Did he take them from his colleague's repertoire in Cologne? Or did they already come to him at an earlier date – independently of the older master – in northeastern France? Perhaps in a studio in Picardy or Artois that was also the first meeting-place of the two masters of the gradual?

Whatever the answers to such questions, the crucial discovery in this connection is that neither Cologne nor northeastern France can have been the decisive breeding-ground for the younger master's style. This is proven by a range of stylistic and iconographic features in his painting which quite clearly indicate Paris. Long practice in Parisian illumination is indicated by the dragons growing from the stem of a tendril or a spiraling leaf, such as the master places in his Annunciation picture or in the gold initials of the Mass (fig. 33; color plate II).[51] Also Parisian, or, more accurately, mediated via Paris, are his few Italianisms: the boxed perspective altar in the Presentation picture (fig. 21), and particularly the lumpy soil in the Ascension and in the picture of the Virgin and Child with St. Anne (figs. 14, 23). This motif betrays its origin in the art of the illuminator Jean Pucelle and his circle, where it can be seen (at the earliest perhaps in the Breviary of Belleville around 1323-1326) as a borrowing from the Sienese painting of the early Trecento.[52] For the illuminated initials of the younger master, and thus for the dating of the gradual as a whole, there is an approximate terminus post quem in the mid-twenties of the fourteenth century.

Pucelle's miniatures in the wider sense have already been mentioned several times as a principal source for the figure style of our master of the gradual,[53] and there can be no doubt that the latter's design owes much to the seriousness and thoughtful profundity of Pucelle's figures. Furthermore, the younger gradual illuminator's sketchlike application of color comes noticeably close to the pencil technique of the Parisian master, as can be seen especially clearly, for example, in Pucelle's grisaille drawings in Jeanne d'Evreux's Book of Hours (1325-1328) (fig. 13).[54] Meanwhile one must, in agreement with Marie Mollwo, explain the stylistic affinity with Pucelle rather by a previous common workshop origin than by a contemporaneous direct dependency. The figures in the gradual appear more robust and abrupt than in the contemporaneous work of Pucelle; their intense gazes and gestures fit less well with each other; hardly a trace of the gentle, lyrical tone of the scenes of the Book of Hours is to be seen here (figs. 14, 17; color plate III). The forces that were determinant in the development of the younger master must have been active

years, if not decades, before Pucelle's appearance. It is not easy to cite works from among the known monuments of Parisian book production around 1300 that might give an idea of the master's artistic background. The book illuminations attributed to Honoré during this period, which must perforce be taken into account as a possible inspiration, are so outstanding that one hardly dares make further comparisons with the illuminated initials of the gradual master. Yet it seems that in the expressively excited figures of the master of the gradual something of the charismatic, serious spirit found, for example, in the figures of Philip the Fair's breviary lives on (fig. 18).[55] The impression is based on similarity of facial features: the outlines of the eyes, the ruffled beards, the bunches of hair over the foreheads, or the movements of the hands with their stiffly bent fingers. The bodies of the gradual's figures differ quite considerably from the metallic, hard modeling of light in the breviary. Rather than being compared with any work of Honoré's, they should be examined in the context of a manuscript like the Missal of Châlons-sur-Marne, probably illuminated in Paris and now in the Arsenal Library in Paris (MS. 595); a work from the late 1290s, it has a thoroughly individual garment style (fig. 15).[56] In this work, not only the sketchlike modeling technique and the outlines depicted by areas of shadow and color contrasts, but also the vertically meandering points of the garments and in particular the masking of the bodily shape by deep folds in the cloth all appear as mature stylistic features (figs. 14, 16, 23; color plate III).

Finally a word must be said about the iconography of the pictures in the gradual. So far as can be recognized at present, it essentially supports the supposition of a Parisian origin for the younger master. Several individual features in the gradual's pictures turn out, on close consideration, to be rare and primarily, if not exclusively, used in Paris. Especially fruitful is the comparison with a missal produced around 1330 for the Sainte-Chapelle in Paris and now kept in Lyon, which, as long as thirty years ago, was mentioned by Gerhard Schmidt in connection with the younger master of the gradual (Bibl. Mun., 5122).[57] In the picture of the Presentation, Simeon appears with a halo, as he does in the corresponding scene in the gradual; but both differ from the normal depiction, which is without any halo (figs. 21, 22).[58] In the same scene the figure of Joseph as Mary's companion is missing from both versions, his basket of doves being placed in the young girl's hand. Other unusual motifs appearing in both places are the blue, red, and white striped drape hanging from a horizontal rail over Anne's bed (figs. 23, 24), and Mary's right hand held in front of her breast in the Annunciation (color plate II).[59] It seems to us that the younger master's Church Consecration picture also demonstrates his broadly Parisian origin. It reproduces almost point by point the composition of a picture codex of the life of St. Dionysius (Bibl. Nat., Nouv. acq. fr. 1098), produced in Saint Denis, which, remarkably enough, does not illustrate a church consecration but the entry of the saint into Paris, thus depicting a quite different topic (figs. 19, 20).[60]

Conclusions

Although the foregoing exposition still leaves a range of questions open, it essentially yields two results. Firstly, it puts us in a position to understand the two masters of the gradual, not only through their individual stylistic features, but also according to their origins and artistic development. Secondly, it enables us to recognize more precisely the long-acknowledged determinant role of France in the development of Gothic book illumination along the Rhine and eastward of it.

The older master clearly emerges as the driving force in the Cologne gradual workshop. In the cases of the Willehalm and the gradual, he is visibly the person addressed by the client; and where, as in the case of the gradual, he hands the work over to his younger colleague at a certain point, his authority is so obviously persistent that the latter takes him as an obligatory model both for the overall format and for many details. The older master received his basic artistic inspiration in northeastern

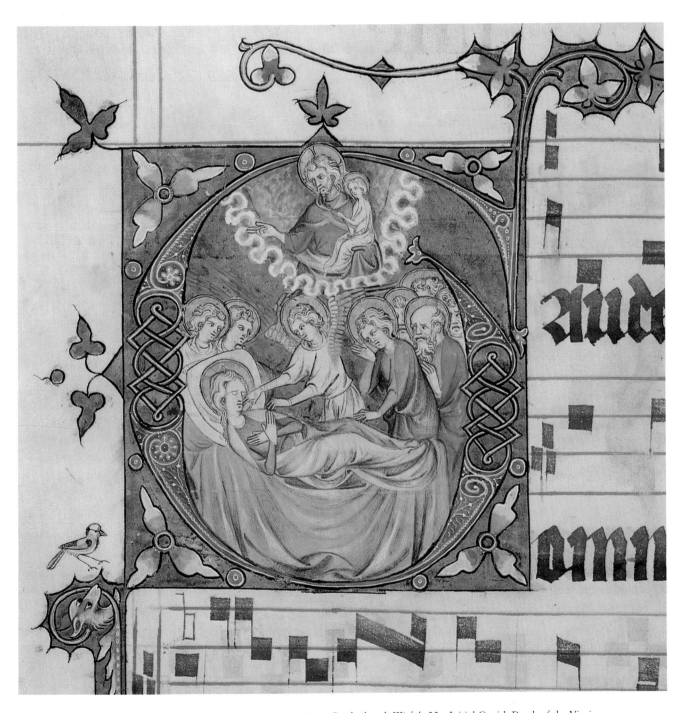

Color plate III: Aarau, Cantonal Library, Ms. Wett Fm 3 (Wettinger Gradual, vol. III) fol. 55v. Initial G with Death of the Virgin.

France, more precisely in Picardy (Amiens) or Artois (Cambrai),[61] a region that, during his apprenticeship years around or shortly after 1300, lay under the more or less enduring influence of the "Court Style" and East Anglian book illumination, and clearly had very little stimulus from the Honoré circle of Paris. The older master can hardly have known the capital of his country and its courtly book-production; rather, after settling in Cologne, he will have taken over local forms of ornament, such as the background of leaf and tendril, and possibly also motifs originating on the Upper Rhine, such as the "integral" gold ground.

The younger master of the gradual gives the impression of a strangely dualistic artist. Besides the borrowing from his older colleague's repertoire, his compositions are marked by highly individual illuminated initials which in the best cases are in no way inferior to the older master's scenes and even surpass them in vital expressive power. In all probability the artist received the decisive stimuli for his figure style in Paris, where he must have known Pucelle and where he likely came into contact much earlier with works of the Honoré circle. Hardly anywhere other than in Paris could he have become familiar with the curious special iconographic forms he – knowingly or unknowingly – employed in several of his pictures. The northeastern French decorative motifs that can be recognized in his work may not have come into his style until his contact with the older master – or perhaps earlier, in northeastern France itself, where he may have lived for some time before settling in Cologne on the Rhine.

Seen in the larger context of overall European stylistic development, both masters of the gradual may be counted among those painters who carried French provincial and Parisian style to Germany during the period from the final years of the thirteenth century through the fourth decade of the fourteenth.[62] In this process, Paris played a far smaller part as a contributing partner than the high quality of its best production might lead one to suppose. Especially in Cologne, the first port of entry for western Gothic into central Europe, the influence of Parisian book production was only slight before the appearance of the younger master,[63] and that lends this illuminator special importance in the city's art history. The Parisian components in the gradual do, however, fail to reach the high standard that characterizes the illumination of, for example, the upper Austrian monastery of St. Florian, which in the early years of the fourteenth century was greatly influenced by the French courtly style. This is connected with the younger master's limited possibilities as well as with the fact that in the 1330s he was clearly no longer able to draw directly on the treasure-house of works in the Honoré style. Against this, however, he proves himself distinctly more progressive in terms of book art in the second quarter of the century, an art which, in the wake of Jean Pucelle, was striving for greater individuality and perceptible depth of composition.

The older master's figure and decorative style, which in all essentials is rooted in the book art of Artois and Picardy, is one of many French provincial components in the evolution of central European book illumination. Its predecessors grew out of the multifaceted north and northeastern French art of illumination, which had freed itself from Parisian tradition in the last quarter of the thirteenth century and, itself influenced by English precursors, spread its influence out to many centers as distant as Bohemia and Austria.[64] Apart from French Flanders and Artois, Picardy is perhaps the most influential artistic area among the provinces. Its significance for book illumination in the Upper Rhine region and around the Lake of Constance is hardly contested by researchers today. Closer familiarity with the older master can now teach us that Picardy played a part as a source of inspiration, even in a locality as artistically active as Cologne in the early fourteenth century. Future investigations must be left to explain whether its

effect on the decoration of the Wettinger Gradual represents an isolated phenomenon, or whether it was also significant in the creation of other Cologne works, such as the magnificent painting on the choir screen in the cathedral.

Translated from the German by BMP Translation Services

fig. 1: Aarau, Cantonal Library, Ms. Wett Fm 1 (Wettinger Gradual, vol. I) fol. 209v. Initial D with Entry into Jerusalem.

fig. 2: Aarau, Cantonal Library, Ms. Wett Fm 2 (Wettinger Gradual, vol. II) fol. 3. Initial R with Resurrection of Christ.

fig. 3: Kassel, State Library, Ms. poet. fol. I (Willehalm Poem) fol. 1v. Majesty of the Lord and Landgrave Heinrich von Hessen.

fig. 4: Aarau, Cantonal Library, Ms. Wett Fm 1 (Wettinger Gradual, vol. I) fol. 27. Detail of initial P with Birth of Christ.

fig. 5: Paris, Bibliothèque Nationale, Ms. nouv. acq. fr. 16251 (Picture codex of the life of Christ and the saints) fol. 24v. Annunciation of the Virgin.

fig. 6: Kassel, State Library, Ms. poet. fol. I (Willehalm Poem) fol. 28v. Release of Willehalm from the Dungeon; Willehalm and Arabel in the Turret Room.

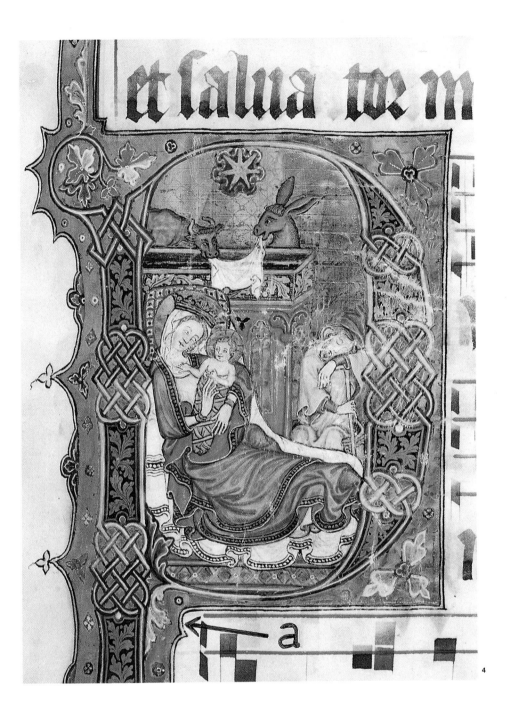

4

5

6

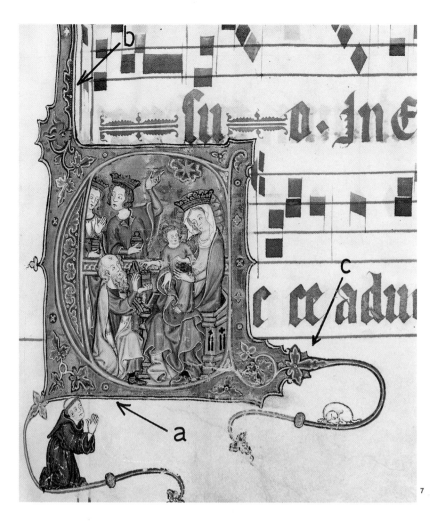

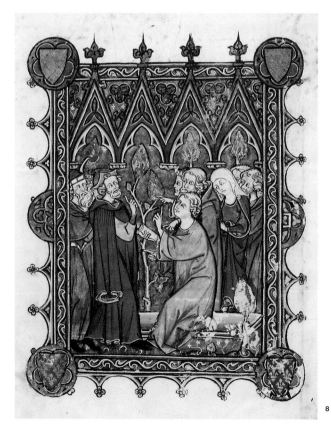

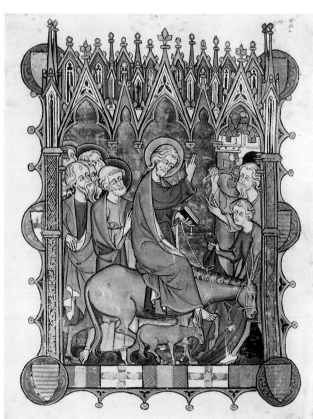

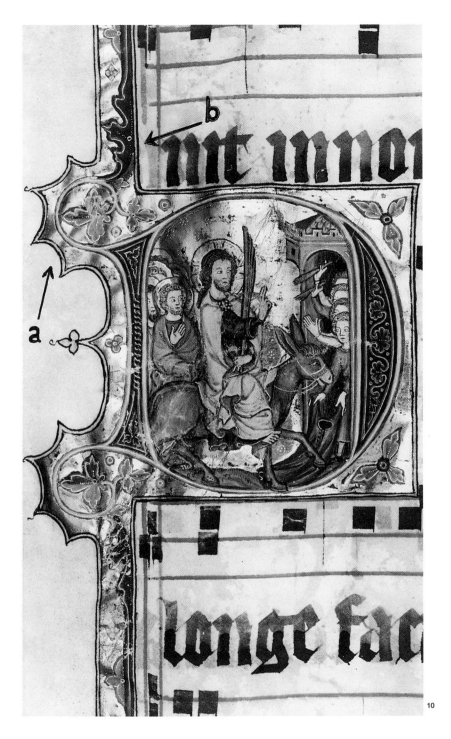

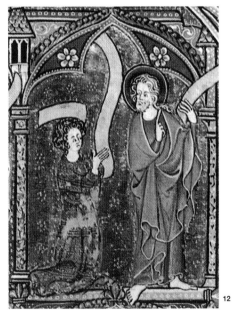

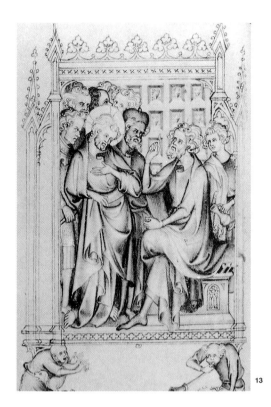

13

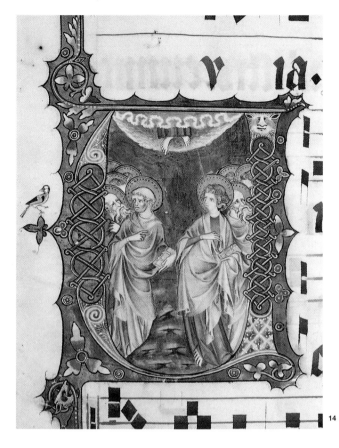

14

15

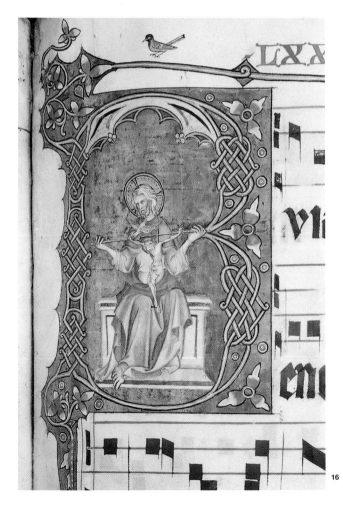

16

fig. 13: New York, The Cloisters Collection, Acc. 54 (1.2.) (Jeanne d'Evreux's Book of Hours) fol. 34v. Christ before Pilate.

fig. 14: Aarau, Cantonal Library, Ms. Wett Fm 2 (Wettinger Gradual, vol. II) fol. 39. Initial V with Ascension of Christ.

fig. 15: Paris, Bibliothèque de l'Arsenal, Ms. 595 (Missal of Châlons-sur-Marne) fol. 244. Detail from the Majesty of the Lord.

fig. 16: Aarau, Cantonal Library, Ms. Wett Fm 2 (Wettinger Gradual, vol. II) fol. 69. Initial B with Trinity.

fig. 17: Aarau, Cantonal Library, Ms. Wett Fm 2 (Wettinger Gradual, vol. II) fol. 54v. Initial S with Miracle of Pentecost.

fig. 18: Paris, Bibliothèque Nationale, Ms. lat. 1023 (Breviary of Philip the Fair) fol. 7v. Samuel Anoints King David.

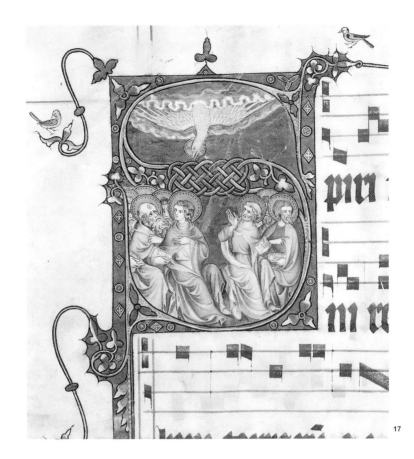

17

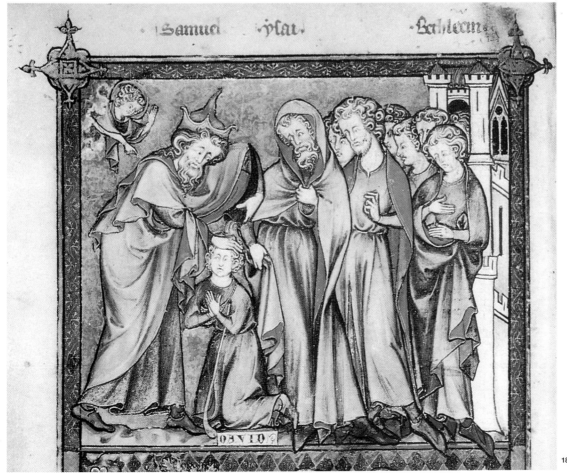

18

49

fig. 19: Aarau, Cantonal Library, Ms. Wett Fm 2 (Wettinger Gradual, vol. II) fol. 175v. Consecration of a Church.

fig. 20: Paris, Bibliothèque Nationale, Ms. nouv. acq. fr. 1098 (Life of St. Dionysius) fol. 37v. Entry of St. Dionysius into Paris.

fig. 21: Aarau, Cantonal Library, Ms. Wett Fm 3 (Wettinger Gradual, vol. III) fol. 9v. Initial S with Presentation of Christ in the Temple.

fig. 22: Lyon, Bibliothèque de la Ville, Ms. 5122 (Missal of the Sainte-Chapelle) fol. 234. Initial S with Presentation of Christ in the Temple.

fig. 23: Aarau, Cantonal Library, Ms. Wett Fm 3 (Wettinger Gradual, vol. III) fol. 64v. Initial S with St. Anne, and Madonna and Child.

fig. 24: Lyon, Bibliothèque de la Ville, Ms. 5122 (Missal of the Sainte-Chapelle) fol. 298. Initial S with Birth of Mary.

fig. 25: London, British Museum, Add. Ms. 24686 (Tenison Psalter) fol. 11. Beatus Page with David Playing the Harp.

fig. 26: Cambridge, Fitzwilliam Museum, Ms. 242 (Grey-Fitzpayn Book of Hours) fol. 29. Initial D with Christ Giving Blessing and Joan Fitzpayn.

fig. 27: London, British Museum, Add. Ms. 24686 (Tenison Psalter) fol. 14v.

fig. 28: Tours, Bibliothèque Municipale, Ms. 558 (Decretum Gratiani) fol. 1. The King Dictates the Law in the Presence of Witnesses.

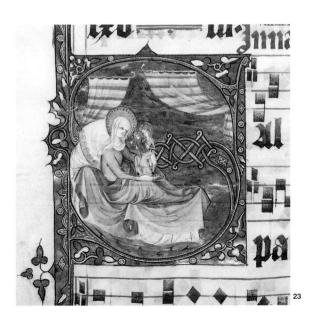

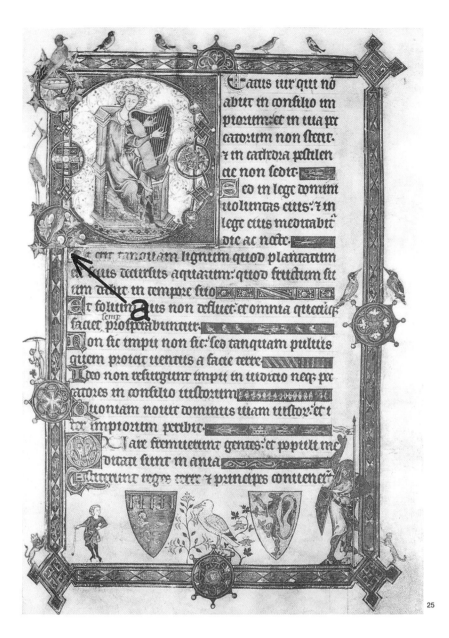

25

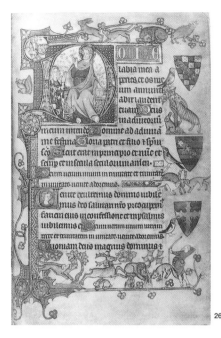

26

27

28

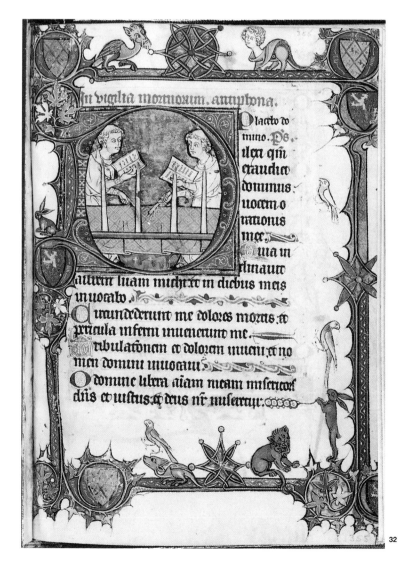

fig. 29: London, British Museum, Ms. Sloane 1977 (Surgical Treatise of Roger of Salerno) fol. 1. The Author Dictates his Text to a Scribe.

fig. 30: Oxford, Bodleian Library, Ms. Douce 366 (Ormesby Psalter) fol. 55v. Initial D with Christ before Pilate.

fig. 31: Paris, Bibliothèque Nationale, Ms. lat. 10435 (psalter) fol. 1. Beatus Page with Scenes of David.

fig. 32: New York, The Pierpont Morgan Library, M729 (Yolande de Soissons' Psalter and Book of Hours) fol. 355. Initial D with Office for the Dead.

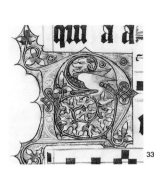

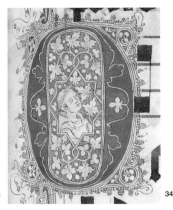

33

34

fig. 33: Aarau, Cantonal Library, Ms. Wett Fm 3 (Wettinger Gradual, vol. III) fol. 42v. Initial N with dragon.

fig. 34: Aarau, Cantonal Library, Ms. Wett Fm 1 (Wettinger Gradual, vol. I) fol. 140. Initial O.

fig. 35: Amiens, Bibliothèque Municipale, Ms. D157 (missal) fol. 29. Queen Bathildis.

fig. 36: Kassel, State Library, Ms. poet. fol. I (Willehalm Poem) fol. 15. Queen Arabel and King Tybalt.

fig. 37: Amiens, Bibliothèque Municipale, Ms. D157 (missal) fol. 23. Initial P with Birth of Christ.

fig. 38: Kassel, State Library, Ms. poet. fol.I (Willehalm Poem) fol. 7v. Emperor Charles on his Death-Bed.

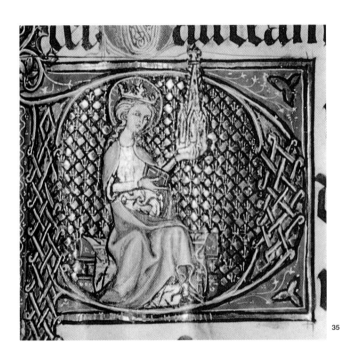

35

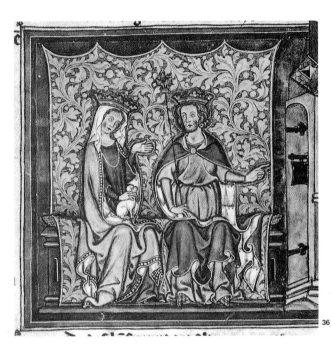

36

37

38

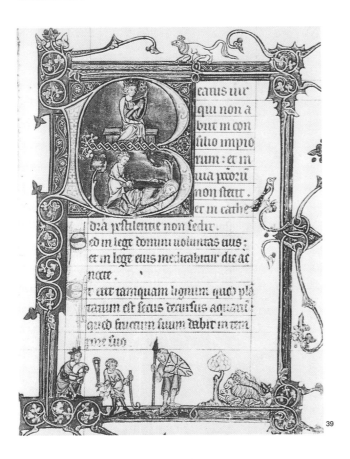

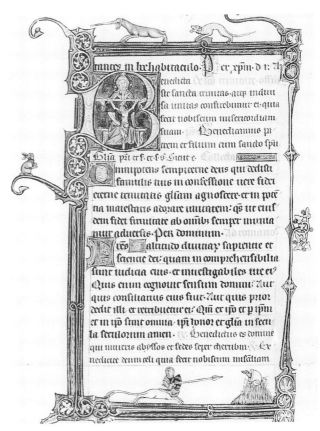

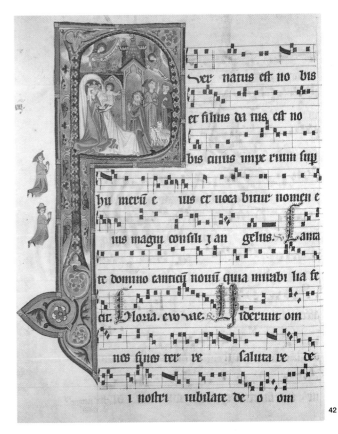

fig. 39: Baltimore, Walters Art Gallery, Ms. W45 (psalter) fol. 16. Beatus Page with Scenes of David.

fig. 40: Cambrai, Bibliothèque Municipale, Ms. 102 (breviary) fol. 337v. Initial B with Trinity.

fig. 41: Cambrai, Bibliothèque Municipale, Ms. 87 (book of hours) fol. 113. Initial D with Office for the Dead.

fig. 42: Zurich, Schweizerisches Landesmuseum, LM 26117 (St. Katharinenthal Gradual) fol. 18v. Initial P with Birth of Christ and Message to the Shepherds.

Notes

The inspiration for the present essay arose from a conversation with Professor Ellen Judith Beer in Bern, whom I would like to thank cordially at this point for valuable information and suggestions. I am particularly indebted to Professor François Avril, Paris, and Professor Beat Brenk, Basel, for enabling me to gain access to certain manuscripts.

1 A. Schönherr, *Katalog der Handschriften in der Kantonsbibliothek Aarau*, manuscript 1955/56; idem, "Das Wettinger Graduale - Eine Ehrenrettung nach sechs Jahrhunderten," *Zofinger Tagblatt* 94-97 (23-27 April, 1954); idem, "Kulturgeschichtliches aus dem Kloster Wettingen," *Jahrbuch des Standes Aargau* II (1955), p. 112; A.Bruckner, *Scriptoria medii aevi Helvetica*, vol. VII: *Schreibschulen der Diözese Konstanz* (Geneva, 1955), p. 120.

2 Marie Mollwo, *Das Wettinger Graduale - eine geistliche Bilderfolge vom Meister des Kasseler Willehalmkodex und seinem Nachfolger* (Bern, 1944). - On the purloined sheet with illustrations of the feast of Augustine, see idem, "Ein illustriertes Blatt in Cleveland aus dem Wettinger Graduale," *Zeitschrift für Schweizerische Archäologie und Kunstgeschichte* XXXI (1974), pp. 97-109; also W.D.Wixom, "Twelve Additions to the Medieval Treasury," *Bulletin of the Cleveland Museum of Art* (April 1972), p. 97, figs. 24, 27 f.

3 Shorter contributions and passing mentions: D. W. H. Schwarz, Review of Marie Mollwo's *Das Wettinger Graduale, Zeitschrift für Schweizerische Archäologie und Kunstgeschichte* VI (1944), pp. 254-256; H.Swarzenski, Review of Marie Mollwo's *Das Wettinger Graduale, Phoebus* 1948/49, II/1, p. 45; A. Boeckler, *Deutsche Buchmalerei der Gotik* (Königstein im Taunus, 1959), pp. 6 ff., 22; Ellen J. Beer, *Beiträge zur oberrheinischen Buchmalerei* (Basel and Stuttgart, 1959), pp. 54 ff.; G. Schmidt, *Die Malerschule von St. Florian - Beiträge zur süddeutschen Malerei zu Ende des 13. und im 14. Jahrhundert* (Linz, 1962), pp. 201 f.; Lucy Freeman Sandler, "A Follower of Jean Pucelle in England," *The Art Bulletin* LII (1970), p. 369; G. Schmidt, "Die Wehrdener Kreuzigung der Sammlung von Hirsch und die Kölner Malerei," in *Vor Stefan Lochner - Kölner Maler von 1300 bis 1430* (Cologne, 1977), p. 24; E. G. Grimme, *Die Geschichte der abendländischen Buchmalerei* (Cologne, 1980), p.198; Ellen J.Beer, "Die Buchkunst des Graduale von St. Katharinenthal," in *Das Graduale von St. Katharinenthal*, commentary on the facsimile edition (Lucerne, 1983), pp. 110 ff; P. Felder, *Der Aargau im Spiegel seiner Kulturdenkmäler* (Aarau and Stuttgart, 1987), pp. 43, 52, color pl. 42; A.Erlande-Brandenburg, *Triumph der Gotik, 1260-1380* (Munich, 1988), pp. 212-214, color pl. 183.

4 Mollwo, *Das Wettinger Graduale*, pp. 10-12, 27-33, 69 ff., 86-90. The younger illuminator must, at least in some places, have been aided or even replaced by an assistant when executing the picture initials, as is clear from noticeable differences in quality; compare, for example, the discrepancy between the Annunciation and the picture of All Saints.

5 Compare the often almost identical facial features and gestures in the groups of apostles in the portrayals of the Last Supper, the Ascension, and Pentecost, or the unaltered repetition of Christ's head. A sisterly similarity links the maiden in the Presentation and Mary in the picture of All Saints.

6 Mollwo, *Das Wettinger Graduale*, pp. 31-33; Boeckler, *Deutsche Buchmalerei*, p. 7; Beer, *Beiträge zur oberrheinischen Buchmalerei*, pp. 54 ff; Schmidt, *Die Malerschule von St. Florian*, p. 201, n. 22; Beer, "Die Buchkunst," p. 110.

7 Swarzenski (note 3 above), p. 45; Schönherr, "Das Wettinger Graduale." Cf. O. Pächt and J. J. G.Alexander, *Illuminated Manuscripts in the Bodleian Library Oxford*, vol. I (Oxford, 1966), p. 10, number 136; and Mollwo, "Ein illustriertes Blatt," pp. 104 ff., n.24.

8 Mollwo, *Das Wettinger Graduale*, pp. 97-115, cf. 131-135; Beer, *Beiträge zur oberrheinischen Buchmalerei* (note 3 above), p. 54; Beer, "Die Buchkunst," p. 110. - Joan A. Holladay of Austin, Texas, who is preparing a new publication on the Willehalm codex in Kassel, also postulates a Cologne origin. My thanks go to Ms. Holladay for generously providing information about the results of her research.

9 Mollwo, *Das Wettinger Graduale*, pp. 24-33, 131-135; R.Freyhan, *Die Illustrationen zum Casseler Willehalm-Codex - Ein Beispiel englischen Einflusses in der rheinischen Malerei des 14. Jahrhunderts* (Marburg, 1927), pp. 30 ff.

10 Cf. Mollwo, *Das Wettinger Graduale*, p. 109.

11 Ibid., pp. 109, 111, 119-122.

12 Oral communication, March 1990.

13 Marie Mollwo does, in one concise chapter, compare the picture initials of the older master with English book illumination, but concludes that the illuminator consciously "rejected the waves of this art which were reaching Cologne." "Here," she writes, "people were disinclined towards luxuriant multiplicity, the piling up of decorative elements, the trend to the grotesque" (*Das Wettinger Graduale*, p. 118).

14 On the psalter: G. Vitzthum, *Die Pariser Miniaturmalerei von der Zeit des hl. Ludwig bis zu Philipp von Valois und ihr Verhältnis zur Malerei in Nordwesteuropa* (Leipzig, 1907), p.75, pl. XVI; Margaret Rickert, *Painting in Britain - The Middle Ages* (London, 1954), p. 139, pl. 118; P.Brieger, *English Art 1216-1307* (Oxford, 1957), pp. 223 ff.; P.Brieger and Marie Farquhar Montpetit in *Art and the Courts - France and England from 1259 to 1328*, cat.(Ottawa, 1972), vol. I, pp. 62, 98, fig. 56.

15 Fragile strips with tendril-like extensions are found in the manuscripts of the Sainte-Chapelle dating from the 1250s. They appear later in the London evangelists of the Sainte-Chapelle and in manuscripts from the Chansonnier de Paris, in 1288 in the Gratian of Tours, and in the early nineties in the so-called Breviary of Philip the Fair and the Somme le Roi Add. 54180. - Illustrations: *Les manuscrits à peintures en France du XIIIe au XVIe siècle*, cat. (Paris, 1955), pl. V; *Art and the Courts* (note 14 above), vol. II, pl. 3-5, 8; Ellen V. Kosmer, *A Study of the Style and Iconography of a Thirteenth-Century Somme le Roi (Brit. Mus. Ms. Add. 54180)* (Ph.D. diss., Yale University, 1973) Part III, figs. 61a-64, 67 ff., 75 ff., 79, 82, 85-88; Ellen J. Beer, "Überlegungen zum 'Honoré-Stil'," *Europäische Kunst um 1300*, XXVth International Congress on the History of Art, CIHA (Vienna, 1983), fig. 37; H. Martin, *La miniature française du XIIIe au XVe siècle*, 2nd ed. (Paris and Brussels, 1924), figs. XXIII, XXVI ff., XLIII-XLV.

The question of Honoré and the identification problems connected with his personality cannot be gone into here. The stylistically sometimes very diverse late 13th-century manuscripts subsumed by recent research under the term "Honoré style" can nevertheless be thought of in our context as a phenomenon which, as a whole, is clearly distinct in its decorative motifs from the "Court style" and East Anglian book illumination. - On the subject, see Kosmer 1973 (see above), part I, pp. 186-230; Ellen V. Kosmer, "Master Honoré - A Reconsideration of the Documents," *Gesta* XIV (1975), pp. 63-68; Ellen J. Beer, "Pariser Buchmalerei in der Zeit Ludwigs des Heiligen und im letzten Viertel des 13. Jhs." (report on the state of research), *Zeitschrift für Kunstgeschichte* XLIV (1981), p. 85; Beer, "Überlegungen zum `Honoré-Stil'," note 2 with bibliography on the subject.

16 Only one representation of a coat of arms by the master of the gradual is known, and that is on the first page of the Willehalm. There can, however, be no doubt about its connection with English book production.

17 On the rarity of trellis work in Parisian book illumination before the 1280s, cf. Beer, "Überlegungen zum `Honoré-Stil'," p. 85, and *Les manuscrits* (note 15 above), pl. V.

18 The English origin of the cabbage leaf was recognized as early as Vitzthum, *Die Pariser Miniaturmalerei*, pp. 70, 156, 228 ff., pl. L. This motif is among the most common decorative designs in East Anglian book illumination. In the Tenison Psalter, for example, it appears on fol. 12v. J.Kvet, *Iluminované Rukopisy Královny Rejcky* (Prague, 1931), fig. 49.

19 In the lower spiraling tendril of the Beatus B in the psalter and in the lower left spandrel of the cushion in the gradual's Epiphany picture.

20 The list of parallels between the Tenison psalter and the master of the gradual could be lengthened; it might include, for example, the related diamond, quatrefoil, and circle motifs used as line-fillers and in the panels.

21 On East Anglian book illumination: O. Elfrida Saunders, *Englische Buchmalerei* (Florence and Munich, 1927), text volume, pp. 115-129, plate volume II (Ormesby psalter: pl. 109); E. G. Millar, *La miniature anglaise aux XIVe et XVe siècles* (Paris and Brussels, 1928), pp. 1-29 (Ormesby psalter: pl. 1-5); Rickert, *Painting in Britain*, pp. 137-150, 143 ff. (Ormesby psalter: pl. 125 ff.); P.Brieger and Marie Farquhar Montpetit in *Art and the Courts* (note 14 above), vol.I, pp. 62-65, cat. number 26, 29-35.

22 See also the Gorleston psalter (Millar, *La miniature anglaise aux XIVe et XVe siècles*, pl. 16 ff.), the Queen Mary psalter (G. Warner, *Queen Mary's Psalter* [London, 1912], pl. 282, 287, 289-291), or the psalter of Richard of Canterbury (J. Plummer, *The Glazier Collection of Illuminated Manuscripts* [New York, 1968], fig. 34). - The cabbage leaf is also found in the Tickhill psalter (D. D. Egbert, *The Tickhill Psalter* [New York and Princeton, 1940], frontispiece and pl. I, XXV), in the first part of the Arundel psalter (Saunders, *Englische Buchmalerei*, plate 108), and in the Stowe breviary (*British Museum, Reproductions from Illuminated Manuscripts*, series II, 2nd ed. [London, 1910], pl. XIV; Saunders, *Englische Buchmalerei*, pl. 112).

23 Beer, "Pariser Buchmalerei," p. 85, fig. 11; Beer, "Überlegungen zum `Honoré-Stil'," figs. 34, 37.- Cf. note 15 above.

24 Egbert, *The Tickhill Psalter*, pl. XCV b, XCVI b - XCIX b, CVI, CVII; Rickert, *Painting in Britain*, p. 146, pl. 128; *Art and the Courts* (note 14 above), vol. I, cat. number 35; vol.II, pl. 51. Cf. also the East Anglian Bromholm psalter (Millar, *La miniature anglaise aux XIVe et XVe siècles*, pl. 6).

25 Cf. also the color illustrations in E. Millar, *La miniature anglaise du Xe au XIIIe siècle* (Paris and Brussels, 1926), frontispiece (Tenison psalter); E.Millar, *The Parisian Miniaturist Honoré* (London, 1959), pl. 1 (Gratian in Tours); J. J. G.Alexander, *Initialen aus grossen Handschriften* (Munich, 1978), pl. 31 (Tickhill psalter), pl. 32 (Sainte-Chapelle – Ev. Lat. 17326); R.Marks and N.Morgan, *Englische Buchmalerei der Gotik* (Munich, 1980), pl. 19 (Gorleston psalter); C.Sterling, *La peinture médiévale à Paris*, vol. I (Paris, 1987), fig. 50 (Miracles of Our Lady, by Jean Pucelle).

26 Millar, *La miniature anglaise du Xe au XIIIe siècle*, pl. 97; cf. pl. 98 and also Alexander, *Initialen*, color pl. 29.

27 The Stowe breviary is also worth mentioning in this context. Mollwo, *Das Wettinger Graduale*, fig. 51.

28 Millar, *La miniature anglaise du Xe au XIIIe siècle*, pl. 70a; Marks and Morgan, *Englische Buchmalerei*, pl 14 ff.

29 Millar, *La miniature anglaise aux XIVe et XVe siècles*, pl. 5a; Egbert, *The Tickhill Psalter*, pl. XXXVII, XXXVIII; Mollwo, *Das Wettinger Graduale,* fig. 51; Freyhan, *Die Illustrationen*, pp. 26-29, comments in detail on English dotting of gold ground in connection with the double outlines in the Willehalm codex.

30 Cf., for example, the Nuremberg breviary (City Library, Solger in quarto number 4) or the breviary of Philip the Fair (Bibl. Nat., Lat. 1023). Schmidt, *Die Malerschule von St. Florian*, figs. 26 ff., 36 ff.

31 Vitzthum, *Die Pariser Miniaturmalerei*, pp. 111 ff., 132 ff., 145 ff., 149-151, 153, 157 ff., 161 ff., 218-220, 222.

32 Karen Gould, *The Psalter and Hours of Yolande of Soissons* (Cambridge, Mass., 1978), esp. p. 52, figs. 5, 9, 12, 17 ff., 20, 24, 39, and others.

33 On folio 196 at the left of the letter cushion, a frieze of this kind has remained at the sketching stage. Gould, *The Psalter,* fig. 18; cf. also figs. 1-4, 10, 14-16, 25 ff., 28-30, 35-38.

34 Ibid., fig. 8.

35 Compare, for example, ibid., fig. 17 with Beer, "Pariser Buchmalerei," fig. 11 (Antwerp Bible) or fig. 12 (missal from Saint-Corneille in Compiègne).

36 Gould, *The Psalter,* p.5, fig. 54 (psalter) and fig. 44 (missal); *Les manuscrits* (note 15 above), numbers 68 (psalter) and 77 (missal).

37 Cf. Beer, "Überlegungen zum `Honoré-Stil'," p. 85, where the possible influence of Amiens book production on trellis-work initials in Paris after 1290 is discussed in connection with the Nuremberg breviary (City Library, Solger in quarto number 4).

38 Beer, "Pariser Buchmalerei," p. 83, fig. 7.

39 Beer, "Die Buchkunst," p. 184; V. Leroquais, *Les Bréviaires manuscrits des bibliothèques publiques de France* (Paris, 1934), vol. I, pp. 194-198; vol. II, pl. XIX, XX; J. Porcher in *Les manuscrits* (note 15 above), number 85.

40 Marie Farquhar Montpetit in *Art and the Courts* (note 14 above), vol. I, pp. 89 ff.; J. Porcher in *Les manuscrits* (note 15 above), number 69.

41 Occasionally the lower extension bears on its uplifted end a standing figure of the kind seen in the gradual's Christmas picture; cf. fol. 113, 155.

42 A.Knoepfli, *Die Kunstdenkmäler des Kantons Thurgau,* vol. IV: *The Monastery of St. Katharinenthal* (Basel, 1989), pp. 166-170, figs. 150-155 (Nuremberg gradual), pp. 170-179, figs. 157-162, color pl. 1, 171 (the St. Katharinenthal gradual); Beer, "Die Buchkunst," figs. 12, 20 ff., 36, 68 (Nuremberg gradual).

43 Beer, "Die Buchkunst," pp. 181 ff.

44 Gould, *The Psalter,* pp. 36-43, 50, 53, figs. 43 ff.

45 Cf. especially figs. 1b, 3 ff., 12, 14, 26, 30, 35 ff. in Gould, ibid.

46 F.Avril and Marie Farquhar Montpetit in *Art and the Courts* (note 14 above), vol. I, pp.83 ff.; vol. II, pl. 16, color pl. III; Beer, "Pariser Buchmalerei," fig. 13.

47 Beer, "Pariser Buchmalerei," pp. 89, 90. - More on the Apocalypse can be found in Saunders, *Englische Buchmalerei,* text volume, pp. 106, 108 ff., plate volume II, pl. 96 (Bibl. Nat., Lat. 10474), pl. 97 (Oxford, Douce 180); in Millar, *La miniature anglaise du Xe au XIIIe siècle,* pp. 73 ff., pl. 93 ff.; and in Rickert, *Painting in Britain*, p. 122, pl. 113a.

48 Gould, *The Psalter,* fig. 8 (M729), fig. 54 (Lat. 10435); Eleanor S.Greenhill, "A Fourteenth Century Workshop of Manuscript Illuminators and its Localization," *Zeitschrift für Kunstgeschichte* XL (1977), esp. p. 17, fig. 19 (Sloane 1977).

49 Schmidt, *Die Malerschule von St. Florian,* pp. 122 ff.; *Art and the Courts* (note 14 above), vol. II, pl. 17; Gould, *The Psalter,* fig, 66.

50 Forerunners of the human mask motif and the tendril loop as early as the Cuerdon psalter and in the Devon bible from the middle of the 13th century. B.Watson, "The Place of the Cuerdon Psalter in English Illumination," *Gesta* IX.1 (1970), pp. 34 ff., figs. 3, 5; Saunders, *Englische Buchmalerei,* plate volume II, pl. 76. - Also cf. folios 12 r and v in the Tenison psalter. *British Museum* (note 22), series III (London, 1908), pl. XVII; Kvet, *Iluminované Rukopisy* (note 18), fig. 49. - The roots of the "curiously balletic step motif with crossed legs and outward-turned toes of the forward-stretched foot" are, according to Schmidt, to be found in English psalter illustrations of the mid-13th century (*Die Malerschule von St. Florian,* p. 122).

51 Cf. the Sainte-Chapelle manuscripts Bibl. Nat. Lat. 17326 and Brit. Mus. Add. 17341, the Missal of Saint-Corneille in Compiègne, the Gratian in Tours, the breviary of Philip the Fair, the Arsenal 3142 poetry collection, the Charles V bible. - Figs.: Vitzthum, *Die Pariser Miniaturmalerei,* pl. V ff.; Martin, *La miniature française,* figs. V-VIII, XXIII, XXV, XXVII; H.Martin and P.Lauer, *Les principaux manuscrits à peintures de la Bibliothèque de l'Arsenal* (Paris, 1929), pl. XIX, XXV, XXVII-XXIX; Schmidt, *Die Malerschule von St. Florian,* figs. 26, 30; *Art and the Courts* (note 14 above), vol. II, pl. 3, 5; Beer, "Überlegungen zum `Honoré-Stil'," figs. 34, 36. - Furthermore, English book illumination also used the aforementioned dragon motif from the middle of the 13th century (Cuerdon psalter, Tenison psalter).

52 R. Haussherr, "Die Chorschrankenmalereien des Kölner Doms," in *Vor Stefan Lochner - Die Kölner Maler von 1300 bis 1430* (Cologne, 1977), pp. 51 ff. - Illustration of the Belleville breviary in Sterling, *La peinture médiévale,* fig. 29.

53 Freeman Sandler, "A Follower of Jean Pucelle," p. 369; Gisela Plotzek-Wederhake in *Vor Stefan Lochner - Die Kölner Maler von 1300 bis 1430,* cat. (Cologne, 1974), p. 61.

54 Sterling, *La peinture médiévale,* figs. 40-49.

55 Color illustration of the David scene, ibid., fig.15.

56 Martin, *La miniature française,* fig. XXIV; Martin and Lauer, *Les principaux manuscrits,* pl. XX ff.; *Art and the Courts* (note 14 above), vol. I, pp. 80 ff.; vol. II, pl. 11 ff. (cf. Vitzthum, *Die Pariser Miniaturmalerei,* pp. 60 ff., 218).

57 Schmidt, *Die Malerschule von St. Florian,* p. 201, n. 22; V. Leroquais, *Les sacramentaires et les missels manuscrits des bibliothèques publiques de France,* vol.II (Paris, 1924), pp. 250 ff., plate volume, pl. LVII ff.; G. de Jerphanion, *Le Missel de la Sainte-Chapelle à la bibliothèque de la ville de Lyon* (Lyon, 1944).

58 Jerphanion, *Le Missel,* pl. XXVI.2. - The halo motif seldom appears in East Anglian book production, whither it must have come via a Parisian-influenced manuscript such as the Queen Mary psalter. Warner, *Queen Mary's Psalter,* pl. 291.

59 Jerphanion, *Le Missel,* pl. XXX.3 and XXVII.1.

60 C. Couderc, *Les enluminures des manuscrits du moyen âge de la Bibliothèque Nationale* (Paris, 1927), pp. 61 ff., plate XXX.

61 In the early and high Middle Ages, the ancient bishops' seat of Cambrai in eastern Artois belonged to the county of Hennegau and thus to the Empire. Union with France occurred only in 1677.

62 Schmidt, *Die Malerschule von St. Florian,* pp. 44-46, 113-126; Kvet, *Iluminované Rukopisy;* Beer, "Die Buchkunst," pp. 120, 181-184, 186, 199-202, 205-210.

63 Vitzthum, *Die Pariser Miniaturmalerei,* pp. 197-215. - Cf. *Vor Stefan Lochner - Die Kölner Maler von 1300-1430,* cat. (Cologne, 1974) and colloquy transcription (Cologne, 1977).

64 Beer, "Pariser Buchmalerei," pp. 83-85, 87-91.

Peter Ochsenbein

Picture and Prayer: Late Medieval
Passion-Centered Piety in St. Gallen Prayer Books

Who ever wishes for great rewards and eternal salvation,
seeks lofty knowledge and profound wisdom, strives to
stand fast in love and sorrow, and to be wholly secure before
all evil, desires to receive the cup of Thy bitter suffering
and Thine extraodinary mercy, that person shall have Thee,
the Crucified Jesus, before his inner gaze always.
(Heinrich Seuse, Büchlein der ewigen Weisheit *I,14).*

The original purpose of religious and devotional pictures is to serve prayer and spiritual contemplation. Art history has studied the relationship of religious pictures and Christian worship in the Middle Ages under a variety of aspects.[1] Too little research has, however, been dedicated to questions of the immediate correlation of pictures and specific, concrete prayers. What and how did the faithful pray in front of devotional pictures in the late Middle Ages? What links can be established between pictorial image and prayer, for example on the basis of illuminated prayer books? These and similar questions cannot be answered globally, as they always depend on local and social circumstances. The following observations take as their point of departure a few specific, Passion-centered pictures and texts in private fifteenth-century Latin and German prayer-book manuscripts, all of which are connected with St. Gallen and each of which originally belonged to an owner of different social standing.

1. Latin and German prayer-book manuscripts from St. Gallen are collections of texts, not picture books. Only a very few codices are illustrated, and those with only a very few modest, sometimes even amateurish, pictures. Precious books of hours as created and sold since 1350 as luxury articles in France, Burgundy, the Nether-

fig. 1: Arma Christi, pen-and-ink drawing, c. 1435, from the abbey of St. Gallen. St. Gallen, Stiftsbibliothek, Cod. Sang. 520, p. 46.

lands, and in isolated cases in Italy, England, and Germany, were hardly known in Switzerland and southern Germany. There were virtually no studios to produce them here because there was no demand. What has been passed down to us are utilitarian books, often copied by the original owners themselves.[2] Consequently it is reasonable to begin our tour not with a picture but with a prayer:[3]

I implore Thee, dearest Lord Jesus Christ, through the very highest love that Thou hast shown for mankind, when Thou, Heavenly King, hung on the cross with love divine, with meek soul, with sorrowful mien, with manner mild, with patience silent, with conscience guiltless, with afflicted senses, with heart pierced, with limbs shattered, with body broken, with wounds bleeding, with arms outstretched, with arteries racked, with praying mouth, with hoarse voice, with countenance pale and swollen, with deadly hue, with weeping eyes, with wasting brain, with burning earnest, with sighing throat, with thirsty desire, with temptations of bitter gall and vinegar, with head wounded, bowed, when death approached, with the departure of Thy Divine soul from Thy gentlest body, with fatal humanity, with the end nigh, with side speared, with streams of blood and water running, with the vital source welling up, which penetrated Thee heart and soul. I implore Thee, Gentlest Jesu, in whose love Thy heart burst: be merciful unto the multitude of my sins, and grant me a holy and blessed end of life, and a blissful, joyful resurrection through Thy gentlest Grace. Thou who resideth with God the Father and the Holy Spirit and reigneth in all Eternity. Amen.

This private prayer in Middle High German, "The Heavenly King on the Cross," already documented in the Trier area around 1300, is probably not only one of the oldest vernacular meditations on the Passion, it also became one of the most popular and oft-copied texts in the fifteenth and sixteenth centuries, as exemplified in St. Gallen.[4] It is composed as a direct prayer: with direct form of address, contents relating to the history of salvation (namely Christ's death on the cross), and a personally formulated plea. The anaphorically strung, rhythmically shaped, litany-like intervening text consists of thirty points of meditation. They are arranged so as not only to fix the se-

quence of the agonizing death in memory, but also to serve as a mnemonic aid, bringing the physical-spiritual totality of this suffering to life in the contemplative reader's mind. For it was not information that the late medieval faithful at prayer needed: they were very familiar with the events of the Passion from their knowledge of the Gospels and – in far greater detail – from histories of the Passion, ascetic-edifying writings, sermons, and other Passion prayers. What all of these writings composed since the twelfth century had in common was their use of apocryphal narrative elements and specific exegetic methods to elaborate and describe the Passion so realistically that the horrible ritual of martyrdom, from captivity to burial, seems to be taking place before the reader and contemplator's very eyes.[5]

The impression conveyed by these points of meditation is that the realistic depiction of the tortured, suffering God-Man on a Gothic crucifix has been translated into language in such a way as to allow the anaphoric sequence to function as instructions for contemplating the devotional picture. The rubric to our prayer appears to confirm this: "Who ever speaks this recopied prayer devoutly before a cross, that same person shall have as many days of indulgence as the Lord Jesus Christ had wounds in His suffering, namely five thousand four hundred and seventy-five." And, in fact, this prayer is likely to have been prayed again and again before a crucifix, as an act of private devotion. Nonetheless, there is no way to determine whether its wording was modeled on the Gothic crucifix or whether, conversely, the visual representation was a product of the textual description. The influence is likely to have been reciprocal and at the same time nourished by so many textual and pictorial sources that a single origin would be virtually impossible to trace. However, the visible crucifix is bound to have helped shape our text, at least as later recast and expanded. One need only think of Christ standing (on a Roman suppedaneum) at the cross in the earliest versions, and being evoked as the hanging Redeemer only in the more modern tradition (from approximately 1400).[6]

2. The second example comes from a collection of Latin prayers compiled by several unknown monks from St. Gallen around 1435; probably meant for private devotions, they were later combined in a single volume.[7] A simple pen-and-ink drawing (fig. 1) is its only illustration. It was probably executed by the copyist who notated the prayer that accompanies it, a suffragium on the instruments of Christ's torture composed of antiphon, versicle, and collect. Picture and text are clearly intended to form a unit here. The introductory antiphon summons to the veneration of the cross, the nails, the crown of thorns, the scourge, and the iron lance, terming them the royal banner through which we can hope for the crown and eternal joy. ("Cruci, clavis, corone spinee, flagello, sacroque ferro lancee honorem impendamus. Haec sunt vexilla regia, per quae coronam et gaudia perpetua speramus.") The concluding collect calls the listed instruments of Christ's torture "arma insignia."[8] The picture includes further instruments (frequently found in Arma Christi pictures): the pole with the vinegar-soaked sponge, the whipping-post, fasces, and the dice the soldiers cast for Christ's garments beneath the cross.

As no doubt intended, the simple pen-and-ink drawing summons to contemplation of the entire Passion, the prayer presumably concluding the process as a meditation focused on pictorial symbols.[9] What the thirty mnemonic points accomplished in the first example, the symbols are to achieve here: an evocation of the individual torments of Christ and at the same time a call for the contemplator to visualize them. Arma Christi pictures want to be read as digests of the whole Passion; symbolic reductions, they are nonetheless graphic enough to serve as aids to memory and intermediary objects of the imagination.[10] In contrast to the mnemonic points in the prayer quoted in the first example, they possess no strict sequence of images; the beginning and end of the meditation on the Passion are not fixed.

3. A private prayer book in German, probably written by a nun at the Benedictine convent of St. Georgen in St. Gallen around 1500, has as its sole illustrations a double page with two colored pen-and-ink drawings: the Crucifixion

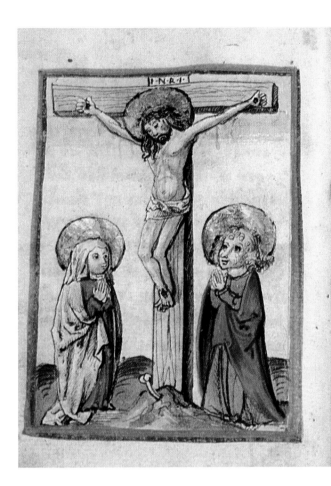

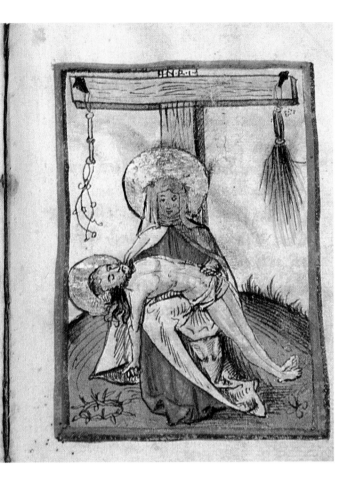

(with the Blessed Virgin and John the Disciple) and a Pietà (fig. 2).[11] While the Crucifixion reminds us of the picture-less prayer "Christus am Kreuz," the Pietà takes up elements from the Arma Christi tradition: hanging on the nails of the cross – in a symbolic and surely not realistic sense – scourge and fasces; lying in the grass, the crown of thorns.

Both of the devotional pictures show Son and Mother as sufferer and fellow-sufferer, as redeemer and fellow-redeemer. Thus for the contemplator the Virgin Mary becomes a model of the compassion demanded of him or her. The Pietà not only illustrates the scene after the descent from the cross; the visible instruments of torture are there to remind the contemplator of the whole painful process of redemption. Passion-inspired piety and Marian worship, the two central themes of late medieval spirituality, are meaningfully united here in the simplest possible way. The text of the prayer into which the pictures are inserted confirms this twofold view of devotion: it is a rosary composed of forty-three decades on salvational themes, addressed to the Virgin Mary and reiterating the life and sufferings of her Son.[12] After every Mystery the praying nun was to add a Hail Mary, giving her the opportunity to turn to the picture pages after each decade and contemplate the two illustrations as she prayed the required Hail Mary. The two pictures can also be linked directly with two Mysteries: "Who interceded for His enemy with His Heavenly Father, who commended Thee, His dear mother, to His dear disciple John" and "Who was taken from the cross, was laid before Thee, His most miserable and wretched mother, and from the cross was buried as a man."

4. A private prayer book in German, written by Gabriel Nagel von Waltdorf in 1481, was, according to the arms on the inside cover, in the possession of the Allgöwer family, merchants in St. Gallen, before the religious schism. It too contains only a single miniature: St. Veronica holding out the sudarium with Christ's (originally gilt) face to the contemplator (fig. 3).[13] This simple devotional picture is an integral part of the prayer that begins on the opposite page.[14] The rubric accompanying it offers the following instructions: "A prayer of praise and devotion to be said before the countenance of God. Look at it as the first thing every day, kiss it and speak this."

In the "true countenance" of Christ, the vera icon, the God unfathomable and incomprehensible to man becomes visible as a suffering God-Man and redeemer. In His sufferings man can approach Him and encounter Him as a fellow-sufferer. As the accompanying prayer proves, the sudarium as an object of contemplation and veneration – attested by a kiss – becomes an incentive and pledge for the future vision of God in heaven:

> *Grant me sinful mortal, o gracious Lord Jesus Christ, to gaze upon Thy holy countenance here on earth and in honor of Thy sacred agony sedulously to contemplate and to lead so fruitful a life that I shall never again be separated from the vision of Thy divine glory.*

5. In 1472 Ulrich Rösch (1463-1491), prince-abbot in St. Gallen, had Simon Rösch, a Wiblingen monk, copy what the title of the principal text calls "Devotionale pulcherrimum." The ornamental initials and over seventy pictures were probably produced by an illustration workshop in Ulm or Constance.[15] The slim parchment volume consists of two parts: first, forty private prayers in Latin, then a cycle of prayers and pictures arranged so that the prayers are always on the left and the corresponding pictures on the right.[16] In over seventy such picture-text units, the praying self – it refers to itself as Ulricus or Udalricus several times in the Rösch prayer book – moves through the whole history of salvation, from the creation of the world to the Last Judgment, with ten of these units dedicated to Christ's Passion. The example we have chosen is the final station of Christ's agony, the entombment (fig. 4).[17]

The text and iconography of this devotional cycle originated around 1150, probably in the Burgundian sphere of cultural influence and most likely at a Cistercian

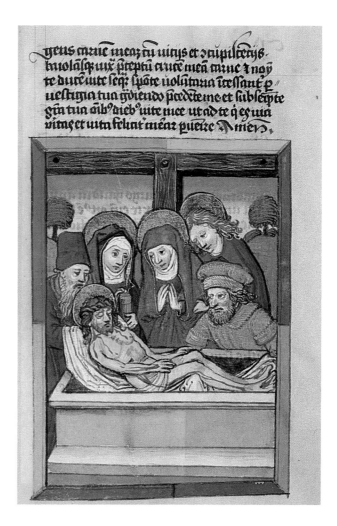

fig. 4: Entombment of Christ.
Private Latin prayer book of the
St. Gallen abbot Ulrich Rösch,
copied in 1472. Einsiedeln,
Stiftsbibliothek, Cod. 285, p.
202.

fig. 5: Christ in Crown of Thorns,
with Scourge and Fasces.
Colored woodcut pasted into a
private prayer book in German,
c. 1500. St. Gallen, Stiftsbiblio-
thek, Cod. Sang. 1870, p. 57.

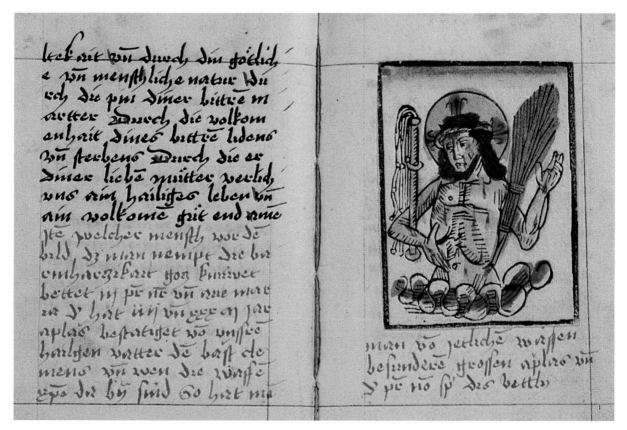

monastery. Two somewhat younger codices have survived: the prayer book (c. 1190) mistakenly attributed to Hildegard von Bingen (1098-1179) and the so-called *Lilienfelder Andachtsbuch* (c. 1200).[18] The Rösch prayer book is much later and is the only hitherto proven successor to this Benedictine-Cistercian tradition. The text and iconographical character have largely been preserved; the almost hieratic late-twelfth-century pictures, on the other hand, have been "translated" into the colorful world of late medieval realism. While the Passion-centered piety of the text is still very subdued in its formulation, the pictures in the Rösch prayer book have a more direct impact. A clear example of this is the blood-stained body of Christ. The unknown master of the Rösch prayer book attempts to individualize the figures by providing them with garments of different colors, or different types of headgear and hairstyle. In our example the Mother of God is wearing a light blue dress; Mary Magdalene, to her right (additionally characterized by the anointing jug), is in violet; while in the background, on the right, the beloved disciple John can be recognized.

Extended prayer-picture cycles centering on the history of salvation, an essentially ideal form of contemplative meditation because the eye can take in text and picture virtually simultaneously, underwent little development in the twelfth century or even later. Alongside wordless cycles of pictures often placed at the front of psalters,[19] the main form to emerge in France, Burgundy, and the Netherlands was the illustrated book of hours.

6. The late medieval Passion-inspired prayers and pictures discussed here – all of them from private prayer books from St. Gallen with owners of heterogeneous social backgrounds (Benedictine monk, nun, urban merchant, prince-abbot) – represent a fair cross-section of handwritten codices for private devotion in the Upper German region. Only Abbot Ulrich Rösch's prayer book was lavish and probably produced at a book-painting studio, as befitted his rank. The other manuscripts have either no illustrations or then at most two. The iconographic origin of these colored pen-and-ink drawings is useful to the understanding of the tradition and its artistic background. Broadsheets identical, or at least very similar, in design can be found for both the Veronica picture (fig. 3), and the Crucifixion and Pietà (fig. 2).[20] It is a known fact that in the fifteenth and early sixteenth centuries many Upper German printers produced woodcuts and broadsheets of devotional pictures and sold them for little money.[21] Many owners of private prayer books, most likely nuns in particular, will have placed such pictures between the leaves of their plain prayer books as a substitute for illustrations, contemplating them as they recited specific prayers. As they were loose sheets, most of them have been lost, but a few have, by way of coincidence, survived. Thus the abbey library in St. Gallen, with the largest collection of late medieval prayer books in Switzerland (some fifty codices, forty-four of them in German), posseses only a single broadsheet with a devotional image (an imago pietatis, in other words Christ in crown of thorns, with scourge and fasces), and it has come down to us only because it was pasted into a prayer book (fig. 5).[22] The pen-and-ink drawings presented here, perhaps even the Arma Christi picture (fig. 1), thus testify indirectly to a pictorial culture of very modest artistic achievement. We can only try to imagine, and certainly cannot reconstruct, the emotional values it must have embodied in conjunction with the accompanying texts.

Translated from the German by
Eileen Walliser-Schwarzbart

Notes

1 No comprehensive bibliography is included here. See Hans Belting, *Bild und Kult. Eine Geschichte des Bildes vor dem Zeitalter der Kunst* (Munich, 1990), with bibliography pp. 667-676.

2 See Peter Ochsenbein, "Spätmittelalterliche Buchaustattung in deutschsprachigen Gebetbüchern am Beispiel der St. Galler Bestände der Stiftsbibliothek und der Kantonsbibliothek (Vadiana)," *Unsere Kunstdenkmäler* 34 (1983), pp. 176-183.

3 Text after "Hortulus animae," so-called Seelengarten version, the printed prayer book with the widest circulation between 1501 and 1525; here after the version printed in Basel by Thomas Wolff, 1520, fol. 37v-38v. See M.C. Oldenbourg, *Hortus animae (1494-1523). Bibliography and Illustration* (Hamburg, 1973), p. 57 (= L 91); P. Ochsenbein, "Hortus animae," *Die deutsche Literatur des Mittelalters. Verfasserlexikon* 2nd ed., ed. K. Ruh, vol. 3 (Berlin and New York, 1981), cols. 147-154.

4 Regarding the tradition, see the brief remarks in P. Ochsenbein, "Eine bisher unbekannte böhmische Handschrift mit Gebeten Johanns von Neumarkt," *Zeitschrift für deutsche Philologie* 98 (1979), pp. 85-107, esp. pp. 102-104 (n. 43 with the textual witnesses thus far discovered in St. Gallen manuscripts).

5 See Frederick F. Pickering, *Literatur und darstellende Kunst im Mittelalter*, Grundlagen der Germanistik 4 (Berlin, 1966); idem; "Das gotische Christusbild. Zu den Quellen mittelalterlicher Passionsdarstellungen," *Euphorion* 47 (1953), pp. 16-37.

6 See the written version of 1380 in Cod. 125 of the Stifsbibliothek Engelberg, fol. 36r (ed. W. Wackernagel, *Altdeutsche Predigten und Gebete aus Handschriften* [Basel, 1876; reprint ed. Darmstadt, 1964], p. 23): "Ich bitte dich durch diner götlichen minne willen, die du herre himelscher küng hette, do du stuende an dem kriutze allein." (...Thou didst stand at the cross alone.)

7 St. Gallen, Stiftsbibl. Cod. Sang 520, p. 46. The one bundle is dated 1436: Beat Matthias von Scarpatetti, *Katalog der datierten Handschriften in der Schweiz in lateinischer Schrift vom Anfang des Mittelalters bis 1550.* vol. 3 (Dietikon-Zürich, 1991), p. 42 (no. 109) and fig. 152. – All of the bundles in this volume are likely to have been produced at the monastery of St. Gallen in the period of the Hersfelder Reform (1430-1436); see Peter Ochsenbein, "Spuren der Devotio moderna im spätmittelalterlichen Kloster St. Gallen," *Studien und Mitteilungen zur Geschichte des Benediktiner-Ordens* 101 (1990), pp. 475-496, esp. p. 483.

8 Versicle: "Adoramus te, Christe, et benedicimus te." Collect: "Ihesu benignissime, qui crucem sanctam ascendisti et matrem tuam sub te stantem mortuus sanguine perfudisti, perfunde corda nostra arida gratia spiritus sancti et presta, ut qui sanctissima nostre redemptionis arma insignia tripliciter veneramur, per hoc indesinenter muniti et trinitatis gloriam consequamur."

9 See Robert Suckale, "Arma Christi. Überlegungen zur Zeichenhaftigkeit mittelalterlicher Andachtsbilder," *Städel-Jahrbuch* N.F. 6 (1977), pp. 177-208, esp. 182 f.

10 Ibid., p. 193.

11 St. Gallen, Stiftsbibl., Cod. Sang. 515, B1, 38v-39r; see Gustav Scherrer, *Verzeichniss der Handschriften der Stiftsbibliothek St. Gallen* (Halle, 1875), p. 160, and Ochsenbein "Spätmittelalterliche Buchausstattung," p. 180. – The same type of picture appears on a letter of indulgence signed by sixteen cardinals in 1503 for the pilgrimage to the Pièta in the Liebfrauenkapelle in Pflasterbach near Sünikon (municipality of Steinmauer near Regensberg ZH) and on a woodcut (after 1503) for pilgrims to that chapel (pictured in Peter Jezler, *Der spätgotische Kirchenbau in der Zürcherlandschaft. Die Geschichte eines "Baubooms" am Ende des Mittelalters* [Wetzikon, 1988], pp. 21, 23 [figs. 8, 10]).

12 Bl. 35v.-40v: "Maria ain muoter der barmhertzikait, ain kingin der gnaden, ain kaiseri der himel und erden, bit din kind für uns, den dir verkint der engel Gabriel...[with 43 decades] den bit, muotter der erbermd, kingin der gnaden und kaiserin ym himel und uff erd, für todsünder und sinderin. Ave Maria sprich."

13 St. Gallen, Stiftsbibl., Cod. Sang. 511, fol. 4v. Regarding the manuscript, see Scarpatetti, *Katalog*, p. 41 (no. 107) and fig. 434 (with coat of arms: in red, a yellow crossbeam, surmounted by a white spur); for the copyist, ibid., p. 290.

14 Bl. 9r-12r: "O aller selikeit ein gnadenricher und erbringer, herr Ihesu Criste, sich an so andechtig und tugenthafftig hertz...zu hilf, tröst und erledigung. Amen."

15 Einsiedeln, Stiftsbibl., Cod. 185. See Peter Ochsenbein, "Das persönliche Gebetbuch von Ulrich Rösch," *Ulrich Rösch, St. Galler Fürstabt und Landesherr. Beiträge zu seinem Wirken und zu seiner Zeit,* ed. W. Vogler (St. Gallen, 1987), pp. 31-64.

16 Cataloguing in Ochsenbein, "Das persönliche Gebetbuch,", pp. 38-41 and pp. 62-64 (pictures and beginnings of prayers for the salvation cycle).

17 Cod. Eins. 285, p. 203 (prayer: pp. 202 f.).

18 Munich, Clm 935 and Vienna, Oesterr. Nat. Bibl., Cod. 2739*. See Ochsenbein, "Das persönliche Gebetbuch," pp. 47 ff.

19 Cycles of miniatures connected with the history of salvation in Latin psalters of Swiss provenience: 1. Sarnen, Library of the college, Ms. 19, 7v-8v and 100 v (see Christoph and Dorothee Eggenberger, *Malerei des Mittelalters*, Ars Helvetica V [Disentis, 1989], pp. 177 f. and fig. 156: Muri c. 1100). 2. Ibid., Ms. 83, 1r-8r (see Eggenberger, op. cit., pp. 178-182 and figs. 157-159: Muri c. 1100). 3. Donaueschingen, Fürstenbergische Bibl., Cod. 180, 1r-4v (see Joachim M. Plotzek, *Andachtsbücher des Mittelalters aus Privatbesitz,* Catalogue of the Schnütgen-Museum (Cologne, 1987), pp. 66 f. [No. 1]: perhaps Rheinau or Muri, last third of the twelfth century). 4. St. Gallen, Stiftsbibl., Cod. Sang. 402, pp. 13-26 (see Johannes Duft, *Weihnacht im Gallus-Kloster* [St. Gallen and Sigmaringen, 1986], (=Bibliotheca Sangallensis 2)], pp. 68-72, 130 and plates VI and VII: shortly after 1235 from the old diocese of Basel). – Besançon, Biblothèque municipale, Ms. 54 (see Eggenberger, op. cit., pp. 221 and fig. 189: c. 1260 for a Cistercian convent in the diocese of Basel).

20 For the Crucifixion in fig. 2, see *Einblattdrucke des 15. Jahrhunderts*, ed. P. Heitz, 100 vols. (Strassburg, 1899-1942), vol. 7, fig. 1; vol. 18, fig. 4; vol. 19, figs. 11-13; vol. 20, fig. 19; vol. 33, fig. 1; vol. 42, figs. 3, 5, and 14; vol. 45, fig. 5; vol. 46, fig. 2; vol. 48, fig. 2; vol. 50, fig. 3; vol. 53, fig. 6; vol. 64, fig. 1; vol. 96, fig. 10. For the Pietà in fig. 2, see ibid., vol. 38, fig. 13; vol. 47, fig. 11; vol. 55, fig. 22; vol. 76, fig. 12; vol. 96, fig. 15. For the Veronika picture in fig. 3, see ibid., vol. 9, fig. 3; vol. 33, fig. 16,; vol. 43, figs. 115 and 116; vol. 50, figs. 20 and 21, vol. 95, fig. 1.

21 See Adolf Spamer, *Das kleine Andachtsbild vom XIV bis zum XX. Jahrhundert* (Munich, 1930); Hans Körner, *Der früheste deutsche Einblattholzschnitt* (Munich, 1979); Belting, *Bild und Kunst,* pp. 474-483.

22 St. Gallen, Stiftsbibl. Cod. Sang. 1870, p. 57. Regarding the manuscript, see Beat Matthias von Scarpattetti, *Die Handschriften der Stiftsbibliothek St. Gallen. Beschreibendes Verzeichnis. Codices 1726-1984* (St. Gallen, 1983),pp.125-129.

Picture credits

figs.1-3 and 5: Stiftsbibliothek St. Gallen (Pius Rast, St. Gallen)

fig. 4: Karl Künzler, St. Gallen

Nott Caviezel

Big Form – Small Form: On Interactions of Late Medieval Art in Border Areas

However strong the countervailing tendencies may be, attempts continue to be made all over Switzerland to forge a single national identity out of the much-vaunted cultural diversity of a multinational state. While the Switzerland of the Swiss spent 1991 applauding an unbroken 700-year tradition, the scholarly disciplines were offering unbiased details and documents highlighting the historical logic of the forces threatening Switzerland with disintegration today. Why should the history of art and architecture sacrifice its impartiality when its core concern confronts it day in day out with the negligibility of national borders?

The multifarious links between present-day Swiss territory and its Italian, French, German, and Austrian neighbors have been a perennial theme of domestic art historiography.[1] In the era prior to the birth of the modern federal state in 1848, cross-border relationships were frequently of purely local or regional significance, often transitory, and so numerous as to make them exceedingly difficult to apprehend. This justified and justifies the research dedicated to individual, definable areas or even homogeneous cultural and artistic landscapes.[2] A field of research new particularly to art history is the alpine region, a subject historians, archaeologists, and above all ethnologists have already been dealing with for some time. Art history admittedly provides a large number of individual studies, but it was not until 1951, with the third Congrès international pour l'étude du Haut Moyen Age, that art history conceived a more comprehensive interest in the alpine

fig. 1: Section of a late Gothic stepped hall-church with saddle roof. The stepped hall-church is a self-contained form of church design. Its nave projects past the side aisles but, unlike the basilica, possesses no windows of its own. Parish church of La Sagne (Switzerland), c. 1500-1526.

region.[3] Hans Sedlmayr, who wrote in 1961 that "the Alps" were still a topic unknown to art history, may have intensified interest in the subject.[4] For the period that followed, Enrico Castelnuovo, who supplied the underpinnings for an "art history of the Alps" not confined to national boundaries, deserves particular mention.[5] Many artistic phenomena in border areas can be explained with the help of political constellations, the source of others – particularly in the late Middle Ages – can be sought in the flow of contemporary ideas throughout Europe, and others again obstinately guard their secret.

Linear art history continually searches for the beginning and end of individual lines of evolution – and is occasionally thwarted by its own vantage point and method. The material presence of art and architecture allows developments to be described and explained from their preliminary stages through maturity to ultimate decline, the opportunity to observe history over long periods offering new and unexpected scope. This has been impressively demonstrated by Fernand Braudel and the Ecole des Annales,[6] and demands not only a chronologically broad but also a geographically far-ranging view. If research into architecture and art in Switzerland is not to be doomed to failure by a lack of Swiss art, it must expand the perspective of the investigation to transcend borders in numerous ways, in accordance with the subject in question and the traditional methods of art history. The art-geographical viewpoint has acquired particular interest for Switzerland: in the past decade art geography has experienced an enormous resurgence and significant advances on Harald Keller's pioneering studies. By the same token, however, art history today, with its sometimes frighteningly positivistic approach, displays little interest in morphology, a discipline whose methods and aggregate knowledge would complement art geography.[7]

Morphology and typology do not disregard the strict historical method, which deals primarily with documental sources. The approach that regards form and structure as potentially conclusive and capable of interpretation, even

independent of the countless historical reasons for their individual existence, proves fruitful in conjunction with geographically and chronologically wide-ranging research. But it is less an exemplary model than the distribution and frequency of its motifs that tends to determine a pictorial or architectural type and the landscape to which it belongs. "Par convergence d'indices,"[8] as André Corboz once put it, hypotheses gain stringency; and this may also lead the archivists among the art historians onto the right path again. As long as research continues to be productive, it makes no difference which method has priority. For the history of form and style, the work of art itself is the source. Form and contents play a role; and it is only their interaction, i.e., the complementary use of stylistic and structural analysis, that can provide the key to an interpretation of complex works of art founded on the two-way movement from the parts to the whole and from the whole to the parts.

Pairs of Concepts and Criteria

Reducing complex relationships to models or looking for coherent patterns is always dangerous. With their "basic concepts" and pairs of concepts, art historians like Heinrich Wölfflin, Alois Riegl, Max Dvorak, Wilhelm Worringer, and Paul Frankl devised, tested, and presented indisputable innovations in art-historical methodology.[9] The methodological dispute ignited by Wölfflin's work was silently laid to rest over the following decades in favor of the often narrow-minded specialization or stubborn interdisciplinarity of our own day. This generates a certain reluctance to return to an approach according to which meaningful dichotomies might represent the key to greater knowledge. As anachronistic as it may seem to revert to these ideas for a study in architectural history, the results have been surprisingly revealing. "Big Form – Small Form" is a new pair of concepts with a certain role to play in art-historical research dealing with cultural border areas like Switzerland. But first a prefatory word should perhaps be said about the term "border area."

fig. 2: St. Maria delle Grazie in Milan (Italy), built 1463-1490 by Guiniforte Solari, is one of the last late Gothic stepped hall-churches in Lombardy.

fig. 3: Map of the Duchy of Savoy at the time of the "Comte vert" (Count Amadée VI, 1334-1383) and the "Comte rouge" (Count Amadée VII, 1360-1391).

"Center," "periphery," and "province" are concepts as relevant to the history of style as elsewhere. The dynamic quality of their reciprocal relationships alters according to the vantage point, meaning that the center may at the same time be the periphery or another center. The terms "province" and "provincial," which so often suggest a negative value judgment, are in themselves comparatively inconclusive.[10]

Provincial art is a result of modest means being employed in small towns and cities – in the shadow of larger cultural centers from which they receive constant impulses. Its achievement restricts itself primarily to copying. "Leaderless" artists are left to their own resources and often take considerable liberties with imperfectly assimilated trends. The way a center radiates to its periphery is fundamentally different. The further a center is from its peripheral areas, the less dominant its effect. This allows for significantly greater creative, artistic activity on the periphery, where imported inspirations can be fashioned into independent artistic achievements. This freedom to develop and display independent artistic intentions generates long, interesting time-lags in style and type. For regions influenced simultaneously by two centers or landscapes, i.e., peripheral or provincial with respect to both, Castelnuovo proposes the confusing concept "double periphery,"[11] a condition Karaman simply, and more aptly, terms "border milieu."[12] Switzerland was and is an artistic border milieu par excellence.

The Example of Gothic Stepped Hall-Churches

The stepped hall-church is a self-contained form of church design. Its nave projects past the side aisles but, unlike the basilica, possesses no windows of its own. The result is a pyramidal space that becomes progressively darker toward the top and opens optically on the ground floor to form a hall-like "light space." The stepped hall is by no means a hybrid – not a pseudo-basilica and certainly not an impure hall-church, as it has sometimes been called.

The Gothic stepped hall-churches of Switzerland – commonly considered a "coincidence" (Rahn),[13] a "rarity" (Gantner),[14] or an "exception" (Reinhardt)[15] in art-historical circles – can be found in the Valais, at the upper end of the Lake of Geneva, at the foot of the Jura Mountains, and in the Jura. They were built in the latter half of the fifteenth century and above all the first quarter of the sixteenth (fig. 1).[16]

Extensive investigations have shown that these Swiss stepped hall-churches go back to over sixty preserved stepped hall-churches in Lombardy and Piedmont, which were completed a good hundred years earlier and were to be found up to the Milanese edifices of the Solari (Sta. Maria delle Grazie, 1463-1490 [fig. 2]); S. Pietro in Gessate, 1475-1485). The form found its way from northwestern Italy across the Alps to present-day Switzerland, descending across the Valais and coming to a close, in a later form, in the Franche-Comté.[17] The vast late medieval duchy of Savoy extended from Nice across the Piedmont, the Aosta Valley, the Maurienne, the Tarentaise, Savoy, the Bugey, Bresse, and into the present-day Swiss areas of the lower Valais, Vaud, and Fribourg. As a kind of "alpine state," it coincides to a surprising extent with the territory in which stepped hall-churches were found, which for its part closely follows the major transit routes (figs. 3-5).[18]

This generous geographical classification of the very "un-Swiss" phenomenon of stepped hall-churches is the result of monographic studies of numerous buildings between Turin and Besançon, supplemented by comparative analyses of form and structure. While the ground plan, elevation, spatial profile, and interior relate directly to northern Italian models and adopt an un-Gothic, Latin notion of space, the sparse architectural sculpture, modenature, and simplicity of ornamentation are in virtual contradiction to it and derive from the most common form of French flamboyant: Big Form – Small Form.

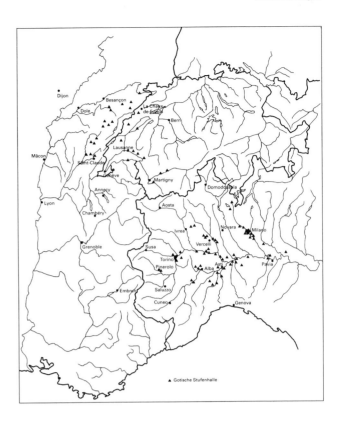

Drawing and Plan

These churches, all but one of which have a nave and two side aisles, are frequently divided into four bays. The width of the nave is identical with that of the recessed choir and, as would be consistent for the stepped-hall type, exceeds the width of the side aisles. This division of interior space generally demands three pairs of piers, usually plain and circular in cross-section; their dimensions, adjusted to the ground plan and elevation, take up the thrust of the arcades, reinforcing arches, and ribs of the vault. The Gothic vaulting ranges from groin vaults to quadripartite, net, stellar, and lierne vaults with pendants. More complicated constructions are reserved for the choir and sometimes the bay preceding the choir.

The only obvious difference between choirs is whether they have a polygonal or a square end.[19] Both types were widespread in French Switzerland during the Gothic era and beyond. If the design of the choirs is considered in connection with the rest of the eastern section and the overall ground plan of the church rather than in isolation, a host of elements and aspects recall monastic architecture. French Switzerland received significant impulses from the buildings erected by the Cistercians. With their foundations of Bonmont (1131), Hautcrêt (1135), Monthéron (1136), and Hauterive (1138) following in quick succession, and with their insistence on strict architectural conventions, the order established norms that would long remain influential.[20] Apart from choirs with square ends, six of our hall and stepped hall-churches have polygonal-end choirs. The early polygonal choirs in French Switzerland were built in St. Ursanne in the last quarter of the twelfth century,[21] in the no longer extant Dominican church of St. Marie-Madeleine in Lausanne around the mid-thirteenth century,[22] in the Franciscan church of St. François in Lausanne around 1270-1275,[23] in the parish church of Lutry around 1250/1260,[24] and on to the superstructure of the Valeria choir in Sion in the course of the thirteenth century.[25]

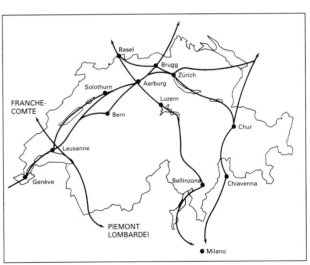

figs. 4-5: Distribution of Gothic stepped hall-churches in Lombardy, the Piedmont, present-day French Switzerland, and eastern France.
The important transit routes through present-day Switzerland in the period after 1500. One route leads from Lombardy through the Aosta Valley, across the Great St. Bernhard into Valais, then traverses the Romandie, and reaches the Franche-Comté by way of the Jura.

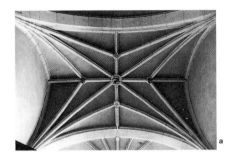

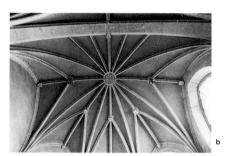

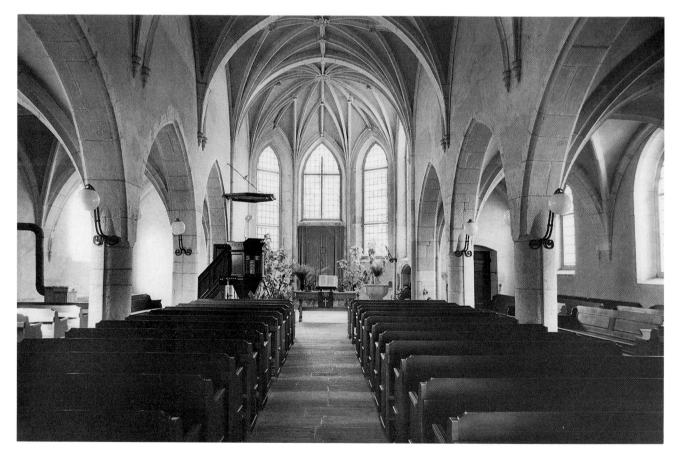

fig. 6: Parish church of La Sagne (Switzerland). Antechoir vaulting with the beginning of the choir vaulting (a); choir vaulting with the beginning of the antechoir vaulting (b).

fig. 7: Parish church of La Sagne (Switzerland). Nave looking toward the choir.

fig. 8: Parish church of La Sagne (Switzerland). Typical ground plan of a French Swiss stepped hall-church with three aisles and recessed choir. Three simple pairs of piers support the ribbed and stellar vaulting.

0 5 10

The massive influence that the architecture of the mendicant orders exercised on the parish churches of German Switzerland, Germany, and Austria cannot be established with analogous ease for French Switzerland.[26] One reason may be that in comparison with the Franciscan Province of Upper Germany and the Dominican Province of Teutonia, the western provinces possessed far fewer monasteries. Moreover, as the churches of the mendicant orders in French Switzerland had a Mediterranean orientation, their features were far less dissimilar to other architecture than was the case for the Franciscan and Dominican churches in the domain of the Province of the Upper Rhine. It may therefore be presumed that the late Romanesque and early Gothic choirs mentioned above influenced our six polygonal churches, particularly as these latter churches have a vaulted choir, nave, and aisles. Countless smaller contemporary country churches equipped with the extensively used polygonal-end choir may also have served as models. The late Gothic polygonal choir displays certain elements that can be traced directly to the architecture of mendicant orders and others based on supraregional architectural conventions whose source can no longer be determined. As has been discussed in greater detail elsewhere, the ground plans of other pre-Gothic buildings cannot be regarded as direct models.[27]

A striking feature shared by all of our stepped hall-churches is their compactness of line. The contours of the exterior walls of the aisles are drawn with impressive clarity, obfuscated by neither projecting transept nor overlong choirs or oversized towers. Following the interior disposition of the bays, there are generally modest, statically necessary buttresses structuring the outside walls. Where they are not needed to counter the thrust of the vaulting, there are no buttresses. All stepped hall-churches exhibit a propensity for axiality and qualified symmetry of design, qualities expressed in the position of the piers, the disposition of the bays, the fenestration, and the unambiguous placement of the buttresses.[28] Only the towers, where they are not central front or crossing towers, violate the sym-

metrical principal of the ground plans. The symmetrical axis from west to east can be drawn anywhere along the apex of the vault. The ground-plan design can help to bring out this axiality, accentuating it and rendering it architectonically visible in various ways: the apex of the nave is on the central axis throughout.

In the church of La Sagne, the intersections of the diagonal ribs – often marked by bosses – are even connected by an axial longitudinal rib in the vaulting of the choir and antechoir (fig. 6-8). In various buildings, the unimpeded view from west to east, made possible by the alignment of the west door with the central choir window, affords a visceral experience of the central axis. The way the walls of the polygonal choir draw the eye to the center can even heighten the effect. In St. Saphorin we encounter a homogeneous stellar vault that spans and integrates the recessed polygonal choir and front bay of the nave (fig. 9). The fact that the easternmost bays of the side aisles, with their formal and structural links to both nave and choir, are marked by elaborate vaulting grants them a hierarchical significance equal to that of the nave bay that precedes the choir. This motif of integrated choir and side aisles can ultimately be traced back to the early Cistercian ground plan and its typical northern Italian forms.

The choir design with only two subsidiary choirs and either no projecting transept or no transept at all is rarely found in Italian Cistercian churches. But this reduced form became virtually prototypical among the northern Italian Humiliati, whose monastic ideal exhibited strong affinities to the Cistercian rule. The reduction went so far that the two flanking chapels often extended almost to the apex of the central presbytery, thus rendering the overall ground plan of the church a nearly closed rectangle. With regard to form and structure, this assimilation in plan meant a total interpenetration of the east and west sections of the building. One of the earliest, and perhaps most typical, examples of this type of choir is the stepped hall-church in Viboldone, south of Milan (fig. 10); until into the fifteenth century, it served as a model for numerous parish churches,

fig. 9: Ground plan of the parish church of St. Saphorin (Switzerland), 1517-1521.

fig. 10: Ground plan of the former church of the Humiliati in Viboldone near Milan (Italy), built 1240-1260; façade 1348.

which even adopted the stepped-hall cross-section, for example S. Agnese in Lodi (late fourteenth century).[29] The next step in the reduction of this eastern plan is opening the subsidiary choirs towards the principal choir. There are many examples of this formal process of reduction, and it can be established not only for northern Italy but for eastern parts of present-day France as well. Three-aisled and one-aisled buildings with recessed choir occasionally had – and some still have – side altars at the choir shoulders. It is not uncommon for the vaulting of the front bay of the east aisle to deviate from, and be finer than, that of the nave. This must be seen as a function of the liturgical, and thus iconological, possibility of emphasizing the choir shoulders and, in the process, the last bays. Taken to its logical conclusion, this conception allows bays of the type described to be interpreted as reduced subsidiary choirs integrated into the longitudinal body of the church, particularly if the vault structures correspond to – or even meld with – those of the choir; and this is a design that originated in the triple choirs of the churches of the Cistercians and Humiliati.[30]

The arrangement of the bays according to a system of squares – or even the well-developed, consistent use of the Ad quadratum system, with or without alternation of columns and piers – was common in northern Italy during the early Gothic period. Cistercian buildings also adopted this design,[31] although, like the churches of the mendicant orders, they wanted to achieve a uniform system of supports. Further developments in northern Italy, particularly in the Gothic styles of Piedmont and Lombardy, show us that the intervals resulting from the Ad quadratum system corresponded to the artistic aims and the general northern Italian concept of space. The nave bays usually remained relatively square or were slightly elongated to form a transverse oblong. This meant that the side aisles would have comparatively narrow, longitudinally rectangular bays, the latter still corresponding to the two-square bays of the Ad quadratum system.[32] It follows that the French High Gothic principle of narrow, transverse, rectangular nave bays and virtually square side-aisle bays never really gained a foothold in northern Italy.[33] Ultimately, the basis for the breadth of vision of Gothic buildings in Italy can already be found in the conception of the ground plan. The large majority of northern Italian hall-churches and stepped hall-churches adopted the broad, slow arcading that permitted statically sound vaulting with a minimum of bays. We can find Swiss examples of this style as well.

Design

Above the Big Form of the ground plan rise the spatial boundaries, also classified as Big Form. At first glance the exterior of French Swiss stepped hall-churches reveals that they are not basilicas, because all of them have a single, usually broad, large saddle roof over the nave and side aisles. The division of the interior cannot be determined conclusively from the appearance of the exterior, but certain organizational principles suggest a relationship in construction and design between the outside and the inside that indicates the presence of three aisles. In this connection, the equilateral triangle described by the angle of the roof of the west gable already plays a significant role. That the aisles are stepped is also often revealed in the articulation of the west front, where the placement of the portal, windows, and occasional buttresses bears a relation to the aisles behind them. These observations allow the connection between exterior and interior design to become clear. The architects of these churches were evidently very anxious to make this relationship as visible as possible. In keeping with the compactness of the ground plan, the continuity of line striven for in the basic contours is carried on in the masonry, up to the very gable and eaves. Bay after bay, wherever possible, simple, comparatively small lancet windows between the buttresses help to articulate the side walls, which tend not to be overly high. The regularity thus achieved contributes to the symmetry and clarity striven for by the whole church – a concept which, with its Latin sense for architecture with the least possible openwork and greatest possible emphasis on solid walls, recalls

both Romanesque tradition and early Renaissance partiality to orthogonal structuring (figs. 11, 12).

The tendency toward a homogeneous, compact exterior prevents the plasticity of the wall from being accentuated. That is why elaborate portals are usually lacking. The windows along the aisles are clearly subordinate in size to the walls that surround them. Only the choir windows in certain of the edifices succeed in establishing a more balanced relationship between a wall-like character and openwork. As a plethora of details would run counter to the principle of overall unity and continuity, the use of tracery is restricted mainly to the windows in the choir. The windows along the aisles tend to be simpler in design. Without tracery, as if simply cut into the wall, they have plain external window ledges, and their inner faces are extremely modest in profile.[34]

The exterior accentuation of the wall is carried on in the interior of these late Gothic churches. This singular interaction of exterior architecture and interior space distinguishes the Swiss stepped hall-churches clearly from all other late Gothic stepped hall and hall-churches north of the Alps. The ground plan of our stepped hall-churches has already been observed to hark back to pre-Gothic traditions; the same applies to the relation of exterior and interior. Apart from the climatically motivated desire for the most compact possible walls, significant influences and impulses from Piedmont and Lombardy are perceptible both inside and outside. As a type, French Swiss stepped hall-churches belong to the periphery of northern Italian architecture in the late Gothic era.

Light

Light is crucial to the effect of a Gothic interior. The sober, neutral white light in stepped hall-churches has nothing in common with the metaphysics of light that played so central a role in the early and high Gothic era. No vestiges remain of "rapture," the "supernatural," and the "cultic power of light."[35] Equally, there are no signs of dependence on theologically based, speculative trains of thought

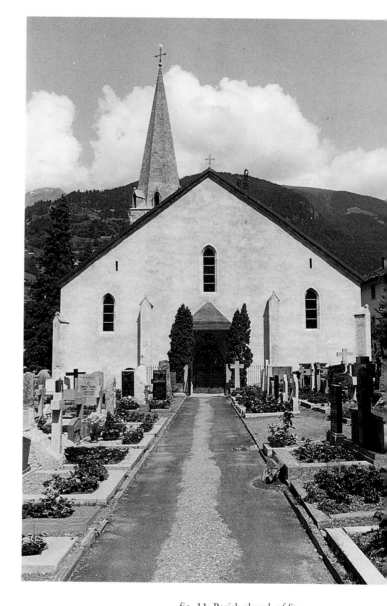

fig. 11: Parish church of St. Maurice in Le Châble (Switzerland). Tower, nave, and choir c. 1488, 1503, and 1519/1520-1534 respectively. The interior division of space can be recognized from the structure of the west façade, with its three narrow windows, central entrance, and single broad saddle roof.

as described by Otto von Simson in his book on Gothic cathedrals.[36] Suger's "lux nova," a formative Gothic concept, is nowhere to be found.[37] We also look in vain for the colorful light connected with it. The windows, most of which are no longer equipped with their original glazing today, are justly restricted to off-white, grisaille tones, or very transparent pastels.[38] So what we are dealing with here are interior spaces from the late or final Gothic period, whose essence, even from the standpoint of illumination, is highly un-Gothic and not even truly medieval any more. Light has lost its transcendental power. The prosaic, indeed modern, treatment of light lends the spatial complex a correspondingly earthbound, neutral overall effect. As symmetrical lateral lighting (ideally) allows the side aisles to appear only slightly brighter than the lower area of the nave, whose upper half is progressively engulfed in darkness, the "ground floor" of the aggregate nave and aisles creates what appears to be a hall-like, horizontally accentuated "light space," adjoined in the east by the often even brighter, directionally oriented choir. The vertical, and thus basilical, element of the higher nave thus recedes into the background and is perceived only to the extent that, in certain cases, pilasters or engaged columns draw the eye upwards, or that an additional window in the west front, if it is not obstructed by galleries and organs, illuminates the upper part of the nave more effectively (fig. 13).[39] But since our stepped hall-churches are ultimately small to medium-sized, there is only limited scope for the hall effect to develop. This is particularly true because the inner structures that keep the individual aisles from merging – and thus prevent a unified flow of space – also seem to lead the eye step by step along the walls and arcades rather than sweeping it gently and all-inclusively around the piers.[40]

Ornament and Modenature

The expression modenature comes from the French and Italian terms "modénature" and "modanatura" (Latin: "modulus"). In its broadest sense it designates the course, form, dimensions, and proportions of profiles and ornamental and structural architectural sculpture. Modenature

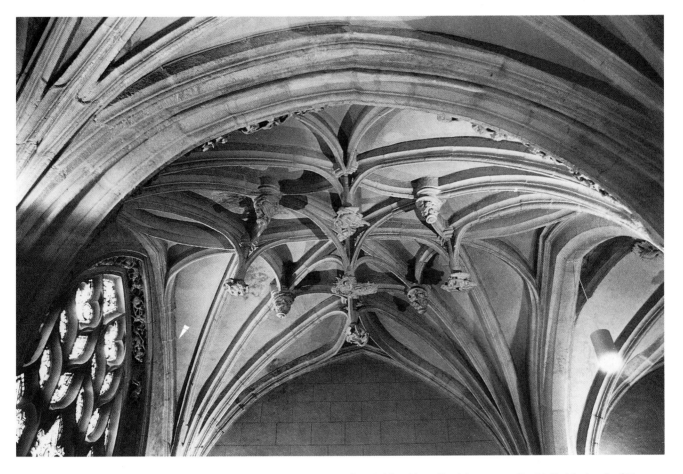

fig. 12: The side walls of the aisles, which tend not to be overly high, are articulated according to the interior division of the church, with buttresses at regular intervals and windows between them. a: Le Châble (Switzerland); b: collegiate church of Castiglione-Olona (Italy), 1421-1428.

fig. 13: The pyramidal space becomes progressively darker toward the top and opens optically on the ground floor to form a hall-like "light space."

fig. 14: Parish church of Notre-Dame in Orbe (Switzerland). The nave was rebuilt between 1521 and 1525, after a fire. Magnificent lierne vaulting with pendants in the southeast side-aisle bay, c. 1525 (?).

15a 15b 16a 16b

is, accordingly, not decisive to the basic spatial concept behind a building, but it may easily help determine its spatial effect (figs. 14-16). Large-scale geographical studies of the morphology of modenature have established that certain stylistic trends have a specific direction of flow. Naturally, these trends are not limited to particular types of buildings.

All but one of the French Swiss stepped hall-churches built around 1500 exhibit a comparatively homogeneous modenature. After 1500 the originality of this late Gothic "uniform modenature" declines significantly. The piers tend to be cylindrical and rest on plain bases. The high art of stonemasonry is displayed in only very few places and only when the builders or individual founders transcend themselves to commission angular compound piers with elaborate profiles, and decorative inlaid strips and bases for special chapels or side-aisle bays intended for specific functions; these decorative elements were constructed on the basis of complicated relations to a given square. The sharp-edged modenature found in French Switzerland was influenced by France, Burgundy, and Flanders. There the early fifteenth century already witnessed its advent in architectural decoration that would, in the course of the century, be enriched by Renaissance forms, culminating, for example, in a church not far from the Swiss frontier, the abbey church of Brou (1513-1532). This modenature can be discovered on windows, portals, piers, vaulting ribs, and bosses, to name only the most important places (fig.17). In contrast to the German Austrian – and German Swiss – late Gothic predilection for lavish decoration and the stonemasons' deliberate display of virtuosity, our French Swiss stepped hall-churches are dominated by the space, walls, and thus the overall design of the directly perceivable edifice.

This phenomenon, too, moves the architecture dealt with here away from the ornate, "baroque" late Gothic and closer to the rational spatial and stylistic notions of the northern Italian Renaissance, which itself draws a great deal from the close, organically grown ties to the indigenous, likewise rational, concept of the Gothic. We seem to sense that the decorative elements in our stepped hall-churches were almost reluctantly employed or are alien to their surroundings. An exact parallel to this can be found in the cotto decorations of northern Italy, which have the identical effect and have often been misunderstood as embodying the spirit of the Gothic north of the Alps.

The center of Gothic architecture that emerged with the construction of Lausanne cathedral in the thirteenth century had only a modest influence on French Swiss building activity. The design of many Gothic parish churches tended to be affected more by the second- and third-rate buildings in their immediate vicinity than by great edifices far away. The extremely homogeneous treatment of Gothic decorative forms in the fifteenth century can be explained generally by the "internationalization" of style. The fact that in French Switzerland the architectural ornamentation common to the French flamboyant style stops at the Alps and reappears in strongly modified form in northern Italy, but continues to be cultivated in Savoy, makes French Switzerland – particularly with respect to the stepped hall-church – a region at the edge of a "zone of shared optical vision," as Gerstenberg would put it,[41] a zone substantially comprehending French Switzerland, the Franche-Comté, Bresse, and Burgundy. If we study the architectural sculpture for itself, we may justifiably claim that, with a few exceptions, French Switzerland's is neither particularly original nor elaborate, but that it fits into an omnipresent repertoire of forms that found more impressive expression in supreme artistic achievements elsewhere. In comparison with its region of origin, the architectural sculpture of French Swiss stepped hall-churches is provincial.

The debate over the quality and function – or even the justification – of ornamentation, which began a century ago and has now somewhat subsided, was in a certain sense an early approach to the subject of Small and Big Form. Discussions relative to the propagation of the

16c

17a

17b

fig. 15: The cylindrical piers in stepped hall-churches tend to rest on plain bases: a. parish church of Môtiers (Switzerland), nave 1460-1490; b. parish church of Montefleur (France), c. 1519.

fig. 16: The sharp-edged mode-nature influenced by Burgundy and Flanders can frequently be encountered on the embrasures of doors. This also applies to stepped hall-churches, for example: a. Abbaye-en-Grandvaux (France), 1445-1472; b. Moirans (France), end of the fifteenth century; c. Montreux (Switzerland), 1495-1501 and 1519.

fig. 17: Two windows with flamboyant tracery, inlaid strips, and drip molding with figural consoles exhibit astonishing similarity in the choice and execution of motifs: a. La Rivière-Drugeon (France), 1415-1490; b. Orbe (Switzerland), 1521-1525.

contemporary modern, but also theoretical investigations of the form and content of decoration, repeatedly pose the question of necessity and avoidance – always going out from the idea that decoration can be judged independently, isolated from its architectonic context.[42] That the power and innovation of the Swiss stepped hall-church around 1500 lay in its being an extremely modern design of a church interior while making sparing use of traditional late Gothic ornamentation is illustrated by certain key sentences like "Lack of decoration is a sign of spiritual strength"[43] or "It is a basic error to regard the undecorated state as the original one: the contrary is true. Decoration is the more naive, spontaneous expression, whereas lack of decoration presupposes conscious reflection."[44]

Recurring Patterns?

The genetic and stylistic distinctions between Big Form and Small Form in late medieval Swiss stepped hall-churches permit two opposing lines of development to be established. These lines, coming from the north and the south, intersect in French Switzerland, merging there to produce new and independent creations. That the resulting concept of spatial form ("Big Form") is modern in comparison with local architecture can be attributed to the fact that the region is part of the periphery of northern Italy; its relatively antiquated architectural sculpture ("Small Form"), on the other hand, belongs to the provincial work of the Franche-Comté/Burgundian art landscape. From this perspective, the French Swiss stepped hall-churches of Italian origin express an idiosyncratic understanding of architectonic space, which, despite the use of flamboyant architectural sculpture and decoration, indirectly rings in the Renaissance in Switzerland north of the Alps.

Big Form and Small Form as discussed here in connection with late Gothic stepped hall-churches in Switzerland point with astonishing regularity to diametrically opposed, geographically distant regions of origin – eastern

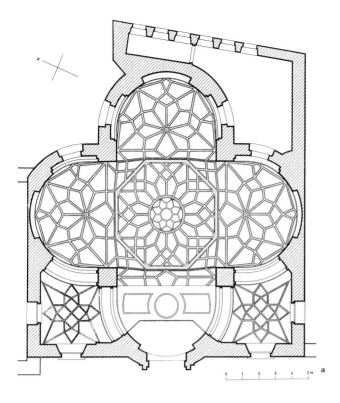

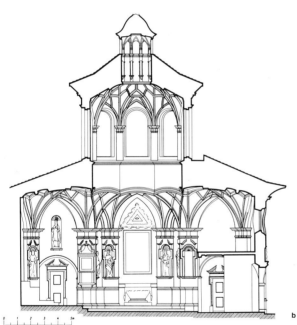

fig. 18: Ground plan and section of the church of the Visitandine Order in Fribourg, built 1653-1656 by Hans-Franz Reyff. The architect skillfully combined the Big Form of an early baroque centralized plan with the Small Form of post-Gothic modenature.

France and northern Italy. The question of dating is only marginally relevant. There is an art-historical rule of thumb stating that decoration and ornament tend to indicate the youngest parts of a work of art. Though this rule appears to apply, it says nothing about the quality or originality of the artwork. It has been posited that, in terms of Big Form, border areas take their impulses selectively from reliable models in artistic centers and that Small Form is imitative, produced in the tracks of generalized, provincial art. This thesis leads to the question of whether the phenomenon established in connection with our example of the late medieval stepped hall-church represents a universally applicable pattern in (late) medieval architecture and art in border areas. If this were the case, countless anonymous works in border areas might be easier to grasp and classify.

Analogous constellations appear to recur in later periods as well. In his survey of Protestant church architecture in Switzerland, Georg Germann has developed a convincing typology based on links with foreign architecture.[45] This typology, ranging from the Charenton type (Temple de la Fusterie in Geneva, Heiliggeistkirche in Bern) to the many Swiss transverse churches (Chêne-Paquier, Zurzach, Wädenswil, Horgen, Uster, Neuchâtel, etc.) may illustrate the same pattern or at least the same phenomenon: that a shared type of functional space derived from pioneering models (Big Form) may exhibit stylistic characteristics – i.e., Small Form – of diverse local, regional, or provincial origin. The churches Germann names as examples – Le Locle (1758-1759), Wädenswil (1764-1767), and Samedan (1771) – provide excellent illustrations of this idea.[46]

Also impressive is the relationship between Big Form and Small Form in Swiss Jesuit churches, whose spatial conception, like later buildings by the Vorarlberg masters, are in keeping with Vignola's Gesù in Rome and the Michaelskirche in Munich. Up to the late examples of baroque "total works of art," the architectural sculpture contributes little in the way of integration. Instead, a more

or less subtle discrepancy between Big and Small Form can be determined once again, their sources deriving from such varied artistic environments as early Roman baroque and southern German high and late baroque. It is, for example, symptomatic that the Jesuit church in Fribourg, built by Abraham Cotti between 1604 and 1613, should have gained in stature when festive rococo plasterwork was added in 1756/1757 – despite the starkness of its spatial conception as a pilaster church and the presumably insignificant, very late or post-Gothic architectural embellishment it was originally equipped with. The most modern concept of interior space developed north of the Alps – inspired by the Gesù in Rome, which was only thirty years older – was combined with very unremarkable, provincial decoration that had existed locally for hundreds of years. The situation of the church of the Visitandine Order in Fribourg is similar; between 1653 and 1656 Hans-Franz Reyff succeeded in skillfully amalgamating the Small Form of post-Gothic modenature with its early baroque centralized plan (fig. 18).

Architecture and art often follow the inherent laws of their disposition without allowing themselves to be disturbed by the ostensible contradiction between art and the patterns of its development. On the contrary: as the contents change, the conjunctions of these patterns often generate works of art that can achieve a remarkable degree of artistic independence of form.

Translated from the German by
Eileen Walliser-Schwarzbart

Notes

1 Two distinguished art historians from different eras have recognized this fact: "The totality of Swiss monuments offers a picture filled with contradictions, which only after a difficult and lengthy survey opens a prospect of somewhat firmer directions and the multifarious influences that converge from here and there, and have since the Romanesque period of art in our country expressed a completely cosmopolitan character." (Johann Rudolf Rahn, *Geschichte der bildenden Künste in der Schweiz von der ältesten Zeit bis zum Schlusse des Mittelalters* [Zurich, 1876], p. VI). "The reason it is difficult to write a book on Swiss style or art history is because there is no Swiss art with a style or history of its own...Our country shares in three major cultural provinces, the German, the French, and the Italian..." (Peter Meyer, *Schweizerische Stilkunde von der Vorzeit bis zur Gegenwart* [Zurich, 1942], p. 23). Interesting more recent insights and surveys on the topic are offered by various articles in *Unsere Kunstdenkmäler* 38 (1987), Heft 3, its subject: *Von Füssli bis Ars Helvetica – Kunstgeschichte in der Schweiz* (with a comprehensive bibliography of standard works and obscure papers).

2 Pars pro toto let me mention Albert Knoepfli's magisterial *Kunstgeschichte des Bodenseeraums,* 2 vols. (Sigmaringen, Stuttgart, and Munich, 1961 and 1969).

3 Third "Congrès international pour l'étude du Haut Moyen Age" (Proceedings Olten and Lausanne, 1954).

4 Hans Sedlmayr, "Probleme der Kunst in den Alpen am Paradigma des karolingischen Mailand," *Vorträge und Forschungen X: Die Alpen in der europäischen Geschichte des Mittelalters,* Konstanzer Arbeitskreis für mittelalterliche Geschichte (Constance and Stuttgart, 1965).

5 Enrico Castelnuovo, "Les Alpes, carrefour et lieu de rencontre des tendences artistiques au XVe siècle," *Etudes de Lettres,* série II 10 (1967), pp. 13-26; later "Pour une histoire dynamique des arts dans la région alpine du Moyen Age," *Zeitschrift für Schweizer Geschichte* 29 (1979), pp. 265-286. Complementary and interesting: Ludwig Pauli, *Die Alpen in Frühzeit und Mittelalter. Die archäologische Entdeckung einer Kulturlandschaft* (Munich, 1980); *Histoire et Civilisations* des Alpes, 2 vols. (Toulouse and Lausanne, 1980); Werner Bätzing, *Die Alpen. Entstehung und Gefährdung einer Kulturlandschaft* (Munich, 1991).

6 Fernand Braudel, *La Méditerranée et le monde méditerranéen à l'époque de Philippe II* (Paris, 1949).

7 Two works by Harald Keller – *Kunstlandschaften Italiens* (Munich, no date [1961]) and *Kunstlandschaften Frankreichs,* Sitzungsberichte der wissenschaftlichen Gesellschaft an der Johann Wolfgang Goethe-Universität Frankfurt a.M.1 (1962), no. 4 (Wiesbaden, 1963), pp. 95-186 - are early precursors of modern art geography, although they still attempt to delimit homogeneous landscapes. At almost the same time as Harald Keller's studies, the art historian Ljubo Karaman published a book in Zagreb that has, for linguistic reasons, received far too little attention. Karaman makes groundbreaking observations for his time using the example of the art of Dalmatia. I am indebted to the late Prof. Jan Bialostocki from Warsaw for this information. Prof. Bialostocki drew my attention to the contents of the book and the quintessence of Karaman's theories in an illuminating personal conversation; the book by Ljubo Karaman, *Odjelovanju domace sredine u umjetnosti hrvatskih krajeva* (Zagreb, 1963), contains a summary in German. In Switzerland, Enrico Castelnuovo has pursued "art geography" in the modern sense. He spent many years studying the phenomenon of cross-boundary art, particularly paintings (cf. note 5 above). The Vereinigung der Kunsthistoriker in der Schweiz also made art geography the subject of one of their colloquiums. The proceedings of the colloquium "Die Schweiz als Kunstlandschaft – Kunstgeographie als fachspezifisches Problem" were published in the *Zeitschrift für schweizerische Archäologie und Kunstgeschichte* 41 (1984), pp. 65-136; the paper by Georg Germann, "Kunstlandschaft und Schweizer Kunst," pp. 76-80, is of particular interest. Dario Gamboni's *Kunstgeographie,* published in the Ars Helvetica series (Disentis: Desertina Verlag, 1987), offers a good summary of art geography as applied and applicable in Switzerland up to the present day; a list of the more recent literature on the subject can also be found there, pp. 219 f.

8 André Corboz, Mathod-Maser. In *Das architektonische Urteil. Annäherungen und Interpretationen von Architektur und Kunst* (Basel, Boston, and Berlin, 1989), pp. 117-138, esp. p. 122.

9 One need only recall "the linear and the painterly," "area and depth," "closed form and open form," "manyness and oneness," "clarity and unclarity" (Heinrich Wölfflin, *Kunstgeschichtliche Grundbegriffe* [Munich 1915]), "abstraction and insight" (Wilhelm Worringer, *Abstraktion und Einfühlung. Ein Beitrag zur Stilpsychologie* [Munich, 1908]), "optic" and "haptic" (Alois Riegl, *Spätrömische Kunstindustrie* [Vienna, 1901]), "subjectivistic" and "objectivistic" (Alois Riegl, *Das holländische Gruppenporträt* [Vienna, 1931]), "spatial addition" and "spatial division", "power center" and "power channel" (Paul Frankl, *Die Entwicklungs-phasen der neueren Baukunst* [Leipzig and Berlin, 1914]), or Max Friedländer's curious system, which yields as its paired concepts: "autocracy and democracy," "serviceable art and autonomous art," "intellectual design and sensory perception," "vigor and the need for peace and quiet," "the sculptor's vision and the painter's vision" (Max Friedländer, *Über die Landschaftsmalerei und andere Bildgattungen* [The Hague and Oxford, 1947]). A fundamental treatment of Wölfflin's basic concepts: Erwin Panofsky, "Über das Verhältnis der Kunstgeschichte zur Kunsttheorie. Ein Beitrag zur Erörterung über die Möglichkeit `Kunstwissenschaftlicher Grundbegriffe'," *Aufsätze zu Grundfragen der Kunstwissenschaft,* ed. H. Oberer and E. Verheyen, 2nd. ed. (Berlin, 1974), pp. 50 f.

10 Castelnuovo did not succeed in establishing a definitive distinction between periphery and province down to the last detail. Karaman, on the basis of his studies of the art of Dalmatia, was, however, able to extract clear and comprehensible criteria that could be verified and confirmed with reference to the Swiss stepped hall-churches investigated. See Enrico Castelnuovo and Carlo Ginzburg, "Centro e periferia," *Storia dell'arte italiana I: Questioni e metodi* (Turin, 1979), pp. 283-352, and L. Karaman, op. cit.

11 Castelnuovo, "Centro e periferia," pp. 330 f.

12 Karaman, op. cit., pp. 111 f.

13 Rahn, *Geschichte der bildenden Künste,* pp. 398 f.

14 Joseph Gantner, *Kunstgeschichte der Schweiz,* vol. 2 (Frauenfeld and Leipzig, 1947), p. 144.

15 Hans Reinhardt, *Die kirchliche Baukunst in der Schweiz* (Basel, 1947), pp. 91 f.

16 They include (summary construction dates in brackets): Raron (1512-1517), Savièse (1523-1525), Le Châble (1488, 1503, 1519/20-1534), Villeneuve (vaulting: 1506-1510), Montreux (tower 1460-1470, choir 1495-1501, nave completed before 1519), St. Saphorin (1517-1521), Orbe (1521-1525, 1687 and 1689), Estavayer-le-Lac (nave 1440-1462, vaulting begun in 1502), Môtiers (1486-1490, choir 1679), La Sagne (1500-1526).

17 Discussed in detail in N. Caviezel, "Spätgotische Hallenkirchen," 3 vols. (Ph.D. diss., University of Fribourg, 1988), two typewritten volumes (457 pp.) plus one volume of illustrations (182 pp. with 508 ill.). The dissertation will be published shortly.

18 Fortunately, monographic studies and exhibitions dealing with the history and art history of this interesting Savoy state are on the increase and offer archival evidence illustrating these lively north-south relations – often for fields other than architecture. Cf. (in chronological order): Marcel Grandjean, "L'architecture de brique `genevoise' au XVe siècle," *Nos monuments d'art et d'histoire* 36 (1985), pp. 326-336; Bernard Andermatten and Daniel de Raemy, *La Maison de Savoie en Pays de Vaud* (Lausanne, 1990); *Stalles de la Savoie médiévale* (Geneva, 1991); Marcel Grandjean, "Les architectes `genevois' hors des frontières suisses à la fin de l'époque gothique," *Nos monuments d'art et d'histoire* 43 (1992), pp. 85-109.

19 Polygonal-end choir in Môtiers, Raron, St. Saphorin, La Sagne, Le Châble. Square-end choir in Estavayer-le-Lac, Villeneuve, Orbe, Savièse.

20 In contrast to the Dominicans, who, at the latest since the "statuta capituli generalis Narbonnensis" of 1260, had to adhere to more or less compulsory architectural prescriptions, the Cistercians are not known to have had any express, comprehensive architectural guidelines. Their lucid, austere architecture is more likely to have reflected the strict asceticism of their monastic attitude, which in the early period made what might be viewed as demonstrative attempts to distinguish itself from the spirit of Cluny. (Thanks to the studies of Marcel Aubert and Hanno Hahn, Cistercian research has moved far beyond this generalized characterization of Cistercian architecture. The latest contribution in the field is Wolfgang Rug, "Der `bernhardinische Plan' im Rahmen der Kirchenbaukunst der Zisterzienser im 12. Jahrhundert" [Ph.D. diss., University of Tübingen, 1983], with an outstanding summary of the current state of research and a comprehensive bibliography.) In general, the literature has pointed out the influence of Cistercian buildings on flat-end choirs; for example, the former choir of the Cathedral of Fribourg, the parish churches of Romont FR, Montagny-les-Monts FR, Moudon VD, Vevey VD, and Nyon VD. The proximity of Bonmont to Nyon, of Hauterive to Fribourg, and of La Fille-Dieu to Romont may have encouraged the adoption of certain architectural forms. This has already been noted by J. Gantner in the second volume of his *Kunstgeschichte der Schweiz,* pp. 56 and 83 f., and before him Camille Martin and Georg Dehio. A choir practically identical in shape to Villeneuve can be found in the Cistercian church on the Maigrauge in Fribourg. (Cf. Marcel Strub, *Les Monuments d'art et d'histoire du canton de Fribourg,* vol. II [Basel, 1956], pp. 324 ff.) An analogous eastern section, also with two flanking chapels, could be found in the former Augustinian abbey church in Gouailles near Salins in the French Jura, consecrated in 1192; its ground plan is shown in R. Tournier, *Les églises comtoises,* p. 137.

21 Inspired by the cathedral of Besançon. (Cf. Claude Lapaire, *Les constructions religieuses de St. Ursanne et leur relations avec les monuments voisins* [Porrentruy, 1960], pp. 130 ff.)

22 Marcel Grandjean, *Les Monuments d'art et d'histoire du canton de Vaud,* vol. I (Basel, 1965), pp. 173-184.

23 Ibid., pp. 185-246.

24 *Lutry, Arts et monuments. Du XIe au début du XXe siècle,* premiére partie (Lutry, 1990), p. 159.

25 *Kunstführer durch die Schweiz,* vol. 2, publ. by the Society for the History of Swiss Art (Zurich/Wabern, 1976), p. 273.

26 Johannes Oberst, *Die mittelalterliche Architektur der Dominikaner und Franziskaner in der Schweiz* (Zurich, 1927); Helma Konow, *Die Baukunst der Bettelorden am Oberrhein* (Berlin, 1954); Richard Kurt Donin, *Die Bettelordenskirchen in Oesterreich* (Vienna, 1935); and Richard Krautheimer, *Die Kirchen der Bettelorden in Deutschland* (Cologne, 1925). For a survey of the topic, see Wolfgang Braunfels, *Abendländische Klosterbaukunst* (Cologne, 1969), pp. 177-198.

27 St. Pierre-de-Clâges in Valais (early twelfth century), the former priory church of St. Jean in Grandson (before 1157), the churches of S. Pietro in Biasca (early twelfth century) and – despite small oculi in the clerestory – S. Biagio in Ravecchia (thirteenth century).

28 Unlimited symmetry would be achieved only if the axis divided the building into two identical mirror images, which is not always the case with our churches. Often the need to integrate existing earlier parts of the building and the terrain itself did not allow the symmetrical ideal to be realized.

29 A further church of the Humiliati with an analogous ground plan would be the – in part badly disfigured – church of S. Maria di Brera in Milan (first half of the thirteenth century). (Ground plan in A.M. Romanini, *Architettura gotica,* vol. 1, p. 117). Even churches built by mendicant orders – for example, S. Francesco in Domodossola (1227-1331) or S. Francesco in Alessandria (early fourteenth century) – follow the compact rectangular ground plan with presbytery and flanking subsidiary choirs aligned with the side aisles. However, in mendicant-order churches and parish churches, this type of choir was often

combined with a polygonal, central sanctuary; the subsidiary choirs, adapting the Lombardic three-apse church form, are apsidal. The outstanding Collegiata in Castiglione-Olona uses this ground plan design, inclusive of Ad quadratum system, as late as the first quarter of the fifteenth century (1421-1428).

30 Iconologically identical in interpretation are the choir shoulders, marked by semi-circular apses, which in combination with a central apse form the Lombardic three-apse choir. Bandmann traces so-called "three-cell complexes," as built in the period of Cluniac reform and the Carolingian period, back to early Christian and classical models (Günther Bandmann, *Mittelalterliche Architektur als Bedeutungsträger,* 2nd ed. [Berlin, 1951], p. 190).

31 For example, S. Maria di Casanova near Carmagnola in Piedmont (c. 1170) or Ripalta Scrivia in Piedmont (c. 1185).

32 As an example, see the ground plan of S. Maria del Carmine in Alessandria, a stepped hall-church from the second half of the fourteenth century. (Pictured in A.M. Romanini, *Architettura gotica,* vol. 1, p. 444).

33 One of the major and outstanding exceptions is the basilica of St. Andrea in Vercelli (consecrated in 1224).

34 The fairly elaborate tracery windows in the nave of Estavayer-le-Lac are an exception. They have three lights and extremely fine Rayonnant-style tracery. Isolated tracery windows can be found in the nave of Orbe, too.

35 Hans Jantzen, *Kunst der Gotik* (Hamburg, 1957), pp. 66 ff.

36 Otto von Simson, *Die gotische Kathedrale,* 3rd ed. (Darmstadt, 1968; first edition in English, 1956).

37 Erwin Panofsky, "Abt Suger von St. Denis," *Sinn und Deutung in der bildenden Kunst* (Cologne, 1975; first edition in English, 1946).

38 The exceptions to this rule are the few colored windows or window fragments from the fifteenth or sixteenth century, which are found mainly in the choir area.

39 For example: Orbe, Estavayer-le-Lac, La Sagne.

40 This "leading" of the eye suggests the "successive reading" that Gothic architecture gives rise to; in our stepped hall-churches, it is achieved predominantly with the help of the orchestration. In the same churches, this subjective, viewer-related perception of space is, however, already confronted with "geometrical space," which Dagobert Frey comments as "essentially making no distinction in the valuation of dimensions" (Dagobert Frey, *Gotik und Renaissance* [Augsburg, 1927], p. 76). Frey calls the concomitant "objectification" or readability of the interior – which, thanks to clearly delineated contours and emphasis on the hall-like quality, also occurs in stepped hall-churches – "the decisive step in the intellectual abstraction of the concept of space on the way to the Renaissance" (ibid.).

41 Kurt Gerstenberg, *Ideen zu einer Kunstgeographie* (Leipzig, 1922), pp.16 ff.

42 Cf. Alois Riegl, *Stilfragen. Grundlegung zu einer Geschichte der Ornamentik* (Berlin, 1893; reprint ed. Mittenwald, 1977). Peter Meyer, *Das Ornament in der Kunstgeschichte* (Zurich, 1944). Ernst H. Gombrich, *The sense of order. A study in the psychology of decorative art* (Oxford, 1979). A good, recent survey of the subject is provided by Günter Irmscher, *Kleine Kunstgeschichte des europäischen Ornaments seit der frühen Neuzeit (1400-1900)* (Darmstadt, 1984).

43 Adolf Loos, *Trotzdem 1900-1930* (Innsbruck, 1931), quoted according to Adolf Loos, *Sämtliche Schriften,* vol. 1, ed. Franz Glück, (Vienna and Munich, 1962), pp. 276 ff.

44 Peter Meyer, "Ornamentfragen," *Aufsätze 1921-1974* (Zurich, 1984), pp. 161-168, esp. p. 163. First published in *Werk* 24 (1937), pp. 53-59.

45 Georg Germann, *Der protestantische Kirchenbau in der Schweiz* (Zurich, 1963).

46 Ibid., p. 173

Picture credits

figs. 1, 6: Jean Courvoisier, *Les Monuments d'Art et d'Histoire du Canton de Neuchâtel,* vol. 3, publ. by the Society for the History of Swiss Art (Basel, 1968)

figs. 2, 10: After Angiola Maria Romanini, *L'architettura gotica in Lombardia* (Milan, 1964)

fig. 3: Drawing by the author, after Marie José de Savoie, *La Maison de Savoie* (Paris, 1956), p. 373

figs. 4, 13: Drawing by the author

fig. 5: Drawing by the author, after "Siedlung und Architektur im Kanton Bern," *Illustrierte Berner Enzyklopädie* (Wabern, 1987), p. 110

figs. 7, 8a, 8b, 11, 12a, 14, 15a, 15b, 16a, 16b, 16c, 17a, 17b: Photographs by the author

fig. 9: *Kunstführer durch die Schweiz,* vol. 2, publ. by the Society for the History of Swiss Art (Bern, 1976)

fig. 10: Marcel Strub, *Les Monuments d'Art et d'Histoire du Canton de Fribourg,* vol. 3, publ. by the Society for the History of Swiss Art (Basel, 1959)

The Renaissance

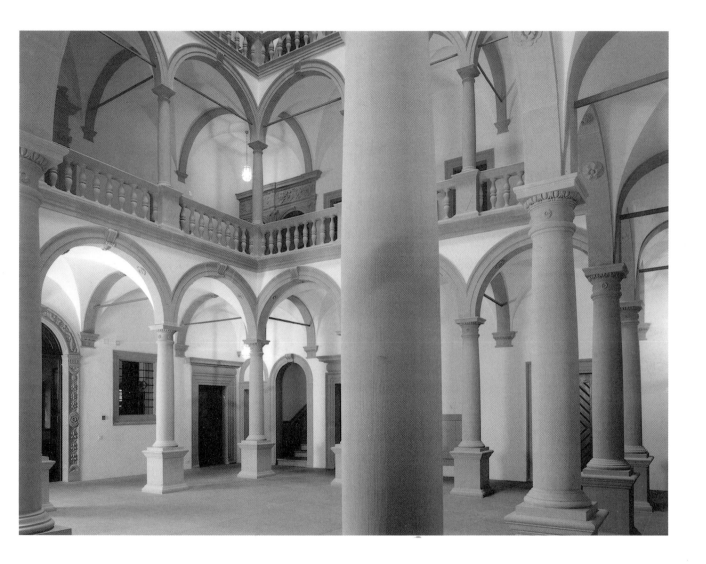

The Ritter Palace in Lucerne is the most impressive secular Renaissance building in Switzerland. Lux Ritter, a mayor of Lucerne who had made his fortune as a foreign mercenary, commissioned the Italian architects Domenico Solbiolo and Giovanni Pietro del Grilio to build him a manorial home in 1556. Vast for its time, it dwarfed the simple wooden townhouses of his fellow citizens. Like other direct imports from early Renaissance Italy, the formal elements employed, from arcaded courtyard to finely hewn decoration, evoke the southern style of life.

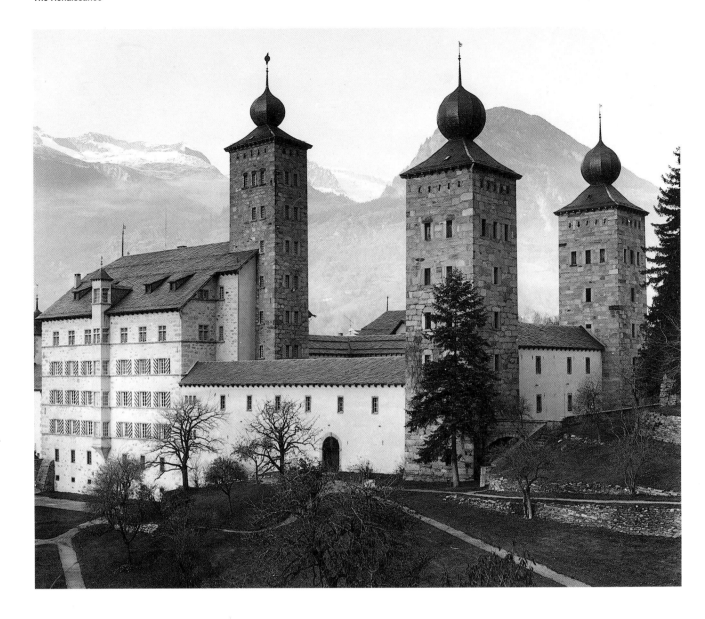

The Stockalp Palace in the town of Brig, an important road-post on the way to Milan, beyond the Lake of Geneva, is the most unusual Swiss building of its time. It was constructed by Prismeller architects from northern Italy for Kaspar Jodok von Stockalper between 1658 and 1678. The builder, whose affluence derived from the opening of the Simplon Pass, and the cloth and silk trade, called the palace "House of the Three Magi," naming the towers after them: Caspar, Melchior, and Balthazar. A variety of architectural allusions recall the well-traveled merchant's foreign impressions: the northern-Gothic living area goes over into the Italian-inspired arcaded courtyard, and the onion-domed towers take up eastern European motifs. The final product is a strongly personified architectural creation, inspired entirely by the personality of the builder.

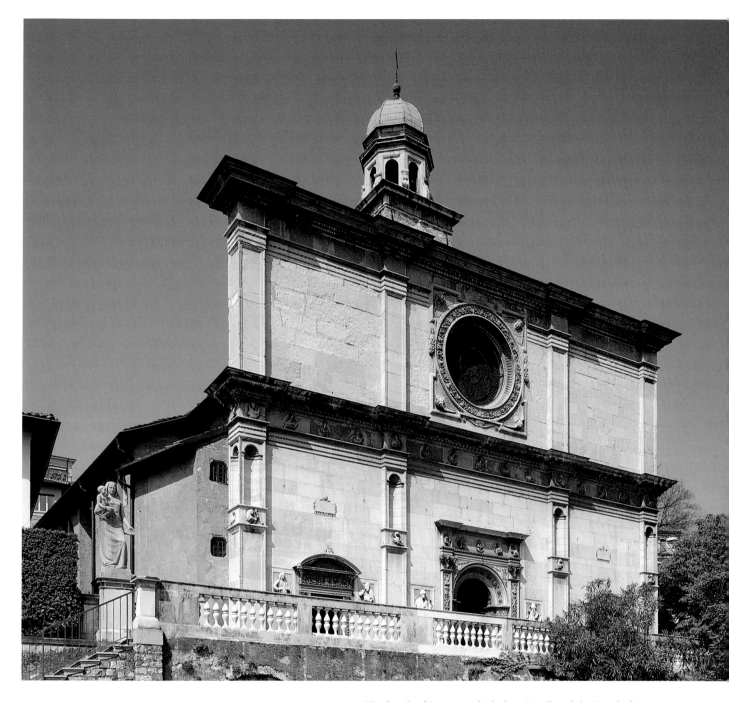

The façade of Lugano cathedral – constructed between 1500 and 1517 as an ornamental front set before the medieval church – represents important evidence of the Lombardic Renaissance. The imposing rose window was not added until after 1578. In the center, the Portale dei Santi, flanked by the Portale degli Uccelli and the Portale dei Giorni. A cool, concise orchestration of pilasters and string-courses, large unadorned surfaces, and exquisitely sculpted jambs combine to create a self-contained, monumental composition that is tantamount to an architectural manifesto, to architectural theory in practice.

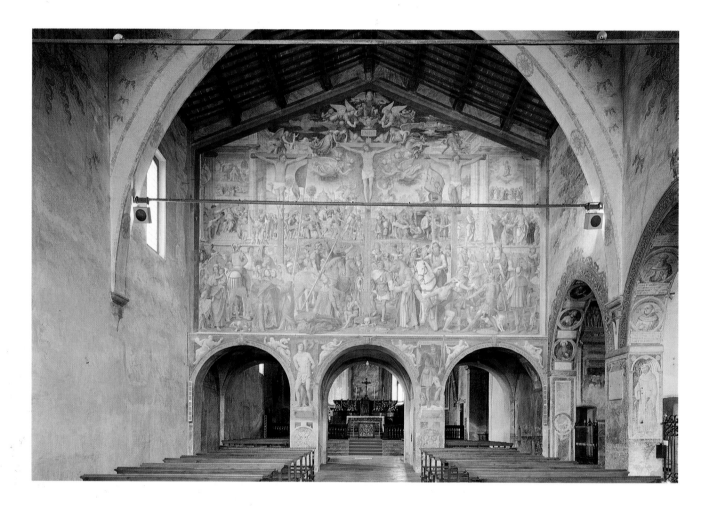

The painting on the rood wall of Santa Maria degli Angioli, the church of the Friars Minor in Lugano, is a prime example of Upper Italian Renaissance painting. Executed by the Milanese artist Bernardino Luini (c. 1485-1532), it depicts the story of Christ's Agony on Calvary and represents a pictorial translation of what the Franciscan monk Bernardino Caimi, appointed Guardian of the Holy Sepulchre in Jerusalem in 1477, strove to recreate architectonically: the "New Jerusalem" as "Monte Sacro" on the slope above the village. In contrast to Leonardo da Vinci, his most important precursor, Luini does not dramatize the expansiveness of space in his representation of the Crucifixion; his static scenes, with their many figures and details, offer a documentary retelling of the Passion. While the architecture itself, with its regional form of rood wall, takes up Upper Italian ground-plan concepts, the monumental painting, too, is wholly a product of Lombardic influence.

The numerous sculpturally ornamented, polychrome public fountains erected in various Swiss towns in the sixteenth century may be considered genuinely "national" artistic achievements. The late Middle Ages had brought forth the Gothic pinnacled fountain, with its figure-decked pillar rising from the center of the basin. The Swabian sculptor Hans Gieng, known to have been in Fribourg from 1525 to 1562 and also to have worked in Bern, created many fountains, among them the Samaritans' Fountain (1550-1551) on Fribourg's Samariterinnengasse. On a richly sculptured Renaissance pillar stand Christ and the Samaritan woman at Jacob's fountain. The decorative reliefs depict the Lamb of God and the Fall. The sculptural group that gives the fountain its name bears traces of polychromy and numbers among the finest fountain sculptures ever created. The dramatized total composition, the combination of architecture and figures, the richness of decoration, and the detailed realism of the representation have never been surpassed.

Pyramus and Thisbe, painting by Niklaus Manuel Deutsch, 1513/1514, distemper on canvas, 151.5 x 161 cm. Public Art Collection, Basel.

The tragic end of Pyramus and Thisbe, as told by Ovid (*Metamorphoses* IV, 55-166), plays in a vast landscape. The lovers, whose fathers oppose their relationship, agree to meet under a tree, near a well. Thisbe, the first to arrive, is forced to flee from a lioness, dropping her cloak in the process. When Pyramus sees the animal with the cloak in its mouth, he assumes it has torn his lover to shreds and plunges his sword into his side. Thisbe returns to find the dying Pyramus and thrusts the sword into her own body. Niklaus Manuel (c. 1484-1530) offers an epic representation of the mythological subject by letting the protagonists appear several times in the same picture, in accordance with the sequence of events. Manuel was a Bern patrician, mercenary, and bailiff. As a painter, writer, and politician, he took an intense interest in the societal effects of the mercenary system. He also made a name for himself as a promoter of the Reformation. That this very Reformation was to call forth the image breaking to which numerous of his religious works fell victim in 1528 is one of the ironies of the time. When he painted Pyramus and Thisbe, Manuel created what is probably the richest, most poetic landscape picture of his epoch.

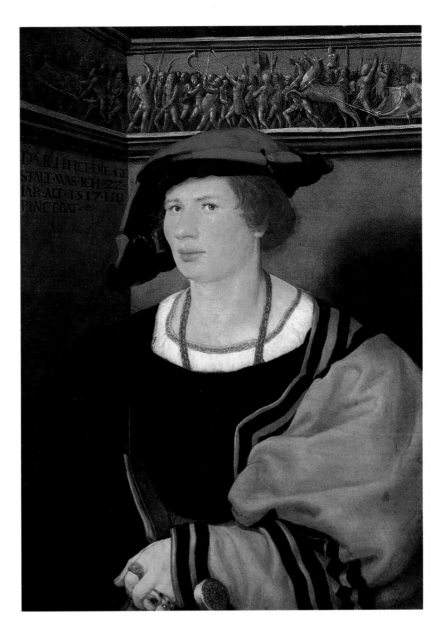

Hans Holbein the Younger,
*Portrait of Benedikt von
Hertenstein*, 1517,
tempera/paper on wood, 52.4 x
38.1 cm. Metropolitan
Museum of Art, New York.

Hans Holbein the Younger was born in Augsburg around
1497 and died in London in 1543. He was active in Basel
for an extended period, then moved to England in 1526,
where he lived on and off until his death. A representative
of international humanism between the Basel-based
Erasmus of Rotterdam and Thomas More, Holbein paint-
ed the portrait of the son of Lucerne's mayor Jakob von
Hertenstein in 1517. As a type, the portrait deviates from
the idiom common in Augsburg, taking up Italian motifs
in its creation of background space and its variations on
Mantegna's *Triumph of Caesar*. The manner of compo-
sition and allusion suggest that the artist spent time in
Italy, but may also denote the trade relations the Herten-
stein family, who commissioned the painting, entertained
with the south.

Hans Funk (c. 1470-1539), *The Old and the Young Confederate*, after 1530, painting on glass, 57.2 x 56.7 cm. Bernisches Historisches Museum, Bern.

Stained-glass panels are the characteristic national art-form of Switzerland. While other countries witnessed the decline of glass painting in the sixteenth century, in Switzerland it continued to attain ever new heights until well into the eighteenth century. The reason for this was less artistic than social, for, according to Swiss custom, when a public – or sometimes even a private – building was constructed or renovated, authorities and individuals with links to the owner of the building would present him with "blazon and window." Consequently stained-glass panels bearing coats of arms were much in demand and produced in large numbers. Nineteenth-century art dealers bought them from meanwhile modernized windows and sold them all over the world, particularly to England and

later to the United States. The stained-glass panel shown here illustrates a subject particularly typical of Switzerland in the sixteenth century: the contemporary lust for power and the mercenary tradition. Beneath the depiction of a battle, with well-disciplined Swiss Confederates driving their panic-stricken enemies into flight, an "Old Confederate" – a simple, honest peasant – is conversing with a "Young Confederate" – a fashionably dressed, glory-seeking mercenary. The Old Confederate is defending the traditional values of the Confederation: God-fearing loyalty; simplicity; friendly, masculine humility; unity; and helpfulness. The qualities of the Young Confederate – arrogance, pride, malice, and extravagance – are of the Devil.

Christoph Eggenberger

The Swiss Carnation Masters: Anonymity and Artistic Personality – Painters between the Late Middle Ages and the Renaissance

The restoration of the high altar of the Cordelier church in Fribourg has provided the occasion for a long overdue project, an investigation of the Swiss Carnation Masters.[1] Not since the book by P. Maurice Moullet has a study of this phenomenon in Swiss art in the period around 1500 appeared, although several important papers have furnished new impulses.[2]

The present article cannot be interpreted as an attempt to present conclusive results - research is too much in flux for that. Our intention is to situate the Carnation Masters in their temporal context. In the process we shall be concentrating on the Zurich Carnation Master and three of his pictures, all of them in the Kunsthaus Zurich today. Questions will frequently remain, answers will be at a premium:

Can the pictures be explained by the ecclesiastical politics of the period shortly before the Reformation? What were the people who commissioned these panel paintings trying to accomplish? Whom were they addressing? How did the artists fulfill their task? What was their relationship to other artistic genres: stained glass, mural painting, book illumination – picture chronicles! – but also sculpture? How did the painters handle the anonymous carnation symbol in a period when artists on either side of the Alps were beginning to develop individual profiles? How did contemporary viewers react to these paintings? And then there is the general subject of response, particularly the question: how do we see these pictures today, what do they say to us – why did the Zurich guilds present the Kunsthaus Zurich with a picture by the Carnation Master in 1986?

fig. 1: Zurich Carnation Master
(Hans Leu the Elder),
Altar of St. Michael, left panel:
The Fall of the Angels.
Kunsthaus Zurich.

fig. 2: Zurich Carnation Master,
Altar of St. Michael,
right panel: *Michael as the
Weigher of Souls.*
Kunsthaus Zurich.

Suggestion and Timeliness – around 1500 and Today

To anticipate one aspect of the answer: our basic premise is the astonishing timeliness of these pictures! Then even more than today, viewers must have been struck by the suggestive power that permeated the Zurich carnation pictures with an intensity matched by very few paintings around 1500. It is as if the painters had divined something that would only succeed in gaining a genuine foothold – with Sigmund Freud and Carl Gustav Jung – in our own century. In their own time this extroverted, even psychologizing, stance must have struck people as revolutionary, a fact that becomes even clearer in comparison with the numerous other pictures produced by the Carnation Masters, not only in Zurich but also in Bern and Fribourg. We shall be coming back to this point.

A comparison with the Carnation Masters in other Swiss cities, where the Reformation made either no or only very modest inroads, would indicate the religio-historical situation in Zurich as a point of departure for the dynamic of the pictures. Even if they were not aware of it, this was the last time that ecclesiastics and artists would try to express themselves within the framework of the church, so to speak to issue a final warning. Only a few years later, in 1524, the city would pass a law prohibiting religious images![3] It is this suggestive power that grips us again today. If the Carnation Master were alive now, Harald Szeemann would call him obsessive. Various pictorial elements bring this out with particularly clarity: the monster on the left panel of the Altar of St. Michael, and, on the right, the damned, presented as a fanaticized mob. The painter characterizes them as a mass that do not know what is happening to them – or perhaps did not know what they were doing and had for that very reason been damned. Above all, there is something about the way the angel looks the viewer in the eye, and in so doing draws him into the midst of the action! The viewer becomes a present link in the chain of the history of salvation.

Suggestion appears to be a phenomenon of bad times, of crises. This was as important for the churchmen commissioning the works as it is today. All other means of ecclesiastical reform from inside had failed; the reform councils, particularly the one in Basel,[4] had not accomplished its purpose – the rift between the reform objectives prevailing north of the Alps and the establishment in Rome had become too great. Today it is once again the rift between Rome and the local and national churches that is generating virtually insurmountable problems, but this time worldwide. In our day churches are building on the suggestive power of the catchword "re-evangelization," a term whose definition appears at best vague or – as in the time of the Carnation Masters – relies on the hypnotic effect of religious communities. What could demonstrate more clearly that the Christian church is no longer the shaping influence in the West that it was in 1500? In his *Weltgeschichtlichen Betrachtungen* (Observations on World History), Jakob Burckhardt comments as follows:

> *Despite all the abuses, extortionary methods, indulgences, etc., religion at the time had the great advantage of abundantly occupying all of man's higher faculties, in any case the imagination. The hierarchy was at times hated beyond all proportions, for which reason religion itself was not merely accessible to the masses but genuinely popular; they inhabited it, it was their culture.[5]*

The crisis of the church weighs all the more heavily today. Now more than ever before, human beings need the spiritual security that the pre-Reformational church once had to offer, and they hardly know where to find it – or then seek it in the numerous sects proliferating everywhere. Catchwords are not enough; the call to preserve the Creation will not suffice. The message of the pictures of the Zurich Carnation Masters remains valid: human beings must muster the energy to achieve the virtue of virtues, humility, for alone they are – in terms of the history of salvation, at the present moment, and eschatologically speaking – nothing.

A violent, iconoclastic Reformation was the only alternative after 1500. We can only hope that a non-violent, a spiritual, way out of the present crisis will be found. As at that time, we should probably think universally but work out solutions on the basis of our own cultural resources. The oft-invoked multicultural orientation of Western society complicates the search for solutions rather than advancing it. Thus many of the Lenten veils of the past few years demonstrate how the churches are fostering their own alienation. The wheel of history should not be turned back. People have always found the lessons of history difficult to learn, but one should for that very reason endeavor to accept one's own roots, to understand them. Only then can what is foreign be understood; understanding the Other is only possible with the help of firm roots in one's own tradition. The 1992 Lenten veil of the Argentinian Adolfo Perez Esquivel was created out of the traditions, concerns, questions, and needs of the Latin American. It can exhort us to solidarity, and that is good. But can it help the Western viewer achieve a religious experience? Must he not feel excluded, a foreigner at the periphery of events, like the man with the turban at the left edge of the picture of the *Decapitation of a Young Saint* in Zurich? This standing apart does not foster the religious experience. The era of reform councils, Reformation, and Counter Reformation were also marked by international rapprochement, with particular vigor between the Greeks and the Romans, and pointedly against Islam. The Christian world of images made efforts to understand the other side; western painting discovered the icon for itself, as exemplified by the extraordinary panel paintings of Giovanni Bellini.[6] But the religious experience and meditation still revolved around traditional pictures relating to the history of salvation, the style but not the contents adapted to the taste of the time, to the Zeitgeist. The meditation panel of Niklaus von Flüe of 1478 in the parish church of Sachseln is an early and outstanding example of this (fig. 6).[7]

The ecclesiastical-religious picture of today is in a profound crisis. Religion and pictorial creation appear to preclude each other, church and taste to shun one another like the plague. A religious picture need not degenerate into sentimental kitsch. The religious content of a picture derives from its truthfulness; the artist shapes truth, and, with it, love, as Vaclav Havel puts it.[8] The true artist, body and soul, expresses a religious message in every work – a banal observation perhaps, but one that seems to have been widely suppressed. Art is always a walk on a tightrope, the assessment of artistic quality no less so.

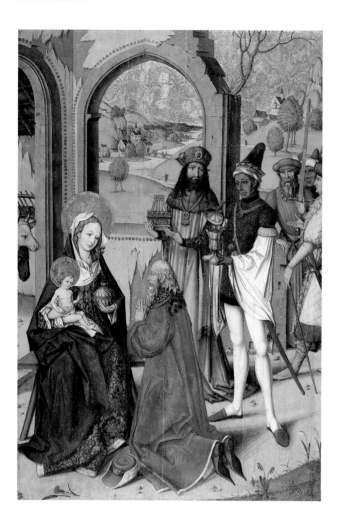

The Altar of St. Michael

The closed Zurich Altar of St. Michael at the Kunsthaus Zurich confronts the viewer with a question of conscience: which side are you on? On the right panel, Michael, as the Weigher of Souls, is emphatically dividing good from evil. The angles of the scales and the raised sword intersect the diagonal formed by the two groups of those who have been accepted into Heaven and those who have been damned. With what is still thoroughly medieval consistency, the painter pits the heraldic right side, as the good, against the diabolical left. And there, leaping to the eye on the good side, are the red and the white carnation: an incontrovertible indication of the spiritual background of the group of artists concealed behind the carnation symbol (figs. 1-4).

Cast out, the damned stand outside the semi-circle that delimits the divine sphere of the archangel; the depiction does not continue on the right, for this is, after all, the right panel. The blessed, on the other hand, float before a gold ground, already partaking in the sight of God.

The vision of Heaven and Hell, of forgiveness and damnation, is embedded in a landscape with realistically depicted details. It is not the topographically identifiable

locale appropriate to the politico-ecclesiastical statement of Konrad Witz's representation of Peter's Draught of Fishes on the Geneva altar.[9] But in his *Portrait of the City of Zurich*, Hans Leu the Elder, who can today be identified as a Carnation Master, took pains to provide the martyrdom of Felix, Regula, and Exuperantius, the patron saints of the city, with a precise local setting (fig. 8).[10]

It is interesting to see how the same painter can find different ways of dealing with divergent pictorial subject matter. The Martyrs' Altar had a specific function to fulfill in Zurich's Grossmünster. It was to provide an unmediated visualization of the history of salvation, of its long arm extending, through the mediation of the saints, from the Holy Land to Zurich. The painter chooses different forms of expression for the pictures portraying the Last Things. The expressionistic representation of the fearful damned is intended as a drastic illustration of the outworking of salvation – at a time, around 1500, when more abstract symbols had lost their ability to satisfy the faithful. The course of stylistic development can be compared to the evolution of piety. Otto Pächt has furnished an astute description of the phenomenon in his work on the van Eyck brothers.[11]

fig. 3: Zurich Carnation Master,
Altar of St. Michael,
right panel: *The Adoration of
the Magi*. Kunsthaus Zurich.

fig. 4: Zurich Carnation Master,
Altar of St. Michael,
right panel: *Pentecost*.
Kunsthaus Zurich.

fig. 5: Zurich Carnation Master,
Decapitation of a Young Saint.
Kunsthaus Zurich.

The left panel shows the Fall of the Angels. This is, however, only a superficial description of the action in the picture: only one angel-like creature is being pushed into the fire. More important is the subject of Michael as the dragon-slayer, according to Revelation 12:7 ff. and 20:2 f.: "And he laid hold on the dragon, that old serpent, which is the Devil, and Satan, and bound him a thousand years."

The way Michael triumphs over Satan in the guise of the dragon, the way he wields his sword, recalls the representation of the so-called Psalm-Christ, an image popular since the birth of Christian iconography. It is the figure of "Christus triumphans," a symbol of His victory over His enemies and over Evil. The image is prefigured in the Old Testament, in verse thirteen of Psalm 90 (91), which reads: "Thou shalt tread upon the lion and adder: the young lion and the dragon shalt thou trample under feet." The figure of David after he had gained his hard-fought victory over his foes and over Saul, as we see him in Psalm 17 (18), is also evoked: David is the precursor of Christ.[12] It is no accident that this is the pictorial formula chosen to symbolize the "Beau Dieu" on the main door of the cathedral of Amiens; readers may want to refer to Wilhelm Schlink's sensitive analysis.[13] It should not surprise us if, in the late period of the Carnation Masters, various levels of meaning are embodied in one and the same picture. Michael stands on the dragon with raised sword and shield in a pose comparable to that of Christ with Satan during the Descent into Hell. According to the apocryphal account in the Gospel of Nicodemus, Christ descended into Hell after the Crucifixion in order to liberate the innocents, particularly Adam and Eve, who had been damned before His act of redemption.[14]

Christ's Descent into Hell and David's victory over his enemies are among the most frequent typologies of the Old and New Testaments. Even the fire is not merely hellfire; it forms a transition to the other panel, and there first to the blessed. They have already passed through the fire of purification, in other words, through Purgatory. It is no coincidence that the picture is on the heraldic right, in oth-

er words, on the good side. At the Council of Florence, successor to the Council of Basel, Purgatory was a subject of heated debate, particularly between the followers of the Greek and the Latin traditions. Purgatory is one of the elements of "continuity of internal church reform" – like the "Devotio moderna";[15] at the Council of Trent, the question of Purgatory was raised again, the target this time being the Protestants rather than the Greeks. Purgatory is also one of the bones of contention in the Reformation, and it would not be amiss to assume that, on the eve of the Reformation, Purgatory rather than hellfire was what the Carnation Masters wanted primarily to depict. The Greeks and Protestants raised the same objection to the concept of Purgatory; they could find no accounts of the fire of purification in either the Bible or the church fathers.[16] It might also be useful to recall that the Counter Reformation had a particular fondness for the subject of the Fall of the Angels to represent victory over false doctrines.[17]

The painted inner frame of the pictures of the Altar of St. Michael calls to mind similar practices in glass painting, for example, in the contemporaneous cantonal stained-glass panels of a Lux Zeiner, but also in Martin Schongauer's engravings and in book illuminations.[18] Clearly the choice of this form of frame was not arbitrary. It is one of the signs of the vital force and graphic energy of the depicted scenes; the picture is not enclosed by a frame of dead material but by wood, which remains recognizable as such, with its branches and knot-holes. One feels reminded of the shape of the Living Cross, the tree cross.

The Decapitation of a Young Saint

In the Zurich picture of the *Decapitation of a Young Saint*, the existential aspect of human suffering, despair, and hope are elevated to a more serene, universally valid plane. Although transcendence as the destiny of the human being is also *the* subject of the Altar of St. Michael, it is communicated there by means of narrative pictures, in a diptych. In the decapitation scene, the painter omits all superfluous narrative elements and concentrates on the

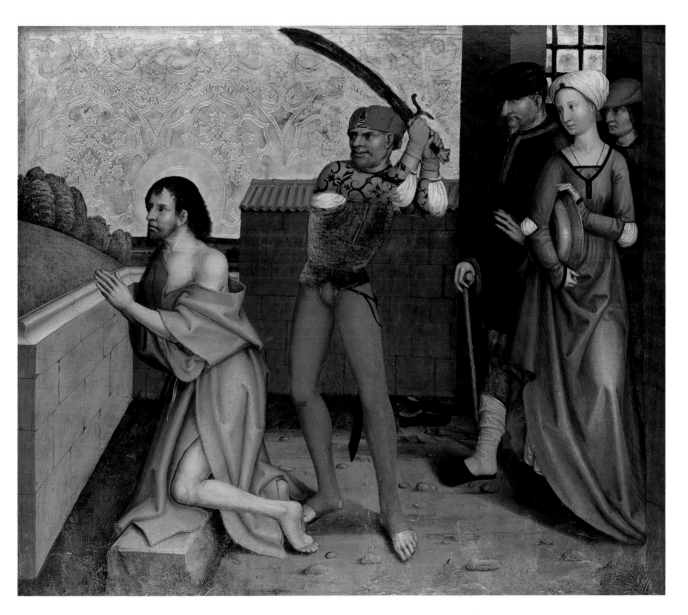

fig. 6: Meditation panel of
Niklaus von Flüe. Parish church
of Sachseln.

fig. 7: Bernese Carnation
Master, *Decapitation of St.
John the Baptist*.
Kunsthaus Zurich.

8

essentials. In analyzing what was essential to him, we gain profound insight into the essence of his art and his time.

The pictorial composition is tranquil, an impression underlined by the allusion to the figural alphabet of the Upper Rhine master E.S. The alphabet has survived in a series of copperplate engravings at the Kupferstichkabinett in Berlin.[19] This also indicates the intellectual and spiritual orientation of the picture. Though despair has departed, it cannot be said to have been replaced by hope – for that the expression is too weak. What is portrayed is the certainty of life after death, of transcendence, conveyed by purely artistic means. The painter knew how to give concrete shape to the pictorially elusive concept of immanent transcendence,[20] the reflection of the vision of God in man shortly before death (fig. 5).

While the painter of the Altar of St. Michael employed the entire medieval "apparatus," the painter of this picture trusted in his artistic possibilities: in this respect it is a modern picture in its period!

As a child of his time, he does not, of course, forgo symbolism; nothing is missing – on the right, the king, giving the command to martyr the man. His counterpart on the left is the figure in the turban. This oriental headdress is more than an exotic accoutrement; it also symbolizes evil, certainly in that era. The fall of Constantinople in

1453 was still fresh in memory and had a great deal in common with the situation in which the church found itself.[21]

The saint has accepted martyrdom; indeed, he sees it as the fulfillment of his earthly life and believes in the eternal life to come. His relaxed pose, the gaze into an undefined distance, attests to this as strongly as the loosely falling rope-end. That he sees himself as a successor to, an imitator of, Christ becomes clear in two hitherto unnoticed iconographic details.

For one thing, the attitude of the young saint is an ambivalent rendering of the "Imago pietatis," which we first encounter around 1300 in the mosaic icon in S. Croce in Gerusalemme in Rome,[22] and then see developed by Donatello in the Santo of Padua and by Giovanni Bellini as a Pietà (figs. 9, 10).[23] The position of the arms and the folded hands correspond, but the head points heavenward, with clear, open eyes; there is no torment, no fear to be recognized in this face. That distinguishes the picture from others of its time, a time with a fondness for dramatic illustrations of torment. The attitude makes his bonds superfluous and causes the contemplator to be aggrieved at the sight of rough soldiers fettering the angelic saint. The "Imago pietatis" is an image of pain, the Pietà, the image of Mary and John, and of the Dead Christ mourned by angels.[24] In drastic pictures it conveys profound despair: the head of Christ is bowed. In other pictures companions support Him in such a way that His head appears to be raised. The young saint in the Zurich picture, however, has his head up; he already seems to be partaking in the vision of God's Countenance, far removed from those around him, like St. Francis during the stigmatization.[25]

In the context of the Carnation Masters, the *Decapitation of St. John the Baptist* by the Bernese Master can be cited as a comparison (fig. 7).[26] The face of John is shown in profile, rendering it more difficult for the viewer to empathize with the saint's devotion. John's prayerful pose is the usual one, which makes the Zurich Master's solution exceptional and extraordinary. But the decisive

point is the way the executioner in the picture by the Bernese Master is depicted: with the almost lustful brutality and ugliness typical of the period.[27] There are worlds separating the two pictures, not only in terms of artistic quality but also of mentality. The Zurich Master is striving to indicate the emotions of the figures suggestively, with fine reticence, in a subtle, psychologizing manner that makes the picture so very "modern." In accordance with the art theories of the Renaissance, above all those of Leon Battista Alberti, the painter draws the viewer into the picture by capturing in the facial expressions of the depicted figures their attitude to, approval or disapproval of, the events portrayed.[28] Unlike most pictures of decapitations, this one shows the saint with his torso turned toward the viewer; his face, too, is almost entirely visible. In accordance with the Italian ideal, the Zurich Master has also taken pains to depict the saint as a handsome young hero.

The second telling iconographic detail relates to the fact that the condemned man's neck must be bared for the decapitation. The way the executioner has draped the saint's grey outer robe not only bares his neck but causes the garment to billow into a shape that has already been noted by Christian Klemm. He compares it to the executioner in the Carnation Master's painting of the Ten Thousand Knights and the Hösch glass panel in the Landesmuseum.[29] But here the painter has imbued the form with special contents; he has designed none other than the bust of the saint in a calyx, a time-honored representational pattern, a symbol of eternal life.[30]

The motif was very popular in the Middle Ages for the representation of the Tree of Jesse and genealogies of monastic orders. In the environs of the Carnation Masters, the Dominican genealogy on the rood screen of the Predigerkirche in Bern can be cited (fig. 11).[31] It must have been a source of particular satisfaction to the painter who signed with flowers to see a saint he evidently venerated honored in this way.

That this interpretation is not purely a product of our modern vantage point is demonstrated by the color com-

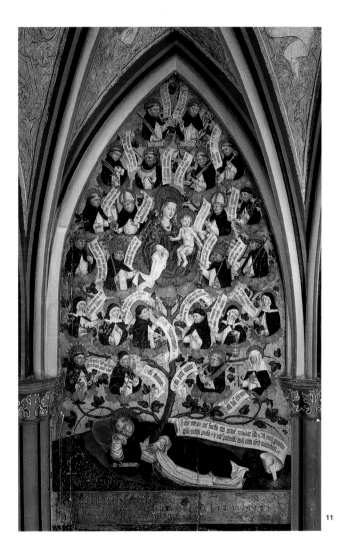

fig. 8: Hans Leu the Elder, *Portrait of the City of Zurich*, left section with view of the Fraumünster in the background. Schweizerisches Landesmuseum, Zurich.

fig. 9: Mosaic icon in S. Croce in Gerusalemme, Rome.

fig. 10: Donatello, *Pietà*. Santo, Padua.

fig. 11: Bernese Carnation Master, *Dominican Genealogy*. French Church, Bern.

position. The painter dressed the saint in red and white robes, in accordance with the red and the white carnation lying at the saint's feet. But the fact that the executioner is dressed in blue and white, characterizing him as a representative of the Canton of Zurich, suggests a message behind the combination of red and white.[32] The profound allusions analyzed here lead to the conclusion that this is a particularly venerated saint. The colors red and white take us to Solothurn. The legend of the Theban Legion recounts that St. Victor and St. Ursus were decapitated.[33] The Carnation Masters had ties to Solothurn; the first master with whom the Cordeliers in Fribourg were in contact, Albrecht Nentz, was the town painter of Solothurn. Basel-born Rutenzweig was also active in the ambassadorial town in 1480.[34]

As if the subtle, symbol-laden allusions were not enough, the painter also places the lighting in the service of his and his commission-giver's purposes. All of the figures are illuminated by an indefinable light, with the gold ground lending it an even more unreal character. Only the kneeling saint is brightly illuminated in the picture; the light comes from the left, all of the figures throw shadows – and yet the light strikes only the saint. Light thus becomes a vehicle of meaning: it is the light that the saint is approaching, that awaits him after his martyrdom; it is the light of the Gospel according to II Cor.4:4,[35] it is Christ, God. The painter has the ability to give visual expression to the incomprehensible – with Renaissance-like finesse, but without the need to resort to representing God the Father as a kindly old man with grey hair, as is the case in the Altar of St. Michael. The longer we study this picture, the more wonderful it becomes! Let us recall for a moment the way present-day medical and psychological research deals with the phenomenon of light at the point of transition between life and death.

Light is the source of truth, truth in Christ.[36] The unquestioning devotion of the saint – in humility, faith, and responsibility – comes very close to the Franciscan ideal. Let me formulate it this way: the saint is exposing himself

to the light of God as St. Francis exposed himself to stigmatization! Add to that the "denial"[37] expressed in the sparse furnishings of the background. Judging by the Fribourg altar of the Cordelier church, the Franciscan background of the Carnation Masters seems obvious. After all, the Franciscans had gained a foothold in Zurich not long after the order was founded. The Franciscan monastery must already have existed in 1247; fragments of the cloister from the 1419 stage have been preserved in the present-day architectural complex of the High Court and cantonal wine-cellars on Hirschengraben. The question whether the Zurich panel might have belonged to an altar from the Franciscan church is overshadowed by the realization that the Zurich authorities placed major obstacles in the way of the mendicant orders.[38] And the Solothurn perspectives we have already mentioned do, in fact, point away from Zurich.

Against the Franciscan background, would the carnation symbol not have to be interpreted as an expression of the artist's humility? The signature of the master E.S. should be recalled; Horst Appuhn has pointed out that it was the master's way of referring to the pilgrimage church of Einsiedeln.[39] A humble attitude of this kind is often found in connection with the "Devotio moderna," as one of the elements of continuity of reform within the Catholic Church before and after the Reformation. At the center of the popular movement of new piety stands a widely circulated manual surpassed in readership only by the Bible, *The Imitation of Christ*, a work later much appreciated by Ignatius of Loyola. It asks: "Of what use is it to discourse learnedly on the Trinity if you lack humility and therefore displease the Trinity?"[40]

All of these facts make the Zurich painting a key work for the whole group. More than any other picture, it embodies and essentializes the basic nature that identifies the oeuvre of the Carnation Masters. But in so doing it also points beyond the limits of this circle. The Annunciation on the rood screen of the French Church in Bern is the only work to equal the Zurich picture (figs. 12, 13).[41] And Luc

fig. 12: Bernese Carnation
Master, *The Angel of the
Annunciation.*
French Church, Bern.

fig. 13: Carnation Master,
*The Annunciation of the Virgin
Mary with St. Elizabeth of
Hungary.*
Cordelier Church, Fribourg.

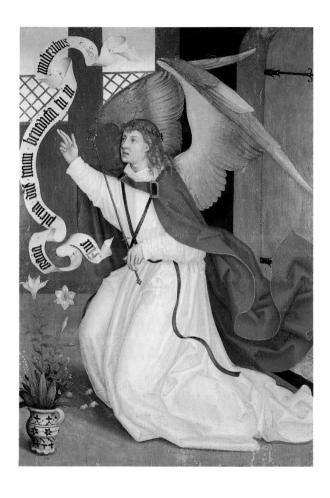

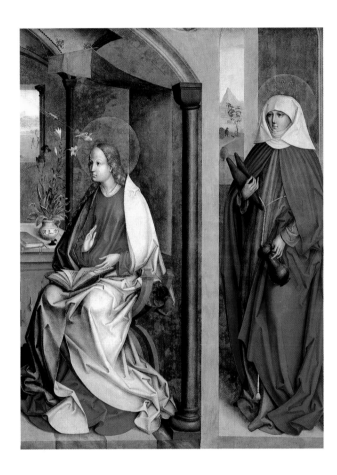

Mojon does not hesitate to cite Leonardo da Vinci in his analysis of the Bern *Annunciation*. The latter painting is dated 1495,[42] the same year that Leonardo began working on the *Last Supper* in the refectory of Santa Maria delle Grazie in Milan, a Dominican monastery. The Bern church is the former "ecclesia Predicatorum," the church of the Dominican monastery.[43] I conclude on this note to indicate that, despite their anonymity, the Carnation Masters were artistic personalities well-equipped to flourish in the context of the mendicant orders in Europe – painters who could rightfully have taken pride in their achievements.

*Translated from the German by
Eileen Walliser-Schwarzbart*

Notes

1 A project of the Swiss Institute for Art Research, Zurich, funded by the Swiss National Science Foundation. Emphasis is on studying the panels by means of infra-red reflectography. – See in this connection the 1991 *Annual Report of the Swiss Institute for Art Research, Zurich.*

2 P. Maurice Moullet, *Les maîtres à l'oeillet* (Basel: Les Editions Holbein, 1943); Christian Klemm, "Zürcher Nelkenmeister. `Enthauptung eines jugendlichen Heiligen'," *Jahresbericht 1986 der Zürcher Kunstgesellschaft* (Kunsthaus Zurich), pp. 89-94; Charlotte Gutscher, "Die Wandmalereien des Berner Nelkenmeisters," *Unsere Kunstdenkmäler* 39 (1988), pp. 22-28.

3 Daniel Gutscher, *Das Grossmünster in Zürich. Eine baugeschichtliche Monographie,* Beiträge zur Kunstgeschichte der Schweiz, vol. 5 (Bern, 1983), p. 158.

4 In this connection, see the article by Dorothee Eggenberger in this volume. See also: *Weissagung über die Päpste. Vat.Ross.374. Eine Einführung von Robert E. Lerner, Robert Moynihan* [Introductory volume to the facsimile edition of the Cod.Vat.Ross.374. Codices e Vaticanis selecti quam simillime expressi iussu Ioannis Pauli PP II consilio et opera curatorum Bibliothecae Vaticanae, vol. LXIX] (Zurich: Belser, 1985).

5 Ed. Werner Kaegi (Bern: Hallwag, 1941), p. 239.

6 Hans Belting, *Giovanni Bellini. Pietà. Ikone und Bilderzählung in der venezianischen Malerei,* Fischer "Kunststück" (Frankfurt, 1985); idem, *Bild und Kult. Eine Geschichte des Bildes vor dem Zeitalter der Kunst* (Munich: Verlag C. H. Beck, 1990).

7 Christoph and Dorothee Eggenberger, *Malerei des Mittelalters,* Ars Helvetica, vol. 5 (Disentis, 1989), pp. 190-192. See finally: Harry Szeemann, ed., *Visionäre Schweiz* (Aarau/Frankfurt/Salzburg: Sauerländer, 1991), pp. 26-29.

8 Vaclav Havel, *Am Anfang war das Wort* (Reinbek bei Hamburg: Rowohlt, 1990); Christoph Eggenberger, "Liebe und Hass – Licht und Finsternis – Himmel und Hölle," *Liebe und Hass,* ed. Peter Grotzer (Zurich: Verlag der Fachvereine, 1991), pp. 3-18.- For the religious content of the pictures, see the studies by Karl Schefold, especially: *Die Bedeutung der griechischen Kunst für das Verständnis des Evangeliums* (Mainz: Philipp von Zabern, 1983).

9 See the article by Dorothee Eggenberger in this volume.

10 Daniel Gutscher, *Das Grossmünster,* pp. 141 f. See also: Emil Bosshard, Renate Keller, and Lucas Wüthrich in *Zeitschrift für Schweizerische Archäologie und Kunstgeschichte* 39 (1982), pp. 145-180.

11 Otto Pächt, *Van Eyck. Die Begründer der altniederländischen Malerei,* ed. Maria Schmidt-Dengler (Munich: Prestel-Verlag, 1989).

12 Peter Bloch, "Christus, Christusbild," *Lexikon der christlichen Ikonographie,* vol 1, ed. Engelbert Kirschbaum (Rome/Freiburg/Basel/Vienna: Herder, 1968), col. 403.

13 Wilhelm Schlink, *Der Beau-Dieu von Amiens. Das Christusbild der gotischen Kathedrale* (Frankfurt and Leipzig: Insel-Verlag, 1991).

14 *Martin Schongauer. Das Kupferstichwerk,* catalogue ed. Tilman Falk and Thomas Hirthe, exhibition for the 500th anniversary of Schongauer's death, Staatliche Graphische Sammlung München (1991), pp. 98 f., no. 29.

15 E. Iserloh, "Devotio moderna," *Lexikon des Mittelalters,* vol. 3 (Munich and Zurich: Artemis Verlag, 1986), cols. 928-930. See also below for the main work of the Devotio moderna: *The Imitation of Christ.*

16 Karl August Fink, in *Handbuch der Kirchengeschichte,* vol. III/2, *Die mittelalterliche Kirche. Vom Hochmittelalter bis zum Vorabend der Reformation* (Freiburg, i. Br.: Herder, 1968; reprint ed. 1985), p. 581.

17 "Engelsturz," *Lexikon der christlichen Ikonographie,* col. 643.

18 For the stained-glass panels by Lux Zeiner, see Jenny Schneider, *Die Standesscheiben von Lux Zeiner im Tagsatzungsaal zu Baden (Schweiz),* Basler Studien zur Kunstgeschichte, vol. XII (Basel, 1954).– They are to be found in the same context in the self-contained Swiss picture chronicles, for example, the so-called *Spiezer Schilling;* see finally: Carl Pfaff, *Die Welt der Schweizer Bilderchroniken, Edition 91* (Schwyz, 1991). – A study by the author of the present article is in preparation.

19 *Meister E.S. Ein oberrheinischer Kupferstecher der Spätgotik,* exhibition cat. (Munich and Berlin, 1987).

20 See Psalm 104 (105): cosmo-theological experience between myth and experience; verses 4-9 describe the struggle with chaos that can be *currently experienced;* everyday experience is transcended. For the reference to the psalm, I am indebted to a lecture delivered by T. Krüger at the University of Zurich on 24 February 1992: "'Kosmo-theologie' zwischen Mythos und Erfahrung – Psalm 104 im Horizont altorientalischer und alttestamentlicher `Schöpfungs'-traditionen."

21 Paper given by Dione Flüeler at the colloquium in honor of Dietrich Schwarz on 3 March 1989 at the Schweizerisches Landesmuseum Zurich.

22 As a sign of "Imitatio Christi." – Hans Belting, *Das Bild und sein Publikum im Mittelalter. Form und Funktion früher Bildtafeln der Passion* (Berlin: Gebr. Mann studio-Reihe, 1981), p. 66-68.

23 Hans Belting, *Giovanni Bellini,* pp. 19-21 and passim.

24 Ibid., passim.

25 See below. – Giotto's panel at the Louvre will serve as an example.

26 Kunsthaus Zurich. – P. Maurice Moullet, *Les maîtres,* p. 51, fig. 38.

27 On the subject of "ugliness," see the studies by Ruth Mellinkoff, Los Angeles.

28 In this connection, see Hans Belting, *Giovanni Bellini,* pp. 34 f. – Leon Battista Alberti, "Über die Malerei, 1435": "A pictorial narrative will move the emotions if the persons painted in it express their own emotions," from: H. Janitschek, *L.-B. Alberti's Kleinere kunsttheoretische Schriften,* Quellenschriften für Kunstgeschichte, vol. XI (Vienna, 1976).

29 Jenny Schneider, *Glasgemälde,* cat. of the collection of the Schweizerisches Landesmuseum Zurich, vol. 1 (Zurich, 1970), no. 53.

30 Hans Jucker, *Das Bildnis im Blätterkelch. Geschichte und Bedeutung einer römischen Porträtform,* Bibliotheca Helvetica Romana, vol. III (Lausanne and Freiburg i.Br.: Urs Graf-Verlag, 1961).

31 P. Maurice Moullet, *Les maîtres,* figs. 42 f.; Charlotte Gutscher, *Die Wandmalereien.*

32 Christian Klemm, "Zürcher Nelkenmeister," p. 93.

33 Legenda aurea.

34 Alfred A. Schmid, in *Renaissance de l'église des Cordeliers,* Pro Fribourg, no. 90-91 (1991), p. 30; Christian Klemm, "Zürcher Nelkenmeister," p. 91.

35 K. Hedwig, "Licht," *Lexikon des Mittelalters,* vol. 5, cols. 1959-1962.

36 II Cor. 11:20; II Cor. 13:8: Eph. 4:21 among others.

37 Christian Klemm, "Zürcher Nelkenmeister," p. 90.

38 Martina Wehrli-Jones, "Zürich und sein Predigerkloster 1320-1524," *Zürcher Predigerchor. Vergangenheit – Gegenwart – Zukunft,* ed. Arbeitsgruppe Predigerchor Zürich (Zurich: Hans Rohr, 1987), p. 21.

39 Horst Appuhn, "Das Monogramm des Meisters E.S. und die Pilgerfahrt nach Einsiedeln," *Zeitschrift für Schweizerische Archäologie und Kunstgeschichte* 45 (1988), pp. 301-314.

40 Thomas à Kempis, *The Imitation of Christ,* chap. I; *Handbuch der Kirchengeschichte* III/1, p. 520; *Lexikon des Mittelalters,* vol. 5, cols. 386 f.

41 Above all in comparison with the altar in the Cordelier church in Fribourg. – Alfred A. Schmid, see note 34 above.

42 Luc Mojon, in Paul Hofer and Luc Mojon, *Die Kunstdenkmäler des Kantons Bern, vol. V. Die Kirchen der Stadt Bern. Antonierkirche, Französische Kirche, Heiliggeistkirche und Nydeggkirche* (Basel: Birkhäuser, 1969), p. 142.

43 Ibid., p. 46.

Picture credits

fig. 1-5, 7, 8: Kunsthaus Zurich

fig. 6: Schweizerisches Landesmuseum Zurich

fig. 11: Städtische Denkmalpflege Bern

fig. 12: Kunstmuseum Bern

fig. 13: Jean Mülhauser, Fribourg

Dorothee Eggenberger

Konrad Witz and the Council of Basel

Konrad Witz, a painter from Rottweil, active in Basel and Geneva in the first half of the fifteenth century, has been the subject of repeated art-historical study since the beginning of our own century.[1] And yet little is known about the late medieval artist's biography. We have no information on either the year of his birth or his death. In 1434 he was admitted to the Himmel guild in Basel as Master "Konrat Witz von Rotwil"; the St. Peter Altar in Geneva is dated 1444. In 1448 his children were placed under the guardianship of his father Hans, at which point Witz can no longer have been alive. The works that have survived, created during a period of a good ten years, attest to the artist's initial and ultimately mature mastery. What brought the Swabian painter to Basel? Was it the international atmosphere of the Council that attracted him, or is it not more likely that he was invited there because he was already a recognized painter?

According to the directives of the Council of Constance in 1417, general councils were to be held periodically. At the Council of Siena in 1424 Basel was chosen as the next place to meet. From 1430 on, Basel, its secular and its religious politics revolved around the Council. Pope Martin V appointed the reform-oriented Cardinal Giuliano Cesarini president of the Council, also empowering him to convoke it.[2] This diplomatically skilled prince of the church took up residence at St. Leonard's, a monastery of the Augustinian Canons, which had gained great distinction under its then provost, the dynamic Johannes Oflatter (1416-1440).[3]

104

fig. 1: Mirror of Salvation Altar: *Ecclesia*. Kunstmuseum Basel.

fig. 2: Mirror of Salvation Altar: *Synagogue*. Kunstmuseum Basel.

The Basel Mirror of Salvation Altar

Although it cannot be proven, it may be assumed that the provost wanted to see the prestige and importance of his monastery as a residence and meeting place for Europe's intellectual elite expressed in an appropriate work of art – a winged altarpiece. Known by art historians as the Mirror of Salvation Altar, it has not survived in its totality; what remains of it is preserved in Basel, Berlin, and Dijon.[4] Source information is sparse, but the following assumptions may lay claim to a high degree of probability. As late as 1450, Matthäus Ensinger, the architect of Bern minster and son of Ulrich von Ensingen, the architect of Strasbourg cathedral, was paid one hundred gulden for an altarpiece "wrought by carvers and painters," which he had "long ago delivered."[5] On the basis of the available information, it would be reasonable to assume that Ensinger had entrusted his compatriot from Rottweil, Konrad Witz, with the painting, thus introducing him to the monastery.

That the commission for the new altar in the choir went to highly reputed foreigners shows the high expectations placed in it. St. Leonard's, the intellectual and ecclesiastical pivot of the Council of Basel, was striving to offer not only church dignitaries from all parts of Europe but also the Hussites an impressive visualization of the plan of salvation. The theological basis for the work is the "speculum humanae salvationis," the *Mirror of Salvation*, a typological outline of the outworking of God's plan of salvation, which is divided into three parts: from the Fall of the Angels to the Flood, the Life of the Virgin Mary, and Christ's Redemptive Acts.[6] The *Mirror of Salvation* was probably written by Dominican circles in Strasbourg in the early fourteenth century as an instructional and devotional book for educated laymen. Every event in the New Testament is paired with its foreshadowing in the Old Testament or the legends and history of ancient Rome. The redemption of mankind through Christ is the fulfillment of the promise given to the Fathers. However, God

revealed himself not only to the Jews but also to the heathens, which is why portents from heathen antiquity are also cited.

According to Albert Châtelet's recent and convincing reconstruction attempts, the two wings of the altar consisted of five panels each, arranged in three vertical rows.[7] The closed altar showed four saints with close links to the monastery on four panels in the bottom row; they were probably the two patron saints of the monastery – Bartholemew (preserved, fig. 4) and Leonard (lost) – as well as Theobald, whose relics were in the possession of the monastery, and the church father Augustine.[8] Above them, in the middle row, were the prophets Isaiah and Jeremiah (no longer extant); the older of the two prophesied the birth of the Son of God, the Messiah, and His Kingdom, while the younger prophet looked forward to the New Covenant. The two prophets were flanked by the still-extant panels of two female figures, Ecclesia and Synagogue, embodying the New and the Old Covenant (figs. 1, 2). The altar is completed by the Annunciation of the Blessed Virgin: through Christ, born of Mary, mankind will be redeemed; only the picture of the angel has survived (fig. 3).

The open altar shows various scenes from the Old Testament and the history of ancient Rome that presage events in the history of salvation. Two panels in the bottom row depict a scene from the life of King David. His three servants Abisai, Sabobai, and Benaias have risked their lives to bring the king drinking water; rather than accepting it for himself, David offers it up to God (fig. 8). On the two panels opposite, the Sibyl of Tibur prophesies the birth of Christ to Emperor Augustus; he is followed by two servants (reconstructed). The two surviving scenes in the middle row – Esther pleading for her people before King Ahasuerus and the Queen of Sheba with King Solomon – are references to the Virgin Mary; the two women represent Mary interceding for mankind with her Son; and, like Mary, Solomon embodies wisdom (figs. 6, 9). Citing the Basel edition of the *Speculum*, Albert Châtelet

would complete the two panels with King Solomon meeting his mother, as an anticipation of the Coronation of the Virgin Mary, and with David and Abigail, prefiguring Mary's intercession. The two top panels correspond to the Annunciation on the exterior and show Abraham and the High Priest Melchizedek, as an allusion to the Eucharist, and the wounded Antipater before Caesar as a reference to the suffering Christ as intercessor with God the Father (figs. 5, 7).

The contract made in 1450 between the architect and sculptor Matthäus Ensinger and the monastery of St. Leonard mentions the delivery of an altar painted and sculpted by Ensinger.[9] This would lead to the conclusion that the central case must have contained a sculpted scene iconographically linked with both the exterior and interior panels. It can only – according to Châtelet – have been a portrayal of the Epiphany.[10] The story of the Adoration of the Magi takes up themes from the other scenes; but because it has particular reference to the Council, it represents the central message of the altar. As the Magi came from distant lands to gather around Jesus in the manger, so the princes of the church are assembling in Basel, in the service of the church founded by Christ, with the aim of reconciling the Eastern and Western churches and regaining the Hussites for Rome. The portraitlike character attributed to many of the heads on the Basel Mirror of Salvation Altar is no coincidence.

The Mirror of Salvation Altar was a modern work in its time, not only because of its outward appearance but also because of its iconography and style; it would be virtually impossible to name a work upon which it might have been modeled. Several artistic problems concerned Konrad Witz: the figures as such, the figures in real space, and the relationship of the figures to one another. The closed altar shows the various individual figures squeezed into narrow, boxlike rooms. The natural light entering these very simple but realistically designed rooms allows the figures to cast hard shadows on the walls. These imposing figures, their size disproportionate to the room, confront the viewer directly. And yet the problem of architectonic space does not seem to be of overly great interest to the artist; his attention is directed toward the actual figure, which he seeks to capture three-dimensionally. This is where Witz proves himself to be a painter of the first half of the fifteenth century who, like contemporaneous Flemish artists, draws on the large sculptures of the High Gothic; we shall return to this subject later. This new concept of the human figure is skillfully demonstrated on the inside panels of the altar. Every panel has two figures in a room identified only by a seat, a tiled floor, and a damasked gold ground. This focuses the viewer's attention on the figures and their gestures. The colors of their flowing robes – Witz's palette consists of tones and tints of the four primary colors – underlines the significance of the single figures. The perfect harmony of color and overall composition demonstrates the meticulous planning and tranquility that mark Witz's mastery.

The sculptural quality of the figures and their gestic language suggest that the artist had firsthand knowledge of cathedral sculpture, above all in the Upper Rhine region. The Esther and Ahasuerus scene on the inside of the wing, for example, brings to mind the Coronation of the Virgin on the south door of Strasbourg cathedral.[11] The Virgin is sitting humbly next to her divine Son, hands upturned, accepting the homage being paid her; Esther is in the same pose next to Ahasuerus.

The Altar of St. Peter in Geneva

The way Konrad Witz presented the eternal truths of salvation cannot have left the Council participants unaffected; the artist must have enjoyed the respect of the ecclesiastical dignitaries assembled in Basel. The immediacy of his expressive means, his ability to depict the events of the history of salvation, must have impressed an ecclesiastical dignitary like Bishop François de Metz from Geneva enough for him to commission an altar of St. Peter for Geneva cathedral from Witz.[12] François, who came from Metz in Savoy and had close links to the House of Savoy, had been Bishop of Geneva since 1426. At the Council of

fig. 3: Mirror of Salvation Altar: *The Annunciating Angel.* Kunstmuseum Basel.

fig. 4: Mirror of Salvation Altar: *St. Bartholemew.* Kunstmuseum Basel.

fig. 5: Mirror of Salvation Altar: *Antipater and Caesar.* Kunstmuseum Basel.

fig. 6: Mirror of Salvation Altar: *Esther and Ahasuerus.* Kunstmuseum Basel.

fig. 7: Mirror of Salvation Altar: *Abraham before Melchizedek.* Kunstmuseum Basel.

fig. 8: Mirror of Salvation Altar: *Abisai before King David.* Kunstmuseum Basel.

Basel he belonged to that majority of secular and spiritual princes who, against the pope's will, advocated the superordinated role of the Council. On 16 May 1439 the Council's superiority over the pope was dogmatized as "veritas fidei catholicae," and on 25 June of the same year Pope Eugene IV was deposed. The new pope, Duke Amadeus VIII of Savoy, was elected on 5 November 1439, taking the name Felix V.[13]

Felix V was to be the last antipope in the history of the church. Born in 1383, he had married Mary of Burgundy in 1393. Savoy achieved its greatest territorial expansion under his rule, and in 1416 Emperor Sigismund elevated the former county to the status of duchy. After the death of his wife in 1422 and his eldest son in 1430, the duke withdrew to the Carthusian monastery at Ripaille, where the news of his election as pope reached him. He acceded to office in Lausanne, the city to which the Council of Basel was transferred in 1448. Upon the death of Bishop François de Metz on 7 March 1444, Felix V himself assumed responsibility for the administration of the bishopric of Geneva. The Geneva bishops had been at the forefront of ecclesiastical reform since the early fifteenth century, with such distinguished personalities as Jean de Bertrand, Jean Courtecuisse, and above all Cardinal Jean de Brogny and François de Metz helping the bishopric to achieve distinction.[14]

Felix V retired as antipope in 1449 and died in 1451. The ambitious politics of Bishop François de Metz had been the operative factor in the election of a Duke of Savoy as pope; in 1440 the bishop was elevated to the rank of cardinal in recognition of his efforts.

This papal election was important to Savoy and the bishopric of Geneva in terms of both ecclesiastical and secular politics: it allowed Savoy to assert itself vis-à-vis France and Burgundy, its neighbors to the west; moreover, the bishopric of Geneva was now not only protected against the enterprises of the House of Savoy, it also acquired the reputation of the leading reform bishopric, where Pope Martin V spent three months after the Council

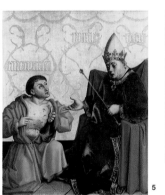

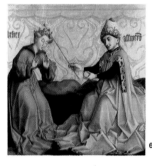

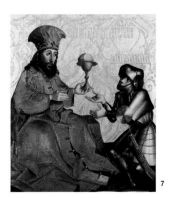

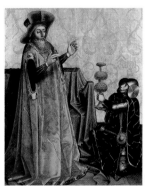

of Constance. Bishop François de Metz wanted a winged altar in his episcopal church as a visual public demonstration of the reforms Geneva was instigating in the Roman Catholic Church; he was also interested in legitimizing his actions at the Council of Basel before God and the world, and in achieving eternal honor for himself as "popemaker" and for the "Savoia felix."

During the very same period, François de Metz's antagonist, Pope Eugene IV, commissioned Antonio Averlino, known as Filarete, to create the bronze doors of the Porta Mediana in St. Peter's Basilica in Rome (fig. 14).[15] Their six large panels show Christ in majesty; the Mother of God; the Princes of the Apostles, Peter – with Eugene IV kneeling before him – and Paul, both standing; and the martyrdom of the two Apostles. The smaller fields portray the most important events in Eugene's pontificate: Emperor John VIII, Palaeologus of Constantinople, coming to the pope; the same emperor appearing at the Council of Florence to unite the Eastern church with Rome; the coronation of the Luxemburg Sigismund as emperor; and the reunification of the Armenians, Jacobites, Nestorians, and Maronites with Rome. Thus the bronze door, with its central location in the old St. Peter's, becomes an expression of Eugene IV's insistence on the "plenitudo potestatis" of the office of pope.[16]

Four of the panels of the Altar of St. Peter commissioned from Konrad Witz by François de Metz can be found at the Musée d'art et d'histoire in Geneva today (figs. 10-13). They show Peter's Miraculous Draught of Fishes, Peter's Liberation from Prison, the Adoration of the Magi, and Peter with the Keys, Commending Cardinal de Metz to the Madonna. On the lower part of the frame, the panel with the Draught of Fishes bears the important signature and date: "hoc opus pinxit magister conradus sapientis de basilea anno mo cccco xliiio." This panel has repeatedly aroused interest because of the landscape. Witz provides a realistic portrait of the landscape, with the lakeside part of the city of Geneva and the Petit Salève, Môle, and hills of the Voirons in the background.

Two events described in Matt. 14: 24-33, Luke 5: 4-11, and John 24: 1-14, take place in this concretely recognizable landscape. The figure of Christ, vertical beneath the Môle, stands in no relationship to the viewer, but for that all the more intensively to Simon Peter, who, at His behest, walks on the water and then, seized by fear, sinks. The scene in the middle ground shows the multitude of fishes that have been caught and is thus also connected with Peter's new vocation: "from henceforth thou shalt catch men" (Luke 5: 8-11).

These events, so very important to the foundation of the church, are now taking place not by the Sea of Genezareth but in the very realistic landscape of the Lake of Geneva, near the city of Geneva. The claim being made is eminently clear: Peter's vocation is being entrusted to him in Geneva; it is from Savoy that Pope Felix V, a successor to Peter, is to be fisher of men.

The panel opposite once again shows two episodes from the life of Peter: Peter asleep in the prison of Herod and his miraculous liberation by an angel (Acts 12: 6-11). This scene is rarely depicted; that Cardinal de Metz wanted it recorded on the altar expresses an unmistakable purpose. The angel liberates Peter from prison so he can fulfill the task Christ has intended for him. The Council of Basel – which regarded itself from the outset as the representative of the church under the guidance of the Holy Spirit – has liberated the church from its "Roman prison" by deposing Pope Eugene IV and transferring the patrimony of Peter to Pope Felix V and Savoy.[17] Thus it is perfectly natural that on the inside panel, Peter, Prince of the Apostles, with the keys symbolizing his office, should be commending Cardinal François de Metz, Bishop of Geneva, to the Madonna. Peter has a twofold function here: as pope, to whom Felix V is a successor, and as patron saint of the episcopal church of Geneva. Mary is gazing at her Divine Child as she points to the bishop, an indication that through his actions the church will undergo renewal. Witz emphasizes this by endowing the bishop with portraitlike features.[18]

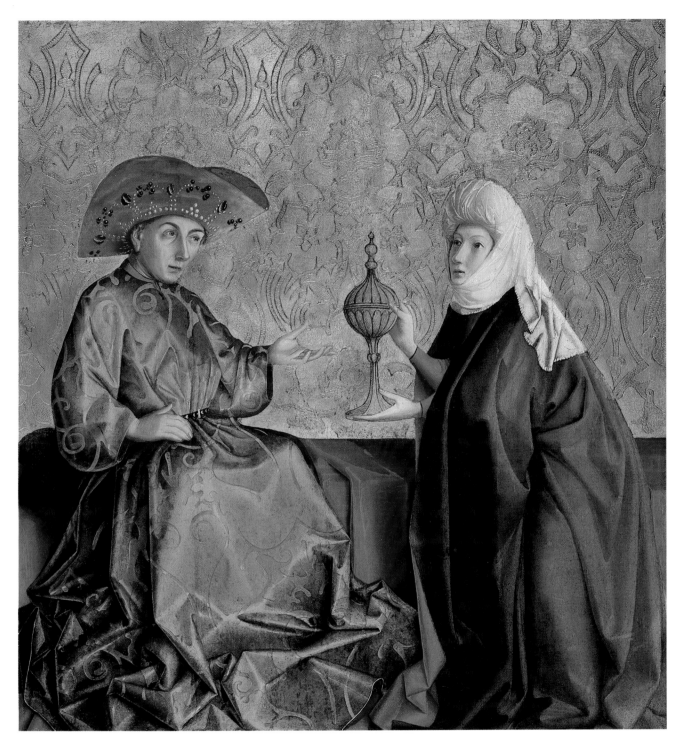

fig. 9: Mirror of Salvation Altar: *King Solomon and the Queen of Sheba*. Gemäldegalerie Staatliche Museen Preussischer Kulturbesitz, Berlin-Dahlem.

The Adoration of the Magi on the other inside panel takes place in a rich architectural setting. The ruins with ox and donkey do not suggest the manger in Bethlehem as much as they do the end of the Old Covenant, symbolized by King David with the harp above the pointed arch at the entrance. Christ is a descendant of David (Matt. 1: 1-17), but through Him the Old Covenant comes to an end and the New Covenant, represented by the church, is established. The tiled floor should call to mind the courtyard of Solomon's Temple as the precursor of Ecclesia, the church.

In the Geneva altar Konrad Witz stresses the truthfulness of the gospel by illustrating three texts from the Gospels in the same picture, not to mention the extension of the cycle in the other panels of the altar. In this the painter is still a wholly medieval artist. The other pictorial elements, which allude to Geneva's "buon governo,"[19] reveal him to be a Renaissance artist in the service of an ecclesiastical dignitary. Thus Witz becomes a key figure of the late Middle Ages, his work marking in the most impressive possible way the end of one era and the beginning of a new era.

The Basel Dance of Death

Konrad Witz and his apprentices created the large Dance of Death on the courtyard wall of the Predigerkirche (Dominican Church) in Basel in 1440. In it the artist illustrated to the public the prevailing secular and ecclesiastical policies of the city of Basel (fig. 15).[20]

The idea of the Dance of Death goes back to the fourteenth century, when Pope Benedict XIII established the dogma (in 1336) that death was followed by individual judgment and purification of the soul in purgatory; only then would the soul attain everlasting life. This did not, however, shake the popular belief that the poor souls would continue to be tormented after their bodily death, that they would not find rest and would perform a compulsive dance, the Dance of Death. This image of the midnight dance of the dead on their graves provided the basis for the oldest Dance of Death poem, which was a work of

spiritual edification. The poem is an exhortation to mend one's ways and repent, for behind the macabre vision the poet sees eternal damnation looming.

In the fourteenth century, when Europe was being swept by plague epidemics and confronted with people dying in vast numbers, the great Dance of Death pictures were created in France and above all in Germany. In Basel, too, the plague epidemic raging during the Council, between April and November 1439, provided the impulse for a public representation of the Dance of Death. As distinguished Council participants, such as the papal protonotary Ludovicus Pontanus, Duke Ludwig von Teck, who was patriarch of Aquileja, and the bishops of Lübeck and Evreux, had fallen victim to the plague, the ecclesiastical dignitaries entrusted the Dominicans with the responsibility for commissioning the painting and donated a sum of money to pay for the work.

The Dance of Death in Basel was not conceived along novel lines. The manuscript upon which it was based, though of Basel origin, was subjected to intensive examination before the frescoes were allowed to be executed, for the work was to be imbued with a popular, missionary character. In consequence, not only were certain figures substituted in Basel; in contrast to other representations of the Dance of Death, the accompanying verses were placed above rather than below the pictures, enabling larger script to be used.

What Konrad Witz created for the Dominicans was not a timeless, universally valid Dance of Death, it was a Basel Dance of Death, a fresco whose contents related concretely to the city of Basel and its citizens at the time of the Council. The prosperous, cosmopolitan, joyful city of Basel is ill, not only physically, as the result of the plague, but, far worse, morally. Witz points out this depravity to the citizens of the town in a sequence of scenes. As is the case in all Dances of Death, a preacher of repentance is exhorting the people to mend their ways; nonetheless, Death asks each one, regardless of standing, to join him in his macabre dance. The emperor bears the features of

fig. 10: Altar of St. Peter:
Peter's Draught of Fishes.
Musée d'art et d'histoire,
Geneva.

fig. 11: Altar of St. Peter:
The Liberation of St. Peter.
Musée d'art et d'histoire,
Geneva.

fig. 12: Altar of St. Peter: *The Adoration of the Magi*. Musée d'art et d'histoire, Geneva.

fig.13: Altar of St. Peter: *St. Peter Commending François de Metz to the Madonna*. Musée d'art et d'histoire, Geneva.

fig 14: Filarete, Bronze Portal. San Pietro in Vaticano.

fig. 15: The Basel Dance of Death.

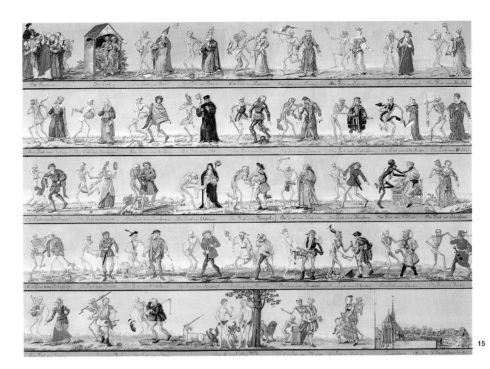

14

15

Emperor Sigismund, the king is a portrait of Charles VII of France – both were directly involved in the Council – and the pope is none other than Felix V, the antipope elected in Basel. Death not only tears worldly and ecclesiastical dignitaries out of this life, he delights in grabbing the Jews and the usurers – representatives of the money economy that leads citizens into moral turpitude. Unmitigated hatred for this occupation finds expression in the Prediger Dance of Death: Witz painted the usurer attempting to buy himself off by offering money even to Death. The citizens are to be led to regard the Black Death as God's punishment for this occupation; and Jews, who are the main practitioners of the trade, are to be delivered into eternal damnation. Typical burghers' professions are pilloried as well; lawyers and councillors had too often proved bribable and contributed to the damage being inflicted on society. But Konrad Witz did not merely hold up a mirror to the city in its present state, he included wider political and spiritual allusions. The heathens – Moslems in Turkish robes – are represented; this can only be understood as a reference to the Ottoman threat to the Byzantine Empire; in 1453 Byzantium fell. It is striking that these Turks are calling not upon Allah and Mohammed but upon the ancient gods Jupiter, Neptune, Juno, and Venus, an unconcealed dig at the Council participants. As the Turks resort to heathen phraseology rather than the cultivation of Islam, so the churchmen have dedicated themselves to heathen literature, neglecting Christendom and the church. The Council had brought the ideas of the Italian Renaissance to Basel; for the Dominicans, as representatives of Scholasticism, the plague was God's punishment for this heathen secularization of the ecclesiastics.

What Witz captured in the Dance of Death are the prevailing currents in the intellectually open-minded, economically open city of Basel at the time of the Council.

The painter Konrad Witz is a complex figure. This article has been an attempt to show how his most important works can be understood as an expression of a period of historical upheaval and only against this background.[21] Witz stands before us as the epitome of a late medieval artist; his open-mindedness, however, allowed him to accept the Renaissance-like demands of those who commissioned him.

Translated from the German by
Eileen Walliser-Schwarzbart

Notes

1 Daniel Burckhardt, "Das Werk des Konrad Witz," *Festschrift der Stadt Basel zum 400. Jahrestage des Ewigen Bundes zwischen Basel und den Eidgenossen* (Basel, 1901); Joseph Gantner, "Zur Ikonographie des Heilspiegelaltars von Konrad Witz," *Jahresbericht der Öffentlichen Kunstsammlung Basel* (1940); idem, *Der Heilspiegelaltar*, Werkmonographien zur Bildenden Kunst, Reclams Universal-Bibliothek 137 (Stuttgart, 1969); Hans Wendland, *Konrad Witz. Gemäldestudien* (Basel, 1924); Hans Rott, *Quellen und Forschungen zur süddeutschen und schweizerischen Kunstgeschichte im XV. und XVI. Jahrhundert. III. Der Oberrhein, Quellen II (Schweiz)* (Stuttgart, 1936).

2 Regarding the Council of Basel, see Karl August Fink in *Handbuch der Kirchengeschichte, vol III/2, Die mittelalterliche Kirche. Vom Hochmittelalter bis zum Vorabend der Reformation* (Freiburg i. Br.: Herder, 1968; reprint ed. 1985), pp. 572-588.

3 François Maurer, *Die Kunstdenkmäler des Kantons Basel-Stadt, IV. Die Kirchen, Klöster und Kapellen* (Basel: Birkhäuser, 1961), p. 150; Beat Matthias von Scarpatetti, *Die Kirche und das Augustiner-Chorherrenstift St. Leonhard in Basel (11./12.Jahrhundert – 1525); ein Beitrag zur Geschichte der Stadt Basel und der späten Devotio Moderna,* Basler Beiträge zur Geschichtswissenschaft 131 (Basel: Helbing-Liechtenhahn, 1974).

4 The Musée municipal in Dijon has two panels showing St. Augustine (or Theobald?) and Emperor Augustus with the Sibyl of Tibur; the Gemäldegalerie of the Staatliche Museen Preussischer Kulturbesitz in Berlin-Dahlem possesses the panel with Solomon and the Queen of Sheba. The following panels can be found at the Kunstmuseum in Basel: The Annunciating Angel – Ecclesia – Synagogue – St. Bartholemew – Esther and Ahasuerus – Antipater and Caesar – Abraham before Melchizedek – Abisai before King David – Sabothai and Benaias.

5 Hans Rott, op. cit., pp. 127 f.

6 *Heilspiegel. Die Bilder des mittelalterlichen Andachtsbuches Speculum humanae salvationis. Mit Nachwort und Erläuterungen von Horst Appuhn,* (Dortmund: Harenberg Edition, 2nd ed., 1989).

7 Albert Châtelet, "Le retable du miroir du salut. Quelques remarques sur sa composition," *Zeitschrift für Schweizerische Archäologie und Kunstgeschichte,* vol. 44, no. 2 *(Konrad Witz. Festschrift zum 90. Geburtstag von Joseph Gantner)* (Zurich, 1989), pp. 105-116.

8 Whether the panel in Dijon depicts St. Augustine or St. Theobald cannot be determined.

9 See n. 5.

10 Albert Châtelet, op. cit., pp. 111 ff.

11 Willibald Sauerländer, *Gotische Skulptur in Frankreich. 1140-1270,* photographs by Max Hirmer (Munich: Hirmer Verlag, 1970), plate 131.

12 Regarding written sources on the Geneva altar, see Claude Lapaire and Anne Rinuy, "Le retable de la cathédrale de Genève," *Zeitschrift für Schweizerische Archäologie und Kunstgeschichte,* vol. 44, no. 2, 1987, pp. 128 ff.

13 Fink, *Handbuch der Kirchengeschichte,* pp. 572-588.

14 For the bishopric of Geneva, see C. Santschi, "Geneva," *Lexikon des Mittelalters,* IV (Zurich and Munich: Artemis Verlag, 1988), cols. 1230-1232.

15 C. Galassi Paluzzi, *San Pietro in Vaticano,* vol. II, Le Chiese di Roma illustrate 76-77 (Rome, 1963), pp. 28 f.

16 J. Helmrath, "Eugen IV.," *Lexikon des Mittelalters,* IV (Zurich and Munich: Artemis Verlag, 1988), col. 81.

17 Raphael's depiction of Peter's liberation from prison (1512-14), at the Stanza d'Eliodoro in the Vatican, makes allusion to the liberation of the church by Pope Julius II.

18 Alfred A. Schmid, "Zur Frühgeschichte des Bildnisses in der Westschweiz," *Von Angesicht zu Angesicht. Porträtstudien. Michael Stettler zum 70. Geburtstag* (Bern: Verlag Stämpfli, 1983), p. 150.

19 Florens Deuchler, "Konrad Witz: der Blick nach Savoyen," *Unsere Kunstdenkmäler,* Gesellschaft für Schweizerische Kunstgeschichte, vol. 36, no. 3 (Bern, 1985), pp. 295-301.

20 Hellmut Rosenfeld, *Der mittelalterliche Totentanz. Entstehung-Entwicklung-Bedeutung* (Cologne and Vienna, 1974). For the Basel Dance of Death, see pp. 103-117. – The *Dance of Death* on the churchyard wall of the Dominican Church was destroyed in 1805; the nineteen fragments that have survived are in possession of the Historisches Museum Basel. The Dance of Death has come down to us in copperplate engravings by Matthäus Merian.– Matthäus Merian, *Todten-Tantz wie derselbe in Basel zu sehen ist* (Frankfurt, 1649).

21 The present article does not offer scope for a detailed treatment of the master's artistic origins and the stylistic classification of his known works; these questions are the subject of a forthcoming study by the author.

Picture credits

figs. 1-8: Kunstmuseum Basel

fig. 9: Gemäldegalerie Staatliche Museen Preussischer Kulturbesitz, Berlin-Dahlem

figs. 10-13: Musée d'art et d'histoire, Geneva

Emil Maurer

Painting Learns to Fly: Hans Bock the Elder, *The Fall of the Angels* (1582). Fore–Words on the Subject of Floating, Flying, Falling

I

The 1582 print (signed and dated) by Hans Bock the Elder (c. 1550/52-1624) – catalogued as Inv.U.IV.85 at the Department of Prints and Drawings of the Kunstmuseum Basel – shows approximately forty-five falling figures and seven that have already landed or are rising again (fig. 1), with a wrathful God (much fainter) floating above them.[1] The depiction has hitherto been interpreted narratively, as the Fall of the Angels, if sometimes with a question mark. Philosopher Peter Sloterdijk reads the print as a coherent representation, with no specific textual allusion, of many individuals meeting a common fate: "everyone falls in his own special way," "to each his own personal falling space," "at a civil distance": a host of single fates illustrating an individualistic, perhaps rather Bâlois, "patrician culture in free fall" – a highly dramatic portrayal of events, in other words, whose structure indicates a society lacking in solidarity.[2]

That is keenly observed and brilliantly reasoned – but probably not firmly rooted in fact, because it does not consider the function the drawing might have had in the period of late Mannerism. A normal compositional study for a large picture (of what type and for what purpose)? A demonstration print for a prospective client? (Bock had a good head for numbers and ran his workshop efficiently.) But an art historian with a reasonably good grasp of Bock's oeuvre and of Manneristic staging in general will notice other details: the careful, paratactic, mar-

fig. 1: Hans Bock the Elder, *The Fall of the Angels* (?), 1582, grey pen-and-wash, 69.1 x 46.4. cm. Public Art Collection, Basel, Department of Prints and Drawings, Inv. U.IV.85.

quetry-like distribution of figures on the rectangular print, from edge to edge, avoiding overlapping or emphatic concentrations and concatenations; the absence of perspective unity through a combination of angles and views from below and above; the different scales of size everywhere, with no systematic consideration of nearness or distance; the uniform attention to sculptural-anatomical detail in a monotonous fortissimo of spasmodic intensification of movement – the same heroes everywhere, essentially the selfsame actor again and again; the programmatic presentation of a variety of "fall motifs," each one unlike the next, with neither repetitions nor assonances.

Everything points to the fact that this is a repertoire of falling figures, a specimen sheet for use in the workshop, a stock of motifs at the ready, a catalogue lacking nought but the numbering.[3] From case to case, and depending on the requirements, one or more falling figures could be chosen and perhaps newly combined. Conversely, the print is also a collection of prior experiences with the subject. The falling figures of the façade designs of 1571 and 1572, for example, were included as types, if not in precise detail.

Bock is indeed a *specialist in falling and flying figures*. They occur with striking frequency in his works, the subjects undoubtedly having been requested by his clients. Thus we find the otherwise rarely chosen Fall of Bellerophon at least three times, and always in connection with Theodor Zwinger (1533-1588), a Basel physician, humanist, and university professor:

1 as the central theme of a design for the façade of Zwinger's house on Nadelberg, 1572 (fig. 2).[4] In an earlier design (1571) for the same façade on the same theme, the main group with Bellerophon is missing, but Jupiter is already depicted at the top and the Chimera at the bottom;[5]

2 in a pen-and-wash drawing from 1571, presumably a study for the façade (fig.3);[6]

3 a so-called "upper picture," an emblematic view through a window in Bock's portrait of Theodor Zwinger.[7]

All of these pictures with Bellerophon on the theme of falling are closely linked with the man who commissioned the work and owned the house. Whether displayed publicly, on the façade of his house on Nadelberg, or confessionally, as part of his portrait, it is his personal motto: a warning against the hubris of reaching too high.[8]

The same message can be found in the two falling figures of Phaeton and Icarus. Smallish oval cartouches on either side of the main axis of the 1571 façade design mentioned above, they are not "historiae" but emblematic contractions, flanked by the allegories of Prudentia and Fortuna (figs. 4, 5).[9] The commencement of a "Fall of the Giants" in the pyramid of titanic heroes is shown in the large 1586 Allegory of the Day for Basilius Amerbach. A single figure on the right is already lying head down beneath the glaring beams of Olympus.[10]

Bock also makes frequent use of floating figures, though more often in his earlier than in his later works. In a further façade design, from 1572, two large floating angels are portrayed in vigorous action – one appearing to Balaam, the other armed with a sword. They testify to the power, wrath, and goodness of the invisible God (Koepplin).[11] As they seem to be floating in front of the actual windowed wall, the illusion they create is even more effective. In the eighteen scenes from the Life of the Virgin Mary for St. Blasien, c. 1600, the angels are pursuing their normal tasks; most of them have been taken over literally from engraved reproductions of the contemporary generation of Netherlandish Mannerists.[12] The murals in the town hall of Basel, renewed by Bock around 1608/1611, are more restrained and "classical" than the early works and do largely without celestial beings.[13]

The six falling figures mentioned – individuals in free fall – are remarkably independent of one another in design. And they do not correspond precisely to any of the "falling studies" on the specimen sheet described. One of them is sinking in a horizontal position, eyes looking up and back, "swimming" in billowing robes. The others are tumbling head down, at assorted angles, bodies twisted in various ways, arms and legs moving in various directions, some of them almost floating, others nearly diving, and all of them moving at different vertical speeds.

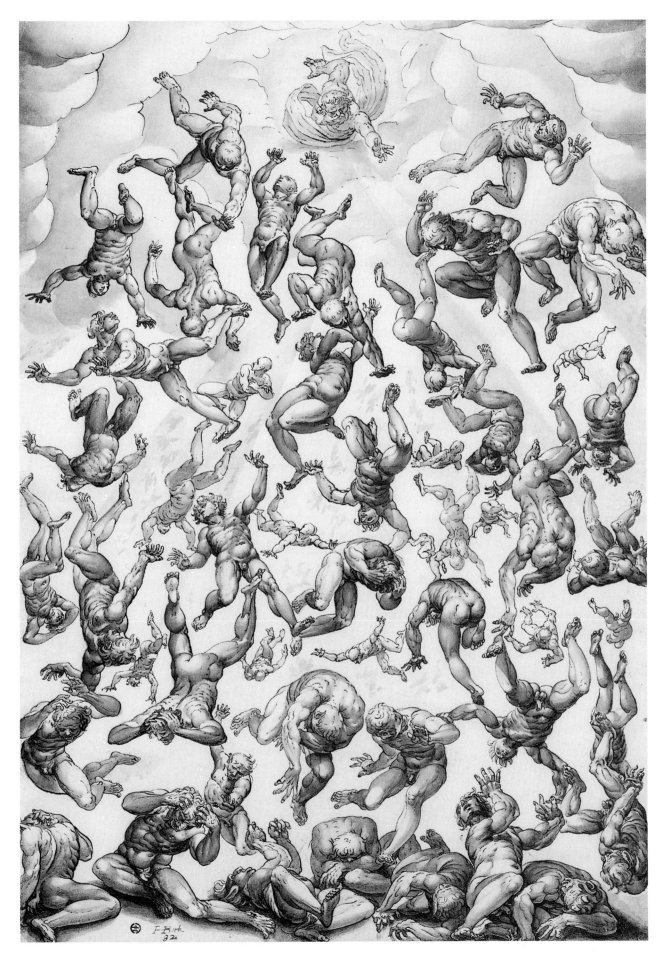

In his larger compositions Bock confirms that he is an unashamed motif hunter, a master of quotation and compilation in the typical Manneristic tradition of reuse, be his models Netherlandish, Italian, or German.[14] Amerbach's amazing thesaurus of fifteenth- and sixteenth-century European graphic art – altogether some four thousand prints arranged in chronological and topographical order, by artist – was undoubtedly available to his artist friend. It will have provided Bock with virtually exhaustive information on the state of design innovation in the sixteenth century.[15] The thesaurus should ultimately allow the sources of Bock's falling and flying figures to be established. Strikingly enough, the painter does not refer to the most prominent reservoir of motifs, Michelangelo's *Last Judgment*, several engraved reproductions of which had, after all, immediately become available.[16] Bock had a far stronger affinity, even stylistically, for motifs like those in Coornhert's 1549 engraving *The Danger of Human Ambition*, after Maarten van Heemskerck, with very similar falling positions, similar emphasis on sculptural anatomy (musculature) and the principle of "variatio" in amazing poses, and even the same moralistic framework (fig. 6).[17] Impulses may also have gone out, for example, from Stradanus' Descent to Hell of the Damned in the tondo engraving by Goltzius (c. 1577) (fig. 7).[18] In overall concept there is some relation to the anonymous engraving after a Fall of the Angels (School of Fontainebleau, after Luca Penni?).[19] Here Bock Italianizes via the Italianizers among the northern Netherlanders of the 1540/1580 generation.

At the same time, Bock's falling figures as individual forms also follow the principle of "variatio" – systematic variety, the declination of motifs. Apart from iconographic treasure troves – the Last Judgment, the Descent of the Damned, the Fall of the Angels, the Fall of the Giants, Phaeton, Icarus, allegories, etc. – the artist mobilized his own physical imagination in "grammatical" studies of the falling body. Thanks to anatomy, the study of the mechanics of movement, and the development of perspective, the necessary visual skills had substantially improved since the early sixteenth century and had, since Michelangelo's "tour de force," made international inroads. The Amerbach print collection provided the necessary vocabulary. Where a stock of motifs is coupled with a passion to produce, a reciprocal challenge is born. The Basel print offers insight into this process. With Bock's variations on falling, the state of total availability of the "ignudo in moto," in supraterrestrial, all-dimensional perspective, had been achieved.

A long development had preceded it. This story – in the broader aspect of "Floating, Flying, Falling" – can only be suggested here and still remains to be told in detail.

II

Iconography, whether sacred or profane, is teeming with themes connected with floating, flying, and falling.[20] Central occurrences and events are depicted as taking place in, or moving toward or away from, Heaven: from the Trinity, Olympus, Ascension, Assumption, apotheoses, visions, and allegories to the Last Judgment, the Fall of the Angels, and the stories of Phaeton and Icarus.

As a superhuman, supernatural gift, air travel is a potential of gods and saints. Their ability to fly does not depend on external aids; it is not subject to the laws of nature. Angels, on the other hand, have wings – or at least they have had since the fourth century, judging from the cherubim and seraphim – so they possess some "technical" equipment. Falling from Heaven is considered the divine punishment for hubris; it puts the subject totally at the mercy of gravity.

Floating, flying, falling: that is easily said through the medium of language. But how is the flying figure to be shown with all the requisite information about position of the body, motor activity, or the functions of the limbs? How does a human being in flight – a creature never before seen and in principle unimaginable – look? How can he be conceived? How imagined? As if in a dream? How can he be visualized (without resorting to the topoi of ancient, medieval, and Renaissance art)?

fig. 2: Hans Bock the Elder,
Design for a Painted House
Façade, 1572, India ink,
colored. Public Art Collection,
Basel, Department of Prints
and Drawings,
Inv. U.IV.92.

fig. 3: Hans Bock the Elder,
The Fall of Bellerophon,
India ink, 41 x 30.1 cm.
Public Art Collection, Basel,
Department of Prints and
Drawings, Inv. U.IV.67.

It was a wide-ranging topic, an extraordinary challenge to the imagination – particularly since the rationalization painting had undergone in the fifteenth century – a task of exceeding difficulty. It must have been much discussed and fretted over in the workshop. And yet historical art theory (a field more at home with the principles of literature and rhetoric than in the studio) has not a word to say on the subject; it remains as mute as art history (which tends to derive its catalogue of problems from the verbal utterings of art theory).

The problem becomes acute as soon as natural laws – such as gravity, optics, the mechanics of movement, anatomy – enter the laws of art in the early quattrocento. Prior to that, medieval visual habits had, for example, allowed the symbolic image of a saint on high, throning against a gold ground, to suffice: the viewer would have known how to "read" the result as a saint "floating" in Heaven. But is there an empirical way to handle the task? Cunning experimental observation perhaps? The empirical spirit of the Renaissance artist moves off onto byways. Imagination takes refuge in analogies and projections: swimming and crawling movements as flying movements, upside-down figures as falling figures, hurrying and running motifs as flying motifs – not really much different from what goes on, on the ground. But where is the astonishing quality, the impossibility of the subject? Only in the cinquecento does the "invenzione" boldly increase to the point of inconceivability. That is when dreams of flying begin to merge with dreams of space.

It is above all anatomy – the modern in-sight into the construction of the human body – that imagination puts to the test, for essentially unverifiable motifs of movement must be conceptualized. They are hypotheses or skewed analogies, which, under the heading of flight, furnish the basis for anatomical research. But even within the context of such substitutions, the multiplicity of ground-less movements gradually increases, until, in his *Last Judgment* and the Cappella Paolina, Michelangelo achieves total mastery of the human body, even in floating, ascending, and falling positions.

When saints and gods fly, the modern viewer – his angle regulated by perspective – can only be looking up from below. The hitherto common horizontal view must therefore yield to the "di sotto in sù" vantage point. And the ideal site for that is obviously the painted ceiling, with perspective manipulating viewer and subject alike. In relation to the viewer, the subject, seen from below, is compressed and "disfigured," and the viewer takes his place according to the laws of perspective. Floating and falling figures are drawn into the dynamics of verticality, the "sursum" and the "descend!" The narrative axis shifts from the view of to the view up to, with all the consequences this entails.

Above all, once perspective develops into a geometrical science – on the basis of abstract diagrams, constructional drawings, stage sets, architectural drawings – it takes on a supremely difficult, non-geometrical task: the human figure, foreshortened as "scurto," a decision with a thousand ifs and buts. For conflicts are continually generated – against the resistance of the sanctity and ideality of the pictorial topic. The dignity of beautiful proportions is compelled to bow to the foreshortened "di sotto" flying figure. The extreme is already reached in Correggio's dome frescoes: instead of a lovely façade, the figures offer a daringly tangential view of footsoles and nostrils.

The problematic airborne human can, if necessary, be equipped with all manner of flying aid. Saints often fly with the help of winged angels, who, be it individually, in hosts, or in ring or halo constellations, support and carry them. A vehicle tried and tested since ancient times is the cloud, which began as an emblematic pedestal and increasingly developed into a dynamic means of transportation. Equally effective and reliable are flapping robes, draperies, and hair – easily interpreted indicators of the direction, character, and intensity of movement in the air. The forces of wind and light are also employed with ever greater frequency.

In the course of the cinquecento, pictorial space may no longer be measurable or possess an unequivocal directional orientation. Figures then appear to be at the mercy of the elements – helpless, tumbling.

fig. 4: Hans Bock the Elder, *Phaeton.* Part of a design for a painted house façade with Chimera, Fall of Icarus and Phaeton, Prudentia and Fortuna, 1571. Grey pen-and-wash, 49.4 x 39.4 cm. Public Art Collection, Basel, Department of Prints and Drawings, Inv. U.IV.65.

fig. 5: Hans Bock the Elder, *Icarus.* Detail of fig. 4.

fig. 6: Dirck Volkertsz, Coornhert naar Maarten van Heemskerck, *Het gevaar van de menselijke ambitie,* 1549. Albertina, Vienna.

In the cinquecento, the difficulty of the task constitutes both an incentive and a point of honor. It demands a maximum of ingenuity and virtuosity. A ground-less *concettismo* must prove itself in a sphere far removed from mere observation. Vasari, for example, does not tire of distributing honorary titles accordingly.

III

The art theory of the Renaissance paid little attention to the specific problem of depicting flight. Although it does use empirical procedures to differentiate in detail the positions and movements of the "figura umana," the flying figure itself is nowhere in sight. As we know, Leonardo made thorough studies of flying birds and flying machines. When he tried to equip the human being with the ability to fly, man remained a (winged) "macchina."[21] The wonderful movement of self-propelled flight, without technical help, is not reflected. Leonardo's angels in the *Annunciation* and the *Virgin of the Rocks* are kneeling on the ground. Nor is he interested in the "scurzi" in painting, doubtless because, unlike spatial conditions, the human figure, at least when in motion, cannot be captured in precise mathematical-geometrical-perspectival terms.[22]

Even the unbridled treatise-ism of the Mannerists does little to alter the situation. Though this is the age of concettismo, no reference is made to ingenuity, to the "imaginare con la fantasia" (Vasari). Lomazzo and Zuccaro are the first to put forward some speculative principles on the subject. "Scorti al di sotto in sù," representations of figures from below, are dealt with at length as "una terribilissima arte" (Vasari), but without even a thought for figures in flight. And the *Codex Huygens* – which follows in the tradition of Leonardo – mentions the "figura a volo" only under the heading of perspective. The rules found there for views from beneath relate to standing and seated figures, and lastly to a walking figure meant to be read as flying.[23] Evidently it is still the ordinary walking figure that, projected into the sky, is declared to be a figure in flight. Lomazzo, a follower of Leonardo, makes a similar statement in his *Trattato*, without going into further detail.[24]

IV

For that, some of the treatise writers are all the more eloquent when it comes to the practice of depicting flight; but here, too, only under two specific aspects: the "scorti delle figure al di sotto in sù" (Vasari) and the technical aids used. Vasari's "Introduzione" to *Della Pittura* is the primary source;[25] Leonardo, Cellini, Lomazzo, Armenini, and others also make comments on the subject, "in passing."

Like the painters, the theorists confront the difficulties of representing flight only on the level of practical execution: observation of living models (as far as possible), problems of foreshortening (between "stupore" and "grazia"), capturing the musculature of the moving body.

The task of making "unimaginable" flying positions imaginable thus leads back to the banalities of the studio. The point is to reconstruct the figure in flight by roundabout means, with the help of workshop aids and substitutes from the workshop vocabulary.[26] Floating motifs are derived from upright, prone, and walking poses. Extremities and garments must be activated to become organs of movement. Falling figures issue from prone, upside-down, and turned crouching positions – once again through transposition, in a derivative, secondary usage. There is a very general notion that memory and long experience are sure to be helpful; Michelangelo appeals to the "act of memory." But in the individual case, the "dal vivo" method, going out from studies of the act of motion, is preferable, the relation between imagination and verification once again not being discussed. Even Malvasia (1678) still circumvents the issue by quoting Raphael of the Farnesina: "You others, too, must see how it is done. One first thinks up a pose... then draws according to a model... then brings everything together..."[27]

The instructions for "scortare" are based on a long, practical workshop tradition. Flying and falling figures merely define the extremes, the most difficult cases; otherwise they are no different from the usual experiments. The warning that, in the interest of proportions and "decoro," foreshortening effects should not be exaggerated applies

fig. 7: Hendrik Goltzius,
Descent to Hell of the Damned,
tondo engraving, c. 1577.

to them, too.[28] Models are used to recreate complicated positions. To avoid tiring the "garzoni," act ropes, model rods, loops, rings, and other such devices are recommended.[29]

Nevertheless, small models of clay, wax, plaster, or wood are particularly well-suited and commonly used.[30] They keep still, can be hung up, turned, observed from different angles, and combined. Moreover, they are excellent objects by which to study certain conditions of light and shadow, and variations of perspective. If need be, a "velo," reticle, glass plate, or mirror can assist in the process of translation into pictorial form. Such aids are also useful in certain studies of draperies (with paste-hardened cloth).[31] When it comes to particularly difficult positions, the "manichino" – a movable, jointed doll – renders the best services.

Already Ghirlandaio, Fra Bartolommeo, and other Renaissance painters are said to have taken advantage of these aids. Flying angels and putti were developed on the basis of wax models. Fra Bartolommeo possessed "22 bozze di cera di bambini" and one life-sized figure for this purpose.[32] Correggio's method for the cathedral dome in Parma can be reconstructed with the help of "manichini": three different figures were evidently derived from a single wax model drawn from three different angles.[33] Tintoretto still made use of the same technical aids.[34] Palma Giovane and the Veronese Paolo Farinati demonstrate how act studies of children, with and without "manichini," were able to develop into compendiums of flying angel motifs on repertoire sheets of engravings.[35]

V

Irrespective of the intellectual deficiencies of the theory and traditional approach to the problem, thousands of floating, flying, and falling figures have been drawn and painted down the ages, some conventional, others highly original. The following milestones could be seen as marking the history of these depictions in the decisive decades of the Renaissance (fig. 8):

- Castagno (S. Apollonia and SS. Annunziata, Florence),
- Melozzo da Forlì (Loreto; SS. Apostoli, Rome),
- Signorelli (Orvieto),
- the painters in the Farnesina in Rome: Peruzzi, Sebastiano del Piombo, Raphael,
- Correggio (Parma),
- Michelangelo, with the ceiling of the Sistine Chapel, the *Last Judgment,* and the Cappella Paolina.

And from him to the Mannerists – like Hans Bock. That is a subject to be dealt with elsewhere.

Translated from the German by
Eileen Walliser-Schwarzbart

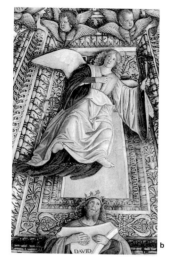

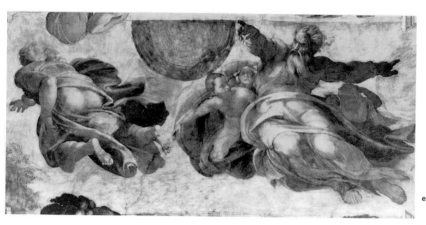

fig. 8: Milestones in the
representation of flight in Italy:
a Castagno (S. Apollonia,
Florence),
b Melozzo da Forli (Loreto),
c Signorelli (cathedral, Orvieto),
d Peruzzi (Farnesina, Rome),
e Michelangelo (Sistine Chapel,
Rome),
f Raphael (Farnesina, Rome),
g Correggio (cathedral, Parma),
h Sebastiano del Piombo
(Farnesina, Rome).

Notes

1 Kunstmuseum Basel, Kupferstichkabinett. Cf. Tobias Stimmer, cat. (Basel: Kunstmuseum, 1984), pp. 51, 511, no. 378. *Das Amerbach Kabinett, Zeichnungen Alter Meister,* cat. (Basel: Kunstmuseum, 1991), no. 139, with illustrations.

2 Peter Sloterdijk, "Jeder Körper ist ein Fall," *Die Zeit,* magazine section (23 June 1989), p. 4.

3 Sloterdijk does not overlook this aspect, using phrases like: "a fantastic lexicon of falling" and "an alphabet." The 1991 Basel catalogue (see note 1 above) already calls it a "Manneristic primer" and a "pattern collection." That the imperative figure at the apex is gesticulating with his left hand may indicate that a reproduction was planned or that a laterally inverted print was used.– Georg Pencz, a student of Dürer, compiled "a whole design collection of the boldest figures seen from below...with no thematic occasion" on a specimen sheet (formerly Liechtenstein Collection, A.P. 1247) (after J. Meder, *Die Handzeichnung* [Vienna, 1919], p. 623).

4 Basel cat. (1984, see note 1 above), no. 16, fig. 34, text (by D. Koepplin) p. 65, note 78. Basel cat. (1991), no. 137 with illustration. E. Landolt, "Materialien zu Felix Platter als Sammler und Kunstfreund," *Basler Zeitschrift für Geschichte und Altertumskunde* 72 (1972), p. 290. Idem, in the Basel cat. (1991),"Beiträge zu Basilius Amerbach," pp. 94-96. Ch. Heydrich, *Die Wandmalereien Hans Bocks d.Ae. von 1608 bis 1611 am Basler Rathaus* (Bern and Stuttgart, 1990). – The author is grateful for the informative conversations with the specialists Elisabeth and Hanspeter Landolt, and Paul Tanner in Basel.

5 Basel cat. (1991, see note 1 above), no. 136, with bibliography.

6 Basel cat. (1984, see note 1 above), no. 15, fig. 25.

7 Kunstmuseum Basel, originally from the Amerbach-Kabinett. Basel cat. (1991, see note 1 above), "Die Gemälde," no. 45. Dating illegible, but posthumous.

8 Verbal explanations in the drawings (door area) and lateral commentary scenes (see above, no. 1). D. Koepplin's interpretation under the heading of "Kunsthybris mit dem erhobenen Zeigefinger" (Basel cat. [1984], see note 1 above, p. 52). As a man of science, Zwinger had great sympathy for the then controversial teachings of Paracelsus (Basel cat. [1991], see note 1 above, "Die Gemälde," p. 28). A further possible source: Erasmus, *Enchiridion militis christiani* (1503). – For the Bellerophon theme, see Pauly-Wissowa, *Realency-clopädie der classischen Altertumswissenschaft,* III/1 (Stuttgart, 1897), col. 248. The subject of falling – besides Bellerophon, particularly Icarus and Phaeton – occurs frequently, e.g. at the court of Prague, not only as a general warning against hubris but directed especially at the uncompromising advance of science (cf. *Prague um 1600,* cat. [Essen, 1988], p. 64).

9 See note 4 above. For iconography relating to Phaeton and Icarus, see B. Jacoby, *Studien zur Ikonographie des Phaeton-Mythos* (Bonn, 1971); P. Maréchaux, "Les Métamorphoses de Phaéton," *Revue de L'Art* (1991), p. 88.

10 Basel cat. (1984, see note 1 above), no. 371; Basel 1991, "Die Gemälde," no. 46.

11 Basel cat. (1984), no. 17, fig. 35, p. 72.

12 Detailed evidence in P. Tanner, "Das Marienleben von Hans Bock und seinen Söhnen im Kloster Einsiedeln," *Zeitschrift für Schweizerische Archäologie und Kunstgeschichte* (1981), p. 75.

13 Ch. Heydrich, *Die Wandmalereien* (cf. n. 4 above), pp. 95, 105.

14 Evidence in Tanner, "Das Marienleben," p. 75, and Ch. Heydrich, *Die Wandmalereien,* p. 108.

15 Cf. (among others) E. Landolt, "Das Amerbach Kabinett," *Beiträge zu Basilius Amerbach* (Basel: Kunstmuseum, 1991). Inventory B of 1580/1581, containing the drawings and prints, has not yet been published; the names of the numerous artists in the collection are, however, known (pp. 134-139). For the friendly relationship between Amerbach and Bock, see Landolt, p. 94; for Theodor Zwinger, see p. 96.

16 On the numerous prints in the cinquecento after Michelangelo's *Last Judgment,* see *The Engravings of Giorgio Ghisi,* cat. (New York: Metropolitan Museum of Art, 1985), pp. 53-57. – The mechanism of a transfer of this kind, from Michelangelo to a painter from the north, is astutely analyzed by J. M. Maldague, "Michel-Ange et Pollaiulo dans la Chute des anges (1554) de Frans FLoris," *Jaarboek van het Koninklijk Museum* (Antwerp, 1983), pp. 169-189. For historico-religious contexts, see R. de Maio, *Michelangelo e la Controriforma* (Bari, 1978), p. 70.

17 Pictured and discussed in *De eeuw van de Beeldenstorm, Leerrijke reeksen van Marten van Heemskerck,* cat. (Haarlem, 1986), pp. 18-20; also in *Art before Iconoclasm* (Amsterdam, 1986), p. 74. Cf. also I. M. Veldman, *Marten van Heemskerck and Dutch Humanism in the Sixteenth Century* (Maarssen, 1977), p. 80. Heemskerck had at his disposal an "enormous repertoire of poses and combinations of figures" (p. 60), full of Italian allusions. He returned from Italy in 1536, just when Michelangelo was beginning the *Last Judgment* (with the planned Fall of the Angels as a pendant on the entrance wall).

18 *Hendrik Goltzius 1558-1617: The Complete Engravings and Woodcuts* (New York, 1977), no. 9, pp. 36-37.

19 *The Illustrated Bartsch,* vol. 33 (New York, 1979), p. 313.

20 The general literature on the topic is either very old or very new. S. Exner, *Die Physiologie des Fliegens und Schwebens in den bildenden Künsten* (Vienna, 1882); E. Schmidt, "Der Knielauf und die Darstellung des Laufens und Fliegens in der älteren griechischen Kunst," *Festschrift Adolf Furtwängler* (Munich, 1909), p. 249; F. P. Ingold, *Literatur und Aviatik: Europäische Flugdichtung 1909-1927,* with an excursus on the treatment of flight in modern painting and architecture (Basel, 1978); idem, "Ikarus Novus," in *Technik in der Literatur,* ed. H. Segeberg (Frankfurt a.M., 1987); J. Simmen, "Fliegen – Schweben: Traum, Realität, Vision," a special edition by Lufthansa (1988); idem, *Vertigo: Schwindel der modernen Kunst* (Munich, 1990); *Schwerelos,* cat. (Berlin: Schloss Charlottenburg, 1991/1992). Our own study goes back to a Mannerism seminar at the University of Zurich in the winter semester of 1980/1981.

21 L. H. Heydenreich, *Leonardo da Vinci* (Basel, 1953), pp. 167 and XIX, figs. 206 and 207; R, Giacomelli, ed., *Gli scritti di Leonardo da Vinci sul volo* (Rome, 1935); J. P. Richter, ed., *The Literary Work of Leonardo da Vinci,* with commentary by C. Pedretti, vol. II (Oxford, 1977), p. 220; H. Ladendorf, *Leonardo da Vinci und die Wissenschaften. Eine Literaturübersicht* (Cologne, 1984), p. 102; M. Kemp and J. Roberts, *Leonardo. Artist, Scientist, Inventor* (New Haven: Yale University Press, 1989).

22 E. Panofsky, "The Codex Huygens and Leonardo da Vinci's Art Theory," *Studies in the Warburg Institute,* vol. 13 (London, 1940)."

23 *Codex Huygens* (ed. Panofsky, cf. note 22): "Hora liberi si fanno andare per l'aria come a volo senza veruno termine di positura." Panofsky (p. 99) calls the Codex "unique in undertaking a systematic perspective analysis of human figures." R. Smith, "The foreshortened figure in the Renaissance," *Gazette des Beaux-Arts* (1977), p. 245; A. W. G. Poseq, "The `terribilissima arte' of Foreshortening in the Mannerist Theory of Art," *Norms and Variations in Art, Essays in Honour of Moshe Barasch* (Jerusalem, 1973), p. 81; K. H. Veltman, *Linear Perspective and the Visual Dimensions of Science and Art* (Munich, 1986).

24 G. P. Lomazzo, *Trattato dell'Arte della Pittura* (Milan, 1584), chaps. X-XII.

25 In chapter XVII, which deals with "scurti" and "di sotto in sù," G. Vasari, *Le vite...,* vol. I, ed. Bettarini-Barocci, (Florence, n.d.), p. 122.

26 The basic study is still J. Meder, *Die Handzeichnung* (cf. n. 3 above), pp. 421-425.

27 C. Malvasia, *Felsina Pittrice,* vol. III (Bologna, 1678), p. 484.

28 See note 23 above. Vasari (see note 25 above) calls "li scorti delle figure al di sotto in sù" the greatest of all difficulties in painting, but goes on to say that it is the very place where "la vera maestria" can be shown. The great master of "scortare" was Michelangelo; his most praised "tour de force," Jonas on the ceiling of the Sistine Chapel. But some good painters "did not enjoy it" because these artworks "bucano le volte." The true masters "hanno nella difficultà une somma grazia e molta bellezza e mostrano un'arte terribilissima." Lomazzo (in *Idea del tempio della pittura* of 1590) also praises Michelangelo's "scorti meravigliosi," and Leonardo and Mantegna, but considered the unity of body and space more important than central perspective (cf. M. Cassimatis, *Die Kunsttheorie des Malers G. P. Lomazzo* [Frankfurt a.M., 1985], p. 70). For the contradiction between "artificio" and "decoro" in the art of foreshortening, see also E. Maurer, "Stimmer in Rubens' Sicht," *Zeitschrift für Schweizerische Archäologie und Kunstgeschichte* (1985), p. 93.

29 Meder, *Die Handzeichnung*, p. 419, fig. 174.

30 Recommended by Theophilus, Pomponius Gauricus, Cellini, Armenini, and others. Meder, *Die Handzeichnung*, p. 551.

31 Already described by L. B. Alberti and Leonardo. Ibid., p. 446.

32 Ibid., p. 402, fig. 160.

33 Ibid., pp. 416, 552, figs. 170, 258.

34 K. Dobai, *Studien zu Tintoretto und die florentinische Skulptur der Michelangelo-Nachfolge* (Bern, 1991), p. 130.

35 Thus in Palma Giovane's treatise *Il vero modo ed ordine per dissegnar tutte le parti et membra del corpo umano* (Venice, 1608). Cf. *The Illustrated Bartsch,* vol. 33, p. 137.

Picture credits

figs. 1-5: Public Art Collection, Basel

fig. 6: Albertina, Vienna

fig. 7: Cf. note 18

fig.8: Emil Maurer, Zollikerberg

Peter Felder

Memento mori
Art and the Cult of the Dead in Central Switzerland

Unlike the people of today, our ancestors, beset as they were by pestilence, wars, and famines, had a very direct relationship to death. Each day it loomed before them, a horrible exhortatory image, heralding agonizing fear but also the consolation of final peace. From the High Middle Ages until well into the modern era, this Memento mori manifested itself in countless literary and artistic statements throughout the western world. Yet death was a less frightening prospect than the Last Judgment and eternal damnation. And as, in the train of numerous wars and mercenary services, the awareness of death was extremely pronounced in Switzerland, some hoped to gain eternal salvation through the intercession of patron saints and religious endowments. Strong pictorial evidence of this appears in the 1513 Mantzet Altar in Lucerne, which, next to the figure of the founder, Philipp von Mantzet, shows a symbolic hourglass with the words "Ich war(t) der Stund" – I await the hour (fig. 1). The distinguished founder, protected here by the two warrior saints George and Achatius, was not to have much time to reflect on the motto, for only two years later he fell in the Battle of Marignano, the last of his line.

What has been passed down to us in tangible form here was also the fate of countless unknown men: for centuries multitudes of men from central Switzerland, above all young men, offered their services to foreign armies – whether purely out of a spirit of adventure or as a result of social conditions – and risked their lives for a few ducats. Many a brave landsknecht bit the dust

while pensionaries accepted princely fees to provide ever new cannon fodder. It is this other side of the ostensibly glorious, but in fact dispiriting, mercenary's life that was so emphatically captured by Urs Graf and Niklaus Manuel, both veterans of several battles – particularly neatly by Graf in the barbed satire of his pen-and-ink sketch of mercenaries being recruited.[1] As a colorful company of carousing citizens and soldiers sit round a table in the guild hall, negotiating vigorously with a French agent, Death suddenly materializes behind a boastful landsknecht who has just sold himself for a large sum. And on one of Graf's last pictures, "which transcends the sphere of personal opinion to achieve the universal validity of a parable" (Gradmann), we see grim Death concealed in the crown of a tree, lying in wait for two cheerful, unsuspecting soldiers who are on their way to a prostitute sitting by a nearby stream.[2]

Within the broad spectrum ranging from love of life to dread of death, from the certainty of salvation to the fear of Hell, the fact that the central Swiss possessed a heightened awareness of death undoubtedly led them to preserve old death-cult-related traditions in a form unparalleled elsewhere in medieval Europe and later to uphold them like a creed vis à vis their Protestant fellow Confederates. This extraordinary phenomenon had already struck the papal nuncio Giovanni Francesco Bonhomini when he noted in 1570 "that with the central Swiss of the Five Cantons piety expresses itself in a truly unprecedented solicitude for the dead."[3] The bonds between the world of the living and the realm of the dead and the ancestors were to remain indissoluble. As a result of this attitude, the Old Confederates did not commemorate battles won with victory celebrations but with days remembering the dead, the custom evidently being to put on athletic tournaments in memory of those who had fallen. Thus mercenaries and unmarried men from central Switzerland used to meet regularly near the charnel house at the Totenhalde in St. Wolfgang near Cham, for example, to remember those who had fallen in the battle of 1388 and to participate in

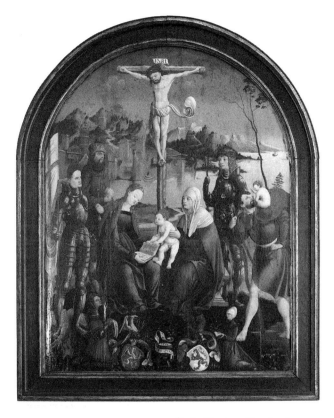

fig. 1: Mantzet Altar by the monogrammist "vHA" (possibly Hans von Arx), 1513, Lucerne. Private collection, Basel.

contests of strength.[4] The most impressive evidence of this death cult – which, in its strange mixture of faith and superstition, far exceeded any ecclesiastical-liturgical practice – can be found in the historical sources on the Battle of Marignano.[5]

Apart from the perpetual Memento mori of the plague epidemics that broke out in 1348 and did not abate until the seventeenth century, the fact that mercenaries were in constant peril is bound to have fostered this intense relationship to death and the dead. As late as 1748 there were still seventy-five thousand Swiss serving in foreign armies – an appreciable proportion of them from the barren mountain regions of central Switzerland. It is thus not surprising that in certain respects the traditional conceptual world of the Last Things resonated well into the nineteenth century.

The principal meeting place of the living and the dead of a parish was the churchyard, with its house of worship and its cemetery. In the late Middle Ages, this consecrated area became the haven for a mysterious cult of Wretched Souls, a cult deeply rooted in popular belief. Through sacrifice and prayer, the Wretched Souls were to be delivered from the torments of Purgatory; some people were even firmly convinced that in times of distress the dead, for their part, stood by the living. Such pious-superstitious notions – about the Wretched Souls who climb out of their graves at night to wander the earth until intercessionary prayers and masses for the departed deliver them – unleashed almost magical powers among the simple people. The spirit world that was invoked would live on in the gripping images of central Swiss legend.[6]

Since the mid-nineteenth century, all the churchyards in central Switzerland have undergone more or less thorough alteration – with one praiseworthy exception: Kirchbühl near Sempach, which thrones on a hilly spur above the lake, not far from the historical battlefield (fig. 2).[7] The mother church of the region – the patrocinium of Martin suggests that it dates from the early Middle Ages – it has preserved its noteworthy architectural ensemble in its entirety, with all of the essential elements of a churchyard, like the house of worship, graveyard, charnel house, ring wall, and gate. A specific historical constellation is responsible for its having retained its unique intactness. The town of Sempach, founded "around 1220," had hardly consecrated the Church of St. Stephen within its own walls when, in 1275, it was mentioned as a branch of St. Martin's, the latter increasingly taking over the function of a burial church. Evidently this functional transformation was already a reason, in the late thirteenth century, for the surprisingly rich treatment of the subject of death on the frescoes painted in the nave at the time. Thus among the fragmentary wall paintings, which have been partially covered by later pictorial layers, we find: the Grim Reaper swinging his scythe; the legend of the three living and the three dead;[8] a monk accompanied by a skeleton (probably Fridolin and Urso); the giant figure of St. Christopher, who, viewed daily by the faithful, was thought to protect them from unforeseen death; a mass being said for the salvation of the Wretched Souls; Archangel Michael as Weigher of Souls, being molested by devils; a horrifying scene of Hell, with Satan and little devils tormenting damned sinners.

The mood for these unremittingly hortatory images of mortality and the next world was set from the very first, for hardly had the churchgoer stepped through the cemetery gate than his eye lit on a forest of uniform grave crosses. Suddenly he was before the prayer window of the charnel house. Through its wide-meshed grille he could peer – whether out of piety or curiosity – at the skulls of his ancestors, piled up by the back wall, and would feel that he was being addressed directly by the ring of inscriptions on the subject of mortality, under the motto "learn to die." Although the cemetery of Kirchbühl was transferred to Sempach as early as 1832, present-day visitors can still experience something of the macabre chill of the medieval cult of Wretched Souls.

Historical plans and vedutas convey quite a good impression of how certain churchyards once looked.

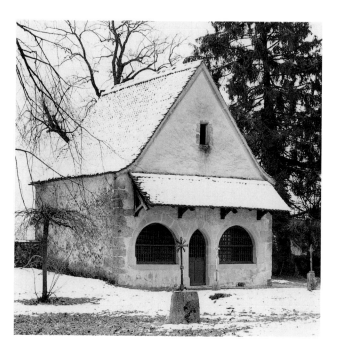

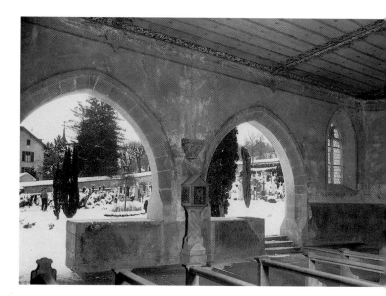

fig. 2: Kirchbühl near Sempach.
Former cemetery with charnel
house, 1575.

fig. 3: Zug. Interior of the
Charnel House of St. Michael,
1515.

Despite modernizations, representative vestiges of the customary churchyard furnishings have survived here and there – for instance, graveyard crosses: a very elaborately sculpted cross from 1636 in Altishofen, a cross at the Heiligkreuzkapelle miraculously spared by the village fire of Schwyz in 1642. Then there are funerary lamps: two finely chiseled ones from 1543 and 1560 in Stans and an equally exquisite one at St. Michael's in Zug (fig. 3).[9] Most of these lamps stand in charnel houses and cemetery chapels today, but were originally in graveyards, where their flickering light radiated a ghostly aura in the nocturnal darkness. Finally, our churchyards often possess sculptural Mount of Olives groups (for example, in Bürglen, Lucerne, Menzingen, and Stans).[10] Christ, deserted and in mortal terror, praying in the Garden of Gethsemane – a model of the way to face death – was one of the most frequent subjects. An extraordinary rendering, recreating with particular intensity the fear-stricken inner conflict of Jesus on the Mount of Olives, can be found in the early baroque altarpiece in the south Pfyfferkapelle near the cemetery of Werthenstein.[11] There Christ is shown, not only suffering spiritual torments, but doing physical battle with Death and overcoming him.

Of the approximately sixty extant charnel houses, some twenty date back to the Gothic era, seven of them exemplifying the two-story type.[12] A classic example of the one-story ossarium is the above-mentioned Kirchbühl, which replaced an older one in 1575. Though local modifications, depending on location and size, may occur, all of them are steep-gabled and rectangular; their large-windowed façades face the cemetery, and the buildings usually end in a three-sided sanctuary or independent choir. A splendid specimen of this type is the late Gothic Charnel House of St. Michael in Zug. On the cemetery side, it receives us with an imposing arcade formerly used for funeral services and the passage of De Profundis processions; it also used to offer an unimpeded view of the so-called "death racks," with skulls piled high (removed 1869).[13] The wooden ceiling, created by the Zug master

Hans Winkler in 1516, deserves our particular attention for the ingenious manner in which eschatological images and ideas are woven into the carved decor. The clear design concept employs banderoles and tracery friezes to achieve an orthogonal division of the ceiling. At the intersections, the friezes are like bosses, framing a cyclical sequence of pictorial medallions, the one with Death bearing the exhortation: "O Man thou shouldst improve thyself / turn to God and look at me."

Plank ceilings decorated with virtuoso tracery and flat carving number among the most original accomplishments of artistic craftsmanship in central Switzerland. One of the best-preserved and most exquisite creations of this kind is the ceiling of the charnel house of Sarnen, executed in 1505 by Peter Tischmacher from Uri; powerful tension is produced by the juxtaposition of a broad decorative frieze and the small surfaces it encloses.[14] The striking quality of all of these interiors is the natural, heartfelt, pious character of their artistic achievement. The charnel house of Steinen is particularly representative in terms of overall plan and decoration. A stylish Gothic construction, its interior is dominated by a fine winged altar from the period around 1520; as a particular rarity, its "death racks" have been preserved.[15]

The liveliest object lessons in the rich and complicated traditions connected with the ancestral death cult are offered by two-story charnel houses, for in them the functional links between architecture and decoration, building and image, are still immediately perceptible. The handsomest examples of this type of building can be found in Altdorf, Schwyz, and Stans, the capitals of the three original Swiss cantons, with the "Kerchel" built in Schwyz around 1518 representing the purest specimen (fig. 4).[16] The elegant, lofty exterior of this late Gothic charnel house encloses a cryptlike, two-aisled ossarium (ground floor) and the pretty, stellar-vaulted Chapel of St. Michael (upper story). Both areas can be entered through three separate doors, the upper one via a terrace-like projecting structure extending along three sides. It is astonishing to

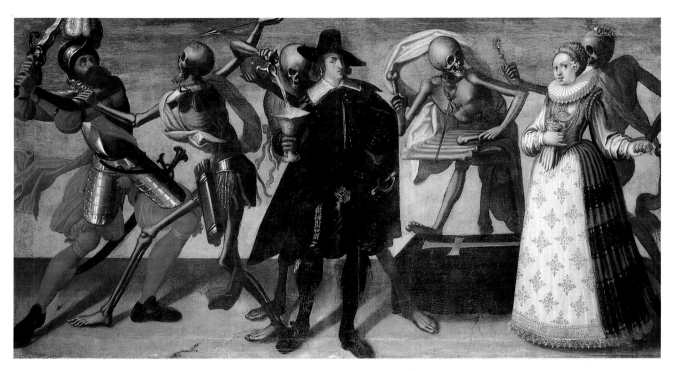

fig. 4: Schwyz. Kerchel and
Chapel of St. Michael at the
edge of the former cemetery,
1518.

fig. 5: From the Dance of Death
cycle by Jakob von Wyl, c.
1610: soldiers and young
patricians – presumably the
founder and his wife. Cantonal
Administration Building,
Lucerne.

note the concentration and flexibility of cultic possibilities that the edifice, originally equipped with six entrances, two sacred spaces, and four altars, had to offer. And what a wealth of altarpieces, frescoes, panel-paintings, sculptures, stained glass, and liturgical objects have been donated over the generations! The effect today is one of a colorful panorama of medieval concepts of the next world transposed into the modern world.

This historical "having become," with all its ingredients and idiosyncrasies, is also demonstrated by other charnel houses and cemetery chapels. A particularly impressive example is the stately charnel house of Stans, rebuilt around 1560, which is twice as big as the Schwyzer "Kerchel."[17] Characteristic of the medieval central Swiss veneration of saints and their links with the cult of the dead are the late Gothic frescoes of the charnel house in Oberägeri.[18] The saints most often invoked at the time were the Fourteen Holy Helpers, who appear together in certain charnel houses (for example, Baar, Root, Sarnen, and Steinen), the ones venerated as guardian saints being Christopher, Barbara, George, and Achatius. We also occasionally encounter St. Anne, patron saint of the dying, the judicial angel Michael, the two pestilence saints Sebastian and Rochus, and in isolated cases the ten thousand knights who served the Old Confederates as guardian saints against mortal terror. The most widespread devotional image in our charnel houses is the Pietà, with the Virgin Mary holding the body of Christ on her lap (for example, Altdorf, Pfeffikon, Schwyz, Steinen). In the sixteenth century, this viscerally experienced, salvation-centered world of images embodied by death chapels is joined by the cryptic language of symbols and emblems employed in the effort to illuminate the Last Things. An exemplary work in the spirit of this more modern form of imagistic thinking is the baroque painted ceiling of the charnel house chapel in Ettiswil, which bears a programmatic cycle of twenty-six allegories of mortality and death – some threateningly admonitional, others wittily instructive.[19]

The torments of Hell endured by the damned – in the form of a dramatic scene of the Last Judgment – were not the only aspect of the Four Last Things to be depicted. Several charnel-house altars focus on equally drastic representations of the sufferings of the Wretched Souls in Purgatory (for example, Inwil, Stans, Sursee). These portrayals of Purgatory were found primarily in connection with the Wretched Souls cult of the Counter Reformation. In the Jesuit Church of Lucerne, for instance, a cycle of paintings was erected in tiers on All Souls' Day to furnish the faithful with concrete examples of how to help the Wretched Souls.[20] Requiem masses, rosaries, and good works play a very important part in this process, a Catholic doctrine defended with poetic eloquence on a painted panel with inscription in Pfeffikon, which verges on Bernese-Protestant Aargau. And the rural-baroque wall paintings in the charnel-house chapel in Buchrain discursively announce the Last Things, with Death coming to man as the forceful admonisher, while the Wretched Souls suffer in Purgatory, begging for help. Folksy graphic imagery reigns, allowing imagination all the latitude it needs to lend eschatological prophesies the highest possible degree of credibility.

There is a lively, sometimes contentious, dialogue going on between this world and the next, as seen, for example, on the Ars-Moriendo fresco in the charnel house of Stans (c. 1570).[21] It shows the Archangel Michael conquering the Devil in a struggle for the soul of a dying woman. She is provided with the Last Rites of the Church and, through the intercession of the Virgin Mary and her own patron saint, is sure to be granted eternal salvation by the Almighty. A similar subject appears on the abundantly figural rococo picture on the high altar of the parish church in Hitzkirch. It depicts the death of a contrite sinner,[22] though rather in the guise of a conflict-free passing away. Even Death, standing next to the bed, has more of the character of a silent assistant.

By far the most enduring effects of the medieval cult of Wretched Souls emanated from the numinous power of portrayals of the dead coming to the aid of the living.

fig. 6: Lucerne. Spreuerbrücke with Dance of Death cycle by Kaspar Meglinger, 1626-1635.

fig. 7: Hasle in Entlebuch. From the Dance of Death cycle in the charnel house, c. 1687, by Jakob Fleischlin: the innkeeper, the scribe, the miller.

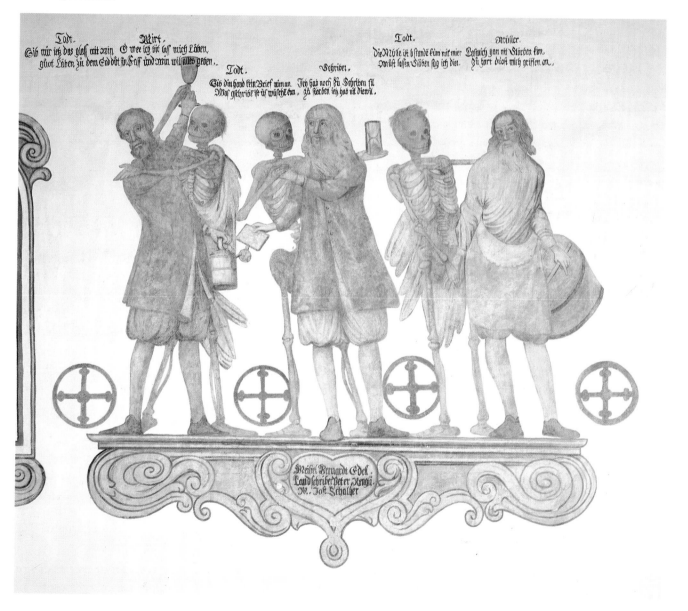

135

Stories of ghostly nocturnal goings-on in churchyards, circulated by word of mouth among the simple people, helped kindle the imagination. The influence of these sagas and legends generated a widespread type of message to be encountered in the frescoes of the two charnel houses in Baar (c.1530/1540), in St. Michael's in Zug (c. 1530/1540), and on a founder's window for Jakob Fuchsberger (1562) in the cloister in Muri.[23] The stained glass possesses particular vehemence: a patrician officer pursued by enemy cavalry seeks refuge in a churchyard and, before the prayer window of the charnel house, entreats the dead to help him. As he prays, the dead – in the shape of enraged skeletons armed with pitchforks and flails – storm out of the charnel house and chase away the alarmed soldiers.

Even more deeply rooted than the popular belief in the gratitude of the dead was the idea of the magic dance of the dead, who, with compelling power, cast a spell on the living. Early Dance of Death pictures expressed the uncertainty and horror of this power in a variety of ways. A particularly forceful rendering is the historically significant cycle at Basel's Prediger (Dominican) monastery (c. 1445/1450).[24] Here it is the dead themselves who climb out of their graves to invite the mortals to dance, pulling their victims – half gently, half violently – toward them. The result is a variegated social panorama of dancing couples moving towards a charnel house populated by music-making skeletons. That the geographically circumscribed region of central Switzerland ascertainably possessed as many as eight such cycles from the seventeenth and eighteenth centuries attests to a traditional way of thinking and a marked awareness of death. However, the medieval Dance of Death typology had, by this time, undergone an essential change under the influence of such Renaissance works as Niklaus Manuel's cycle for Bern's Dominican monastery (1516/1517) or Holbein's famous series of woodcuts (1538). No longer do we see the unpredictable dead suddenly abandoning the peace and quiet of their graves and imperiling the lives of the living. They have been replaced by the figure of Death itself. No longer a

cause for numinous shudders of terror, he is there to provide a graphic reminder of the fate that awaits us all. With this reinterpretation of the central figure, the pictures are imbued with a new, more didactic, edifying, and aesthetic quality.

Both the first and most outstanding central Swiss cycle is the 1610 Dance of Death by Jakob von Wyl in the Cantonal Administration Building (former Jesuit college) in Lucerne (fig. 5).[25] The eight pictures on canvas exhibit a continuous, half life-sized figural frieze with twenty-four Dance of Death groups moving across an earth-colored strip of stage in contrasting hues, standing out effectively against the sky-blue ground of the picture. As in Basel and Bern, the procession leads toward the charnel house, with skeletons wildly drumming and fifing to the dance, and Adam and Eve, the first mortals, being banished from Paradise. In strict hierarchical sequence, and in accordance with the high esteem enjoyed by ecclesiastical dignitaries, the pope and the emperor lead the macabre dance; in their train follow representatives of all strata of society, down to the cripple and the child, with due respect for women as well. In the midst of this illustrious society stand the self-complacent, pleasure-seeking cavalier – unwittingly serving the poisoned chalice – and his magnificently garbed bride. The only two figures in the cycle facing us directly, they are, according to Heinz Horat, a "double portrait of the founders." The portraitlike character of further figures has also been rightly pointed out, especially that of the painter, whom we believe to be a self-portrait of von Wyl. In view of this modern concept and the many impulses derived from Holbein, the extent of the painter's recognition of hierarchical authority and loyalty to the church may seem surprising. There is nothing here of Holbein's barbed satire or Manuel's anticlerical polemic: the work is a broad, conciliatory vision of man's departure from this life, with sparks of belligerent resistance in only a few isolated scenes. Our artist has in fact gone even further: as a protagonist of the Counter Reformation, he forgoes the constructional architectural painting and the softening

landscapes of the Renaissance, returning consciously to medieval models by presenting his Dance of Death as a continuous figural scene. He must have been particularly inspired by the "Prediger" cycle in Basel, for he has presented essentially the same "untiringly varied play of striding ahead, pulling, hesitating, standing still, shrinking back, turning away, and straining backward, employed in the service of refined rhythmic structuring and intertwining" (François Maurer). But the painter does not make do with simply quoting and drawing from the past. Like a brilliant colorist, he animates the bare figural frieze with magnificent robes, period costumes, and armor, with keenly observed insignia, weapons, and utensils, with single pieces of furniture and a plethora of props, all meticulously drawn. And taken together they evoke a strangely suprarealistic atmosphere. Von Wyl was addressing his sumptuous Dance of Death above all to Lucerne's patrician class, holding up the mirror of vanity to them. The pronouncedly didactic character of the paintings and the highborn society depicted are perfectly matched to the spiritual and intellectual world of the elitist Jesuit order. A patrician couple obviously struggling to overcome vanity in themselves must have presented the edificational cycle to the Lucerne college.

Between 1626 and 1636, when the plague was claiming thousands of victims in central Switzerland, Kaspar Meglinger produced the Dance of Death cycle on the Spreuerbrücke (a bridge in Lucerne) as a public Memento mori (fig. 6). Meglinger had been a student of Jakob von Wyl and ultimately took over his workshop.[26] Like the two pictorial cycles on the Hofbrücke and the Kapellbrücke, the sixty-five thematically connected, triangular painted panels positioned among the roof timbers of the bridge were almost exclusively donated by citizens. The one distinguishing feature here, however, is that some of the donors were not immortalized solely by their coats of arms but evidently also by their likenesses: like actors, they appear in the scenes they donated, sometimes even playing the main role, ever aware of the dignity of their rank and

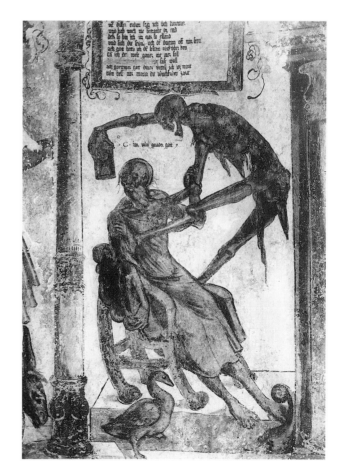

fig. 8: Lucerne. From the Ages of Man cycle in the house of the zur Gilgen family, c. 1520/1530; *The Hundred-Year-Old Man and Death.*

fig. 9: Sarnen. Deathbed portrait of Landammann Melchior Imfeld, 1622. Convent of St. Andreas, Sarnen.

standing, even in the face of death. This face to face encounter with well-known personalities forced, like Everyman, to exit from the world stage, must have been a consolation to critical contemporaries. Evidence that many of the figures are indeed portraits – a method already applied by Niklaus Manuel in his Bern cycle – has been adduced by A. Reinle on the basis of hunting scenes depicting three prominent members of the Gilgen family. It is also obvious that, within the sequence of donors, the hierarchy of rank, origin, birth, and profession was upheld. Thus the emperor panel and king panel were allocated to the two leading statesmen of the time, Ulrich Dulliker and Leodegar Pfyffer the Elder respectively; and Councillor Jost Kündig and his wife Anna, a scion of the eminent Dorer family of Baden, were given the queen's panel. In certain cases the public or professional activity of the donor and the subject of the picture even correspond: for example, banneret Ludwig von Segesser as a standard-bearer quarreling with Death, the "Gutfergger" Melchior Balthasar as a merchant, or the sculptor Adam Meyer being taken by surprise in his studio by the skeleton that is Death. The panel donated by the painter Lienhard Haas is of particular interest to us: it shows Kaspar Meglinger sitting before his easel in the company of eight of his Lucerne colleagues, all of whom have been identified. Similar group portraits, a form very popular in the Netherlands at the time, appear in the councillors' panel, the judges' panel, and the scholars' panel. Add to that the precisely rendered costumes, utensils, and furnishings – the rich multiplicity of everyday life – and the cycle, with its pointed four-line comments, proves a unique cultural mirror of seventeenth-century Lucerne.

By comparison, the artistic value of Meglinger's Dance of Death is far more modest, even if its numerous thorough-going renovations are taken into account. The cycle is permeated by an ambivalent feeling. Despite the obvious joy of narrative elaboration and the ingenuity of pictorial composition, given the problematic triangular format, there is a theatrical, constructed quality about the scenes.

This impression is reinforced by the architectural prospects and landscape backgrounds, which produce the effect of backdrops. The solemnity of the final hour remains superficial; again and again the eye is drawn to the joys and pleasures of this world, while Death is perceived more as a troublemaker than as the destroyer of life. Little is left of the forceful immediacy of von Wyl's cycle.

In contrast to these scenic transpositions to a bourgeois urban atmosphere, the original idea of a continuous round dance of death survived longer in rural areas. An outstanding example of this is the pictorial decoration created by an unknown fresco-painter for the charnel house of Wolhusen (c. 1661). For the last time we see a flash of the elemental spiritual power of the medieval Dance of Death.[27] The almost life-sized cycle extends along the three walls of the nave, with pointed four-liners furnishing the commentary on the dado strip. The basic concept follows the usual plan: the emperor and the pope are leading twelve groups of chained dancers toward the choir arch from either side; above the arch thrones the Judge of the World. Concise outlines and delicate interior modeling serve to characterize each of the symbolically linked figures. This expressive figural frieze, with its genial overlappings and interpenetrations, shows Death seventeen times in alternating, uniquely conceived form: either staring at his dancing partner out of the eye sockets of a walled-up skull or directly at us, seemingly baring his teeth. The extraordinary quality of this macabre work of art probably derives from the fact that the painter has succeeded in uniting all of these sculpturally projecting heads and the diverse rhythms of the dancing figures in a single, forceful, harmonious whole.

The Lucerne master Jakob Fleischlin was probably influenced by the Wolhusen cycle when he painted his own Dance of Death in the charnel house of Hasle in 1687 (fig. 7).[28] Though it is a charming artistic document of its time, it comes nowhere near achieving the spiritual verve and agility of its model. The secular and ecclesiastical dignitaries in both Wolhusen and Hasle are followed by a few

local people, presumably identifiable at the time, who lend both cycles a cheering touch of local color. In the market town of Wolhusen, they are the innkeeper, the usurer – who is immediately fetched by the Devil – the baker, and the monk (the last an allusion to the nearby monastery of Werthenstein); in pre-alpine Hasle, it is the farmer, the cowherd, the innkeeper, the scribe, and the miller.

As the final typological link in the chain of traditional Dances of Death we can cite the 1710 cycle by an unknown country painter in the charnel house of Emmetten.[29] It is an attractive piece of naive folk art and unites, on a huge wooden panel, twenty-three individual pictures recapitulating all of the classic sequences, from the skeletons' invitation to dance and the banishment from Paradise to the social panorama, from pope and emperor to peasant and beggar.

However much these modern Memento mori pictures may have lost touch with the numinous world of imagination, turning increasingly to allegories and symbols, to the grotesque and the scurile – the oppressive sense of the inescapable power of Death remained. And despite the ever greater joy in earthly existence, it continued to find expression in countless paintings and sculptures. Not only do we discover images like the fidgety skeletons in the charnel house of Schwarzenbach or the good cheer of the skeletal putto swinging his scythe in the large hall of the Zurlaubenhof in Zug. Again and again we also encounter pictures portraying, with merciless stridency, the violent intervention of Death. They are eerie scenes of being taken unawares. Thus in the wonderful *Ages of Man* cycle in the Gilgen house in Lucerne, Death pounces furiously on the one-hundred-year-old, who, seated in his comfortable armchair, resists with all his might (fig. 8).[30] And on the carved antependium of the Felix Altar in Hergiswald, Death has just drawn his bow, preparing to shoot the young gravedigger who is busy digging a grave.[31] The effect of the two unusual deathbed scenes in the convent at Sarnen is equally threatening.[32] One of the portraits shows the dying abbess Maria Scholastika von Wil (died 1650),

fig. 10: Stans. *Vanitas and Death*, by sculptor Rolf Brem, 1976.

139

with a brisk little Death shooting his arrow at her. The other depicts the body of the landammann Melchior Imfeld (✝ 1622) (fig. 9). He is holding an extinguished, smoking death candle in his hands, Death's arrow still sticking in his breast. Such portraits of the dead were usually exhibited publicly during the annual commemorative service for the respective person. The picture of Imfeld, who was the principal patron of the Capuchin monastery in Sarnen, was still shown at the church there as late as 1802.

The idea of death is depicted with far less drama on the tomb of Lucerne patrician Jost Bernhard Hartmann (✝ 1752). Two skeletons in the costumes of mayor and standard-bearer keep vigil on either side of the sarcophagus, which is encircled by angels with trumpets and mourning putti.[33] But tombs of such princely pomposity were the exception in central Switzerland. Even epitaphs, originally for persons of rank, were usually kept simple and came into wider use only in the nineteenth century. For centuries the plain grave cross had served as the typical regional grave-marker for all social strata. In long-established families, these crosses, often elaborately wrought and gilt since the seventeenth century, have survived and can still be admired in many a cemetery in the three original cantons of Switzerland.[34] The uniformity of the symbol recalls a saying found in many charnel houses (for instance, Altdorf and Stans): "Here God insures that justice will abide / with masters and servants lying side by side." But this uniformity of commemorating the dead furnishes impressive proof above all of the markedly democratic civic sense of the central Swiss, to whom differences in rank and position meant far less than elsewhere in Europe.

Vestiges of the traditional awareness of death – reinforced in heroic times – and its companion piece, the cult of the Wretched Souls, survived into the nineteenth century. The evolution of these attitudes and beliefs in the modern era is widely documented by the conversion of open charnel houses into closed cemetery chapels. This was a deliberate, gentle restructuring according to the will and taste of the conservative builders. In terms of a new building, by far the most successful solution was ventured in 1693 by the Uri priest Johann Jakob Scolar. As designing architect, he erected two gracefully matching centrally planned buildings in the churchyard of Bürglen to hold a charnel house with "death racks" and a sculptural Mount of Olives group. Gradually the richly eloquent sacred space of the charnel house was transformed into a sober mortuary for corpses. An early specimen of this type of building is the classicistic funeral chapel in Ruswil, built in 1843.[35]

The cult of Wretched Souls may have lost its inner meaning, the religious veneration of the dead may have been profaned, but the Memento mori lives on. As recently as 1976, a bronze sculpture of Death seizing a beautiful young woman – representing Vanitas – from behind was erected on the fountain at Rathausplatz in Stans (fig. 10). It is a site all village funeral processions must pass.

Translated from the German by
Eileen Walliser-Schwarzbart

Notes

Abbreviations: Kdm with cantonal abbreviation for the series *Die Kunstdenkmäler der Schweiz*, publ. by the Society for the History of Swiss Art. Basel, 1927 ff.

1 E. Major and E. Gradmann, *Urs Graf* (Basel, n.d.), p. 23, fig. 46.

2 Ibid., p. 41, fig. 151.

3 H. G. Wackernagel, *Altes Volkstum der Schweiz. Gesammelte Schriften zur historischen Volkskunde,* Schriften der Schweizerischen Gesellschaft für Volkskunde, vol. 38 (Basel, 1956), p. 9.

4 Ibid., pp. 12 f.

5 F. Bächtiger, "Marignano. Zum Schlachtfeld von Urs Graf," *Zeitschrift für Schweizerische Archäologie und Kunstgeschichte* 31 (1974), pp. 31-54 (42).

6 Cf. among others, K. Müller, *Die Luzerner Sagen* (Lucerne, 1942), pp. 1-54: "Die Welt der Geister und Armen Seelen."

7 Kdm LU IV, pp. 374-386; VI, pp. 348-350.

8 W. Rotzler, *Die Begegnung der drei Lebenden und der drei Toten* (Winterthur, 1961), pp. 103-106 (Kirchbühl).

9 Kdm LU V, p. 37 (fig.), cemetery cross Altishofen; Kdm SZ I (new edition), p. 203 (fig.), Heiligkreuzkapelle Schwyz; Kdm Unterwalden, pp. 820 f. (fig.), funerary lamps, Stans; Kdm ZG II, pp. 119 and 125 (fig.), funerary lamp, Zug.

10 Kdm LU II, p. 151 (fig.), Lucerne; Kdm ZG I, p. 236 (fig.), Menzingen.

11 Kdm LU I (new edition), p. 409 (fig.); *Renaissancemalerei in Luzern*, cat., pp. 158 f., with picture of a similar representation of the Hofbrücken cycle. "The iconographically unusual interpretation of the Mount of Olives scene is, to our knowledge, found only in Lucerne and taken up once again in the *Mount of Olives Altar* in one of the Pfyffer chapels in Werthenstein." (Horat)

12 In this connection, see the basic survey by R. Odermatt-Bürgi, "Volkskundliches über die Beinhäuser der Innerschweiz," *Der Geschichtsfreund* 129/130 (1976/1977), pp. 183-214.

13 Kdm ZG II, pp. 114-125.

14 Kdm Unterwalden, pp. 542-545.

15 Kdm SZ II, pp. 688-698; A. Meyer, *Steinen SZ. Kirche und Kapellen*, Schweizerischer Kunstführer (Basel, 1972).

16 Kdm SZ I (new edition), pp. 190-200. For the functional two-story complexes, see R. Odermatt-Bürgi, op. cit, p. 188.

17 Kdm Unterwalden, pp. 815-826; R. Odermatt-Bürgi, *Pfarrkirche St. Peter und Paul in Stans NW,* (Bern, 1989), pp. 28-34.

18 Kdm ZG I, pp. 277-281.

19 Kdm LU V, pp. 80 f. Pictured in the periodical *Schweiz* (11/1979), p. 1.

20 For the 1620/1630 cycle ascribed to Kaspar Meglinger at the Historisches Museum in Lucerne, see the catalogue *Renaissancemalerei in Luzern*, pp. 186 f.; A. Reinle, "Der Luzerner Maler Kaspar Meglinger," *Innerschweizerisches Jahrbuch für Heimatkunde* XVII/XVIII (1954), pp. 9-30 (16 f.).

21 R. Odermatt-Bürgi, *Pfarrkirche*, pp. 31 f. (fig.).

22 Kdm LU VI, pp. 104, 106 (fig.).

23 Kdm ZG I, pp. 72 f.; II, p. 122; F. Styger, "Die Sage von dankbaren Toten im Beinhaus St. Michael," *Zuger Neujahrsblatt* (1931), pp. 35-42; B. Anderes, *Glasmalerei im Kreuzgang Muri* (Bern, 1974), pp. 80 f. (color ill.); R. Odermatt-Bürgi, "Volkstümliches über die Beinhäuser," p. 199.

24 Kdm BS V, pp. 290-314. Dependent on it, the not much later Dance of Death cycle in the Klingental monastery in Basel (Kdm BS IV, pp. 95-114). More on the subject: J. R. Rahn, "Zur Geschichte des Totentanzes," *Der Geschichtsfreund* 36 (1881), pp. 211-233; W. Stammler, *Der Totentanz. Entstehung und Deutung* (Munich, 1948); H. Rosenfeld, *Der mittelalterliche Totentanz. Entstehung, Entwicklung, Bedeutung,* 2nd. ed. (Cologne, 1968).

25 Kdm LU II, pp. 315-317; W. Y. Müller, *Der Luzerner Totentanz von Jakob von Wyl* (Zurich, 1941); *Renaissancemalerei in Luzern*, cat., pp. 174-176.

26 Kdm LU II, pp. 94-103; P. Hilber, *Der Totentanz auf der Spreuerbrücke in Luzern* (Lucerne, 1937); A. Reinle, op. cit., pp. 12-16. Of the original sixty-five panels (two of them painted by Andreas Wysshaupt), forty-three are at their original site today, two are in the Kunstmuseum, five in the Gewerbemuseum, and seven are in storage with the Civic Building Authority in Lucerne.

27 Kdm LU IV, pp. 497-499; VI, p. 353; J. R. Rahn, op. cit., pp. 220-227.

28 Kdm LU I (new edition), pp. 191 f.

29 Kdm Unterwalden, pp. 93-99; J. R. Rahn, op. cit., pp. 227-233.

30 Kdm LU III, p. 115 (fig.).

31 Kdm LU I, p. 379 (fig.). Relief by sculptor Hans Ulrich Räber, c. 1652 (original at the Historisches Museum in Lucerne).

32 Kdm Unterwalden, p. 699. *Renaissancemalerei in Luzern*, cat., pp. 182 f., with ill. Deathbed portraits were very popular in Central Switzerland; for further examples, see ibid., pp. 165 f. and 181-184, with ills.

33 Kdm LU II, p. 202 (fig.). A typologically interesting piece for comparison is the funerary monument, also from 1752 but decidedly more pompous, for the Bern mayor Hieronymus von Erlach, by sculptor Johann August Nahl. P. Felder, *Barockplastik der Schweiz* (Basel and Stuttgart, 1988), p. 156 (fig.).

34 See, among others, Kdm SZ I, p. 227 (fig.); Kdm Unterwalden, pp. 811, 1054 (fig.).

35 Kdm LU IV, pp. 340 f.

Picture credits

fig. 1: Uta Bugmann, Sursee

figs. 2, 5, 6, 8: Kantonale Denkmalpflege Luzern

fig. 3: Kantonale Denkmalpflege Zug

fig. 4: Kantonale Denkmalpflege Schwyz

fig. 6: P. Ammon, Lucerne

fig. 7: Hans Bühlmann, Hasle

fig. 9: Theres and Urs Bütler, Lucerne

fig. 10: Franz Jaeck, Rombach

The Baroque

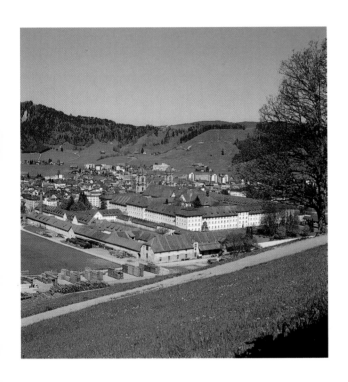

The baroque Benedictine abbey of Einsiedeln was largely built in the years 1704-1738, according to plans by Brother Caspar Moosbrugger. As a successor in type to the Escorial, it represents the large baroque monastery with church in the center, surrounded on either side by a double courtyard. The integration of the church into the monastic plan results in a monumental symmetrical principal façade capable of serving as a focus for its environs. By this means religious architecture embraces the absolutist demands of French castle architecture under Louis XIV. In Pedro Calderon's *The Great Theater of the World*, performed on the monastery square of Einsiedeln every five years, the "Master" speaks:

"World, I am your Director.
You shall be my Stage Manager.
I've had a marvellous idea for a show
Which you shall stage so cleverly
That the whole Universe will applaud.

I want you [World] to make a festival
To celebrate my power
So when my greatness is made manifest
All Nature will rejoice.
Everyone loves it when a show really works
And the audience shouts "Bravo!"
Human life is nothing but acting, so
Let Heaven sit in the best seats
To watch a play on your stage, World.

As I'm Director and the play is mine,
It shall be acted by my company
Whether they want to act or not.
As I chose human beings to be
The most important creatures of all
They'll be members of my company
And they shall act out, as well as they can,
The story of the play that's called The World.
I shall cast each in a suitable role.
Now an entertainment of this kind
Needs beautiful props and transformations
And richly-decorated costumes.

So now I want you, cheerfully,
To create all these and to make some sets
Which will stagger the chilliest audience.
Work quick as light, for I'm Director."

Adapted by Adrian Mitchell, Absolute Classics, pp. 162-163

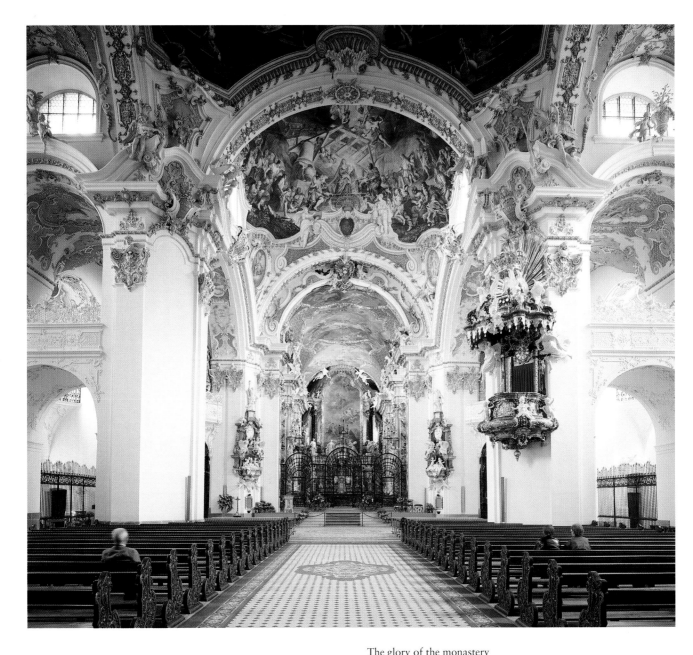

The glory of the monastery complex of Einsiedeln is its church, an outstanding example of baroque splendor. This masterpiece of spatial illusion was largely the work of southern German artists: Brother Caspar Moosbrugger embarked on the construction of the building in 1719, Egid Quirin and Cosmas Damian Asam from Munich executed the plasterwork (1724-1726) and frescoes. The older choir was decorated (1746-1748) by Augsburg painter Franz Anton Kraus.

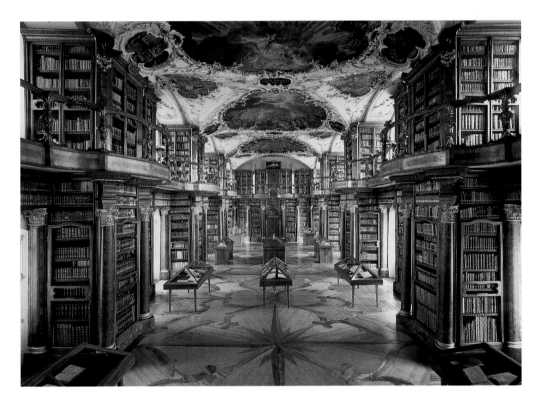

The library of the former Benedictine abbey of St. Gallen, built between 1758 and 1767 by two architects from Vorarlberg, Peter Thumb father and son, and furnished by numerous artists, is a major work of rococo architecture. Pilasters divide the gently vaulted room into four bays; elaborate plaster-work, paintings, and inlay are wedded in an exhilarating late-baroque celebration of form and color. Books, collected on this venerable site since the abbey was founded in the seventh century, are stored on both the main floor and the gallery. In 1983 the entire monastery precints were placed on the "Unesco register of humanity's major cultural monuments." One of the most important documents preserved here is the ground plan of the monastery of St. Gallen, see p. 12.

The Hôtel du Peyrou in Neuchâtel was built between 1765 and 1771 for the French-born Pierre-Alexandre Du Peyrou, a friend of Jean-Jacques Rousseau's, according to plans by the Bernese architect Erasmus Ritter. The *palais* is typical of Swiss building projects of its time. Planned by an architect accredited by numerous European academies and sited in the open country, beyond the confines of the medieval town, it is an expansive edifice set atop a ground floor housing the winter garden. The gardens in the rear integrate the slopes of the Jura that rise before them; the prospect from the principal front sweeps down past newly planted trees to the lake and on to the high, snow-covered Alps.

Giovanni Serodine (1600-1630),
Portrait of his Father,
Cristoforo, oil on canvas,
152 x 98 cm. Museo Civico,
Lugano.

The Ticinese artist Giovanni Serodine, a famous painter in his time, was born, lived, and died in Rome. With his father, Cristoforo, and his brother Giovanni Battista, he restored the family home in Ascona, the Casa Serodine, around 1620, decorating the façade with plasterwork reliefs and statues. The recumbent figures on the segmental gables of the windows are after Michelangelo's Medici tombs in Florence.

The German sculptor Johann August Nahl lived and worked in Bern in the years 1728/1729 and 1746 to 1756. He executed this funerary monument – as extraordinary in his own time as it is today – for the recently married parson's wife, Maria Magdalena Langhans, who had died giving birth to a stillborn son on Easter eve of 1751. Easter and resurrection on Doomsday have rent the grave slab, and the dead woman is visible through the cleft in the burst stone. Awakening from her slumber, she is beginning to stir. Her little boy has already come to life and is scrabbling out of his mother's lap, reaching his hand past the edge of the crack toward eternal life. As inconspicuous as the church itself is, numerous travelers have visited this tomb, for already in the eighteenth century it was considered one of Switzerland's major sights. James Fenimore Cooper came to the church in 1828. His description closed with the words: "No work of art – no, not even the Apollo – ever produced so strong an effect on me as this monument, which – because the most exquisite blending of natural sentiment with a supernatural and revealed future – I take to be the most sublime production of its kind, in the world. It was the grave giving up its dead."

Funerary monument for Maria Magdalena Langhans in the parish church of Hindelbank, 1751/1752, by Johann August Nahl (1710-1781).

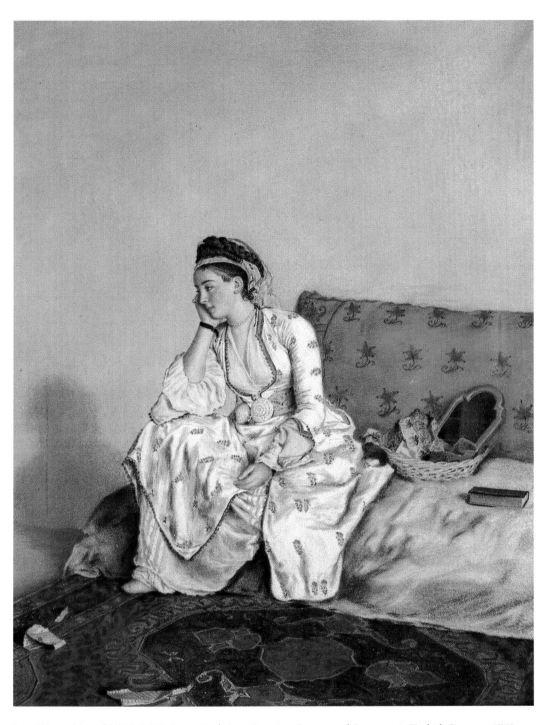

Jean-Etienne Liotard (1702-1789), *Portrait of Mary Gunning, Countess of Coventry, in Turkish Costume*, 1749, pastel on parchment, 23.5 x 19 cm. Musée d'Art et d'Histoire, Geneva.

Apart from short stays in the city of his birth, Geneva-born artist Jean-Etienne Liotard divided his time between Lyon, London, Paris, Den Haag, Rome, Constantinople, Vienna, Venice, and Darmstadt. Liotard trained as a pastel and enamel painter, engraver, and miniaturist in the Geneva watchmaking environment. In 1738 he joined Sir William Ponsonby on a journey to the Greek islands and Constantinople, remaining there for five years and totally immersing himself in the Turkish way of life. The Turkish styles he introduced when he returned soon became very fashionable. This is the context of one of his loveliest portraits, *Mary Gunning, Countess of Coventry, in Turkish Costume*, painted in 1749. It combines Turkish dress and the systematic treatment of color with all the elegance of the time. The countess is sitting on an ottoman. Her robes, the cushion, the basket, and the rug are all based on the color scheme so typical of the tastes of the time: red and blue with white and grey accents.

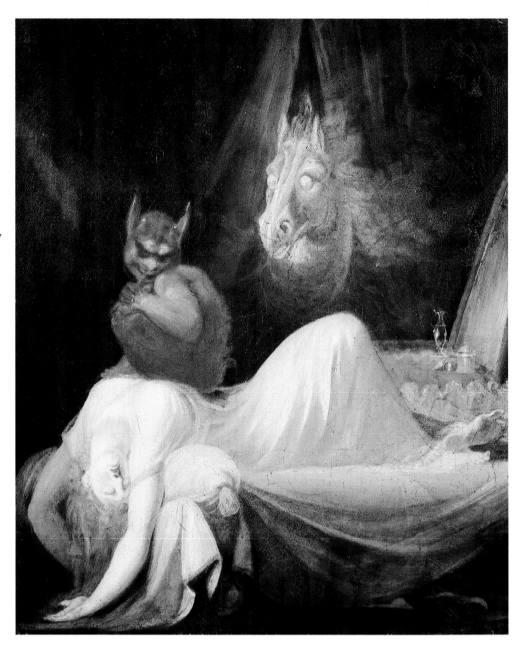

Henry Fuseli (1741-1825),
The Nightmare, second version,
1790/1791, oil on canvas,
76 x 63 cm. Goethe Museum,
Frankfurt am Main.

In 1762 Zurich artist Henry Fuseli was forced into political exile from the city of his birth. Emigrating to England, which he considered a land of political freedom and highly developed literature, he soon gained access to upper-class society. His predilection for things dramatic, heroic, and horrible drew him to Shakespeare and Milton. Long active in the field of literature and literary history, he was encouraged to devote himself to painting, above all to historical subjects, by Sir Joshua Reynolds. He achieved his artistic breakthrough with *The Nightmare*, painted in 1780/1781, during his last extended stay in Switzerland. Perhaps his most famous picture, he produced several variations of it and in 1802 exhibited it at the Royal Academy, where he had acquired the post of professor of painting. Nightmares and obsessions, violent fantasies and perverse desires come together in this rococo bedroom - the latter among the popular subjects of the time. The sleeping woman is paralyzed with fear, haunted by a demon and a ghostly horse, "the night mare."

Adolf Reinle

A Copybook for Stonemasons between the Gothic and the Renaissance

As early as 1950, a study of sources for *Kunstdenkmäler des Kantons Luzern* (Monuments of Art of the Canton of Lucerne) led to the discovery of some to date unresearched architectural plans. Such plans had again and again fascinated me as documents offering insights into a stonemason's shed, the drafting, revising, and final realization of buildings, the forces at play between principal and master mason, the migration of building experts, and the spread of building types and models.[1]

For that very reason, I considered it a gift from the gods when I found – around the time I retired from teaching – a to date completely unknown book I immediately recognized as a rare copy of a "stonemason's copybook."[2] I totally underestimated the significance of its contents at the time, however, for the meaning of its drawings was only revealed by many years of research, one finding providing the key to the next, somewhat similar to working on a coded text. At that time, I would have been surprised if somebody had told me that – because of this stonemason's copybook and the clarifications it required – I was to become a regular visitor of the Zurich national archives, town archives, and libraries, but also of the Stuttgart national archives and library for the next six years or so. Or that my research would lead me to such unusual and distant places as Neumarkt, Predigerkirche, and the Zunfthaus zur Waag (guildhall) in Zurich, the surroundings of the Alte Schloss in Stuttgart, the spiral staircase in the stonemason's shed of the Strasbourg minster, the castle of the elector and archbishop in Aschaffenburg

figs. 1a, 1b: Codex Stadler, folio 79 v and 80 r. Ground plan of a square net vault. The fragmented impression of a four-pointed star is created by breaking parts out of the diamond network of the ribs. The "design" belonging with it is not a cross section but shows the orientation of the ribs.

Ground plan of a church choir. Most ribs are pivoted in the manner of late or post-Gothic edifices.

am Main, and the apartments of the president of Italy in the Palazzo Quirinale in Rome, which are quite difficult to gain access to. Or that I would have to study the famous garden of Heidelberg Castle, Renaissance fountains in Italy, early baroque festival architecture in Parma, buildings in Rome, Venice, and Naples, or the Protestant Drei-einigkeitskirche in Regensburg.

The book – height 41.5 cm, width 28 cm – is bound in paperboard, the exterior of which is covered by a fragment of a fourteenth-century liturgical manuscript. The paper almost exclusively shows Zurich watermarks, and only once a Basel one. The old folio pagination consists of 119 original pages, 41 of which have, however, been torn or cut out, somewhat loosening its binding. Thirty empty pages prove that additional drawings were to be added in various places. On the other hand, several sheets of drawings probably executed at an earlier date were added, too. Most of the architectural drawings were methodically drawn in dark brown ink, with compasses and a ruler, and constructed ad hoc.

The author of this codex is mentioned by his son at the top of the interior page of the book cover: "Disse Nach Folgenden Figuren vnd grund Riss hett g…/ Lieber Vatter hanss heinrich Stadler, hört Jedz mir / Vlrich VS Stadler Steinmetz / 1666" (The following figures and ground plans have been … dear father Hans Heinrich Stadler and now belong to me, Ulrich US Stadler, stonemason, 1666). The missing part of the first line probably read: "gemacht [oder gezeichnet] mein" (made [or drawn] by my…). Several pages, moreover, show the signature "Hans" or "Hans Heinrich Stadler" and dates ranging from 1631 to 1635, though they do not cover the much longer period the book was compiled in.

The man was certainly easy to identify; I already knew him to be the builder or cobuilder of the guildhall called "zur Waag" near the Zurich Fraumünster (1636-1637). The elevation of its still-extant main portal, with his stonemason's sign, was in fact included in our codex. [3]

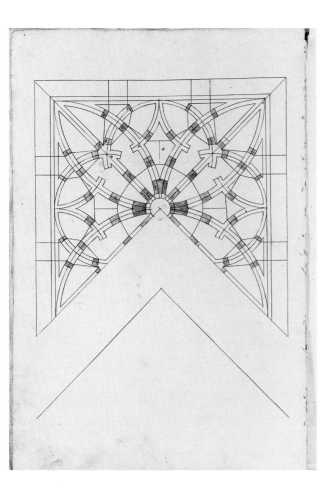

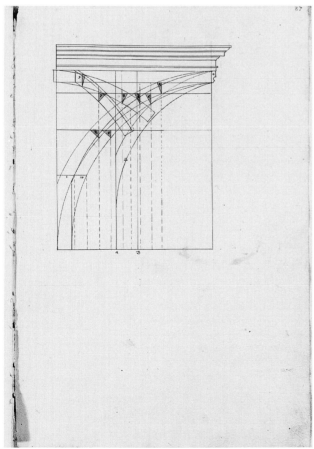

figs. 2a, 2b: Codex Stadler, folio 86 v and 87 r. Ground plan and design of a rectangular oriel. There are few equally rich examples that were actually realized and still exist: for example, the Kaufhaus in Freiburg i. Br. (Germany), built between 1525 and 1532 by cathedral architect Lienhard Müller, or the so-called Ratsstube of the Alte Hofhaltung in Bamberg, built from 1570 to 1576 by Erasmus Braun and Daniel Engelhardt.

I soon realized that for once – contrary to most stonemason's copybooks still extant – we were investigating a clearly identifiable person, who could be studied not only as to his style and technique, but also genealogically and sociologically. This led to countless reciprocal findings as to the person and the book concerned.

Stadler is quite a well-known name in the history of Swiss architecture. Classicist Hans Conrad Stadler (1788-1846) – trained in Karlsruhe, Geneva, and Paris, creator of the first monumental postal building constructed near the Fraumünster in Zurich (1834-1835) – and Neo-Gothicist Ferdinand Stadler (1813-1870) – the fondly remembered architect of the Basel Elisabethenkirche (begun in 1858) – numbered among the most important Zurich architects, while the last of the line, Hermann August Stadler (1861-1918), introduced modernism to the townscape with his iron and glass building for the Jelmoli department store chain.[4]

There seemed to be no reason to focus on the more distant family past, at least not from the point of view of an architectural historian. Hans Heinrich Stadler (1603-1666) featured in local history only in relation to the guildhall "zur Waag." Now, all of a sudden, his stonemason's copybook made him the focus of our attention. I made it my business to study the history of the Zurich line of the Stadler family by sifting an enormous number of written sources, from council minutes and parish records to population censuses, the annual statements of the Board of Works, guild history, the history of public servants, magistrates, and craftsmen, finally even adding military documents, including those dealing with the construction of the fortifications built in Zurich as a result of the Thirty Years' War.

In 1504 Antoni Stadler, a carpenter and shipwright originally from the Canton of Uri, was made free of the town of Zurich. From 1500 till 1900, his descendants included about twenty building experts, stonemasons, carpenters, cabinetmakers, some six painters, and a goldsmith. The history of their social success reads like a

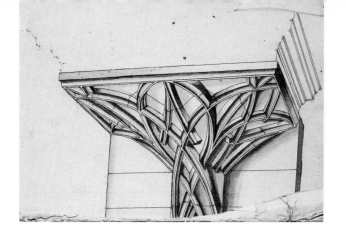

fig. 3: Codex Stadler, folio 118 r. Perspective view of an oriel with a ground plan similar to that shown in fig. 2. Contrary to the previous Gothic plans, this drawing shows how the art of perspective, such as it was studied by Stadler and his contemporaries on the basis of the Italian theory of architecture, was applied.

thrilling novel by Gottfried Keller: they began their ascent under the protection of reformer and Zwingli disciple Heinrich Bullinger, later going on to become magistrates, so-called "Amtsmänner." Hans Ulrich Stadler (1567-1647), the father of our Hans Heinrich, was not only a stonemason; he also served (1612-1618) as a magistrate of the former abbey of Stein am Rhein, where Hans Heinrich spent six years of his youth, worked from 1656 till 1660, and was finally buried in the Gothic cloister cemetery. Their residential quarters were located within the old town of Zurich too: the sixteenth-century Gothic ancestral home, "Zur Stund" (with the hourglass as symbol of the transitoriness of life), at the Neumarkt address still exists; the simple half-timber house of Hans Heinrich, "im Kratz," in the stonemasons' settlement on the Fraumünster construction site, fell victim to the metropolitan blocks constructed along Bahnhofstrasse at the end of the nineteenth century. Another Stadler family home, a country seat in the midst of a vineyard on the lower slope of the Zurichberg, had to yield to the fortifications begun in 1642. Hans Heinrich's brothers were artists, too: Hans Ludwig (1605-1660) and Gottfried (1616-1664) were painters and stained-glass specialists, the former a friend of Samuel Hofmann, Zurich's only well-known baroque painter; Hans Georg (1612-1642) was a cabinetmaker and furniture designer. Painter and engraver Dietrich Meyer – who taught Matthäus Merian the niceties of his etching technique – lived close by as well.

There are no written records of Hans Heinrich's apprenticeship years and travels. There is proof he came back to Zurich in 1629 though, for his name appears among those of the stonemasons – as a rule about six – who were procuring their material from the official quarries. In 1656 he is, however, suddenly called "Sir," and his nomination as a magistrate of St. Georgen in Stein am Rhein is entered into the minutes of the local council, which list him as an engineer.

The drawings in the Stadler Codex do not show a strict thematic sequence. Of course, designs such as those for Gothic vaults or Renaissance portals are combined in groups, though not all of them are composed along logical parameters. In addition, many drawings have been torn out – doubtlessly the most interesting and beautiful ones, presumably views or façades of buildings. Only three times are actual plans or views referred to: the "Schneckentreppe" (helical staircase) of the Neue Marstall (Mews) in Stuttgart, the Ulm town gate, and the portal of the Predigerkirche in Zurich.

As studying the Stadler Codex was the delightful and leisurely pursuit of an old man who had no deadlines to meet, I was left to my own devices. That is why I first concentrated on the twenty-eight Gothic drawings, recalling – considering late Gothic religious and secular architecture – the subjects of German fifteenth- and sixteenth-century stonemasons' books and collections of plans. For quite some time, I ignored the many Renaissance portals, not being particularly attracted to German Renaissance architecture. I moreover believed them to be copies of illustrations taken from printed books on architectural theory. This seemed logical at the time, as Stadler included numerous pages with adapted drawings of perspective model drawings from Sebastiano Serlio's publications on architectural theory, volume II, *Prospettiva*. I became familiar with Serlio in 1950, when – among the plans of the Einsiedeln abbey architect, Brother Caspar Moosbrugger (1656-1723) – I found the latter's copies of church projects in volume V of Serlio's works.[5]

Without compiling an actual catalogue, I shall now briefly summarize the main groups of the Stadler Codex.

The Gothic group is characterized by its limitation to two tasks: vaults and oriel bases. Surprisingly, there are none of the window traceries normally included in other stonemasons' books, nor are there pinnacles and (flying) buttresses or window posts, particular favorites of our region. A single church vault, that of a choir, is included; all other drawings seem to refer to secular spaces. Equally surprisingly, the rectangular, polygonal, or semicircular bases serving as "consoles" for various types of oriels are always covered by ribbing. Characteristically, the organ

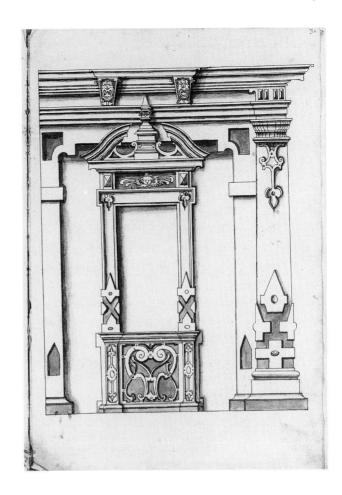

figs. 4a, 4b: Codex Stadler, folio 29 r and 30 r. "Neuer Bau" in Stuttgart, plans for the ground floor and the second floor at the corner projection, drawn in 1600 by Heinrich Schickhardt, copied by Hans Heinrich Stadler. Below, the portal; above, the balcony portal.

base by Anton Pilgram of 1513 in St. Stephen's Cathedral in Vienna is shown in Stadler's etchings. Such oriel bases are rare and limited to important buildings.

The Gothic spiral staircase in Stadler's drawings is a piece of art integrated into Renaissance architecture, as in the case of the castle in Aschaffenburg, or as a basic form translated into Renaissance elements, as in the "Neue Bau" (New Building) in Stuttgart. Stadler focused on the three largest and most modern castle buildings of his time in southern Germany: the "Neue Bau" in Stuttgart (which we shall return to later on), the margravial castle in Aschaffenburg am Main, built by Strasbourg master builder Georg Riedinger (1568-1617), and Scharffeneck castle in Baiersdorf-Erlangen, begun by Frankish architect Valentin Juncker in 1627 and destroyed, still unfinished, in the war of 1632. But while Stadler's drawings of Gothic vaults and oriels may hardly be considered representations of real buildings, these castle architectures might very well be complete sets of plans copied on site in the construction office.

They are followed by two drawings, one a corner view, the other the main portal of the Protestant Drei-einigkeitskirche in Regensburg. This important and at the time of its realization highly praised Protestant church, created 1627-1631 by Nuremberg engineer Johann Carl, is almost always missing from current works on the history of art.

Finally there are a large number of gates and portals in Stadler's book, headed by a drawing of an Ulm town gate, clearly referring to Wendel Dietterlin's models, published in 1598, in particular folio 154. This is hardly surprising given the fact that the list Stuttgart court architect Schickhardt compiled of his own works states that he supplied evaluations and plans for the Ulm fortifications in 1608, 1609, and 1613. He moreover confirms that he owned Dietterlin's work and called him his dear friend.

The Hans Heinrich Stadler Codex also contains some pen-and-ink sketches of designs for volute carvings, signed GS. They were doubtlessly made by his brother, carpenter Georg Stadler.

The Stadler Codex ends (folio 100 r to 114 v) with a thirty-page treatise on the principles of fortification building, including three plans signed HHS 1633. This text, almost certainly compiled from excerpts of works on the theory of fortification building and written in careful chancery script, also includes information on the disposition of armed forces, and at first glance was rather puzzling. Why did it end up in a stonemason's book? As Stadler is twice mentioned as an engineer, he presumably worked as an army engineer, too, though obviously only part of the time.

We ought to ask ourselves what professional projects Hans Heinrich Stadler was able to realize, what relation his stonemason's book had to his life in Zurich and his earlier travels. We can only speculate on the basis of certain facts about the Zurich building trade in the seventeenth century. On the one hand, there is his book of drawings and plans, undeniable evidence of the fact that Stadler mainly studied the predominantly Protestant region of southern Germany, in keeping with his Zurich origins. He familiarized himself with the most important works of architecture representing the current trends of his times by drawing them, and finally returned home when the Thirty Years' War began to engulf southern Germany. Zurich building ventures of this era were characterized by two crucial aspects: the prevalent Puritanism preferred buildings to be as sober as possible, "unnecessary ornaments" were frowned upon, balconies forbidden. Only two really large urban buildings were realized in that century: the granary built in 1619 behind the chevet of the Fraumünster above the left embankment of the Limmat, a warehouse designed by head workman Ulrich Schwytzer along rather severe lines, with simple rows of windows and portals; and after 1694, the new town hall on the right bank – the first truly magnificent baroque building the town called its own.

In addition to the prevailing puritanical attitude, the town had both foreign and domestic policy reasons to be fortified: the Thirty Years' War and the religious dualism of Protestant and Catholic cantons after 1642. This included putting a full stop to any building subsidies to private persons after 1639 in order to reduce expenses. But what did Stadler and half a dozen of his colleagues among the Zurich stonemasons provide themselves with building materials for? We cannot now know how far Stadler considered himself a tragic figure. We may only recognize the discrepancy between his knowledge of the most important buildings of his times in southern Germany and the architectural poverty of his home town. The magistrate's life both the father and the son led may have provided a certain compensation for professional satisfaction, his book on "figures and plans" – much like a diploma – proving his training as an architect and serving as a kind of album. To us it is a truly valuable collection of plans and designs, including some demolished buildings, and an excellent document of the history of architecture.

Let me present a few reproductions of and comments on a selection of the drawings in the codex.

Pages 79 v and 80 r offer some plans of vaults typical of this book: the design of a square net vault and the net vault of a nave choir.

The square vault is an example of a seemingly effortless composition. Out of a network of facets, shorter and longer parts are broken out to form a four-pointed star. The keystone in the center and the intersecting vertical separation lines ensure better articulation. In this manner, the dominant bay quoin of the ribs after their intersections is emphasized.

With the help of the numbers and letters indicated, the sites of some of the vault ribs shown in the drawing may be located.

But though the site of the vault just discussed is not established, we do have a good idea of the building shown by the plan of a longitudinal choir with a three-sided closure. The space opens towards the nave along its entire width. Windows consisting of two lancet arches dominate, with the one in the apex broader and much more detailed. Strikingly, a pointed form is inscribed above the rectangular one in the chevet. This might mean different things.

fig. 5: View of the fire-ravaged
"Neue Bau" in Stuttgart. Crayon
drawing by Viktor Heideloff,
before its demolition in 1778.
Württembergische Staatsgalerie,
Stuttgart, Graphische Sammlung,
inventory no. 6512.

figs. 6a, 6b: Codex Stadler,
folio 26 v and 27 r.
The "Neue Bau" in Stuttgart;
plans for the types of windows
designed for the ground floor
(top) and the second floor
(bottom).

It might be a suggestion for two variants, either a rectangular or three-sided buttress, or a proposal to place one in the lower and one in the upper part. Spurlike pointed buttresses were used for the cathedral choir in Prague (begun in 1344) and Peter Parler's choir built in Kolin (1360-1378), in some fifteenth-century Austrian and south German churches, and in Switzerland in the nave of the Bern minster, begun in 1421 by Matthäus Ensinger, and the choir begun in 1471 by Austrian Stefan Klain at St. Martin's in Chur. Buttresses which are three-sided in the upper part are formed by halved corner pinnacles, similar to the cathedral choir in Bern and the choir of St. Mary's in Laudenbach near Weikersheim, Württemberg (1412-1459).

There are several vaults similar to the one shown in our plan. Obviously this is a curved translation of the frequently used zigzag molding. But while plan no. 62/16877 of the Viennese collection was only an indifferent version of this type, the drawing in the Stadler Codex decidedly sequences pointed-arch ribs. This is only surpassed by a plan in the Stromer master-builder's book in Nuremberg, volume I, folio 235, created around 1600, where the zigzag molding or dancette is retained but enriched by a single row of pointed-arch ribs and superimposed by broad eight-part loops. Compared with this, Stadler's plan is more homogeneous.

Out of the series of oriel designs, I would now like to focus on the integral double-page 86 v and 87 r, showing a rectangular oriel growing out of a quoin. Based on the ground plan and the design, it becomes obvious that as a rule the ribs are not the constituting and de facto supporting architectural element as in the case of a vaulted space. They show the same decorative forms as in a vault, but they are carved as a relief out of the hewn stones. In this meticulously executed drawing, the joints of the hewn stone are reproduced, too. Folio 188 r also shows the perspective view of a similar oriel base, where once again the stone joints are visible. We may assume that such precious and subtly instructive plans belong among those that were most frequently torn out and lost in the course of the centuries.

fig. 7: Codex Stadler, folio 74 r. The "Neue Bau" in Stuttgart; visible underface and details of the large spiral staircase, defined in the appendix as "die Schnecke im Neuen Marstall zu Stuttgart." A combination of Gothic blind tracery and Renaissance ornamental fittings.

fig. 8: Codex Stadler, folio 75 r. The "Neue Bau" in Stuttgart. Ground plans and two-dimensional rendering of part of the large spiral staircase. The basic Gothic form is dissolved by Renaissance elements.

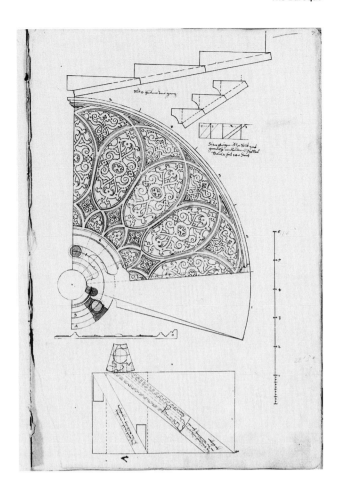

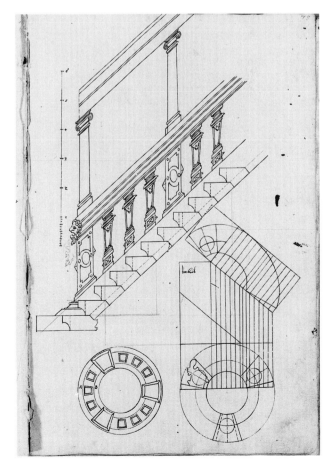

As a conclusion, at least one Renaissance example of southwestern Germany in the Stadler Codex ought to be mentioned. A stroke of luck allowed me to acquire a whole series of Stadler plans representing details of the so-called "Neue Bau" or "Marstall" in Stuttgart, including the royal stables, the festival hall, and the collections.[6] This building, an important example of German Renaissance architecture, built 1600-1607 by Württemberg court architect Heinrich Schickhardt, was ravaged by fire during a Molière performance in 1757 and finally demolished in 1778. Schickhardt's original plans of 1600 and the respective model were destroyed in the fire, too; one set of plans was, however, preserved in the Württemberg national archives – the ground plans of four floors and a cross section – for the internal remodeling of the ruin which was finally demolished anyway. The Stadler Codex contains, as I realized in two steps, no less than eight pages, presumably, however, ten or more plans which Stadler meticulously copied in Schickhardt's office. In 1985, immediately upon acquiring the book, I noted the addendum made by Stadler on one of the staircase drawings, stating it to represent the large spiral staircase of the Neue Marstall in Stuttgart. All other detail plans, portals, and windows by Stadler were unsigned and dispersed within the codex, so we considered them to be copies from books on the theory of architecture and various other sources.

By now, I had already neglected a more precise analysis of these Renaissance drawings for some years. In January 1989, I finally began to skim through some relevant illustrated works and was shocked when I recognized in Dehio's *Geschichte der deutschen Kunst* (History of German Art, vol. 3, 1927, p. 272) a corner view of the "Neue Bau" ruin, executed by Viktor Heideloff around 1778. This single, precisely detailed view (today at the Staatsgalerie Stuttgart, Department of Drawings) proved that a series of Stadler drawings were copies of the detail plans for the main façade, oriented toward the town, of this very building. In addition, there were the two Stadler plans with detailed drawings for the "Grosse Schneck," the spi-

fig. 9: The "Neue Bau" in Stuttgart. Ground plan recorded after the fire of 1757, including proposals for a baroque extension. Plan A – ground floor with the columned hall of the Royal Mews. Below, the part turned toward the town, from which Stadler copied his façade details; above, the garden view with the large spiral staircase (left corner). Hauptstaatsarchiv A 249 Bü 2435, Stuttgart.

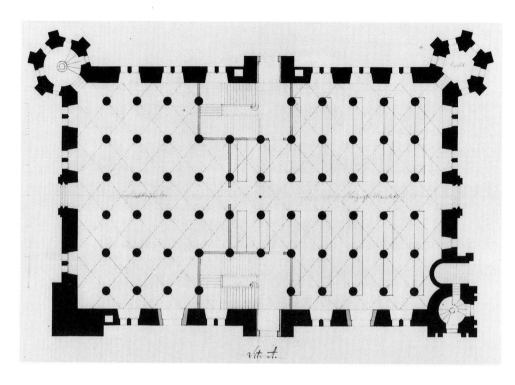

ral staircase in the "Neue Bau," the exterior of which had to date been undocumented.

In view of the large number of plans for this single building, we assumed that there were overall views of the elevation as well, though these had of course been the very first to be torn from the codex. There is little hope of finding such fragments, given the simple principle of all research: namely, that you will never find what you need most.

But the story does not end there. In the winter of 1990/1991, when I began to add the finishing touches to my manuscript on the Stadler Codex, I wanted once again to reevaluate all the people and sites, in particular those of his colleague, engineer Johann Ardüser (born 1585 in Davos, Grisons, died in Zurich in 1666), the builder of the contemporary Zurich fortifications. In his rather neglected collection of plans for an *Architectura Civilis*, I found two plans referring to the Stadler drawings, the plan of a town gate in Ulm designed by Schickhardt, and the overall elevation designed for the main façade of the "Neue Bau" in Stuttgart. Given this second, last-minute discovery, we now face a twofold editing task: the biographies of two original experts and contemporaries working and living in Zurich, and the consequent publication of their respective copybooks.

Translated from the German by Suzanne Leu

Notes

1 Adolf Reinle, "Ein Fund barocker Kirchen- und Klosterpläne," *Zeitschrift für Schweizerische Archäologie und Kunstgeschichte,* vol.11 (1950), pp. 216-247, vol. 12 (1951), pp. 1-21, and addendum vol.13 (1952), pp.170-181; Adolf Reinle, "Ein unbekanntes Kirchenprojekt Filippo Juvarras und einige andere piemontesische Baurisse," *Zeitschrift für Schweizerische Archäologie und Kunstgeschichte,* vol. 27 (1970), pp. 5-28; Adolf Reinle, "Ein Konvolut sächsischer Schlosspläne in der Luzerner Zentralbibliothek (entdeckt 1950) ," *Zeitschrift für Schweizerische Archäologie und Kunstgeschichte,* vol. 32 (1975), pp. 148-165.

2 I am using the recently created term "stonemason's copybook" to define books of patterns and collections of plans, because it is short and in our case designates a book whose author was a stonemason, trained as such, practiced his craft, and was designated as such in documents.

3 Konrad Escher, *Die Kunstdenkmäler des Kantons Zürich*, vol. IV, *Die Stadt Zürich*, Part I (Basel, 1939), pp. 456-462.

4 Andreas Hauser, *Ferdinand Stadler (1813-1870). Ein Beispiel zur Geschichte des Historismus in der Schweiz* (Zurich, 1976).

5 Two new and quite comprehensive books offer a compilation of literature on medieval planning: *Les bâtisseurs des cathédrales gothique. Publié sous la direction de Roland Recht* (Strasbourg, 1989), a treatise and catalogue to complement a Strasbourg exhibition of Gothic plans; Werner Müller, *Grundlagen gotischer Bautechnik* (Munich, 1990).

6 The existing literature on the "Neue Bau" and its context is summarized in Werner Fleischhauer, *Renaissance im Herzogtum Württemberg* (Stuttgart, 1971).

Picture credits

figs. 1-4, 6-8: Staatsarchiv des Kantons Zürich

fig. 5: Württembergische Staatsgalerie, Stuttgart

fig. 9: Hauptstaatsarchiv, Stuttgart

Heinz Horat

Santa Croce in Riva San Vitale
An Early Work by Carlo Maderno

Though historians of architecture have described and discussed the church of Santa Croce in Riva San Vitale at length, they are very cautious when it comes to placing it in the stylistic and biographical context of its time.[1] Scholars fluctuate between classifying it as one of "Switzerland's most important ecclesiastical buildings of the Renaissance" and accentuating its early baroque tendencies, in the latter case citing its supervising architect Giovanni Antonio Piotti. They then go on to point out that the author of the plans is unknown and presume, among other things, that the ground plan was influenced by the early medieval baptistery in the same village.[2] It is genuinely difficult to be more precise than that. Santa Croce is one of a kind, sparsely documented, and formally alien to its surroundings (figs. 1, 2).[3] Here is a late-sixteenth-century church built in the shadow of the cultural centers of Lombardy, and yet, despite certain northern Italian motifs, its major formal elements point directly toward Rome; and it exhibits a consistency of planning hardly to be expected of a contemporaneous architect from the area. As there are virtually no archival sources relating to the planning phase, it comes as no surprise that over the past century attributions have ranged from Donato Bramante to Cristoforo Solari and Pellegrino Pellegrini Tibaldi. The two former men can be eliminated because of the construction date, which has meanwhile been definitely established; and there are no formal characteristics apart from the door that could be ascribed to Tibaldi.[4] Tibaldi's oft-cited centrally planned San Sebastiano in

Milan cannot be compared stylistically to Santa Croce, nor do the proportions of the building correspond to the principles laid down by Tibaldi in his commentary on architecture.[5]

The History of Recent Research

In 1941 Aldo Crivelli interpreted the original contracts pertaining to the construction of Santa Croce, published by A. Lienhard-Riva in 1940. They name Giovanni Antonio Piotti, known as Vacallo, a Milanese fortifications engineer and architect living in Como at the time, as the architect.[6] In the past few years Stefano Della Torre has been most active in attempting to unearth further source material about this little-known man. Although he has made appreciable headway, he has been unable to produce positive identification of any Piotti building that would be even moderately representative, which forces him to state: "Manca forse ancora... un'opera di spicco."[7] Crivelli, who had already made efforts to discover buildings by Piotti, noted: "Non si conosce l'architetto progettista," and Giuseppe Martinola wrote categorically: "Del Piotti... non si conosce un solo edificio."[8]

Thus the edifice that, from a historical perspective, Adolf Reinle rightly classified with the Roman buildings of the early baroque[9] is known to have had a clearly identified supervising architect who would hardly have been in a position to design the church. Consequently there is no obstacle to a line of reasoning based on the hypothesis that Carlo Maderno designed Santa Croce in Riva San Vitale and left its realization to Piotti. At present this thesis cannot be proven conclusively as there are no known documents to substantiate it. Nonetheless the building deserves to be reconsidered and discussed under a hitherto neglected aspect, for it is one of the finest pieces of architecture produced in northern Italy or Switzerland at the time.

Architectural History

The church of Santa Croce was founded by Giovanni Andrea Della Croce.[10] Scion of a regionally influential family, he became archpriest of the collegiate church of Riva San Vitale in 1553, probably relinquished the office in 1563, and later became provost of Santa Maria di Vico in Como, living in his house in Riva San Vitale during one year of his tenure, 1591; he made a will in 1594, died in 1595, and was buried in his church of Santa Croce. Giovanni Andrea Della Croce had two bells cast for Santa Croce in 1588 and the third in 1590, an indication that construction must already have been well under way, since bells would hardly have been cast before definitive plans had been made for the tower. All surviving contracts relating to the decoration and furnishing of the church date from the year 1591: with the painters Pozzi, from Puria, Valsolda, and Camillo Procaccini, a Bolognese residing in Milan; with Gaspare Mola, from Coldrerio, for three wooden altars; with the plasterwork specialists Domenico Fontana, from Muggio, and Pietro Mazzetti, from Arogno; and with Domenico de Fossati, from Arzo, for the decoration of the façade in Arzon marble and speckled stone from Meda. These contracts indicate that Piotti had a major influence on the furnishing phase initiated in 1591, and that the work must have been largely completed by 1592. Filippo Archinti, the Bishop of Como, consecrated the church on 30 May 1599. A further contract, dated 24 May 1604, attests to the "Lombardic" modification of the "Roman" dome, when the drum was given an additional story and covered with a tented roof typical of the region and the climate.[11] In 1916 the dome was returned to its original condition. A thorough restoration took place in 1940. As it appears today, the church is the result of the 1973-1975 restoration of the exterior and the restoration of the interior completed in 1988.

An analysis of the architectural history of the church shows that the surviving documents shed light on only the first stage of furnishing and decoration but not on the actual planning and construction phase, which ended in

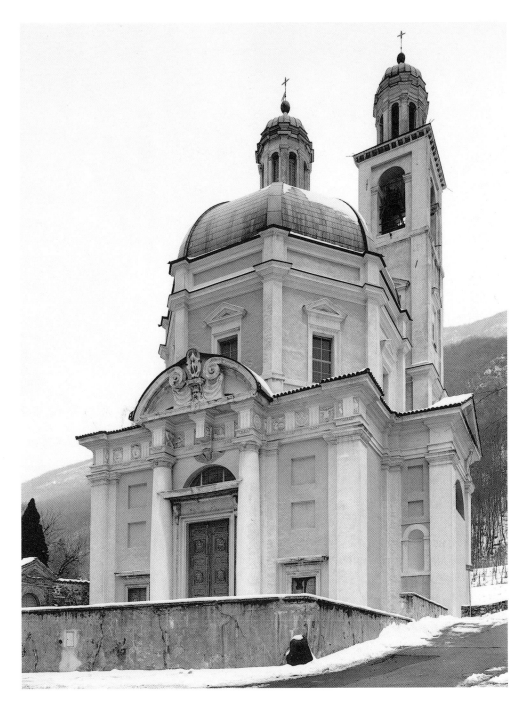

fig. 1: Santa Croce in Riva San Vitale from the east, after the 1973-1975 restoration, 1991.

1591. The plasterwork specialists were not responsible for the tectonic plasterwork (ribs, entablature, triglyphs, metopes) but had been commissioned only to design the moldings around the paintings and the wall panels in the chapels. The decoration of the giant order of the main front, based on drawings by Piotti, was commissioned comparatively late, certainly when the building was already standing. And, in fact, the main door has a discordant quality; like the metopes of the main front and their somewhat thicker pilasters, it speaks a different architectonic language from the rest, contrasting particularly to the interior of the church.[12]

The Architectural Concept

The surviving original plans for Santa Croce indicate that the design, above all of the main front of the church, was modified. Two of the three preserved ground plans - which have recently been dealt with by Stefano Della Torre, who justifiably ascribes them to Piotti – pertain to the octagonal dome and are of little further interest to us.[13] The third plan, preserved in the Archivio di Stato di Novara, bears the inscription "La gessa del S. Andrea dalla Croce" on the reverse and exhibits a main front different from the one actually constructed (fig. 3).[14] As this plan also contains details of the floor, it may well be a copy by Piotti after a lost original; in any case, the person who drafted the plans need not be identical with the designer of Santa Croce.[15]

Like the lateral façades, the main front also has a central, projecting ressault and embodies the cruciform design of the ground plan even more consistently, for the three ressaults are all of equal width. The choir adopts the exterior width for the interior. The lack of monumental columns on the main front similar to those already planned for the interior will have produced an even more mural, tranquil, Renaissance-like effect. The width of the exterior pilasters is approximately the same as those that were executed. The blocklike ressault of the main front recalls the modern Roman church façades of Francesco da

Volterra, for instance, San Giacomo degli Incurabili or Santa Chiara, and thus resembles Giacomo Vignola's Gesù front.[16] The main front as executed cannot simply be understood in terms of baroque intensification of effect toward the center, along the lines of Carlo Maderno's façade for Santa Susanna in Rome; the two columns flanking the door are too isolated for that. Likewise, the manneristic voluted frontons bear no relation to the overall edifice and are not formally integrated (figs. 4, 5). The motif remains restricted to a single part of the building.

The Novarese plan articulates the interior space by setting off the chapel-like entrance niche, the domed octagon, and the barrel-vaulted choir against each other. It achieves a baroque axial effect, even in the central section. The plan that was carried out scales back the entrance area so much as to render it imperceptible from inside. The increased diameter of the massive interior columns in comparison with the Novarese plan reveals nothing about the monumental character of the earlier plans for the ground floor, since the dimensions of the exterior pilasters already postulate a giant order in the dimensions of the building as constructed.

The original project calls for two squares with sides 42 bracci long, pushed 6 bracci apart choirwards from the façade of the central ressault of the main front, the ultimate result being a rectangle measuring 42 x 48 bracci (fig. 6). This rectangle establishes the alignment of the ressaults of the four fronts. The diagonals of the square of the main front intersect at the center of the octagon, the radius of which determines the width of all ressaults but that of the choir. Laterally the ressaults project forward half a radius. Whereas the main square also follows the choirward exterior walls of the vestry and tower, the second square, which is displaced choirward by one seventh of the total width, defines the apex of the choir, and its diagonals, the vertices of the vestry and the tower. Inside, the intercolumn of approximately 7 bracci can be marked off five times in width and six times in length. It delimits the side chapels and the choir. The combination of the two squares

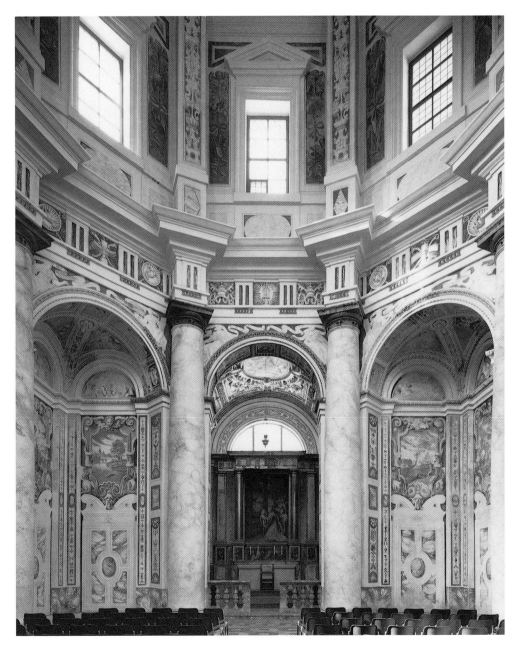

fig. 2: Interior of Santa Croce in Riva San Vitale, looking toward the high altar, after the 1988 restoration, 1991.

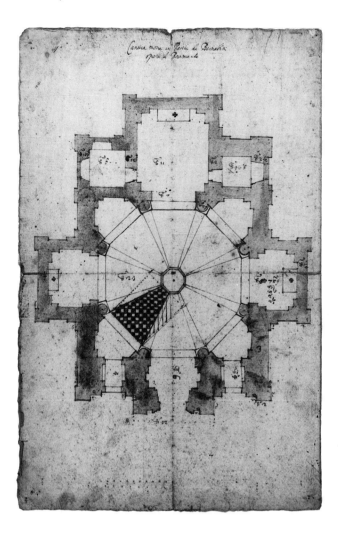

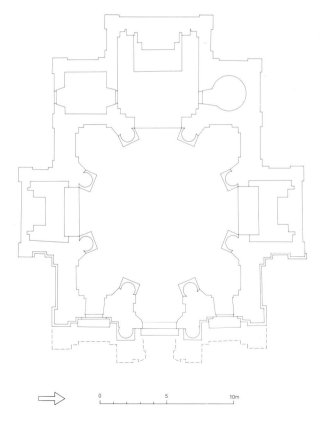

fig. 3: Preliminary project for Santa Croce. Original plan in the Archivio di Stato di Novara, c. 1588.

fig. 4: Ground plan of the church as built. The dotted line indicates the main front as originally projected.

plus the octagon inscribed in the main square with three units of measure – the displacement of the square, the radius of the octagon, and the intercolumn – permits the most important constructional points to be established. This attests to a simple but, in its inner and outer congruence and logic, highly developed principle that can only have been devised by a gifted architect.

It is even easier to reconstruct the way this principle was translated into an actual building because the dimensions can be measured not only on the 56 x 43 cm original plan (fig. 3) but on the edifice itself. It will immediately be noted that the building as it stands is not totally symmetrical, but that the lateral ressault in the south had to be shortened by one module, probably because of the stream that flows by it. As the original plan is based on symmetry, our studies of the proportions of the actual building show the south ressault symmetrically extended by one module. The module, which is the basic unit of measure, represents the radius of an interior column above the base. Its size, approximately 51.5 cm, is probably identical with the braccio measure commonly used in the region.[17] Measured above the lateral ressaults, the exterior width of the building comes to 42 modules, which corresponds to the length of the sides of the two squares that have been displaced choirward on the finished building. The displacement of the squares measures 6 modules. The total width equals 7 x 6 modules. The octagon inscribed in the main square, on the other hand, exhibits an intercolumn of 7 modules. The units of measure of 6 and 7 modules can be found again and again throughout the ground plan and the façades (figs. 6, 7). Thus the ground floor of the main front is 21 x 42 modules, meaning half as high as it is wide, whereas the drum above, with its ratio of 2:3, is narrower than the ground floor and also half as high; the same holds true for the semicircular dome. The same proportions are found in Donato Bramante's Tempietto San Pietro in Montorio, a building that, as remains to be demonstrated, also served as an important model in terms of the orders employed. The semicircle of the lantern of Santa Croce measures 6

modules, which can be marked out along the total height of the church. The semicircle of the tower dome is based on a size of 7 modules, and these, too, define the height of the single stories of the shaft. The then widespread "regola tedesca" after Cesare Cesariano could also be applied, but the proportions yielded by the building itself are more conclusive (fig. 8).[18] The numerous dimensions and proportions of the architectural orders and individual elements, for example the doors and windows, could be broken down further, for they follow a unitary principle based primarily on Giacomo Vignola. As Aldo Crivelli has already pointed out, only the height of the Doric shaft, 15 modules, exceeds the height demanded by Vignola by 1 module.[19]

The principal front as built underwent an illogical development vis à vis the original project and its concomitant structural principle by taking back the central ressault marking the base of the principal square and replacing it by two monumental columns flanking the door. But these columns do not follow the basic pattern as consistently and are also thicker than the interior columns, and that in turn affects the pilaster division on the front. Moreover, these columns support a voluted gable, whose profile, sculptures, and crude metopes in the style of Galeazzo Alessi contrast starkly with the more delicate shapes of the interior.[20] Attempts to explain this by way of choice of materials or the necessary overemphasis on monumental detail prove untenable considering how close one can get and how precisely the stone can be worked.

Thus there appear to have been structural and formal reasons for modifying the original concept. This modification can be ascribed to Giovanni Antonio Piotti, for one of the extant contracts names Piotti as the designer of the main front. But if this modification is distinctly different in both form and structure from the original plans, Piotti cannot have created the original concept. It is true that Aldo Crivelli wrote: "Chi a costruito la facciata ha progettato anche la pianta"; but for the reasons listed above, I consider this view incorrect.[21]

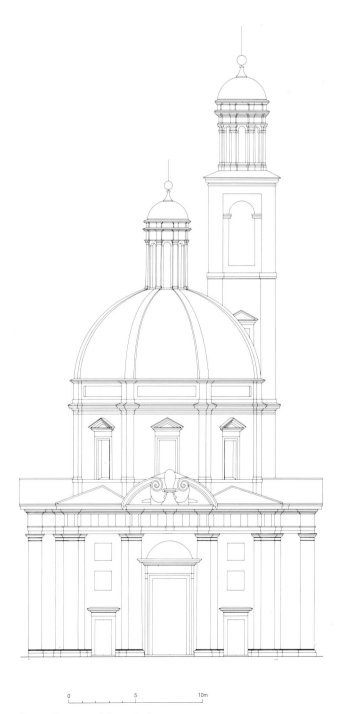

fig. 5: Elevation of the main front.

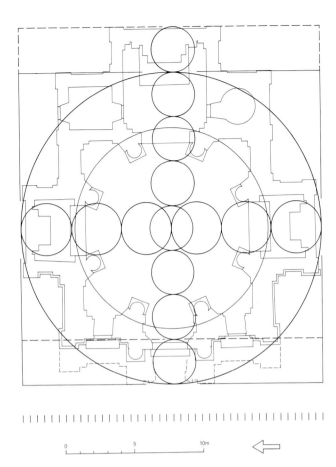

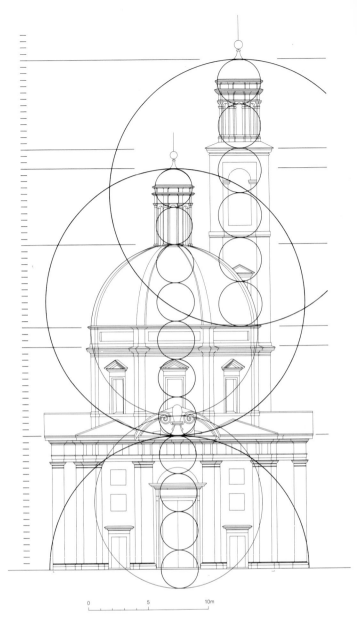

fig. 6: Ground plan of the church as built. The dotted line indicates the original project. At the bottom, the module scale; on the vertical center axis, the 6-module circles; on the horizontal, the 7-module circles; above, the two displaced squares of the basic construction. 2 modules (column diameter), 6 modules (choirward displacement of the square), 7 modules (intercolumn), 27 modules (dome diameter), 42 modules (exterior width = one side of square).

fig. 7: Main front of the church as built, with circles of the principal dimensions.

Carlo Maderno

Carlo Maderno was born a citizen of Riva San Vitale in Capolago in 1556 and died in Rome in 1629.[22] He went to Rome in 1576, where he apprenticed with the building enterprise belonging to his uncle, Domenico Fontana, who was then at the height of his fame. Carlo's father died in 1581. Being the eldest son, Carlo assumed responsibility for his large family and founded a family chapel in the church of Capolago; consequently, he will have had to return home frequently. In 1588 he became a citizen of Rome, like his four brothers. The first Roman document to mention him as "architetto" is dated 1589; by 1593 he had become one of Rome's best-known architects and is named in this connected by Giacomo della Porta. Between 1597 and 1603 he designed and built his masterpiece, the façade of the church of Santa Susanna. If Giacomo della Porta mentions Carlo Maderno by name as an architect in 1593, enough buildings must have existed by then to earn the thirty-seven-year-old the reputation he had evidently achieved. A few smaller projects are indeed known, but just when Carlo Maderno began designing projects for his uncle Domenico Fontana is not clear.

Although Domenico Fontana took credit for the important Cappella del Presepe, built onto the basilica of Santa Maria Maggiore for Pope Sixtus V between 1584 and 1589, it is likely that Carlo Maderno had already made decisive contributions to the plans.[23] Despite the fact that its ground plan is laid out in a Greek cross, the chapel offers no points of comparison with Santa Croce. A more modest project, the first directly attributable to Carlo Maderno, goes out from a cruciform ground plan that suggests octagonal development on the interior (fig. 9). Eight engaged three-quarter columns were to support the dome above the cradle. The total exterior width can be reconstructed at approximately 20.5 m, which corresponds roughly to Santa Croce. The foundation stone for the building was laid in January 1585, but only a few months later the project was abandoned in favor of a significantly more imposing one, which replaced the columns by cross-ing piers. Where the idea of the engaged columns came from – whether inspired by Michelangelo's Sforza Chapel in Santa Maria Maggiore or by some other, particularly northern Italian, models – cannot be determined.[24] In any case, Carlo Maderno was interested in the idea and adopted it in the Cappella Lancellotti before 1598 and in the Cappella Salviati near San Gregorio Magno in 1600.[25] The same theme had been employed in northern Italy, notably by Pellegrino Pellegrini Tibaldi, and was also used in Santa Maria di Canepanova in Pavia, the building bearing the greatest similarity to Santa Croce; it was begun in 1492 and was largely completed by 1564.[26] The temporal context of Santa Croce calls to mind the planning variants of the Sixtus Chapel in Rome.

One reason for this is that the tabernacle of the chapel, a product of that very time, represents what might be termed a perfect example of a centralized plan – an octagonal ground plan extended into a cross by means of colonnaded porticos, similar to Perugino's painting of Peter receiving the keys in the Sistine Chapel.[27] Above the ground floor, an octagonal drum supports a semispherical dome with lantern (fig. 10). The vertical and horizontal proportions – for instance, the ratio of approximately 3:2 between the width of the ground floor and the width of the drum, or the heights of the ground floor, drum, and dome, have a strong similarity to those of Santa Croce. Although the name of the artist who executed the tabernacle is known here, too, the design for this small architectural work may be assumed to have originated with one of the architects involved in the building, perhaps Carlo Maderno. There is all the more reason for this hypothesis as it is formally so very different from the finished chapel that Domenico Fontana took credit for, and its proportions would be likelier to presuppose a ground plan resembling the preliminary project (fig. 9). The comparatively low ground floor crowned with a balustrade and figures, the drum encircled by double columns, the powerfully angulated entablature decorated with figures at the base of the dome, the semicircular dome with its double ribs, and

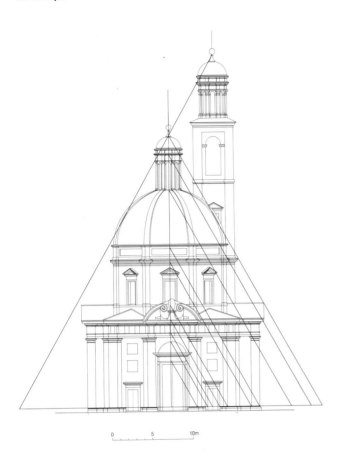

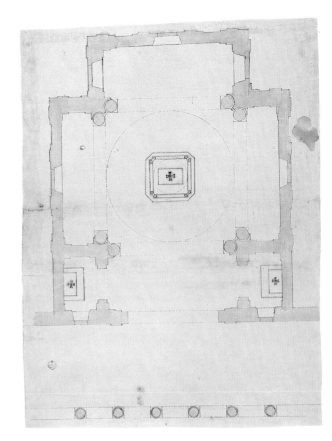

the type of lantern – all of these aspects recall the most modern, most important dome of the time, St. Peter's. As no other domed centrally planned building then standing united all of these features, they could be understood as universally comprehensible allusions to that building as an inspiration.

The same may be postulated for Santa Croce, and not only because nothing similar was planned or to be seen in northern Italy. The reason is that the characteristics of Michelangelo's St. Peter's – the tripartite division into ground floor, drum, and dome with a ratio of 3:2:2, the tectonically striking articulation of the drum, the power-fully angulated entablature, the lantern, and the semicir-cular domes of the side towers – appear in materially reduced form in Santa Croce. Domenico Fontana had engineered Michelangelo's dome. Thus it is not surprising if his nephew, a young Swiss-born architect who had re-ceived his object lessons from the original, should take his "Roman experience" and try to translate it to the scale of a local architectural project.

Centrally planned buildings closely related to the cen-tralized plan of Riva San Vitale were part of Carlo Maderno's personal frame of reference directly before and during the planning of Santa Croce. There is a three-quar-ter portrait of Carlo Maderno at the Museo Civico in

Lugano (fig. 11).[28] Its origins are unknown and there are no identifying inscriptions, but it has traditionally been considered a picture of Maderno. And, in fact, the features of the perhaps thirty- or forty-year-old man bear a dis-tinct likeness to those of Carlo Maderno as an old man, as depicted in a portrait in the Vatican Library.[29] The subject is facing the viewer. In his left hand he holds a compass next to a clock, in his right, some partially unrolled plans. The broad lace collar on his buttoned doublet is in the style of around 1580-1590.[30] The partially unrolled plan shows a church with lateral towers or staircases set slightly back from the façade (fig. 12). The main front is structured by massive pilasters and semi-circular statue niches, with a staircase of three steps in front serving as a podium. A bev-eled interior pier suggests a centrally planned building. A domed building, probably the one on the plan, can be seen in the background; three axes of a cube-shaped, balus-trade-crowned ground floor, an octagonal drum, and a semicircular dome with lantern can be recognized (fig. 13). Once again the striking features are: the relationship of the height of the ground floor to that of the drum; the flat-tened semicircular dome and its prominently structured entablature; and the balustrade above the ground floor, as found in the tabernacle of the Sixtus Chapel and adorning the tympanum of the façade of Santa Susanna – the latter

fig. 8: Main front of the church as built, with diagram of the "regola tedesca."

fig. 9: First preserved original ground plan of the Capella del Presepe, Santa Maria Maggiore, Rome, c. 1584.

fig. 10: Tabernacle for the host in the basilica of Santa Maria Maggiore, Capella del Presepe. Gilt bronze by L. del Duca and B. Torriggiani, 1588.

a source of great annoyance to the "classicists" of the next generation. The building depicted on the portrait has not yet been identified, nor can it be identified as any of the buildings attributed with certainty to Maderno; but it definitely fits into the group of centrally planned buildings discussed here.

In the history of architecture, semispherical domes with a 2:1 ratio of interior diameter to maximum interior height are contrasted with very steep domes, typified, for example, by the cathedral in Florence and Sant'Andrea della Valle. The following list of selected examples provides a survey:

Florence cathedral, Filippo Brunelleschi, 1420-1436	1.35:1
Santa Maria delle Grazie, Milan, Bramante, 1492-97	1.9:1
Tempietto San Pietro in Montorio, Bramante, 1504	2:1
St. Peter's, Rome, Bramante project, 1505-1514	2:1
St. Peter's, Rome, Michelangelo project, 1547-1564	2:1
Medici chapel, San Lorenzo, Florence, Michelangelo, 1547-1522	2:1
San Giovanni Fiorentini, Rome, Michelangelo project	2:1
San Giovanni Fiorentini, Rome, della Porta project	1.65:1
San Fedele, Milan, Pellegrino Pellegrini Tibaldi	1.85:1
San Sebastiano, Milan, Pellegrino Pellegrini Tibaldi	1.5:1
Gesù, Rome, Giacomo Vignola, Giacomo della Porta	1.65:1
Sixtus chapel, S. Maria Maggiore, Rome, Domenico Fontana,	1.45:1
Tabernacle of the Sixtus chapel, S. Maria Maggiore, Rome	c. 2:1
Santa Croce, Riva San Vitale, 1588-1592	2:1
Sant'Ambrogio della Massima, Rome, Carlo Maderno	1.55:1
Santa Maria della Vittoria, Rome, Carlo Maderno	1.35:1
Sant'Andrea della Valle, Rome, Carlo Maderno	1.2:1

It is clear from the above that a host of centrally planned buildings with semispherical domes (2:1) and powerful entablature existed in Carlo Maderno's surroundings, the visibly vaulted exterior domes being concentrated in Rome. A similar link between Riva San Vitale and Rome can be established with respect to the Roman formulation of the Doric order, with triglyphs and metopes. Once again Carlo Maderno proves the most likely intermediary.

The Roman Doric giant order in the church of Santa Croce in Riva San Vitale is unique in so far as a distinction must be made between its interior and exterior use. Not only are the sculptures (mascarons) and metopes on the main front far heavier-handed in execution, they are also different in subject (fig. 14). Whereas the main front exhibits only motifs illustrated in Giacomo Vignola's treatise, the metopes in the octagon relate directly to the builder (fig. 15). Santa Croce is the sepulchral church of its founder, the archbishop and apostolic protonotary Giovanni Andrea della Croce. Consequently, the octagon of Santa Croce is encircled by St. Peter's keys and the papal tiara, a sacramental monstrance, a chalice, a ewer and

fig. 11: Portrait of Carlo Maderno in the Museo Civico, Lugano, c. 1590.

fig. 12: Ground plan of a church. Detail from the portrait of Carlo Maderno in the Museo Civico, Lugano.

fig. 13: View of a domed church. Detail from the portrait of Carlo Maderno in the Museo Civico, Lugano.

basin, a processional cross and aspergillum, a miter and ostensories, a censer with incense boat and cruet, candlesticks, stole and breviary, and musical instruments.

"Personified" metopes and other "concetti" are comparatively rare in the history of architecture and tend to appear with particular frequency in the vicinity of the Mannerists, for example Giulio Romano. Domenico Fontana used them on the portals of the Palazzo della Cancelleria and the Palazzo Lateranense. The most significant parallel to Santa Croce is once again Bramante's Tempietto in San Pietro in Montorio. Because the building was considered the site of St. Peter's martyrdom, the metopes of the Roman Doric order were equipped with his symbols:[31] the frieze is decorated with the keys, chalice and paten, censer, and tabernacle. The Doric order was not an ecclesiastical order and had been inadequately passed down by Vitruvius. Consequently, Bramante's Tempietto entered the treatises of Serlio and Palladio as a new creation and was considered an "archaeological" example of the order. Christendom transferred the order of Jupiter to Christ and male saints, as Serlio noted in the preface to the Fourth Book:

> *Gli antichi dedicarano quest'opera Dorica a Giove, a Marte, ad Hercole, ed ad alcuni altri Dei robusti, ma dopo la incarnation de la salute humana devemo noi Christiani procedere con altro ordine: percioche ha vendosi ad edificare un tempio consacrato a Giesu Christo Redentor nostro, o a san Paolo o san Pietro, o a san Giorgio, o ad altri simili santi, che non pur la profession loro sia stati di soldato, ma che habbiano havuto del virile, e del forte ad esponere la vita per la fede di Christo, a tutti questi tali si convien questa generation Dorica.*[32]

The links between Bramante's Tempietto and Santa Croce – the proportional relationships of the height and width of the stories, the 3:2 ratio of the exterior width of the ground floor to the exterior width of the drum, the 2:1 ratio of the drum and the dome – become even more con-

fig. 14: Metope frieze on the main front of Santa Croce in Riva San Vitale. Detail.

fig. 15: Metope frieze above the columns of the octagon of Santa Croce in Riva San Vitale. Detail.

clusive in the overall use of the Roman Doric order and the "personified" subject matter of the metopes. For even after Bramante and up to Carlo Maderno's activities, the Roman Doric order was a rarity in Roman churches.[33] In fact, Francesco da Volterra's project for San Silvestro in Capite does not provide for triglyphs. Not only did Carlo Maderno introduce them here after Volterra's death; he added further personified decoration to the metopes, as he had on his own house at Via dei Banchi Nuovi 3 or on the Palazzo Mattei. They are also lacking on Francesco da Volterra's Sant'Atanasio dei Greci, whereas they can be found on the façade of San Giacomo degli Incurabili, the part of Francesco da Volterra's ovoid church that may justifiably be ascribed not only partially – for which there is documentary evidence – but totally to Carlo Maderno. Interestingly enough, the 15-module shafts of the columns here are also higher than usual, like the Corinthian columns in Santa Susanna, where Maderno first integrated columns into the plan of a Roman church front, as he had probably seen done in northern Italy.[34] Finally, it is striking that the Roman Doric order was carried on into the next generation of baroque architecture by his relative and confidant Francesco Borromini.

Conclusions

Recent research concludes that Pellegrino Pellegrini Tibaldi cannot be considered the author of the church of Santa Croce in Riva San Vitale.

Though the supervising architect named in the written sources, the Milanese architect Giovanni Antonio Piotti, known as Vacallo, is indeed well documented, no major buildings can be attributed to him. That is reason enough to assume that Piotti was responsible only for overseeing the actual construction process but cannot have been the designer of Santa Croce. This hypothesis is all the more convincing as the main front, which he is known to have designed, is relatively unimaginative and crude, and does not fit in with the overall concept of the building.

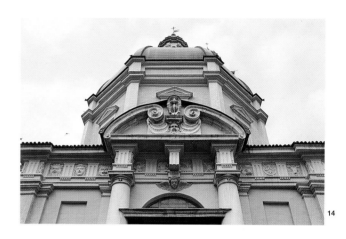

14

15

There are reasons to presume that the church of Santa Croce in Riva San Vitale was planned by Carlo Maderno, an architect from the neighboring village of Capolago who had emigrated to Rome early in life, and that Maderno left supervision of the construction to the local architect Giovanni Antonio Piotti. The numerous allusions to Rome in stylistically alien surroundings can only have been conveyed directly – by Carlo Maderno – from Rome to the Mendrisiotto: the use of the Roman Doric order on both Santa Croce and in Rome, the way its proportions were adapted, the quality of the design concept, the architect's contemporary frame of reference, and the buildings created in his proximity. Ultimately, the logic of a close local relationship between a prominent founder and a young, talented, well-trained architect – Carlo Maderno – furnishes convincing grounds to investigate and formulate the observations presented here.

Translated from the German by
Eileen Walliser-Schwarzbart

Notes

1 My thanks go to Anton Hofmann, from Zug, for preparing the drawings; and to Pierangelo Donati and Giulio Foletti, Ufficio dei monumenti storici del cantone del Ticino, Bellinzona, for making the photogrammetric plans available to me. The proportional studies (figs. 4-8) are based on 1:50 copies of the photogrammetric plans by A. and R. Pastorelli, Lugano, 15 November 1971.

2 For a characteristic summary of the present state of research, see Bernhard Anderes, *Kanton Tessin,* Kunstführer durch die Schweiz, vol 3. (Zurich, 1976), pp. 629-630.

3 For the contemporary regional architecture, see Gian Battista Maderna, "Per l'architettura religiosa nelle diocesi di Milano dopo S. Carlo. Il Catalogo del fondo Spedizioni Diversi," *Arte Lombarda* 70/71 (1984), pp. 47-136.

4 Attributions in Aldo Crivelli, "L'architetto della chiesa di Santa Croce di Riva San Vitale: Giovanni Antonio Piotti," *Rivista storica ticinese* 4 (1941), pp. 457-462, 506-510, esp. p. 460; Hans Willich and Paul Zucker, "Die Baukunst der Renaissance in Italien," *Handbuch der Kunstwissenschaft 11/12* (Wildpark-Potsdam, 1930), p. 159; Stefano Della Torre, "L'architetto Giovanni Antonio Piotti da Vacallo e la renovatio cinquecentesca del *S. Abbondio,*" *S. Abbondio, lo spazio e il tempio* (Como, 1984), pp. 277-282, esp. n. 16.

5 Giorgio Simoncini, ed., *"L'architettura" di Leon Battista Alberti nel commento di Pellegrino Tibaldi* (Rome, 1988), esp. p. 151; Aurora Scotti, "L'architettura religiosa di Pellegrino Tibaldi," *Bollettino del centro internazionale di studi di architettura Andrea Palladio* 29 (1977), p. 238 and n. 47. Compare also the Capella Poggi in San Giacomo Maggiore, Bologna, by Tibaldi, with engaged, fluted columns of the Tuscan order, and triglyphs and metopes in a strongly Manneristic but classically cool idiom which cannot be compared to Santa Croce. Proceedings of the Pellegrino Tibaldi congress: *Nuove proposte di studio,* ed. M. L. Gatti Perer, Valsolda, 19-21 September 1987 (in preparation).

6 See note 4 above and A. Lienhard-Riva, "Contributo alla storia artistica della chiesa di Santa Croce di Riva San Vitale," *Bollettino Storico della Svizzera italiana* 15 (1940), pp. 113-118. The plans had been deposited in the files of the attorney Giovanni Oldelli fu Matteo, in the Archivio Cantonale, Bellinzona, Scatola 2906. Aldo Crivelli, *Artisti Ticinesi in Italia,* vol. 4 (Locarno, 1971), pp. 67-88, with a definitive attribution to Piotti. For older monographic literature on Santa Croce, see Augusto Guidini, *Il tempio di Santa Croce in Riva San Vitale* (Milan, 1905); Giovanni Rocco, "Il Tempio di Santa Croce in Riva San Vitale progettato da Pellegrino Pellegrini," *Rivista Archeologica dell'Antica Provincia e Diocesi di Como* 99/100 (1930), pp. 201-26; Cino Chiesa, *L'Architettura del Rinascimento nel Cantone Ticino* (Bellinzona, 1934), pp. 41-45.

7 Note 5 above and Stefano Della Torre, "Disegni di G. Antonio Piotti per S. Croce di Riva S. Vitale," *Il disegno di architettura. Notizie su studi, ricerche, archivi e collezioni pubbliche e private* (1 May 1990), pp. 21-22. Piotti built a fish pond for Baldassarre della Croce in Riva San Vitale in 1583, so the family had already been acquainted with him for several years before the construction of Santa Croce. Stefano Della Torre, "L'architetto," p. 278.

8 Crivelli, "L'architetto," p. 509. Giuseppe Martinola, *Inventario delle cose d'arte e di antichità del distretto di Mendrisio* (Bellinzona, 1975), p. 460.

9 Adolf Reinle, *Kunstgeschichte der Schweiz,* vol. 3 (Frauenfeld, 1956), p.14.

10 Information according to the *Historisch-Biographisches Lexikon der Schweiz,* vol. 2 (Neuenburg, 1924), p. 648, and Crivelli, "L'architetto."

11 Contract quoted in Crivelli, "L'architetto" p. 462; photos in the Eidgenössisches Archiv für Denkmalpflege, Bern, Inv. Nos. 65849 (B. 4847), 65850 (B. 4848), 65860 (B. 4858), 65852 (B. 4850).

12 This discrepancy between outside and inside was already noticed by Giovanni Rocco *(Il Tempio),* whereas Aldo Crivelli ("L'architetto") describes the whole edifice as homogeneous in construction.

13 Della Torre, "Disegni." The two drawings are in the Archivio della Curia Vescovile di Como, fondo Fabbrica del Duomo, serie Fabbriche e riparazioni, fasc. 5, n. 83, 84.

14 The ground plan in the Archivio di Stato di Novara, raccolta De Pagave n. 21, was long misinterpreted as the plan of the church of Santa Maria di Canepanova in Pavia: Francesco Malaguzzi Valeri, *La corte di Lodovico il Moro,* vol. 2 (Milan, 1915), p. 120, fig. 138; Giuseppe Struffolino Krüger, "Disegni inediti d'architettura relativi alla collezione di Venanzio de Pagave," *Arte Lombarda* 16 (1971), pp. 277-298, esp. p. 293. Rocco ("Il Tempio") and Crivelli ("L'architetto") recognized the connection with Santa Croce. Cf. Della Torre, "Disegni."

15 There is no need to try to attribute the plan to Carlo Maderno, for the calligraphy has no influence on the hypothesis developed here. For the difficulty of defining Carlo Maderno's style of drawing, see Howard Hibbard, *Carlo Maderno and Roman Architecture 1580-1630* (London, 1971), pp. 85-86.

16 Ibid., p. 29. For Carlo Maderno's probable authorship of the front of San Giacomo degli Incurabili, see below.

17 The 51.5-cm value of the southern Swiss braccio, which is mentioned in the relevant literature, was used on the building itself, as proven by the diameter of the giant columns inside, where the radius, as a module, once again averages 51.5 cm. The columns on the main front are somewhat thicker. The dimensions of the altars as we find them are somewhat smaller, 50.70 cm. Cf. note 19 below.

18 Fabrizio Frigerio, "La simbologia del Tempio di Santa Croce a Riva San Vitale," *Conoscenza religiosa* (Florence: I, 3, 1973; II,1, 1974; III,4, 1976). Kind communication from Elfi Rüsch, Locarno. Hermann Reinhard Alker, *Michelangelo und seine Kuppel von St. Peter in Rom* (Karlsruhe, 1968).

19 This elongated Doric order is a further argument against Pellegrino Pellegrini Tibaldi, who, in his treatise, adheres to the traditional shaft height of 14 modules. Simoncini, "L'architettura," p. 151.

The dimensions for the high altar mentioned in the original contract will serve as an example of the heightening of the orders. Cf. Lienhard-Riva, "Contributo," p. 118:

Proportions according to Vignola		Dimension in contract
1 1/2 module	entablature	6 1/2 uz.
1 1/2 "	frieze	6 1/2 uz.
1 "	architrave	4 1/4 uz.
1 "	capital	4 1/4 uz.
16	column with capital and base	77 uz.
14 " (shaft)	column without capital and base	68 1/2 uz.
1 "	base	4 1/4 uz.
2 "	column diameter	8 1/2 uz.
5 "	pedestal	21 1/3 uz.
		115 7/12 uz.

The proportional relations thus correspond to Vignola except for the height of the shaft of the column, which is 16 instead of 14 modules and was also executed that way, whereas the shafts in the church are 15 modules high. According to Vignola, the pedestal measures 5 modules; the contract names a somewhat smaller number, but the execution is once again adjusted to Vignola, so that the altar width of 116 uz. corresponds to the actual total height of pedestal, column, and entablature. The outer width above the free-standing columns is identical with the height of the shaft at the main and side altars. A comparison of the dimensions named in the contract with the dimensions as built yield a braccio of approx. 50.70 cm.

20 Nancy A. Houghton Brown, *The Milanese Architecture of Galeazzo Alessi* (New York, 1982).

21 Crivelli, "L'architetto," p. 460.

22 The following according to Hibbard, *Carlo Maderno,* pp. 35 ff., 93 ff.; Giovanni Baglione, *Le vite de' pittori, scultori, architetti...,* 2nd ed., (Rome, 1649; Velletri 1924), pp. 307-309. Nina Caflisch, *Carlo Maderno* (Munich, 1934); Ugo Donati, *Artisti Ticinesi a Roma* (Bellinzona, 1942), pp. 97-162. 1556 cannot be established with absolute certainty as the year of Maderno's birth, it is deduced from the age he is said to have been when he died.

23 Domenico Fontana, *Della trasportazione dell'obelisco vaticano et delle fabriche di Nostro Signore Papa Sisto V* (Rome, 1590); Klaus Schwager, "Zur Bautätigkeit Sixtus' V. an S. Maria Maggiore in Rom," *Miscellanea Bibliotheca Hertzianae* (Munich, 1961), pp. 324-354, with no mention of Carlo Maderno.

24 Peter Murray, *Architektur der Renaissance,* Weltgeschichte der Architektur (Stuttgart, 1975), fig. 321. On Michelangelo and his project for San Giovanni dei Fiorentini in Rome, see Alker, op. cit., fig. 42.

25 Hibbard, *Carlo Maderno,* pp. 124, 121.

26 Malaguzzi Valeri, *La corte,* vol. 2., pp. 115-26.

27 The form is missing in Giovanni Battista Montano, *Tabernacoli diversi novamente inventati* (Rome, 1628).

28 Museo Civico, Lugano, "Autore anonimo, Ritratto di Carlo Maderno," oil on canvas, 122 x 97 cm.

29 Caflisch, *Carlo Maderno,* pl. 31.

30 Cf. for example the exhibition catalogue *Nell'età di Correggio e dei Carracci. Pittura in Emilia dei secoli XVI e XVII* (Bologna: Pinacoteca Nazionale, 1986), with self-portrait by Annibale Carracci 1585, Brera, Milan. Ball at the court of King Henry II of France, 1581, school of François Clouet, Louvre Paris.

31 Murray, *Architektur,* pp. 142-148.

32 Erik Forssman, *Dorisch, jonisch, korinthisch: Studien über den Gebrauch der Säulenordnungen in der Architektur des 16. bis 18. Jahrhunderts,* (1961; Wiesbaden, 1984), p. 20.

33 Hibbard, *Carlo Maderno,* p. 120.

34 Ibid., p. 41.

Picture credits

figs. 1, 2: Theres and Urs Bütler, Lucerne

fig. 3: Archivio di Stato di Novara

figs. 4-8: Amt für Denkmalpflege und Archäologie des Kantons Zug, Anton Hofmann

fig. 9: Gabinetto dei disegni e degli stampi, Uffizi, Florence

figs. 10, 14, 15: Heinz Horat, Kantonale Denkmalpflege Zug

figs. 11-13: Museo Civico, Lugano

Albert Knoepfli

Art History and Art Historiography of the Lake Constance Region

When greeting Swiss neighbors, the mayor of Feldkirch in the
Vorarlberg Rhine Valley used to observe drily that his town was
closer to Paris than to the Austrian capital, Vienna – and not just
in terms of kilometers. And I recall the legend on a road map,
published in Vienna in 1938, which stated that in Austria people
drove on the left; only in Vorarlberg, as in Switzerland, did they
drive on the right, using the left to overtake. To the east and
south of the lake, the region of Vorarlberg and the Swiss cantons
of St. Gallen and Thurgau securely abut onto the hills of
Bregenzerwald and Alpstein. To the north lies the Schwäbische
Meer (Swabian Sea), ridge upon ridge of mostly rolling hills,
receding from the German side of the lake as far as the eye can
see. They have an unresolved look about them, as if the lake
were recalling the efforts of its branch waters at one time to
reach out to the Danube basin. Only during the course of the
last Ice Age did the original Rhine (Ur-Rhine) seek out and find
a way to the west, at about the same time as encroaching glaciers
were preventing the Thur from reaching the lake, causing it, too,
to strike out westward. The new direction was not an easy one
for the Rhine to take. Scarcely out of the Untersee (lower lake)
with its many inlets, it ran into the rocky barriers of the Jura not
far from present-day Schaffhausen.

Lake and River, Land and People

The Lake of Constance, at the very heart of Europe, is one of the largest inland bodies of water of the continent, with a surface area of some 539 square kilometers. Its name goes back a long, long way. Pomponius Mela, in AD 43/44, called it Lacus Venetus, after the Rhaetian tribe of the Veneti, who belonged to the Illyrian language group. The Latinized Lacus Brigantinus of Pliny the Elder, perhaps also the Lacus Acronus, the Untersee, would seem to be of Celtic origin. It is not difficult to relate the German name for the lake, Bodensee, to Bodmann, the name of the ancient Frankish palatinate situated on the Überlingen arm of the lake and dating back to 579. According to Arno Borst, the scholarly Reichenau monk Strabo did not want to be reminded of Alemannia's former oppressors and thus preferred a Graecizing Lacus Potanicus, or river-lake.

The national boundary, running east-west through the middle of the lake, was a result less of complicated treaties than of cleverly perpetuated common usage. Vorarlberg borders on the eastern inlets, and the town of Bregenz, not far from the confluence of the Rhine, is more closely connected with the Lake of Constance area than with the Austrian heartlands. At the north end of the upper lake, near Lindau, Bavaria secured a short length of lakefront for itself. With Constance, Baden-Württemberg advanced to the left of the Rhine, where, in terms of settlement, it entered into a marriage of convenience with Thurgau's Kreuzlingen. Conversely, where the Rhine leaves the lake near Stein, Switzerland made a slight incursion northward across the river, the name of which had already been established before individual dialects had developed. On the opposite side, slightly lower down (already Zurich territory) on the left of the Rhine, lies the town of Schaffhausen, likewise Swiss, whose northern and only hinterland extends far into the hilly border area.

Lake and river are both bridge and valley at the same time. The Irish missionary Columban (c. 530-615), who re-Christianized the Arbon and Bregenz area, extolled the lake as a golden shell. In the same vein, the German poet Emanuel von Bodmann saw it in 1946 as a shell wrought of mother-of-pearl. The rivers and streams flowing into the lake from all around mingle with its waters. Only the Rhine, shortly after its confluence and with some of its thrust spent, plunges into the depths, its cold waters laden with suspended matter, but yielding none of their momentum until leaving the Untersee far to the west. The fate of cultures is not unlike that of the tributaries. They gather in the lake's basin, attest to its spiritual unity, and yet bring something of their own cultural landscape with them to add to the waters. Ultimately, the waters have come to symbolize the region. Other kinds of currents have failed to churn up the depths and, like the Rhine, more or less manage to avoid intermingling. But what is the effect of such metamorphoses, characteristic as they are of the region? The dramatic contrasts of the great stylistic currents diminish as they encounter the introverted character of Alemannic man. They meet a being turned in on itself, an inwardness often shielded by a mantle of sobriety. Language and the monuments of language are, like art and landscape, devoid of heroic traits. Romance, the language of the Roman province of Rhaetia, did not yield to southern Alemannic until the early Middle Ages. The latter is the language spoken in a variety of colorful dialects throughout the whole of northeast Switzerland. It is distinguished on the right side of the Rhine, west of the Radolfzell bay, from the Alemannic of the upper Rhine by a dividing line extending into Alsace. Its own territory, under pressure from Swabian, is restricted to a narrow corridor to the northeast of Lake Constance.

Fine distinctions like these are of little concern to us Swiss. The people living across the lake are just *Schwoobe*, or Swabians, to be alternately loved, hated, or made fun of. As late as the nineteenth century, Constance was referred to as "the secret capital of Thurgau." They and we understood each others' dialects, and if from time to time there was a certain distance between us, we were soon on good terms again. In the twentieth century the horrors of two world wars (1914-1918 and 1939-1945) put this

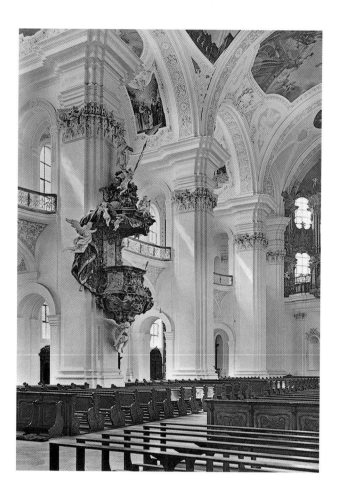

peaceful coexistence severely to the test, as did the Hitler era to scarcely less disastrous effect. From its position of neutrality on the sidelines, Switzerland, at times completely isolated, also suffered, but to a much lesser degree than her more unfortunate neighbors, plunged as they were into National Socialism and war. Our country, having to fend for itself, strengthened internal ties within its quadrilingual confederation. Things foreign began to seem strange again. High German, a foreign language compared to Alemannic, seemed even harder to learn - though our neighbors, experiencing even greater linguistic turmoil, may have found it easier.

But in spite of everything, particularly political divergences, the basic feeling of belonging together was never entirely lost, especially when neighbors' profound suffering made itself heard across the border. In the second half of this century, the barriers have gradually fallen. Culturally speaking, interchange has never completely stalled. But the thread cannot simply be picked up where it was broken off; too much has been lost, and too much that is new has come along. And today, when the dream of a Euroregion centered on the Lake of Constance is supposed to become more than just a pipe dream, when there is not just a rush but a positive stampede to forge links, the ever-recurring dilemma of how to achieve the much vaunted unity without sacrificing variety, contour, and profile could become the key question of our time.

Art History of the Lake Constance Region: A Tentative Overview

No matter how brief our account might be, we must first consider the subject matter of our art historiography, while bearing in mind the risk of simplification and distortion.

Little is known about the art produced in our area from the first traces left by Stone Age man up to the importations and individual achievements of the Celts, Romans, and early medieval Alemanni. Twice in history the Rhine and Lake of Constance were the frontier of the Roman

figs. 1-2: Church of the Benedictine monastery in Weingarten, 1715-1724. Supervised until 1716 by the Vorarlberger Franz Beer and completed by the German-Italian Donato Giuseppe Frisoni. Brother Kaspar Moosbrugger of Einsiedeln, Johann Georg Kuhn, Johann Jakob Herkommer, Joseph Schmuzer, and Brother Andreas Schreck were provably involved in the design phase. The interior shows a tendency to disengage the pilasters.

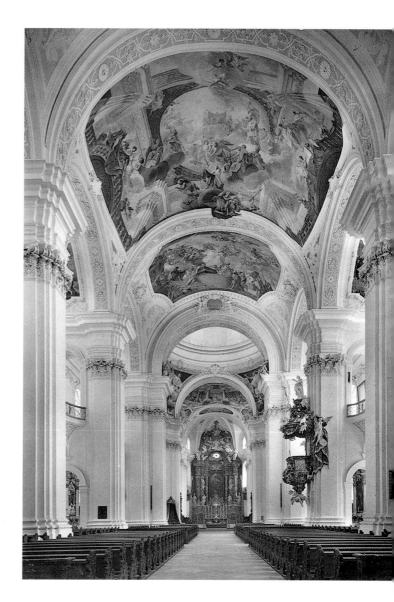

Empire. After their advances in 15 BC, the conquerors divided the province of Gaul from the province of Rhaetia with a *limes*, a boundary which was defended with towers and forts and ran from the Schaffhausen border area to Eschenz (Tasgetium), then diagonally to Pfyn (Ad Fines), and on southward to the Hörnli. In the second and third centuries AD, the Rhine frontier lost some of its importance owing to the onward march of the Romans, but it regained this in AD 260, when they were driven back by the Alemanni. Between the beginning and the middle of the fifth century, the Germanic tribes seized this area too, but their acquisition of the land destroyed neither the Gallic nor the Rhaetian provincial culture.

Early medieval times were marked by Christianization, already started under the Romans, by the struggle of the Alemannic dukes against the more powerful nation-building Franks, and by their need, through the legitimacy conferred by the continued potency of the idea of the Roman Empire, to confront the legacy of antiquity. In the Lake Constance area it was the Benedictine monastic foundations that became both the vehicles and the beneficiaries of this process, notably St. Gallen and Reichenau, but also the diocese of Constance, founded in 590.

When the Irish missionary Columban left Bregenz and Arbon, his companion Gallus stayed behind as a hermit in the inaccessible valley of Steinach. At the site of Gallus's cell the Alemann Otmar founded the monastery of St. Gallen in 719. Around 724, apparently at the behest of the Frankish palace mayor Charles Martel, the monastery of Pirmin, an itinerant bishop from Aquitaine, was founded at Reichenau. The monks not only painted murals in St. Gallen's abbey church; the famous St. Gallen monastery ground plan, dating from about 824, was also drawn at Reichenau, and is not, as was long thought, the product of Aachen centralism. The St. Gallen abbey library houses examples of fantastically ornamented Irish manuscripts not produced there but left behind as pilgrims' gifts, and outstanding examples of locally produced late Carolingian illuminated manuscripts which are quite clearly influenced

by the rationalizing effects of the Carolingian revival of interest in classical antiquity. What has survived in the way of Reichenau illuminated manuscripts and murals are from the tenth/eleventh century and were influenced either directly by antiquity or in a roundabout way through Carolingian and Byzantine byways. Here different currents joined forces to form a mode of expression directed toward the abstract – mysteriously moved by the spirit, visionary, and wonderfully transfused with light. It transcends the violent impulses of the Carolingian epoch. Similarly, in the Ottonian period, the bishops of Constance endeavored to make "Felix Mater Constantia" a splendid reflection of the holy city of Rome and to show this to effect in the church architecture of their city.

The contribution of the secular patrons of culture, the high nobility in their forts and castles, is more difficult to define because the nimbus of the sacred long enveloped the profane. Ottonian art was overlapped by its successor, Salian art. This, together with the art of the Hohenstaufen period, is classified as "Romanesque." Its square module, frequently applied in combined systems, had a formative impact on architecture. Its unique achievement, not modeled on the column orders of antiquity, is the purely geometric block capital. The Lake Constance/Rhine regions appear to have made telling use of the block capital at a very early stage (Schaffhausen, Reichenau). This was the time of Cluniac or Hirsau monastic reform, the ecclesiastical and political turbulence of which left its mark on our region as well. The Romanesque style only slowly managed to free itself of a typical fossilization of form during the thirteenth century, shortly before the Gothic manner spread from France.

In place of a complex network of currents, a broad stream now started flowing from Ile-de-France and the Rhenish states. The whole Gothic world of thought and its repertoire of form – the heightened sense of proportion, the mystic play of light in the cathedrals, the devotional pictures ingratiatingly addressing the individual – now embraced the art of the Lake Constance region, arriving,

however, not with the customary stylistic delay, but making an immediate and powerful impact. The heralds this time were not the Benedictines but the new preaching and mendicant orders, whose efforts were focused on towns and their inhabitants. They included the "unworldly" Cistercians as well as the Dominicans and Franciscans. In our region, however, Gothic splendor was transmuted in the still depths into more modest yet intimate forms, notably into an art expressing a quasi-mystical love of God, the strongholds of which were the nunneries. In an oddly profane way, the minnesong of the knights, with its worldly but idealized expression of love, formed an appropriate counterpart.

Politically and culturally, Constance asserted its claim to be both a center and a hub. In some ways, its importance and cosmopolitanism culminated between 1416 and 1418, when the Council of Constance was held. Its diocese stretched to the Alps, and its trade relations also extended far and wide. The influence of the Low Countries was another element in the north-south current which intensely affected south German art.

After these years, however, things became less auspicious. The dominance of the nobility waned. Competition sprang up in the form of a burgeoning bourgeois culture, its numerous lesser urban centers also attracting important artists. In 1414, with the conquest of Thurgau, the confederation advanced to the very edges of Lake Constance, pushing the Habsburgs off to the east. But too often the Swiss responded to the peaceful Swabian pilgrimages to Einsiedeln and on to Santiago de Compostela with attacks by bands of irregular soldiers. Mutual harassment and bottled-up hatred exploded in 1499 in the Swabian, or Swiss, War. The fissure that had begun to form at the end of the fourteenth century now opened up, severing the southern piece of the Lake Constance region de facto from the Holy Roman Empire of German States, though this was not officially ratified until 1648 in the peace agreement following the Thirty Years' War. Meanwhile the impact of the Reformation on both sides of the

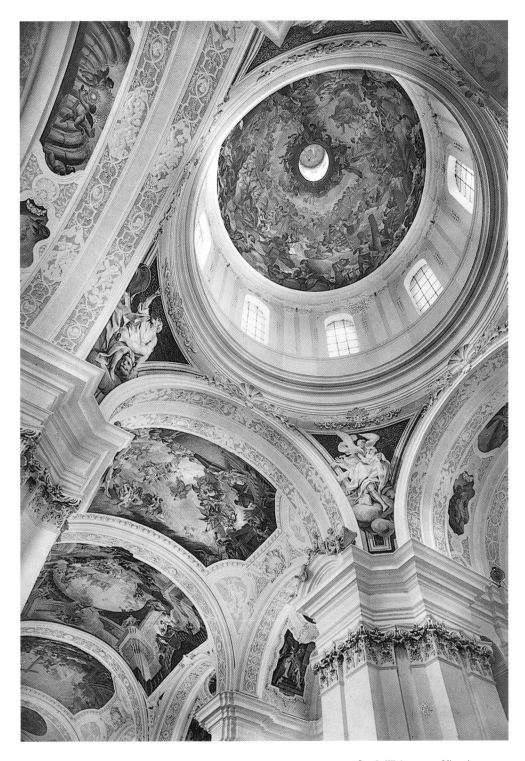

fig. 3: Weingarten. View into
Frisoni's lantern, an indication of
the way this baroque space
is to be traversed for its triumphal
culmination to be experienced.
Plasterwork by F. Schmuzer, fres-
coes by the Bavarian Cosmas
Damian Asam.

fig. 4: Weingarten. The convex façade between the towers. Frisoni's contribution above the cornice of both façade and towers is clearly perceptible. The power unleashed by the central section seems to be forcing the towers apart.

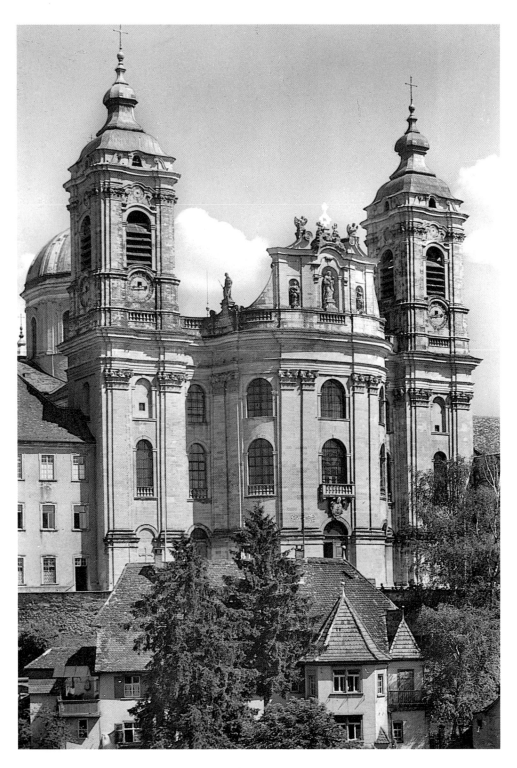

new political divide had led to further disintegration. A variegated confessional patchwork was a serious impediment to cultural unity. The bishop transferred his seat to Meersburg, and Constance struggled on unhappily and irresolutely, losing its status as a free imperial city in 1549 and eventually being relegated to the standing of an Austrian provincial town.

It is as if the future schism were already being prefigured in the late Gothic passion for church construction. Numerous new churches of a uniform type were built in villages on both sides of the divide. A smaller vaulted chancel lantern mostly abutted a widened nave. In the towns, however, the hierarchically structured basilica gave way to the staggered-apse church and hall-church, which could accommodate more townsfolk to hear the sermon.

Typically, the new Renaissance, well disposed as it was toward antiquity, did not reach the Lake Constance region by way of the Swiss Alpine passes. Like a kind of current in reverse, it arrived from Augsburg around 1515, initially influencing the painting, printwork, and sculpture of the workshops established along the lake and the Rhine. In the more static discipline of architecture, it gave rise mainly to hybrid styles of an anecdotal character.

Soon the Gothic sense of form reawakened, and the abandoned Gothic repertoire was taken up again: by the Catholics as a demonstration of their traditional orthodoxy, and by the Protestants to legitimize their rediscovery of early Christianity. Under a thin Renaissance veneer, inhospitable fortresses turned into more habitable castles, and the still predominantly wooden town dwellings came to be interspersed with stone buildings, which, however, seldom had anything palatial about them. The replacement of wood by stone in the towns was a slow process. During the Counter Reformation, Jesuit master builders embraced the pilaster church. In Vorarlberg, influenced by Italian, Bavarian, and Austrian models, they developed this further, interrupting the uniform progression of bays, redistributing the spatial elements, transposing them, centering them, until fusion and excessive exuberance of design totally overshadowed the basic architectural plan.

If the art of the Italians, the Austrians, and the Augsburg Academy held sway here, it was not long before the chill wind of classicism, deriving from the principles of the French Enlightenment, bore down on a Lake Constance region now tired of rococo. Quickly enough, it is true, its cool correctness of style was transformed into the warmhearted bourgeois coziness of Biedermeier; yet increasingly the creative forces of the region, also influenced by the development of mass production techniques, began to fall into line with the stock international models of the surrounding schools of art and architecture. This can be seen in the clear differences between "real" Gothic and the Neo-Gothic, Neo-Baroque, and other imitative and pluralistic styles, which are themselves distinct from one another. Even now the stimuli emanating from Zurich, Vienna, Paris, Munich, or Stuttgart have not been exhausted. Thus we have art nouveau, reform style, *Heimatschutz* (conservation and protection movement), the *neue Sachlichkeit* (new functionalism), and so-called postmodernism. And we also have what might teasingly be called "high-yield Gothic" – an over-the-top hotchpotch of housing styles, which is beginning to invade our countryside and recreational areas.

Art History Defined in Terms of Nation States

Nineteenth-century statistics on works of art, the "inventories," handbooks, and art guides, were – if only because of their national origins – not sensitive either to regional or cultural links. The pen-strokes of the politicians, i.e., the often quite arbitrarily drawn state and national boundaries, were, and still are, what mattered. Regarding such divisions as self-evident, F. X. Kraus published his account of the Constance region in 1887, and in 1899 J. R. Rahn's work on the municipalities of the Canton of Thurgau appeared. Both books were almost exclusively concerned with works of art up to the Renaissance. The inventory scene livened up with pre- and post-World War II publications dealing with the Lake of Constance region – but there was still a good deal of catching up to do. However,

183

there was a growing realization that, without an appropriate methodology for compiling inventories, the whole enterprise of conserving historical and artistic monuments was doomed to failure. In 1931 the state of Württemberg produced the volume on Tettnang by Matthey/Schahl, and in 1937, that on Ravensburg by R. Schmidt/Buchheit. Switzerland, which adjoins Liechtenstein, published an account of the Zurich Andelfingen district by H. Fietz in 1938 and a volume on the Principality of Liechtenstein by E. Poeschel in 1950. Three volumes on Schaffhausen by R. Frauenfelder appeared between 1950 and 1960, three volumes on Thurgau (A. Knoepfli) between 1950 and 1962, and an account of Winterthur (E. Dejung/R. Zürcher) in 1952. Württemberg followed with a volume on Wangen i. Allgäu by Count Adelmann (1954) and in the same year one on Swabian Bavaria, including Lindau, by A. Horn/W. Meyer. Then came South Baden with a volume on the cathedral of Constance by H. Reiners (1955), and from 1957 to 1961 that doyen of the inventory, E. Poeschel, sprang a surprise with volumes on St. Gallen and its abbey, following the important groundwork done by A. Fäh, A. Hardegger, and others.

Dagobert Frey's Vorarlberg/Feldkirch volume of 1958, edited from far-off Vienna, shows just how problematic national demarcations can be in practice; Poeschel's work of eight years earlier, which dealt with the Vorarlberg's immediate southern neighbor Liechtenstein, was published under the aegis of Bern. Further gaps have since been filled with three volumes on Appenzell Ausser Rhoden (1973-1983, E. Steinmann), one on Inner Rhoden (1984, R. Fischer), one on north Winterthur (1986, H.-M. Gubler), and one on the St. Katharinenthal Dominican convent in the Canton of Thurgau (1989, A. Knoepfli).

A cause of disquiet everywhere was the way in which epochal limits were becoming ever more flexible and the focus of art history was shifting to cultural phenomena in general, with the stress being laid on the ensemble, on the coherence of cultural history, rather than on the individual detail. The handbooks of German works of art started and edited by G. Dehio between 1905 and 1912, and running to five volumes, were extended by E. Gall in 1938 and then taken up anew in 1974 in Austria. The volume on Vorarlberg appeared in 1983, and we have to be satisfied with it, given the absence of any inventory volume on Bregenz. In the German Dehio undertaking, Switzerland was relegated to an appendix, with a contribution by K. Escher.

During the Hitler regime and World War II, Switzerland found itself completely isolated, turned in on itself, and Hans Jenny's 1934 monumental pioneering guide to Swiss art was a cause for rejoicing. This project was promoted by, among others, J. Zemp and L. Birchler, both presidents of the Federal Commission for the Preservation of Historical Monuments. Between 1971 and 1982, under the direction of H. R. Hahnloser and A. A. Schmid, the Society for the History of Swiss Art published a revised edition of "Jenny" in three volumes, complete with a survey by Peter Meyer.

There was, of course, no digression over the border, just as there was none in the numerous special series – which were constrained by both subject matter and national boundaries – on the architecture of the town house, castle, and stately home. The same limitation applies to the superb *Corpus vitrearum Medii aevi* series, of which – building on the groundwork of H. Rott, H. Wentzel, E. Maurer, and G. Spahr – E. J. Beer wrote *Switzerland* I (1956) and III (1965), and R. Becksmann the volume on Baden/Pfalz (1979), i.e., the volumes concerning works of art that should be discussed in connection with the stained glass of the Lake Constance region. Even publications like the German *Glockenatlas* (S. Thurm, 1959) are oriented to art history and cultural history. But here we are in danger, though the ways be good and our selection rigorous (but not completely free of capriciousness), of getting lost in thickets of names! Not exactly interesting for the reader, but invaluable for the cause.

As is only to be expected, any ordering of the literature suffers from constant overlapping. The general

fig. 5: St. Gallen. Former abbey church, now cathedral. Contributors to the two-towered façade (1761-1766) include the Vorarlberg architect Johann Michael Beer von Bildstein, St. Gallen monk Gabriel Loser von Wasserburg (ennet dem See), who built the model, and Joseph Anton Feuchtmayer, from Mimmenhausen near Salem, as sculptor. Before the tower-beleaguered central section can develop, it is wrenched into the vertical by the towers' upward lift.

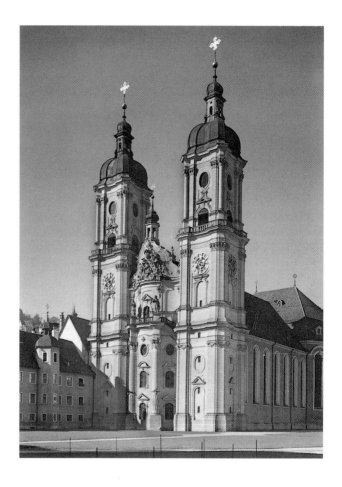

 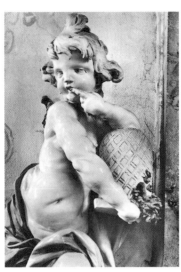

figs. 6, 7: Birnau on the Lake of Überlingen. Cistercian pilgrimage church built and decorated by Peter Thumb (architect), Joseph Anton Feuchtmayer (sculptor, stuccoworker), and Gottfried Bernhard Göz (painter), 1747-1750. Gallery: Gospel side, gilt wood bust of St. Peter; Epistle side, Altar of St. Bernard of Clairvaux, marble putto - the so-called "Honey-licker" – both by Joseph Anton Feuchtmayer.

accounts of Baden-Württemberg and Bavaria more or less cover the art history of the whole German hinterland, and so we will restrict ourselves to nationally oriented art histories of Switzerland and Vorarlberg. The nuances of the titles alone are revealing. Rahn (1879), the textbook by O. Pupikofer (1914), and Paul Ganz (1960) offer a cautious formulation, *Kunst in der Schweiz* (Art in Switzerland), while H. Waschgler in his *Kunstgeschichte Vorarlbergs* (Art History of Vorarlberg) of 1927 dismisses the idea that the art of the Vorarlberg could be misunderstood as a uniformly national art. Likewise, J. Gantner published the first two volumes of his *Kunstgeschichte der Schweiz* in 1936 and 1947, and A. Reinle retained this title in volumes three and four (1956, 1962) and a revised version of the first volume (1968). Volume four of the series *Landes- und Volkskunde, Geschichte, Wirtschaft und Kunst Vorarlbergs*, edited by K. Ilg, is simply entitled *Kunst* (1967, K. Spahr, G. Ammann, N. Lieb, H. Machowitz), and Switzerland impressively cleared the hurdle in the twelve volumes of *Ars Helvetica*, edited by F. Deuchler, which appeared in 1991, the year in which the Confederation celebrated the seven hundredth anniversary of its founding. The title of the first volume, *Kunstgeographie*, by D. Gamboni (1987), subtitled *Die visuelle Kultur der Schweiz* (The Visual Culture of Switzerland), comes very close to the heart of our theme. An examination of the bibliographies shows quite clearly how often the authors felt the need to look across borders.

Cross-Border Monographs on Artists

Almost all the masters active in the Lake of Constance region turned their backs on regional insularity and worked in an environment that was not staked out with boundaries. The discussion about attributions and de-attributions, a favorite of the experts, has at times been quite heated, particularly in painting and sculpture. To take an example, Ilse Futterer and Karl Frei attributed, among other things, the carved *Jesus and John* group, which had been spirited away to Antwerp, to Heinrich of

Constance. They based this attribution on written records in the St. Katharinenthal Dominican convent, where this gloriously carved expression of mystic art originated. I have been able to confirm this identification. Julius Baum and Hans Wentzel used the same source to attribute the work, certainly incorrectly, to the late Gothic master Heinrich Iselin. This "Iselin legend" was accepted by Thieme-Becker as incontrovertible, but I refer readers to my volume on St. Katharinenthal (1989), where the matter is disentangled. The same volume also explains how the attribution of the convent's choir stalls to Heinrich Iselin, proposed by Baum in 1947, deprived Augustin Henkel of the credit for creating them, even though M. Bendel had already indicated as much in 1943. W. Deutsch also attributed these works to Henkel, basing his claim on my arguments, among others (1963/1964). Albrecht Miller, in his latest research, associates Henkel's father, Hans, with the similar choir stalls at Weingarten.

Taking the Lake Constance region as a whole, there are monographs on the woodcarvers, sculptors, and stuccoworkers: J. A. Feuchtmayer (W. Boeck, 1946, 1948), G. A. Machein, the Zürn dynasty of woodcarvers (C. Zoege von Manteuffel, 1969), the stuccoworkers Andreas and Peter Moosbrugger (A. Morel, 1973, one of the many monographs which I included in 1981 in H. Maurer's collection *Der Bodensee*, pp. 332 ff.), and the variously gifted C. Wenzinger (J. Krummer-Schroth, 1987).

The attribution of works to artists active in several regions often necessitated cross-border collaboration. The Three Kings Altar from St. Katharinenthal in the Swiss Landesmuseum in Zurich is a case in point. G. Otto (1935, 1948/1949) thought that the reunited pieces were the work of Yvo Striegel, until A. Miller proved in 1987 that this member of the Memmingen workshop was not known with any certainty to have been a woodcarver, and that the work should be attributed to the Constance artist Heinrich Iselin. W. Hugelshofer's attribution of the Dominican genealogy on the back of the shrine remained unchallenged (Hans Haggenberg, 1490). However, the attributive merry-go-round continued with the sidepieces (in the episcopal collection of St. Gallen), both of which seemed to bear the hallmark of the "Hohenlandenberg Master" (T. Brachert, 1963; Hans A. Lüthy, 1964, 1969; A. Knoepfli, 1964, 1989)… except that they could not be reconciled with the Three Kings Altar. F. Thöne tried to identify the painter of the sidepieces, i.e., the Hohenlandenberg Master, as M. Gutrecht the Elder, but more recently B. Konrad has proposed M. Haider.

Among baroque painters, tribute has been paid to the Constance artist J. C. Stauder by T. Onken (1972), to A. Brugger by H. Hosch (1987), and to J. Wannenmacher by M. Reistle (1990). The architects are mostly considered in connection with regional groups. Even where authors concentrate on an individual personality, they cast their nets wide, thus: L. Birchler (1924) in *Br. Kaspar Moosbrugger und Einsiedeln*, or H. M. Gubler on Peter Thumb (1972) and on K. Bagnato (1985). The same holds for those altar builders who were at the same time stuccoworkers or plasterwork specialists. In this respect our region proved to be a melting pot of the nations. The most powerful were the Italians, then the locals encountered strong competition from Wessobrunn (Bavaria), the latter group in turn being upstaged by Vorarlberg artists. Monographs have been written on Lorenz Schmid, who was sidetracked into classicism (K. Medici-Mall, 1975), Dominik Zimmermann, who drifted from Regency to rococo (H. Schnell in conjunction with der Wies, 1979), and J. G. Dirr in Salem, who gave himself over to French classicism (C. Häusler, 1986).

Cross-Border Fields of Art

Whoever reads H. Ginther's grandly conceived *Südwestdeutsche Kirchenmalerei des Barock*, published in 1930, or volumes four and seven of A. Stange's *Deutsche Malerei der Gotik* (1951, 1955; complete catalogue revised by N. Lieb, 1970) will find national boundaries a source of irritation. Before I could begin compiling my Thurgau inventory, I had to have a good look round in the

neighboring parts of Germany and Austria. Innocent of any desire to make territorial gains, C. and D. Eggenberger included chapters on Lake Constance and the upper lake in volume five of *Ars Helvetica* (1989), which is devoted to medieval painting.

Illuminated manuscripts, the most footloose of all the arts, which time and again have managed to slip through the border checks, have found any number of champions. Since the sixties, for instance, the art historians E. Beer and R. Kross have rendered particularly valuable services. A large body of scholarly writings has grown around the Manesse and Weingarten collections of songs. Because, in the search for a spiritual home, nationality has played a role from time to time, the issue has also become one of prestige ... thereby favoring a holistic approach to the Lake Constance region.

The art of the goldsmith is another much sought-after field. At first, the splendid Reichenau shrines, for example, were attributed to French workshops, then to Strasbourg and Freiburg in Breisgau, and finally even masters of the Habsburg Vienna circle, until someone actually dared to suggest that they had been produced in Constance itself. Soon, treading warily at first but then at an alarming pace, D. F. Rittmeyer, I. Krummer-Schroth, W. Noack, A. Ohm, K. Guth-Dreyfuss, L. Ehrat, and many more reconnoitered the terrain until H.-J. Heuser, not entirely faultless, yet right in many ways, finally shed light on much that had been distorted. His monumental *Oberrheinische Goldschmiedekunst im Hochmittelalter* appeared in 1974. His work was subsequently built upon and revised, and the thread was traced through to the baroque period, the latest researchers in the field being E. von Gleichenstein and Count Douglas (1985).

Thanks to P. Kurmann's researches in the seventies, the architecture and sculpture of Constance around 1300 underwent a kind of rehabilitation. Kurmann believed that the creative achievements of the town at that time were on a par with the very best of the period, and he laughed out of court the convenient notion of a "stylistic lag." In the

publication of a catalogue of pre-Romanesque churches, protracted discussion led to the barely practicable geographic-spatial classification being replaced by a dynastic-temporal one. The three volumes, published by F. Oswald, L. Schaefer, and H. R. Sennhauser between 1966 and 1971, cover the period up to the end of the Ottonian empire and also include the whole of the Lake Constance area.

The same applies, albeit in a longer time frame, to W. Hoffmann's 1950 study of the Hirsau school of architecture, which only modified local architectural traditions where these diverged from the liturgical intentions of the reformers. Something else that was drastically cut down to size was the dogmatically held belief in the existence of a Vorarlberg school of architecture in the seventeenth/eighteenth centuries. This belief seems to have sprung up in connection with the growing esteem accorded to the once frowned-upon decadent style. Heinrich Wölfflin (1888) and A. Riegl (1908) characterized the late phase of every style as "baroque," whereas A. Schmarsow (1897) narrowed it down to the period between the Renaissance and classicism. Yet even a Linus Birchler (1893-1967) had to defend, with characteristic central Swiss robustness, the status of baroque works of art. And when I was a young man, even bad but "stylistically pure" Gothic was regarded as superior to good but more recent baroque.

From about 1914 on (B. Pfeiffer), one used to refer to a rigid Vorarlberg style of cathedral building and a doctrinaire school of architecture. But the seminal work on the baroque master builders of Vorarlberg by F. Dieth and N. Lieb (1960) changed all that, revealing a development that was anything but static and necessitating a revision of attitudes. Under the guidance of O. Sandner and W. Oechslin, a more balanced view of things began to emerge, as represented in exhibitions mounted in Bregenz and Einsiedeln. An extensive, painstaking catalogue was prepared by H. M. Gubler, F. Naab, O. Sandner, and H. J. Sauermost (1973). N. Lieb, for his part, also made a substantial contribution (1966, 1967, 1976), above all shedding light on

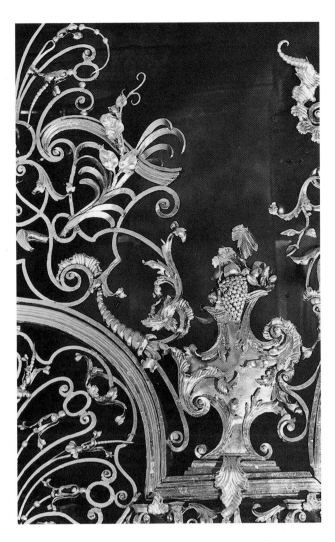

fig. 8: Fischingen, Thurgau. Monastery church. Wrought-iron work with gold and silver luster, in the arcade to the Idda Chapel; by Joh. Jakob Hoffner in Constance, 1743/1745.

the group of master builders native to the Bregenzerwald area, which from 1651 to 1687 comprised some six hundred members and trained eighteen hundred apprentices. Throughout the whole of central Europe cooperation flourished, and there was a lively exchange of ideas, rather like that of the Wessobrunn plasterers, master builders, and altar builders, who used to return to their Bavarian homeland during the winter, undergo further training, and absorb, for example, the canon of Regency forms which had been acquired from France in the form of patterns, subsequently disseminating them even further afield, including the Lake Constance region.

The crucial part played by the use of color was appreciated only very late, as was the case in the plastic arts in general. This had unfortunate consequences in the field of art conservation, which is why I became involved at an early stage, for the most part out on a limb, in researching stucco polychromy in Lake Constance baroque.

It is not particularly difficult to forge cross-border links when the objects of research are monuments linked from the outset by a common intellectual-historical bond, for instance, the shared Benedictine heritage of the monasteries of Reichenau and St. Gallen. Regardless of individual fortunes and cultural omens, the unity of the region is evident, even though the material may have been treated only fragmentarily in monographs. In 1925 a two-volume cultural history of Reichenau appeared, a bold undertaking overseen by Konrad Beyerle. The architectural history was written by Otto Gruber, an engineer, to be modified and amended only three years later by the high-school teacher Josef Hecht in his *Romanischer Kirchenbau des Bodenseegebietes.*

The continual refinement of archaeological methods and excavation techniques necessitated rethinking in all branches of architectural history research, and also set things in motion again with regard to Reichenau. Tragically, E. Reisser's account only appeared in 1960, eighteen years after the engineer's death. It proved necessary to rework his rich material, a task which was undertaken by

A. Zettler, who added important results from his own research and excavations, and published the whole in 1988. Zettler was able to reveal that the celebrated St. Gallen monastery ground plan was not just drawn up at Reichenau, but was a product of the architectural tradition there, rather than being imposed, as had previously been assumed, by Aachen. This unique document, which is housed in the abbey library of St. Gallen, was reproduced in facsimile form in 1952, with a commentary by H. Reinhardt. But that was not the end of the matter. B. W. Boeckelmann, for example, took it up again in 1952 and 1956, and K. Gruber in 1960. In 1961 E. Poeschel reported on the current state of knowledge, and in 1962 J. Duft published the proceedings of an international conference which had taken place in 1957. In 1979 W. Horn and E. Born presented their findings in three superb monumental volumes, published in Berkeley, and in 1983 Konrad Hecht and W. Jacobson took up the story. In short, there would be too little space here to do justice to all the twists and turns of the protracted debate.

But to return to Reichenau: here, too, research has long since been internationalized. The study and preservation work being done on the wonderful murals in the Church of St. George reflect the work of an international advisory commission. Particularly prominent on the publications front is Koichi Koshi of Tokyo University. Anyone interested in a brief introduction to the artistic significance of Reichenau should procure the eighth edition (1986) of the *Kunstführer* produced by Wolfgang Erdmann, who is also a distinguished archaeologist. Those interested in St. Gallen abbey will find the 1990 book edited by W. Vogler useful; it contains contributions on manuscript illumination by J. Duft and C. Eggenberger, on medieval architecture by H. Horat, and on baroque architecture by H. M. Gubler. J. Duft and E. Ziegler had already written about the monastery and the town in 1985, and B. Anderes on the abbey precinct in 1989. Here, too, it would be invidious to single out any particular work.

Artistic, Cultural, and Historical Landscape

There are one or two works not mentioned above which should now be considered by way of introduction to the final section. They include Josef Hecht's pioneering work on Romanesque church architecture (1927), his two-volume work on early medieval murals, completed posthumously by his son Konrad and published in 1979, and the first two volumes of H. Rott's work on southern German and Swiss art history of the fifteenth and sixteenth centuries (1933). These last two books are devoted to the Lake of Constance (1933), but, alas, their attributions are made in a very free manner. G. Poensgen's copiously illustrated book of 1951 also dealt with the Lake of Constance area as a whole, while in the second edition of 1964 the author no longer restricted himself to the area immediately surrounding the lake, but produced an overall picture of the main focuses of artistic interest in the different geographical subregions.

A. Schahl published his guide to the art of the Lake of Constance area in 1959; F. Thöne, his short book *Vom Bodensee zum Rheinfall* in 1962; and O. Fegers, his three-volume *Geschichte des Bodenseeraumes* between 1956 and 1963. This was the period after World War II, when Harald Keller began work on his *Kunstlandschaften Italiens* and I started on my *Kunstgeschichte des Bodenseeraumes.* Keller's work reached the bookshops in 1960, mine in 1961. I published a second volume in 1969 and, drawing on Arno Borst's *Mönche am Bodensee,* followed it up in 1981 with *Vier Bilder zur Kunstgeschichte,* which revised that earlier second volume and in some sections, for example that on "eternal Gothic," extended it into the twentieth century. These publications were included both in the *Bodensee* anthology, edited by Helmut Maurer, and in volumes 99/100 of the publication of the Verein für die Geschichte des Bodensees und seiner Umgebung (Association for the History of Lake Constance and its Surroundings). That volume of the yearbook, like the ponderous, antiquated title itself, is indicative of the long

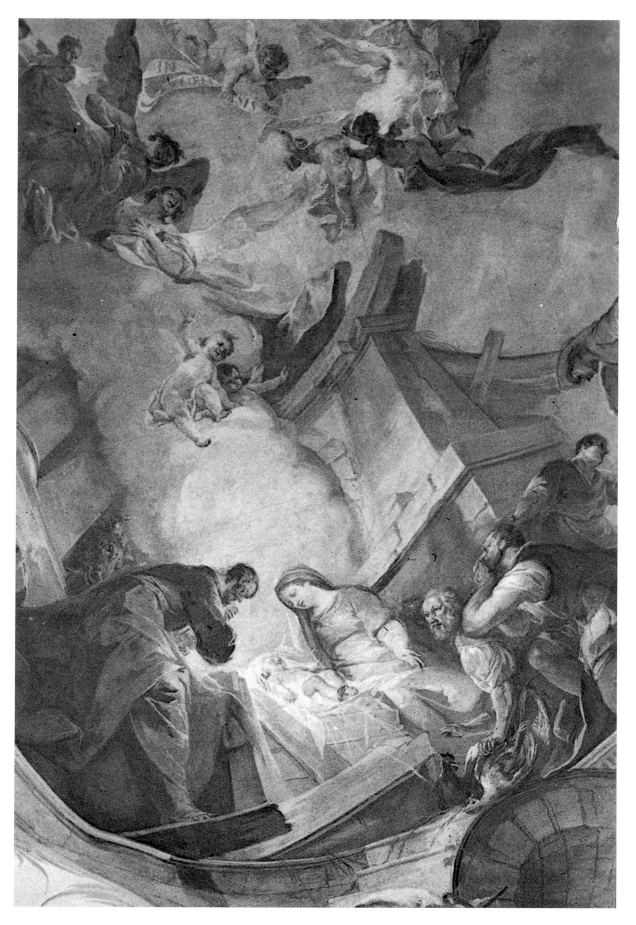

fig. 9: Baitenhausen near Meersburg. Ceiling painting (detail) by J. W. Baumgartner, 1760.

tradition that researchers and learned societies can draw on, and derive succor from, in their common, holistic endeavors.

In 1910 the Vienna-born Hugo Hassinger coined the term "art geography." Whether and to what extent he traced its roots back to antiquity, to art history movements of the nineteenth century, or to the milieu theory of H. A. Taine (1828-1893) still requires closer study. At any rate, others were striving in the same direction: J. Strzygowski (1918), K. Gerstenberg (1922), J. A. Brutails (1923), J. Puig i Cadafalch (1930), H. E. Kubach (1936 and later), and D. Frey (1938).

The work of H. Keller encountered a mood that was still suspicious of the so-called *Blut und Boden* doctrine of the Hitler era. And the Lake Constance area, too, was not without researchers whose eyes of innocent blue (or of whatever hue) turned a distinct shade of brown. Two examples will suffice. In 1945 the professor of art history at the University of Fribourg in Switzerland was deported on suspicion of National Socialist activities. Not very subtly, the South Baden government transplanted him to Constance to work as an inventory compiler – right under the noses of the Swiss. The Tübingen prehistorian H. Reinert had delighted Thurgau in 1925 with the general part of a prehistory of the region and was widely admired as the creator of the pile village of Unterruhldingen (1930). Unfortunately, however, he was appointed to Kossinna's chair in Berlin in 1934 and from 1942 rampaged as director of the Fachgruppe für deutsche Vorgeschichte (Special Group for the Study of German Prehistory), much to the horror of his more independently minded colleagues. With my art history of the Lake Constance area, I, too, became embroiled in the sad legacy of the Nazi era, though to a much lesser extent than H. Keller. Whether this was because my work on the area stood me in good stead or because people did not attach as much importance to my work, seeing reflected in it the dynamism of events rather than any static doctrine, I do not know.

Generally speaking, the art of the region has been characterized by constancy only in its very essence. At the geographic fringes and as periods ended and began, things changed as the situation demanded. But this does not invalidate Heinrich Wölfflin's basic ideas about that element in works of art that is independent of time and space. At the thirteenth German Conference of Art Historians held in Constance in 1972, the theme (discussed in the section "Lake Constance Art Landscape") was treated more judiciously. A shortened version of my paper appeared in *Unsere Kunstdenkmäler*, published in Bern in 1972. It also appeared together with the other papers and the closing remarks of R. Hausherr in *Kunstchronik* 10, 1972. Following a seminar at the University of Basel (Professors Brenk and Landolt), the *Zeitschrift für Schweizerische Archäologie und Kunstgeschichte* reopened the discussion in 1984 in connection with the question whether there is such a thing as typically Swiss art. Among others, L. Stamm investigated "the art of Lake Constance" as a pendant of Upper Rhine art, while G. Germann considered the criteria applied: causal connections, topographical demarcation, time frame, and objective validity. Contributions were to the point, taboos were lifted, and the far-ranging perspective of a works-of-art landscape (T. Breuer) was reconciled with the business of inventory-making.

At a time when Europe is becoming increasingly integrated, this sounds promising indeed, particularly if one considers how well it goes with that awareness, never quite lost even in times of greatest estrangement, of a unifying mentality and common cultural basis, with supportive material and spiritual cross-border interaction, and with the formal *Euregio Bodensee* that is now being vigorously pursued. But it must not come about in the sense of a leveling down that throws all federalistic thinking overboard. Only a fool would want to build a bridge after he has demolished the river banks. And the ties radiating outward and backward of each of the countries touching on the Lake of Constance should not be severed in one fell

swoop in favor of those powers that are concentrated in, and focused on, the region. But for me the dangers lie less in the barriers of state than in the setting up of barriers in the academic disciplines in general and our own field in particular. It has been my experience as a long-standing member of both the Bodenseegeschichtsverein (Lake Constance History Association) and the Konstanzer Arbeitskreis für mittelalterliche Geschichte (Constance Medieval History Association), founded by Theodor Mayer, that, in spite of generally cordial relations, the two circles in reality have very little to do with each other. Even for someone in Zurich, the Lake Constance region is already on the fringe of things – they say, not unjustifiably, that "abroad" begins east of Winterthur! As long as Thurgau, my stamping ground, was written off as a cultural wasteland, it was difficult to gaze both into the Confederation and across the lake and Rhine at the same time. The danger of becoming cross-eyed was great.

To turn to intermural difficulties, on the fundamental changes and upheavals to which border areas are much more sensitive than the far better cushioned central regions, it would be possible to write a whole book. It would range from the decline in the creative power of scientific language to the new Babylon of the different sorts of professional jargon, which, extending far beyond the true needs of the specialty, enter asocial spheres excellently designed to limit understanding and conceal sloppy thinking. And then there is the tidal wave of information flooding in on us through the euphoric media. This information is as intellectually indigestible as it is unfathomable in terms of usefulness and depth, but it is often designed to eradicate hastily, all too hastily, the achievements of previous generations from the public memory. In this context, even the computer is relatively powerless to help. Finally, we should not overlook the overweening egoism and pathological ambition that destroys the very things it is seeking to foster. When I discussed this with the California art historian Walter Born in 1957, he said: "That is just the difference between us Americans and you Europeans;

when a truth is discovered here, we are all jubilant. In Europe, however, only the discoverer rejoices."

Teamwork no more excludes individual achievement than international cooperation excludes a healthy portion of ambition, exceptional endeavor, and the predominance of any one of the participating nations. Much is made of the generation problem, and even if close links are severed and all (essential) overlapping is declared to stand in the way of progress, it will still be a problem. In the final analysis, however, let us not lose sight of that glimmer of silver on the horizon of the Lake of Constance, and let us continue to take comfort from it as a favorable omen for our joint pursuits.

Translated from the German by BMP Translation Services

Picture credits

fig. 1: Dr. Johannes Steiner, Munich (Schnell and Steiner)

fig. 2: Landesbildstelle Württemberg; Deutscher Kunstverlag, Munich

fig. 3: Helga Schmidt-Glassner, Deutscher Kunstverlag, Munich and Berlin

fig. 4: Helga Schmidt-Glassner, Deutscher Kunstverlag, Munich and Berlin

fig. 5: Rud. Suter, Oberrieden-Zurich

fig. 6: Karl Alber Freiburg i.Br. No. 8002

fig. 7: Simon und Koch, Constance

fig. 8: Thurgau Denkmalpflege Frauenfeld, Willy Müller.

fig. 9: Alfons Rettich, Constance

Paul Hofer

High Altar and Church Floor

The Church Floor as an Autonomous Level of Movement in Southeastern German and Swiss-German Eighteenth-Century Ecclesiastical Architecture

The following study is part of a series of analyses of late baroque high altars begun in collaboration with Richard Zürcher († 1970) and focuses on the relation between these altars and the sequencing of interior spaces.[1] The core of these studies consists of five high altars in southeastern Germany, measured according to actual scale by Swiss Federal Institute of Technology workshops in 1973/1974, and complemented by the detailed measurements and evaluations of the Rheinau abbey church compiled by Hans Fietz in 1932. They provide the precise figures almost always lacking in the plans documented in the relevant literature.[2] The first visual field upon which this evaluation is based is the interior of the church as seen from the high-altar. The floor level is therefore principally defined as an east/west gradient, and not as an ascending one based on the parishioners or visitors' line of sight.[3] The extension of the high altar plan and its crowning in the choir is the second, complementary area of comparison underlying the core analyses.[4] Methodologically sound results are, however, subject to two main conditions. Firstly: collegiate and abbey churches on the one hand, and pilgrimage churches, on the other, may not – in view of the second group's frequent, if not total, lack of a choir – be judged in the same manner. For in spite of the high number of existing variants, the level changes of the church floor were, in the majority of pilgrimage churches, subject to other conditions than those governing monastic church buildings of the same period. Secondly: an adequate, if scant, number of chief examples must be presented to allow

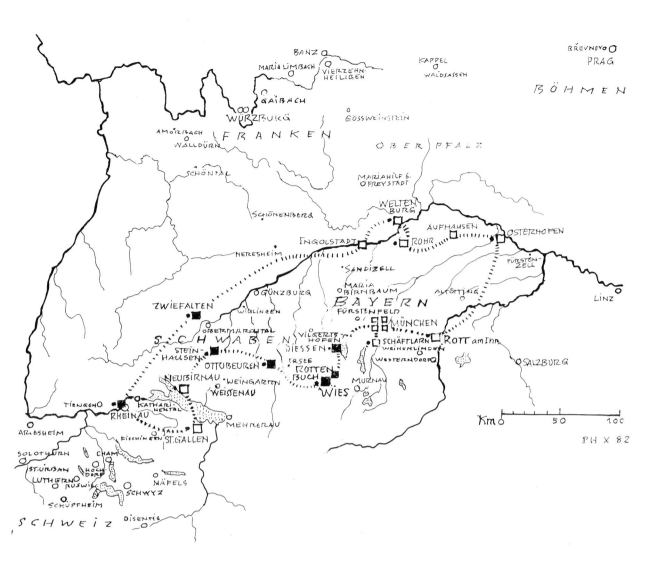

fig. 1: Core regions (Lake of Constance, Swabia, Bavaria) and peripheral regions (the German-speaking part of Switzerland, Franconia, Upper Palatinate, Prague): survey map.

■ Measurements by the Swiss Federal Institute of Technology (ETHZ) 1973/1974; Rheinau measurements, 1932.

❑ Measurements according to actual scales taken from the relevant literature.

•■ •❑ According to the longitudinal sections of figs. 2 and 3, recorded according to the actual scale.

○ Ecclesiastical buildings analyzed according to published plans and drawings outside the core group.

valid comparisons. Obviously, the six altars and chancels of the core group represent an insufficient number of examples. For that reason, six additional spatial compositions of the monastic type[5] and a third pilgrimage church[6] were added. Even so, the twelve test units thus arrived at offer only an acceptable, minimum number of examples. Therefore, the following investigations cannot possibly comprise all possible conditions or number of types, though they allow us to analyze some to date not, or only partially, evaluated structures of late baroque ecclesiastical spaces.

I

The first series to be analyzed, comprising the choirs of ten collegiate and abbey churches situated between the Upper Rhine and the Inn, and built between 1710 and 1760 (figs. 1, 2),[7] is introduced by the Benedictine abbey church of Rheinau. Here J. Th. Sichelbein of Wangen added a high

altar[8] scarcely a decade after the completion of the church building by Franz Beer (1710-1723). This drastically projecting work, quite unique for the period, with its high-pitched, bow-shaped canopy, two festoons, and a diagonally placed pair of columns, forms a grand entrance to the eastern choir bay,[9] though neither the longitudinal wall division nor the floor level distinguishes the choir from the chancel.[10] The transverse axes or spatial boundaries are emphasized only by elongated steps extending along the entire width between the choir and the crossing, on the one hand, and the crossing and the nave, on the other.[11] There is no projection or shifting of the stepped floor in respect to the ascending division.[12] Indeed, the altar resembles a stage décor masterfully inserted into the existing framework, while the wall and the floor remain unchanged (figs. 2.1, 4).

If we proceed from the Upper Rhine Valley to Bavaria and the Danube, there is a fundamental change in style. At the same time the Rheinau high altar was built, the Asam brothers created the extravagant finale of the interior of their two main early works. In the Benedictine abbey church of Weltenburg (1716-1721), the far less impressive staggering of the church floor between the mensa and the main body adds substantially to the dramaturgical staging of the "theatrum sacrum," but remains unnoticed, given the éclat of the light-flooded equestrian statue of St. George in the high altar gate. And while the eastern of the two stairs projects convexly across the entire width of the choir, unlike the conventional short flights of stairs leading to the tabernacle, it closes the altar area toward the west (fig. 2.2) without interrupting the vertical articulation of the two lateral walls. The gradient of the stepped floor is not governed by the architecture of the longitudinal walls but by the high altar. This is repeated in the transition of the choir to the elliptical longitudinal rotonda of the main body. Emphasized by broad baluster screens, the centrally concave step is no longer placed between the column bases of the choir entrance, it is brought forward and shifted to the west by 4.20 m.[13] Its sides extend slightly into the

fig. 2: Gradient steps of the church floor, leading from the chancel to the main body, in partial longitudinal sections of ten collegiate and abbey churches between the Upper Rhine, the Danube, and the Inn (1710-1760). Right to left: level changes between the rear of the chancel X-X and the middle of the clear overall longitudinal church space, including the (shaded) extension and boundaries of the eastern spatial divisions; cf. fig. 3 (pilgrimage churches).

Three annotations to longitudinal sections no. 1 (Rheinau), no. 2 (Weltenburg), and no. 7 (Ottobeuren):

no. 1: + Because the choir stalls are shifted into the crossing, the structural and functional divisions differ: the crossing becomes the monastic choir; the (clearly defined) choir section, the chancel. For that reason, the easternmost spatial boundary is marked (A) , the two level changes further westward (a) and (b).

no. 2: ++ Unlike the sequencing of the majority of interior stairs, including those of the late baroque period (Rheinau, Osterhofen, Schäftlarn, etc.), the steps leading to the tabernacle extend across the entire width and thus separate the levels of the anteroom of the chancel from the podium of the high altar – an early design of the solution applied in Diessen, Zwiefalten, and Ottobeuren. Because of this, the unit of level change is designated (a), although including the chancel and the steps leading to the altar.

no. 7: +++ Maximum projection of four instead of three concavo-convex steps leading to the high altar (unlike the one extended in the middle section, shown in the ground plan according to Gruber [1952/1953], LIEB 1976, fig. 34), according to the measurements by Rick-Pfeiffer in *Barock, Rokoko und Louis XVI in Süddeutschland und der Schweiz* (1897, Hauttmann 1921, p. 184, fig. 6, top left); cf. stairs in Fischer's design of 1748; LIEB 1976, fig. 28).

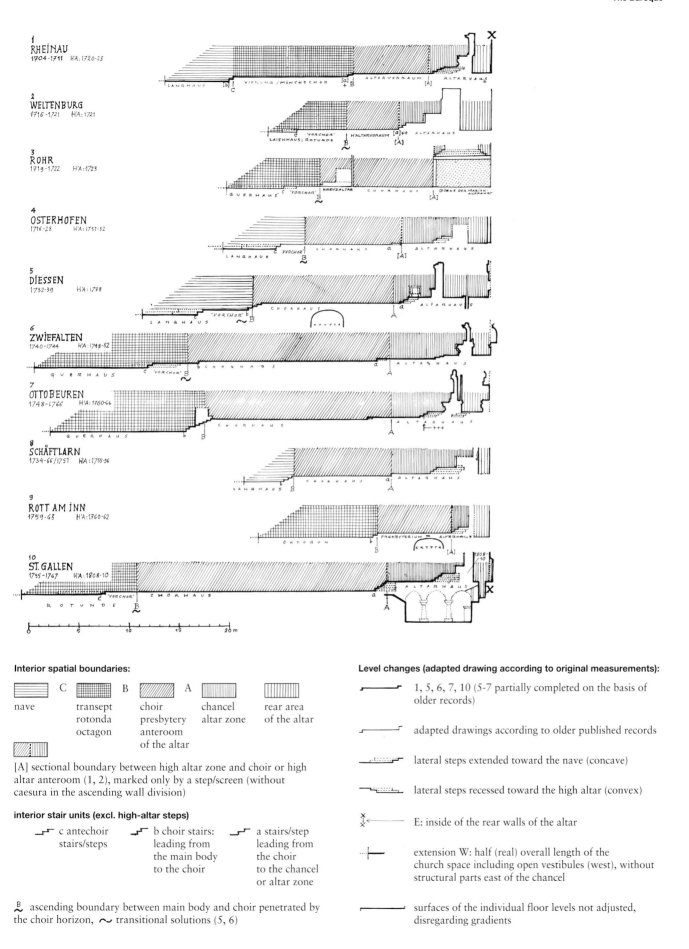

Interior spatial boundaries:

C	B	A		
nave	transept rotonda octagon	choir presbytery anteroom of the altar	chancel altar zone	rear area of the altar

[A] sectional boundary between high altar zone and choir or high altar anteroom (1, 2), marked only by a step/screen (without caesura in the ascending wall division)

interior stair units (excl. high-altar steps)

c antechoir stairs/steps

b choir stairs: leading from the main body to the choir

a stairs/step leading from the choir to the chancel or altar zone

B ascending boundary between main body and choir penetrated by the choir horizon, ~ transitional solutions (5, 6)

Level changes (adapted drawing according to original measurements):

1, 5, 6, 7, 10 (5-7 partially completed on the basis of older records)

adapted drawings according to older published records

lateral steps extended toward the nave (concave)

lateral steps recessed toward the high altar (convex)

E: inside of the rear walls of the altar

extension W: half (real) overall length of the church space including open vestibules (west), without structural parts east of the chancel

surfaces of the individual floor levels not adjusted, disregarding gradients

197

narthex and separate the eastern from the central part of the main body. In other words, the choir level extends exedralike into the rotonda. *Both stepped units are independent of the boundaries of the spatial divisions.* Seen from the high altar, they are a projection of the sanctuary and no longer of the spatial articulation onto the church floor. This once, however, Cosmas Damian Asam is not its inventor.[14] Disengaging several steps from the elevation of the longitudinal walls in Weltenburg – to my knowledge for the very first time – subdues the most important caesura in the interior of the church: the line separating its main body from the choir. The pathos and pantomime of the altar are mutually enhancing rather than contradictory; the visual drama created by the statues of the equestrian figure, the dragon, and the princess in the high altar gate spreads to the floor level like a wave.

The brothers never spurned the dramaturgical effect of projection toward the main body in their important works. In the choir end of the Augustinian collegiate church of Rohr (1717-1723),[15] the spatially dominating Resurrection is imbued with declamatory drama by its placement on a stage elevated 3.10 m above the choir. The dramatic impact not only develops back into the interior of the church but also rotates upward – a spiral-shaped expression of pure ecstasy. The tabernacle, separated from the Lady Chapel by the entire length of the monastic choir, is positioned beneath the triumphal arch, though the actual choir level once again crosses the boundary between chancel and main body (figs. 2.3, 8), its U-shape with convex projection in the center encircling the entire transept. The concave circumference of the choir level around the transept aisles provides a spatial counterpoint to the mensa vestibule projecting into the crossing. Consequently, the end of the nave, framed by the sides of the higher level, seems an integral part of the crossing. The three main parts of the ground plan – nave, transept, and choir – thus interface within the crossing; the western projection of the choir floor encircles the nave, which extends eastward. The traditional, clearly articulated demarcation between

the space reserved for the congregation and the presbytery has shifted: the two zones now overlap.

Scarcely a decade later (1731-1732), the abbey church of the Premonstratensians in Osterhofen, which had just been completed by Johann Michael Fischer, was equipped with a high altar and two side altars by Egid Quirin Asam (figs. 2.4, 7), located in the spandrels between nave and triumphal arch.[16] Abstaining from the choreographic rhetoric of an elevated group of figures, the high altar, once again placed against the rear wall of the choir end, returns to the basic form of the retable or reredos altar. Only by separating the two steps within the choir and beyond the triumphal arch from the end points of the spatial units does Asam vary the disposition of the level changes in Weltenburg, at the same time creating far greater fluidity of movement by the use of uninterrupted, curvilinear steps. Again, only the single convexly projecting step to the east of the choir marks the boundary between altar area and monastic choir missing in the elevation. Underneath the triumphal arch, the choir floor penetrates the western boundary of the presbytery on the same level, projecting into the east bay of the nave by concave steps. In the side chapels of the main body, elevated by a single step, the floor reaches its fourth, and in the middle aisle its fifth and lowest level (fig. 7). Those who notice the eloquence with which the curved sides of the two steps reflect the lineament of the side chapels on both sides of the choir arch will agree that the energetically staged articulation of the interior intentionally includes the floor level, though no longer as a subservient element of the elevation, but as an *autonomous level of movement.*[17] The corner pillars or clustered columns of the wall systems are no longer conclusive end points, they mark the crossing of boundaries.[18]

The last truly important work created by the Asam brothers, the Church of St. Johann Nepomuk in Munich (1733-1746), already indicates a less emphatic version. Once again the formula of Weltenburg and Osterhofen is used. This time, however, the relation of the first two convex steps to the second level of concave stepping into the main body is far more compact,[19] though the steps leading

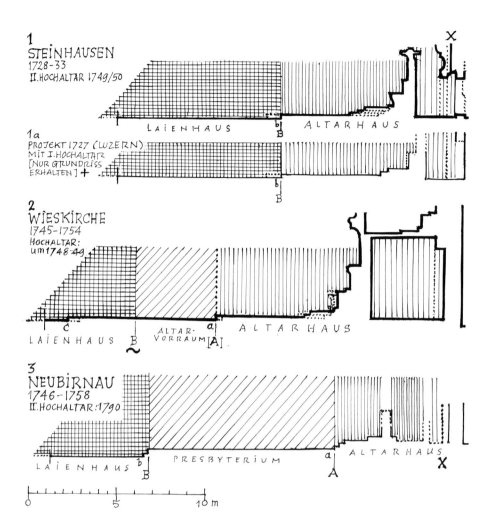

1
STEINHAUSEN
1728-33
II. HOCHALTAR 1749/50

LAIENHAUS — b B — ALTARHAUS

1a
PROJEKT 1727 (LUZERN)
MIT I. HOCHALTAR
[NUR GRUNDRISS
ERHALTEN] +

b B

2
WIESKIRCHE
1745-1754
HOCHALTAR:
um 1748·49

C
LAIENHAUS — B ~ — ALTAR-VORRAUM [A] — a — ALTARHAUS

3
NEUBIRNAU
1746-1758
II. HOCHALTAR: 1790

LAIENHAUS — b B — PRESBYTERIUM — A — a ALTARHAUS — X

0 ——— 5 ——— 10 m

fig. 3: Gradient steps of the church floor from high altar to main body, in partial longitudinal sections through three pilgrimage churches built between c. 1730 and 1760. – Captions and symbols as in fig. 2; plans, cf. note 37 below.
From right to left: stepping of the rear chancel wall X-X to half the (clear) length of the entire church (without vestibule), including extension and boundaries of the eastern spatial units; cf. fig. 2 (collegiate and abbey churches).

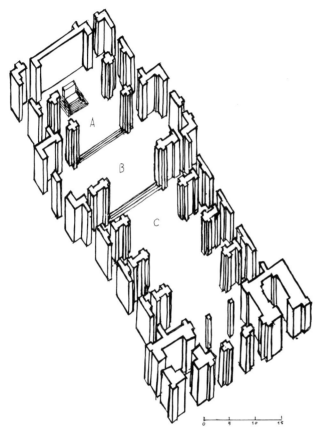

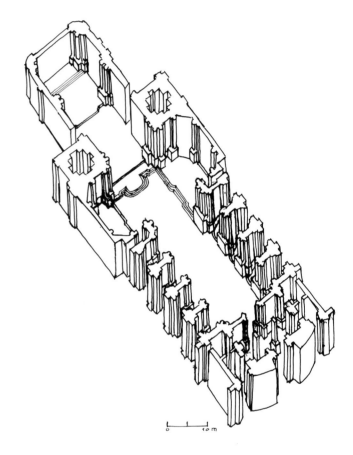

fig. 4: Rheinau. Benedictine
abbey church, built 1704-1710,
high altar 1720-1723.
A = chancel,
B = crossing, monastic choir,
C = nave; cf. fig. 2.1.

fig. 5: Zwiefalten. Benedictine
abbey church, built 1739-1752;
cf. fig. 2.6.

to the chancel are firmly embedded in the entrance to the transverse oval of the high altar area. Only the antechoir directly in front of it covers the entire width of the ante-room, unaffected by any constraints of elevation. There simply was not enough space for the levels to be shifted twice vis à vis the spatial division on this exceedingly narrow site. As in the majority of transverse-oval end spaces in late baroque ecclesiastical architecture, the chancel steps are once again clearly embedded in the ground plan of the eastern part of the church.[20]

The alternation between stepped floor and spatial sequence changes as soon as we leave the Asam brothers' workshed, though we remain within the same generation and region, turning to the work of Johann Michael Fischer.[21] We have seen that in Osterhofen, Fischer's first major edifice, the dynamic structuring of the floor has far more in common with the work of the Asams, who were responsible for the altars, than with the architect's own earlier oeuvre.[22] The Jeromite abbey church of St. Anna am Lehel in Munich (1727-1737) provides the first example of the way Fischer, the much more strongly articulating designer, managed to dissociate himself from them in order to render the sequence of level changes somewhat independent of the spatial divisions. Like almost all early works by Fischer, this church is the product of his collaboration with the Asam brothers. The strong convex stairs leading down from the chancel to the double transverse oval of the main body are an obvious segment of the circular sanctuary.[24] But though the projection intersects with the main body, the ambition to separate the floor from the ground plan of the elevated part, which characterizes the interior space of Osterhofen, is completely lacking. St. Anna am Lehel remains literally on a level of development that not even the most daring spatial creations of the seventeenth or eighteenth century in Italy or France managed to surpass: the main space is cut into by steps leading to the chapels and choir, their convexly or convexo-concavely projecting design completing the curvature of the ground plan of the lateral spaces that delimit them at floor level.[25]

Construction of the Augustinian convent church of Diessen on Lake Ammer (figs. 2.5, 9), begun in 1720 and practically finished by 1728, was taken over by Fischer between 1732 and 1739. Its interior shows the development from his early approach to his mature works. The newly appointed prior, Herkulan Karg, and the architect he appointed decided to abandon the original design – with the sole exception of the nave walls. Their precise respective share in the overall design and execution of the newly designed choir is, however, not clear to date. Lieb even questions François Cuvilliés's authorship of the high altar.[26] As the clustered columns of the high-altar sides, the solemnly pantomimic descent of the four church fathers by Joachim Dietrich from the sides of the tabernacle to the bases in front, and the convexly cambered altar stairs form an uninterrupted sequence of spaces characterized by a single integrative and dynamic approach, the high altar and chancel must have been designed by one person – either Fischer or Cuvilliés. The configuration of the three steps behind the opening of the apse, the spatial boundary between the chancel concha and the presbytery, is neither demarcated nor ignored, but efficiently blended with the opening of the semi-circular apse extending upwards.[27] However, in the second stepped unit – the stairs between the domed choir and the east bay of the nave (B) – the traditional pattern of extended choir stairs consisting of four steps as a projection of the triumphal arch survives. The third level change (C) leads via two steps from the higher level of the east bay of the nave to the lowest level, the main body or middle aisle. Between nave and choir there is, therefore, an intermediate level covering the entire width of the church. No longer part of the nave, nor yet of the choir, it is a kind of antechoir, whose ground plan can be understood only by looking at the western, centrally concave stairs (fig. 9). This intermediate level continues in the two rows of side chapels in the nave, its U-shape encircling the middle aisle. In the alternation between convex chancel stairs and concave antechoir steps, Fischer once again alludes to the solution of Osterhofen.[28] However, he

fig. 6: Ottobeuren. Benedictine abbey church, built 1737-1766; main period, 1748-1760; high altar finished in 1766; high altar steps according to the measurements taken by Kick-Pfeiffer in 1897; cf. fig. 2.7.

fig. 6a: (Top right) Crossing steps according to J.M. Fischer's design of 1748. (LIEB 1976; fig. 28/LXXXIII).

completely abstains from the "revolutionary" continuation of the choir level underneath the triumphal arch into the transept and the lateral parts of the main body, as introduced by the Asams in Weltenburg and Rohr,[29] their extreme examples of level changes independent of spatial divisions. The inherent dynamics of the gradient structure, still visible in the extension of the antechoir level to the sides of the nave, are less emphasized. Diessen is thus less a mature than a transitional work, where two creative periods intersect.[30]

A year after the consecration of the collegiate church on Lake Ammer, Fischer completed the church of the Augustinian hermits in Ingolstadt.[31] In stark contrast to Diessen, the three steps in front of the choir project convexo-concavely into the nave, their strong curve touching the pillars of the triumphal arch, thereupon modulating the ground plan of the rotonda. An interpenetrating space between the rotonda and the choir opens toward the west and lets the lineament of the curved stairs take the lead, so to speak.[32] Any factor to render the levels autonomous in relation to the ascending divisions is eliminated. After Diessen, Fischer created many variations of this stair design, though he no longer included any shifting of levels and steps toward the boundaries of the individual spaces. This applies equally to his mature works[33] – Aufhausen (1736-1746), Berg am Laim near Munich (main period, 1739-1742), and Zwiefalten (1739-1753, figs. 2.6, 5) – and to his two most important late works – Ottobeuren (1737-1766; figs. 2.7, 6)[34] and, recalling Aufhausen, built almost two decades earlier, Rott am Inn (1759-1762, fig. 2.9).[35] It also applies to the two main achievements of court architect Johann Baptist Gunetzrhainer, who followed in the steps of Fischer but remained overshadowed by the latter. Gunetzrhainer created the ingenious, small St. Anna Damenstiftskirche (1723-1735) in Munich[36] and completed the Premonstratensian abbey church of Schäftlarn in the Isar Valley (fig. 2.8).[37] But no matter how diverse the spatial types, wall structurings and spatial sequences intersect and combine; they are all linked at floor level by a

return to the orthodox or freely varied relation of stair design to the caesurae of the respective spatial disposition. Comparable to the trusses of a horizontal roof structure, stepping and wall elevation are once again part of a rigid or flexible overall organization.

The strongly contrasting patterns exhibited by the two *pilgrimage churches* – Steinhausen (1728-1733) and Wieskirche (1745-1754) – in terms of the five choir structures measured to scale in 1973/1974 and the problem of floor levels have already been briefly described in the introductory section (figs. 3.1/.2).[38]

In Peter Thumb's main work, the pilgrimage church of Neubirnau above the north shore of the Lake of Constance (1746-1750; cf. fig. 3.3), built by the Cistercian imperial foundation at Salem, the leading designs of the middle of the century combine in an unsentimental but festive coda.[39] The dual character of the building as a pilgrimage church *and* a priory is shown in the square monastic choir between the single-aisle nave and the U-shaped chancel, the latter slightly recessed compared with the main body. Here, these two long and strictly separated main types of non-parochial ecclesiastical architecture – the pilgrimage and the monastic church – are reunited. And even though a last syncopated element survives in the vaulted part (the extension of the central ceiling structure into the hardly noticeable transverse axis of the two nave sections and into the third vault bay), the chancel and the choir stairs strictly adhere to the recessed points of the ground plan. Only the lateral parts once again project curvilinearly into the adjoining spaces, encircling the side altars.[40] In the course of the five years needed to realize Neubirnau, several other churches were begun: Wieskirche in Bavaria, Vierzehnheiligen in Franconia, Zwiefalten and Ottobeuren in Swabia, and lastly Neresheim. With the sole exception of the transverse steps in the choir of the Wieskirche, the individual units of the floor stepping in these six main works of southern German ecclesiastical architecture in the years shortly before and after the middle of the century[41] were once again strictly embedded in the corner and end points of the spatial division.

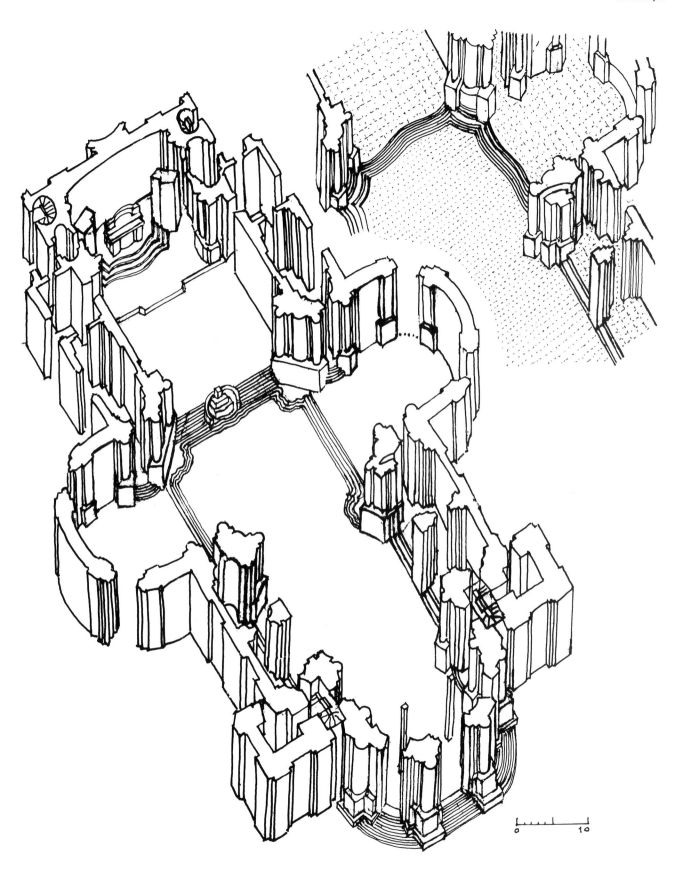

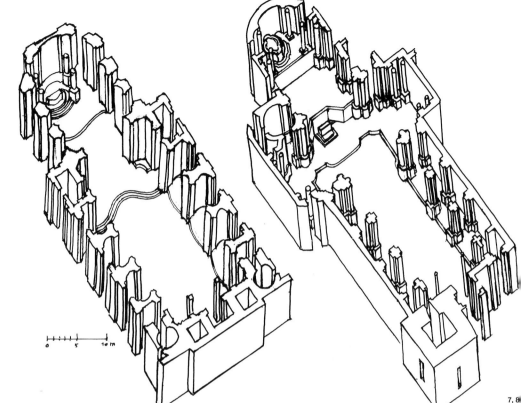

fig. 7: Osterhofen. Premonstratensian abbey church, built 1728-1740; high altar 1731-1732; cf. fig. 2.4.

fig. 8: Rohr. Augustinian collegiate church, built 1717-1722, high altar 1722/1723; cf. fig. 2.3.

fig. 9: Diessen. Augustinian collegiate church, built 1720-1728 and 1732-1739; high altar completed in 1738; cf. fig. 2.5.

fig. 10: St. Gallen. Benedictine abbey church, as built 1755-1760 (nave and rotonda), 1761-1772 (choir), 1808-1810 (high altar); cf. figs. 2, 20, 21.

7, 8

II

But let us return to the question asked at the beginning. What is the relationship between floor level and church space in the analyzed core group of German ecclesiastical buildings created between 1710 and 1760? There are two entirely different, but – despite a broad range of variants – clearly definable, behavioral modes. We shall try to represent them three-dimensionally, with the help of isometry.

The *first*, "conservative," basic behavior characterizes the stepping of the floor level, always defined along the axis of movement leading from the high altar to the center of the church, as an essential element of spatial division. The caesurae of the wall system also apply to the siting of the interior stairs. Chancel and choir steps are placed beneath the transverse or triumphal arches of the entrance openings or immediately in front of them (fig. 4). Even in case of strong orthogonal or curvilinear projections, the lateral stairs are strictly embedded in the corner or recessed points of the boundaries in the individual spaces between the high altar and the main body of the church. Even if the single- or multi-step lineament of the stepping is strongly curved, it is always "attached" to the ends of the lateral parts (figs. 5, 6). In the following, the two types of non-shifted steppings are designated as *boundary-respecting floor-level changes*. We have compared their relationship to the divisions of the ascending wall system with the trusses of a horizontal roof structure. Such a comparison, though formally unacceptable, is perfectly adequate in terms of the spanning of the horizontal with the ascending parts. The relationship it yields may be defined as stable, horizontal, and predominantly simultaneous.[42]

The *second*, "progressive," behavior eliminates the boundaries of the individual spaces as points of departure for floor stepping. The caesurae of interior sequencing are no longer used for scaling; the dimensional depth of the levels and the depth of the individual spaces are shifted, their proportions changed.[43] Obviously, the chancel and choir stairs clearly differ as to the energy and degree of separation from the markings of the wall system. The ascent to the chancel remains at the point where the choir level continues underneath the triumphal arch toward the west, apart from a few rare but all the more striking examples still located at the easternmost spatial boundary.[44] However, the level of the choir is lower than the choir arch in this second group: the stairs between choir and main body are shifted to the west and thus into the eastern part of the nave (figs. 7, 8); in the case of transepts or rotonda variations, to the crossing or the eastern segment of the

9

10

central space (fig. 10).[45] Below, the term *boundary-cross-ing level changes* designates a floor profile independent of individual spaces. By extending the choir level into the lon-gitudinal rectangle of the main body, an antechoir area above the floor of the middle aisle is created. Significantly, the extension never covers the entire depth of the last nave-vault bay or the crossing; by a concave recessing of the central part of the steps, it encircles the main body in a U-shape, as a slightly raised exedra.[46] Only this renders the basic relation we have postulated as the formula of our thesis visible in its three dimensions. At least where the floor stepping frees itself from the dependence on the boundaries of the spatial division, it ought no longer to be perceived and evaluated as a movement of the spatial sequence but of the high altar. If, however, its "choreog-raphy" expands into the *upper zone* of the principal cor-nice or molding and the canopy, laterally projecting into the spaces adjoining to the west, then the second main step extending the high altar toward the west consists in extending the concave design of the *floor level* into the main body. Though this second step may be less apparent, it is nonetheless an element of the very same dramaturgi-cal calculation.[47] The rule that the almost always convex chancel stairs generally comprise concave, recessed steps

leading down from the choir or the antechoir into the main body, as a counterpoint,[48] is not contradicted by the same directional orientation for both "waves" of movement. This is only a first impression gained by a casual glance at the projection and the recess. If, however, one is aware that the concave center of the descent to the lowest level forms the simple hollow shape between the two curved parts projecting into the main body, the – at first glance hidden, but all the more compelling – logic of two main movements within a single dynamic sequence will be rec-ognized. Within the latter, the central section – between the high altar and the transept or nave of the U-shaped projecting ascent to the choir – is not defined as a coun-terpoint but as a main act belonging to a dynamic cadence of two impulses projecting from east to west. Like count-less other matters transcending spatial boundaries in late baroque ecclesiastical architecture, this one, too, is diffi-cult to define in sequential verbal terms.[49] Let us therefore once again try our hand at creating a well-balanced com-bination of transparency and precision, though perhaps in a simplified way, by presenting the entire process three-dimensionally (fig. 11). Applied to the entire interior of a church, the relation of boundary-crossing level changes has to be defined as a dynamically "subversive," and therefore destabilizing, element.

III

From this point of view, a more comprehensive discussion of the origins and spread of the phenomenon becomes inevitable. We can, however, provide only some points of departure on both questions, all of them subject to temporal as well as regional additions or shifts of emphasis.[50] As already briefly mentioned, the whole of European baroque architecture outside the German-speaking regions seems to have rejected the idea of separating levels and interior stairways from the demarcations of the interior sequencing. Wherever chapel or choir steps project into the main body of the church, they remain firmly embedded in the basic configurations of the ascending elements. Even this rigidly disciplined manner of transition is rare in the Latin, western, or northwestern parts of Europe.[51] Of course, extreme cases of internal projections do occur in peripheral regions, such as in the late baroque architecture of eastern Sicily in the second quarter of the century. In the longitudinal sections of the centralized architecture of the *Trattato iconografico sull' Architettura chiesastica* by Rosario Gagliardi (1726-1732), the first of two axial flights of stairs leading to the altar occupies the entire depth of the three altar chapels.[52] In Gagliardi's project for S. Domenico in Noto, two convex stairs lead from the raised chancel floor to the lower level of the choir bay.[53] In both cases (figs. 12, 13), the move to separate these interior stairs from the fixed points of the ascending division seems imminent but is not executed.[54]

It is tempting to seek the reason for this refusal in the desire to employ the more stable Latin and western spatial design until the very last. In this light, shifting the steps away from the interior spatial boundaries would be rejected as affecting the sense of balance, weakening the physical architectural control, and therefore constituting an inadmissible game with acute feelings of vertigo.[55] The author will reserve judgment until more extensive comparisons and studies provide sufficient material.[56] If the growing independence of the church floor as a special level of movement proves to have been the particular preserve of the German-speaking part of Switzerland and Franconia, the problem is narrowed down to the search for origins within this – still comparatively large and richly varied – area. Even then, we can present only a rough preliminary survey.

Two degrees of emancipation of the caesurae of the wall system will have to be discussed separately. The more reserved version leaves the main level change – the stairs leading to the choir – in its traditional place; its position between the pillars of the triumphal arch remains unchallenged. As the solution limits itself to the choir area, it only comprises the steps leading up to the level of the high altar. After the first, still unspecific, beginnings in the Munich Theatinerkirche (1674) and the Jesuitenkirche in Solothurn (1680), the first step seems to have been taken by the late seventeenth-century architects of the Vorarlberg. In Obermarchtal (1686-1701) (fig. 17), the chancel stairs, which have no links to a caesura in the longitudinal wall division, are located between the only slightly projecting choir stairs and the tabernacle – a novelty completely lacking in Schönenberg near Ellwangen (1682-1686), completed just before by the very same Thumb.

Upon closer inspection of the phenomenon under scrutiny, the main early-eighteenth-century Franconian and Bohemian works by the Dientzenhofers seem strikingly vague. Indeed, the original 1702/1703 design for St. Nikolaus in the Lesser Quarter of Prague is content with a choir screen whose convex curvature is placed closely in front of the high altar.[57] Johann Dietzenhofer's Banz (1710-1718), on the other hand, shows a more complicated relation of gradient level and spatial sequence: the convex choir step, which is part of the first transverse-oval choir space, projects far back into the third nave oval while remaining firmly linked with the pillars of the triumphal arch. In the comparatively narrow choir, the unattached steps immediately in front of the high altar create an independent antechoir level; however, the perforated transverse line of the rood altar and the removal of the monastic choir to a point behind the rear wall of the altar obscure the spatial impression of the gradient steps.[58] The issue of

the emancipation of floor level from the sequence of stairs is touched on, though, contrary to the pathos of the syncopal superposition of spatial units in the walls and vaulting, it is not fully developed. From this perspective, the same strangely unspecific behavior repeats itself in Christoph Dientzenhofer's abbey church of Brevnov in St. Margreten (1709-1715), although the choir is structured differently: on the floor, the convexo-concave choir step and the choir screen mark the choir entrance; in the overall spatial context it moves westward, back into the intermediate oval of the antechoir. The end of the step, however, remains in front of the high altar, without any link to the spatial boundary articulated in the ascending part, for only here may an indication of the high altar area be found.

As I see it, outside our core group the use of two distinct levels of choir floor without a corresponding differentiation between choir and chancel in the walls and ceilings remains limited to a number of widely scattered ecclesiastical buildings with no obvious links. A richly varied approach can be found in the elongated choir design of St. Peter's in Vienna, commonly ascribed to J. J. von Hildebrandt (1730-1733);[59] in Maria Limbach (1751-1756), a late work by Balthasar Neumann;[60] in the late baroque remodeling of Arlesheim cathedral (1759-1761), executed shortly afterwards;[61] and finally, far from our core region, in the Michaeliskirche in Hamburg (1751-1762), built in the same period but only vaguely reminiscent stylistically, because of the complicated spatial sequence leading from the ground level to the gallery.[62] The full impact of eliminating the step sequence from the rhythm of ascending divisions is visible only where, instead of restricting itself to the chancel and the choir, it "undermines" the most important caesura in the church, the westward boundary between the presbytery and the nave. Within the core group, we have seen this second, far more extensive, version in Weltenburg, Rohr, and Osterhofen, and in limited form in Diessen. Further afield, outside southeastern Germany, the search for archetypes of this phenomenon leads us back to the domain of the Vorarlberg architects.

fig. 11: Diagram of the interior levels of a late baroque ecclesiastical building; stair units fully independent of the spatial divisions.

A chancel
 A' chancel level adjusted to the front, into the choir area
B choir
 B' choir level adjusted to the front, into the crossing and transept area (antechoir zone)

B" antechoir level continued into both nave chapel rows or side aisles
C crossing W
D nave
 (C, D lowest level)
E west bay vestibule and step to the nave

Cf. figs. 4, 7-10.

In 1711 Caspar Moosbrugger added his design to the project for a new St. Ursenmünster in Solothurn (not built until 1762-1773); it leaves the frontal tower and the nave of the existing building largely intact. The easternmost nave bay is, however, massively elevated by five steps and turned into an antechoir, the rectangular central part of which cuts into the ascending stairway, projecting like a rostrum into the nave (fig. 15).[63] There is not yet any curvilinear element; stairway and rostrum are linked but not combined.[64] Among the younger Vorarlberg architects, the highly talented son of Franz Beer von Blaichten, Johann Michael Beer, took this step in St. Katharinental (1731-1735, fig. 18) with a sweeping convexo-concave extension of the choir floor deep into the transeptlike, broad middle aisle.[65] At the end of the decade, the lateral expansion of the choir level into the transept appears in a polygonal design by Johann Michael Beer von Bildstein for the abbey church of Mehrerau near Bregenz (c. 1740, fig. 17)[66] and, a decade later, in an unrealized project for the new church of Fischingen (1750-1753).[67] In the two designs and the drawing for the church of Tiengen (1752, fig. 19),[68] the younger namesake of the architect of St. Katharinental seems to limit himself to demarcating the extension of the choir area by orthogonal or curved screens.[69] However, his concave, stepped antechoir traversing the crossing of the parish church of Rheinau (1752/53) – destroyed in 1862, but reliably documented – shows how important he considered the linking of choir and transept on the floor level.[70] The – usually small-scale – changes only hesitatingly implemented in the Upper Rhine Valley and on the Lake of Constance move center stage shortly after the middle of the century in the last of the Vorarlberg architects' great achievements, the abbey church of St. Gallen.

In relation to our own research, a comparison of the eight projects still extant in the abbey archives and in Lucerne from the decisive years between 1750 and the beginning of construction in 1755 shows that, amazingly enough, the majority of designs extended the choir level beyond the choir and into the western part of the church.

Again, two levels of "progress" have to be distinguished. J.C. Bagnato's[71] project, dated 1750, and the wooden model by Gabriel Looser (around 1715-1752) leave the central part of the choir ascent in its traditional position underneath the triumphal arch.[72] The choir level of both spatial concepts expands laterally into the northern and southern peripheral zone of the transept[73] and, much like Zwiefalten a decade earlier, continues the wavelike, contoured floor of the side aisles.[74]

The second, much more progressive, step is taken where the shifting of gradients vis à vis the interior walls also generates movement in the central zone. We cannot be certain whether the concavely projecting screens were to be placed a step higher, elevated by its height over the interior level of the central space.[77] The two projects probably most important for the construction of the building were: design VIIIa of the abbey church archives, which still respects the old choir version and is ascribed to Johann Michael Beer von Bildstein (c. 1752, fig. 20)[75]; and the Lucerne drawing,[76] which Adolf Reinle attributes to Peter Thumb, although the question of its authorship and whether it dates from *before* the beginning of construction work is controversial. If we base our considerations on these plans, Beer's design clearly shows that the solution finally adopted, with its spatial interfacing of rotonda and choir (figs. 2.10; 21), became a favorite after 1750. With the sole exception of J. J. Rischer's project of 1754, the traditional concave or convex main stairway in the choir opening, found in the pilot designs of 1750-1755, disappeared in the finished building.[78] The upper level is carried on underneath the choir arch for another three meters, up to the apex of the screen. Only the latter, its double concavity inscribed into the rotonda, provides access to the lowest level, the central rotonda floor, by the two steps of the axial passage.[79] Decisively, the five-cornered pillars and the triumphal arch demarcate the spatial boundary between rotonda and choir. On the floor, however, it dissolves. In its ascending role, the "curved spatial layer" at the rear of the choir screen clearly belongs to the rotonda,

fig. 12: Rosario Gagliardi, project of a centrally planned building with cupola and steeply ascending altar steps. Partial adaptation of the drawing according to a section in the *Trattato Iconografico*; c. 1726-1732.

fig. 13: Rosario Gagliardi, project for S. Domenico in Noto (Sicilia). Adaptation of the drawing of the choir in a longitudinal section and ground plan from the *Trattato Iconografico*; c. 1725-1726.

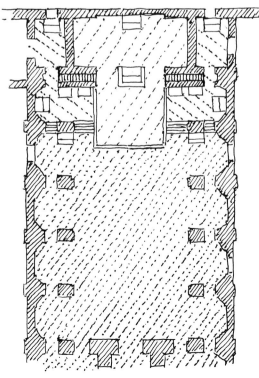

but at floor level equally clearly to the choir.[80] Around 1750-1753, both Bagnato and Looser planned a choir level framing the transept and the nave, basing their projects on architectural designs of 1720.[81] The building designed and executed by Johann Michael Beer von Bildstein (fig. 21)[82] does not use this extreme version of floor expansion. In a reversal of the formula developed around the middle of the century (fig. 20), the two levels are so well integrated that the lower floor of the rotonda core and gallery, encircling the lateral parts of the antechoir area in a pincerlike embrace, continues eastward, until just in front of the choir-arch pier. Only there do two steps on each side lead to the raised horizon. As far as I know, this solution has no counterpart in eighteenth-century ecclesiastical architecture. It is not tempered by the dynamic choir-floor expansion toward the west, however greatly enhanced by the compact center zone.[83] Four decades after Osterhofen, a double projection of the levels from east to west was created, in combination with the convex five-step ascent to the high-altar rostrum at the rear of the choir (fig. 10): once at the western limit of the altar area, once – beyond the triumphal arch – into the interior of the rotonda, and this in the spatial composition of an ecclesiastical building of the first water.[84]

IV

The phenomenon studied here is not a "chasse gardée" of old Bavarian and Vorarlberg late baroque style. But outside the core regions between the Upper Rhine, Danube, and Inn, it no longer occurs in a unified context of related genetic and architectural origins. Instead – or so it seems at first glance – it appears in individual and borderline cases with little in the way of mutual traits.[85] Let us once again return to the end of the second decade. Weingarten, Weltenburg, Rohr, Weissenau, Fürstenfeld, and finally Einsiedeln were about to be built – these were years of a veritable explosion of monastic and architectural productivity. Franconia, however, was not yet equal to this development. With the exclusion of Banz (completed in 1718) –

fig. 14: Obermarchtal. Premonstratensian abbey church, built 1686-1701; diagram of the interior levels (E-W).

fig. 15: Solothurn. St. Ursenmünster. Remodeling design (not executed) by Caspar Moosbrugger (1711, Lucerne); diagram: antechoir steps – antechoir level – anteroom of the altar; nave walls and retrochoir preserved according to the original design.

fig. 16: Würzburg. St. Peter's (parish church); nave 1717-1720, choir (thirteenth-century version) preserved; diagram of the interior levels (E-W): chancel and choir (raised in 1717) – antechoir – nave; cf. fig. 23.

fig. 17: Mehrerau. Benedictine abbey church; project by Johann Michael Beer von Bildstein, c. 1740 (Lucerne); diagram: chancel steps – choir screen.

the main work by Bavarian Johann Dientzenhofer – and Joseph Greissing's remodeling of the Würzburg Neumünster (1711-1716), building activities there were still characterized by provincial diversity. In fact, however, not the much more sophisticated Neumünster, but a parish church in Würzburg, St. Peter's (1717-1720, fig. 16),[86] remodeled in the baroque style a short time later, shows the full impact of an almost unnoticed tripartite system of level changes from west to east. Greissing raised the early Gothic choir, which was otherwise preserved; the last bay, which was not linked to any wall system, was eliminated through the addition of two elongated steps as a chancel. Underneath the triumphal arch – the traditional site – two steps lead down to the laterally concave, curved western part of the middle aisle. There, a third flight of stairs, doubly concave at the center, is enclosed along the entire width of the nave. There are four levels: two in the choir, preserved in its original form; two in the newly built nave. The extreme version of integration, of continuing the choir horizon underneath the triumphal arch into the nave, was not adopted, however. When it comes to the Würzburg Hofkirche by Balthasar Neumann and J. L. v. Hildebrandt (1732-1743) – probably the most sopisticated example of Franconian late baroque architecture – whether the two convex steps in front of the altar conform to an interior spatial boundary essentially depends on whether the original drawing from 1731/1732, now in the museum in Frankfurt am Main,[87] is read as a sequence of three or five closely integrated ovals. If one assumes a transverse oval not only in the western but also in the eastern part of the central longitudinal oval and *in front of* the high altar area,[88] and then questions the position of the choir stairs within this composition, it is obvious that they cross the intersection between the third (longitudinal oval) and fourth spatial unit (second-last transverse oval) without any link to an interior boundary.[89] The syncopation produced by shifting the stairs into a zone of intersection precisely conforms to that of the vaulted zone and is visually tempered by the fact that the lateral stairs are attached to a free-standing support of the central body.[90]

fig. 18: St. Katharinental. Church of Dominican nuns; design by Franz Beer of 1719, execution by Johann Michael Beer (von Bleichten) 1734-1734; diagram: chancel – antechoir zone – levels (final design by J.M.B.).

fig. 19: Tiengen. Town parish church; project by Johann Michael Beer von Bildstein of 1752; diagram: chancel – high altar – antechoir zone – screen; cf. figs. 20-21.

Some of the large parish churches of central Switzerland (fig. 1, left) show the long survival of a dynamic concept that goes at least as far back as Caspar Moosbrugger's 1711 project for the Solothurn St. Ursenmünster (fig. 15). Inside St. Martin's in Hochdorf, Jakob Singer, developing some preliminary designs of Luthern (1751-1753) and Silenen (1754-1757), continued the choir level (1757-1758) about one meter below the choir arch and included the two side altars (fig. 22)[91] as a scant but decided projection toward the main body. This design was once again abandoned in the rich lateral level changes of St. Martin in Schwyz (1768-1778),[92] in St. Fridolin and Hilarius in Näfels (1777-1782),[93] and St. Jakob in Cham (designed in 1755, executed 1783-1785),[94] by the brothers Jakob and Johann Anton Singer, and in the parish church of Ruswil (1781-1783) (fig. 23), by Niklaus Purtschert. Instead the traditional formula was chosen: an elongated or flatly curved ascent to the raised choir, placed between or immediately in front of the piers of the choir arch.[95] In the parish church of Schwyz, the antechoir horizon develops out of the choir level on two lower levels. The upper one houses the six side altars, the lower one forms an intermediate step across the entire choir opening; both offer a doubly concave opening into the transept, once again recalling the screen figures of Mehrerau, Fischingen, and Tiengen. In Näfels, Jakob Singer continues the choir level on both sides of the flat, concave choir ascent to the side altars. Contrary to Schwyz, there is no intermediate level here.[96] Only Purtschert's late works once again show the choir and nave horizon interfacing on three levels.

In Ruswil, the antechoir area extends on either side to the beginning of the two diagonal transept ellipses,[97] the end point of a tripartite system of levels leading from the high altar to the east bay of the nave. In all three spatial compositions, the process suggested in Hochdorf – the longitudinal continuation of the choir level beneath the triumphal arch into the eastern part of the main body – was given up.[98] One must recall Johann Michael Beer's solution in St. Gallen (figs. 10, 21) in order to fully perceive

that the principle of "boundary-crossing level changes" in Ruswil and in the final work of the group presented, the parish church of Schüpfheim (1804-1808),[99] had gone into decline decades after the European changes of 1750-1760, even in regions where strong traces of the design still make themselves felt.

V

We have tried, in a series of brief surveys, to touch upon the three basic patterns visible in the imaginative liberation of floor horizon and level changes from the cadence of ascending divisions. These include: the projecting axial (convex) and U-shaped (concave) stairway combined with an unchanged lateral space adjoining one of the interior spatial boundaries (A);[100] the introduction of independent intermediate levels not based on the caesurae of the wall system between choir and main body, keeping the traditional choir ascent on the line of the triumphal arch (B);[101] the rejection of any links between the boundaries of these levels and the caesurae of the spatial sequence, "undermining" boundaries by shifting stairs into the spatial unit adjoining to the west (C).[102] Only in their main phases do the three versions follow a temporal sequence, with the extreme version (C) covering the shortest period. The latter did not follow and supplant the two older ones, it coexisted and was closely connected with their late (A) and early (B) area of distribution. As already mentioned, Latin and western European ecclesiastical architecture does not form part of phases B and C, with the sole exception of some sporadic, inchoate approaches.[103]

In the above interpretation of interior level changes in late baroque ecclesiastical architecture, these two basic patterns expanding interior spatial boundaries toward the center of the church by way of gradient levels are treated as inward-oriented horizons of the high altar, not as eastward ascents.

Here, at the very latest, an objection is bound to be voiced: namely, that the majority of people perceiving the interior in its entirety, even those with an eye for detail,

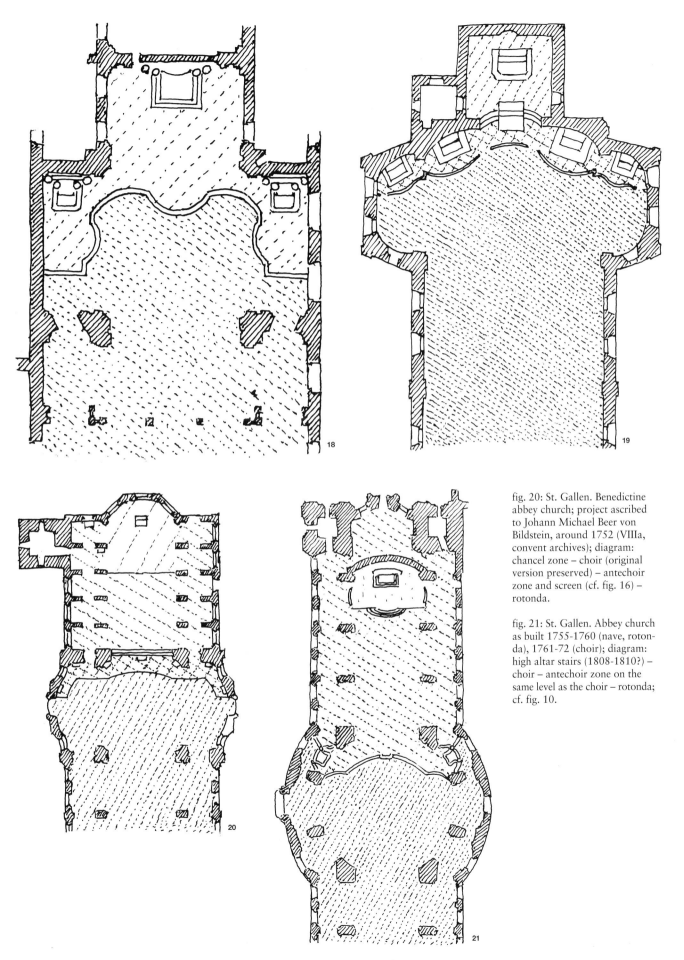

fig. 20: St. Gallen. Benedictine abbey church; project ascribed to Johann Michael Beer von Bildstein, around 1752 (VIIIa, convent archives); diagram: chancel zone – choir (original version preserved) – antechoir zone and screen (cf. fig. 16) – rotonda.

fig. 21: St. Gallen. Abbey church as built 1755-1760 (nave, rotonda), 1761-72 (choir); diagram: high altar stairs (1808-1810?) – choir – antechoir zone on the same level as the choir – rotonda; cf. fig. 10.

fig. 22: Hochdorf. Parish church by Jakob Singer, 1757-1758; diagram: high-altar podium – choir plus choir-wall extension – central transept/nave.

fig. 23: Ruswil. Parish church by Niklaus Purtschert, 1783-1786; diagram: chancel – choir – antechoir including side altars – western part of the nave; cf. figs. 16, 20.

fig. 24: Chronological chart of types A, B, C.

1580	90	1600	10	20	30	40	50	60	70	80	90	1700	10	20	30	40	50	60	70	80	90	1800	10

A — precursor

B — precursor .. later versions up to 1850

C

cannot possibly recognize the floor horizon, as it is covered by pews, choir screens and stalls, and the high altar. In a purely visual respect, the objection is a valid one, with the exception of a small number of extreme cases of level-change systems. The reading of longitudinal sections and cross sections, however, is not affected by it. Floor covering and furniture, stairs and threshold are calculated, cut, and built, like pillars, walls, and vaults. Those who confirm this for themselves can perceive it in the superordinate spatial organization. Where high altars, such as in Osterhofen, Zwiefalten, and Ottobeuren, have become ambiguous, only the visual processing of spatial designs influences the dynamic center of the entire installation. Sometimes they are figurative and enclosing, while at the same time projecting a double step of sharp-edged crossed bases and space-enclosing figures, whose decided progress toward the choir shows a multistep floor movement deeply advancing into the interior of the church space, frequently overstepping the boundary of the main body. In Diessen, the double group composed of the four church fathers – the two forward figures accompanied by putti – traverses the tabernacle area and integrates the lateral parts of the convex chancel stairs. Seen from a greater distance, the four bases and statues combine into a single descending, and at the same time creative, pantomime. Comparable to choirmasters, they are the protagonists of the entire altar area, but they are also the "speakers" of a lively ensemble and a clue to a concept first visible in the three steps of the church floor, but including the wall and vault zones.[104] In view of this dramaturgical figure, the doubt uttered as to the effectiveness of the floor horizon as a level of the high altar can no longer be upheld, as logical as it may have seemed at first. The dynamics of altar construction take place on three levels: firstly, they are introverted, self-centered, self-supporting; secondly, through the tabernacle stairs, the chancel, and the choir steps, they exert a certain influence on the floor level; thirdly, through the cornice or canopy, they influence the vault zone, too. Truly a far cry from the simultaneity of southern and western choirs. The high altar relates to the interior of a church as a three-voice chorale does to an instrumental concerto.

Translated from the German by Suzanne Leu

Notes

1 Cf. Richard Zürcher, "Die kunstgeschichtliche Entwicklung an süddeutschen Barockaltären," *Der Altar des 18. Jahrhunderts*, Forschungen und Berichte der Bau- und Kunstdenkmalpflege Baden-Württemberg, vol. 5 (Munich/Berlin, 1978), pp. 53 f. This extensive study, entitled *Hochaltar und Kirchenraum*, a research project of the Swiss National Science Foundation, was interrupted by R. Zürcher's death on 2 May 1982, shortly before its completion, and has to date remained unpublished.

2 Among the three relevant surveys published since 1970 and offering the greatest wealth of material, more than half the ground plans in C. Norberg-Schulz's *Architettura barocca* (Milan, 1971) and almost half of his *Architettura tardobarocca* (1972) show neither a high altar nor a stepped floor. In N. Lieb, *Barockkirchen zwischen Donau und Alpen*, 4th ed. (Munich, 1976; hereafter cited as LIEB 1976) – the main publication the present study is based on – the high altar does not figure in five of the eight ground plans and eight of the twelve longitudinal sections.

3 "Eastern" and "eastern part," etc. as a rule refer to the high altar side, "western," etc. to the other, more distant half of the longitudinal extension, even if the church should (as an exception) not be oriented in an easterly direction (e.g., St. Johann Nepomuk in Munich, cf. note 19 below).

4 The author hopes to add the results of the series of evaluations omitted here at a later time.

5 In addition to *Rheinau* (Fietz, 1932), *Diessen, Zwiefalten*, and *Ottobeuren* (Swiss Federal Institute of Technology [hereafter cited as ETHZ], 1973/1974), the core group includes *Weltenburg, Rohr , St. Johann Nepomuk* in Munich (Asam); *Osterhofen, St. Anna am Lehel* in Munich (J.M. Fischer and Asam); the Augustinian church of *Ingolstadt, Rott am Inn* (Fischer); *Schäftlarn* (Cuvilliés, Gunetzrhainer, Fischer), *St. Gallen* (J.M. Beer von Bildstein). – The author considers the lack of precision caused by the inclusion of ground plans and longitudinal sections taken from the relevant literature (cf. figs. 1 and 2), in view of the relatively substantial lengths indicated in the *basic* comparison (floor steps), acceptable.

6 Including – in addition to *Steinhausen* and *Wieskirche* (ETHZ, 1973/1974) – *Neubirnau* (cf. fig. 3.3), added exclusively because of its floor stepping (high altar not contemporary; remodeled in 1790). Cf. fig. 1 regarding the geographical grouping of all thirteen ecclesiastical buildings included.

7 The ten partial longitudinal sections shown in fig. 2 were developed on the basis of the plans and drawings listed below. *Rheinau*: original measurements by H. Fietz (1932), 1:100, Kantonsbauamt Zurich; cf. note 10. – *Weltenburg*: *Kunstdenkmäler von Bayern*, LIEB 1976, figs. 9, 10. – *Rohr*: cf. Weltenburg, LIEB 1976, figs. 7, 8; cf. note 13. – *Osterhofen*: measurements by M. Gruber (1953); LIEB 1976, figs. 12, 13. – *Diessen*: chancel according to new measurements recorded by the ETHZ in March/Oct. 1973, 1:20/1:125, based on plans and drawings compiled by the Landbauamt Weilheim and the Bavarian Landesamt für Denkmalpflege in Munich; measurements by M. Gruber (1952/1953), LIEB 1976, figs. 14, 15.– *Zwiefalten*: chancel according to new measurements recorded by the ETHZ in March/Oct. 1973, 1:20/1:125, based on plans of the Staatliches Hochbauamt Reutlingen, *Kunst- und Altertumsdenkmale von Württemberg*, Atlas IV, 1926, in R. Zürcher, *Zwiefalten*, 1967, p. 23. – *Ottobeuren*: chancel: new measurements, ETHZ (1973), according to scale, as in Zwiefalten; high-altar stairs according to Kick-Pfeiffer (1897), cf. caption fig. 6; measurements recorded by M. Gruber (1952/1953), in R. Zürcher, op. cit., 1967, p. 33. – *Schäftlarn*: Kunstdenkmäler Bayern I (Oberbayern), R. Hoffmann (1928), (cf. note 36), fig. III; measurements by M. Gruber (1952/1953), LIEB 1976, figs. 38, 39. – *Rott am Inn*: measurements by M. Gruber (1952/1953), LIEB 1976, figs. 36, 37. – *St. Gallen*: original measurements by A. Bayer (St. Gallen) for *Kunstdenkmäler des Kantons St. Gallen* III (1961), figs. 50-54, Eidg. Archiv für Denkmalpflege, Bern.

8 For further information as to the builder of the altar, its construction, and delivery, cf. H. Fietz, *Der Bau der Klosterkirche von Rheinau … zu Anfang des 18. Jhdts.* (Zurich, 1932), pp. 28, 42 f., 97 and Doc. annex X; figs. 5, 24, and longitudinal section on p. 32; the drawings compiled are repeated in *Kunstdenkmäler des Kantons Zürich Land* I (Basel, 1938), plan enclosures I, II, acc. to pp. 246 and 256, fig. 212, cf. figs. 223, 225.

9 The high altar drawing by Caspar Moosbrugger handed in at the end of February 1719 (not extant) already has, judging by the still-extant bill for the wooden model that was manufactured accordingly, a crown, fluting, four "arches" (probably bow-type ones), and the six twisted columns on both sides of the predella panel. The basic concept of the high altar has therefore to be ascribed to Moosbrugger, while the two pairs of columns in front, the free-standing festoons, including the "attachment" of the altar to the eastern choir bay, have to be ascribed to Sichelbein. Cf. Fietz, *Der Bau*, p. 42 and n. 28; A. Knoepfli in the catalogue published for the twelve-hundred-year jubilee exhibition in Rheinau (Zurich and Einsiedeln, 1978), p. 27. Sichelbein finally supplied the pivoting tabernacle in 1728.

10 As the choir stalls are placed in the crossing, the latter assumes the function of the monastic choir, instead of, as usual, the first bay of the choir to the east; the part shown on the ground plan and the elevation as the choir area actually functions as the chancel.

11 Below, the *tabernacle stairs* are shown to be the most conventional component of the high-altar base, and – with the exception of Weltenburg – do not cover the entire width of the interior space (figs. 2, 3, right), though they are only a peripheral item in this paper. The same applies to the *choir screens* and the *choir lattices*, whose importance within the spatial composition of the church interior is significant, but cannot be used for a precise comparison, because in particular the main buildings of the core group do not have any (wooden screens in Ottobeuren, chancel lattices in Wieskirche).

12 Franz Beer's late works, in particular *Weissenau* (1717-1724), are not discussed in-depth, as the antechoir bay inserted into the transept and the (original) choir (1628-1631) continue the choir level to the west and around the crossing, but do so with the help of three U-shaped, convexo-concave steps descending to the main body and rigidly based on the interior division. Cf. fig. 18 as to the interior space of *St. Katherinental*, designed at the same time, though the execution of the steps is ascribed to his son, Johann Michael B. (1732-1735).

13 In the in-depth analysis of the interior space of Weltenburg by Norbert Lieb (LIEB 1976, p. 38), which for once does not refrain from criticizing problematical aspects, the concave step traversing the eastern part of the rotonda is lacking in the text as well as in the ground plan shown in fig. 10; in the longitudinal section of fig. 9, it can just be recognized.

14 See below for the origins of the autonomous disposition of stair units in the ecclesiastical architecture of the late seventeenth century and early eighteenth century. – According to LIEB 1976, p. 163 (cf. also p. 149), the design of the Weltenburg high altar is ascribed to Cosmas Damian, its execution, however, to Egid Quirin ("1721 and thirties").

15 LIEB 1976, pp. 38 f., 149, 163, including the excellent pictures on pl. I and figs. 24-28.

16 LIEB 1976, pp. 55 f., 153, 164; contrary to Weltenburg, this paragraph defines the floor movement as an element of the now much more flexible arrangement of the curvatures (p. 58).

17 In view of the definitely reserved attitude shown by J. M. Fischer as to the growing independence and liberation of the floor level (beginnings visible in the early works, e.g. Diessen), it seems logical to ascribe to E.Q. Asam not only the entire altar, choir stalls, and church father monuments, including the wall and ceiling stucco, but the design of the floor levels in Weltenburg, Rohr, and the St. Johann Nepomuk chapel, too. Cf. ground plans, LIEB 1976, fig. 10 (complemented by the rotonda stairs, cf. Hans Koepf, *Baukunst in fünf Jahrtausenden* (Stuttgart, 1960), figs. 598/599, plus figs. 11, 13.

18 See below.

19 Here toward the east: the narrow strip lot is placed transverse to the road (chancel in the west).

20 LIEB 1976, pp. 49 f. figs. 11a, b; pp. 150, 164, and pl. 63.

21 Egid Quirin Asam and J.M. Fischer were both born in 1692. Cf. LIEB 1976, pp. 12 f., as to the dominating influence of the 1685-1695 generation, including – in addition to the two mentioned above – Dominikus Zimmermann (a contemporary of Bach and Handel), Joseph Effner, Balthasar Neumann, K. J. Dientzenhofer, J. B. Gunetzrhainer, and François Cuvilliés.

22 The unquestioningly accepted definition of the *Murnau* parish church (1725-1727) by Max Hauttmann, *Geschichte der kirchlichen Baukunst in Bayern, Schwaben und Franken* 1550-1780, 2nd ed. (Munich, 1923), p. 122, as a first main work by Fischer, has rightly been contested. As isolated as the triconchos of the choir in the ecclesiastical buildings of that decade may be, so conventional is the pairing of strongly projecting chancel stairs firmly attached to the corners of the main apse entrance with the straight stairs between rotonda and choir.

23 After being partially destroyed in 1944, reconstruction by Erwin Schleich, 1950 f.; the Asam altars are partially preserved.

24 The ground plans in Hauttmann, op. cit., p. 172, and Norberg-Schulz, *Architettura tardobarocca,* fig. 101, are adaptations of this design.

25 The most remarkable cases are François Mansart's amazingly progressive Ste. Marie (a church of the Visitation Order) of 1632-34 in *Paris* (rue St. Antoine) and Guarini's S. Lorenzo of 1668 in *Torino;* cf. the latter's projects for Ste-Anne-La-Royale in Paris (1662, side chapels of the cross arms), and St. Maria of Altötting in Prague (1679); Norberg-Schulz, *Architektur des Barock* (Stuttgart, 1975; figs. 121, 225, 240, 249). In Borromini's work, even this disciplined form of the interior step projection is lacking, apart from a few peripheral approaches (S. Carlino, high-altar step; S. Ivo, corner chapels in the triangular points on both sides of the high-altar niche). Cf. notes 52-54 as to the special development of eastern Sicilian late baroque architecture (Gagliardi, around 1730).

26 In the main text, op. cit. 1976, p. 64, still uncontested, but questioned in the annex (p. 165, top). The relation of the high altar of Diessen (the retractable predella panel as "theatrum sacrum," cf. fig. 2.5) to Cuvilliés' later "Residenztheater" in Munich is – in my opinion – not sufficient to ascribe it to C.

27 The integration of stair design and spatial boundary conforms to the ambivalence of the ascending stairs in relation to the entire high altar: on the one hand, it functions as tabernacle stairs, on the other, it covers the entire width of the entrance to the main apse and bridges the difference in height between chancel and choir.

28 LIEB 1976, cf. ground plans fig. 15, plus fig. 13. In *Osterhofen,* Fischer chose curvatures which were interrupted several times instead of continuously curved steps (cf. ascription to E.Q. Asam, note 14 above).

29 What is "revolutionary" here is not the leveling between choir floor and nave chapels, which at the very latest Palladio (from 1576) adapts in the Redentore – though without any spatial connection between the transverse oval choir and the rows of chapels in the nave – but the "flowing" level of circulation between the two spaces on both sides of the choir arch, an uninterrupted connection which Massaris Gesuati (1726 f.) may first have realized in Venetian ecclesiastical architecture, with an unchanged choir ascent underneath the triumphal arch.

30 LIEB 1976, p. 61, recognized the "linguistic" meaning of the gradient between nave and choir, but not the renunciation of continuing the choir level into the nave, which – in my opinion – is quite significant to the relation to *Osterhofen.*

31 Begun in 1736, consecrated in 1740, destroyed in 1945; ruins demolished 1949/1950. Hauttmann, op. cit., ground plan p. 174; LIEB 1976, p. 152.

32 This solution is also interesting as the site of Fischer's closest approach to the work of Dominikus Zimmermann, which is contrary to his in almost all aspects: the "zone of interpenetration" between the main body and the choir is closely related to that of the *Günzburg* Frauenkirche (1736-1740) and practically contemporary with Ingolstadt.

33 In *Aufhausen,* return to the conventional, straight choir ascent between the pillars of the triumphal arch; the same in *Berg am Laim,* where Fischer definitely took over construction after the Köglsperger intermezzo (two-tower façade) in 1737; in *Zwiefalten* (fig. 2.6), the chancel stairs as well as the choir ascent are provided with blunt projections toward the west, but the lateral parts of the stairs are strictly ensconced in the ascending choir division. Hauttmann, op. cit., ground plan p. 178; LIEB 1976, figs. 16, 19; in addition A. Reinle in *Zeitschrift für Schweizerische Archäologie und Kunstgeschichte* 12/(1951), ground plan in Lucerne (chart 113a), for Berg am Laim, R. Zürcher in *Zwiefalten,* p. 64, n. 36, ascribed to Aufhausen or Ingolstadt.

34 Fischer's designs for the ground plans of 1748 f., LIEB 1976, figs. 28/LXXXI-II, 29/LXXXII – in a striking return to Franz Beer's *Weissenau* of 1717-1723 – provide a convexo-concave curve for all three flights of stairs around the crossing; the Lucerne project published by A. Reinle (op. cit., fig. 1a, text p. 59) does so only around the choir ascent; the Lieb LXXXIII plan adds the chancel stairs; while the finally executed solution refrains from using any curvature at all and – as in *Berg am Laim* and *Aufhausen* – returns to the elongated, bluntly projecting version (fig. 27a), avoiding all convexo-concave variation. The "preclassicist" return to sobriety, contested by Lieb, may therefore be read at least at floor level; the fact that the measurements of the ground plan of 1897, the version by Kick-Pfeiffer (fig. 6, top left), shows the high altar stairs still in a convexo-concave, curved version, however, forces us to be cautious in our evaluation.

35 Rott and Aufhausen conform as to the ground plan of the area between the central rotonda and the chancel (diagonal chapels on both sides of the triumphal arch, elongated choir stairs), cf. LIEB 1976, fig. 37, with Hauttmann, op. cit,, ground plan p. 178.

36 Destroyed in 1945, including the three Asam altars; rebuilt by E. Schleich; ascription to Gunetzrhainer not fully ascertained. Between the nave and the chancel – both traverse oval spaces – an elongated ascent of three steps; slightly curvilinear altar accesses laterally to the central space and in front of the high altar.

37 Already in 1733, under the supervision of François Cuvilliés; 1740 interrupted by the onset of war; 1751 work taken up once again, this time under the supervision of Gunetzrhainer, including (a not precisely definable) collaboration by J. M. Fischer; termination of the shell in 1757; only the exterior walls of choir and presbytery were executed according to the much more extensively dimensioned project by Cuvilliés (R. Hoffmann, *Kloster Schäftlarn im Isartal* [Augsburg, 1928], p. 17). With the dogmatic rigidity of its straight stairs at A (chancel stairs) and at B (choir ascent, cf. fig. 2.8), Schäftlarn represents probably the most obvious return to the "lower geometry" of boundary-respecting level changes (LIEB 1976, figs. 38/39; Hoffmann, op. cit., figs. II-IV).

38 Cf. note 5 above. The three partial longitudinal sections of the table shown in fig. 3 are based on the plan measurements indicated below. *Steinhausen*: chancel according to the new measurements by the ETHZ in March/Oct. 1973, according to the following scales: 1:20/1:100; *Kunstdenkmäler in Württemberg* (1943), LIEB 1976, fig. 43. – *Wieskirche*: chancel according to the new ETHZ measurements, same as Steinhausen, using plans of the Landesbauamt Weilheim; *Kunstdenkmäler Bayerns*, LIEB 1976, fig. 44 . – *Neubirnau*: LIEB 1976, fig. 46.

39 LIEB 1976, pp. 128 f., 160 f., 169, fig. 46; Hans Martin Gubler, *Peter Thumb* (Sigmaringen, 1972), pp. 80 f. (no sections). The high altar was remodeled in 1790, though the chancel and the altar stairs are certainly part of the new building finished in 1750.

40 "The floor level remains unbroken throughout the space." LIEB 1976, p. 131.

41 *Wies*: as to the late group of shifted stair projections in the ecclesiastical architecture of *Franconia* (Maria Limbach), *northern Germany* (Hamburg, Michaeliskirche), and *Switzerland* (St. Gallen and the central Swiss parish churches of the Singer-Purtschert group), see below.

42 The continuous, unshifted sequence of stairs linking the chancel (or retrochoir) – choir – crossing or nave, at the latest since the middle of the sixteenth century, is, moreover, the standard solution for an interior level change in a longitudinal ecclesiastical building; Palladio's S. Giorgio maggiore in *Venice* (retrochoir-choir, four recessed steps; choir-main body, three steps between the choir-arch pillars) is a typical example.

43 The formula used by Norbert Lieb for the main ceiling division projecting back into the third nave bay of *Neubirnau* – "shifting two systems of metrical patterns against each other," op. cit., p. 33 – may be applied to the floor level of the interior spaces of *Weltenburg, Rohr, Osterhofen, Diessen,* etc., though not to Birnau itself (cf. note 39; figs. 2, 2-5).

44 Within the core group: *Rohr* (beginning of a choir apse); *Munich,* St. Johannes Nepomuk; *Diessen* (immediately behind the recess of the chancel). Exceptions: Osterhofen, Wieskirche.

45 Nave: *Osterhofen*; crossing: *Rohr*; rotonda: *Weltenburg*.

46 *Weltenburg, Osterhofen, Rohr, Wieskirche.* See above for the special form used in *Diessen* ("antechoir" with a special level between that of the main body and the choir, but also encircling the lower main body). Analogies outside the core group: *Mehrerau, Katharinental; St. Gallen*; see below.

47 For the possible application of the term 'syncopes' from the vault sequences extending beyond the bays to the division of the floor level, see below.

48 Clearly visible in *Weltenburg, Osterhofen, St. Johann Nepomuk*; in Rohr the antechoir stairs project convexly in the center, but because of the inclusion of the transept arms into the higher level of the antechoir step, the overall design of the stairways remains clearly concave. – Outside of the core group: *St. Gallen* (execution), *Ottobeuren* (designs of 1748, LIEB 1976, figs. 28, 29, and the Lucerne project, Reinle, op. cit., fig. 1a).

49 Still valid, A. E. Brinckmann's *Von Guarino Guarini bis Balthasar Neumann* (Berlin, 1932), pp. 4 f. For today's observer, however, the problem of a spatial concept analyzed there lacks the aspect of the limitation of *verbal* transparency in the translation of complex spatial references into the combination and sequences of human language.

50 See note 2 for the meager contents of the majority of the relevant literature on the aspect of floor levels. A valid evaluation within a larger horizon of comparisons requires an "autopsy," though this is – given the number of existing monuments – hardly feasible for the individual. In addition, one would have to ask for the contemporaneity of interior stairs and ascending divisions in each single case, data normally known in-depth only if such buildings have been thoroughly analyzed, or then quite incidentally.

51 See note 25.

52 First published by Luigi Di Blasi and Francesco Genovesi, *Rosario Gagliardi* (Catania, 1972), annex table XLII. Square central building with crossing cupola and a small high-altar apse more like a niche: in the ground plan on table XLI, the steps are lacking. – In eastern Sicilian late baroque ecclesiastical architecture – and this is probably the only instance in Italy – such a treatment of the vertical main divisions also occurs, e.g., where the main front is placed on the central podium of a sequence of steps descending from the interior to street level. S. Benedetto in Catania (Crociferi, 1762) is a typical example.

53 Ibid., table XXXVIII (section); the respective ground plan of table XXXVII omits the stairs, too. In the adaptation of the drawing shown in fig. 13, it is stippled, based on the original plan (the author was lucky, because its owner, engineer Luigi Di Blasi of Noto, showed it to him), and not on the basis of the (almost unreadable) reproduction of 1972.

54 Of these two designs, the centrally planned building (note 52) remained a project; the three-aisled basilica (note 53) was built and still exists (Noto, S. Domenico), but without the semicircular transept-ends, and characteristically without the two ramplike stairs.

55 In view of the problematic verification of psycho-architectural deductions, the obvious – almost suspiciously tautological – line of reasoning has not been continued.

56 The existence of exceptions not known to the author is quite likely, but such cases would have to be analyzed as to whether a direct or indirect influence of transalpine aspects was exerted.

57 Cf. Norberg-Schulz, *Architettura tardobarocca*, pp. 93 f. and fig. 109. The centralizing expansion of the choir area by K.I. Dientzenhofer (1739-1752) shows no shifting of the levels in respect to the wall division.

58 Cf. R. Zürcher, "Die kunstgeschichtliche Entwicklung," p. 70: derivation of the rood altar and retrochoir from *Venice* (S. Stefano, Scalzi) by way of *Prague* (S. Maria de Victoria); cf. M. Kuhn, Kloster *Banz* (n. d.), pp. 8 f. and figs. 27, 34, and in particular fig. 37, regarding the high altar as a "perforated transverse barrier" between the level of the altar anteroom and the retrochoir.

59 The measurements of the ground plan of the condition existing before the choir extension executed from 1730 and recorded by K.I. Dietzenhofer (fig. in Grimschitz, *J.L. von Hildebrandt* [Vienna and Munich, 1959], table 58, pp. 48 f.) does not yet show the – centrally concave – step bridging the width of the rectangle in front of the chancel.

60 Cf. W. H. v. Freeden, *J.B. Neumann*, 3rd ed., (Munich and Berlin, 1981), pp. 65 f., p. 72, with an interesting contemporary perspective section in fig. 66. The ground plan (among others, Hauttmann, 1921) shows, in the varied repetition of the convexly curved steps leading up to the altar in the middle of the choir by the likewise convex choir step, the multi-unit stepping analyzed in the next group; in the center, the bizarre laterally projecting stairs between main body and choir still respect the spatial boundary.

61 The flat, convex, two-step ascent to the chancel freely included in the choir by Jakob Engel (1680) conforms once again to the four-step choir stairs projecting into the nave, though the lateral parts are firmly attached to the choir-arch pillars. The choir is thus slightly expanded to the west, but without eliminating the ascending caesura on the floor level. Hanspeter Landolt, *Schweizer Barockkirchen* (Frauenfeld, 1948), pp. 40 f., ground plan, p. 41, fig. 132; A. Reinle in *Kunstgeschichte der Schweiz* III (1956), pp. 172 f., fig, 102; H. R. Heyer in *Kunstdenkmäler Basel Landschaft* (1962), p. 82, fig. 63, 64.

62 The fact that the projecting, convex choir step is placed along the ascending wall division in the anteroom of the altar without any attachment, preluding the inclusion of the longitudinal, convex gallery into the transverse axial cross arms, is not discussed in the still fundamental analysis of syncopal spatial shiftings by Paul Frankl, *Entwicklungsphasen der neueren Baukunst* (Leipzig and Berlin, 1914), p. 83.

63 The interfacing of the raised altar anteroom with the antechoir and the ascending stairs, instead of the rectangular space in front, is a novelty, for the latter has frequently been adopted by Italian ecclesiastical architecture since the mid-sixteenth century. To be mentioned in this context: *Milan*, S. Maria presso S. Satiro (around 1550) and S. Giuseppe (Ricchini, 1607); *Rome*, Gesù (1568), and *Caprarola*, S. Teresa (Rainaldi, 1620); *Venice*, Salute (Longhena, 1631); in southern Germany since the end of the sixteenth century (*Würzburg*, Universitätskirche, 1583-1591), Hauttmann, op. cit., p. 109.

64 Two variants; in both, the rostrum forms the anteroom of the high altar; the latter is placed "underneath the choir arch, behind which the priests' choir, adopted from an earlier design, is placed": A. Reinle, first publication of the design, *Zeitschrift für Schweizerische Archäologie und Kunstgeschichte* (1950), pp. 229 f., table 77a bottom; Lieb-Dieth, *Die Vorarlberger Barockbaumeister*, 2nd ed., (Munich and Zurich, 1960), fig. 201; Einsiedeln exhibition catalogue, *Die Vorarlberger Barockbaumeister* (1973, hereafter cited as Einsiedeln cat.); nos. 32/33, fig. 65. – Whether the extended steps are of anticipatory significance for the early parish churches by Jakob Berger (Sursee, 1638; baroque version, 1751, high altar only in 1776/1777; *Stans* from 1641), depends on whether they were built by Berger himself or part of later alterations. Reliable findings have to be discussed in a new investigation of building history. Ground plans in A. Reinle, *Kunstgeschichte der Schweiz* III, p. 24 and figs. 13/2, 14; ibid., p. 26 and figs. 13/3, 15: *Kunstdenkmäler Luzern* IV, 427 f.

65 One-step version with curved sides covering two-thirds of the central space; cf. A. Knoepfli, *St. Katharinental*, Guides to Swiss Art, publ. by the Society for the History of Swiss Art, 2nd ed., (1967). According to H.-J. Sauermost in *Münster* (1966), p. 54, and Einsiedeln cat., pp. 14, 101, J. M. Beer's execution (1732-1735) is essentially based on the project developed by Franz Beer (c. 1719 -1726, Einsiedeln cat. 64a, table 91a), or rather, a reliable copy of a longitudinal section through Peter Thumb's copy of the same. As his longitudinal section, however, places the choir step to the *east* instead of to the west of the choir arch, the extension of the choir level into the transeptlike central space (and therefore the curvature of the step and baluster screen) has to be considered a novelty added by Johann Michael Beer. In my opinion, we cannot exclude the possibility that a certain distant influence (transept stairs in *Rohr* of 1717-1723, cf. fig. 8) was exerted by the Asam brothers. Renewed investigations of the main influence by Franz and Johann Michael Beer on the basis of the Weesen plan findings by A. Knoepfli (*Festschrift N. Lieb, Zeitschrift für bayrische Landesgeschichte* 35/1 [1972], pp. 234 f.) touch only slightly upon the temporal aspect of steps and screens; cf. pp. 249, 264 f. and figs. 128-130, 1989 (St. Katharinental), figs. 32, 22; cf. *Kunstdenkmäler Thurgau* IV.

66 J.M. Beer von Bildstein was Franz Anton Beer's head mason, but the design (Lucerne) is generally considered Johann Michael Beer's earliest still-extant work. The building itself was demolished in 1808. A. Reinle in *Zeitschrift für Schweizerische Archäologie und Kunstgeschichte* 12 (1951), 14, table 5b; Einsiedeln cat. (1973), no. 93, p. 128, and fig. 110.

67 A. Knoepfli and P.-H. Boerlin in *Zeitschrift für Schweizerische Archäologie und Kunstgeschichte* 14 (1953), p. 214 and figs. 81/19.

68 Since the logical analysis by H.-M. Gruber *(Zeitschrift für Schweizerische Archäologie und Kunstgeschichte* 07 [1970], pp. 226 f. and fig. 1), the former attribution of the design to Peter Thumb has shifted in favor of J. M. Beer von Bildstein; cf. Einsiedeln cat. no. 99, fig. 118; as to Beer's position within the planning history and to the relation of his design to the building actually executed by Thumb (1753-1755), cf. H.-M. Gubler, *Peter Thumb*, pp. 110 f. The flexible convexo-concave lineament of the screen concentrically follows the triconchos form of the choir, but is, like the polygonal antechoir screen of Mehrerau, freely placed in the transverse oval main body.

69 Whether the designs for *Mehrerau* and *Fischingen* actually contain stepless choir screens, cannot – contrary to Tiengen – be fully ascertained (cf.Knoepfli/ Boerlin, 1953, p. 214 and the quoted fig. of the plan in notes 63/64 above). The spatial relationship of the choir screen and the choir stairs or the entire transitional zone between nave/crossing and choir entrance need to be investigated separately; cf. note 12.

70 For the parish church of St. Felix and Regula, cf. H. Fietz, *Kunstdenkmäler Zürich Landschaft* I (1938), p. 316, and enclosed plan III, no. 76; Gubler, *Peter Thumb,* pp. 229 f. and fig. 4. In spite of the entirely different ground plan, the simple concave antechoir stairs are based on the basic shape already used by the Asams around 1730-1740. (*Osterhofen*, 1726-1734, St. Johannes Nepomuk church in *Munich*, 1733-1746).

71 Abbey archives, project XIII: in particular P.-H. Boerlin, "St. Gallen und J. M. Beer von Bildstein," *Zeitschrift für Schweizerische Archäologie und Kunstgeschichte* 14 (1953), pp. 228 f., table 94, fig. 47; idem, *Die Stiftskirche von St. Gallen* (Bern, 1964), pp. 54 f., 106 f., 115, and fig. 32. The lively undulating choir step reaches up to the lateral parts of the transept, but its center (choir ascent) remains in the traditional position, between the choir bay pillars.

72 St. Gallen abbey library; Boerlin, "St. Gallen," p. 223, fig. 96 (51); idem, *Die Stiftskirche,* pp. 109 f., 115, 119, and figs. 36- 42. Unlike Bagnato, the high altar is preceded by a rostrum, accessed by convexo-concave chancel steps – an early form of the later, much simpler shape (double stepping). – H.-M. Gubler considers neither Bagnato nor Looser, but J. M. Beer von Blaichten to be the author of the nave and the rotonda; *Peter Thumb*, pp. 105, 109.

73 Project XII of the abbey archives attributed by Boerlin, *Die Stiftskirche,* 1964 (pp. 50 f., 99 f., 115, 124, to figs. 27-30), to Caspar Moosbrugger and dated around 1720-1723 (unlike Gubler, *Peter Thumb*, plan III, no. 100, 104 f., and figs. 539, 542), who attributed it to J. M. Beer von Blaichten); interesting because of its placement of the middle part closely east of the triumphal arch. See Boerlin, *Die Stiftskirche*, pp. 161 f., for the conformity of the building diagram and the type of space of the St. Gallen rotonda (octagonal step in *Murnau,* 1717, note 22 above). For the contemporary presence of the rotonda deambulatory on the same level as the choir floor, we only refer to the main body of Wieskirche (1749-1753), which was under construction at the time the Looser model was created.

74 This, too, is not a mid-century novelty; cf. the ground plans of *Weissenau* (1717-1724), *Rohr* (1717-1722), *Osterhofen* (1726-1734), and *Diessen* (1732-1739); where the continuous encircling of a lower interior level by a higher level without shell remains within the ascending part (colonnade), it may be interpreted as a reduced form of the double-shell hall (base – surface shell).

75 Boerlin,"St. Gallen," fig. 89 (36), and *Die Stiftskirche,* pp. 46 f. 98 f., 115 (dated 1951, "January – March 1952" latest), fig. 18. The old choir was probably preserved with the choir stairs, according to the wishes of the "Seniorenrat" confirmed in 1752 (Boerlin, *Die Stiftskirche,* p. 18). The flat, concave screen delimits a shallow antechoir zone along the entire width of the transept. The existence of a step has not been confirmed, but the intervals clearly denoting the screen as stepless, such as in the *Tiengen* project, are lacking (the passages are on the same level as the transept).

76 A. Reinle in *Zeitschrift für Schweizerische Archäologie und Kunstgeschichte* 12 (1951), pp. 3 f., and fig. Ib. According to Boerlin, *Die Stiftskirche,* pp. 64, 113 f., 115 ad fig. 43 (agreeing with A. Knoepfli in *Montfort* 18 (1966), p. 182 and Gubler, *Peter Thumb,* n. 555), the Lucerne drawing is – in spite of the still-lacking two-towered east façade – not Thumb's work, but a copy of the no longer extant plan as executed, with its remodeled choir; *Unterlage für die Anordnung der Innenausstattung im Kuppelraum*. The "Auer Plan" of April 1755, Gubler, op. cit., pp. 112, 114, considered Peter Thumb's plan for the new building incorporating the original choir but neglected the design of the floor level (ibid., fig. 44).

77 According to an oral communication by P.-H. Boerlin – to whom the author owes his extensive knowledge of the St. Gallen plans and sources plus a series of valuable clues and references – the eastern, slightly convexo-concave double line of the Lucerne drawing between the choir-arch pillars is to be read as a choir screen, the western ones as a baluster screen; there is, however, no absolutely positive identification of the levels and steppings in this ground plan.

78 As far as I know, the fact that Rischer's project, (Abbey Library no. XI a-d), Boerlin, *Die Stiftskirche,* p. 194, text pp. 48 f., 80, 98, and figs. 23/24), dated 1754 and signed, extends the choir level without steps into the transept, as the only design extant from before the beginning of construction, has to date remained unnoticed: antechoir level and three-step, convex descending stairs underneath the crossing cupola; convex chancel stairs between the apse pillars. According to Boerlin, p. 80 (n. 176), Rischer's work had virtually no effect. Whether the continuation in the choir, executed after 1761, of the floor level underneath the triumphal arch and into the rotonda – not as to its design (here concave, there convexly curved), but in its concept of interior spatial boundary crossing – is based on Rischer's idea can be neither confirmed nor excluded.

79 The two steps of the middle passage through the choir screen – but not the step below its concavely projecting sides – have, since 1967, been covered by the wooden podium of the new celebration altar. In addition, the communion bench, running parallel to the western side of the lattices, was eliminated by a recent interior restoration. A. Knoepfli, *Kathedrale St. Gallen*, Guides to Swiss Art, publ. by the Society for the History of Swiss Art, 6th ed., (1979), ground plan p. 5. For more in-depth information on the condition since 1967, the author wishes to thank his colleague A. Knoepfli.

80 A kind of "blending" of the choir with the nave, probably first recognized by E. Poeschel, *Kunstdenkmäler St. Gallen* III (1961), p. 153: "… letting (the choir) flow into the rotonda space by placing the lattice and the step in front" (cf. p. 194). There is no direct definition of the westward choir floor expansion but a clear reference to its syncopal effect as a counterimpulse to the dominating symmetry of the entire space: A. Knoepfli, *Kathedrale St. Gallen*, pp. 8 f.

81 Cf. notes 72, 73 above.

82 The authorship of J.M. Beer von Bildstein in the second of the main construction phases (choir and towers) is hardly contested any more; cf. Gubler, *Peter Thumb*, p. 101, and end of fig. 584.

83 This statement does not contradict, does, however, strongly modify the in–depth spatial analysis by H.-M. Gubler, ibid., pp. 108 f .

84 According to the valuable information once again provided by P. H. Boerlin, whether the segmented stairs leading to the high-altar podium belong to the choir built beginning in 1761 or to the classicist high altar of 1806 could not be determined. Its ground plan seems to belong to the later period, but the projects of 1750-1753 propose a longish (Beer, drawing VIIIa) or convexo-concavely curved (model Looser) ascent from the middle choir to the altar podium. As to the high-altar design of 1764/1765 (painting, unsigned) and to the temporary situation existing until 1808, cf. Boerlin, *Die Stiftskirche*, p. 24 and n. 75.

85 The only exception is – as far as I know – the group of large parish churches built in central Switzerland around 1752-1810 (Singer-Purtschert diagram); cf. notes 87-94 below.

86 Ground plan: Hauttmann (1923), p. 150; destroyed 1945 in an air raid; later reconstructed, though the interior furnishings were lost.

87 Eckert Collection LXVI; without doubt attributed by B. Grimschitz to Hildebrandt; the respective longitudinal section of 1732 in the Staatliche Kunstbibliothek Berlin (v. Freeden, *J. B. Neumann*, fig. 51) neglects the floor level.

88 As already stated by A. E. Brinckmann, op. cit. 1932, fig. p. 8 and text p. 11 (formula a-b-c-b-a), and more recently by Norberg- Schulz, op. cit. (1971), p. 151. In the original Würzburg ground plan, the first (vestibule) of the two oval units, *the third* (longitudinal oval), and the *fifth* (chancel) are indicated by points. The *fourth* (choir), not indicated one can be imagined as the mirror-symmetrical reflection of the *second* one (W central space), marked by free-standing columns.

89 Cf. Brinckmann's compositional diagram, op. cit., p. 8 bottom, plus the instructive photographic view of the choir in Grimschitz (1959), fig. 223.

90 Cf. Norberg-Schulz, op. cit. (1971): "queste soluzione (sc. della compenetra-zione sincopata) si avvicina a quella di Banz, ma, int roducendo delle colonne libere, Neumann rivela un più forte desiderio di separare il sistema dei baldacchini dai muri esterni" (these solutions [of a syncopal penetration] approached that of Banz, but, by introducing free-standing columns, Neumann revealed a stronger desire to separate the system of the canopies from the exterior walls) (p. 151 and figs. 207-212). In the rather reserved attitude shown by Neumann – whose authorship of the *spatial concept* of the Hofkirche is hardly contested any more – in view of the spectacular shiftings of the floor level, the reservedness shown by the Dientzenhofers, whose Frankfurt and Bohemian main works never exert-ed more influence than here, continues to flourish.

91 Cf. Heinz Horat, *Die Baumeister Singer im schweizerischen Baubetrieb des 18. Jahrhunderts* (Lucerne, 1980), pp. 72 f., p. 74 ("strongly projecting choir steps"); cat. no. 52, pp. 296 f., in particular p. 298 bottom; older literature, p. 299, ground plan fig. 44.– For the preliminary forms in Luthern, cf. ibid., pp. 52 f. (p. 54: "the choir steps already reaching far into the nave"), cat. no. 40, pp. 275 f., in Silenen, ibid., pp. 54 f.; ground plan, fig. 28, cat. no. 44, pp. 287 f.: "… access to the choir by way of two curved steps leading up from the side altars and two additional ones below the choir arch" (p. 288).

92 André Meyer in *Kunstdenkmäler des Kantons Schwyz* I, new edition of 1978, pp. 106 (the ground plan in fig. 79 corrects the one in A . Reinle, *Kunst-geschichte der Schweiz* III [1956], fig. 142); Horat, op. cit. (1980), p. 107 f., longitudinal section and ground plan figs. 80/81, cat. no. 70, pp. 323 f.; older literature, p. 355.

93 Horat, op. cit., pp. 80 f., longitudinal section and ground plan, figs. 51/52, cat. no. 80, pp. 352 f.; older literature, p. 355.

94 Horat, op. cit., pp. 77 f., cat. no. 85, pp. 368 f.; older lit., p. 369; E. Müller and J. Grünenfelder, *Pfarrkirche St. Jakob, Cham,* Guides to Swiss Art, publ. by the Society for the History of Swiss Art (Bern, 1982), pp. 6, 8, 21.

95 Horat, op. cit., pp. 75 f., 80, 213, ground plan fig. 45. Cf. ibid., pp. 222 f., 224: relationship between the Singer brothers and Josef and Niklaus Purtschert.

96 See note 89 above; "… the strong difference in height that the steps in front of the side altars have to bridge lets us assume the integration of an earlier choir" (Horat, op. cit., p. 354).

97 As already in the early work by Jakob Singer (Cham, design; Hochdorf) and in the late work by Purtschert (Schüpfheim, cf. note 94 above), the concave opening of the antechoir zone toward the main body anticipates the curvilinear transition of the transept to the triumphal arch and the choir; the motto of the Singer-Purtschert diagram (exception: Näfels) is interesting, too, as probably the latest proof of the reappearance of spatially integrative compositional for-mulas of the early eighteenth century: cf. ground plan of St. Peter's in Würzburg (1717 f.), here figs. 16, 22, 23, plus note 72.

98 In this respect, Adolf Reinle's statement on the parish church of Schwyz – "the stair podium of the choir flows into the nave and comprises all the side altars" – ought to be rendered more precise by a more definite limiting of the Singer-Purtschert diagram of the St. Gallen solution (the only church to which the formula quoted above fully applies). The same applies to the (more precise) formulation by André Meyer, *Kunstgeschichte Schwyz* I, p. 106.

99 X. von Moos and L. Birchler, *Kunstdenkmäler des Kantons Luzern* I (1946), pp. 141 f. Original ground plan and longitudinal section by Purtschert; figs. 119/120. Five-step choir stairs between the choir-arch pillars, plus a shallow, one-step mezzanine level, bluntly projecting at the sides (antechoir zone), anal-ogous to Ruswil. Stairs replaced by an overall renovation (1977-1979) but still extant in the old form (oral information in situ on 29 Sept. 1983); cf. J. Röösli in *Festschrift* for the inauguration of the restored church (Schüpfheim, 1979), p. 18, plus F. Portmann, in *Bll. für Heimatkunde a.d. Entlebuch* 12 (1939).- As to the last example, built fully a century after Luthern, cf. *Rain* (1853-1854), *Kunstdenkmäler des Kantons Luzern* IV (1963), p. 232, (cf. p. 389), figs. 201, 204, 205.

100 *Preliminary versions*: Paris, St. Roch (Lemercier 1603); Bologna, S. Salvatore; Paris, church of the Visitation Order (cf. note 25 above) ; Rome, S. Carlo alle quattro fontane; Ariccia, S. Maria dell'Assunzione; Gabel; Weingarten; Fürstenfeld, Munich, Dreifaltigkeitskirche; Ingolstadt, Franciscan church; Munich, St. Anna am Lehel, Rott am Inn; Vienna, Piaristenkirche; Günzburg; Vierzehnheiligen, Etwashausen, Maria Limbach; Dresden, Hofkirche; Noto, S. Domenico (project fig. 13); Torino, Carmine; Brà, Sta. Chiara; Besançon, St. M arie Madeleine (1762).– *Interim versions* (shifting only within the chancel and the choir): Obermarchtal 1686-1701, fig. 14; Waldsassen; Vienna, St. Peter, choir extension of 1731; Wieskirche; St. Gallen, (project XII and model by Looser); Arlesheim, late baroque remodeling of 1755-1760.

101 Preliminary version, university church 1583-1591. – Salzburg, Kollegien-kirche (1696); Linz, seminary church; Würzburg, St. Peter, fig. 16; Solothurn, St. Ursen, project 1711, fig. 15; Weissenau; Mehrerau, Tiengen (project of 1752, fig. 17, 19); Munich, St. Johannes Nepomuk; Bruchsal, St. Peter; Diessen, Zwiefalten (figs. 5, 9); St. Gallen, Project VIII and Lucerne drawing.- Hochdorf, Schwyz, Näfels, Ruswil, Cham, Schüpfheim: figs. 22, 23.

102 Weltenburg (1716), Rohr, Osterhofen; St. Katharinenthal, Rheinau St. Felix and Regula; Münster, Clemenskirche; St. Gallen project by J.J. Rischer of 1754 (transition choir-transept, cf. note 78 above) and execution beginning 1761; cf. figs. 7, 8, 18, and diagram fig. 10.

103 See notes 52, 53, and figs. 12, 13.

104 See above.

105 Compare the suggestive measurements taken by Max Hirmer, LIEB 1976, figs. 68-83, in particular 69, 77-80 (Diessen); 55, 56, 60 (Osterhofen); 108, 109, and color pl. IV (Ottobeuren). Plus, for Zwiefalten: R. Zürcher, *Zwiefalten*, pl. 14, 35 (Helmut Hell).

Picture credits

All drawings and diagrams by the author.

Leïla el-Wakil

Aspects of Genevois Architecture from the Reformation to the Nineteenth Century

The Part Played by Foreigners – between Repression and Status

Ever since the publication of the *Recueil de Renseignements sur les beaux arts à Genève* (Collected Information on the Fine Arts in Geneva, 1845–1849), a precursory work by mayor and connoisseur Jean-Jacques Rigaud, historians have all too often painted Geneva as a city devoid of major art; they have almost always put the blame on Calvin and the measures to forbid luxury. Geneva's artistic development, shattered during the iconoclastic days of 1535, should have remained dormant. Constrained by rigorous sumptuary statutes, it should not have risen again until the end of the eighteenth century. Between these times, the city should have been content with applied arts intended for export – jewelry, silver, enamel painting, or engraving.

However, although it cannot be denied that the effects of the Reformation – and in particular the loss of commissions from the Church – did represent a handicap for painting and sculpture, they had little impact upon architecture. On the contrary, the increase of foreigners seeking refuge in this Protestant Rome gave a welcome stimulus to building. It was in this community of French and Italian refugees that the finest architects and the wealthiest patrons were found up to the eighteenth century. Had they not managed to import and impose international fashions, Geneva would have retained the look of a small provincial town. The flowering of Genevois architecture in the seventeenth and the eighteenth centuries raises questions that often overlap. Who

220

influenced architecture? What part did foreigners play? What was the religious influence? Were there reactions against foreigners? What was the real impact of the sumptuary laws on architecture?

This study's purpose is to unravel some threads of the tangled skein of human and social relationships underlying architectural achievements in Geneva.[1]

The Notion of Fashion and Luxury in Genevois Architecture

The influence of the sumptuary laws on art has been much debated. These measures, a contemporary practice in many European cities, should be considered less emotionally. The excessive importance sometimes given to them sounds like an alibi for an artistic dearth. It is better to use some basic common sense to filter the denunciatory dictates: the harsher the threat, the less heeded. Besides, would it have been really possible to keep the Genevois away from forbidden fruit? Reading between the lines, it is soon obvious that, from the eighteenth century on, the Chamber of Reformation was no more than a lone voice preaching in the desert.

Regulations concerning the luxury of private buildings evolved with time and, until the beginning of the eighteenth century, affected furnishings and decoration more than architecture itself. The most explicit prohibitions relative to buildings appeared in a statute of 1710. The government, which included representatives of the builders' families, was probably torn between the need to embellish the city and concern over ostentation. As for the Chamber of the Reformation, it tried to nip in the bud an emerging tendency. The powerful merchant Jean-Jacques Bonnet had closed off the lake perspective from the place du Molard with a large house begun in the 1690s (fig. 1). Jacques Eynard, a wealthy refugee merchant from French Dauphiné, had ordered master mason Moïse Ducommun[2] (c. 1667–1721) to build his beautiful house, Derrière le Rhône – overlooking the port of La Fusterie (1694–1695) – possibly according to the plans of architect-engineer

fig. 1: Main façade of the Maison Gonnet, giving on the place du Molard. This old photograph shows a careful architecture using the superposition of orders.

Pierre Raby[3] (1627-1705). Above all, the first town mansions had appeared. Three years later, Léonard Buisson (1643-1719), delegate to Louis XIV at Versailles in 1696, built the first townhouse sited between courtyard and garden "to a plan imported from Parys," very close to the project of Jules-Hardouin Mansart for the Hôtel de Lorge (fig. 2).[4] In 1705 Jean-Antoine Lullin-Camp commissioned Joseph Abeille to design the opulent building of La Tertasse.

To such constructions marking an unmistakable turning point for residential architecture in Geneva corresponded regulations limiting floor-to-ceiling space to a maximum of eleven feet. The use of fine materials such as polished marble, walnut, parquets made of woods other than pine, or richly carved wood paneling was equally forbidden. Statues, whether indoors or out, and costly paintings were prohibited. The owners, and even the workers who tried to get around the law, were liable to fines.[5] In 1720 the Chamber of the Reformation tried to outlaw the hôtel or mansion type of construction. In a debate in the Council of the Two Hundred, the syndics retorted that it was necessary to remove from the statutes the "article pertaining to buildings as, in certain cases, it is impossible to apply due to the laws of architecture."[6] Texts of these 1739 statutes prove that their voices were heeded: fashionable styles, mainly from France, could no longer be resisted.

During the eighteenth century, more and more cheating occurred among "top-class people." The *Traité du Luxe* (Treatise on Luxury, 1774) by Jean-François Butini (1747-1800), while apparently praising the wisdom of austerity measures as set down by the Chamber of Reformation, rang the bell for sumptuary ordinances abolished soon after. Nobody could ignore that, in Paris during the same period (1778), Madame de Vermenoux, young widow of George-Tobie Thelusson, a banker of Genevois origin, engaged Claude-Nicolas Ledoux, assisted by Claude-Jean-Baptiste Jallier-de-Savault (1740-1806).[7] The visionary architect invented for her a sensational folly with a portal in the shape of a "mouth opened on nothing," which was the talk of *Tout-Paris*.

In his treatise, Butini played down an important phenomenon when speaking of "some Genevois who, used to the pomp and delights of great cities, consider any sumptuary ordinance as a monastic rule, a chain only fit to be broken."[8] In fact, the Genevois aristocrats, the majority of whom were bankers and important merchants, found themselves influenced by daily and family contact with the international elite and felt their influence. Through their links with Lyon and Paris, they were on familiar terms with French artistic circles.

In Paris, the clique that gathered around banker Robert Butini was a good example of the sort of network fashioned between Genevois of Geneva, Genevois abroad, and the French. Butini owned "a mansion with carriage entrance, courtyard, and garden, at the Clairvaux cul-de-sac and the corner of rue Saint-Martin,"[9] where he received his colleagues Gédéon Mallet and Pierre Cramer, who stayed with him between 1718 and 1720. During this sojourn, the two brothers-in-law met Rouen architect Jean-François Blondel[10] (1683-1756) and asked him to design their own houses.[11] In 1721 Gédéon Mallet, one of many Genevois who got out of Paris following Law's bankruptcy, chose the site of the ancient cloister of the Cour St. Pierre to build an up-to-date, spacious and luxurious mansion (fig. 3).[12] Three years later, the young and wealthy minister Ami Lullin (1695-1756) began a country house at Creux-de-Genthod (fig. 4). Described by Blondel as having "a main building in the Italian style,"[13] the type of villa erected here offered new prospects to the Genevois upper-class: for fifty years, local builders copied it with few variants.

Though often infringed, the sumptuary ordinances left their stamp. Bourgeois practicality marked the Genevois mentality. For every Apollon Tronchin[14] who, influenced by Voltaire's gibes, quietly disdained the sumptuary edicts, how many patricians felt truly and profoundly concerned?

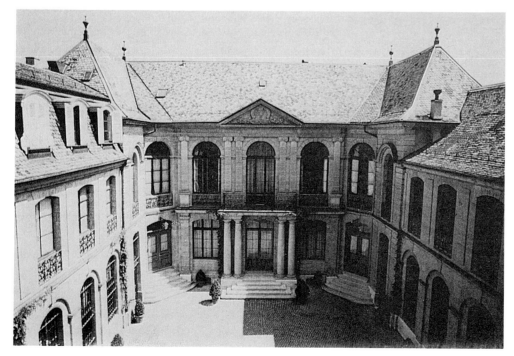

figs. 2a,b: The inner court and garden façade of the first mansion built in Geneva. It is often said that "luxury came to Geneva by the carriage door of the Buisson mansion."

Probably warned by his patron, then a member of the Venerable Company of Pastors, Jean-François Blondel, writing to Lullin about the interior decoration of the Creux-de-Genthod manor, insisted: "I have not put any kind of ornament on the ceiling cornices, feeling apprehensive that it might not be properly done in Geneva and seem too rich to you."[15] The French architect Claude-Jean-Baptiste Jallier-de-Savault, commissioned in 1762 to design plans for Antoine Saladin's house in Crans, submitted a project that seemed too Parisian to the eyes of Isaac-Robert Rilliet-Fatio, the future builder of Varembé and a friend of Saladin's, who compared it with local builders' plans:

> I don't know whether you will be pleased by the plans of your house; I think that the ones you had drawn up in Geneva, and that you showed me, were just as agreeable and comfortable as those of M. Jallier, who, by trying to give each bedroom toilets, wardrobes, entryways, etc., in my opinion has cut up the apartments and made the rooms too small; this looks a bit like the ways of Paris, where one cannot even go to the country without a full retinue…[16]

And at the beginning of the nineteenth century, when jeweler Jacob-David Duval was about to return definitively to Geneva, he took into account his mother's written advice praising the simplicity of Geneva houses.[17] He gave up the idea of creating the Château de Cartigny after Rastrelli's opulent neo-classical models for St. Petersburg. Jean-Gabriel Eynard, himself one of the richest men under the Restoration, also felt that "it is not done for an owner to appear too wealthy."[18] This led him to downgrade the project of an urban palace created for him by Florentine architect Giovanni Salucci to more "Genevois" proportions. Which did not prevent General Guillaume-Henri Dufour from writing to French colonel Baudrand: "Right now, I am supervising the construction of a small palace one of our rich fellows is putting up."[19]

Master Craftsmen, Local and Foreign

The employment of foreign artists and craftsmen was a Geneva tradition dating back to the Middle Ages. In the golden age of the bishoprics of Jean de Brogny and François de Metz, Geneva was a center of artistic activity, attracting masons, painters, and sculptors from as far as Burgundy and Flanders in the north, Piedmont and Provence in the south. The Chapelle des Macchabées (prior to 1400) ordered by Cardinal Jean de Brogny is one example of this artistic mix. The architecture is similar to realizations in Avignon. The concert of musician angels adorning the vaulted ceiling came from the Piedmont atelier of Giacomo Jaquerio,[20] initiator of international Gothic art in Geneva. The sculpture of the cenotaph, as well as that of the cathedral stalls, was entrusted to Brussels sculptor Jean Prindale,[21] who busied himself between Dijon and Chambéry. Later, François de Metz called upon Balois painter Conrad Witz for an important altar screen dedicated to St. Peter (1444).

This presence of foreign craftsmen went on after the Reformation, except that the workmen now came to Geneva for religious reasons. A large contingent of French construction workers from the south of France (Dauphiné, Languedoc, the Cévennes, Montpellier) poured in after the Revocation of the Edict of Nantes. However, toward the middle of the eighteenth century, the majority of masons were "Swiss," traditionally recruited from the Canton of Neuchâtel.[22] Bonded by origin and family ties, the teams from Le Locle or Fleurier dominated after 1750. The four dynasties of Bovet, Matthey, Vaucher, and Favre monopolized the construction scene. Handsome buildings, such as the Lutheran church (1763),[23] no doubt designed by the older Jean-Louis Bovet – who built the Château de Malagny (1753-1757)[24] and that of Crans,[25] the granary of Rive (1769-1771), the military barracks of La Treille – are the work of teams of master masons and master carpenters originally from Neuchâtel.

Nevertheless, until the second half of the eighteenth century and the pivotal date of 1751, which marks the cre-

fig. 3: Jean-François Blondel's engraving of the elevation of Hôtel Mallet in Cour St.Pierre (reproduced in Jean Mariette, *Architecture française*).

ation of the Ecole de Dessin (School of Drawing), there were practically no Genevois architects. As such, Geneva was no different from other provincial towns. Even her important neighbor Lyon, the first commercial and banking seat of France before being dethroned in the eighteenth century in favor of Paris, was described as a "great provincial town, but a town with neither prince nor aristocracy [that] at the end of the seventeenth century is a town without an architect."[26] Lyon's first architect was Jacques-Germain Soufflot (1713-1780), whose activities were also tied to the architectural destiny of Geneva.[27]

In the eighteenth century, perhaps only the son of Vaudois builder Jean-Michel Billon[28] was worthy to be called an architect. It was to him that the Genevois authorities entrusted the important project of a mansion for the French Resident (1740-1743), a repeat on the theme of the mansion *"à la française."* His career followed in the wake of such foreign personalities as Abeille, Vennes, and Blondel, whose principles he applied, though never their student.[29] As for the talented Jean-Louis Bovet the Younger (1725-1754), whose possible collaboration on the constantly changing works of the Ecole Militaire in Paris remains to be examined,[30] it is easy to imagine that he might have been an outstanding figure among Genevois and even Suisse-Romande architects of his time had he lived longer.

The creation of the Ecole de Dessin in 1751, thanks to the persistence of councillor Jean-Jacques Burlamaqui[31] (1694-1748) and after many false starts, represented a great victory for art in Geneva, even though the Genevois hid it from themselves for a long time. The motive was not artistic education, but a teaching destined to improve the average level of local craftspeople. As Pierre Soubeyran, director of the Ecole, continued to repeat as late as 1770:

We never intended to train here first-rate sculptors or painters for whom this study (of live models) is essential, because we have no need for them in Geneva; but to train artisans who manufacture things for commerce or those who serve civic needs and not magnificence.[32]

However, one must await the dawn of the Restoration and the strong personality of Samuel Vaucher-Crémieux[33] (1798-1877), born of a family of master masons from Fleurier, to see the first generation of Genevois architects.[34] Trained at the Ecole Polytechnique of Paris, and then under engineer Guillaume-Henri Dufour, for some twenty years Vaucher was given the state's main commissions. Following a resolutely international and modern style, he built, one after the other: the Musée Rath (1823-1824), the rue de la Corraterie (1827-1833) derived from Percier and Fontaine's model for the rue de Rivoli, the Rive penitentiary (1822) – thereby gaining international repute by applying the panoptical process of Englishman Samuel Bentham – the new riding school (1827-1828), the covered market by the Rhone (1829-1833), the lunatic asylum at Les Vernets (1847-1861), and worked on the building designed by Hector Lefuel for the imperial residence of Napoleon III at Faro. This master mason's son rose in society to become the architect of the French emperor's house in 1852 as well as being internationally recognized as an authority on penitentiary buildings.

Huguenot Nicolas Boqueret at the Service of the Republic

The first great works in the aftermath of the Reformation were erected by the state and showed the young republic's twofold ambition – democratic and cultural. The models of Genevois magistrates "given to construction and architecture,"[35] Pernet Desfosses and Nicolas Bogueret, a refugee from Champagne,[36] transformed the old town hall into a classical palace as early as 1555, while the Académie de Calvin went up almost simultaneously.

The Maison de Ville, "superbly rebuilt as new, with its paved ramp for horsemen," was highly admired and, with the market halls of Neuchâtel, heads the list of Swiss Renaissance public works.

fig. 4: Elevation of the Lullin mansion at Creux-de-Genthod, reproduced in *Maison Bourgeoise*, after a project of Jean-François Blondel.

Some fifteen years later, the government mandated this same Bogueret for the first reconstruction of the Halles du Molard, a top priority government project, then that of the Arsenal in front of the Hôtel de Ville (1573). Only too content to rely on the advice of a French master, the Council retained him with exceptional conditions: the best salary of any master mason in the Seigneurie.[37]

Because of his renown, neighboring governments, such as the town of Morges (1574), the Senate of Savoy (1575), or the Bernese authorities (between 1593 and 1600), also called upon him.

Thus, the Seigneurie conformed to the image of "good government,"[38] purveyor of equipment and public buildings that enhanced the city. But the desire for similar architecture spread among the population; private owners joined the trend.

The Maison Turrettini: Two Refugees to Build One Palace

After the great international merchants – the Medici, the Asinari, the Sassetti – of the end of the Middle Ages came the refugees, a French and Italian elite of bankers and brokers. Used to a gentler lifestyle, the refugees played a dominant role in introducing new artistic forms. Through them, Renaissance and Mannerist principles finally arrived in Geneva.

The main agent of this artistic renewal was François Turrettini,[39] husband of Camille Burlamaqui. In his *Mémoires,* he tells of his flight from Lucca, a European odyssey that brought him to Geneva (1574), Antwerp (1579-1585), then Frankfurt, Basel, Zurich, and finally, to settle in Geneva in 1592. Linked to banking as well as the manufacture and international commerce of silk, he belonged to the elite of Lucca, as did the Burlamaqui, Calandrini, Diodati, and Micheli. He himself came from the picturesque castle of Nozzano near Lucca, built in the festive style of the Très Riches Heures du Duc de Berry. His wife was related to conspirator François Burlamaqui, who built the remarkable Villa Gattaiola around 1540.[40] They liked

to live well. This explains why they were the first to have a "master carpenter and sculptor" from Burgundy, Faule Petitot,[41] build them a palace as innovative[42] by its size and details as the Ritter Palace (1556-1561), in the Renaissance style of Florentine palazzos, was for Lucerne, or the Hôtel Ratzé (1581-1583), created in a Lyon manner still under Gothic influence, was for Fribourg.

"The fame of this house spread so that strangers, great lords and others, who came to this town were curious to see and visit it."[43] The palazzo, erected on the site of three medieval houses, had an inner court with two superposed galleries, something never seen before in Geneva (figs. 5, 6). The very idea of the courtyard, with arcades of basket-handle vaults on two sides, systematized by Petitot at the Hôtel de Ville (1614-1615), effectively broke with the local Gothic tradition of noble turreted houses and owed much to Italian Renaissance models the architect had seen in Rome.

Around Geneva, the Renaissance was already flowering. In the first half of the fifteenth century, Nicolas Perrenot, from the Jura, had built for himself a palace in Besançon with a vast inner court edged with porticoes. Elsewhere in Savoy some forty years earlier (1575-1582), Cardinal Gallois de Regard, who had spent some of his life in Rome and the Neapolitan region, built the castle of Clermont,[44] surrounding a spacious inner court with superimposed galleries, in a possible reminiscence of the one of St. Damasus.

However, in the Maison Turrettini, the Italianate style began to compete with the French – a comment that may be extended to all Genevois architecture of the old regime. The inner court contrasted with the beautiful Mannerist façade and its diversified repertoire of window frames, carved breast walls and window sills, and reliefs enhanced with volutes. Otherwise, the belated use of the Gothic twin window precluded Italian models.

The taste for handsome architecture spread among the members of the rich Lucca community, and the innovations brought in by Petitot began to be found in their

own homes, as in the house of Vincent Burlamaqui, son-in-law of François Turrettini (1627),[45] the gallery of Barthélémy Micheli's house[46] (fig. 7) and Marc Micheli's house,[47] said to be "a very attenuated likeness of the Turrettini house," as well as the old Arsenal building drawn by the selfsame Petitot to form an ensemble with the newly built façades of the Hôtel de Ville (fig. 8). Some twenty years later, Jean Turrettini (1600–1681), son of François, transposed the idea of a portico to the patio of the Château des Bois de Dardagny. For this reason, it was called "a tall house in the Italian style."

In his *Histoire de Genève de 1686*, Gregorio Leti noted the opulence of this first wave of private buildings at the beginning of the seventeenth century, saying:

> *For about fifty years now, people have been building in the modern style, and the brothers Turrettini, the demoiselle Andrion, and Sire Calandrini the merchant have built three superb palaces. Now all the houses of the well-to-do are well built.*

The Exemplary Faith of Faule Petitot

Settled in Geneva since 1597, Petitot was one of the many Huguenot artists and artisans that came to shelter in Calvin's shadow for a time or for good. The state and the wealthy families called on them to build the edifices of power, faith, and aristocracy. Petitot, like Bogueret, was an individual, referred to as "the sculptor," with no further need for a name and to whom was offered free citizenship "in consideration of the services that the Seigneurie hopes to receive from him and his art for public buildings."[48]

The faithful account of Petitot's life, transmitted by his son Jean, a famous portrait and miniature painter, describes him as an exemplary refugee:

> *He (God) brought my father from the dark depths of idolatry to which, apparently, it seems we are all born. It is in Rome, where he had been established for many years, enjoying every advantage a man of his condition could hope, being, with no intent of flattery, well appreciated for the sciences he knew, among others architecture and sculpture. God, in his almighty compassion, touched his heart and opened his eyes, showing him the idolatrous worship of people who bowed before works of their own making hardly had they made them, which finally made him detest this earthbound and superstitious religion. He came to Geneva in 1597 (where he found the light he was seeking) to finish his days here and was happy enough to be particularly cherished by the late Monsieur de Bèze, who contributed a great deal to his contentment.... He preferred the ways of heaven to those of this earth and, from the beginning of his retirement, spurned the quite important advantages that a neighboring prince offered him, along with the same freedom of conscience as he enjoyed here, should he ever wish to go to Torino.*

Resistance to the Catholic Artists

Protestant artists and artisans were warmly welcomed. Catholics were just as actively repressed until the beginning of the eighteenth century. There are many references to the expulsion of Lombard masons who "go to mass every Sunday around here."[49] For a century and a half, the Seigneurie seem to have brooked neither concession nor exception. Vicenza painter Cesare Giglio[50] was Protestant. He came to Geneva in 1589, before going on to Lyon in 1622, and did the restoration work (1604) on the Allegory of Justice in the council room of the town hall. Twenty years later, two painters had to leave town[51] before even being allowed to finish their work: Leonard Colbert from Milan and the Frenchman Nicolas Tremier, "living in Geneva for a year, dismissed for the injury he causes to other painters."[52] The same thing happened, at the end of the seventeenth century, to painters Arnulphe and Joachim.[53] The rejection of Catholic painters, especially Italians, explains as much as the sumptuary laws

why there were no mural paintings in Geneva at a time when quadrature and wall scenes flourished in Italy. The rich had to be content, within the limits set by the authorities, with tapestries.

The feeling against Catholics eased during the eighteenth century. Though rare, the passage of Italian decorators in private homes showed already in the first half of the century. Although, under Parisian influence, current taste tended to paneling or painted wallpapers, a few Geneva residences show some little-known samples of wall painting.[54] At the dawn of a brilliant career as a portrait painter,[55] Carlo Rusca (1696-1769), from Ticino, took part in 1735 in decorating a ballroom on the Grand Morillon property of Jean-Louis Du Pan. A landscape painter accompanied him: "An Italian painter called Restelino has painted frescoes of four windows in the gallery; the figure of the peasant seen in them was done by chevalier Rusca, another Italian painter."[56]

However, in the forefront of all proprietors who acquired some sort of trompe-l'oeil were the Vasserots, whose foreign extraction, cosmopolitan outlook, and recent fortune prompted them to act like nouveaux riches scorning social conformity and any respect for the sumptuary statutes. On intimate terms with banker Law, this prosperous merchant, Jean Vasserot the Elder, nicknamed the "Mississippian," was knighted by Frederic William I of Prussia in 1715. In 1720 he bought the manor of Vaux, then, in 1722, that of Dardagny. His son David died young but acquired, in 1724, the manor of Vincy[57] and built the handsome residence whose interiors were later decorated by Genevois sculptor Jean Jaquet. The imposing Château de Dardagny was adorned around 1725[58] by a ballroom decorated with an architectural trompe-l'oeil unique in Geneva. Otherwise, the virtuoso effects of perspective were in the Juvarrian tradition, worthy of comparison with the grand salon of the Hindelbank residence devised by Joseph Abeille for Hieronymus von Erlach.

Throughout the eighteenth century, Italian painters were only consulted by way of exception. The completion of the theater in the place Neuve[59] – an enterprise that dealt

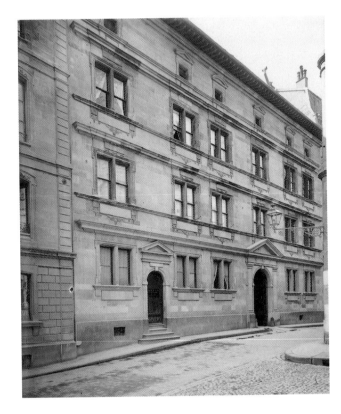

fig. 5: The street façade of the Turrettini mansion, with characteristic Mannerist details. Faule Petitot gave free rein to his sculptural talents. Old photograph.

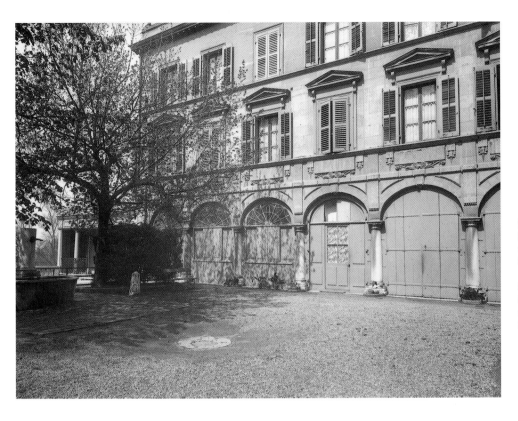

fig. 6: The inside courtyard of the Turrettini mansion, with its superposed loggias. Old photograph.

fig. 7: The gallery of the Micheli mansion copies some of the characteristics of the Turrettini mansion. Old photograph.

the final blow in 1782 to the spirit of sumptuary or-dinances – required expert ultramontane scenographic painters. Ornamentalist Jean Jaquet (1765-1739),[60] who reigned as master over the Ecole de Dessin and private interior decoration, continued the tradition of French pan-eling but never acquired these new talents. Likewise, a cen-tury later, the Eynards ordered the decor of their private theater from Alessandro Sanquirico, stage designer for La Scala and the inventor of ephemeral architecture.

At the Restoration, the taste for art and the admi-ration of talent overcame religious prejudice; Calvin's citadel was drawn into an Italophile current. Around the Eynard, Mirabaud, Saladin, and Bartholoni families grav-itated fresco and stucco artists. The team of Italians first called on to decorate the extension of Beaulieu (1812), then the Palais Eynard after 1821, introduced the neo-clas-sic manner. Giuseppe Vincenzo Lodovico Spampani (1768-1828) settled in Geneva (1821) after an itinerant career at the court of Württemberg, in Winterthur, and in Zurich. He received official commissions, such as the inte-rior decoration of the theater of the Cour St. Pierre (1824), and offered to give "a free course in painting as applied to the decoration of homes."[61] After some hesitation, the authorities accepted, with a tinge of protectionism:

*These lessons could give birth to a new branch
of industry that will not only contribute to
the enjoyment of our homes but will supply the sort
of relief ornamentation that we must now bring
from abroad. It can in no manner harm any
professions practicing in our own country, not even
the wallpaper trade, because fresco or painting
on plaster will so rarely be used to paint the walls of
apartments, being mostly destined for the decoration
of ceilings and cornices. The Board has gratefully
accepted the offer of M. Spampani and a committee
will see it is executed.*[62]

Jacques-Marie Jean Mirabaud (1784–1864), a convinced Italophile from having long lived in Lombardy, "would have liked in our own mores a blend of the severity and

fig. 8: The Town Hall (right)
and the Arsenal (left), treated as
a whole by Faule Petitot.
Old photograph.

fig. 9: The strongly rhythmic
façade of the former General
Hospital, a rare example
of baroque in Geneva. Old pho-
tograph.

tenacity that are our characteristics with the lighthearted grace and the aesthetic sense of the Milanese."[63] He managed in 1827 to wipe out two centuries and a half of resistance to things Italian: to the detriment of the Genevois Almeras, he named Gaetano Durelli from Milan (1789-1855) as Jaquet's successor at the head of the Ecole d'Ornement et d'Architecture (School of Ornament and Design). Toward 1830, at the time the brothers Vicario executed the prodigious Neo-Gothic trompe-l'oeil in Chambéry's Cathédrale St.François, painted decors became the rage in private Geneva homes.

The Case of Papist Joseph Abeille

At the beginning of the eighteenth century, the spirit of intolerance still rife among the population calmed down to some extent among members of the government and the upper class. A century after the sorry fiasco of the "water artifice," invented around 1611-1612 by Huguenot Jacques Gentillâtre (1578-post 1622?),[64] and other unsuccessful attempts in the seventeenth century, the Seigneurie called in 1700 upon a hydraulics engineer, Joseph Abeille, to solve the problem of supplying water to the city of Geneva.[65] The Frenchman, a native of Brittany then domiciled in Paris, was at the beginning of a promising career. A competent engineer as well as an excellent architect, he had a particularly wide range of skills.

> *His debut in Geneva was difficult. Antipathy around him was hard to overcome: "One can only praise Abeille," reads a report of the end of the century, for his courage in setting up the hydraulic works at his own expense at a time and in a country where a Catholic could find no support and much opposition. Hydraulic science was still profoundly obscure. He was accused, it seems, of holding papist meetings and poisoning the people through the fountains he controlled.*[66]

Despite this ill will, the Seigneurie gave him citizenship and allowed him to buy a house near the waterworks.

The government also asked him to think about the burning question of the Hôpital Général (General Hospital) then being built – a fact that was completely obliterated until some time ago (fig. 9).[67] The Genevois historical tradition has preferred to remember the Huguenot refugee Jean Vennes as the hospital's only author. However, there is proof of the primary role Abeille played, possibly to the consternation of hard-core Calvinists, in this affair: the reward of "fifteen louis d'or... for the plans and other care he has given to the new building up to now..."[68] as stated in February 1710; the style and plasticity of the drawing of the main façade, poles apart from the style of the façade attributed to Vennes for the Temple Neuf; and finally the fact that he was called to Bern a short while later to study hospital projects.

At the same time, a Franco-Genevois silk manufacturer, banker, and resident of Lyon, Jean-Antoine Lullin-Camp (1666-1720), entrusted to Abeille the project of his *hôtel particulier* at La Tertasse (1707-1712). If the intervention of the young architect was of primary importance, it had no direct influence on Genevois architecture. In baroque mass and colossal impact, this mansion can be compared, more or less consciously, to projects for episcopal palaces planned by his master builder, Robert de Cotte (fig. 10).

One would like to know more about the circumstances whereby Abeille was summoned from Geneva to Bern by Hieronymus von Erlach (1667-1748), an officer with an international career and future councillor of the city of Bern.[68] Abeille drew up for him the plans of two exceptional country residences in the region. First, Thunstetten (1713-1715),[70] an elegant one-story main building topped by an enormous Bernese-style roof, surrounded by a park in the manner of Le Nôtre, and second, the even more sumptuous property of Hindelbank (from 1721), with its U-shaped wings surrounding an entrance court. Abeille also took part in working out the plan of the *hôtel particulier* that von Erlach built within the city walls.[71] The style of Blondel was obvious, however, in this realization.

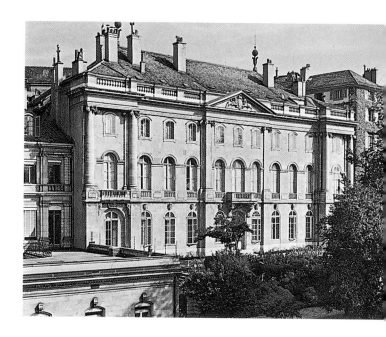

fig. 10: The garden façade of the Hotel Lullin at La Tertasse, by Joseph Abeille. Its colossal Ionic order gives it great plasticity.

For the time being, the strong resemblance with certain Genevois mansions such as those erected as early as 1721 by the Boissiers and the Sellons in the rue des Granges can only be noted.

Introduced to the Bernese government by Hieronymus von Erlach, Abeille was intensely active in the city of Bern. In 1715 he was asked, among other architects, to draw up plans for the reconstruction of the Inselspital.[72] In 1726 he entered a competition for a design of the new town hall. But it was later, between 1732 and 1734, that he played a determining role in the project of the Burghers' Hospital. The kinship with the General Hospital of Geneva is marked by the lavish treatment of the main gateway. The comparison is obvious down to the details of the stair rail, which literally copies the models of Genevois locksmith Pierre Gignoux (1713).[73] However, both also followed the unavoidable prototype of Jules-Hardouin Mansart's Hôtel des Invalides.

From 1720 on, Abeille was the "famous architect and head engineer of His Most Christian Majesty appointed for the reconstruction of the town of Rennes."[74] Assisted by his sons, Abeille managed two parallel careers, constantly traveling between France and Switzerland.[75] This man, who made such remarkable beginnings in Geneva, deserves a study taking into account the important French career he carried on simultaneously under the king's architect, Jacques Gabriel, in the towns of Rennes and Nantes.[76]

A New Temple – in the Image of the Temple of Charenton

Little is known about Jean Vennes (c. 1653–1717), native of Sommières and a refugee from Languedoc, other than what is in the Genevois archives – such scant detail that he might be thought no more than a dilettante. His French career remains an enigma to this day. In 1700 his presence is proven in Geneva: that year he was consulted, along with two local masters, Pierre Raby and Moïse Ducommun, for the project of the Salle du Conseil (Council Chamber of the Two Hundred) in the town hall.[77] In 1701

he furnished plans for the Vevey town hall. In 1708 he was rewarded by the Seigneurie for various jobs he had completed:

> ...several people considering that he has rendered several services to the people, either in the construction of the town hall, or that of the Hospital, or for the temple that is to be built, and otherwise, by various plans, side views, models, and such, believing that not only is there no need for him to pay dues, but also that one should make him some gift. By general assent, it was said that one should make some sort of an honest gesture. And, in the second discussion about what kind of a present...that in consideration for his services and for those one still hoped to receive from him, he would be given fifty golden louis, once he has delivered the plans and elevation that he has said he would do for the Temple de la Fusterie...[78]

Thus, the name of Vennes is especially linked to the projects for the Hospice Général and the Temple Neuf de la Fusterie (fig. 11).[79] Because of this last building, Vennes is of particular interest to this study. Determined to build a new place of worship in the Lower Town and, with the help of a legacy of thirty thousand florins from Jean-Antoine Lullin de Châteauvieux (1708), the Genevois authorities first consulted the Republic's engineer, Du Châtelard. Then they consulted Vennes. He looked for inspiration to the second temple of Charenton by Huguenot Salomon de Brosses, symbolic archetype of a Protestant place of worship, and provided a project obeying the general wish for a temple "octogonal and oval in shape, with

no bell tower,"[80] "and no additional structures."[81] The project was accepted, and Vennes directed it from 1713 to 1715.

The novelty of the plan, deliberately breaking the tradition of churches in the form of a Latin cross, struck mind and soul. Minister Bénédict Pictet underlined, in his dedication sermon of the new temple, its "structure so different from any others that we have."[82] The interior, organized in the way of Vitruvian basilicas, played on the theme of the "galeria porticata" and recalled the public places of antiquity.

The main façade, on the other hand, was but a timid rendering along the lines of the tympanum of Sta. Maria Novella and its scrolls, conceived by Alberti and reconfirmed by Giacomo della Porta in the Roman Gesù. Some forty years later, the Genevois again brought up the question of a temple façade when they built St. Pierre. Only one project, attributed to the Genevois master Armand Mignot, reproduced a Jesuit-type façade. The Genevois did not hesitate to distance themselves from Catholic forms by recuperating for St. Pierre the archetype of a pantheonic temple.

Furthermore, in 1711, along with Le Quint and Peschaubeis, better known as La Jeunesse, Vennes took part in an expert examination of the cathedral, already in an alarming state of disrepair; he signed with them a *Mémoire sur les Réparations à faire à l'Eglise de St-Pierre* (Memorandum on the Repairs needed for St. Pierre).[83] However, nothing was attempted immediately, the republic probably having its hands full with the Hôtel de Ville, the Hôpital Général, and the Temple Neuf. The complete transformation of the cathedral had to wait for better times and the arrival of fresh political figures.

After Vennes' death, the Bernese built the Heiliggeistkirche (1726-1729), another replica of the Charenton temple, where the colossal interior evokes the columns built at the Hôtel Lullin at La Tertasse. One suspects that Abeille – whose name was never mentioned in this realization,[84] but who happened, at the same time, to be working on the competition for the town hall, and later on the construction of the nearby Burghers' Hospital – may have breathed a little of his own particular emphasis into this project.

Many Hands for One Portico: Between Soufflot and Alfieri, Soubeyran and Bovet the Younger

Several generations of historians[85] have studied the astounding façade in the form of a porch added onto the old Cathédrale St. Pierre (figs. 12-15). But no one has really untangled the circumstances of its conception. Rather inclined to favor foreign personalities, the Genevois for a long time gave credit for the façade to Benedetto Alfieri, the court of Piedmont's sole architect. This really did not do justice to a number projects – admittedly of uneven value – submitted by local masters.

Essential to keep the building standing, the renovation of the façade of St. Pierre (1749-1756) gave an excuse to bring in "a foreign architect expert in this kind of a building before beginning anything, for though we have here people who can execute the work, we have none wise enough to guide us in it."[86] Thanks to its situation at an artistic crossroads, Geneva benefited from the advice of two men, Jacques Germain Soufflot (1713-1780), then at the beginning of his career, and Benedetto Alfieri (1699-1767), a proven architect.

Mathematician Jean-Louis Calandrini (1703-1758), to whom is attributed the project for the baroque Protestant Temple de Chêne Bougeries (1756-1758), played a determining role in the commission of the Petit Conseil, mandated to study the renovation. No doubt, it was he who guided the penning of the reports of the *Abrégé des Mémoires présentés au Magnifique Conseil, touchant le Temple de St. Pierre* (Resumé of the Report presented to the Magnificent Council regarding the Temple of St. Pierre, 1750). This document tells of plans already drawn up by local masters that disclose a notable preference for a "tasteful but simple and modest façade, according to our

Religion and our position" rather than a "Gothic and lu-gubrious façade" – this being the gabled façade of Pied-montese inspiration.[87]

The classic variants enabling the Protestants to take over the ancient cathedral were inspired by two grand models: "the handsome façade of St. Gervais in Paris," conceived by Salomon de Brosses in 1616;[88] and the "Ro-tonda in Rome, one of the beautiful remnants of an-tiquity."[89] The Pantheon was the principal subject of such painters of *vedutte* and *capricci* as Paolo Pannini or Hubert Robert. It vividly struck the imagination of people on the Grand Tour, far more than the new Roman façades recently added to the ancient Paleo-Christian basilicas of Sta. Maria Maggiore or St. Jean de Latran.

The renovation of this façade was a chance to prove artistic determination. This unusual awareness was un-derlined at a time when the new precepts of the Ecole de Dessin were laid down:

> *…one must examine whether the expense of these ornaments may not be balanced by the beauty added to the Cathedral & for the place & the propriety which we should give at this time, as proof of progress made in the Fine Arts for our city & the zeal of the magistrates to honor both Country and Religion.*

Lyon banker Camp became Calandrini's go-between to speak to Soufflot. This architect seems to have been the most qualified to sound the sick building. A few years ear-lier (1741), he had distinguished himself before the Lyon Academy by a *Mémoire sur l'architecture gothique* (Report on Gothic Architecture). In December 1749, as he was about to undertake a Grand Tour of Italy with the Marquis de Marigny and the engraver Cochin, Soufflot received the reports and plans of the Genevois. Had the notion of a porch, a hint of the future solution for Ste. Geneviève of Paris, already taken form in the blueprints?[90]

Soufflot's Grand Tour began in 1750 with an oblig-atory stop at the Teatro Regio of Turin built by Benedetto

Alfieri. Soufflot noted down its plan. Did the two men meet just as the plan for St. Pierre's new façade was being discussed? At the time, Alfieri's career was at a standstill: the Duchy of Piedmont was at war with Austria. A little later (1752), he drew up a project of the reconstruction of the Château de Chambéry, burnt down by the French in 1743. The castle was renovated a first time according to the plans by Giuseppe Piacenza (1775-1776) and Piedmontese Francesco Garella (1786), who both took part in the creation of Carouge, near Geneva. When com-ing by Geneva via Chambéry in 1751, Alfieri was invited to give advice on the local projects. He corrected those of the Genevois, especially the ones attributed to Bovet the Younger, who had been to Rome, and to Pierre Soubeyran, back from Paris and about to take on the direction of the soon-to-be-created Ecole de Dessin. Those two local masters worked out a façade with an eight-col-umn Corinthian portico that won support for both aes-thetic and liturgical reasons.

Alfieri perfected the formula. Far from being a classi-cist,[91] he delivered to the Genevois a plan that, without fol-lowing Palladian tradition,[92] anticipated architectural ideas to come and certainly placed Geneva in the lead of international neo-classicism – a fact not admitted up to now. Born of a collective inspiration and the very Ge-nevois desire to de-Catholicize St. Pierre, the portico some-how illustrated a still theoretical search formulated at the time by abbé Laugier in his *Essai sur l'architecture* (Essay on Architecture):

> *I tried to find if in building our churches in the style of ancient Architecture, one could not give them a lightness and an elevation equal to our beautiful Gothic churches. And having long pondered this, it seems to me that not only is it feasible, but easier to do this successfully with the Architecture of the Greeks than with all the discoveries of Arabesque Architecture.*

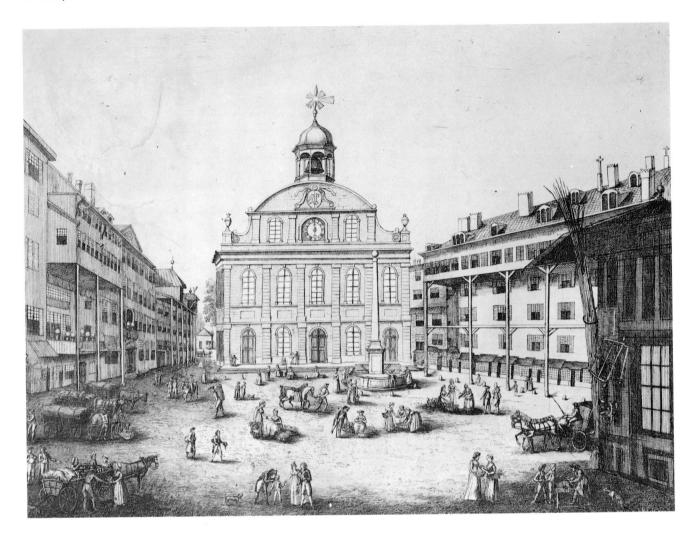

fig. 11: A Geissler engraving
showing the façade of the
Temple Neuf at the beginning of
the nineteenth century. Not
entirely true to the original, it
accentuates the lack of relief of
the architecture.

fig. 12: A project for St. Pierre
attributed to Armand Mignot.

fig. 13: A project for St. Pierre's
façade, attributed to Jean Louis
Bovet the Younger.

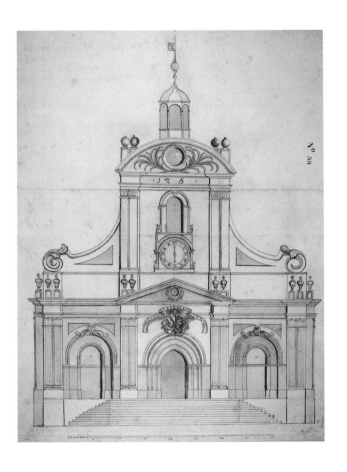

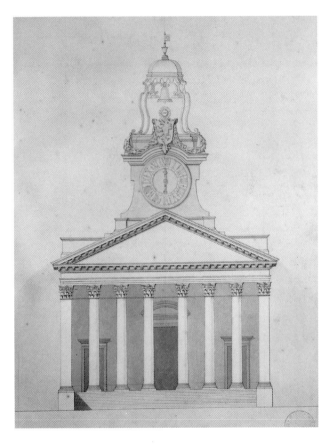

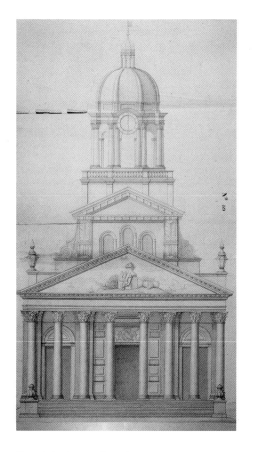

fig. 14: Project attributed to
Pierre Soubeyran.

fig. 15: Project signed by
Benedetto Alfieri.

In Conclusion

Ever torn between austerity imposed by their religion and the temptation of luxury suitable to their means, patrician Genevois simultaneously encouraged and criticized elaborate architecture. Though tolerated to some extent in public buildings, until the eighteenth century it was officially discouraged for private buidings.

In this context, it was foreign architects who were often either guilty parties or accomplices to forbidden aspects of Genevois architecture. Commissioning outsiders made it easier to defy the rules or, at least, be forgiven trespasses. Trapped by their own ambiguity, the Genevois screened themselves behind these architects who came from afar and managed to erect a bit more than intended: buildings flaunting what sumptuary statutes did not permit.

With the creation of the Ecole de Dessin and the portico of St. Pierre, 1751 became a key date. It was a turning point in artistic history. From then on, the Genevois leaned less on foreign architectural taste and assumed responsibility for their creations. The teaching of the Ecole de Dessin was based on drawing to serve art and on the imitation of models. It gave the students an elementary grounding that built up self-confidence. From that time on, handsome Genevois buildings were the work of talented local masters, no longer referring, as earlier in the century, to a "plan imported from Parys." Only recently has the extent of the reference libraries of Genevois masons been realized. They were fully familiar with foreign models and able to turn out similar work.

This emancipation corresponded to a change in mentality. In the middle of the eighteenth century, the Citadel of the Reformed Religion was opening out to the world. The crusading spirit had calmed down, and, at the same time, quarrels about luxury ceased. Attributing the portico of St. Pierre to the hand of Count Alfieri alone may have been one last indication of false modesty. Pretending that local masters were incompetent and provincial was no longer a valid excuse.

While Geneva began to produce architecture of its own, foreign projects did not disappear entirely. During the nineteenth century, Giovanni Salucci, Luigi Bagutti, Félix-Emmanuel Callet, and Jean-Baptiste-Cicéron Lesueur were usually associated with local architects who carried out the work. The foreigner became a distant inspiration, the local master the true executor.

Translated from the French by Mavis Guinard

Notes

1 Waldemar Deonna, *Les arts à Genève des origines à la fin du XVIIIe siècle* (Geneva, 1942), p. 300.

2 Barbara Roth-Lochner and Livio Fornara, "Moïse Ducommun (1667?–1721), maître maçon, architecte et entrepreneur genevois," *Nos Monuments d'Art et d'Histoire*, XXXII (1981/3), pp. 390–406. Jacques Eynard is the great-grandfather of Jean-Gabriel, for whom Giovanni Salucci built a sumptuous neo-classic mansion at the beginning of the nineteenth century.

3 Also architect of the Calandrini house (1680); see Barbara Roth-Lochner and Livio Fornara, "Un bâtiment neuf pour des ambitions nouvelles," in *Sauver l'Ame, Nourrir le Corps,* ed. Bernard Lescaze (Geneva, 1985), p. 194.

4 Livio Fornara and Barbara Roth, "Note sur l' Hôtel Buisson," *Genava* XXX (1982), pp. 99–116, and André Corboz, "Une oeuvre méconnue de l'agence Mansart à Genève: l'Hôtel Buisson (1699)," *Genava* XXX (1984), pp. 89–111.

5 Ordinance of 1710, art. XXVIII and XXIX.

6 Registres du Conseil, 11 February 1821, see Rigaud, p. 172.

7 Jallier's works show the complex network of private relationships linking Geneva to Paris and Lyon. This Burgundian, student of Soufflot at the Académie, worked with Gabriel in Paris, possibly on the building of the Ecole Militaire where the Genevois Jean-Louis Bovet (son) distinguished himself, as well as with Bélanger, in whose orbit Wolfgang-Adam Töpffer also gravitated (between 1786 and 1792), engraving, among others, Bélanger's project for an opera. In 1764, Jallier drew the plans for Antoine Saladin's château in Crans. Almost twenty years later, Saladin had him make up plans for the theater of the place Neuve and paid him six hundred livres "for the plans and designs... relative to the Salle de Comédie of Geneva." And possibly he advised the master masons Matthey, the presumed builders of the rental buildings of the rue Beauregard, owned partly by Jean-François Thelusson.

8 Jean Butini, *Traité du luxe* (1774), p. 245.

9 Herbert Lüthy, *La Banque Protestante en France de la Révocation de l'Edit de Nantes à la Révolution,* I (Paris, 1959), p. 59.

10 On Jean-François Blondel, see Louis Blondel, "L'influence de l'architecture française à Genève au XVIIIème siècle," *Actes du Congrès d'Histoire de l'Art,* t. II (1921), 2nd section, pp. 219–225, particularly p. 222 and Louis Hautecoeur, *Histoire de l'architecture classique en France,* t. III (Paris, 1950), pp. 96–103, on French architects in Switzerland.

11 Four projects, two of them realized, are known by their publication in the collection of Jean Mariette, *L'architecture française* (Paris, 1727).

12 Armand Brulhart, "La maison Mallet oeuvre de Jean-François Blondel," *L'Information immobilière* (1985), pp. 153–157.

13 Armand Brulhart, "Le domaine du Creux-de-Genthod", *L'information immobilière* (summer 1986), no. 30, pp. 59-63; Geneva's Bibliothèque Publique et Universitaire (BPU), Ami Lullin ms. 71, *Journal no 3 commencé le prem. janvier 1723 A L,* and Ami Lullin ms. 73.

14 This is François Tronchin, an important amateur of paintings, who sold his collection to Catherine the Great of Russia in 1771. See Mauro Natale, *Le goût et les collections d'art italien à Genève* (Geneva, 1980), pp. 15-25.

15 Brulhart, "Le domaine," p. 63. Blondel letter (Paris, 16 February 1725).

16 Monique Fontannaz and Monique Bory, "Le château de Crans, une oeuvre genevoise?" *Genava,* n.s., t. XXXVII (1989), p. 63.

17 "...for in these parts (near Cartigny) all country houses are very simple, they show no luxury, and I fear that if you turn your house into a manor you would find yourself alone among a delightful society..." BPU, Fr. ms. (20 October 1802), Marie-Louis Duval-Dumont to her son.

18 BPU, suppl. ms. 1847 (20 August 1809), Jean-Gabriel Eynard to his father in Rolle.

19 Edouard Chapuisat, *Le Général Dufour 1785-1875* (Lausanne, 1953), p. 52.

20 Enrico Castelnuovo, Giovanni Romano, *Giacomo Jaquerio e il gotico internazionale* (Torino, 1979), no. 5, pp. 167-172.

21 Pierre Quarre, "Perrin Morel, Jean Prindale et la sculpture 'bourguignonne' à Genève au temps du cardinal de Brogny," *Archives de l'art français,* XXV (1978), pp. 99-105.

22 Barbara Roth-Lochner and Livio Fornara, "Moïse Ducommun (1667-1721)," op. cit., p. 391 and Alfred Perrenoud, *La population de Genève, XVIeme-XIXeme siècle* (Geneva, 1979), pp. 321-322.

23 Leïla el-Wakil, "L'Eglise luthérienne: 'une maison pour y faire le culte'," *Revue du Vieux Genève* (1988), pp. 93-104.

24 Guillaume Fatio, *Le château de Malagny* (Genève, 1924).

25 Fontannaz and Bory, op. cit.

26 François-Régis Cottin, "L'architecture à Lyon au XVIIIe siècle," *Soufflot et l'architecture des Lumières* (Paris, 1980), p. 103.

27 See below on the façade of Cathédrale St.Pierre. Soufflot also maintained relations with Voltaire and corresponded with François Tronchin, who was his host at the Délices far later. See BPU, Archives Tronchin, *Lettre de Soufflot à François Tronchin* (Paris, 18 August 1776).

28 Eugène-Louis Dumont, *Plan Billon 1726,* vol. II (Geneva, 1987), pp. 23-32.

29 ".. au fils de Mre Billon pour avoir copié divers plans de laditte maison donné 4 louis d'or," BPU, Lullin ms. 71 (7 August 1824), op.cit., p. 32.

30 See Marcel Grandjean, *Les temples vaudois* (Lausanne, 1988), p. 202. In a recent work, Michel Gallet and Yves Bottineau, *Les Gabriel* (Paris, 1982), there is no mention of this intervention by the Genevois master builder.

31 This law professor, also passionately interested in art, became from 1718 on, the advocate of artistic teaching in Geneva. In 1732, he presented to the Council of the Two Hundred a report invoking the value of such education. Burlamaqui encouraged the engraver and miniature painter Jacques Saint-Ours (1708-1773), father of the historical painter Jean-Jacques Saint-Ours, to open a school for painters (1746). In the same way, he sponsored Pierre Soubeyran, son of a locksmith from Languedoc, refugee from the Revocation of the Edict of Nantes, offering him a trip to Paris to perfect his artistic knowledge. Soubeyran was for over twenty years a drawing master at the Ecole de Dessin.

32 BPU, ms. Jallabert 77, *Mémoire sur l'Etablissement d'une Ecole de Dessein & en particulier sur celle établie à Genève,* folio 67.

33 Leïla el-Wakil, *Architecture et urbanisme à Genève, dans l'enceinte des fortifications, sous la Restauration* (Geneva, February 1976), pp. 173-175.

34 See Leïla el-Wakil, *Bâtir la campagne: Genève 1800-1860* (Geneva, 1988), pp. 241-255.

35 Bonivard, *Chroniques,* ed. Dunant, t. I, p. 86.

36 Bogueret may have come from Langres, a town possessing a few early Renaissance examples inspired by ancient models that are still standing, such as the façade of no. 8, rue Cardinal Morlot, according to Louis Hautecoeur, *Histoire de l'architecture classique en France,* t. I, vol. 2, pp. 402-404.

37 Guillaume Fatio, "Notre architecture locale," *Nos Anciens et leurs Oeuvres* (Geneva, 1905), pp. 90-93.

38 As defined at the end of the eighteenth century by Butini, op. cit., chap. I, p. 28.

39 For a detailed account of François Turrettini's professional activities, see Liliane Mottu-Weber, *Genève au Siécle de la Réforme. La draperie et la soierie (1540-1630),* MDG, LII (1987), pp. 331-340.

40 Isa Belli Barsali, *Le ville lucchesi* (Rome), pp. 36-38.

41 It would be interesting to find out his exact relationship with the Petitot branch of Lyon, especially Simon Petitot (1682-1746), who built the waterworks of Lyon in 1729; as well as Ennemond-Alexandre Petitot (1727-1801), a student of Soufflot, Prix de Rome, and later Architect of the Ducal Manufactures of the Court of Parma after 1753.

42 Livio Fornara, *Maison Turrettini et quelques exemples d'architecture civile à Genève au début du XVIIe siècle* (Geneva, September 1978) typed ms., and Camille Martin, "La Maison Turrettini à Genève," *Nos Anciens et leurs Oeuvres* (1901), pp. 25-34.

43 *Annalistes,* p. 617.

44 Michel Melot, "Le château de Clermont", *Congrès archéologique de France* (1965), pp. 167-174.

45 Once no. 8, rue de la Cité; now demolished but reproduced in *La Maison Bourgeoise en Suisse, Genève* (Zurich, 1960), pl. 19.

46 No. 10, rue des Granges.

47 No. 4, rue de l'Hôtel de Ville.

48 Fornara, *Maison Turrettini,* vol. 3 (see note 42 above), p.31. Quotes Registre du Conseil, 114, fol. 149, 27 June 1615.

49 Registres du Conseil, 109, folio 210, 3 August 1612, quoted by Livio Fornara, ibid., vol. 2, p. 24.

50 James Galiffe, *Le refuge italien de Genève au XVIe et XVIIe siècles* (Geneva, 1881), p. 142.

51 Carl Brun, *Dictionnaire des artistes suisses,* suppl.

52 Rigaud, op. cit., p. 82.

53 Ibid.

54 Deonna, op. cit., p. 375, and note 3, which give little importance to Genevois mural paintings.

55 A career that brought him into the entourage of magistrate Hieronymus von Erlach in Bern, whose portrait he painted with all military trappings.

56 *Nottes sur Morillon,* private archives, ms. on the history of Grand Morillon.

57 Gaston de Lessert, *Le château et l'ancienne Seigneurie de Vincy* (Geneva, 1912), esp. p. 19.

58 I wish to thank Aline Ramu for this oral information.

59 See Ariane Girard-Cherpillod, "Le théâtre des Bastions," *Revue du Vieux Genève* (1992), pp. 14-21, mentioning Giovanni Allesatro Moretti of Lyon and the Galleari of Torino.

60 See Christian Brun, *Jean Jaquet, sculpteur et ornemaniste,* (Geneva, 1987), typed ms.

61 el-Wakil, *Bâtir*, pp. 285-286 and more generally the chapter entitled *Genevois et Etrangers: le provincialisme contrecarré.*

62 "Rapport de la Classe des Beaux-Arts," *Procès-verbal annuel de la Société des Arts* (1828), pp. 191-192.

63 "Bulletin de la Classe d'Industrie et de Commerce," *Procès-verbal annuel de la Société des Arts* (1865), pp. 8-9.

64 Fornara, *Maison Turrettini*, annexes, and *Jacques Gentillâtre.*

65 Alfred Bétant, *Puits, fontaines et machines hydrauliques de l'ancienne Genève* (Geneva, 1941), pp. 52-58. These were the town council problems of the time: Simon Petitot (1682-1746) was commissioned in 1729 to build the waterworks of Lyon, see *L'art baroque à Lyon,* pp. 48-49.

66 Ibid., p. 58 from the memorandum of Nicolas Paul (1796), who was put in charge of "caring for the waterworks" during the French period.

67 Roth-Lochner and Fornara, "Un bâtiment neuf pour des ambitions nouvelles" (see note 3 above), chap. "Qui est l'architecte de l'Hôpital?" pp. 193-196.

68 Ibid.

69 See Hans Ulrich von Erlach, *800 Jahre Berner von Erlach, Die Geschichte einer Familie* (Bern, 1989), chap. 16, pp. 352-383.

70 It would be useful to find out more about the links between Geneva and Bern (through Abeille?). It is known that, in 1730, Ami Lullin employed in Genthod, sculptors Jean-Frédéric Funk and Charles-Christophe Haag, Bernese artisans who were active on Erlach's works; see BPU, ms. Lullin 8.

71 *Der Erlacherhof in Bern* (Bern, 1980).

72 Paul Hofer, *Die Stadt Bern, Monuments d'Art et d'Histoire*, vol. I, pp. 402-417.

73 Reproduced in *Divers ouvrages de serrurerie comme Balcons Rampes d'escalier console porte de fer desus de porte seintre Portanseigne. Le Tout Invantez et fait et gravet par Pierre Gignoux père et fils Mestre serruriers A Genève. Et Le Tout finit en l'année Mille sept Cent Treize et Le presant livre se debite chez Lauteur a Geneve.*

74 Paul Hofer, op. cit., p. 352.

75 Of his "Swiss" career, one knows that he built several private dwellings in the town of Bern, made plans for Solothurn's new hospital (1735) and church, and provided, at the request of Agrippa d'Aubigné, a model of a dredge for the maintenance of the port of Morges (1735).

76 In 1726, they worked together on a project for a canal in Burgundy. In 1730, Joseph Abeille was designated to supervise the reconstruction of the town of Rennes, destroyed by fire in 1721. He took along his two sons as assistants. At the end of his career, he was in Nantes to study the rebuilding of the Bourse de Commerce (1741), a plan to canalize the Erdre river (1745), a project of reconstruction of the *quai Brancas* with two covered market buildings (1751-1755). See Claude Nieres, *La reconstruction d'une ville au XVIIIe siècle. Rennes 1720-1760* (Rennes, 1972), p. 188 and Pierre Lelièvre, *Nantes au XVIIIe siècle. Urbanisme et architecture* (Paris, 1988).

77 Marcel Grandjean, *Les temples vaudois* (Lausanne, 1988), p. 168.

78 Fornara and Lochner, "Un bâtiment neuf pour des ambitions nouvelles" (see note 3 above), p. 134. Quotes Registre du Conseil 208, p. 507, 1 September 1708.

79 See Georg Germann, *Der protestantische Kirchenbau in der Schweiz* (Zurich, 1963), pp. 55-59.

80 Nonetheless topped with a small belfry "à la genevoise." On these typical tiny Genevois belfries, see Marcel Grandjean, op. cit., p. 173.

81 Camille Martin, *Le Temple Neuf de Genève* (Geneva, 1910), p. 6.

82 Bénédict Pictet, *Dissertation sur les temples, leur dédicace et plusieurs choses qu'on y voit, avec un sermon* (Geneva, 1716).

83 BPU, B 117, Tronchin archives, *Temple de St-Pierre* (1752).

84 Paul Hofer and Luc Mojon, *Die Kunstdenkmäler des Kantons Bern*, vol. 5 (Basel, 1969), p. 170. Germann, op. cit., pp.69-70.

85 Camille Martin, "Les projets de reconstruction de la façade de Saint-Pierre au XVIIIe siècle," *Bulletin de la Société d'Histoire et d'Archéologie de Genève,* 3 (1909), and *Saint-Pierre, ancienne cathédrale de Genève* (Geneva, 1911); André Corboz,"Il portico della cattedrale di Saint-Pierre a Ginevra," *L'Architettura*, no. 166 (August 1969); Livio Fornara, "Transformations de la cathédrale au XVIIIe siècle," *Saint-Pierre, cathédrale de Genève. Un monument, une exposition* (Geneva, 1982), pp. 91-102.

86 Fornara, "Transformations" (see note 85 above), p. 91, quoting the R.C. (December, 1750).

87 Only Jean-Michel Billon, in one of the drawings attributed to him, presented a project reusing the Gothic entrance portal and its gable with a sculpted but partially mutilated tympanum.

88 Also placed directly onto a Gothic building.

89 *Abrégé des Mémoires...,* op. cit., pp. 16-17.

90 The influence of Soufflot's Lyon activity is of great importance to Geneva. The symmetrical houses aligned along the quai Saint-Clair were admired by Guillaume-Henri Dufour, the future cantonal engineer during the Napoleonic campaign, and reflected on the quartier des Bergues, then along the Genevois quays in general during the next century. See Leïla el-Wakil, "Guillaume-Henri Dufour et le nouveau visage de Genève," *Guillaume-Henri Dufour dans son temps 1787-1875* (Geneva, 1987), pp. 199-214.

91 Except for his drawing of the façade of the Cathedral of Verceil and the never-realized project for the Cathedral of Torino.

92 It is quite different from Inigo Jones' portico for old St. Paul's in London or from Gibbs portico for St.Martin-in-the-Fields.

Picture credits

figs. 1, 5-9, 11-15: Musée Vieux, Geneva

figs. 2-4, 10: University of Geneva

The Nineteenth Century

La Chaux-de-Fonds from the
northwest. Aerial photo taken in
1955.

La Chaux-de-Fonds in the Neuchâtel Jura was largely
destroyed by fire in 1794. In the nineteenth century it
developed into a rapidly growing watchmaking center. An
extensive expansion program along the lines of the Amer-
ican grid system was begun in 1835, according to plans by
the engineer Charles-Henri Junod. In the fourth chapter of
Das Kapital, published in 1867, Karl Marx referred to La
Chaux-de-Fonds as one large manufactory, explaining
that the number and density of local factories plus its out-
standing significance on the international market sur-
passed all other watchmaking centers of the time. In 1854
La Chaux-de-Fonds produced 160,000 watches, approxi-
mately twice as many as Geneva. Its resolute verticality
and austere structuring are an architectonic reflection of
rationalized methods of production. The division of labor
developed in watch factories at the time has manifested
itself in the city planning; practical and organizational rea-
sons have enabled the assembly line to take on concrete,
three-dimensional form in the layout of the town.

As a result of the rapid growth of tourism, the Hotel Schweizerhof in Lucerne, built 1844-1846 according to plans by Xaver von Segesser, was soon enlarged, and in 1885/1886 an additional story was added. Lucerne is still a tourist center, and the building, thanks to its architecture and location, continues to dominate the cityscape. View from the Lake of Lucerne.

I arrived in Lucerne last evening and put up at the best hotel in the city, the Schweizerhof. 'Lucerne is an old cantonal town on the shores of the Lake of Lucerne,' says Murray, 'one of the most romantic places in Switzerland; three important roads cross in this city; only one hour away by steamship lies Mount Rigi, its peak offering one of the most magnificent views in the world.' I do not know whether this is true or not, but the other tour guides make the same claim; that is why there are masses of tourists of all nationalities, but especially Englishmen. The sumptuous five-story 'Schweizerhof' has only recently been built on the quay, directly on the lake, at the very same spot where in olden days stood a crooked roofed wooden bridge with chapels at the corners and pictures of saints on the piers. Now, thanks to the incredible throngs of Englishmen and out of consideration for their needs, their tastes, and their money, the old bridge has been torn down, and in its stead an arrow-straight embankment has been built, and on that embankment several rectangular five-sto-

ry buildings in a straight line, with two rows of lime trees planted before them and protected by pales. Green-painted benches have been distributed between the trees, as is customary everywhere. This is the promenade; here Englishwomen in their Swiss straw hats and Englishmen in their practical, comfortable suits stroll and enjoy the fact of their existence.

Leo Tolstoy, Lucerne, 7 July 1857.

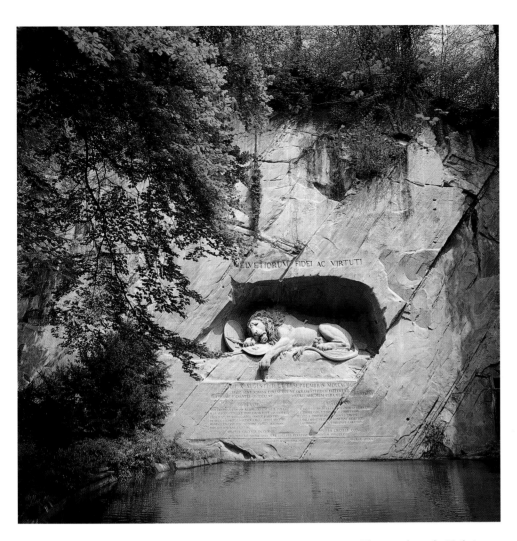

The monument to the end of a heroic career commemorates not only the brave men of Lucerne who, true to their oath of loyalty, went to their deaths; it is a monument to old, bellicose Lucerne itself, indeed to the whole Confederation. Practiced in war, accustomed to victory as no other European nation, it laid down its arms to become the most peaceful nation of all. The monument is not intended as a tourist attraction. The noble animal has withdrawn to the inaccessible rock wall to die in solitude. The once terrible head collapses, the mighty claw hangs helplessly over the broken spears. What remains of the forest entwines its twigs around the dying king in pity and awe. In the autumn they glow like torches at a bier. At night, when all is silent, one might perhaps hear blood from the fatal wound dripping into the dark water at the foot of the rock…

Ricarda Huch, Lucerne, 1932.

The assault on the Tuileries in Paris on 10 August 1792 cost numerous Swiss mercenaries in the service of the French king, Ludwig XVI, their lives. In 1819 Lieutenant Carl Pfyffer von Altishofen commissioned the Lion Monument in Lucerne in their honor. The Dane Bertel Thorvaldsen designed the model for the monument in Rome; the Solothurn artist Urs Pankraz Eggenschwyler and the Constance sculptor Lukas Ahorn executed it on the chosen site, an old stone quarry. It was unveiled in 1821, making it Switzerland's oldest figural monument.

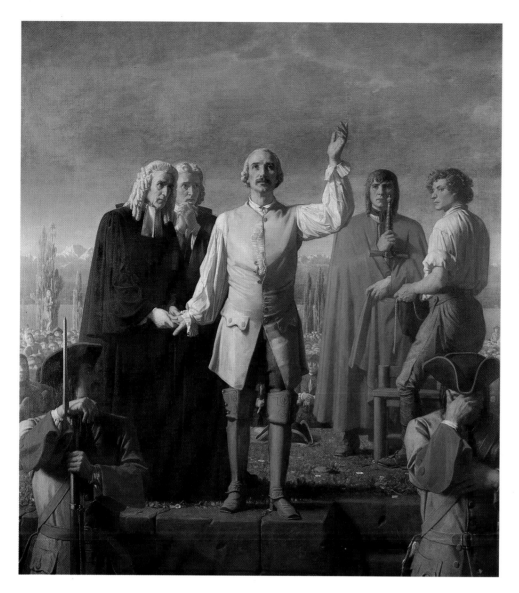

Charles Gleyre (1806-1874),
The Execution of Major Davel,
1846-1850, oil on canvas,
300 x 270 cm. Formerly in the
Musée des Beaux-Arts,
Lausanne; destroyed in 1980.

The Lausanne artist Charles Gleyre worked chiefly in Paris. Between 1846 and 1850 he produced Switzerland's first major historical painting, *The Execution of Major Davel*, commissioned by the government of Vaud. Gleyre shows Major Davel, leader of the failed Vaudois struggle for liberation in 1723, immediately before his decapitation. Surrounded by two pastors, the executioner with assistants, and two soldiers, the hero of the people addresses his fellow citizens, proclaiming that he willingly sacrifices himself for God and the fatherland that has been forced under the yoke of Bern. Under the influence of Jacques-Louis David's *Death of Socrates* and the iconography of the *Ecce Homo*, Gleyre depicts Davel as an innocent victim and his execution as a political murder.

Alexandre Calame (1810-1864),
*La Dent du Midi et le fond du lac
de Vevey* (Lac Léman), 1849, oil
on canvas, 100 x 140 cm. Musée
d'Art et d'histoire, Geneva.

Alexandre Calame, a painter from the Geneva School, is
the most important representative of romantic landscape
painting in Switzerland. His central theme is the over-
whelming force of nature, in both its peaceful and its
destructive guise. His paintings and lithographs sold the
world over even in his own lifetime. Customers would, for
example, order *A Swiss Lake, Peaceful.*

> *One evening, can you remember?*
> *We drifted in silence;*
> *In the distance, on the waves and under the skies,*
> *nought could be heard but the sound*
> *of the rowers stroking in cadence*
> *Your harmonious streams.*
> Alphonse de Lamartine, "Le Lac," 1817

Frank Buchser (1828-1890),
The Song of Mary Blane, 1870,
oil on canvas, 103.5 x 154 cm.
Kunstmuseum Solothurn
(Gottfried Keller Foundation).

When peace was made at Appomattox on 9 April 1865, it not only marked the end of the American Civil War, it meant the end of slavery. The cosmopolitan Solothurn artist Frank Buchser, who made the first of several visits to the United States in 1867, began depicting blacks very early on and wanted to create a large painting to keep alive the memory of the inhuman era of slavery. *The Song of Mary Blane*, describing the fate of a young black woman, served as his inspiration. Buchser completed the painting in Charlottesville in 1870. It was exhibited in Boston the same year, in New York in 1871, and was later shipped back to Europe. Senta Erd's version of the text goes as follows:

I once did know a pretty gal
And took her foe my wife
She came from Louisiana and
I lik'd her as my life.
We happy lib'd togedder
She nebber caused me pain,
But on one dark and dreary night
I lost poor Mary Blane.

(Chorus:) Oh farewell,
Farewell, poor Mary Blane

One faithful heart will think of you.
Farewell, farewell, poor Mary Blane,
If we ne'er meet again.

While in de woods I go at night
A huntin' for some game.
A nigger came to my old hut
And stole my Mary Blane.
Long times gwan by it griebe'd me much
To tink no tiddings came.
I hunt de woods both night and day
To find poor Mary Blane.

I often asked for Mary Blane
My Massa he did scold
And said, you saucy nigger boy,
If you must know, she's sold.
If dat's de case she cannot live
Thro' out a weary life.
Oh let me die and lay me by
My poor heartbroken wife.

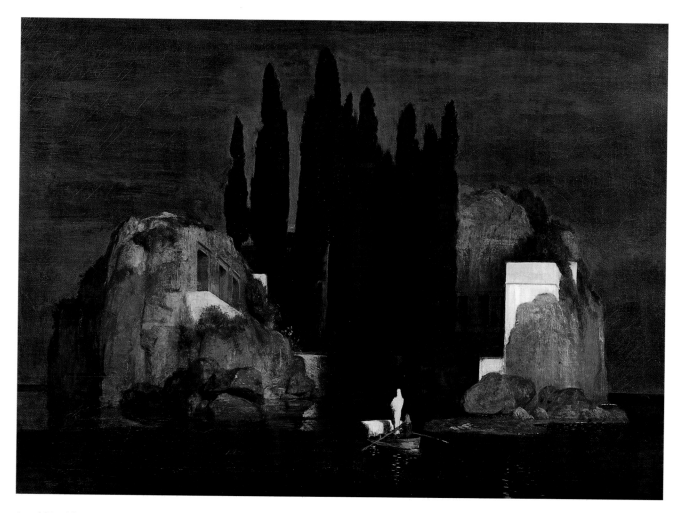

Arnold Böcklin (1827-1901),
The Isle of the Dead,
first version, 1880,
oil on canvas, 111 x 155 cm.
Kunstmuseum Basel.

The Basel artist Arnold Böcklin created what is probably
his most famous painting for Marie Berna, later Countess
of Oriola. She had requested from him "a picture to dream
by." Using no direct topographical or thematic model, he
invented a landscape of solemn stillness, where every word
would break the spell and constitute an infamous act of
rationality. An island of graves and a passage call to mind
a Mediterranean island and Charon's bark.

I leave, my friend, a boat! I travel far.
My final word... a word of gratitude...
As well to you, island, my prison green!
Hutten is impelled to go awandering.
There are things left to do. Quick! Where is the
bark?
The waves crowd in! A billowing sail approaches!
The snowy peaks stare bleakly in my face...
The pale land of the ghosts does not alarm me...
A tall, gaunt ferryman is rowing there...
Hey! Over here! A wanderer wants to leave!
Why do you, friend, clasp me so to your breast?
* Am I a slave to let myself be bound?*
Let go! Let go! Back! I leap into the boat...
Ferryman, I recognize you! You are – Death.

After Conrad Ferdinand Meyer,
"Hutten's Letzte Tage," 1871, LXXI.

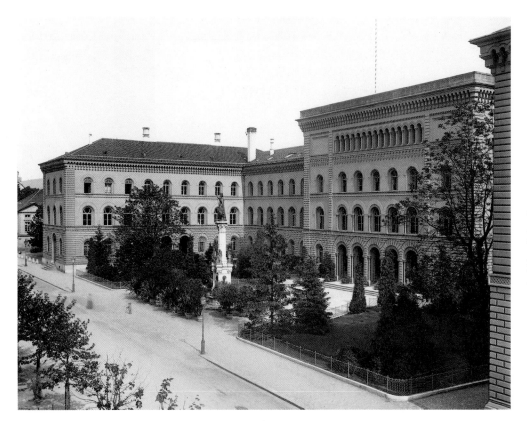

The Bundesrathaus in Bern from the northwest. Below a view from the southwest in James Ferguson, *A History of the Modern Styles of Architecture* (London, 1862).

Once the Swiss federal state had been founded and Bern chosen as the nation's capital, plans were begun for a federal government building. The first federal "town hall," the Bundesrathaus (today the Bundeshaus West), built (1851-1866) by Friedrich Studer, possessed two wings positioned around a courtyard. The central section was allocated to the Federal Council and the federal administration, while the lateral tracts housed the parliamentary chambers for the National Council and Council of States. Strongly influenced by the Florentine semicircular-arch style of the early Renaissance cultivated in Munich, the reticently orchestrated, blocklike building exudes an aura of calm, republican matter-of-factness - an ideal architectural image of the young federal state. The English architect and writer James Ferguson called the Bundesrathaus "perhaps the best specimen of the Florentine style that has yet been attempted" and viewed it as a model for the Houses of Parliament in London. The Berna Fountain in the cityward courtyard takes up the theme of traditional Swiss figural fountains: four gargoyles in the shape of swans symbolize the four rivers that rise in the center of Switzerland - Rhone, Rhine, Reuss, and Ticino; on the water crane, Berna, deity of the city, towers over the statues of the Four Seasons.

Beat Wyss

Lucerne
The Simultaneity of Urban Processes
in the Nineteenth Century

...facies non omnibus una,
Non diversa tamen...
Ovid, *Metamorphoses II,* 13/14

The title of this essay addresses the prejudice that art-historical hunting and gathering is in itself devoid of theory. Every survey must begin by deciding on its criteria of selection. Thus the present text is a kind of epilogue to my collaboration on the *Inventar der neueren Schweizer Architektur* (Inventory of Recent Swiss Architecture – INSA).[1] A series of volumes published under the auspices of the Society for the History of Swiss Art, it carries on the inventory begun by the *Kunstdenkmäler der Schweiz* (Art Monuments of Switzerland)[2] in the direction of the present day. The INSA has set itself the task of studying residential patterns in forty larger Swiss towns between 1850 and 1920. Thorough knowledge of architectural trends lays the foundations for an overall analysis of city planning. The road leads from the specific to the general.

Induction is an essential feature of studies in urban development. But how admissible is it to extrapolate a theory of urban development from individual urban communities? Modifying Kant's question of the a priori nature of synthetic judgments: how can theoretical statements about city planning be made on the grounds of individual cases? The following will provide a basis for inductive procedures. The proposed method – I call it "poleognomy" – is an attempt to grasp the individual phenomenon as a monad of general historical processes. Lucerne, a town whose development into a tourist center reflects the industrial age, will serve as a touchstone of urbanizing processes.[3]

251

City Planning and Art History

Works on the technical-practical aspect of city planning have been written since ancient times.[4] The subject has remained the writing architect's most ambitious activity up to the present day,[5] and *Städte-Bau*[6] by Camillo Sitte takes its place in this long tradition. When the book was published in 1889, the industrial expansion of the cities, with their belts of perpendicular grids, had already created realities whose "lack of motifs and unimaginativeness"[7] Sitte could complain of. His demand for picturesque squares, winding streets, and asymmetry as a design element marked the urbanistic attitude that informed late historicism and Jugendstil – Art Nouveau as practiced in the German-speaking world.[8] But it was to take another three decades for the history of urban development to be described not only by architects but by art historians as well. The final volume of the series *Handbuch für Kunstwissenschaft* (Handbook of Art History), published in 1920,[9] inaugurated the acceptance of "the art of city planning" as an art-historical field. In stark contrast to the interests of practical engineering, attempts were now made to describe the town as a stylistic phenomenon. Going out from stylistic terminology applied in art history, Brinkmann worked out the distinctive features of the Gothic town, the Renaissance town, and the baroque town. He followed up his subject into his own time, an undertaking not to be taken for granted in an art historian of his day. Rejecting Sitte's historicism as an eclectic architecture of masks, Brinckmann accomplishes the transition to the reform movement of *Heimatstil* (vernacular style).

Behind the models for small cooperative dwellings – the Fuggerei in Augsburg and the row houses in Bath – stands the English concept of the garden city. Brinkmann's critical approach is carried on in Josef Gantner's work.[10] Going out from Heinrich Wölfflin's "principles," Gantner sketches a historico-systematic outline of the art of urban development: Gantner sees city planning as the effect of the polarity between "irregular" and "regular," a notion traceable to Aristotle.[11]

Brinkmann already makes the distinction, supplementing it with the polarity of the "spontaneously grown" as opposed to the "founded" town. With the consistency of an exacting historian, Gantner contradicts not only Brinkmann but even Aristotle when he interprets regular and irregular cities as two basic types of city layout that do not succeed each other chronologically but have been available simultaneously since time immemorial.[12]

The formal historical approach, which is even reinforced by Paul Zucker,[13] may suffice for the systematic treatment of cityscapes up to the end of the eighteenth century – that is how far Gantner's study extends – but the explosive excesses of urban growth during the industrial revolution can no longer be explained by means of a simple polar model. In Switzerland two architects rang in the new phase of research into urban development in 1929: in comparative studies Camille Martin and Hans Bernoulli[14] recorded the contemporaneous scope of the larger towns, enlisting topography, and sociological and economic statistics in the process. Whereas the first art-historical theoreticians of city planning strove to preserve the autonomy of their discipline by restricting themselves to the "analysis of the formal features of the city as it has evolved,"[15] the authors of the postwar era devoted themselves to practice rather than theory. The method of formalistic aesthetics was considered quaintly unworldly or was even totally discredited for having been employed for the purposes of Nazi propaganda by people like Schulze-Naumburg. Whereas Brinckmann had still wanted to "discover laws of artistic design in urban development that have eternal validity,"[16] the reconstruction of war-devastated cities confronted urbanists with more pressing problems. Sigfried Giedion's *Space, Time and Architecture*,[17] published in 1941, offered aesthetic guidelines: while Europe's cities were being reduced to rubble, a book had appeared in the United States that drew an unbroken line of progress from the invention of central perspective in Florence to Rockefeller Center in New York. A German emigrant's theses brought a kernel of American optimism,

overlaid with European tradition, back into the hopeless devastation of the Old World. The aesthetics of the repatriated Bauhaus shaped the reconstruction of Europe. The relevant literature of the 1950s and 1960s interpreted city development on the basis of political, economic, and social history. Conceived in the spirit of economic boom, it used statistics as an aid;[18] the city was understood as an expression of rates of growth. The theory of urban development had moved into the realm of social criticism: Lewis Mumford[19] and Leonardo Benevolo[20] published books that produced broad effects. The standard work in French, by Michel Ragon,[21] also defined urban development as the result of the means of production.

The tendency to view the city as a mere function of economic and social processes encountered incipient opposition at the end of the 1970s. "Socio-economic conditions are like a picture-frame; they offer a certain 'space' within which life can take place, do not, however, determine its existential significance,"[22] wrote Christian Norberg-Schulz in a "phenomenology of architecture," borrowing from German existential philosophy. Heidegger's *Sein und Zeit* (Being and Time)[23] and the philosopher's essay "Bauen Wohnen Denken" (Building Living Thinking)[24] are cited to establish the essence of architecture as "being in the world." However striking the claim may be that the essence of a constructed place has been grasped, the result remains rather vague; the programmatically invoked *genius loci* is reduced to a quid pro quo – when, for example, a façade with oriel window in Innsbruck is classified alongside a row of columns in a temple of Selinunt, under the heading of "standing and rising loftily."[25] "Phenomenology" of this type is fatally reminiscent of the illustrated volumes by Schulze-Naumburg popular in the 1930s. It is not the object that is being presented but an already strongly interpretational photograph of it. A suggestive camera angle shows it in such a way that it cannot but conform to the preconceived theses of the interpreter.

"Poleognomy": A Method

What is needed is a procedure that attempts to mediate between the historico-sociological and phenomenological methods. *Genius loci*, a term already codetermined by the economic, social, and historical development of a place, is taken over from Norberg-Schulz and his phenomenological approach.[26] The "being" of a city remains a genteel abstraction; its concrete *genius loci*, on the other hand, consists of the sediments of collective experience, where all history, from great events down to the anonymous routine of everyday life, has been deposited. Urban studies cannot exclude ostensibly banal, obsolete cultural phenomena; they cannot consider themselves too good for framing the quotidian – the "Gestell," to speak with Heidegger.

Studying the *genius loci* suggests employing an inductive method. Special features are to be extrapolated experimentally from the specific example. The *Inventar der neueren Schweizer Architektur* (INSA) limits itself chronologically to the nineteenth and early twentieth centuries, the one hundred years that marked the greatest upheavals in urban development. My own research focused on Lucerne, in other words, not on a metropolis whose sheer size would justify a claim to the normative force of a universal law. It is a comparatively small tourist center that has exhibited very specific forms of development.

Is there, strictly speaking, such a thing as a deductive process in art history at all? Already Braunfels employed the term "city personalities";[27] all urban theories must go out from concrete examples: Paris, London, and Vienna have been cited most frequently by art historians, enabling a few universal laws to be extrapolated from a comparison of their respective historical development. The conditions and zones of growth more or less distinctly recognizable in all cities of industrialized Europe can be summarized in five points:

1. In the first half of the nineteenth century, industries invade the cities. At first they still force themselves into the traditional structures of city centers or are built along arte-

rial roads, where trade has been located since the Middle Ages. Industrial concentration in the city brings an influx of country people looking for work. Living space in the existing urban configuration becomes scarce.

2. Shortly after the middle of the century, the actual re-construction of cities begins. In this age of promoterism the authorities have to regulate real estate speculation, while the liberal economy reins itself in through cartels. Fortifications fall, large-scale construction of blocks cuts straight through labyrinthine historical quarters while at the same time spreading to hitherto non-built-up areas beyond the formerly self-contained city. Residential apartment blocks with courtyards transform the "phalanstère," the socio-revolutionary model of Fourier, into reality within the framework of capitalistic property ownership. Razing the fortifications has made land available. Most of it is municipal property, which now becomes the site of public parks and buildings, the latter to fulfill new administrative and political needs.

3. The city becomes a machine. Shortly after the tangible boundaries of city fortifications are eliminated, subterranean pipes and thin overhead wires emerge as new forms of drawing together an urban area: the "veins" and "nerves" of the gas pipelines (before 1850), the sewage system (since the 1870s), and electricity and the telephone (since the 1890s).

4. The focus of city planning in the nineteenth century is the railroad station. Where it stands and where its tracks lead determine growth. The initial complex, dating from before mid-century, often has to be enlarged toward the turn of the century in order to increase capacity and adjust to the new facts of urban organization.

5. Outside the areas containing large apartment blocks, the loose belt of one- and several-family houses sited between existing country estates and old suburbs becomes ever denser throughout the nineteenth century. Buoyed by an international economic boom, workers follow the bourgeoisie out into the green belt toward the end of the century. The ideological leitmotif is the reform movement, which denounces dehumanizing high rises in inner-city areas. The new dwellings that emerge are one-family houses and row-houses with gardens, patterned after the English garden city.[28] In the first three decades of the twentieth century, the *Heimatstil* predominates in these lower middle-class and working-class areas. *Neues Bauen* (International Style) spreads selectively in the large cities. The separation of home and work on a large scale necessitates the construction and expansion of public transport facilities; even streets on the outskirts of towns have to be paved. Around 1930 urban planning projects for cities adapted to cars begin to appear.[29]

The general principles of urban development in the age of industry as outlined above had been arrived at inter-inductively, by comparing the growth patterns of large cities. They were now taken to be a quasi deducible generality, and I wanted to test them against a specific case, the city of Lucerne, according to Sigfried Giedion's exhortation that although anonymous history is directly connected with the general principles of an age, it must at the same time be traced back to the specific forms that generate it. The ideal of anonymous historiography is comparable to the eye of an insect, which can perceive a variety of facets simultaneously while also taking in the process of their interpenetration.[30] My inventory of the city of Lucerne strove to contribute a facet to Giedion's "eye of modernity"; Lucerne was to be the exemplary urban microcosm, refracting and reflecting the macrocosm of the industrial age. Every city, no matter how insignificant, so the theory goes, proves to be a monad of general processes in the industrial age. That the acquisitions of industrial culture appeared all over Europe with the simultaneity of a magnetic field is a conviction that Giedion, too, expressed.[31] This contradicts the notion that the Industrial Revolution spread gradually from England and France to the rest of Europe, as recently posited, for example, by Koch.[32] The creative amalgamation of scientific discovery and economic enterprise that was to revolutionize Europe in only a few decades made itself felt at the same time and

even in remote places. It is one of the unique features of industrial genius that it could flourish far from metropolises, where the spirit of enterprise was often impeded by royal and corporate privilege. That technical production depended on the proximity of watercourses favored the growth of industry in the country.

The fact that simultaneity has been observed should not obscure the differences in scale: in 1857, the year the famous Ringstrasse in Vienna[33] was begun, Hirschengraben, a moat in Lucerne, was covered and turned into a ring road for vehicles on the left shore of the historical center. The construction of straight street axes by demolishing the old, small-scale composition of Lucerne's suburb took place during the same fifteen-year period that Baron Haussmann was laying out the boulevards of Paris through narrowly proportioned districts of the city (1853–1869).[34] The urban development plans of Lucerne in 1864 were marked by the impulse of industrial growth that was achieving recognition all over Europe: in the expansion of Barcelona (since 1859), in the sanitation of Florence (1864–1877), in Anspach's measures for Brussels (1867–1871).

The development of European cities in the nineteenth century followed a general pattern, and yet each city has its own unmistakable face and its own special fate. The concrete city is evidence of superordinated processes of "anonymous history" and at the same time more than just that: it is a collective individual acting creatively in the current of historical forces. Every city has a *genius loci*, an individual presence which manifests itself as productive strength. Thus what stands as a *petitio principii* in the history of city development has been philosophically underpinned by Lübbe. In his essay on "History's Function of Presenting Identity," he uses the city as a visual example:

Historians who want to acquaint us, in theoretical works, with the nature of historical subjects appreciate cities as particularly suitable examples.

That makes sense. In their silhouettes, prospects, and street configurations, etc., cities offer the synchronous presence of architectonic and urban design elements from different eras. At that moment it becomes evident that individuality is the result of a history – not of a self-contained, undisturbed rationality with a will to act, not the realization of a plan, not the consequence of an intention to bring forth this product. Historical individuality cannot be explained by such intentions or plans, but only by history. Certainly the parties responsible in every phase of city development had rational intentions behind their actions. For secondary reasons, those who came later will have had different intentions, which did not necessarily fit in with the purposes and plans of their predecessors and thus led to those interference phenomena of human intentions and plans for which the cities stand before us as reality turned into stone. Formulated in general terms this means: history consists of processes of system individuation by means of self-preservational transformations of systems under circumstances that cannot be deduced from the original functional purpose of the system.[35]

Lübbe's thoughts can be cited as an argument against equating the history of urban development with the history of city planning. The outward appearance of a city cannot be reduced to the result of conscious planning. The unconscious design concepts of local mentality, the interplay of historical coincidences and necessities, the vagaries of topography – all these are the forces through which the general formal laws in urban development become concretely operative. Establishing these individual productive forces of a place are what I call poleognomy; it includes the topoi, the urban leitmotifs, in which the sense and essence of a city crystallize. These motifs show the polis idea of a city; to recognize them in the network of streets like an iconographic program woven into a pictorial construction would be the ideal of poleognomy.[36]

This leads us to the key word "phenomenology," used by Norbert-Schulz. Where does the *genius loci* become visible? In the buildings, monuments, topographical idiosyncrasies, and legend-permeated places with which citizens identify, in which they see their own nature as city-dwellers expressed. This procedure might give rise to objections: why this kaleidoscope of architectural symbols and cultural leitmotifs instead of the attempt to emphasize the visual aspect of the city as a spatial body? Would it not be better to deal with the history of urban development purely in spatial terms, as Gantner suggested? – Characteristically enough, Gantner's study ends in the nineteenth century, when self-contained cities began to dissolve. "Evident" city-space no longer exists.

Habermas asks whether the term "city" has not become outmoded in modern times, because in the industrial age the urban experience has been despatialized:

> … *not even railroad stations had the visual*
> *power to embody the functions of the transportation*
> *network to which they connected travelers as*
> *effectively as city gates had once reflected concrete*
> *links to surrounding villages and the nearest city.*[37]

The mechanization of cities in the twentieth century has even reinforced this tendency: connected by subway tunnels, the mosaic of selective knowledge of a place can emerge without the experience of city-space as a continuum. The disintegrating body of the city breaks up into a kaleidoscope of non-spatial signals. Modern buildings are urban symbols: from the period of the French Revolution through historicism to postmodernism, "architecture parlante" can be sensed – the simplified two-dimensional front conceals the complexity of technical and social functions. Modern architecture compensates the loss of "bienséance," of spatial evidence of its significance and purpose in the city, through planar visual-semantic symbols on its façades. The designs of postmodern architects accomplish what modern urban perception has been unconsciously registering all along.

Reflections on nineteenth-century material culture adopted a mimetic method early on. Three precursors of poleognomy can be cited at this point, among them Dolf Sternberger. In *Panorama vom 19. Jahrhundert* (Panorama of the 19th Century) he calls his historiographic method "physiognomic, descriptive."[38] It portrays "the world of phenomena and thoughts, figures, gestures, and feelings" that characterize the nineteenth century. Cultural leitmotifs are extrapolated from the lived life of the era and illustrated to the reader by concrete examples: the Berlin panorama of the Battle of Sedan, a group tour to Egypt, the "inner Orient"[39] of a middle-class home – all these combine to evoke the facets of a cultural history. Sternberger's essay appeared in 1938. There is bound to have been some jealousy at work when Walter Benjamin condemned it "bluntly and harshly,"[40] for at the time he was sitting over his own *Passagen-Werk*, whose monumental uncompletability must have revealed itself all the more clearly in the face of similar, finished works. The *Passagen-Werk*, originally intended as the continuation of *Einbahnstrasse* (One-Way Street),[41] was conceived as "material philosophy of history of the nineteenth century."[42] Benjamin wanted to:

> *introduce the principle of montage into historiog-*
> *raphy. In other words to construct large*
> *edifices from tiny, keen-edged elements. Yes, to*
> *discover the crystal of the totality of events*
> *from an analysis of the small, individual moments.*
> *In other words, to break with historical naturalism*
> *in its vulgar form. To grasp the construction of*
> *history as such.*[43]

The material Benjamin obtains for his philosophical tableau of the industrial age are such obsolete remains of the nineteenth-century merchandise world as he was still able to unearth in the dusty shopping arcades of Paris. The montage process in historiography consists in ranging the "refuse of history" – newspaper advertisements, police regulations, poster texts – kaleidoscopically next to one

another; the historian's interpretation, in form of a commentary, is kept ascetically brief, comparable to the cement in a mosaic. Sources and documents, the historical shards from the ruins of the past, are supposed to speak for themselves. Benjamin replaces knowledge through abstraction by the historian's mimetic behavior; the method is to unmask the lumbering stuffiness that strikes the student of the nineteenth century by imitating it. The sense of this form of historiography is "tactile knowledge,"[44] a way of thinking that replaces concepts with images. Such "gentle empiricism"[45] is reminiscent of Goethe's search for the original phenomenon, which does not reside behind or above things but, as a germ of potential, in the things themselves. Benjamin had learned the montage process from the French surrealists, who recognized in the "objet trouvé," the junk that has become useless, the slumbering revolt against the purposive rationalism of the bourgeoisie. Max Ernst's collages with scraps of illustrations torn from nineteenth-century magazines dismantle the pretensions of late-nineteenth-century middle-class dreams. Benjamin employs a parallel technique using text fragments from the era of the Paris shopping arcades.

Benjamin sees the shopping arcades as urban aquariums, where a sunken world of material objects exists in a sort of twilight state. His messianic desire is to tear that world out of its reverie. The material philosopher of history makes his entrance with the claim to being the dream interpreter of history. The goal is awareness; with that, Benjamin, as Sigmund Freud before him, moves away from the surrealism of André Breton. He feels that, parallel to the psychoanalytic process, the historically reflecting subject should experience "the darkness of the lived moment,"[46] which must be awakened from. The "organon of historical awakening,"[47] with its sudden, volatile illuminations, is dialectics. History becomes a cathartic experience of oneself: "The new, the dialectic method of history: to go through what has been with the intensity of a dream in order to experience the present as the waking world to which the dream refers."[48] Historiography is the

wakeful person bearing in mind the dream of the past, now. As a "notion of awakened consciousness,"[49] history is at the same time the historian's way of finding himself. Benjamin investigates the Paris arcades as "architectures in which we relive the lives of our parents and grandparents as the embryo relives the life of animals inside the mother."[50] History starts out from the subject in order to return to it again. This radical distance from a positivistic concept of history is reminiscent of Georg Simmel, whose philosophy-of-life-oriented, epistemological theory[51] of history Benjamin supplements with what might be called a psychoanalytical one.

The methodological vision in *Passagen-Werk* is "materialistic physiognomy"[52] – the proximity to Sternberger is unignorable. And one of the reasons Benjamin may have criticized him is because he was too close. The physiognomic, mimetic aspect means distance from Marxist ideological criticism; Benjamin ridicules it as "now boastful, now scholastic."[53] Ideological criticism is deductive; Benjamin's method is radically inductive: the precisely drawn monad of the particular is to allow the general to become evident on its own. The method of induction is at the same time an ethic that takes a stand for the powerless and those deprived of power. One could speak of Benjamin's "black socialism" in contrast to what Stanislaus von Moos, characterizing Giedion's attitude, calls Fordistically "white socialism." While Giedion was sketching an unquestioning history of American modernity,[54] Benjamin was deconstructing Parisian faith in progress. Both of them are "socialistic" in siding with what is small and special. Like Benjamin, Giedion too strives to "investigate the anonymous history of our era."[55] Nothing is banal to the historian: "The sun can be reflected even in a coffee spoon."[56] With that the Wölfflin follower radicalizes "art history without a name"; Burckhardt, Wölfflin, and the artists of the avant-garde have taught him "that one must have the courage to take small things and raise them to large dimensions."[57] Like Benjamin, Giedion dives into the "junk-room" of mecha-

nization and, with the "magic of bad taste,"[58] conjures up in his texts an era of cast iron and plush that has shaped our view of the nineteenth century. Giedion too wants to make the blind laws of history conscious by letting objects speak for themselves; "stuff" is to be snatched from the sphere of unreflected utility by allowing it to spark aesthetic reflection. The artistic technique of montage is employed for this; it – in Giedion's view automatically – imitates the logic of progress, in the continuity of which one may place one's unreserved trust. Here Benjamin disagrees: in his view, historical progress is a continuum of catastrophes; hence, thanks to its abruptness, montage has the purpose of delivering so great a shock to the dreamer that he will awaken from history. Whereas under the spell of the American dream Giedion's books could also dream this dream, Benjamin's *Passagen-Werk* is the wreckage of a crashed utopian time machine built to evacuate the passenger by waking him from history as nightmare. Giedion and Benjamin, the two archaeologists of industrial culture, embody the Janus face of modernity as a "project of the Enlightenment," in whose success the conditions of its failure also reside. The concept of "postmodernism" is misleading because, in its modern optimism and skepticism of modernity, it suggests chronological succession. The simultaneity of Giedion and Benjamin's approaches demonstrates that an era's spectrum of ambivalence should be interpreted as systematic rather than historical. The "post" aspect of the modern era is as inherent to it as manneristic refraction is to the Renaissance.

Not only were Benjamin's *Passagen-Werk* and Giedion's *Mechanisation Takes Command* written the same time; German editions of the books also appeared the same year, 1982. Their publication fell into an era of rediscovery of the object, method, and commitment of early historical studies of industrial culture. Peter Röllin's book about *Sankt Gallen*[59] might be mentioned as an example from the domain of the history of Swiss urban development. Here, too, a single case serves to focus gen-

eral urbanistic facts and problems. Röllin examines St. Gallen's "experiential space," a term introduced by Thomas Lieverts.[60]

Architecture is a technical discipline. Jean-François Lyotard maintains that technical knowledge has always sought to trace its roots to the narrative:

> Rough proof: *what do scientists do when, after having made some "discoveries," they are invited to appear on television and give interviews to newspapers? They relate an epic about knowledge that has absolutely nothing epic about it. In this way they comply with the rules of the narrative game, whose pressure remains considerable, not only in the media consumer, but also in their own innermost selves.*[61]

Already Vitruvius yielded to this pressure, allowing little legends of origin to luxuriate arabesque-like among the dry business of constructional engineering – from the first huts to the "Eureka" of Archimedes in the bath. With the touching story of the invention of Corinthian capitals, the functional column even ascends into the realm of tales of wondrous transformations. Not the least reason that the Roman engineer spiced his *Ten Books about Architecture* with anecdotes was to render them appealing to at least one powerful layman who commissioned architecture on a grand scale: Emperor Augustus, to whom the work is dedicated. Today the history and theory of city development continue to cater to decision-makers and those affected by their decisions, most of whom tend to have no art-historical bias. Dealing actively with problems of urbanism is one of the practical sides of art history: in conjunction with architects, curators of monuments, and politicians, it serves the public. Poleognomic research discloses those urban symbols that unconsciously express the cultural identity of a community. Making the concept of the polis, in its forms and fables, manifest to planners is to reveal the narrative foundations to them: this is where the sense – or nonsense – of technical endeavors must be tested and perhaps anchored.

The City-Machine

Art historians essentially stumbled into technical history. It was ironic that this distinguished ivory-tower discipline, which tended to overlook the commonplace present with aesthetic far-sightedness and to view modern "civilization" as the decline of the lofty values of the "culture" it guarded, should have had to lower itself to the quotidian depths. The first "foster parents" may still have been outsiders to their discipline, like Benjamin, or propagandists for the avant-garde, like Giedion; but since the 1970s art history has adopted the object world of technical history and incorporated it under the heading of "industrial culture." Two major exhibitions in Berlin in the 1980s popularized the subject. One of them was mounted in 1981 for the 125th anniversary of the Verein Deutscher Ingenieure (Association of German Engineers),[62] the other was organized in 1986 by the Neue Gesellschaft für Bildende Kunst (New Society for the Fine Arts).[63] During the same period a body of essayistic literature began to flourish, which, following Benjamin's lead, explored the medium of the material culture of the modern era.[64] There has as yet been no survey of the history of world's fairs and international exhibitions; the small illustrated volume by Christian Beutler[65] has cut the first small clearings in the forest of nineteenth-century industrial design and its staging.

The cultural landscape of Switzerland is saturated with the influence of industry and tourism; this fact has been duly noted by the field of regional art history.[66] In monument preservation circles, interest in technical achievements and the culture of trivia is growing, subjects that even fifteen years ago would have been perceived as at best a nuisance. The concept of the monument is expanding apace: as protection-worthy objects move ever closer to the chronological present, mountain railways, factories, and steamboats are being transferred to the custodianship of curators of monuments. The practical business of restoration is no longer concerned with the classic individual object but with its spatial environment. Federally funded institutions record town- and cityscapes, even whole landscapes.[67]

Lucerne, for Instance
a: An Advance from the Field

An analysis of the development of residential patterns in Lucerne recapitulates the general dynamics of urban development in the industrial age.[68] The purpose is to demonstrate that the impulses for industrial restructuring initially came from the country, not the town. In the Lucerne region this occurred when the area was discovered by, and opened up to, tourists – a form of industrialization of the landscape. All round the town, and even in the idyllically remote sites on the shores of the Lake of Lucerne, farming hamlets became factory villages. In the 1870s, the so-called period of promoterism, it was central Swiss farmer-entrepreneurs, self-made inventors, and impetuous men like Caspar Blättler from Hergiswil or Franz Joseph Bucher-Durrer from Kerns who shaped the touristic face of the Lucerne landscape.[69]

The industrial impulse did not necessarily go out from metropolises: the first railroad lines in the world linked Stockton and Darlington in 1825, and Liverpool and Manchester in 1830. In Germany, France, and Austria the first railroads began to be constructed in the 1830s. In the mid-nineteenth century, when Europe already possessed a railroad network of twenty thousand kilometers and seven hundred operating railroad stations, Switzerland had only twenty-five kilometers of tracks – the tail-end of the Chemin de Fer de Strasbourg à Bâle (1844) and the "Spanischbrötli-Bahn" between Zurich and Baden (1847). Apart from its harsh topographical conditions, the reasons for Switzerland's backwardness were the efficiency of a road network dating back to the Napoleonic era and the country's conveniently situated lakes, which were plied by boats that, as time went on, were put under steam. But soon steps had to be taken to prevent Switzerland from falling behind other nations and regions in the competition for railroad routes through Europe. After the Sonderbund War, the politicians in the new federal state founded in 1848 therefore undertook measures to initiate the use of steam on land routes as well. George Stephen-

son, son of the inventor of the train, was commissioned to work out a plan for a Swiss railroad network. By the end of the 1860s, there were fourteen hundred kilometers of track in operation. As the railroads were at first the province of the cantons and private enterprise, expansion of the system was subject to the forces and mechanisms of speculation. Investors from England and France wanted a say when it came to a future transalpine route through Switzerland. But the train not only shortened distances, it also consolidated the cyclical fluctuations of economic regions. The five-year economic slump in Europe around 1880 resulted in a distinct downturn of growth in the city of Lucerne. The next twenty-five years, after the opening of the Gotthard Railroad (1882), brought a new boom. From 1897 on, Lucerne was located on the north-south axis of the Swiss railraod system, where, until the outbreak of World War I, it fulfilled the technical demands for a meeting place of the rich and the beautiful – the circles that produced the "Belle Epoque."

b: Defortification

The purpose of the industrial restructuring of the landscape was to decrease the time needed to traverse distances. As railroad tracks began to plough through open fields, the city also began to open up. Its closed configuration had always served to insulate it from the open spaces of the countryside, enabling patrician privilege to be horded in urban confines. But there was ultimately no withstanding the iron channel that brought remote places into reach. Although the development of a rail system had been delayed for one and a half decades in Switzerland, technical energy had already made its entrance in the shape of the steamship. As elsewhere in Europe the first railroad stations were altering the traditional face of the city, Lucerne was beginning to raze its own fortresses for a steamboat landing at Schwanenplatz in 1835. A quay was built on the lakeshore to handle the growing traffic between road and ship.

In 1856 Lucerne decided to pull down its fortifications. At the time, the medieval towers were being used as prisons, a domain of the cantonal government. Protracted negotiations were necessary before the old symbols of sovereignty and law could actually be torn down. In accordance with the hypothesis that urban processes are simultaneous, similar problems between municipalities and higher authorities repeatedly cropped up during the period of the physical opening up of cities. In Cologne[70] the future of the city fortifications did not become a subject of debate until 1860. A proposal to enlarge the narrow gates was made in 1864 – at a time when the majority of towers were falling in Lucerne. The petition to pull down the bulwarks, submitted by a group representing building interests, was rejected by the Prussian Ministry of War on 20 January 1870. Admittedly, Cologne was in a more parlous position on the eve of the Franco-Prussian war; Lucerne's walls had served their final military function in the Sonderbund War of 1847, when the frightened rural population had sought refuge behind them. In Cologne the bulwarks were permitted to fall only after a chain of forts had been built further forward. After dogged political preliminaries and futile attempts to bargain with Bismarck, the municipality of Cologne paid the higher Prussian authorities 11,794,000 Reichsmark, in twelve annual installments, for the terrain. That same year, 1870, a competition was mounted for a plan to build over the semi-circular "Ring"; it was won by Professor Karl Henrici and City Architect Josef Stübben, from Aachen. Lucerne's city-planning projects had gone into force six years earlier. In terms of urban development, political importance and size can sometimes be an obstacle.

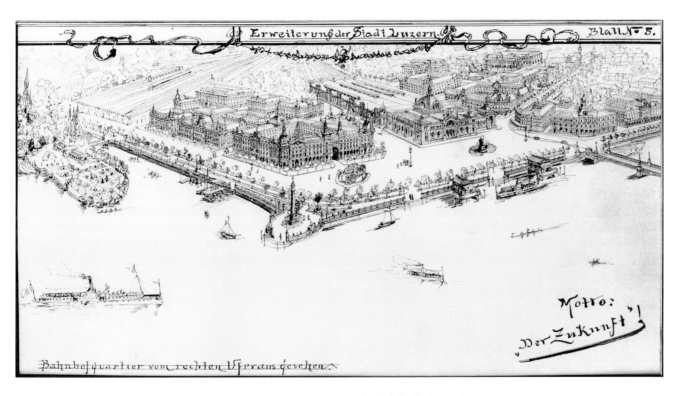

fig. 1: "To the Future."
Perspective of the Lucerne city-
development plan, 1897, by
Heinrich Meili-Wapf and Robert
Winkler.

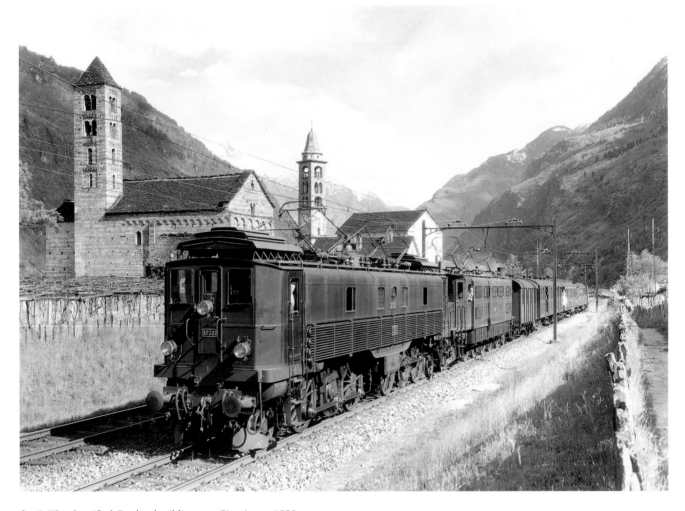

fig. 2: The electrified Gotthard rail-line near Giornico, c. 1930.

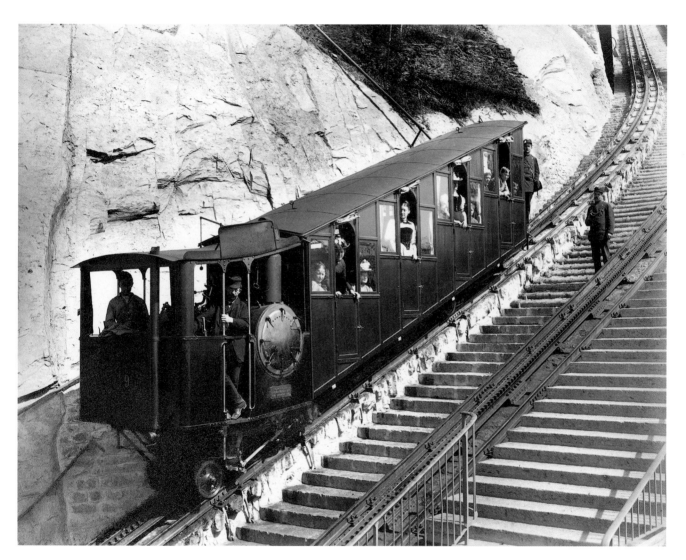

fig. 3: Steam-car of the Pilatus Railway, opened 1889.

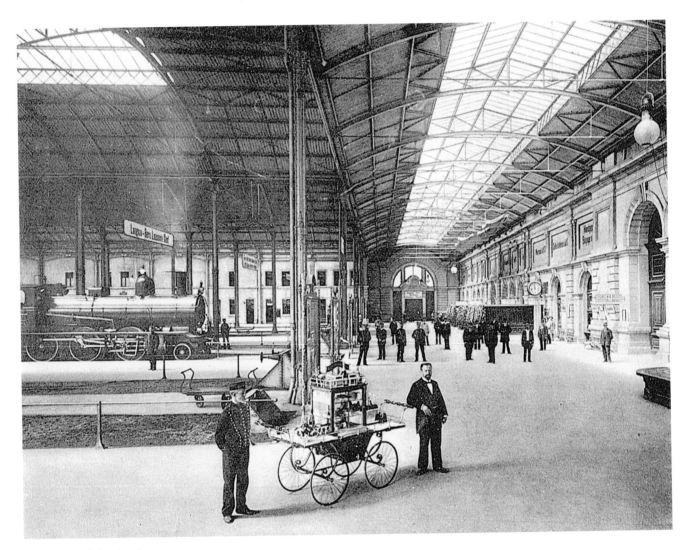

fig. 4: Postcard showing the
station platform in Lucerne, c.
1900.

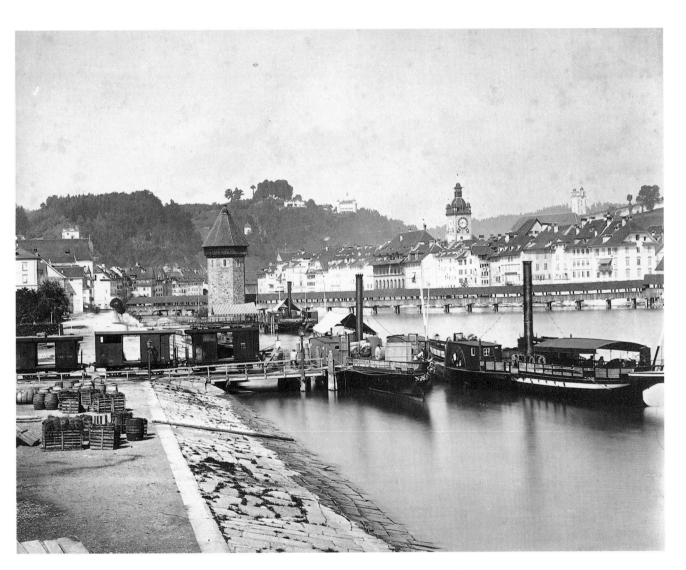

fig. 5: Lucerne. Wharf between
Bahnhofplatz and Schifflände,
c. 1865.

fig. 6: Railroaders, c. 1900.

fig. 7: Lucerne. Demolition
of the Kropftor, a city gate on
Hirschgraben, 1891.

fig. 8: Decoration for a façade, copied by Joseph Bielmann in 1883, after a design by Hans Holbein the Younger at the Louvre, Paris.

fig. 9: Lucerne. The old railroad station, decorated for the visit of the German emperor and his wife on 2 May 1893.

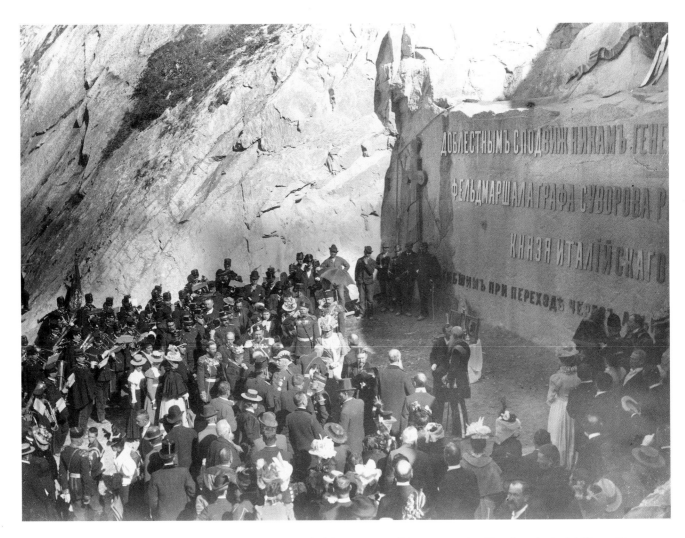

fig. 10: Unveiling of the monument for Alexandr Suvarov, general of the Russian coalition army against Napoleon, in the Schöllenen Gorge on the Gotthard, 26 September 1898.

fig. 11: Lucerne. Weather
monitoring equipment at the
Seebrücke, 1873.

fig. 12: Lucerne. Schwanenplatz, c. 1900.

fig. 13: Rathausen.
Building of the Central Swiss
Power Company, 1895.

fig. 14: Rathausen.
Turbine plant of the Central
Swiss Power Company, 1896.

fig. 15: Lucerne. Reuss
Island with commercial build-
ings, c. 1894.

fig. 16: Project for a garden city
in Lucerne's Brüelmoos, 1914.

c: Light, Water, Speed

The effect on modern urban development is multiplicational and differentiating: houses with polymorphous uses evolve into new architectural types scattered across the growing urban area, the latter consequently experiencing functional disentanglement. The pre-modern house possessed a certain autarchy, it was taken care of by the inhabitants themselves. Official interference in new construction was correspondingly modest in the eighteenth century, limiting itself to fire-police inspections of furnaces and kitchen stoves – potential sources of danger to the general public. Such interference increased as buildings became more technical. Heads of households had to learn that the absolute sovereignty they had thus far exercised was beginning to dwindle as gas, water, and electricity invaded from outside. Residents became dependent on a supply system they were in no position to influence. As soon as a building was attached to sanitary and technical services, it became a component of the total urban machine. The city had torn down its fortifications; underground, through the sewage system, it was a self-contained unit once more. The city's energy and water supply, and the public transportation system had replaced the jurisdiction once marked by towers and gates.

The open city was held together from the inside through its technical infrastructure, the construction of which was generally initiated in the final third of the nineteenth century. When the first technical handbook for urban development was published in 1876,[71] Lucerne's new planning projects had already been in force for ten years. In accordance with nineteenth-century economic trends, public services were either left to the free play of pioneering inventor-entrepreneurs, in the spirit of economic liberalism, or were entrusted to the municipal authorities. In Europe there was a far stronger tendency toward municipal services than in the United States. Conflicts between private initiative and public needs, but also the boundaries of profitability of technical services, led to key facilities being taken over by the municipality or

state. Lucerne took over the gasworks in 1894; a few years later, in 1898, the people of Switzerland voted to nationalize the railroads.

The mechanical substructure of the city fulfills three needs: hygiene, light, and speed. The first great achievement was the rationalization of light in the form of gas.[72] London built its first gasometer in 1814; during the 1820s gasworks were built in all the larger cities of England. On the Continent there was initially widespread suspicion of the suddenness with which night could be banished. The magic charm seemed to reveal its cloven hoof in the eerie omnipresence of industrial smog, which crept in on the family's private smells, threatening to contaminate them. In 1829 Paris began by restricting itself to gas streetlamps; not until the mid-1840s did private households tap the mains. In Germany the breakthrough of gas lighting came in the 1850s. With the *Journal für Gasbeleuchtung* (Journal of Gas Lighting), founded in 1858, the industry made use of popular advertising to eliminate residual fear of the technology. The same year a private gasworks was opened in Lucerne. Conversion to electricity forty years later was a far less problematic process. People had grown accustomed to having external powers dictate the comfort of their interiors. The first transformer plants went into operation in London and New York in 1882. Thomas Edison, the inventor of electricity, adopted the gasworks model of central provision. In 1886 the first private electric power plant in Switzerland was opened near Lucerne; in 1899 electricity was placed under city control. In 1900 the Paris World's Fair displayed a symbol of the victory of the new energy, the artificially illuminated, much marveled-at Palais de l'Electricité.

The second measure undertaken by the modern city concerned the technical availability of water. The prime object now was no longer the energy supply: as electricity spread, artificial millstreams and industrial canals were able to be filled up. What was in demand was water in the service of public health. But to be able to serve hygienic purposes, the water itself first had to be regulated by means of quay plants and solidly built canals to separate

the wet from the dry. The nineteenth century is an era of crusading against swamps, under the spiritual leadership of fringes of the scientific theory of "miasmas."[73] Water in a city was no longer to be allowed to occur in the form of stagnant moats, stinking cesspools, and marshy shores; it was to be concealed in pipes, conducted under pressure in large quantities, clean and quickly flowing – in the pressure water and self-cleaning sewage system. Hamburg set the example; after the 1842 fire, which destroyed one third of the inner city and rendered twenty thousand people homeless, the municipality decided to build a sewage system as part of the reconstruction. The English railroad engineer William Lindley supervised the work.[74] The city of London, which already had a sewage system, began to convert to pressurized waste-disposal in 1859. Frankfurt followed in 1867, then Danzig in 1868, Berlin in 1874, and Munich in 1880. The peculiar way the city of Paris clung to its smells – construction of a self-cleaning sewage system was not decided on until 1889, the year of the World's Fair – has been analyzed by Alain Corbin.[75] Lucerne, which had had a pressure water system since 1875, is comparatively early in the list of cities with modernized sanitation. The reasons for this were less the needs of the population than the tourist industry's fear of "epidemics that would be bad for business."[76] In large cities, installation of pressure water and self-cleaning sewage systems were important for social hygiene; after all, epidemics that broke out in poor areas threatened the districts of the affluent as well. It is typical of the technocratically-minded nineteenth century that social problems were mastered by technical means. Thus the Hamburg experts constructed a self-cleaning sewage system as an "installation to suppress the bad practices and irregularities of the lowest class."[77] The smaller German towns, where social tensions were less, or hardly, noticeable, received their self-cleaning sewage systems only in the 1880s.

The third measure undertaken by the modern city related to mobility.[78] The railroad station was the pacemaker of urban development in the nineteenth century. The city grew with the economic energy generated by attachment to the accelerated stream of goods and people.[79] Contemporary planners often underestimated the influences the new mobility would have on urban development. Lucerne was not the only place to regard the steam locomotive as a mechanically accelerated mail-coach and thus to demand a railroad station located, if possible, in the existing center. The German word "Bahnhof" – literally "rail court" – for railroad station still embodies this anachronism: the new constructional requirements were to be fulfilled in the manner of an inn-cum-post office, with a main building for passengers and goods surrounded in a "courtlike" fashion by coach-houses and stables along the rails. But railroad stations ate themselves more quickly and malignantly into the old fabric of a city than harmless post offices. That Lucerne's first railroad station was sited on a green field, far from the city center – to the anger of many locals, who would not have minded the steam locomotive right on the doorsteps of their shops – is evidence of far-sighted planning. Elsewhere the railroad station in the city center was reason to raze the ring of fortifications. Moats were turned into access roads to the station – for example, Bahnhofstrasse in Zurich or Aeschengraben in Basel. The city fortifications that had originally been used to check the circulation of people and goods were forced to yield to the principle of free, mechanized mobility. Some of the parts of city fortifications that had to make way for railraod stations were: the Clarabollwerk (1852–54) and Aeschenbollwerk, including the Aeschentor (1858–1861), in Basel; the Christoffelturm (1864) in Bern; the Untertor (1867) in Winterthur. New bridges leading to the station overcame the former communicative limits of cities by the water: the Pont du Mont Blanc in Geneva (1862), the Bahnhofbrücke in Zurich (1864), the Seebrücke in Lucerne (1869–1870). The city walls had fallen, now railroad tracks marked the boundaries of social privilege. Imposing residential and commercial buildings appeared on the entrance side of the station, while on the other side of the tracks the industrial and warehouse zone spread, accompanied by the dwellings of the cottagers of the factory age.

d: The Emergence of the "Old Town"

The transformation of the city into the city-machine was a means of adapting urban space to the new "liberal" forms of traffic, transport, and economy. These interventions generated "conservative" countercurrents; for the history of urban development, they must be regarded as progress-curbing design factors. It was not until the late nineteenth century that concern for the preservation of the traditional architectural fabric began to have a broad, perceptible impact; much of Old Lucerne had already disappeared when Liebenau invoked it in his popular housebook, published in 1881, one year after the foundation of the Schweizerischer Verein zur Erhaltung vaterländischer Denkmäler (Swiss Association for the Preservation of the Monuments of the Fatherland).[80]

The nineteenth-century concept of monument preservation evolved in three phases: conservative romanticism in the first third of the nineteenth century, a historicistic revival after mid-century, and the *Heimatstil* in the framework of the reform movement around 1900. Collecting antiques is an activity of educated people with roots in the humanism of the Middle Ages and even more so in the Renaissance. In the nineteenth century, the era subject to the greatest upheavals in terms of material culture, the tradition of preservation – out of respect, the need to legitimate, the search for models – developed into the public institution of monument preservation. Strong impulses had already gone out from the Napoleonic cultural policies supported in Switzerland by the Helvetic government. But the notable preservational objectives of a Philipp Albert Stapfer foundered with the Helvetic Republic.[81] In the Restoration era, the Kingdom of Bavaria undertook the first official measures: in 1827 a decree for the "preservation of architectonic, plastic, and other monuments" was issued. In republican Switzerland similar efforts were made by individuals and private organizations. Lucerne's modern monument-consciousness was kindled by the question of preserving the medieval battlement and promenade walk across the mouth of the Reuss. In 1828

the lithographic printers Gebrüder Eglin published pictures of the spandrels of the Kapellbrücke in Lucerne – an early example of modern monument inventorization. The partial demolition of the bridge necessitated by the quay on the left bank of the river (1833–1837) led to quarrels between the liberal municipal authorities and Lucerne's Kunstgesellschaft (Art Society). This organization, founded in 1819 by Carl Pfyffer, a representative of the patrician class, was restorational in attitude. After militant beginnings in a spirit of politicized romanticism, the Lucerne Kunstgesellschaft became harmless and congenially homespun in the 1830s. Pavilions, teapots, and picturesque moonlit chapels were designed and visited. "Monuments patterned after nature" were also sketched – a method of art-historical inventorization that was at the same time an artistic study. The Lucerne organization was attitudinally comparable – but far inferior in talent – to the Gesellschaft für Altertumskunde von den drei Schilden (Society for the Study of Antiquity of the Three Shields), founded under the aegis of the poet, artist, and musician Franz Graf von Pocci in Munich in 1840.

While in the first half of the century interest in artistic monuments was largely restricted to the aesthetic dabblings of the higher social strata, in the last third the call for preservation became more widespread. By now the restructuring of the cities was making the gaping wounds of demolition ever more visible. The revival concept offered a popular compromise between the constraints of progress and the longing for tradition. New buildings in colorful stylistic garb stand for historicism's desire to do the one and – ostensibly – leave the other.[82] The murals in the spirit of Holbein number among the highlights of historicism in Lucerne. From the 1880s until the turn of the century, the façades of many townhouses were painted with frescoes. The initiator of the idea was Seraphin Weingartner, founder of Lucerne's school of applied art. Weingartner and his students painted scenes and allegories from local history, executing them in the style of the Düsseldorf School. The historical make-up applied to the

fronts of Lucerne's houses followed on the lavish celebrations in 1886 of the Battle of Sempach (against the Habsburgs in 1386). The symbolism, iconography, and decorum of the frescoes were strongly influenced by the festive procession and the pageantry of its ephemeral architecture. Transferral of the spire of the Battle Chapel of Sempach to the oriel of the richly painted Bossard house at Löwengraben 15 forms an architectural link between the Sempach celebration and the frescoes of Lucerne. The artist acted as director of the middle-class society that dressed in historical costume and staged tableaus. A parallel can be drawn between this patriotic commemoration day in Lucerne, with its effects on the local art scene, and the famous festive procession Hans Makart organized in Vienna in 1879, as a tribute to the silver anniversary of the emperor and his wife.

The proliferation of new historicistic buildings honed a sense of the authentic; and in the final two decades of the nineteenth century, the concept of monument protection generally began taking on institutional forms.[83] The Swiss Association for the Preservation of Monuments of the Fatherland was founded in 1880. In 1886 the federal government provided its own complement with the federal Commission für Erhaltung schweizerischer Altertümer (Committee for the Preservation of Ancient Swiss Buildings). A few international dates show that the time for the "monument" had come.[84] England witnessed the foundation of the Society for the Protection of Ancient Buildings, of which William Morris was a member, in 1877. In the German Reich, Bavaria retained the initiative with a statute concerning the inventorization of architectural monuments in 1882. Heinrich von Riehl, a professor of art history, became Curator General in 1885. France followed in 1886 with its comité des monuments français. In 1899 the *Handbuch für Denkmalpflege* (Handbook of Monument Preservation), containing the first German-language dictionary of art history, was published in Hannover.[85]

It was monument preservation circles that voiced the first protests against historicistic renovation. Victor Hugo's phrase "vandalisme restaurateur" is well known. Auguste Rodin, who belonged to the comité des monuments français, took up the idea in his book on the cathedrals of France;[86] in it he fulminated against the completion and renovation of medieval cathedrals. Rodin was familiar with such work from his own experience: as a young stonemason he had earned his living working at cathedral building sheds, where renovations were undertaken in the spirit of Viollet-le-Duc. In Austria, too, it was a curator of monuments who formulated the critical argument against historicism: in his study on the modern cult of monuments,[87] Alois Riegl placed the "value of age," the lofty uselessness of the monument, above its appearance of newness. In Germany, Hermann Muthesius criticized the completion of Cologne cathedral because it derived from a mentality that sought to camouflage temporality and aging.

> *A well-known, bitter judgment of the deeds of architects in the nineteenth century states that new buildings were made to seem old and old ones new. Many believe that the first reproach has now been surmounted. And now the time has come to set about finally eliminating the second![88]*

Muthesius fulfilled his own demands by becoming one of the cofounders of the Deutscher Werkbund in 1907.

Revival or preservation? The contradiction between stylistic historicism and preservation of monuments became ever sharper in the 1880s. The renovation of the Tell Chapel in Sisikon,[89] completed in 1883, constituted a further triumph of naive historicism; the baroque histories of the Marian pilgrimage chapel were replaced by Stückelberger's William Tell frescoes. But toward the end of the nineteenth century, the conviction that monuments should be preserved, not renewed, gained the upper hand. That public criticism put a stop to the 1899 project for a Neo-Manneristic, "in-the-style-of" expansion of the town hall of Lucerne only documents the general shift from historicism to a form of monument preservation closely linked

in spirit with *Heimatstil*. Every European city possesses similar plans that were never carried out, plans in which sumptuously outmoded historicism breathes its last breath on paper. The Altstätter Town Hall of Hannover[90] is a typical example. According to plans from the 1880s, an old building in the regional brick-Gothic style was to make way for a larger building. A petition prevented the demolition. The new town hall, a late historicistic domed building by Hubert Stier, was ultimately erected around 1895 in Ägedien-Matsch, newly reclaimed marshlands southwest of the Old Town. From the perspective of urban planning, the new Lucerne Stadthaus on the Hirschmatte was located in a similar position. Around 1900, planners everywhere suddenly began to show consideration for the cityscapes of old town districts by moving major building projects out into new town areas.

e: Monuments and the Idea of the Polis

The open city of the nineteenth century required a new concept of the polis to hold together urban society, replacing the fortifications that had been demolished. Through stylistic evocation, historicism invoked the past and its legitimacy, while sacrificing genuine tradition. The poleognomy of the industrial age investigates the principal architectural themes that, as structural leitmotifs, lend the city its new corporative form of self-expression. Monuments are a direct expression of the polis notion for modern times.[91] With its dying lion of 1821, Lucerne possessed Switzerland's second public monument (the first was the Salomon Gessner monument, erected on Zurich's Platzspitz in 1793). Lucerne's first political monument also grew out of a final burst of baroque mentality. It addressed, not the modern patriotism of the national state, but "fides" and "virtus," the old virtues of the Swiss mercenary. The Lion Monument was conservative Lucerne's attempt to cope with the results of the French Revolution.[92]

In Switzerland the new concept of a "national monument" spread during the "regeneration" era. This visionary architectural task was discussed by members of the Swiss Art Society in 1830, the same period that saw the foundation stone laid for Walhalla near Regensburg. The Bavarian king Ludwig I had commissioned Walhalla from architect Leo von Klenze to commemorate the Battle of the Nations near Leipzig (1813). A second effort was made by circles connected with the Swiss Art Society in 1845, when Melchior Ziegler, from Winterthur, underwrote a competition to collect ideas for a Swiss national monument. This private initiative was once again preceded by two German events: the completion of Walhalla in 1842 and the laying of the foundation stone for the Befreiungshalle (Liberation Hall) in Kelheim. The program for furnishing the German Walhalla was modeled on the Galerie des Batailles, installed in the prince's wing of Versailles in France, 1833-1837.[93] Conceived as halls of fame for major national figures and national historical events, the two interiors are equipped with a series of portrait busts and historical paintings. The Swiss competition program prescribed an analogous conception.

The position of a monument is of topological significance.[94] For the French, the residence of Ludwig XIV has remained a focus of the modern national state, despite the ascendancy of the bourgeoisie. While the identity of a traditionally centralized state tends to converge at a single point, federalistically structured states incline to horizontal extension. Here monuments line major transit routes connecting different regions: Walhalla stands on the banks of the Danube, the Swiss monument – a sort of alpine citadel of the Swiss Confederation – would have been sited at the foot of the Gotthard, near Lucerne. The ideal project demonstrates the link between monument and fortress, which even now, at the end of the twentieth century, remains characteristic of the Swiss self-image of the rolled-up hedgehog prepared to defend itself on all sides.

The national monument was not built. The Winkelried monument unveiled in Stans in 1865, two years after the opening of the Befreiungshalle in Kelheim, provided a modest substitute. While the French and German national

monuments had been donated by monarchs, the Winkel-ried sculpture, enshrined in a Neo-Gothic aedicule, suits the modest republican format of Switzerland, a country without a great tradition of political rhetoric to look back upon. Once again the impulse had come from the Swiss Art Society: in the nineteenth century it was the artists, literati, and aesthetes who largely determined the image of "fatherland." With the demise of religious subjects, they saw patriotism as an opportunity to create a new "total work of art."

Even the modest statue in Stans, financed via a collection, encountered criticism on the part of the Swiss, who acknowledged republican thrift as the sole form of monument. It is not surprising that the only national architectural monument of the Confederation connects the symbolic with the useful: the Bundesrathaus, built 1851-1866. A three-winged palazzo in the Munich round-arch style, it was both a monument and the nation's administration and parliament building. And even here the builders were constantly forced to counteract the imminent reproach of courtly opulence: plans for the artistic appointments of the building were abandoned for political reasons.[95] At the apex of the period of promoterism, when Switzerland had long conformed to the international standard of pathos and extravagance, the suspicions of the spartanic Swiss remained very much alive: the dome motif over the central tract of the Bundeshaus (Parliament Building), built by Hans Auer between 1894 and 1902, was rejected as "un-Swiss."[96]

The federalistically-minded people of Lucerne, among them a host of Art Society members, numbered among the opponents of a national monument. Simply dismissing their attitude as backward takes no account of the fact that the noisy pathos of historicism was irksome even to great and famous minds. Friedrich Nietzsche turned his back on Wagnerian bombast, and Richard Muther lamented the rampant "monument epidemic"[97] of the age. It is into this mental context that the Lucerne project for a Landesmuseum, a national museum, in 1890 must be placed. The proposal to house the documents pertaining to Swiss cultural history in the old town hall of Lucerne – where the Confederate Diet had once met – rather than in a new building is untimely in Nietzsche's sense of the word: old-fashioned and aristocratic in its thrift, but progressive in its respect for authenticity, already anticipating the monument preservation trend of the coming era. The idea was not spectacular enough for the spirit of the time. The Landesmuseum, a new building by Gustav Gull, was ultimately erected right next to the railroad station in Zurich between 1893 and 1898, the same period that Gabriel von Seidl's Bavarian National Museum was constructed in Munich (1894-1899). Both buildings are mock castles, simulating, with the help of asymmetries and stylistic variety in the late historicist manner, the impression of having grown organically in the course of time.[98] The Confederation compensated Lucerne twenty years later by locating the headquarters of the Schweizerische Unfallversicherungsanstalt (Swiss Accident Insurance Company) there; it is crowned by a cloistered vault reminiscent of the dome of the Bundeshaus in Bern. Here was architectural confirmation that the once secessionist, conservative Sonderbund canton was now a well-integrated part of the new Confederation dominated by liberals.

f: Ruralization

If curators of monuments level criticism at stylistic historicism, this should not obscure the fact that it is to this very trend that they owe their existence. Ruskin's writings[99] contain both sides: the enticement to imitate, fired by the study of architectural styles of the past, but also encouragement of pre-industrial "authenticity," which Ruskin ascribes to handmade as opposed to industrial goods. The rejection of the industrial and make-believe culture of the nineteenth century, the call for "the genuine," "the natural," and "the healthy," reflected a general shift in mentality, which expressed itself in the reform movements around 1900 and profoundly affected architecture and

urban trends at the turn of the century. Against the backdrop of revolutionary tensions in the industrial societies of Europe, there was a call for "life reform"; in answer to the social conflicts of the era, the reform movement invoked the spirit of earthy, shared local values as against the centrifugal tendencies of capitalism and class warfare. The coldness of the technical revolution was viewed as the cause of cultural and social decline. A return to pre-industrial traditions was seen as a potential cure for society's ills.

Swept along by the international ground swell of life reform, the Schweizerischer Heimatschutzverein (Swiss League of National Heritage) was founded in 1905. Historicism had only wanted to conceal industrial culture behind an outward mask of tradition, the reformist *Heimatstil* aspired to "holistic" measures. No longer was the architectural shell alone subject to renewal; "inner life" too was to be instilled with a spirit of tradition firmly anchored in the bedrock of *Heimat,* home. Stylistic historicism had been as remote from fatherland as had technical engineering: the apparently arbitrary way it copied stylistically formative buildings, from the Pantheon to Chartres and Versailles, had been totally without regard for regional traditions. *Heimatstil,* on the other hand, demanded the architect's affirmation of the province – a reorientation that finally gave real meaning to the idea of regional monument preservation. Now the little baroque votive church could be divested of the brittle Neo-Gothic pinnacles that had rendered it a faint-hearted echo of some once stylistically decisive cathedral; now its beauty was discovered to lie precisely in the awkwardly rural simplicity that historicistic remodeling had tried to obscure.

The longing for rural simplicity, the weariness with industrial culture, originated in the selfsame England that had produced the leitmotif of architectural engineering with the Crystal Palace built for the Great Exhibition of 1851.[100] William Morris took on the role of prophet of life reform in the spirit of medieval socialism.[101] Theoretically, in his literary works, and practically, as the owner of a fur-

niture workshop, Morris fought for the revival of arts and crafts. In his view, the goods-producing machine had robbed man of his creativity and given rise to a disequilibrium in the harmony of usefulness and beauty. To rescue work from alienation and its products from false pretenses, production was once again to be placed into human hands. Ideas of this kind were a smoldering mental fire eating its way into the creative heads of industrialized Europe; Jugendstil between Glasgow and Barcelona, Brussels and Vienna, was seized by it. Artists' associations and secessions sought to achieve the concrete unity of art and life. The Mathildenhöhe artists' colony in Darmstadt represented an attempt to realize this ideal; that its founder, Grand Duke Ernst Ludwig, issued Germany's first, and still operative, law concerning the preservation of monuments attests to the strong reciprocal links between monument preservation and the idea of reform through crafts.[102]

In his utopian novel *News from Nowhere*, Morris described the transformation of industrial London into Garden City.[103] He planted the ideal of living as craftsmen and farmers in the midst of the metropolis. Like the reform dress that was to replace stiff collars and stays, the concept of the garden city with relatively low housing densities was posited as an alternative to the sooty grey tenements on the outskirts of the nineteenth-century town.[104] The German edition of *News from Nowhere* is likely to have been laid out on many a coffee table in Lucerne's "Eisenbahnerdorf," the railroad-workers' village built in the green expanses at the southeastern edge of the city between 1911 and 1914 as one of the earliest cooperative developments in Switzerland. The total impression, disfigured by new buildings today, was that of a small rural town with houses surrounded by gardens. The gate at the entrance symbolized the self-contained quality of this "village" of employees of the Swiss Railways. It was a sign of initiation into the district of life reform. The original model, Hampstead Garden Suburb,[105] completed in 1909 on the road from London to Oxford, was at once open and

closed to visitors making pilgrimages from as yet unredeemed urban areas. Lucerne's Eisenbahnerdorf combined social life reform and the architecture of *Heimatstil*, affirming an urban development ideal also expressed in the "Landidörfli," the artificial village complex constructed for the Swiss National Exhibition in 1914. Given that *Heimatstil* was an architecture of national awareness and reconciliation, the outbreak of war brought it to full efflorescence.

The *Inventar der neueren Schweizer Architektur* treats the period from Biedermeier classicism around 1800 to *Heimatstil* around 1920 as a single, self-contained era. Like most small and middle-sized cities outside the sphere of influence of major schools of art, Lucerne was unaffected by the avant-garde ideas of the Bauhaus, Le Corbusier, and the CIAM until the 1930s. That is when a new phase of urban development began, informed architectonically by the so-called Inernational Style and urbanistically by the increasing number of private vehicles.[106]

Conclusion

From "The City-Machine" to "The Emergence of the 'Old Town'" and "Ruralization," the present paper has outlined the general productive forces at work in nineteenth-century urban development. These forces form the epochal magnetic field within which an urban area in Europe develops.

The question: how can theoretical statements about urban development be made on the basis of single cases? finds its answer in the law of the simultaneity of urban processes. The simultaneous workings of productive forces within a historical and cultural space are the reason why an inductive history of residential patterns can have general validity. The poleognomic technique considers the city as a monadic mirror of general processes by combining the historico-sociological with the phenomenological method.

As a magnetic field becomes visible only through the iron shavings it influences, so general historical processes become recognizable only through comparative knowledge of single cases. Wölfflin's "art history without names" can define its basic terms only with the aid of concrete works of art; the history of urban development must go out from "names" in order to distill anonymous laws from them. I chose Lucerne, treating it as a collective individual acting creatively in the tide of historical forces. Poleognomy strives to be portrait art. As a painter depicts nose, eyes, and ears in such a way that the viewer unmistakably recognizes a specific face, so the history of urban development tries to let a system of streets, squares, and façades reveal the soul of a city .

Translated from the German by
Eileen Walliser-Schwarzbart

Notes

1 Zurich, 1984 ff. Six volumes have appeared thus far.

2 Basel, 1927 ff. Eighty-four volumes have appeared thus far.

3 I dealt with the history of residential patterns in Lucerne as part of the INSA, op. cit., vol. 6, pp. 357–512.

4 Vitruvius' *Ten Books about Architecture,* from the Augustan era, is the first surviving work; it was preceded by earlier writings, now lost. Advice on the siting of cities, the construction of fortifications, streets, and squares is found in the First Book. For an edition with the most important Vitruvius illustrations from modern Vitruvius editions, see *Vitruv. Baukunst,* trans. August Rode, ed. Beat Wyss, with an introduction by Georg Germann and archaeological notes by Andri Gieré (Zurich, 1987).

5 For contemporary examples of theories of urban development by practicing architects, see Aldo Rossi, *L'architettura della città* (Padua, 1966); Rob Krier, *Stadtraum in Theorie und Praxis. An Beispielen der Innenstadt Stuttgarts* (Stuttgart, 1975).

6 Camillo Sitte, *Der Städte-Bau nach seinen künstlerischen Grundsätzen. Ein Beitrag zur Lösung modernster Fragen der Architektur und monumentalen Plastik unter besonderer Beziehung auf Wien* (Vienna, 1889).

7 Ibid., p. 88.

8 For the history of critical response to Camillo Sitte, see George R. Collins and Christiane Crasemann-Collins, eds. and trans.,*The Birth of Modern City Planning,* (New York, 1986).

9 A. E. Brinckmann, *Stadtbaukunst. Geschichtliche Querschnitte und neuzeitliche Ziele,* Handbuch der Kunstwissenschaft, vol. 32 (Berlin, 1920).

10 Josef Gantner, *Grundformen der europäischen Stadt. Versuch eines historischen Aufbaus nach Genealogien* (Vienna, 1928). See also Gantner's shorter preliminary study, *Die Schweizer Stadt* (Munich, 1927). The popularly oriented picture-to-text ratio of this little book reveals its proximity to the didactic spirit of national heritage preservationism.

11 Aristotle describes two possibilities of building a city: the checkerboard/straight-lined city ("Εὔτομος"), which was built "Κατὰ τὸν νεώτερον καὶ τὸν Ἱπποθάμειον τζόπον," is more beautiful and attractive; the irregular city, "ὡς εἶχον κατὰ τὸν ἀζχαῖον τζόπον," however, is more suitable for war because intruders have difficulty finding their way. Aristotle recommends a mixture of the two forms as the ideal city in *Politica, Opera omnia, Graece et Latine,* Cum praefatione A. F. Diotii et translatione Latina revisa per Fridericum Hübernum, vol. I (Hildesheim and New York, 1933), lib. VII, cap. X, 39–49 (1330 b 18).

12 Piero Pierotti polemicizes against the parallelism in equating "spontaneously grown" with "irregular" city and "founded" with "irregular" city in "Città spontanea e città fondate," *Urbanistica, storia e prassi* (Florence, 1972), pp. 25–35. The ideological aspect of this polarism is analyzed by Juan Rodriguez-Lores: "Gerade oder krumme Strassen? Von den irrationalen Ursprüngen des modernen Städtebaus," in *Stadterweiterungen 1800–1875. Von den Anfängen des modernen Städtebaus in Deutschland,* ed. idem and Gerhard Fehl (Hamburg, 1983), pp. 101–134.

13 Zucker terms the spontaneously grown city "linear," the founded city "cubic-tectonic." See Paul Zucker, Entwicklung des Stadtbildes. *Die Stadt als Form* (Munich and Berlin, 1929; reprint ed., Braunschweig and Wiesbaden, 1986).

14 Camille Martin and Hans Bernoulli, eds., *Städtebau in der Schweiz,* publ. by the Bund Schweizer Architekten (Zurich, 1929).

15 Zucker, op. cit., p. 7.

16 Brinckmann, op. cit., p. 107.

17 Sigfried Giedion, *Space, Time and Architecture, the growth of a new tradition* (Cambridge, Mass., 1941).

18 Surveys dealing with the time include: Alexander Christen, *Zur Entwicklungsgeschichte des Städtebaus* (Zurich, 1946); Ernst Egli, *Geschichte des Städtebaus,* 3. vols.(1959–1967); E. A. Gutkind, *International History of City Development,* 8 vols. (London and New York, 1964–1972).

19 Lewis Mumford, *The City in History* (New York, 1961).

20 Leonardo Benevolo, *Storia della città* (Rome and Bari, 1975); German edition, *Die Geschichte der Stadt* (Frankfurt and New York, 1983); for Benevolo on the city of the 19th and 20th century, see *Le origini dell' urbanistica moderna* (Bari, 1968) (3); German edition, *Die sozialen Ursprünge des modernen Städtebaus, Lehren von gestern, Forschungen für morgen* (Gütersloh, 1971).

21 Michel Ragon, *Histoire mondiale de l'architecture moderne,* 3 vols. (1957; reprint ed., Tournai, 1986).

22 Christian Norberg-Schulz, *Genius loci, paesaggio, ambiente, architettura* (Milan, 1979); German edition, *Genius loci, Landschaft, Lebensraum, Baukunst* (Stuttgart, 1982), p. 6.

23 Martin Heidegger, *Being and Time* (New York, 1962) (7).

24 Idem, "Bauen Wohnen Denken," *Vorträge und Aufsätze, Teil II* (Pfullingen, 1967) (3), pp. 19–36.

25 Norberg-Schulz, op. cit., p. 67.

26 The idea is indebted to the morphological view of cultural geography as developed by the historians of the Annales group around Georges Duby and Fernand Braudel; see, for example, Fernand Braudel, *La Méditerranée. L'espace et l'histoire.* For an attempt to define Switzerland's cultural space in this spirit, see Dario Gamboni, *Kunstgeographie,* Ars Helvetica 1 (Disentis, 1987).

27 Wolfgang Braunfels, *Abendländische Stadtbaukunst. Herrschaftsform und Baugestalt* (Cologne, 1979), p. 322.

28 To cite only one of the many works on the topic: Ebenezer Howard, *Garden-Cities of Tomorrow* (London, 1902).

29 In this connection, see "Von der futuristischen zur funktionellen Stadt. Planen und Bauen in Europa, 1913–1933," *Tendenzen der Zwanziger Jahre,* 15th European Art Exhibition Berlin 1977 (Berlin, 1977), vol. 2, pp. 1–208.

30 Sigfried Giedion, *Mechanisation Takes Command* (Oxford, 1948). Henning Ritter, editor of the German edition of the book, recognized a "parallel undertaking to Giedion's mechanization book" in Benjamin's *Passagenwerk* in his introduction to the colloquium "Kulturgeschichte der Technik, Der Beitrag Sigfried Giedions," at the Werner-Reimer-Stiftung, Bad Homburg, June 14–16, 1985. Dorothee Huber also discusses this relation in 'Konstruktion und Kaos': il grande progetto incompito," *Rassegna* 25/1, March 1986, pp. 63–71.

31 His book *Mechanisation Takes Command* strives to show that unconsciously, without planning, phenomena of astonishing similarity occur, which need only be placed side by side to produce an awareness of the tendencies and sometimes the meaning of a period. As a magnet lends iron shavings, small and insignificant particles, shape and form, and reveals the existing lines of force, so the inconspicuous details of anonymous history can make the basic tendencies of a period visible. See Giedion's own introduction to the book.

32 *Michael Koch, Leitbilder des modernen Städtebaus in der Schweiz, 1918–1939. Ein Beitrag zur Genese des Städtebaus als Disziplin und ein Versuch, dessen jüngere Geschichte für die heutige Städtebaudiskussion nutzbar zu machen* (Ph. D. diss, University of Zurich, 1988).

33 *Die Wiener Ringstrasse,* preface by Fritz Novotny, introduction by Renate Wagner-Rieger, 2 vols. (Vienna, 1969).

34 See, for example, Henri Malet, *Le Baron Haussmann et la Rénovation de Paris* (Paris, 1973).

35 Quoted according to Odo Marquard and Karlheinz Stierle, eds., *Identität, Poetik und Hermeneutik,* Arbeitsergebnisse einer Forschungsgruppe VIII (Munich, 1979), p. 277.

36 Braunfels opts for this method when he reads the city as a product of intellectual, economic, and political mentalities. His typology distinguishes the episcopal city and the city-state, the port, the imperial city, ideal residential and capital cities. Like Lübbe, Braunfels emphasizes the individual and unplannable nature of the city. For the notion that the city can be read as an expression in stone of ruling mentalities, see Michael Hesse and Joachim Petsch, "Stadtplanung zwischen Kunst und Politik," *Funkkolleg Kunst. Eine Geschichte der Kunst im Wandel ihrer Funktionen,* ed. Werner Busch, vol. II (Munich and Zurich, 1987), pp. 586–616.

37 Jürgen Habermas, "Moderne und postmoderne Architektur," *Die neue Unübersichtlichkeit, Kleine politische Schriften V* (Frankfurt a.M., 1985), pp. 24 f.

38 Dolf Sternberger, *Panorama oder Ansichten vom 19. Jahrhundert* (1938; reprint ed., Frankfurt a.M., 1974), p. 8.

39 Ibid., p. 162.

40 Ibid., p. 9.

41 Walter Benjamin, "Einbahnstrasse," *Gesammelte Schriften,* ed. Rolf Tiedemann and Hermann Schweppenhäuser in collaboration with Theodor W. Adorno and Gershom Scholem, vol. IV.1 (Frankfurt a.M., 1972), pp. 83–148.

42 Tiedemann in *Walter Benjamin, Das Passagen-Werk,* in Walter Benjamin, *Gesammelte Schriften,* vol. V.1, ed. Rolf Tiedemann (Frankfurt a.M., 1982), p. 11.

43 Benjamin, op. cit., p. 574.

44 Tiedemann in Benjamin, ibid., p. 19.

45 Ibid., p. 15.

46 Benjamin, op. cit., p. 1028.

47 Ibid, p. 59.

48 Ibid., p. 1006.

49 Ibid., p. 491.

50 Ibid., p. 1054.

51 Georg Simmel, "Vom Wesen des Historischen Verstehens," *Das Individuum und die Freiheit* (1954, reprint ed., Berlin, 1984), pp. 61–83. In this connection, see also Beat Wyss, "Simmels Rembrandt," *Georg Simmel, Rembrandt. Ein kunstphilosophischer Versuch* (1916) (Munich, 1985), pp. VI–XXXI.

52 Tiedemann in Benjamin, op. cit., p. 31.

53 Benjamin, op. cit., p. 581.

54 That Giedion cannot be dismissed as an uncritical "hagiographer of the modern" is set forth by Sokratis Georgiadis in *Sigfried Giedion, Eine intellektuelle Biographie* (Zurich, 1989). On Giedion and modern design, see *Schweizer Typenmöbel 1925–1935, Sigfried Giedion und die Wohnbedarf AG* (Zurich: Institut für Geschichte und Theorie der Architektur, 1989).

55 Giedion, *Mechanisation* (German ed.), p. 14.

56 Ibid., p. 19.

57 Giedion, *Space, Time,* p. 4.

58 von Moos in Giedion, *Mechanisation* (German ed.), p. 803.

59 Peter Röllin, *Sankt Gallen, Stadtveränderung und Stadterlebnis im 19 Jahrhundert. Stadt zwischen Heimat und Fremde, Tradition und Fortschritt* (St. Gallen, 1981).

60 Thomas Lieverts, *Die Stadt als Erlebnisgegenstand in der Bundesrepublik Deutschland, Lebensbedingungen, Aufgaben, Planung,* ed. Wolfgang Pehnt (Stuttgart, 1974).

61 Jean-François Lyotard, *Das postmoderne Wissen* (Graz and Vienna, 1986), p. 87. (*La condition postmoderne* [Paris, 1979]).

62 Tilmann Buddensieg and Henning Rogge, eds., *Die nützlichen Künste. Gestaltende Technik und Bildende Kunst seit der industriellen Revolution,* exhibition cat.(Berlin, 1981).

63 *Absolut modern sein: zwischen Fahrrad und Fliessband, culture technique in Frankreich 1889–1937,* exhibition cat. (Berlin: Neue Gesellschaft für Bildende Kunst, 1986).

64 For example, Christoph Asendorf, *Batterien der Lebenskraft. Zur Geschichte der Dinge und ihrer Wahrnehmung im 19. Jahrhundert,* Werkbund Archiv 13 (Giessen, 1984).

65 Christian Beutler, with a contribution by Günter Metken, "Weltausstellungen im 19. Jahrhundert," exhibition at the Staatliches Museum für angewandte Kunst München (Munich, 1973).

66 For example, in 1989 the annual conference of the Society for the History of Swiss Art in Interlaken dealt with the history of tourism in the Bernese Oberland; the program is published in *Unsere Kunstdenkmäler,* 1989, no. 2, pp. 208–225. For the technological history of Switzerland, see Bruno Fritzsche, "Neue Technologie und Industrialisierung," *Damals in der Schweiz* (Frauenfeld and Stuttgart,1980).

67 Inventar der neueren Schweizer Architektur (INSA); Inventar der schützenswerten Ortsbilder in der Schweiz (ISOS); Inventar historischer Verkehrswege der Schweiz (IVS). The literature on the history of Swiss cities in the Middle Ages and modern era is vast. For a recent survey extending into the modern era, see André Meyer, *Profane Bauten,* Ars Helvetica, vol. 4 (Disentis, 1989), pp. 159–266. The attempt to characterize the architecture of the 19th century with the aid of specific, exemplary architectural projects was undertaken by Ludwig Grote, ed., *Die deutsche Stadt im 19. Jahrhundert. Stadtplanung und Baugestaltung im industriellen Zeitalter* (Munich, 1974). See also Othmar Birkner, *Bauen und Wohnen in der Schweiz 1850–1920* (Zurich, 1975); Fehl and Rodriguez-Lores (cf. n. 12 above); Dorothee Eggenberger and Georg Germann, *Geschichte der Schweizer Kunsttopograhie,* Beiträge zur Geschichte der Kunstwissenschaft in der Schweiz 2 (Zurich, 1975).

69 In this connection, see Beat Wyss, "Der Pilatus, Entzauberungsgeschichte eines Naturdenkmals," *Das Denkmal und die Zeit. Alfred A. Schmid zum 70. Geburtstag,* ed. Bernhard Anderes, Georg Carlen, P. Rainald Fischer, Josef Grünenfelder, and Heinz Horat (Lucerne, 1990), pp. 184–193.

70 In this connection, see Hiltrud Kier, *Die Kölner Neustadt., Planung, Entstehung, Nutzung,* Beiträge zu den Bau- und Kunstdenkmälern im Rheinland, vol. 23, with volume of maps (Düsseldorf, 1978).

71 Reinhard Baumeister, *Stadterweiterungen in technischer, baupolizeilicher und wirthschaftlicher Beziehung* (Berlin, 1876).

72 Wolfgang Schivelbusch, *Lichtblicke. Zur Geschichte der künstlichen Helligkeit im 19. Jahrhundert* (Munich and Vienna, 1983).

73 In this connection, see Alain Corbin, *Le miasme et la jonquille. L'odorat et l'imaginaire social XVIIIe–XIXe siècles* (Paris, 1982).

74 Jutta von Simson, *Kanalisation und Stadthygiene im 19. Jahrhundert* (Düsseldorf, 1983).

75 Corbin, op. cit.

76 Quoted according to Paul Huber, *Luzern wird Fremdenstadt. Veränderungen der städtischen Wirtschaftsstruktur 1850–1914* (Lucerne, 1986), p. 182.

77 Marianne Rodenstein, *"Mehr Luft, mehr Licht", Gesundheitskonzepte im Städtebau seit 1750* (Frankfurt a.M. and New York, 1988), p. 87.

78 For the cultural history of the railroad, see Wolfgang Schivelbusch, *Geschichte der Eisenbahnreise, Zur Industrialisierung von Raum und Zeit im 19. Jahrhundert* (Munich, 1977). A survey of the development of railroads and railroad stations in Switzerland is given by Werner Stutz, *Bahnhöfe in der Schweiz. Von den Anfängen bis zum ersten Weltkrieg* (Zurich. 1976).

79 In this connection, see Wulf Schadendorf, "Der Grossstadtbahnhof nach 1870. Hannover und Dresden," in Grote, op. cit., pp. 235–246.

80 Theodor von Liebenau, *Das alte Luzern* (Lucerne [1881], 1937).

81 In this connection, see Eggenberger and Germann, op. cit.

82 In this connection, see Beat Wyss, "Jenseits des Kunstwollens. Anmerkungen zum Historismus," *Jahrbuch 1984–1986 des Schweizerischen Instituts für Kunstwissenschaft. Beiträge zu Kunst und Kunstgeschichte um 1900* (Zurich, 1986), pp. 26–37.

83 The development of monument preservation in Switzerland has been thoroughly studied. See Albert Knoepfli, *Schweizerische Denkmalpflege, Geschichte und Doktrinen,* Beiträge zur Geschichte der Kunstwissenschaft in der Schweiz (Zurich, 1972); Lisbeth Marfurt-Elmiger, *Der Schweizerische Kunstverein, 1806–1981. Ein Beitrag zur schweizerischen Kulturgeschichte* (Bern, 1981); Beat Wyss "Die Institutionalisierung der Kunstgeschichte in der Schweiz," *Unsere Kunstdenkmäler* 38/1987, no. 3, pp. 382–398.

84 For the international development of monument preservation, see Uwe Paschke, *Die Idee des Staatsdenkmals.Ihre Entwicklung und Problematik im Zusammenhang des Denkmalpflegegedankens. Mit einer Darstellung am Einzelfall: der Stadt Bamberg,* Erlanger Beiträge zur Sprach- und Kunstwissenschaft, vol. 45 (Nuremberg 1972); Gottfried Kiesow, *Einführung in die Denkmalpflege* (Darmstadt, 1982).

85 *Handbuch für Denkmalpflege,* publ. by the Provinzial-Kommission zur Erforschung und Erhaltung der Denkmäler in der Provinz Hannover, ed. J. Reimers (Hannover, n. d. [1899], 1911 [2]), p. III.

86 Auguste Rodin, *Les cathedrales de France* (Paris, 1914); German trans. by Max Brod, Die Kathedralen Frankreichs (Munich, 1916); new edition ed. Beat Wyss (Zurich and Munich, 1987).

87 Alois Riegl, "Der moderne Denkmalskultus," *Gesammelte Aufsätze* (Augsburg and Vienna, 1929), pp. 144–193.

88 Hermann Muthesius, *Kultur und Kunst. Gesammelte Aufsätze über künstlerische Fragen der Gegenwart* (Jena and Leipzig, 1904), p. 155.

89 Lisbeth Marfurt-Elmiger, *Der Schweizerische Kunstverein, 1806–1981. Ein Beitrag zur schweizerischen Kulturgeschichte* (Bern, 1981), pp. 77–84.

90 Charlotte Kranz-Michaelis, *Zur deutschen Rathausarchitektur des Kaiserreichs, Das neue Rathaus von Hannover* (Munich, 1976), pp. 189–208.

91 For a fundamental work on the subject, see the anthology by Hans-Ernst Mittig and Volker Plagemann, eds., *Denkmäler im 19. Jahrhundert* (Munich, 1972). In it: Martin Fröhlich, "Zur Denkmalgeschichte in der Schweiz," pp. 23–26. A reference work on German monuments was written by Helmut Scharf: *Kleine Kunstgeschichte des deutschen Denkmals* (Darmstadt, 1984). A comprehensive study of Switzerland is still lacking. A locally restricted, chronologically arranged inventory of monuments was compiled by Karl F. Wälchi, J. Harald Wäber, Peter Martig, and Peter Hurni: *Bernische Denkmäler. Ehrenmale der Gemeinde Bern und ihre Geschichte* (Bern, 1987).

92 The crisis of the city around 1800 is connected with the decline of the mercenary services, which played a central economic, political, and social role in old Lucerne. For the historico-cultural significance of the mercenary service see Christoph von Tavel, *Nationale Bildthemen,* Ars Helvetica, vol. 10 (Disentis, 1992).

93 Both monuments are documented in comprehensive monographs: for the Walhalla, see Traeger, op. cit.; for the Galerie des Batailles, see Thomas W. Gaethgens, *Versailles als Nationaldenkmal. Die Galerie des Batailles im Musée Historique von Louis-Philippe* (Antwerp, 1984).

94 In this connection, see Ekkehard Mai and Stephan Waezoldt, eds., *Kunstverwaltung, Bau- und Denkmal-Politik im Kaiserreich* (Berlin, 1981). In it the following authors deal specifically with the subject of monument topography: Karl Arndt, "Denkmaltopographie als Programm und Politik. Skizze einer Forschungsaufgabe," pp. 165–190; Lutz Tittel, "Monumentaldenkmäler von 1871–1918 in Deutschland. Ein Beitrag zum Thema Denkmal und Landschaft," pp. 215–275.

95 In this connection see Hans Martin Gubler, "Architektur als staatspolitische Manifestation, Das erste schweizerische Bundesrathaus in Bern," in *Architektur und Sprache. Gedenkschrift für Richard Zürcher,* ed. Carlpeter Braegger (Munich, 1982), pp. 96–126.

96 In this connection, see Johannes Stückelberger, "Die künstlerische Ausstattung des Bundeshauses in Bern," *Zeitschrift für Schweizerische Archäologie und Kunstgeschichte,* vol. 42, no. 3, pp. 185–234.

97 Richard Muther, "Die Denkmalseuche" (1902/1909), in idem, *Aufsätze zur bildenden Kunst,* 2 vols (Berlin, 1914). On the response to monuments, see Hans-Ernst Mittig, "Über Denkmalkritik," *Denkmäler,* op. cit., pp. 283–301.

98 On the architectural tasks of the museum of art and the museum of history and culture, see Volker Plagemann, *Das deutsche Kunstmuseum* (Munich, 1969); Bernward Deneke and Rainer Kahsnitz, *Das kunst– und kulturgeschichtliche Museum im 19. Jahrhundert. Vorträge des Symposions im Germanischen Nationalmuseum* (Nuremberg and Munich, 1977); Wolfram Lübbeke, "Das Bayerische Nationalmuseum an der Prinzregentenstrasse," in Grote, ed., op. cit., p. 223–234.

99 On Ruskin, see Wolfgan Kemp, *John Ruskin, Leben und Werk, 1819–1900* (Frankfurt, 1987).

100 For the exemplary nature of English reform culture, see Stefan Muthesius, *Das englische Vorbild. Eine Studie zu den deutschen Reformbewegungen in Architektur, Wohnbau und Kunstgewerbe im späten 19. Jahrhundert* (Munich, 1974).

101 In this connection, see Hans-Christian Kirsch, *William Morris – ein Mann gegen die Zeit. Leben und Werk* (Cologne, 1983).

102 For the relation between monument preservation, life reform, and *Heimatstil,* see Marion Wohlleben, *Konservieren oder Restaurieren? Zur Diskussion über Aufgaben, Ziele und Probleme der Denkmalpflege um die Jahrhundertwende* (Zurich, 1989).

103 First printed in Morris's own magazine, *Commonweal,* in 1890.

104 On the subject of the garden city, see Philippe Panerai, Jean Castex, and Jean-Charles Depaule, *Formes urbaines: de l'îlot à la barre* (Paris, 1977); German edition: *Vom Block zur Zeile, Wandlungen der Stadtstruktur* (Braunschweig, 1985).

105 Ibid. (German ed.), pp. 49–62.

106 In national heritage preservation circles the New Architecture had been a subject of debate since the early twenties; in this connection, see Jacques Gubler, *Nationalisme et internationalisme dans l'architecture moderne de la Suisse* (Lausanne, 1975)

I would like to thank Michael Riedler of the Prints Collection of the Lucerne Central Library for providing all of the illustrations; I am also indebted to Harald Imhof of the Central Swiss Power Company for supplying me with technical data.

Picture credits:

figs. 1-16: Zentralbibliothek, Lucerne

Georg Luck

"My true home in this world..."
John Ruskin and Switzerland

Switzerland as an Inspiration

When sixteen-year-old John Ruskin stood at the top of the *Col de la Faucille* in the summer of 1835 and looked toward Mont-blanc, he had a distinct vision of the "Holy Land" of his future work and his "true home in this world." His vast literary output, his letters and diaries (still partly unpublished), and, perhaps most impressively, his many accomplished drawings of Swiss motifs, now made accessible in John Hayman's beautiful volume,[1] can be understood as the realization of that one single vision long ago.

At the time, Ruskin was thinking of writing a poem in the Byronic manner, a combination of *Don Juan* and *Childe Harold*. There is a depth of thought, an almost religious feeling unlike anything Byron had hitherto written, in the Third Canto of *Childe Harold,* and Ruskin probably associated it with the poet's experience of the Alps.

Fourteen years later, Ruskin's enthusiasm was as strong as before. In the summer of 1849, he noted in his diary: "I repeated 'I am in Switzerland' over and over again, till the name brought back the true group of associations." He had abandoned the idea of a dramatic poem and was not yet thinking of writing a book on Swiss history, but he had already produced a series of charming and perceptive drawings of Swiss towns.

Ruskin visited Switzerland for the first time in 1833 with his parents, traveling in a spacious coach, rented in England and specially outfitted for the long journey. Later the famous author

288

fig. 1: John Ruskin, *Geneva from the Rhône*, 1842 or 1846, pencil and wash on grey paper. Bembridge 1290.

used to arrive by train and was unhappy about the progress that had so profoundly changed a country he had explored for more than half a century, in almost thirty separate journeys.

English Painters Discover the Alps

For centuries, the high Alps, with their barren rocks and vast expanses of eternal snow and ice, had terrified travelers. It was an Englishman, John Fennis (1657–1734), who, for the first time, as far as we know, drew attention to their beauty; but even he felt a "delightful horror," a "terrifying joy."

Ruskin knew that there had been a change of attitude in the eighteenth century, long before Byron, Shelley, and Wordsworth arrived in Switzerland. In *Praeterita* (*Works* 35.115) he wrote: "Till Rousseau's time, there had been no 'sentimental' love of nature; and till Scott's, no such apprehensive love of 'all sorts and conditions of men'."

The first English artists to tour Switzerland probably accompanied noblemen who had read the *Nouvelle Hé-loise* and wished to see the shores of the Lake of Geneva, which had served as backdrop to the love of Julie and Saint-Preux. If they wanted to proceed to Italy, the St. Gotthard was an obvious choice. William Pars (1742–1782), one of the founders of the English school of watercolors, traveled through Switzerland in 1767 with Henry Temple, the second Viscount Palmerston (1739–1802). Pars drew the *Devil's Bridge*, a subject that was to attract many other artists, including Turner.

John Robert Cozens (1752–1799) was a superb landscape artist who is little known outside England today. He explored Switzerland en route to Italy, in the company of Richard Payne Knight, an art collector, connoisseur, and authority on the "picturesque." As a record for Knight, Cozens made, in the late summer of 1776, no less than fifty-four watercolors of Swiss scenes, including *View on the Reichenbach* and *Flüelen*, and later executed them in an album. Twenty-four of the album's drawings were bought by the British Museum, others went to various private collections; *Valley of Sion* is in the Birmingham City

Art Gallery. In Rome, Cozens met the Swiss painter A.-L.-R. Ducros and apparently learned from him a new technique which combined watercolor and gouache. It has been said that Cozens's "pictured poems" anticipated Turner, and according to Constable he was "the greatest genius that ever touched landscape." Cozens went insane in 1794 and spent the last years of his life under the care of Dr. Thomas Munro, a psychiatrist, art collector, and early patron of Turner and Girtin. While they were still boys, Munro made them copy Cozens's works, including some of his Swiss landscapes, and there can be no doubt that both learned something about the potential of watercolor as an artistic medium at that early age. Girtin did not travel beyond France, but Turner later visited some of the parts of Switzerland to which Cozens had introduced him. A large number of the copies he made are apparently still in existence.

One of William Pars's students, Francis Towne (1740-1816), visited Switzerland with his colleague John 'Warwick' Smith in 1780 and 1781. Several views of the Splügen are preserved, but best known is probably his *Sources of the Arveyron near Chamonix*, a work which anticipates Turner's technique of abstracting from landscape its essential geometric forms by opposing light and dark areas.

The Alsatian artist Philip-James de Loutherbourg (1740-1812) had visited Switzerland before 1771, the year he settled in London, and returned there in 1783 and 1789. He produced a number of dramatic paintings, one of which – *Avalanche ou chute de glace dans les Alpes, près de Scheideck, dans la vallée de Lauterbrunnen* (1804) – is said to have given Turner the idea for his *Avalanche in the Mountains of the Grisons* (1810).

Samuel Prout (1783-1852), one of the "true masters of the nobler picturesque," according to Ruskin, visited Switzerland in 1824, perhaps also in 1834 and 1835, and his views of Geneva, Martigny, Brig, Sion, Basel, Schaffhausen, and other towns influenced some of Ruskin's early drawings. Prout was skillful at rendering decaying

medieval architecture in a mannered style, cultivating the broken line. It was Prout's *Facsimiles of Sketches Made in Flanders and Germany*, published in the spring of 1833, that awakened in Ruskin's parents the desire to visit these cities with their son that year, and this led to John Ruskin's discovery of Switzerland. A few years later Prout published *Sketches in France, Switzerland and Italy*.

On his way from Geneva to Milan in 1826, Richard Parkes Bonington (1801-1828) drew the *Place du Moland* and the *Bridge of Saint-Maurice*. He also sketched a Swiss girl in Meiringen and put her, in more finished form, in his large oil painting *Doge's Palace in Venice* (about 1827): a woman in the traditional Bernese costume, with her wide-brimmed yellow hat, sitting in Venice among the natives – certainly an amusing touch!

Considering the lives of some of the most gifted English landscape painters of this period, one is struck by the tragedy of their early death. Cozens went insane at the age of forty-one and died a few years later; Girtin and Bonington both died at age twenty-seven, probably of tuberculosis. It was Turner's good fortune to live to a ripe old age and produce some of his greatest works toward the end of his life, but his debt to those whom he survived is great.

Some fine, meticulous craftsmen whom Ruskin admired and sought to emulate also led long, productive lives, though not all of them worked extensively in Switzerland. One thinks of Copley Fielding, David Roberts, and J. D. Harding. Both Fielding and Harding had been Ruskin's art teachers; Harding visited Switzerland at least four times, once with Ruskin, and his *View of Fribourg* and *Falls of Schaffhausen* received honorable mention in the Paris exhibition of 1855. Ruskin worked in both cities during the same decade.

Thanks to his two patrons, Count Yarborough and Walter Fawkes, Turner was able to visit Switzerland for the first time in 1802, after the brief Peace of Amiens. It was the same year that his friend Girtin went on a picturesque tour to France. Turner's travels took him to

fig. 2: John Ruskin, *Fribourg,* 1854 or 1856, pencil and wash, 238 x 305 mm. Bembridge 1284.

Geneva, over the Great St. Bernard, to Martigny, Vevey, Saanen, Thun, Lauterbrunnen, Grindelwald, Reichenbach, Lucerne, over the St. Gotthard to Bellinzona, and then to Zurich, Schaffhausen, and Basel. It is said that, during this first tour, he made over four hundred sketches, some of which – for example, *The Devil's Bridge, Rhine Fall Near Schaffhausen* – were later "worked up."

The artist went back to Switzerland in 1819/1820, it seems, a few times between 1830 and 1840 (once, in 1836, with H.A.J. Munro, another patron), and apparently every year between 1841 and 1844. In the summer or fall of 1844, the year of his last visit, he painted *Goldau, Brunnen, Lucerne,* and *Lake of Zürich.* Ruskin had the greatest admiration for the Swiss landscapes of Turner's last phase, but he wrote (*Works* 13.535) that Turner, who considered it his duty to record certain things he had seen, felt that in his last Swiss paintings he could record only imperfectly the effects of nature.

The beautifully produced volume *Turner in Switzerland* (Dübendorf, 1976) gives an excellent account of the master's Swiss scenes, even though it is only a selection. A *catalogue raisonné* of all the sketches and drawings of Swiss subjects still in existence would be useful.

We have seen to what extent Turner was guided, in his selection of Swiss motifs and his approach to them, by other artists. As a boy he had copied the drawings of Cozens, de Loutherbourg was an influence, and he probably knew the works of Bonington and Fielding. Today, he seems to tower like a lonely giant over his half-forgotten predecessors and contemporaries; in fact, he worked within a solid tradition of landscape painting, always willing to learn, while creating his own unique language.

fig. 3: John Ruskin, *Unterseen*,
1835, pencil, 197 x 260 mm.
Bembridge 1575.

Ruskin on Swiss Artists

In his small book on Ruskin (London, 1963), the art historian Quentin Bell has stated, with all due respect, that hardly any author of Ruskin's stature has uttered so much nonsense on art in general. Scholars and critics normally write on artists whom they admire or find congenial, while Ruskin wrote page after page on painters whose work meant little to him. In order to praise Turner he felt obliged to condemn some other landscape painters; and he was rather unfair to Constable.

Bell observes that Ruskin's tastes and interests, always somewhat limited, became narrower as he grew older. After about 1845, the only seventeenth-century painter he valued was Velasquez, the only German, Dürer, the only nineteenth-century French painters, J.L.E. Meissonier, Edouard Frère, and Rosa Bonheur.[2] The Dutch and Flemish masters left him cold, he seemed to ignore the impressionists, and he learned to appreciate Tintoretto only after several visits to Venice. For a man of Ruskin's authority, this seems a small range. It should be said that he was a good judge of British landscape painting, Turner above all, and that he understood the art of the minor craftsmen, being one of them himself.

Not surprisingly, he seems to have known few Swiss artists, and the ones he knew, he did not always admire. In his published works, he says nothing about Jacques-Laurent Agasse, Albert Anker (though he was fond of Jeremias Gotthelf), Frank Buchser, Angelica Kauffmann, Caspar Wolf, or Robert Zünd, to mention only a few. He casually mentions P. Bourgeois, a pupil of de Loutherbourg's, and refers without enthusiasm to Jean-Jacques Chalon and Henry Fuseli. Alexandre Calame was, in his opinion, inferior to Harding as a landscape artist and "merely a vulgar and stupid portrait painter"; he seems to have Calame in mind when he refers to the "professors at Geneva" and their (clearly inadequate) "study of Alpine scenery" (*Works* 3.449). This was written at a time when Calame was beginning to enjoy considerable esteem in England.

fig. 4: John Ruskin, *Mountain side, pines, and Alpine roses*, 1844 or 1849, watercolor, 298 x 413 mm. Bembridge 1395.

On the other hand, Ruskin praised Rodolphe Toepffer as a "wise and benevolent man" (he may have known him personally) and admired his "perfection of pure linear caricature," even where Toepffer gently ridiculed the typical English tourist of his time, for example in *Excursions dans les Alpes.*

Ruskin was convinced (*Works* 3.449) that "all foreign landscape" (he obviously means all Swiss landscapes done by non-British artists) he had ever met with had been "so utterly ignorant" that he hoped for nothing except "from our own painters." Only the English landscape painters, most eloquently Turner, of course, were able to do justice to the combination of the sublime and the picturesque that Switzerland had to offer.

Although Ruskin has no respect for the "professors at Geneva," he speaks warmly of the "Swiss prints" (he seems to be thinking of colored etchings), without naming individual artists. He probably knew that Turner had used them in the way that he, Ruskin, later used daguerrotypes, in order to find a good viewpoint and establish a sort of inventory of "what was there," so as to be free, later on, to concentrate on the "picturesque detail." Turner might

borrow an idea or two from these humble etchings, but he always supplied "the fire they lacked," as Ruskin puts it. One suspects that he sees these works in relation to Turner, even where he does not refer to the master. *A Descent from the Splügen on the Italian Side* he calls a "most lovely piece of quiet work, full of honorable and right feeling." He is also very fond of the *Two Mythen Above Schwyz* (by G. Lory sen.?) in his art collection at Oxford: it shows such a "high degree of affection, intelligence and tender observation" that "our modern enthusiasts" (whoever they may be) seem "at best, childish." *The House of the Baron Zurlauben in Zug* (probably from the magnificent work of de la Borde and Zurlauben, 1780-1786) he valued, perhaps not only because Turner had made such good use of it (*Works* 21.85; 133).

He refers approvingly to all the "prints" for sale in the shops of the Swiss towns at the time of Turner's early travels, and he recommends the "best watercolours to be bought in Switzerland" (*Works* 3.433 f.; 6.293), but adds that they are not completely successful. This, of course, is the domain of the British *paysagistes.* The prints have their value because they were useful to Turner, and one won-

ders whether Ruskin did not read a little too much into them, just as he tended to exaggerate the artistic value of Turner's vignettes in Samuel Rogers' *Italy*, which are, after all, in the same class.

The Kunstmuseum Bern has a portrait of John Ruskin between Ernest-Auguste Gendron (1817-1881) and Eugène-Paul Dieudonné (?), painted in Florence in 1846 by the Bernese artist Johann Ludwig Rudolf Durheim (Hayman, p. 11). Durheim was born in Bern in 1811 and died there in 1895; he traveled in Italy, Egypt, and Palestine, and exhibited in Bern between 1838 and 1888. Ruskin had met him in 1845 and in a letter calls him "a poor Swiss artist of very sweet character and great power."[3] He remembers him affectionately in *Praeterita* (*Works* 35.361 f.):

> *I did make one friend in Florence, however, for love of Switzerland, Rudolph Durheim, a Bernese student, of solid bearish gifts and kindly strength. I took to him at first because of a clearly true drawing he had made of his little blue-eyed twelve-years-old simplicity of a goat-herd sister, but found him afterwards a most helpful and didactic friend. He objected especially to my losing time in sentiment or over-hot vaporization and would have had me draw something every afternoon, whether it suited my fancy or not. 'Ça vaut déjà la peine,' said he, stopping on the way to the Certosa, under a group of hillside cottages; it was my first serious lesson in Italian background, and if we had worked together, so and so might have happened, as so often aforesaid. But we separated, to our sorrow then, and harm afterwards. I went off into higher and vainer vaporization at Venice; he went back to Berne and under the patronage of its aristocracy made his black bread by dull portrait-painting to the end of a lost life. I saw the arid remnant of him in his Bernese painting, or daubing, room, many a year afterwards and reproached the heartless Alps, for his sake.*

Ruskin says nothing about the painting – Durheim must have taken it back to Bern – but hints at the tragedy of the Swiss painter's life: he evidently never became the artist he wanted to be and might have been. One wonders what would have happened had Durheim not returned to his "goat-herd sister" in Bern and the "heartless Alps." Did Ruskin have plans for him in 1846? Did he see a future in England for him?

Turner, Ruskin, and the Picturesque

For Ruskin, Switzerland was the ultimate challenge for the landscape artist, because it combined, in a unique way, the "sublime" and the "picturesque."[4] The Alps – Montblanc above all – were "sublime." Byron had proclaimed that "high mountains are a feeling," and that was good enough for Ruskin.

But what is the "picturesque"? Generally speaking, any landscape, any building suitable to be represented in art, but also, more specifically, any work of art which strikes one by the expressive quality of an unusual subject. It is an aesthetic approach that delights in roughness, irregularity, in "bits of contrasted feeling," as Ruskin would say. It is possible to appreciate the picturesque and the sublime in one picture. This is what Ruskin attempted to achieve in his *View of the Valley of Lauterbrunnen* of 1866 (Hayman, p. 134): the chalet in the foreground represents the picturesque, the towering mountain range in the background, the sublime. The peculiar charm of a Swiss chalet – or an English windmill – is caused by external circumstances and by the observer's imagination; the sublime is simply there.

In Ruskin's youth, the picturesque was still a kind of specialty of the British landscape painters. They went on "picturesque tours," first in England, then abroad, in search of appropriate subjects. One of the early enthusiasts was William Gilpin, a friend of Samuel Rogers's. Thomas Girtin, Turner's friend, went on sketching tours in the north of England and proceeded to France in 1802, but never reached Switzerland; he had learned a good deal

fig. 5: John Ruskin, *Mount Pilatus, near Lucerne*, 1835 or 1836, watercolor, 241 x 186 mm. Bembridge 1437.

from copying the drawings of Cozens and had developed a bold, spacious style which anticipated Turner's most accomplished landscapes with their transparent luminosity. Turner must have been aware – as Ruskin certainly was – of Girtin's influence; he is supposed to have said: "If Tom had lived, I would have starved." The discovery of Switzerland clearly gave a new meaning to the idea of the picturesque.

By the time Ruskin first visited Switzerland, *védutistes* and *ruinistes* were busy satisfying the public's growing appetite for the picturesque. One of the tricks they were fond of consisted in placing so-called *fabriques* into their landscapes: a romantic ruin, a trellis covered with climbing plants, a pavilion, a belvedere, and, yes! a Swiss chalet. Treated in this manner, a cemetery could be turned into a garden populated by *fabriques*.

In his autobiographical novel *Green Henry*, first published in 1854/1855, Gottfried Keller remembers, with a heavy dose of sarcasm, his strange apprenticeship with "Habersaat" (in reality Peter Steiger), a commercial artist whom Keller characterizes as

*painter, copperplate engraver, lithographer
and printer all in one, who drew views of well-
known Swiss scenery, in a style now obsolete,
engraved them on copper, printed off copies and had
them coloured by a few young people. These sheets
he dispatched all over the place and did a good
trade in them...*[5]

This man "cherished only one single tradition, namely that of the odd and diseased which he confused with the picturesque." He encouraged young Keller (who might have become, with proper guidance, an excellent landscape painter instead of a great poet and novelist) to seek out "hollow, broken trunks of willows, weatherbeaten trees and romantic spectre-like rocks with all the bright colours of corruption and decay..." His gifted pupil promptly became intoxicated with all this morbid stuff, wandered about "in the wilder places," and whenever he found a remote and mysterious spot, as he says, hurriedly made a drawing of his own invention, in which he piled up "the strangest images that his invention could furnish."

In principle, this is not so different from Turner's approach, as described by Ruskin; but Turner, of course, avoided the cheap tricks of the *védutistes*, chose his point of view with great care, and concentrated on "what was there" (though this statement of his must be taken with a grain of salt), refining the essence of his art more and more.

Ruskin on the Swiss Chalet

At age nineteen, after his first two visits to Switzerland, Ruskin published a series of lectures entitled *The Poetry of Architecture* (1837/1838), in which he had something to say on the traditional style of the Swiss chalet (*Works* 1.1–188; cf. Hayman, p. 25). He lists a few technical details, and one of his early pencil drawings, *Unterseen* of 1835 (Hayman, p. 26), shows how thoroughly he understood the basic structure of the chalet as well as its picturesque aspects: the carved windows, the overhanging roofs, the whole mass of "phantastic projection." But, as so often, he gets carried away and proclaims, among other things, that "in the chalet there is everything of Switzerland as hope and experience," that the chalet is the "soul of the Alps," and that it expresses all the typical Swiss virtues. He is indignant that the Swiss do not seem to respect their chalets as they should and that, instead of conserving and restoring them, they allow them to decay or, worse, tear them down to make room for "progress." One should remember that, in Ruskin's youth, Interlaken was still a village of chalets, although three or four of them already served as inns or pensions. But we should give credit to Ruskin: he was perceptive enough to predict the forces that eventually swept away not only chalets in the Bernese Oberland but sturdy medieval towers in Lucerne. What disturbed him no less was the vulgar fashion of transplanting chalets from Switzerland to the suburbs of London or the parks of the English nobility.

fig, 6: John Ruskin,
Falls of Schaffhausen, 1863?,
pencil, 178 x 530 mm.
Bembridge S/46.

In these pages we already find all of Ruskin, the future art critic: his boundless enthusiasm, his keen powers of observation, his mellifluous prose – and his lack of any solid knowledge of his subject. It is the same way he later approaches the geological structure of the Alps or the architecture of Venetian palazzi. He is always the dilettante, in the best sense of the word, to be sure, but therein lies his weakness as well as his strength.

His interest in the chalet remained strong throughout the years. In 1858 he commissioned John William Inchbold to draw some cottages for him, and a decade later he sent J.J. Laing on a similar mission, after having himself attempted, in 1866, the lonely chalet in the *Valley of Lauterbrunnen* (Hayman, p. 134). "If I ever see Switzerland again," he wrote in 1886, "it will only be to get a last Swiss cottage painted." He did see Switzerland once more, in 1888, accompanied by a young student of architecture, but his bouts of mental illness made any sustained art work impossible.[6]

Ruskin's Swiss Views

John Hayman has assembled over a hundred reproductions (all in black and white; only the cover shows the colors of *The Walls of Lucerne,* p. 107) of Ruskin's Swiss views, including some daguerrotypes. A general introduction is followed by three portraits of Ruskin, including the one by Durheim (see above). Chapter I (pp. 15–26) is entitled "Tours of 1833 and 1835," chapter II (pp. 27–39) "Tours of the 1840s." The central part, chapter III (pp. 41-132), deals with the "historic towns of Switzerland" in alphabetical order: Baden, Bellinzona, Brugg and its environs, Fribourg, Geneva, Laufenburg, Lucerne, Neu-

châtel, Rheinfelden, Schaffhausen, Thun. There is a brief chapter (IV), "On the Old Road" (a well-chosen title), dealing mainly with the 1860s. An appendix lists almost fifty works not reproduced in the volume.

Although quite a few drawings cannot be dated with certainty, it appears that 1854, 1858, 1861, and 1863 were Ruskin's most productive years in Switzerland. All the Lucerne drawings presumably made in 1858 have question marks, as do many of the Fribourg drawings tentatively placed in the same year. This is puzzling and leaves room for further research. If one accepts Hayman's dates, there are no drawings at all for certain years, for example, for 1841, and again for 1851 and 1852, which is also curious.

Ruskin's interests changed over the years. During his earliest visits, in the 1830s, he was clearly attracted by the "picturesque" (see, for instance, Hayman, pp. 22-26). In the 1840s and 1850s his main purpose was to study the difference between what he called the "pure and simple Swiss topography," i.e., what he – and, presumably, Turner before him – actually saw, and the "Turnerian topography," i.e. what Turner's genius made out of it. The *Pass of Faido* series (Hayman, pp. 34 ff.) is instructive. Ruskin thought that he had found Turner's viewpoint and thus was able to demonstrate exactly how Turner had transformed the "simple topography" into something grand and enduring.

Perhaps an anecdote which circulated in different versions should be related at his point. Its essence may be extracted from a long editorial footnote in *Works* 6.275. There was a dinner party at Denmark Hill consisting of Ruskin's parents, young John, Turner, and George Rich-

mond. Over the mantelpiece in the dining-room hung Turner's *Pass of Faido*. Young John was in an expansive mood, and his mother, after a while, interrupted him, saying: "John, you are talking too much, and you are talking nonsense," whereupon her dutiful son simply said "Yes, mother." After dinner, everyone stood round the fire, listening to Ruskin's elaborate interpretation of Turner's picture, "explaining this, making a symbol out of that." Turner whispered to his father: "The fellow sees much more in my work than I ever intended." Ruskin evidently did not hear this, for he turned to the master and asked reverently: "Is it not all true, Mr. Turner?" But the painter's answer was: "I just felt like painting that heap of stones!"

On another occasion, Turner stood before one of Ruskin's paintings, *Falls of Schaffhausen* (Hayman, p. 27), and "looked at it long, evidently with pleasure, and shook his finger at it." It was the only one of Ruskin's drawings that he ever saw the master interested in.

A project quite unrelated to the topographical studies began to take shape in 1856. Ruskin had decided to write an illustrated history of Switzerland, as part of a ten-volume work entitled *Our Fathers Have Told Us*. The "historical towns" to be included were, in 1856: Fribourg, Basel, Thun, Schaffhausen, Sion, and Lucerne. At one point, Ruskin decided to exclude Geneva and Bern, because these cities were already "too much spoiled," and he hoped that they would be properly humiliated to find themselves left out.

After a winter spent sorting out many thousands of sketches in the Turner Bequest, Ruskin was particularly taken by a "magnificent series among the later coloured sketches of Swiss towns on the Rhine between Basel and Constance." He also found Baden and Bellinzona worth his while because of Turner's interest in them.

It is curious to see how the prestige of Bellinzona rose over a period of time. Stendhal, in his *Itinéraire Italien* (1818), had pronounced it "un trou infâme." Ruskin, in 1845, did not like it, and Murray's *Handbook* advised at about the same time: "A few hours of Bellinzona are quite enough, and Locarno is a more pleasant place." But by then Ruskin had discovered Turner's drawings of Bellinzona, and he went back, made many "furious" or "meekly obstinate attempts" (how wonderfully humble and descriptive!) at extracting the essence of the place, and declared it "on the whole, the most picturesque in Switzerland!"[7]

Ruskin had read two popular books on Swiss history, one by A. Vieusseux and one by E.H. Gaullieur. Hayman (p. 41) reproduces a page of text from Gaullieur, with some passages underlined by Ruskin, and on the next page a picture of William Tell as he might have appeared in a contemporary performance of Rossini's opera.

Gaullieur, Vieusseux, and the Swiss guides, couriers, and hotelkeepers that Ruskin came in contact with had taught him to revere the "sacred names" of Sempach, Grandson, and Morat. He admired the legendary valor and superb military skills of the armies of the Old Confederation, and he loved the Swiss because of their commitment to freedom, their "undeceivable common sense," and their "obstinate rectitude."

What disturbed him was the relentless industrialization, transferred from England to Switzerland like an infectious disease, causing historical landmarks to disappear. He deplored the development of mass tourism, apparently without realizing that his own writings, enormously popular in the English-speaking world, contributed to it. There is more than a little irony in the situation of this charming, cultured, idealistic English gentleman, sitting in an elegant suite of the Schweizerhof in Lucerne or the Hôtel des Bergues in Geneva, lamenting eloquently the loss of so much that had been "picturesque," yet enjoying the very real comforts that made travel more pleasant.

Geneva is a case in point. Ruskin had seen the massive ramparts near what is now the railroad station and the quaint old mills spanning the river, as shown in Turner's pencil sketch of 1836 (Hayman, p. 79). One of the pic-

fig. 7: John Ruskin, *Bellinzona*,
1858, pencil and wash,
132 x 200 mm. Bembridge 1149.

turesque features of Geneva before 1850 was the "penthouse street" (Ruskin seems to be thinking of arcades or covered walks), with its five-story buildings, its rough-hewn timber constructions, and its wooden projections or loggias. One catches a glimpse of this old architecture from Ruskin's *Geneva* (c. 1835, Hayman, p. 80); but some of the wooden houses had already disappeared by the time of Ruskin's first visit, in 1833, and by 1838, according to Murray's *Handbook,* many more had been torn down. Ruskin was obviously fascinated by the old hydraulic machine of 1702, as well as the new machine house built between 1862 and 1843 (Hayman, pp. 80,82). In 1858 he declared Geneva "no longer habitable"; in 1872 he noted in his diary "Here – happy, yet infinitely sad," and in 1882 he felt depressed about "what was once GENEVA."

Among his beautiful views of Geneva, one is particularly moving when a passage from *Praeterita* (*Works* 35.322) is used as a commentary: *Old Houses on the Rhone Island* (1862 or 1863, Hayman, p. 84), where there is a mood of almost Mediterranean serenity about these

huddled structures. Yet this was, at the time, a kind of dignified slum, where lower middle-class families subsisted on cottage industries, such as spinning and watch-wheel cutting, in dark, crowded rooms, taking care of their old and infirm.

Ruskin's Lucerne drawings, too, preserve much of a past that is gone forever: the elegant tower of the Burgertor, demolished in 1864, with part of the Reusssteg and the Krienbach, now covered over, in *Lucerne* (c. 1854, Hayman, p. 99); the Jesuitenkirche as it looked before the addition of towers in 1893 and the Bruchtor, removed in 1869, in *Lucerne* (1861 or 1866, Hayman, p. 104); the Freienhof, demolished in 1949, in *Lucerne: the Bahnhofquai* (1861 or 1866, Hayman, p. 106).

Something should be said about Ruskin's use of the panorama technique. Best known is his panorama of the *Bernese Alps from the Fletschhorn to the Matterhorn* (Hayman, p. 30), on five sheets, each approximately 357 x 533 mm, drawn from the Belalp in 1844. Ruskin seems to have been one of the first tourists to climb up to the Belalp in search of a view. In 1860 a chalet-hotel, which soon

became very popular, was built on the Belalp, and both Murray and Baedeker promptly recommended it.

Like Turner, Ruskin was fond of panoramic views of towns: *Baden* (1835, Hayman, p. 23) achieves a panoramic effect by means of cleverly adjusted distances; *Fribourg* (1854 or 1856, Hayman, p. 73) manages, by a well-chosen perspective, to include a number of picturesque structures; and *Rheinfelden: Panorama of Town* (1858, Hayman, p. 118) so pleased the artist that he wrote, about twenty years later: "I never did nor shall do better."

Conclusion

It does not happen very often that a man of genius discovers his "Holy Land" at an early age and lives long enough, not only to write volumes in praise of it, but also to produce a substantial number of accomplished drawings. Switzerland is fortunate to have such a perceptive and articulate interpreter in the person of John Ruskin. Admirably trained and schooled, highly gifted and full of enthusiasm, he came to Switzerland after it had already been discovered by adventurous landscape painters and romantic poets, following in their footsteps, reliving their experiences, and creating a coherent body of thoughts, impressions, and images that deserves to be studied today as an important part of the discovery of Switzerland by the British.[8]

took a larger view of art. Mr. Ruskin continued,'I do not see that you use purple in your shades.' 'But,' she said,' I never see shade two days alike, and I never see it purple.' 'I always see it purple,' and he emphasised it, 'yes: red and blue.' After Mr. Ruskin took his leave, Gambart asked her opinion of him.'He is a gentleman,' she said, 'an educated gentleman; but he is a theorist. He sees nature with a little eye – *tout à fait comme un oiseau*'." One is immediately reminded of Ruskin's drawing *Near Bellinzona* (1858, Hayman, p. 58), which represents his attempt to "draw every stone of the roof right in a tower in the vineyards, "cette *baraque*," as his guide Couttet called it (*Works* 35.595).

3 H.I. Shapiro, *Ruskin in Italy*; Letters to his Parents, 1845 (Oxford, 1972), p.136.

4 A brief bibliography may be useful: Richard Payne Knight, *The Landscape: A Didactic Poem* (London, 1805) (London 1794); idem, *An Analytical Inquiry into the Principles of Taste*(2) (London, 1805);
Sir Uvedale Price, *Essays on the Picturesque*, 3 vols. (London, 1810; new ed. by Sir Thomas Dick Lauder, London, 1842); C. Hussey, *The Picturesque* (London, 1927); J.J. Mayoux, *Richard Payne Knight et le pittoresque* (Paris, 1932); W.J. Hipple, *The Beautiful, the Sublime and the Picturesque in 18th century British Aesthetic Theory* (Carbondale, USA, 1957); C.P. Barbier, *William Gilpin (1724–1804): His Drawing, Teaching and Theory of the Picturesque* (Oxford, 1963); J. Dobai, *Die Kunstliteratur des Klassizismus und der Romantik in England*, vol. 3 (Bern, 1977), pp. 15–35; A. Wilton, *Turner and the Sublime* (London, 1981); M. Clarke and N. Penny, eds., *The Arrogant Connaisseur: Richard Payne Knight, 1751–1824* (Manchester, UK, 1982); T. Brownlow, *John Clare and the Picturesque Landscape* (Oxford, 1983); A. Bermingham, *Landscape and Ideology: The English Rustic Tradition* (Univ. of Calif. Press, 1986); M. Andrews, *The Search for the Picturesque: Landscape Aesthetics and Tourism in Britain 1769–1800* (Aldershot, UK, 1989); W. Kemp, *The Desire of my Eyes: The Life and Work of John Ruskin*, trans. from the German by J. van Heurck (London, 1991), e.g. pp. 42 ff.; 76 ff.; 156 ff.

5 A. M. Holt's translation (New York: Grove Press, 1960), pp. 192 ff.

6 Ruskin was also interested in the wooden bridges of Switzerland. They were actually admired as masterpieces of technology; see P. de la Ruffinière du Prey, in *Zeitschrift für Schweizerische Archäologie und Kunstgeschichte* 36 (1979) 51 ff.

7 *Curé's Garden at Bellinzona* (1858, Hayman, p. 57) shows the garden, the steeple of the church, and, in the distance, the old St. Gotthard road. The church has not been identified so far, but a few years ago I spotted it from the Bellinzona railroad station and then went up to look at it. It is the church of Dario, a small village just above Bellinzona. Ruskin called it "a little San Miniato," after the site above Florence of which he was so fond.

8 The author would like to thank the Swiss Tourist Office, Zurich, especially its director, Walter Leu, but also John Geissler and Theodor Wyler for generous support and encouragement in connection with his research on John Ruskin in Switzerland.

Notes

1 John Hayman, *Ruskin and Switzerland* (Waterloo, Canada: Wilfrid Laurier University Press, 1990). I have learned a great deal from Sir John Wraight, *The Swiss and the British* (Wilton, UK: Michael Russell, 1987). Some of the ideas presented in this article are borrowed from my contribution to *Festival of Switzerland in Britain 1991*, ed. Ambassador Franz Muheim (pp. 46–51).

2 In his *Reminiscences* (1902, p. 130, quoted in *Works* [14.17/3]) Frederick Goodall tells about a conversation Rosa Bonheur and John Ruskin had in 1856 in London, in the house of Gambart, the art dealer. "After he had seen most of her studies of Highland cattle, he asked, 'Why don't you work in watercolours, for if you did you could, with a very fine sable brush, put in every hair in your studies.' Her answer was 'I do not paint in watercolour, and I could not; it would be impossible to put in every hair; even a photo could not do it.' 'If you come and dine with me some day,' he retorted,' I will show you a watercolour drawing – made in Scotland – which I put in every leaf of a tree in the foreground.' By and by, when she spoke of the Old Masters,'of Titian, and especially the Entombment of Christ, he only remarked,'How wonderful the little flowers in the foreground are painted!' I felt at the moment that she

Picture credits

figs. 1–5: The Ruskin Galleries, Bembridge School, Isle of Wight (Frank Taylor, Newport)

figs. 6–7: Andrew Morris, Ambleside

Georg Germann

A Sunday Morning (1908-1909) by Edouard Vallet

A Popular Painting

The economic boom in Switzerland around 1885, after a decade of Europe-wide depression, gave the country's elite the self-confidence to demand a commensurate position in the arts among the concert of nations. This led to the founding of a Federal Commission for the Arts in 1887.

In addition to the world fairs staged in major European and American cities, the so-called civilized nations vied with each other in international art exhibitions, but with varying degrees of success. Like many of their kind, the two International Art Exhibitions of Switzerland that took place in Interlaken in 1909 and 1910 were ephemeral; by contrast, the International Art Exhibition organized every few years at the Crystal Palace in Munich from 1869 to 1931 enjoyed international renown comparable to that of the Venice Biennale since the twenties. Countries were invited to participate with group shows, which gave them the opportunity to promote national art in an international forum.

Edouard Vallet's painting *A Sunday Morning*, executed 1908-1909, owed its contemporary popularity to these circumstances (fig. 1).

How is the popularity of a painting to be measured? Obvious quantitative criteria are the quality and frequency of its reproductions and the circulation of the publications which choose to reproduce it. In the catalogue for the painter's centenary exhibition in 1976, Bernard Wyder produced the necessary

evidence by tracing reproductions of Vallet's paintings to monthly and weekly magazines of general interest and even to art calendars.[1] He counted twenty four black-and-white and eleven color reproductions of *A Sunday Morning*. The painting has been reproduced in color in prestigious publications at least twice since then: in a book commemorating one hundred years of federal patronage of the arts, *Der Bund fördert – Der Bund sammelt. 100 Jahre Kunstförderung des Bundes* (Bern, 1988, p. 240), and in the sixth volume (by Oskar Bätschmann) of a series on visual culture in Switzerland, *Ars Helvetica. Die visuelle Kultur der Schweiz* (Disentis, 1989, p. 229).

As a masterpiece of Swiss art, the painting has left the country several times, most frequently in the twenties. It was on view in Venice (1920), in Karlsruhe (1925), and in Brussels (1928).

In the following, I shall try to show the circumstances that have contributed to the enduring popularity of Edouard Vallet's *A Sunday Morning*. Major factors include official Swiss cultural policy and the attitude toward culture that prevailed around 1910.

The Acquisition

Edouard Vallet (1876-1929) was born in Geneva of French parents. He studied at the Ecole des Arts industriels and the Ecole des Beaux-Arts, acquired Swiss citizenship in 1902, and expanded his horizons through travels in Germany, France, and Italy, 1904-1905. From 1908 he concentrated his search for motifs on the French-speaking area of the Canton of Valais. He won prizes in Geneva (1903, 1907, 1909) and in Munich (1909, 1913). *A Sunday Morning* (oil on canvas, 105 x 105 cm, signed lower right, "Edouard Vallet 1908-1909") consolidated his fame. The painting shows a peasant woman from Valais on the balcony of her house. Dressed in native costume, a prayer book and rosary in her hands, she is ready to attend church. The landscape in the background shows the view from Hérémence, a village south of Sion, the capital of Valais, where the painter stopped off in 1908, 1909, and

1912. At the time, nearby Savièse, where Vallet lived in 1910-1911, was a popular retreat for Genevois and other Swiss painters.

In 1908 the federal government accepted the Bavarian invitation to send a group exhibition of Swiss work to the Xth International Art Exhibition in Munich.[2] Wilhelm Ludwig Lehmann, a professor and painter (from Zurich in Munich), was appointed Swiss commissioner of the exhibition, a post he had filled once before, in 1905; his assistants were the painter Adolf Thomann (from Zurich in Munich; he answered from Savièse on 14 October 1908) and the sculptor Hugo Siegwart (from Lucerne in Munich). The Federal Council passed a resolution on 9 March 1909 defining the procedure for naming a jury of eleven to select which of the submitted works were to be sent to Munich, as a rule one work per artist. The three representatives from the Federal Commission for the Arts were Wilhelm Ludwig Lehmann (Munich), Paul Amlehn (Sursee), and Albert Sylvestre (Geneva). The artists selected the following representatives: (German-speaking) Wilhelm Balmer from Rörswil near Ostermundigen, Ferdinand Hodler from Geneva, and Albert Welti from Bern; (French-speaking) Albert Angst from Paris, Ernest Biéler from Savièse, and Abraham Hermenjat from Aubonne; (Italian-speaking) Edoardo Berta from Lugano and Giovanni Giacometti from Stampa; and as runners-up: Max Buri (Spiez), James Vibert (La Chapelle-sur-Carouge near Geneva), and Filippo Franzoni (Locarno). The most votes went to Ferdinand Hodler (127), Giovanni Giacometti (109), and Albert Welti (91). Under Thomann's chairmanship, the jury convened from 27 April to 30 April 1909 at the parliament building in Bern. Edouard Vallet submitted only one painting, which was accepted (cat. no. 1596). The international jury in Munich (including the Swiss delegate Wilhelm Ludwig Lehmann and, as deputy to the president of the Federal Commission for the Arts, the painter Charles Giron) awarded a first-place medal to Albert Welti and a second-place medal to twelve other Swiss artists.

fig. 1: Edouard Vallet, *Sunday Morning*, oil on canvas, 105 x 105 cm. Signed lower right "Edouard Vallet 1908-1909." Kunsthaus Zurich, inv. no. 900 (Depository of the Swiss Confederation, 1910).

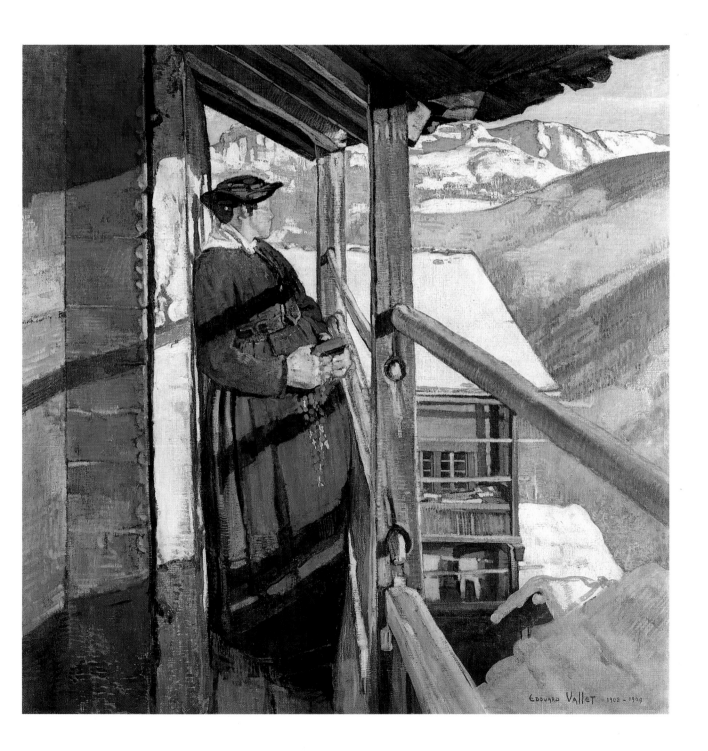

Chaired by painter Burkhard Mangold (Basel), the Federal Commission for the Arts met in Munich on 3 June 1909, filed a request with the Federal Council for a grant of fifty thousand Swiss francs to subsidize the Kunsthaus in Zurich, which was in the final stage of construction, and recommended the acquisition of twelve works from the exhibition in the Crystal Palace. The six recommended paintings included our painting (listed as *Sonntagsmorgen* and *Un dimanche matin)* by Edouard Vallet, *Summer Meadow in the Upper Engadine* by Christian Conradin, with similar subject matter, *Shore of Lake Constance* by Carl Theodor Meyer, and *Le Haut du Cry, Valais* by Alfred Rehfous.[3]

The Kunsthaus subsidy was turned down by the federal government, but on 18 June 1909 the Federal Department of the Interior under Minister Marc Ruchet resolved to purchase the recommended works for the "elevation and promotion of Swiss art."[4]

Ruchet encouraged the protection of the national heritage; his brother was a museum curator and he was married to an animal painter.[5]

The Swiss Confederation has no national gallery. The Federal Commission for the Arts therefore places the works it acquires in those museums in Switzerland that file a request for them.

At the meeting of 18-19 January 1910, the commission had thirteen options for placing Edouard Vallet's painting *A Sunday Morning*, more than for any other work of art that year. The requests had come from Aarau, Basel (the Public Collection and the Art Society), Biel, La Chaux-de-Fonds, Glarus, Le Locle, Lugano, St. Gallen, Solothurn, Vevey, Winterthur, and Zurich. The painting was turned over to Zurich, which had listed it as first choice and whose Kunsthaus was to be officially inaugurated on 17 April 1910.[6]

Before construction had begun in 1905, the Art Association of Zurich had solicited a contribution from the municipality on the basis of the wish to encourage "popularization" and "make the Kunsthaus a place for the people."[7] And prior to its completion, the association filed for a federal grant to fund "this house dedicated to art, above all to Swiss art."[8]

Vallet's painting satisfied both conditions: it was popular and soon came to epitomize Swiss art.

Contemporary Opinion

In October 1909 *Die Schweiz. Schweizerische illustrierte Zeitung* published a glossy black-and-white reproduction of Vallet's painting as one of five "art inserts" to accompany Willy Lang's report on Swiss artists represented at the Xth International Art Exhibition in Munich.[9] Lang opens with a general characterization of the Swiss group, described in terms of the prevailing dichotomies of the day: "idiosyncratic instinct" versus "elegant pose," "serious" versus "playful," "Germanic" versus "Romanic." He sees Ferdinand Hodler as the initiator and measure of Swissness: "Moreover, contemporary Swiss art is often primitive in a positive sense, which is in part Hodler's achievement. The style appears simple, curious, almost experimentally reduced." Lang situates our painting in this context:

> *New and excellent is Edouard Vallet (see second art insert), who places a peasant woman on a loggia in a compelling, primitive manner. She gazes out upon the mountains – on a Sunday morning. Confidence is expressed not only by the simple rendition of the figure but also by the sophisticated use of colorful hues in combination with the brown woodwork and shimmering bluish snow on the mountain slopes.*

On presenting recent painting in Switzerland to the German public in Karl Scheffler's monthly *Kunst und Künstler* in 1910,[10] the Geneva-based author Dr. Johannes Widmer had more territory to cover than critic Lang. Moreover, in response to the then current predilection for thinking in terms of polarities, Widmer attempted to show that Swiss art itself encompassed polarity and could therefore not be ascribed to one pole or another. Thus he opens his essay with Ferdinand Hodler and Arnold Böcklin: "It is no small achievement for a people like that of Switzer-

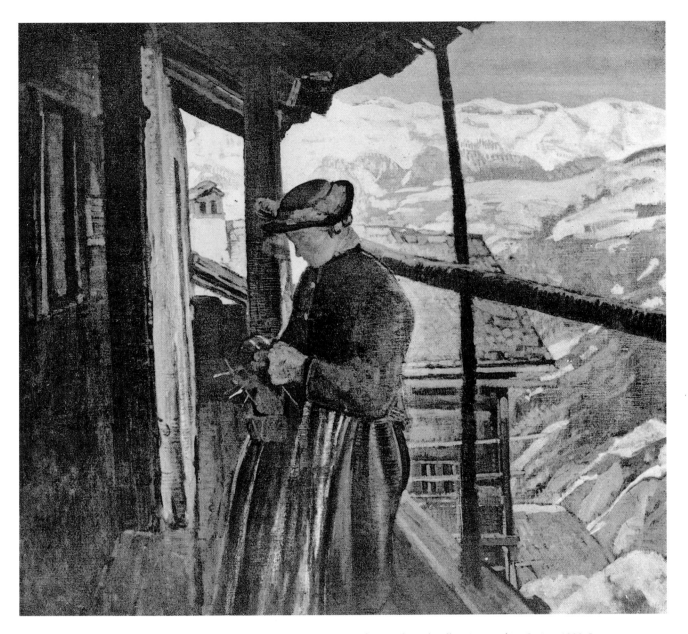

fig. 2: Edouard Vallet, *Approaching Spring*, 1908. Lost.

fig. 3: Giovanni Segantini, *On the Balcony*, oil on canvas, 65.5 x 42 cm. Signed lower right "G. Segantini 1892." Bündner Kunstmuseum, Chur, inv. no. 05/64 (Depository of the Gottfried Keller Foundation, 1905).

land to bring forth two great masters in quick succession and with an inner congeniality." Once again Edouard Vallet's *A Sunday Morning* is found worthy of reproduction and comment:

> The decisiveness with which Vallet defines the composition in instructive views through windows, doors, and other suitable obstructions, and the intimacy he has achieved in the rich coloring used to emphasize the individual shapes are exemplary in his painting of a peasant woman from Valais. The strong contours of the house, the balcony, the village, and the mountains produce a lively whole; and significant hues, the red of the bricks, the blue of the jacket, the sumptuous green of the apron with the coral red of the rosary beads on it, create a solemn present.

A year later, in 1911, the artist's oeuvre was characterized by Dr. Hans Trog, accomplished art critic of the *Neue Zürcher Zeitung*. His essay "Edouard Vallet," published, like Willy Lang's review, in the Zurich-based magazine *Die Schweiz*,[11] begins with the words,

> In the collection of the Zurich Kunsthaus, in the gallery reserved for the work of contemporary artists, there hangs a picture whose radiant coloring and sunniness will attract the eye of every beholder, causing him to pause before it. On the brownish-red gallery of a wooden farmhouse, situated high up in a mountain village, with a magnificent view across to the mountains and down to the village below, there stands the stately, imposing figure of a peasant woman in her beautiful green Sunday apron. She has paused for a moment before setting off to church. In her strong, thick hands she holds a small prayer book and a rosary with large, red, wooden beads. A superb, sunny day has risen above the snowscape. We are almost blinded by the glistening, sparkling snow, and the strong light reflexes color even the shadows blue. One notices at once:

> a painter of elemental power has created this work, a painter who has a keen, receptive eye for the colorful appearance of the outside world – the red rosary brilliantly matches the green apron, and this red as the complementary color of the magnificent green patch of apron is most felicitously heightened in the foreground by the wood of the house aglow in the sparkling sunshine. Freshness, firmness, and clarity mark the character of the painting. With a jolt we are transported into the radiance of nature's mountains. And the figure with its resolute detachment precludes any thought of a standard genre picture of the mountains. The artist does not wish to achieve a particular expression of devoutness; it is the rough-hewn peasant woman who has caught his fancy, because she stands there so sumptuously colorful in the sunlit clarity of the wintry day.

The above sings the praises of vitality, and the viewer is invited to join the farmer's wife and the painter out on the wintry gallery. The effects of light and color, discreetly presented to the reader, were still relatively daring around 1910. In Trog's interpretation, the concept of *Sachlichkeit* (matter-of-factness), which was established as a stylistic term after World War I, distinguishes Vallet's picture from "a standard genre picture of the mountains."

Trog sees Vallet as a reporter of rural life in Valais, an approach that defines the focus in the second half of his article. An earlier work of 1908 – the lost painting *Approaching Spring*, also known by the title *On the Balcony* – is not read as a forerunner of *A Sunday Morning*, but rather as its "pendant in a certain sense" (fig. 2). As Trog puts it:

> Once again we stand on the lightly built gallery of a simple farmhouse in the mountains. The sun gives off so much warmth that the peasant woman has ventured out of doors with her knitting. The native costume indicates that, like the woman in *A Sunday Morning*, she also comes from the Canton of Valais."

Pictures of Landscape and Native Costume

For Hans Trog, Vallet's two balcony pictures are representations of weekdays and Sundays although they were obviously not conceived as a pair. He has hit upon the essence of Vallet's oeuvre with his observation that the artist painted as if he were ethnologically documenting folk life: "With genuine artistic piety, Vallet studies the life and times of these isolated people: he observes them at their daily tasks; he follows them to church on holy days."

He puts his finger on the nostalgia that led to the founding in 1905 of the Swiss Heritage Protection Association, whose goal it was "to protect folkhood in all its manifestations from utilitarian activities and attitudes."[12] This "folkhood" – Trog uses the same word in his essay – does not refer to the cultural tradition of Switzerland as a whole, but rather to specific historical landscapes or to the political units of the cantons. The native costume in both pictures tells us that the "sturdy, imposing figure" (later described as the "rough-hewn peasant woman," to distinguish her from romanticized genre pictures) is an inhabitant of the Canton of Valais. Trog makes it clear that Vallet – like Friedrich Simon, Albert Anker, and Ferdinand Hodler before him – did not produce for tourist consumption, seeking instead to create a realistic image of life in Switzerland.[13] Trog on his part avoids speaking of the "Alps," a geographical designation bogged down with a steadily growing burden of meanings and associations since the publication of Albrecht von Haller's poem of the same name, written in 1732. The reference would have been too trite, too obvious. He speaks instead of a "mountain village," of the "mountains," and of Valais.[14] Finally, he situates the painter in the context of contemporary art, associating him with the Geneva School, held to be the leading school since the mid-nineteenth century; its members formed the modern artists' colony[15] in Valais, similar – one might say in retrospect – to the groups in Pont-Aven or Worpswede: "The Genevois Vallet fell in love with Valais, as did Ernest Biéler, as did Bille and Dallèves. And

he has chosen to settle down in the same locality of Savièse, where Biéler spends a good portion of the year."

Vallet's subject matter touched the heart of his age. Along the similar lines as the success of his painting *A Sunday Morning* was the popularity in Germany of mountain and peasant novels by German-speaking Swiss authors of the same period.[16] But why was this particular work singled out from among the many by Vallet and his contemporaries?

The "Balcony Picture"

In the painting *A Sunday Morning* Edouard Vallet gave his own imprint to the balcony motif popular at the turn of the century. Sine qua non of the "balcony picture" – closely related to the romantic "window picture"[17] – was the introduction of balconies in urban residences of the nineteenth century: a narrow platform projecting from the wall of a building, accessible through a door, and enclosed by a railing. In comparison to the loggia, the oriel, the gallery, and the veranda, the balcony conveys a stronger sense of leaving a building and stepping outside, especially in large apartment buildings.

As such, this structural element obeyed the new maxims of hygiene – light, air, and sun – that were applied towards the mid-nineteenth century to the design of hospitals, apartment buildings, and hotels.[18]

French caricaturists drew attention to its significance as a "ruler's loggia." In their representations, it stands for the hubris of the crowned monarch or the ruling bourgeoisie: Grandville in *Malheureux enfants – Malheureux chiens* (Unfortunate Children – Unfortunate Dogs), 1844; Daumier in *Le roi de Naples* (The King of Naples), 1851.[19] Subsequently, in French painting, balconies in private homes became a place of repose on the border between private and public spheres, as in Edouard Manet's *Balcony* (1868), which shows a full-length group portrait. However, here we look at the scene from outside, while the genre of the "balcony picture" customarily places viewers directly on the balcony, so that the composition encom-

passes the façade of the house, the balcony, and the view, usually of a city street, as in Ferdinand Hodler's painting of Via Olivio in Madrid (1878/1879)[20] or Gustave Caillebotte's rendition of Boulevard Haussmann in Paris (1880).[21] In contrast, another painting by Caillebotte of the same year, titled *Homme au balcon*, conveys a sense of privacy and domesticity since the man leaning over the balcony is not wearing a hat.[22] Edvard Munch apparels his observer in the painting *Rue Lafayette* (1891) in frock coat and top hat, but does without an identifying figure of this kind in *Rue de Tivoli* (1891).[23]

In the painting *On the Balcony* (1893), Giovanni Segantini transports us to the village of Savognin in the Grisons Alps (fig. 3).[24] A peasant woman is standing on the balcony of her house, in a pensive mood, while the viewer looks out over the high parapet onto the stables, houses, and church of the village. The pictorial motif juxtaposes the image of rural life after the day's work is done with the hectic and idle life of the city.

Other subject matters can, of course, also be rendered in the "balcony picture." When Giacomo Balla places a madwoman (*La pazza*, 1905) with hair awry on a balcony, he conjures up a sense of peril, for she may hurl herself over the railing.[25]

In Vallet's paintings *On the Balcony* (1908) and *A Sunday Morning* (1908-1909), the narrowness of the walkway, the rickety railing, and the view of the village clinging to the mountainside all impart an impression of the perilous mountain world against which the inhabitants of the Alps must persevere. But only the second version imbues the motif with the emblematic impact that has contributed to its fame. In *A Sunday Morning*, the Valaisian peasant woman – ideal and allegory of Switzerland[26] – leans against the wall and gazes with unshakable faith in God into the radiant sunshine of an early winter morning.

Translated from the German by Catherine Schelbert

Notes

1 *Edouard Vallet (1876-1929)*. Exhibition curated and catalogue edited by Bernard Wyder under the auspices of the Musée d'art et d'histoire de Genève. With an essay by Hans A. Lüthy. Geneva, Musée Rath, 29 April to 30 May 1976 (...), no. 48.

2 Swiss Federal Archives, 8 (E), Ve 346, 1908-1909, Box 22.

3 Swiss Federal Archives, 3001 (B), 1979/121, Box 5a.

4 Swiss Federal Archives, 8 (E), Ve 365, 1893-1909, Box 25.

5 *Historisch-Biographisches Lexikon der Schweiz*, vol. 2 (Neuchâtel, 1929), pp. 730-731.

6 Swiss Federal Archives, 3001 (B), 1979/121, Box 5b.

7 Ulrike Jehle-Schulte Strathaus, *Das Zürcher Kunsthaus, ein Museumsbau von Karl Moser*, Schriftenreihe gta, 22 (Basel, Boston, and Stuttgart, 1982), p. 37.

8 Swiss Federal Archives, 3001 (B), 1979/121, Box 5a, 80th meeting of the Federal Commission for the Arts, 5/6 February 1909, item 17.

9 "Die Schweiz in der X. internationalen Kunstausstellung in München," vol. 13, pp. 391-394. Swiss writer Willy Lang also used the pen name Alexander Castell.

10 "Die neuere Malerei in der Schweiz," vol. 15, pp. 143-160.

11 Vol. 15, pp. 283-285.

12 For background information, see Ulrich Im Hof, *Mythos Schweiz: Identität – Nation – Geschichte 1291-1991* (Zurich, 1991), pp. 223-233.

13 Cf. Hans A. Lüthy, "National and International Aspects of Realist Painting in Switzerland," *European Realist Tradition*, ed. Gabriel P. Weisberg (Bloomington, Indiana, 1982), pp. 145-186.

14 Cf. Marie-Claude Morand, "Tourisme et production artistique en Valais dans la première moitié du XXe siècle," *Zeitschrift für schweizerische Archäologie und Kunstgeschichte*, vol. 41 (1984), pp. 125-132. – *Zeichen der Freiheit. Das Bild der Republik in der Kunst des 16.-20. Jahrhunderts*, ed. Dario Gamboni and Georg Germann with François Capitani. 21st European Exhibition of Art under the patronage of the Council of Europe, Bern, 1991, pp. 394-454 (*Die Alpen, Wiege der Freiheit*).

15 Bernard Wyder, "L'Ecole de Savièse ou le centenaire d'une appellation controversée," *Vallesia, Bulletin annuel des Archives de l'Etat...*, vol. 46 (1991), pp. 155-167.

16 Charles Linsmayer, "Die Eigenschaft `schweizerisch' und die Literatur der deutschen Schweiz zwischen 1890 und 1914," *Auf dem Weg zu einer schweizerischen Identität 1848-1914. Probleme – Errungenschaften – Misserfolge*, ed. François Capitani and Georg Germann for the Schweizerische Akademie der Geisteswissenschaften (SAGW). 8th colloquium of the Swiss Academy of the Humanities, Fribourg, Switzerland, 1987, pp. 403-426.

17 J.A. Schmoll genannt Eisenwerth, "Fensterbilder. Motivketten in der europäischen Malerei," *Beiträge zur Motivkunde des 19. Jahrhunderts*, ed. Ludwig Grote, Studien zur Kunst des 19. Jahrhunderts, Forschungsunternehmen der Fritz Thyssen Stiftung, 6 (Munich, 1970), pp. 13-143.

18 Axel Hinrich Murken, *Die bauliche Entwicklung des deutschen Krankenhauses im 19. Jahrhundert*, Studien zur Medizingeschichte des 19. Jahrhunderts, Forschungsunternehmen der Fritz Thyssen Stiftung, 9 (Göttingen, 1979), p. 316; Jacques Gubler, "Entre mer et forêt: la ville aux balcons d'argent," *La ville d'hiver d'Arcachon* (Paris: Institut français d'architecture, 1983), pp. 75-109.

19 I am grateful to Philippe Junod (Lausanne), Eva Korazija Magnaguagno (Zurich), and Juerg Albrecht (Bern) for drawing my attention to various "balcony pictures."

20 Exhibition catalogue, *Ferdinand Hodler, Zeichnungen*, Zürcher Kunstgesellschaft, Helmhaus (Zurich, 1963), no. 10 (fig.).

21 Exhibition catalogue, *The New Painting. Impressionism 1874-1886*. An exhibition organized by The Fine Arts Museum of San Francisco with the National Gallery of Art, Washington (San Francisco, 1986), no. 116 (fig.).

22 Joel Isaacson, "Impressionism and Journalistic Illustration," *Arts Magazine*, LVI/10, June 1982, pp. 95-115, fig. 56.

23 On urban "balcony pictures," see J.A. Schmoll genannt Eisenwerth, "Die Stadt im Bild," *Die deutsche Stadt im 19. Jahrhunderts*, Studien zur Kunst des 19. Jahrhunderts, Forschungsunternehmen der Fritz Thyssen Stiftung, 24, ed. Ludwig Grote (Munich, 1974), pp. 295-309.

24 Annie-Paul Quinsac, *Segantini. Catalogo generale*, 2 vols. (Milan, 1982), vol. 2, no. 470 (fig.); *Bündner Kunstmuseum Chur. Gemälde und Skulpturen*, Schweizerisches Institut für Kunstwissenschaft, Kataloge Schweizer Museen und Sammlungen, 12 (Chur, 1989), pp. 64-65 (fig.); the reasons for the acquisition of Segantini's painting by the Gottfried Keller Foundation in 1905 were similar to those that led to the purchase of Vallet's painting by the Federal Commission. Cf. Hanspeter Landolt, *Gottfried Keller-Stiftung. Sammeln für die Schweizer Museen... 1890-1990*. With contributions by Hugo Wagner (Bern, 1990), esp. pp. 38-40, 68, and 609 (here and in Quinsac, erroneously dated 1893 instead of 1892).

25 Exhibition catalogue, *Futurismo and Futurismi*, Palazzo Grassi (Venice, 1986), p. 27 (fig.).

26 Cf. Gerhard Eimer, *C.D. Friedrich und die Gotik* (Hamburg, 1963), p. 22. Eimer reads what he calls "Söllerbilder" as symbols of national society; *Italia und Germania* by Friedrich Overbeck (completed in 1828) is a balcony picture of this kind, representing the commanding view from a terrace on top of a castle.

Picture credits

Hans A. Lüthy

From Heimatkunst to "Degenerate" Art
On the Contemporary Reception of Swiss
Painting, 1890-1914

The development of European painting in the nineteenth century might be compared to an express train pulling out of a station (fig. 1). The social upheavals of the French Revolution had led to an initially hesitant reevaluation of how artists saw themselves, which rapidly gathered momentum as early as the first half of the nineteenth century. The clearly defined niche that had been allotted to the artist since the Middle Ages as an admired but socially integrated craftsman began to disintegrate. French romanticism, which followed in the wake of the slightly earlier German movement, and its champion, the new bourgeoisie, treated the artist as an independent individual. Individuals were now recognized as joyous or suffering beings, equipped with a heart and emotions, and thus the right publicly to disclose their inner state, for instance, in works of art or literature. The two protagonists of French romanticism in painting, Théodore Géricault and Eugène Delacroix, conquered new worlds with their exploration of new subject matters: Géricault, the inner world of the insane; Delacroix, the world of appearance in theater, through which he reinterpreted the traditional subject matters of painting. Horses and wild animals became symbols of individual freedom.

The theory of a Bohemian society, as it developed in the romantic period, served to legitimize the role of the artist as an outsider. In France, still the leading nation in matters cultural and scientific, the state fiercely defended its right to subordinate art to political principles. Gustave Courbet and Edouard Manet's

fig. 1: Rudolf Koller
(1828-1905), *The Gotthardpost*,
second version, 1874,
oil on canvas, 139 x 117.5 cm.
Private collection.

struggle to be included in the official salon testify to this cultural policy. The position of Paris as the center and focus of the European art world led almost all the other nations to try to emulate French institutions. Germany was too fragmented and did not begin developing a national identity until 1871. The situation in Italy was similar, and England was politically too isolationist to wield influence on the continent. The signifiance of the Austro-Hungarian Empire as a counterbalance and a conservative force declined in the nineteenth century. Smaller countries or splinters of states acquired the status of satellites, moving between conservative academic and reformational currents, and subject to the pull of the greater powers. More remote regions began to live lives of their own, while, curiously enough, we are just beginning to rediscover and study the art of these areas – most recently, Russian or Nordic painting of the nineteenth century.[2]

The subversion of cultural policy in Paris began to manifest itself successfully in the 1860s. The reform in 1863 of the Ecole des Beaux-Arts and the organization of a Salon des refusés in 1864 unmistakably signaled the decline of state authority. The so-called *chefs-d'école*, who were rewarded for educating young talent, not only with social acclaim, but with financial recompense as well, suffered a complete loss of influence on the following generation in the next few decades; many successful foreign artists of the 1890s did not study in Paris but in Brussels, Düsseldorf, Munich, or Milan; in France new academies were founded that successfully competed with state institutions. Traditional values were fast disintegrating, with no new ones emerging to take their place. An analysis of the microclimate in various art centers of the period yields a disparate picture, disparate not in a leveling off or lack of talent but rather in the almost impenetrable variety of original impulses, movements, and tendencies.

In Paris proper, the 1890s saw the first burgeoning of symbolism in the fine arts. Josephin Péladan (*Sâr Péladan*), an outré figure possible only in those days, called for participation in his first exhibition, the "Salon de la Rose et

fig. 2: Félix Vallotton
(1865-1925),*The Mistress and
the Servant,* 1896,
oil on cardboard, 52 x 66 cm.
Private collection.

fig. 4: Karl Stauffer (1857-1891),
Portrait of Lydia Welti-Escher,
1886, oil on canvas,
100 x 65 cm. Kunsthaus Zurich.
Gottfried Keller Foundation.

fig. 5: Albert Trachsel
(1863-1929), *The Wave*, c. 1890,
watercolor on paper,
30.5 x 40.5 cm. Private collec-
tion.

fig. 3: Albert Anker (1831-1910)
Exam at the Village School,
1862, oil on canvas, 95 x 174 cm.
Kunstmuseum Bern.

Croix"; Puvis de Chavannes stood at the peak of his international fame with his symbolistically disposed allegories; Odilon Redon illustrated Oscar Wilde; and Hamburg-born, elective Genevan Carlos Schwabe created the poster for the "Salon de la Rose + Croix," in which six other Swiss artists, including Félix Vallotton (1865-1925), participated (fig. 2). After a brief brush with symbolism, Vallotton went on to become one of the most caustic critics of contemporary European society. In addition, Pierre Bonnard, Edouard Vuillard, Paul Sérusier, Emile Bernard, and others joined to form the *Nabis*. The newly founded Salon du Champ-de-Mars successfully competed with official French art events. Paul Gauguin moved, for reasons still unknown, to the South Seas, leaving behind Paris and his summer residence in Pont-Aven. Vincent van Gogh succumbed to the nightmares that plagued him and committed suicide. As a rule, art history calls this period post impressionism. As vague as it is, the concept at least has the advantage of saying nothing at all, although it does encourage misinterpretation among the general public. The only common denominator of post impressionist painting is its intellectual reaction to an overrated optical approach and to the painterly lust for life displayed by the impressionists.

Similar, though much diluted, phenomena can be observed in other cities of Europe. Almost for the first time since the Middle Ages, there was as much happening in the arts outside the main cities as in them. A case in point is Giovanni Segantini (1858-1899), the painter-cum-philosopher who lived in the Engadine. Although still inconclusively interpreted and often misconstrued, his motifs appealed to an international audience, and his pictures won gold medals in Austria, Germany, the Netherlands, the USA, and Australia. As early as 1850, French realists – Camille Corot, for instance, and the Barbizon School – had discovered the charm and the potential of the provinces. The Swiss Gleyre pupil Albert Anker (1831-1910) left Paris to go to the Black Forest, where he painted village scenes that still enjoy undiminished popularity as the ideal of life in a small community (fig. 3).

In 1890 Julius Langbehn, author of *Rembrandt als Erzieher* (Rembrandt as Educator), invented the concept of *Heimatkunst*[*]. Langbehn's nationalist tract sold sixty thousand copies in the first year, and the fortieth edition was in print by 1892. His theories, saturated with an early "blood-and-soil" mentality, along with Paul de Lagarde's *Deutsche Schriften* (German Writings) were so successful because they appealed to a so-called healthy folk mentality and fancied that the enemy was lurking in the art of their age.[3] It was imperative to combat degeneration and decadence, the corruptors of the people. By conjuring up the fearful specter of the degeneration of German spiritual life, these two writers created a hostile image of contemporary forms of life within a democracy of universal conformity. This, they said, could happen only in the newly emerging and universally dominant cities, whose hallmark – feverishly high-strung cultural activity – was to be forced out by revitalizing traditional, time-honored values.[4] In town and country, "itinerant preachers" of culture spread the word of Langbehn to mass audiences. The Hungarian-born Jewish writer Max Nordau, whose influence on his contemporaries is still underestimated, propagated the view that impressionist and other contemporary artists were suffering from nystagmus, an eye disease. In his much-read two-volume work *Entartung* (Degeneration), he classified as degenerate such movements as the British Pre-Raphaelites, the Wagner cult, symbolism, and Zola's naturalism. He found, for instance, that Tolstoy's *Kreutzer Sonata* reveals feelings a normal person would never experience. Other, supposedly statistically substantiated, causes of degeneration listed by Nordau include the consumption of alcoholic beverages, urban migration, the expansion of the railroads, and rising newspaper circulation.[5] Max Nordau and Sâr Péladan mark opposite poles in the bewildering panorama of society in 1890. Their standpoints were undoubtedly based on reaction and counterreaction. The fact that both extremists (as we would call them today) were successful is symptomatic of our modern age.

The year 1890 in Switzerland was also marked by events and decisions that were to have far-reaching consequences. On 1 May, the "First National Exhibition of Art" opened at the Bern Kunstmuseum. It was the first such event to be subsidized, and very generously at that, by the Confederation. In June the Federal Council moved to erect a Swiss National Museum, and in September Lydia Welti-Escher (fig. 4) signed the founding charter of the Gottfried Keller Foundation, a national institution endowed with contemporary millions for the acquisition of works of art. These events were the fruit of earlier efforts, but their simultaneous realization was no accident; a climate favorable to national deeds prevailed, encouraged no doubt by conditions in France and Germany. Since the 1880s, a determined promotion of artists had been the policy, not only of the court, but also of the regional parliament, especially in nearby Bavaria, much frequented by Swiss artists.[6] The difficulties that cropped up there were reflected in Switzerland virtually without exception: the First National Exhibition ran into vehement opposition, and the president of the committee in charge resigned out of protest. The conflict was fired by new, timidly budding tendencies in European painting, which could not be reconciled with the ideals of an older generation. Once again critique targeted the lack of beauty, the realism and poetic indifference of the motifs as well as the disregard of detail. This criticism transports today's observer to France in the 1850s. Although the problems that arose in Paris at the time did not reach Switzerland until some thirty to forty years later, they were discussed with the same lack of consistency. Reactions to the exhibition of 1890 speak of a leveling boredom, which was confirmed by a reconstruction of the 1890 exhibition at the Bern Kunstmuseum in 1980.[7] The modern period was perhaps best represented by two large compositions painted by Ferdinand Hodler (1853-1918). However, the situation changed when Hodler resorted to a private showing of *Night* in Geneva after the painting had been rejected at an official exhibition of the City of Geneva for supposedly transgressing the bounds of decorum. After its remarkable success in Geneva, *Night* was exhibited at the Parisian Salon du Champ-de-Mars and applauded by colleagues and critics. Thus, apart from Arnold Böcklin (1827-1901), who was generally held to be German, Switzerland was able to chalk up an unexpected success abroad, inspiring an upcoming generation of young artists not yet represented at the 1890 exhibition. These successes also led to federal support of the arts through the introduction of scholarships in 1898. Although various scandals blurred the ideal image of national cultivation of the arts, at least they provoked debate on the meaning and purpose of art in parliament and the press, thus belying earlier accusations of official and public indifference. A storm of controversy broke in 1897 over Hodler's frescoes in the new Landesmuseum (National Museum) in Zurich. Both conservative and liberal forces joined the dispute, which ended in victory for Hodler thanks to the unexpectedly direct intervention of the entire Federal Council. The finished murals were solemnly unveiled in 1900.

The controversy over Hodler sensitized the public at large to issues of the arts and led to a polarization of views, similar to the earlier effect of Langbehn's book in Germany. As Hans Ulrich Jost puts it, the moral state of the nation itself was at stake.[8] In 1906, instigated by circles in Lucerne, a few conservative, patriotic artists split off from the Gesellschaft schweizerischer Maler, Bildhauer und Architekten (Association of Swiss Sculptors, Painters, and Architects), supposedly dominated by Hodler, and founded their own group, known as the Secession, which wielded some influence on Swiss fine-arts policy in the years that followed.[9] Disagreement on various fronts continued until the outbreak of World War II. Despite running battles between individual exponents, Swiss painting flourished as never before. The resonance it enjoyed was reflected in the rise of the first contemporary collections. Industrialists – Oskar Miller in Solothurn, Gustav Henneberg, Franz Meyer and Richard Kisling in Zurich, Theodor Reinhart in Winterthur, and Louis LaRoche-Ringwald in

fig. 6: Cuno Amiet (1868-1961), *The Cottage Garden*, 1904, oil on canvas, 120 x 158.5 cm. Kunstmuseum Solothurn.

Basel – began accumulating the first major collections, initially skipping the impressionists.[10] Oscar Miller, a German-born paper manufacturer, made a rather conventional beginning but went on to become a prominent collector of the coming generation, accompanying his acquisitions of works by Ferdinand Hodler, Cuno Amiet, Albert Trachsel (fig. 5), and others with essays published in various versions between 1904 and 1912.[11] His introduction of the siblings from Solothurn, Gertrud Dübi-Müller and Josef Müller (the latter is one of Switzerland's most important collectors), to Cuno Amiet (1868-1961) ushered in a new epoch of private sponsorship of the arts in Switzerland.[12] At the same time, art societies were able to implement long-cherished plans for new museums. One example is the Museum of the City of Solothurn, opened in 1902, which immediately received major loans and gifts including Hodler's *Avalanche* and Cuno Amiet's *Evening Riches*, both acquired thanks to the new policy of federal promotion. Additional works by Hodler and Amiet (fig. 6) came from private endowments.[13] As mentioned above, the works collected by Oscar Miller were painted by the new generation after 1900, who won instant acclaim abroad.

The federal government had also initiated sponsorship of Swiss artists in exhibitions abroad, albeit for only one exhibition a year; but the exposure led to participation in other events as well.[14] Hodler and Amiet received invitations, as did Amiet's painter-friend Giovanni Giacometti (1868-1933) (fig. 7) and the Bernese Max Buri (1868-1915) (fig. 8), who had studied in both Paris and Munich. Donald Gordon's research on art exhibitions in Europe lists twenty-three exhibitions for Amiet, seventeen for Buri, nine for Giovanni Giacometti, and fifty-four for Hodler.[15] Hodler first attracted international attention at the Vienna Secession exhibitions in 1903 and 1904. Amiet, who had earlier shown work in Vienna, also received a certain amount of attention there in 1904, chiefly as a successor to Hodler – much to his displeasure. Nevertheless, various German authorities subsequently invited him to exhibit, the most consequential being Emil Richter's Art

Salon in Dresden. Richter's gallery represented the newly established association *Die Brücke*, whose artists Kirchner, Heckel, and Pechstein, unlike the public in Vienna, were much impressed by Amiet's work. A year later, in 1906, Amiet even joined *Die Brücke* and was represented in their first show at the Seifert lamp manufactory in Dresden and again in 1907 at Richter's Salon (fig. 9).[16]

While Hodler and Amiet are still represented in museums and exhibitions outside Switzerland, Max Buri and Giovanni Giacometti have been virtually forgotten abroad. I single out Buri because he seems to embody the identity of Switzerland more than any of the artists mentioned above. In a statement characteristic of the fifties, the encyclopedia of Swiss artists calls Buri "an indepedent and forceful representative of the Swiss national style founded by Hodler."[17] Buri does in fact unite several qualities that can be identified with Switzerland. His motifs are the countryside and customs of Bern, and portraits both of himself and his family. In contrast to Amiet and Giacometti, who also cultivated the iconography of the family, Buri was exceptional, even for Switzerland, in the single-minded focus on his own small world.[18] To understand why Buri's paintings met with such a lively response especially in Germany (in Munich alone he won two gold medals, in 1905 and 1913), we must take a closer look at relations between Germany and Switzerland. With the political cement joining the country barely dried, Bismarck and William II's Germany was seeking a new definition of itself on another level, much like the circles in Switzerland that sought to counteract cantonalism. After 1890 a cautious but steady move toward rapprochement between the two countries can be observed, which culminated in William II's visit in 1912. In the art world, this rapprochement was reflected in a strongly represented Switzerland at the Sonderbund exhibition in Cologne that same year. Marcel Baumgartner has drawn attention to the diverse activities of the Verband der Kunstfreunde in den Ländern am Rhein (Association of Art Patrons in the States along the Rhine), founded in 1903, and its chairman Wilhelm

fig. 7: Giovanni Giacometti (1838-1933), *Mother and Child*, 1900, oil on canvas, 100 x 80 cm. Bündner Kunstmuseum, Chur.

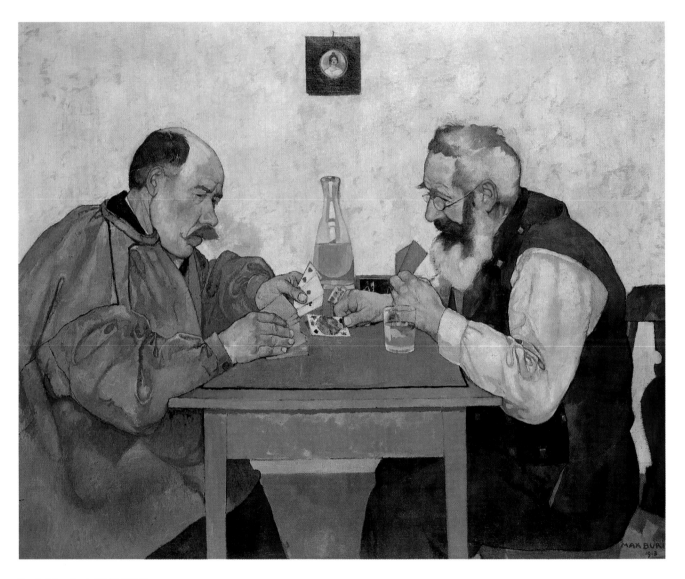

fig. 8: Max Buri (1868-1915),
Two Cardplayers, 1913,
oil on canvas, 121 x 150 cm.
Private collection.

Schäfer.[19] By 1904 Alsace-Lorraine had already joined the organization and negotiations were underway to include Switzerland as well; the Swiss branch was established in 1908. The quintessence of these endeavors rested on a view of Switzerland as a kind of *Ur-germania*; Swiss characteristics such as rough, unhewn social conduct combined with spiritual depth were held to be archetypically German and thus "more of the essence" than contemporary developments. Hodler and his "successor" Buri, considered inmost purveyors of the German race, were fostered by Schäfer and Theodor Alt to counterbalance the "formal caprices of diseased and decadent French artists."[20]

Quite aside from the fatal consequences of these theories in Germany itself, the radically misconstrued view of Switzerland elicited reactions that Baumgartner calls an "act of self-defense."[21] Since Schäfer considered French- and Italian-speaking Switzerland basically alien elements that ought to be sloughed off, people like Carl Albert Loosli, Hodler's confidant and general secretary of the Association of Swiss Painters, Sculptors, and Architects, espoused a revaluation of circumstances in Switzerland, which were so different from Germany's. The fruitful tension of multilingual and multicultural coexistence was actually the guarantor of national unity in Switzerland, as manifest in the new heights achieved in Swiss painting by Hodler, Amiet, Giacometti, and Buri. Hodler, a native of Bern, had lived in Geneva since his youth; Giovanni Giacometti had come from Italian-speaking Bergell, and Amiet from traditionally Francophile Solothurn. The only one who really satisfied the requirements of the German formula was Buri, who suffered a fatal accident in 1915 and ranks considerably lower in the history of Swiss art than the Hodler-Amiet-Giacometti trio.[22] A glance at the situation in contemporary literature is of relevance in this context. The above-named writer, C.A. Loosli, proved to be a key figure in contemporary criticism. Also active in the Association of Art Patrons in the States along the Rhine, Loosli was equally versed in art and literature, and published a variety of articles on the question of a Swiss

fig. 9: Cuno Amiet
(1868-1961), *The Yellow Hill*,
1903, tempera on canvas,
98 x 72 cm.
Private collection.

national culture. In an essay of 1911, he came to the conclusion that art in Switzerland is not national but autochthonous, advancing an astonishingly modern theory of the revaluation of the region. In fact, much of the thinking and writing of that period is still of relevance today.[23]

We cannot comment on all the other, equally significant aspects of the period prior to World War I, but, given his special situation, mention must be made of Paul Klee (1879-1940). Born in Bern in 1879, he belongs to a slightly younger generation than the artists discussed above. His father was a German musician from the Rhineland, his mother a Swiss singer born in Besançon. He trained in Munich from 1898 to 1901 and was as much at home there as in Bern, but even after political circumstance compelled him to return to Switzerland in 1933, he was never awarded Swiss citizenship. Both his writings and his artistic output are a mine of information for the investigation of the relationship between the cities of Munich and Bern. Klee's mastery of ironic, satiric language was unmatched by any of his predecessors. Like the generation that came after Hodler, he did not share older colleagues' visionary inclinations.[24] Hodler, born in 1853, and Segantini, five years his junior, constructed an idealistic *Weltanschauung* that sought to improve the world and society (fig. 10). In a lecture given in Fribourg on 12 March 1897, *La mission de l'artiste*, Hodler summed up his simple but often abstruse ideas.[25] Their prehistory can be traced in his writings and especially his paintings since the 1880s. *The Lonely One* and *The Chosen One* represent a world view tantamount to that of a seer or a prophet. The public, unprepared for the uncompromising imagery of the two paintings and also of *Night* (1891), showed little appreciation of them. These innovative elements were international in scale: Edvard Munch, from the north (1863-1944), and Italian-born Giovanni Segantini (fig. 11) had produced similarly visionary compositions. Hodler, Munch, and Segantini also shared the idea of the cycle. The key works produced by all three between 1890 and 1900 revolved around the subject matters of birth, love,

longing, age, and death.[26] Segantini's recently published letters offer more insight into the spiritual content of the paintings in question. In a letter of 12 November 1896 to poet Domenico Tumiati, he writes, "… il nostro gruppo manderà scintille nell'oscurità della prossima decadenza e manderà fiamma in un lontano rinascimento futuro" (…our group will send sparks into the obscurity of encroaching decadence and send flames into a distant future rebirth).[27] Obviously, an idealistic message of this kind does not directly invoke demands for national painting or the moral claims of a Langbehn or a Lagarde, but it may well have stimulated more trivial forms of *Heimatkunst*. A more frequent phenomenon around 1900 was the attempt of critics and self-appointed philosophers to read a misunderstood sense of *Heimat* into Hodler's and Segantini's paintings, as exemplified by parliamentary debates on culture. On the other hand, the Bavarian Minister of Culture, Ludwig Anton von Müller, had already acknowledged the freedom of art and artists in 1892 and opposed state interference in this sector.[28] Debate on these issues ensued much later in Switzerland, and was inflamed largely by Hodler and his friends.

The outbreak of World War I snuffed out Europe's flourishing and colorful artistic landscape. On coming home from abroad, many artists were called up for duty. In September 1914, Hodler was signatory to a protest by artists, scientists, and intellectuals in Geneva, condemning German artillery attacks on the Cathedral of Reims as a "barbaric atrocity."[29] In consequence, he was expelled from all the artists' associations in Germany, and his murals in Jena and Hannover were covered up. Reaction and counterreaction signaled the rupture of the once lively artistic relations between Switzerland and Germany. They would never recover their former intensity, not even after the war.

Translated from the German by Catherine Schelbert

fig. 10: Ferdinand Hodler
(1853-1918),
Sensitivity I, 1901/1902,
oil on canvas, 193 x 280.5 cm.
Private collection.

fig. 11: Giovanni Segantini
(1858-1899) "Death" (right pan-
el of *Becoming, Being, Passing*
triptych), 1898/1899, oil on
canvas, 190 x 322 cm.
Segantini Museum, St. Moritz
(Gottfried Keller Foundation).

Notes

* Translator's note. The word *Heimatkunst* refers to native art that may be regional, folkloric, patriotic, quintessentially Swiss, or all of these.

1 Revised version of a lecture given in January 1991 at the Hällisch-Fränkisches Museum der Stadt Schwäbisch-Hall.

2 Cf. for example, Neil Kent, *The Triumph of Light and Nature: Nordic Art 1740–1940* (London: Thames and Hudson, 1987); *Russische Malerei im 19. Jahrhundert: Realismus, Impressionismus, Symbolismus*, cat. (Zurich: Kunsthaus, 3 June–30 July 1989).

3 Julius Langbehn, *Rembrandt als Erzieher* (Leipzig: Hirschfeld, 1922, 50th–55th ed., 1st ed. 1890); Paul de Lagarde, *Deutsche Schriften* (Göttingen, 1886, 1st ed.).

4 Cf. Donald E. Gordon, *Expressionism: Art and Idea* (New Haven, CT; London: Yale Univ. Press, 1987), pp. 9–11.

5 Max Nordau, *Entartung* (Berlin: Duncker, 1892–1893).

6 Cf. Horst Ludwig, *Kunst, Geld und Politik um 1900 in München: Formen und Ziele der Kunstfinanzierung und Kunstpolitik während der Prinzregentenära (1886–1912)*, Kunst, Kultur und Politik im deutschen Kaiserreich 8 (Berlin: Mann, 1986).

7 *Kunstszene Schweiz 1890: Künstler der ersten Nationalen Kunstausstellung im Jahr der Entstehung von Hodlers "Nacht"*, cat. (Bern: Kunstmuseum, 30 May–24 August 1980).

8 Hans Ulrich Jost, "Nation, politics, and art," *From Liotard to Le Corbusier: 200 years of Swiss painting*, cat. (Atlanta, Ga.: High Museum, 9 February–10 April 1988), pp. 13–21.

9 Cf. Lisbeth Marfurt-Elmiger, "Kunstverein und Künstlergesellschaften," *Der Bund fördert, der Bund sammelt: 100 Jahre Kunstförderung des Bundes*, cat. (Aarau: Aargauer Kunsthaus, 1 October–13 November 1988), pp. 25–39.

10 Cf. Lukas Gloor, *Von Böcklin zu Cézanne: die Rezeption des französischen Impressionismus in der deutschen Schweiz* (Bern, etc.: Lang, 1986), pp. 128–149; Hans A. Lüthy, "Von Hodler-Sammlern," *Ferdinand Hodler: Sammlung Max Schmidheiny*, Kataloge Schweizer Museen und Sammlungen 11 (Zurich: Schweizerisches Institut für Kunstwissenschaft, 1989), pp. 29–38.

11 Oscar Miller, *Von Stoff zu Form: Essays* (Frauenfeld: Huber, 1904, 2nd enlarged ed. 1906).

12 Cf. *Schweizer Kunst in der Sammlung Josef Müller*, cat. (Solothurn: Museum der Stadt, 15 June–7 September 1975).

13 Cf. Peter Vignau-Wilberg, *Museum der Stadt Solothurn: Gemälde und Skulpturen*, Kataloge Schweizer Museen und Sammlungen 2 (Zurich: Schweizerisches Institut für Kunstwissenschaft, 1973), p. 9.

14 Cf. Marguerite and Cäsar Menz-von der Mühll, "Zwischen Kommerz, Kompromiss und Kunstvorstellung," *Der Bund fördert, der Bund sammelt: 100 Jahre Kunstförderung des Bundes*, cat. (Aarau: Aargauer Kunsthaus, 1 October–13 November 1988), pp. 53–55.

15 Donald E. Gordon, *Modern art exhibitions 1900–1916*, Materialien zur Kunst des 19. Jahrhunderts 14/I–II (Munich: Prestel, 1974).

16 Cf. *Amiet und die Maler der Brücke*, cat. (Zurich: Kunsthaus, 18 May–5 August 1979; Berlin: Brücke Museum, 31 August–4 November 1979); Günter Krüger, "Die Künstlergemeinschaft Brücke und die Schweiz," *Zeitschrift des Deutschen Vereins für Kunstwissenschaft* 34 (1980), pp. 131–161.

17 *Künstlerlexikon der Schweiz XX. Jahrhundert*, vol. 1 (Frauenfeld: Huber, 1958–1961), p. 154.

18 Cf. Marcel Baumgartner, *L'art pour l'Aare: bernische Kunst im 20. Jahrhundert* (Wabern: Büchler, 1984), pp. 96–100; Hans Graber, *Max Buri: sein Leben und Werk* (Basel: Schwabe, 1916).

19 Marcel Baumgartner, " 'Schweizer Kunst' und 'deutsche Natur': Wilhelm Schäfer, der 'Verband der Kunstfreunde in den Ländern am Rhein' und die neue Kunst in der Schweiz zu Beginn des 20. Jahrhunderts," *Auf dem Weg zu einer schweizerischen Identität 1848–1945: 8. Kolloquium der Schweizerischen Akademie der Geisteswissenschaften 1985* (Freiburg, Switz.: University Press, 1987), pp. 291–308.

20 Theodor Alt, *Die Herabwertung der deutschen Kunst durch die Parteigänger des Impressionismus* (Mannheim, 1911), p. 441; cf. also Wilhelm Schäfer, *Die moderne Malerei der deutschen Schweiz* (Frauenfeld and Leipzig: Huber, 1924).

21 Marcel Baumgartner, "Schweizer Kunst" und "deutsche Natur"... (see note 19), p. 295.

22 Cf. Hans A. Lüthy and Hans-Jörg Heusser, *Kunst in der Schweiz 1890–1980* (Zurich and Schwäbisch-Hall: Orell Füssli, 1983), pp. 20–21.

23 On Loosli, see also Erwin Marti, "Die GSMBA, Ferdinand Hodler und Carl Albert Loosli," *Der sanfte Trug des Berner Milieus*, cat. (Bern: Kunstmuseum, 26 February–15 May 1988), pp. 101–125.

24 Cf. Hans Christoph von Tavel, "Dokumente zum Phänomen 'Avantgarde': Paul Klee und der moderne Bund in der Schweiz, 1910–1912," *Beiträge zur Kunst des 19. und 20. Jahrhunderts*, Jahrbuch SIK 1968/69 (Zurich: Schweizerisches Institut für Kunstwissenschaft, 1970), pp. 69–116.

25 Manuscript facsimile in *Hodler und Freiburg: die Mission des Künstlers*, cat. of exhibition at Musée d'art et d'histoire, Fribourg, 11 June–20 September 1981 (Bern: Benteli, 1981).

26 Cf. also Harald Szeemann, ed., *Visionäre Schweiz*, cat. of exhibition at Kunsthaus, Zurich, 1 November 1991–26 February 1992, Städtische Kunsthalle, Düsseldorf, 26 June–30 August 1992 (Aarau, etc.: Sauerländer, 1991).

27 Giovanni Segantini, *Trent'anni di vita artistica europea nei carteggi inediti dell'artista e dei suoi mecenati* / a cura di Annie-Paule Quinsac (Oggiono, Lecco: Cattaneo, 1985), p. 720.

28 Cf. Horst Ludwig, *Kunst, Geld und Politik um 1900 in München* (see note 6 above), p. 51.

29 Cf. Jura Brüschwiler, "*Ferdinand Hodler* (Bern 1853–Genf 1918): chronologische Übersicht," 2 March–24 April 1983, Paris: Musée du Petit Palais, 11 May–24 July 1983, Zurich: Kunsthaus, 19 August–23 October 1983), p. 158.

Picture credits

figs. 1–3, 5–11: Schweizerisches Institut für Kunstwissenschaft, Zurich

fig. 4: Kunsthaus Zurich, Gottfried Keller Foundation

The Twentieth Century

Erected on a natural sun deck high above Davos and exemplary for its type and time, this building fulfills modern medicine's demands for a closed, strictly regimented sanatorium. Even the exterior suggests hygiene and functionalism. The private balconies of the patients' rooms and the communal relaxation rooms on the sides form the characteristic skeleton of the architecture of health, for which Switzerland was famous in the late nineteenth and early twentieth centuries.

> *.... And to the pulsation of the floor, and the*
> *snapping and cracking of the forces at play, Hans*
> *Castorp peered through the lighted window,*
> *peered into Joachim Ziemssen's empty skeleton.*
> *The breastbone and spine fell together in*
> *a single dark column. The frontal structure of the*
> *ribs was cut across by the paler structure of the*
> *back. Above, the collar-bones branched off on both*
> *sides, and the framework of the shoulder, with*
> *the joint and the beginning of Joachim's arm, showed*
> *sharp and bare through the soft envelope of flesh.*
> *The thoracic cavity was light, but blood-vessels were*
> *to be seen, some dark spots, a blackish shadow.*
> Thomas Mann, *The Magic Mountain*, chap. 5
> (Penguin Books, p. 217).

Ernst Ludwig Kirchner, one of the prime representatives of German expressionism, moved to Davos in 1917 "because of a lung condition and weakness," living and working there until his death in 1938.

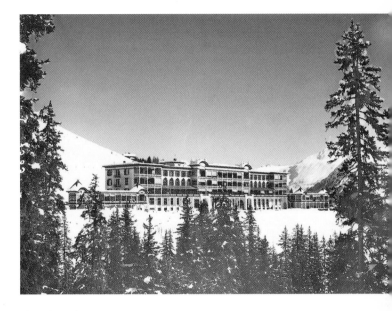

The Schatzalp Sanatorium in Davos, built 1899-1900 by the architects Otto Pfleghard and Max Haefeli.

Ernst Ludwig Kirchner, *The Madmen*, woodcut.

Hans Arp, *Configuration*, 1927/1928, painted wood relief,
145.5 x 115.5 x 3.3 cm. Kunstmuseum Basel.

Paul Klee, Swiss-born son of
a German father and a Bernese
mother, fled back to Switzerland
in 1933 and died there in 1940,
shortly before his application
for Swiss citizenship was ap-
proved. "Emigration" to the
land of his birth, the ambivalent
feeling of having come home
and yet being in exile, but also
Klee's view of himself as an art-
ist unfathomable in this world –
all of these elements are present
in his late works. Both-And,
Neither-Nor, In-between and
Reversible, Klee's last creations
bring home the artist's situation
with particular intensity. The
inscription on his gravestone
reads: "I cannot be fathomed on
this earth / for I can as easily
live among the dead / as among
the unborn / Somewhat closer to
the heart of Creation than usual
and far from close enough."

The isolation of neutral Switzerland during World War I
had a direct effect on art. Dada, the new freedom of and in
art, was the brainchild of immigrants in Zurich. Between
1915 and 1920, Zurich, with its "Cabaret Voltaire," was
one of the centers of dada, a movement that reacted to the
destruction of European tradition by breaking radically
with conventional aesthetics and politics of any kind.
Dada was the consistent expression of intellectual protest
against so-called reason, against national interests, the
bourgeoisie, and war. Primarily a literary-theatrical move-
ment, it also attracted artists and musicians. The Alsatian-
born Hans Arp (1887-1916) participated in the foun-
dation of "dadaism," a response to the absurdity of war.
He created his "collages with squares arranged according
to the laws of chance" in 1917, in close collaboration with
his wife, Sophie Taeuber-Arp (1889-1943). The resolve to
abandon traditional means of expression led the Arps back
to nature as metamorphosis and constant wellspring.
"Like nature, dada is devoid of meaning. Dada is for na-
ture and against art. Dada is as immediate as nature and
attempts to provide every object with its essential place.
Dada is as moral as nature," wrote Hans Arp program-
matically.

Paul Klee, *Still Life*, 1940, oil on canvas, 100 x 80.5 cm. Private collection.

*They still give me this funny feeling: they are
familiar, they walk down the street. Thus they are at
the bottom of time, at the origin of everything;
they are forever approaching and shrinking back into
absolute immobility. My gaze may try to tame them,
to get closer to them – but without anger,
without exasperation or heat, simply because of a
distance between them and me that I had not
noticed before because it was so very compressed and
reduced to the point of making them seem quite
close – yet they move out of sight: this distance
between them and myself has unfurled. Where are
they going? And although their effigy remains visible,
where are they? (I am talking mainly about the
eight large statues exhibited in Venice this summer.)*
Jean Genêt, *The Studio of Alberto Giacometti*, 1957.

Alberto Giacometti
(1901-1966), *Place*, 1948-1949,
bronze, base 43.1 x 63.5 cm,
height 24.1 cm.
Kunstmuseum Basel.

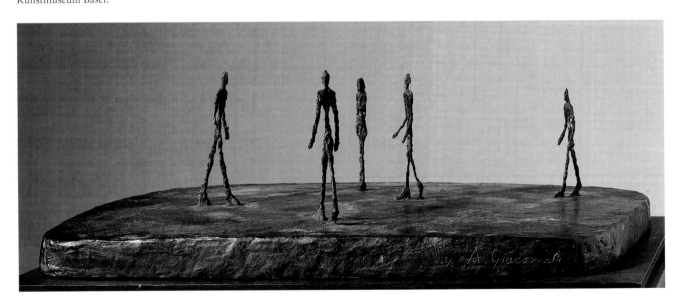

Richard Paul Lohse (1902-1988), *Twelve vertical and twelve horizontal progressions*, 1943-1944, oil on canvas, 78 x 90 cm.

During World War II, Switzerland became a haven – as it had already been in World War I – for a variety of people, among them artists of all orientations. And it was here that constructive art as formulated by the Zurich "concretes" evolved. Max Bill's 1944 exhibition at the Kunstmuseum in Basel, entitled "Concrete Art," was at once culmination and program of this form of artistic expression. Richard Paul Lohse enjoyed a singular position in Zurich's concrete-art circle:

Every cultural expression has a corresponding social basis, every aesthetic its cosmology.
In no other form of art do the media and methods of this global strategy find legitimate expression as they do in constructive, logical or systematic art, which is the sublimated and critical echo of the structures of civilization. No other art form in the field of visual creation partakes to such a degree of a phenomenon that is characteristic of our times: structural thinking.

Richard Paul Lohse, *Modulare und Serielle Ordnungen*, 1982.

Meret Oppenheim (1913-1985), *Fur Breakfast*, 1936, fur-covered cup, saucer, and spoon; 7.3 cm high, saucer 23.7 cm in diameter. Museum of Modern Art, New York. Purchased 1946.

Probably Meret Oppenheim's most famous work, *Fur Breakfast* became an icon of surrealism – understood here as an undogmatic, even casual alienation of familiar things (dishes, fur). The whimsical inspirations of this imaginative, versatile artist, who could not be classified in "isms," are among the rare specimens of Swiss, or even of surrealist, art to reveal sparks of visual wit and relaxed humor. When the cup object was shown at the "Fantastic art, Dada, Surrealism" exhibition at the Museum of Modern Art in New York in 1936, one paper wrote: "Whatnext? cries the surrealism-beset world. Just as though things weren't dada enough, the surrealists had to come to America with their fantastic art. The fur-lined cup and saucer, with spoon thrown in for good measure, gives an idea of the cause of all the goofiness started by the surrealist art exhibit in New York." A mass-produced object had been alienated from its purpose by fur-lining, been declared a work of art, and had landed in the MOMA, where it still rests on its pedestal today. Meret Oppenheim was somewhat amazed at all this, but found it exceedingly funny. The artist was born in Berlin-Charlottenburg to a German physician and his Swiss wife, Eva Wenger, in 1913. She was taken to Switzerland to live in 1914, spent the years 1932 to 1937 in Paris, where she created *Fur Breakfast*, and then returned to Switzerland. In 1983, the year of her seventieth birthday, the City of Bern erected a fountain based on her designs on Waisenhaus Square. The result is a combination of pillar and tower, encircled by two spiraling metal tracks, one an openwork gutter discharging water and one filled with green plants. Meret Oppenheim calls her designs for the fountain Algae Tree, Spiral Pillar, and Water Pillar.

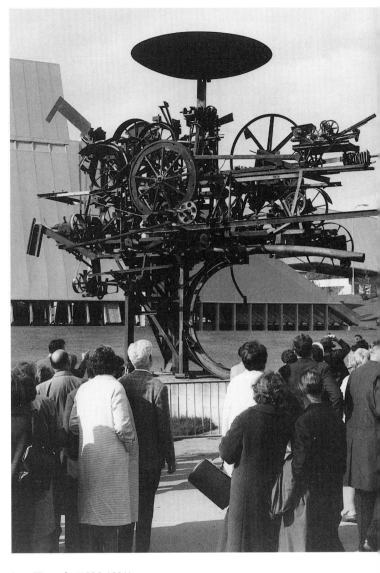

Jean Tinguely (1925-1991),
Eureka, sculpture machine,
1963-1964 for
the Swiss National Exhibition
in Lausanne, now in the Seepark
Zurichhorn, Zurich. Metal,
wood, electromotors, rust-col-
ored, 780 x 600 x 410 cm.

For Static Being.
Everything moves. Immobility does not exist.
Do not be dominated by antiquated notions of time.
Forget hours, minutes, seconds. Don't resist
metamorphosis. Live in time. Be static. Be static –
With movement. Resist the anguished fear that
leads you to halt movement, crystallize the passing
moment and kill what is alive. Stop insisting
on self-destructive 'values.' Be free, live! Stop
'painting' time. Stop building cathedrals and pyra-
mids destined to fall into ruins. Breathe deeply.
Live in the present. Live in time and according to time
for a wonderful and absolute reality.
Jean Tinguely, March 1959.

The park had been embellished with a work of art:

It is a work by Pierre Töbeli, Movement IV, three
times as tall as a man, the most advanced
model of an experimental series of engine-driven
sculptures. It moves. When a small engine is
attached, cleverly mounted cog-wheels, pistons,
connecting rods, and transmissions are set
into motion over massive train-springs from the last
century, with no recognizable plan or practical use,
but with a certain iron solemnity and a sledge-
hammer charm that many find appealing.
Despite its thick concrete foundations, Movement IV
has the ability to make the ground around it
quake. On Sundays, when the weather is dry, it
is set into motion, and the little engine, coughing up
blue smoke, adds its stammering rhythm to
the general noise. When the demonstration is over,
the engine is detached and locked into the
'mountain' firehouse. So Movement IV is protected
against mischief.
Adolf Muschg, *Gegenzauber*, 1967

Mario Botta, Headquarters
of the Banca del Gottardo,
front Viale Stefano Franscini.
Lugano, 1982-1988.

From the competition program:

> *The new building is to be planned in such
> a way that its architectonic concept and outward
> appearance express the bank's young, dynamic
> spirit. As the bank's headquarters, the building
> should stand out and stand up for itself. At the same
> time it should provide the city with a new center
> of interest. All this notwithstanding, it should
> not be forgotten that apart from having a
> representative character, the building will also be
> serving administrative purposes. The economic
> aspect must also be taken into account.*

Adolf Max Vogt

How Danube and Bosporus
Made a European out of Le Corbusier

In October 1991, the Collège européen de coopération culturelle (CEEC) held a conference in Czechoslovakia, not in Prague but in Bratislava, the second major city and capital of the Slovakian minority. The organizers wanted to present profiles of the lives of prominent "Europeans *avant la lettre*." They addressed the following question to me: What experience made Corbusier an early, prophetic European? My reply: His journey on the Danube in 1911 with his friend "Klip." – In a nutshell, had he not passed Bratislava on a Danube steamer in the summer of 1911, Charles-Edouard Jeanneret would never have become Le Corbusier.[1]

At the time, he called the voyage "useful" (*voyage utile*), but looking back over fifty-four years of endeavor shortly before he died, Le Corbusier wrote in the foreword to the publication on his *voyage d'orient* that the year 1911 had been "the decisive year... for his development as an artist and an architect." Apparently this man from the Jura hills of Switzerland, the watershed between Rhone and Rhine, owes the turning point in his life to neither of these rivers nor even to his beloved Seine but instead to the Danube, *fleuve colossal*.

The itinerary of the journey published in 1925 in *L'Art décoratif d'Aujourd'hui* (fig. 1) shows, first, an unusual, in fact a "reverse," route; second, a remarkable subsequent classification of the stages of the journey (C for culture, F for folklore, and I for industry); and third, a subtle distortion, or rather a euphemistic treatment, of the enterprise, since it did not begin and end in

fig. 1: Le Corbusier, itinerary
of his journey through eastern
Europe, 1911, drawn up for
L'Art décoratif d'Aujourd'hui,
1925.

Paris: it began in Munich and Vienna, and ended in the architect's native Jura.

Le Corbusier at the Acropolis, Le Corbusier in Rome: these experiences are often described in essays and books as if he had arrived en route from the usual western European trails. The author himself, however, clearly states in the first and second sentences of his preface that he and Klip wanted to undertake a journey *"dont le but est Constantinople"* – whose goal is Constantinople. "With very little money, the two friends traveled from May to October through Bohemia, Serbia, Romania, Bulgaria, and Turkey."

Thus, they were coming from an unwonted direction when they finally reached Athens and Rome, and this, in retrospect, is exactly what Corbusier considered the decisive factor. In contrast to the standard route prescribed by the Grand Tour, the "reverse" itinerary via the Balkans and Istanbul-Constantinople meant:
– besides very little "high" art, a great deal of so-called "low" art, tied up with function and "folklore";
– besides a minor taste of classical antiquity, a great deal of ancient East-Roman and Byzantine art;
– besides rare samplings of Latin Christianity, a plethora of Greek Orthodox samples, buried, however, under layers of Islam as spread by the Turks in eastern Europe since 1453.

This travel route is part of an even now uncompleted project, oriented towards an inclusive rather than an exclusive history of art. It is a history that would not sup-

press the east of Europe and would not have a Roman bias; it would not be Italocentric, but would instead recognize and embrace the Greek-speaking eastern Roman Empire and, with it, the Balkans.

One question remains: who inspired the two friends to undertake such a journey? Le Corbusier enjoyed a geographical advantage, having grown up between two language boundaries. His hometown, La Chaux-de-Fonds, in the Swiss Canton of Jura, is only a few kilometers away from the French border and a mere thirty kilometers from the "border" to German-speaking Switzerland, which runs southeast. The most important teacher at the local art school, L'Eplattenier, knew as much about the contemporary art scene in Germany, specifically Munich, as he did about artistic developments in France. Le Corbusier also learned a great deal from William Ritter, a painter and writer from Neuchâtel, who fascinated him with tales of the Balkans, his home for many years.

August Klipstein, a student of art history in Munich, thus found in Jeanneret a well-prepared and receptive partner. Klipstein, as will be shown, took advantage of every opportunity to introduce his "pupil" from French-speaking Switzerland to the intense developments that marked a new approach to art history, described above as a project oriented toward an inclusive rather than an exclusive history of art and championed especially by Alois Riegl and Wilhelm Worringer.

fig. 2: Le Corbusier's travels
in Germany, 1910/1911, after
Giuliano Gresleri.

The Traditional Grand Tour
and Le Corbusier's "Journey in Reverse"[2]

In his important book *Le Corbusier, Viaggio in Oriente*,[3] Giuliano Gresleri speaks of a "viaggio alla rovescia," a journey in reverse. The old, literally "classical" procedure for the Grand Tour, which had become a must for every cultivated northern European by the end of the seventeenth century, consisted of crossing the Alps, studying the most important monuments in northern and central Italy, and then spending a few weeks or months in Rome as the climax of the journey. People from England, Scandinavia, and German-speaking countries often stopped in Switzerland to spend a night on the Rigi and take in its fabled sunrise, nestled in a wreath of Alps, before tackling the granite of the Gotthard Pass. The Grand Tour thus became an extraordinary highroad, leading from exquisite heights of natural beauty to exquisite heights of culture. Those who had seen the panorama of jagged peaks and icy clefts from the summit of the Rigi and had then studied the cultural panorama of countless ruins and mute witnesses to antiquity in Rome – they knew the world and the world knew them.

Seen in this light, the Grand Tour was indeed a grand, albeit elitist, finale to a bourgeois education in northern Europe. Young, talented burghers from the north left bad weather, material wealth, and scientific progress behind in order to pay their respects to the south with its beautiful weather, its poverty, and its lack of progress, and to try to absorb the rich southern past. Rain versus sun, rich versus poor, progress versus stagnation, present versus past, mere cultivation versus the riches of genuine culture: these bewildering contrasts between northern and southern Europe seemed to fall into place and become reconciled along the route to Rome via the Alps. They seemed to be articulated in the Hegelian thesis of the migration of the world-spirit from the (southern) orient to the (northern) occident.

A unique accumulation of French, English, German, and Scandinavian travel diaries – so-called Italian Journeys

– accompanied by a sea of sketches and travel books, testify to the proliferation of cultural tourism. Even Goethe (1786-1788) considered the prescribed route sacrosanct (the opportunity for an extension or "detour" to Dalmatia and Greece, proposed to him on 28 March 1787, was turned down with anxious regret). But Goethe's contemporaries, the two French architects of the revolution Boullée and Ledoux, apparently refused to undertake the journey to Rome (or kept it a secret), despite the fact that, since 1663-1666, France had insisted on bestowing a "Prix de Rome" upon all talented young painters and architects and dispatching them to the Académie de France à Rome for a few years.

Alternatives to "Rome" and "High" Art

With the advent of romanticism, alternatives to "Rome" began to surface. The traditional song, the fairy tale, folk literature, and folk art were discovered. Intellectuals realized that not all roads led to Rome but that there were and are, in Klee's words, at least "main roads and side roads." Toward 1900, ethnology and anthropology held a grow-

fig. 3: Le Corbusier's friend
and traveling companion,
August Klipstein.

the publication of this far from brilliant photographic testimony: Jeanneret had shot photographs, Le Corbusier did not. According to André Wogensky,[4] Le Corbusier used to say: "Don't take pictures, draw; photography disrupts seeing, drawing impresses itself upon the mind."

Be that as it may, Gresleri's defense of the documentary value of the photographs is invaluable to anyone interested in the time-honored tradition of the Grand Tour, especially since he made a considerable effort, including on-site investigation, to identify the locality shown in each picture. Gresleri researched the drawings with the same devotion, collating and localizing them in view of the most recent findings. His weighty, four-hundred-page synopsis of text, drawings, and photographs presents a definitive study of one of the important alternative Grand Tours of the twentieth century. His judicious and meticulous study of the documents, his astonishing familiarity with local conditions in Germany, the Balkans, and Istanbul stood him in good stead in examining the earlier findings of other scholars (Maurice Besset, Stanislaus von Moos, Paul V. Turner, Patricia Sekler, Tim Benton, Bruno Reichlin, etc.) with the grace of one whose knowledge is firsthand, although he is basically an outsider. As an Italian, he belongs to the Mediterranean people, to those who did not visit because they were visited, who did not travel because they were already "there." And this, I suspect, is exactly what spurs his subtle interest in Le Corbusier's alternative Grand Tour.

August Klipstein, Friend and Fellow Traveler

Gresleri's documentation shows that the alternative Grand Tour would have been inconceivable without the preceding years of tremendously valuable travel in 1910/1911 through German-speaking countries, which took Jeanneret not only to Berlin, where he saw Behrens, but to many other major cities as well (fig. 2). Moreover, the impetus for the grand journey was decisively influenced by his friend Klipstein, a student at the University of Munich when they first met. A look at August Klipstein's un-

ing fascination. Native costumes and songs, pottery and ornamentation, dialect and farmhouse were enthusiastically rediscovered and pitted against "high" classical art. When Jeanneret, sitting in a café in Athens, writes that the Parthenon, perched on the rocky pedestal of the Acropolis, "gets deader up there by the hour" (C'est à chaque heure plus mort là-haut), his "là-haut" has that same aggressive, sarcastic tone that came to be adopted by anthropologists at the turn of the century when speaking about "high" art. In short: Jeanneret and Klipstein's journey to Istanbul-Constantinople (1911), like Klee, Macke, and Moillet's journey to Tunisia (1914), obviously reflects the debate between "high" and "folk" art.

Given these circumstances, Giuliano Gresleri had cogent, persuasive reasons to document the *voyage utile* as thoroughly as possible, even including the publication of numerous photographs of the journey. But first Gresleri had to overcome a weighty objection from the LC-camp to

published diary substantiates this hypothesis. "Klip" (fig. 3), born in Flanders, raised in Laubach near Frankfurt, and Jeanneret's senior by two years, also acquired his education by way of detour.

Originally trained as a book dealer, he went back to school to get his *abitur* (required for unversity entrance), which enabled him to study art history, first in Paris and later in Munich. Wanting to improve his French, he posted a notice on the university bulletin board for someone to practice conversation with. When Jeanneret turned up, "three steps along the street in front of the university and we were friends."[5] The dual-language experiment in conversation led to plans for the journey and a lasting friendship that survived the hardships of strenuous traveling conditions. Klipstein was interested not only in the modern French painters of his day, from Manet to Cézanne, but especially in El Greco, whose oeuvre he had studied on a trip to Spain and about whom he wrote his dissertation. One of his goals, therefore, was to view the El Greco collection at the summer residence of the imperial court of Romania (Sinai) – a good reason for the Balkan variation of the Grand Tour.

Mrs. V. Wolker-Klipstein of Küsnacht near Zurich has kindly lent her father's travel diary to the Institute for the History and Theory of Architecture at the Federal Institute of Technology. It is a fifty-three-page typed manuscript with obviously unfinished, handwritten corrections and additions. Since contact between Gresleri and the Institute was not established until shortly before his book on the *Viaggio* went to press, it was unfortunately too late for him to include the manuscript in his documentation.

The following quotations from Klipstein's notes will enable readers to judge for themselves the importance of Klipstein's contribution to the journey and the advisability of publishing his text in full. One thing is certain: "Auguste" was a partner and not merely an accessory to the journey. There is, in fact, ample indication that it was he rather than Jeanneret who conceived of the alternative Grand Tour. Jeanneret was of course receptive to ideas of

this nature, having been influenced by his older friend and compatriot William Ritter, who, as mentioned above, spent many years in the Balkans and devoted some of his writings to the cultures of the Danube.[6]

A passage at the very beginning of Klipstein's notes surprisingly advances a theoretical explanation for the alternative Grand Tour:

> *The Age of Romanticism, in which the passionate wish of sensitive natures culminated in enjoying Constantinople ... is long past. You [Jeanneret] remember the long hours we spent arguing at night about the definition of culture and civilization.... Over the centuries, we have forgotten what we owe the Orient; public schooling has only managed to preserve for the people a purely superficial understanding of Greece; and school, our important educator, has entirely forgotten that the Greeks led earlier achievements to ultimate perfection, that they took over most of them, and that the direct source of those early and so advanced civilizations was the Orient of today. The future will bring a great transformation in this field, and, above all, the oriental arts will be met with the same appreciation as Attic and Florentine-Roman art.*
> (Klipstein, MS pp. 1/2)

Klipstein Talks to his friend about the Latest Art Theory

The reasoning behind the nascent revaluation of oriental art is expressed in terms of the most modern spirit of Klipstein's age:

> *In Mohammedan art, the pictorial aspect* excludes the figurative representation of man with a literary motif. *What remains is* only *the distribution of line and color. It is of the greatest importance that* literary content disappear from the outset, *a state that greatly detracts from the appreciation of the occidental work of art....*
> (MS p. 2, emphasis A.M.V.)

However awkward or clumsy, this passage clearly discloses the motivation underlying the alternative journey. The two young men set themselves the goal of reaching the most important city of Islam in the hopes of finding art "without a literary motif," i.e., a tradition of abstract art. After all, Klipstein was in Paris just as cubism entered the scene. Now, like Jeanneret, he is in Munich – along with Franz Marc, Gabrielle Münther, Wassily Kandinsky, and other artists in the *Blaue Reiter* group, who were seeking the breakthrough to abstraction.

How conscious art historian Klipstein was of this motivation is demonstrated by the words of Wilhelm Worringer, unexpectedly quoted (MS p. 39) in the midst of notes on three mosques (Sultan Mehmed, Selim Pasha, and Mihrimah) and a Byzantine church (the Serguis and Bacchus Church) in Istanbul:

> *The primordial art drive has nothing to do with the representation of nature. It seeks* pure abstraction as the only opportunity for rest within the confusion and uncertainty of the world, and, with instinctive necessity, creates geometric abstraction of its own accord.
> (Worringer, *Einfühlung und Abstraktion*)

This passage is quoted verbatim from Worringer's book (p. 44), whose title, erroneously reversed by Klipstein, actually reads *Abstraktion und Einfühlung* (Abstraction and Empathy) – and for good reason since Worringer championed the theory that the first, primordial articulation of art was abstract in nature. The book – one of those rare dissertations that was to become widely read and to enjoy several editions – was published in 1907, making it four years old at the time of the trip and apparently part of Klipstein's luggage. The quoted paragraph toward the end of Worringer's theoretical reflections acts as a summary. It opens with two words, omitted by Klipstein, that unmistakably mark it as a main thesis: "We recapitulate: the primordial art drive ..."

This quotation conjures up an image of the two traveling companions discussing these issues for hours, alternately speaking French and German. Gradually one realizes that many of Klipstein's notes were a commentary on or corroboration of Worringer's hypotheses and that he had actually planned the journey as an on-site investigation, as it were, of Worringer's theories. And Jeanneret? To him, these two sentences must have sounded like a challenge to transcend the experience of design acquired from the Perrets and Peter Behrens in order to set out on a path of his own.

Financing the Journey: Le Corbusier's Notes for Newspaper Articles

Unlike Klipstein, Le Corbusier made more systematic notes on the journey as source material for newspaper articles, some of which were actually published in the *Feuille d'Avis*, his hometown newspaper in La Chaux-de-Fonds. Le Corbusier's uncle was on the editorial staff and apparently willing to help support his nephew's journey in this manner. Three years later, in 1914, Gaspar Valette wanted to publish the revised text as a book with Mercure de France, but the outbreak of the war thwarted his plans. For years the manuscript gathered dust among other papers and was forgotten. After more than half a century, this *Testimony of Doubt and Discovery* acquired renewed meaning for Le Corbusier; he reworked the text and prepared it for publication. In July 1965, six weeks before his death on 27 August, he corrected the proofs. Thus his first book became his last.

The Danube, the Balkans

As mentioned above, when Le Corbusier subsequently drew up a map of the "voyage utile" for *L'Art décoratif d'Aujourd'hui*, he classified it according to the categories of C for culture, F for folklore, and I for industry. After Vienna and Istanbul, the route is stamped exclusively "F" (fig. 1), although, for instance, the lightweight iron bridges

fig. 4: Fire in the Old Town of Istanbul, 23/24 July 1911. Photograph from Le Corbusier's archives.

fig. 5: Istanbul. Watercolor by Le Corbusier.

over the Danube (planned in part by Gustave Eiffel's team in Paris) were a fascinating sign for Jeanneret of advancing industry and although Adrianople (Edirne) made a strong impression (as "C") on the two travelers as the first ancient Turkish city of mosques on the way to Constantinople.

In his chapter "Le Danube," Jeanneret describes meeting a student of architecture from Prague on the steamship, with whom he had an impassioned exchange about the iron bridges: "...our interlocuter has only contempt for them. We defend the beautiful, modern technique." In this respect, however, Klipstein actually seems to side more with the student from Prague in his section on Baja, the Hungarian city of potters on the Danube. Having observed that modern pottery is trying to change the old patterns "through any number of new ideas," he comes to the pessimistic conclusion that "the machine has killed craftsmanship in our age and has thus undercut the artistic aspect of tradition." (MS p. 9)

In contrast to Jeanneret, Klipstein had no literary pretensions; his impartial, at times undeniably naive account oscillates between realistic reporting and ponderous expository deduction, as shown by his visit to a potter:

The potter did not disappoint us. After passing through a charming little garden, we had to climb a small chicken ladder to the attic, where the heat was suffocating, and there found a whole mountain of wonderful black-glazed pottery with yellow and brick-red flowers. Edouard (Jeanneret) was ecstatic and immediately began making a selection. In the potter's room lived his old mother, who was 102 years old. She wept with joy at hearing German spoken again for the first time in thirty years. She had come from the region of Frankfurt. There is something very special about peasant pottery, because it represents an applied art whose components are tradition and purely instinctive creation, a self-contained form whose organism is given highly sensual expression through drawing.

Here is a means of uniting the three-dimensionality of space, heightened and given expression through linear design, with the decorative effect of color, without relying on a literary motif. (MS pp. 8/9)

Istanbul – Constantinople – Byzantium

Since the route via the Sea of Marmara was considered the most impressive approach to the city of three names, the two friends took it upon themselves to travel from Edirne to Rodosto (Tekirdag) and to embark there. While waiting for the ship, they acquired a sunburn on their first swim in the sea, "a glacier burn of the worst sort."

One has to endure dreadful discomfort. At night in a place full of bedbugs, with fever and pain making it impossible to sleep, and then at five o'clock the next morning boarding a small steamer for the fourteen-hour sail in storm and rain

fig. 6: Istanbul. Drawing by
Le Corbusier.

fig. 7: A view of Tarnovo
(Bulgaria). Drawing by
Le Corbusier.

As one can see, Jeanneret drew on models in literature as
well; even in his early days he suffered few scruples regard-
ing appropriation! The result is both worse and better than
Claude Farrère. Jeanneret makes a dilettantish move in
reiterating the imperious "I want" but adds something
that Farrère would hardly have been capable of seeing: the
comparison of the color white to rough chalk and the
acoustic association of "crunching light."

The Splendor and Horrors of Istanbul

According to Klipstein, the travelers stayed in Istanbul
from 5 July to 24 August 1911 (MS p. 25). Towards the
end of July (23/24 July), there was a major fire in the Old
Town of Stamboul which had a profound impact on the
two friends. The disappointment upon their arrival grad-
ually turned into fascination, but also into visions of hor-
ror. After only a few days Klipstein wrote:

*to Constantinople! It is curious that I did not get
seasick. All the people around me were a miserable
sight to behold. We were thrown from one
corner to the other as the ship pitched and rolled.
These were not particularly pleasurable days.
Even our good mood abandoned us for a few hours.
And then, to top it off, the very reason for taking
the sea route proved to be in vain, for the grandiose
view of Constantinople on approaching the
city by sea was grey in grey. We were not a little
disappointed, which we still are. There is far too
much talk about the beauty of Istanbul. One's
expectations are much too high and are bound to be
disappointed. (MS p. 25)*

These high expectations are forcefully described by Jean-
neret in his chapter on Constantinople: "I want Stambul
to be white, rough like chalk, so that the light grates upon
it.... Under the white light, I want an utterly white city; but
it has to be dotted with green cypresses." The intensely,
imperiously formulated image apparently had literary
precedents, as scholars have come to realize; the above
lines draw on Claude Farrère's novel *L'homme qui assas-
sina*, which was in Jeanneret's possession. In Farrère's
words: "Under the white light, I want to find a complete-
ly new city, and dotted with green cypresses.... I have come
in order to admire these things, which I recognized as
being so beautiful."[7]

*We feel very comfortable here, have superb lodgings,
with a magnificent view of the Golden Horn,
Stamboul with the Aya Sofia, Sultan Ahmet, Sultan
Suleiman, Sultan Mehmed, and a number of
smaller mosques. One can see a narrow slice of the
Sea of Marmara and, on the horizon, the high
wall of Asian mountains with the snowcapped peak
of Olympus (Uludag). A bit too panoramic – but
that is, after all, what the much vaunted beauty of
Constantinople consists in. (MS p. 28)*

Jeanneret also devoted a chapter to the calamitous blaze
that consumed nine thousand buildings: "Le désastre de
Stamboul." Gresleri found a night photograph of the fire
and the glowing arc of flame in the Le Corbusier archives
(fig. 4). Klipstein's words read like an articulation of this
photograph.

*From our windows above the Petit Champs,
we were able to watch the grandiose drama the
whole night. The Golden Horn was bathed
in golden reflection, above it the jagged black line of
the horizon with the pyramidal superstructures of*

*the various mosques set off in sharp silhouette
against the gigantic masses of luminous yellow
smoke. One vast sea of fire from Sultan Bayazit to
Sultan Mehmed, out of which one saw mighty flames
shooting up periodically, and the cypresses in the
smaller cemeteries burning like huge torches.*
(MS p. 34)

The travelers made up for their bungled arrival by taking
further boat rides on the Sea of Marmara, probably to the
Princes' Islands. A watercolor by Jeanneret imparts the
brilliance of the water city and its castle (seraglio), with
cypresses, domes, and minarets (fig. 5); and at least one
drawing clearly shows how the mosques appear, in the
morning and evening light, as strictly two-dimensional sil-
houettes divested of materiality (fig. 6).

Long-term Consequences: the Turkish
Oriel Motif

Gresleri's collation of the documents and their localiza-
tion, and the study of Klipstein's diary (with his reflec-
tions on Worringer) not only reveal new findings; they also
pose new questions. One of these questions is, of course,

how the alternative Grand Tour affected Jeanneret's paint-
ing and architecture in the following years.

Author Jeanneret reacts repeatedly to the fascination
of geometry and the color (or, rather, noncolor) white.
Draftsman and photographer Jeanneret reacts not only to
le plein et le vide (fullness and emptiness); he also shows
an astonishingly consistent interest in the demarcation and
transition between the two zones, namely, openings such
as windows and doors, and especially intermediate ele-
ments, such as grilles and pergolas. Since space does not
allow a discussion of all of these motifs, we must restrict
ourselves to that of the Turkish oriel.

Interest and delight in projecting, usually slanted and
buttressed parts of buildings was already evident in Tarno-
vo (Bulgaria), where Jeanneret drew the portion of the city
(fig. 7) that slopes steeply down to the Jantro River. The
steeper the terrain, the more obvious the "oriel principle"
of projection and protrusion, which Jeanneret immediate-
ly recognized as a constitutive element of Turkish housing
(which also spread to the north during three hundred years
of Turkish domination in the Balkans). On arriving in
Istanbul, his interest spread to playful variations and
microforms, as in his drawings of dovecotes (fig. 8) that
jut out not only in front but on either side as well.

343

fig. 8: Entrance to an unknown
mosque in Istanbul. Drawing by
Le Corbusier.

The careful shading demonstrates how much attention
Jeanneret already paid to any projection out of the verti-
cal. The Turkish oriel structure is still dominant in the old
parts of Istanbul that were not ravaged by flames.
Jeanneret missed no variants. He made several drawings
of the standard form (figs. 9, 10), two of a deviation in
which the oriel takes in the entire façade (fig. 11), and
finally he shows us a series of oriels along a steep street
(fig. 12). He was especially fascinated by the bold projec-
tion of two-storied oriels, its effect emphasized by a sup-
porting wall (fig. 13). This particular house, whose exten-
sive grille in front of a side window might have been
designed by a Josef Hoffmann in Vienna or a Mackintosh
in Glasgow, must have ignited the decisive spark: the
drawing anticipates what the other Jeanneret, Le Corbu-
sier, was to design a dozen years later. On the left edge of
the picture, at a right angle, there is a sketch of the Bospo-
rus, where the oriel motif becomes a platform above the
water.

I always thought I would find among Jeanneret's
sketches the type of summer house on the shores of the
Bosporus (Yali) that juts out over the water and is sup-
ported at a slant above the embankment. It has finally
cropped up in Gresleri's *Viaggio*, in the picture of the boat
(fig. 14). We also learn from Klipstein that the two friends
were definitely at the Bosporus on 28 July:

> *The route as far as Terapiwé (Tarabya) is nothing
> special, despite its reputation. Kitschy, monstrous
> palaces. The wooden Turkish structures at the
> sea are pleasantly calming by comparison, with their
> oriel-like protruding second stories, which are affixed
> to the first story through inwardly curving wooden
> columns. We become increasingly fond of these
> structures as our understanding of them grows...
> Jean(neret) makes sketches of them. Would love to
> see the inside of such a house. The rooms must be
> spacious and let in a great deal of light.*
> (Klipstein, MS pp. 36/37)

figs. 9, 10: Standard Turkish
oriel house in Istanbul.
Drawing by Le Corbusier.

fig. 11: Variation of Turkish
oriel house with oriel taking
in the entire façade. Drawing by
Le Corbusier.

fig. 12: Series of oriels along a steep street in Istanbul. Drawing by Le Corbusier.

fig. 13: Two-story oriel in Istanbul. Drawing by Le Corbusier.

fig. 14: Summer house on the shore of the Bosporus (Yali). Drawing by Le Corbusier.

One of these sketches by "Jean" is the picture with the boat – probably hastily drawn from the Bosporus steamer, but with exactly those accents that testify to his interest in oriel architecture: the entire structure appears as if lifted above the shore, which is conveyed by a few solid, short lines of shading.

The photographer Jeanneret also reacts on seeing two oriels mirroring each other or mutually heightened (fig. 15). In short, one may advance the thesis that the long-term effect of the ceaseless study of the "oriel principle" on the Grand Tour of 1911 is reflected in the projection over Pilotis propagated by Le Corbusier in the Weissenhof development (Stuttgart, 1927), especially (Tarnovo!) in the building on the steep slope in front (fig. 16).

One final comment regarding this thesis: What Jeanneret and his second self can hardly have known is that the Turkish oriel house derives from the Anatolian farmhouse – a finding made by Turkish anthropologists. In this primitive type of Anatolian structure, the ground floor is merely an open area of supporting beams on top of which the projecting living quarters are constructed. Thus an open but shaded and dry space is provided for animals and the storage of food supplies. If this house on free-standing supports is seen as an early form of the oriel house, which in turn was Jeanneret's inspiration for Le Corbusier's "Weissenhof," then the "Villa Savoye" is its opposite: a late and obviously unconscious response to the primitive type of Anatolian house. Where donkey and hay were situated centuries and millenia ago, three automobiles with brass fittings now roll over the gravel, a Delahaye, a Talbot, and a Hispano-Suiza.

Translated from the German by Catherine Schelbert

fig. 15: Two oriels. Photograph
by Le Corbusier.

fig. 16: Weissenhof develop-
ment, Stuttgart, 1927. The
building stands on a steep slope.

Notes

1 The relevant comment in *Voyage d'orient* (Geneva, 1966), ed. and preface
by Jean Petit, reads: "Presburg (Bratislava) avait élevé sur un mont le
cube de sa forteresse. Puis cette guerrière apparition s'était effondrée dans le
bleu et gris de la pleine. La 'puszta' de nouveau s'étendait, indéfiniment."
(p. 35)

2 What follows is an abbreviated, partially altered version of my essay
on the architect's centenary birthday: "Die 'verkehrte' Grand Tour des Charles-
Edouard Jeanneret," *Bauwelt*, double issue, no. 38/39 (7 October 1987),
p. 1430 ff.

3 Giuliano Gresleri, *Le Corbusier, Viaggio in Oriente*, (Venice: Marsilio
Editori/Paris: Fondation Le Corbusier, 1984). German edition: *Le Corbusiers
Reise nach dem Orient* (Zurich and Paris, 1990).

4 André Wogensky, introduction to *LC Sketchbooks*, vol. I, (Cambridge, Mass.,
1981).

5 Cf. Gresleri, op.cit. (German edition), pp. 26 ff.

6 William Ritter in ibid., pp. 41 and 49.

7 Claude Farrère in ibid., p. 51.

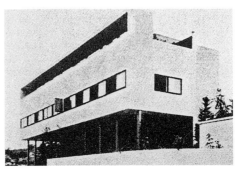

Dario Gamboni

Whistler, Welles, and the "Swiss" Cuckoo Clock

In 1885 James Abbott McNeill Whistler delivered a lecture in London, in Cambridge, and in Oxford. The time chosen was unusually late, and he entitled it *Ten O'Clock*. It was published in 1888 and translated into French by no less a writer than Mallarmé.[1] The painter had been prompted to expose publicly his ideas about art by the success that his former disciple, Oscar Wilde, had obtained with lectures indebted to their previous conversations.[2] Whistler aimed at proving that art was, by its very nature, autonomous and that in order to prosper, it had to be kept free from any extraneous encroachment. His targets were the mimetic and narrative functions imposed upon art, its submission to the influence and power of the literati, and, last but not least, "the fabled link between the grandeur of Art and the glories and virtues of the State," which he deemed false, "for Art feeds not upon nations, and peoples may be wiped from the face of the earth, but Art is":

> *A whimsical goddess, and a capricious, her*
> *strong sense of joy tolerates no dulness,*
> *and, live we never so spotlessly, still may she*
> *turn her back upon us. As, from time immemo-*
> *rial, she has done upon the Swiss in their*
> *mountains. What more worthy people!*
> *Whose every Alpine gap yawns with tradition,*
> *and is stocked with noble story; yet, the perverse*
> *and scornful one will none of it, and the sons*

of patriots are left with the clock that turns the mill,
and the sudden cuckoo, with difficulty restrained
in its box! For this was Tell a hero! For this
did Gessler die ! Art, the cruel jade, cares not, and
hardens her heart, and hies her off to the East,
to find, among the opium-eaters of Nankin, a
favourite with whom she lingers fondly – caressing
his blue porcelain, and painting his coy maidens,
and marking his plates with her six marks of choice –
indifferent in her companionship with him, to all
save the virtue of his refinement![2]

A similar argument was directed to a broader audience sixty-five years later, in 1949, when Harry Lime, the villain in Carol Reed's film *The Third Man*, tried to make his old friend Holly Martins a party to his racketing of penicillin in postwar Vienna:

After all, it's not that awful – you know
what the fellow said.... In Italy for thirty years under
the Borgias they had warfare, terror, murder,
bloodshed – they produced Michaelangelo,
Leonardo da Vinci and the Renaissance. In Switzer-
land they had brotherly love, five hundred years
of democracy and peace, and what did that produce?
The cuckoo clock...[4]

According to Carol Reed, this line of dialogue "was written into the script by Orson Welles," who played the role of Lime.[5] The statement is, of course, provocative and essentially a caricature. By connecting a state of public immorality with an exemplary blossoming of the arts – thus reversing Whistler's "fabled link between the grandeur of Art and the glories and virtues of the State"– it proposes to legitimate immorality itself through the sanctity of culture. Whistler's argument is more complex and momentous. It postulates the amorality of art (as a part of its independence) and infers from it the uselessness and inefficiency of any attempt, on the part of the state, to support or direct the arts and artists.

The problem of knowing whether the similarity of these two assertions derives from an actual filiation may be left unsolved here. The interesting fact is that in both cases a cosmopolitan American selects Switzerland and the Swiss to serve as paradigms for a nation and a people rich in virtue (particularly political) and history, and yet – or therefore – deprived of artistic expression.[6]

Moreover, these statements were made precisely at two moments when, due to the international political and ideological conjuncture, the quest for "national art" and the idea that a more or less prosperous state of the arts is an important indicator of the quality and viability of a regime, a state, or a nation were (or had just been) crucial points on both political and cultural agendas. Despite his hint at Switzerland, it is unlikely that Whistler should have been thinking of the Swiss debates about cultural politics. He may rather have had in mind the French interventionistic conception of the relationship between art and the state,[7] which he knew well and could compare with the more liberal (in the economic and political sense) tradition of England, where he had chosen to settle after some hesitancy.

For Whistler, born in Lowell, Massachusetts, was an émigré. Artistic emigration brings the history of art and artists in the United States and in Switzerland together.[8] In both countries the absence of royal, church, or state patronage, due to mainly republican and Protestant institutions as well as to the corresponding social and economic structures, compelled most artists, well into the nineteenth century, to go abroad for training, experience, and commissions[9] – Johann Heinrich Füssli alias John Henry Fuseli being a standard case in the eighteenth century.

The resulting artistic "brain drain" progressively appeared as a reason to promote and justify some kind of state support of the arts. The argument was explicitly put forward by Philipp Albert Stapfer, the remarkable Minister of Art and Science of the short-lived unified Helvetic Republic (1798-1803), in his ambitious overall project for cultural policies.[10] This endeavor, which remained without

any direct consequence, was also based on an enlightened and French-inspired view of the contribution of art to the moral and political progress of mankind – and, more specifically, of the nation.

After the Restoration, it was mainly through the action of artists and private associations (of artists and amateurs) that some of these ideas were taken up again and to some extent realized.[11] A corporative aim of theirs was to establish the conditions for the development of an art market and regular artistic activity. But this appeal for official support for the arts was also part of an overall effort to modernize the state, a process in effect between 1848 (replacement of the old confederation of states by a new federal state) and 1874 (revision of the constitution with more centralized authority).[12] This political side is apparent in the career and work of the main artist advocating national support of culture, the painter Frank Buchser, who was involved in a left-wing project to decorate the Swiss Houses of Parliament. It would have paid tribute to the North American republic and in particular to the leaders of the Civil War – while in the United States, Buchser also managed to depict the life of the Blacks in an unusually direct manner.[13]

The result of these efforts was the creation of national artistic institutions: with the passing of two federal decrees (on the Acquisition and Conservation of National Antiquities in 1886, on the Advancement and Encouragement of the Arts in Switzerland in 1887), the creation of a Federal Art Commission (1887), of National Art Exhibitions (1890), of a Swiss National Museum (1898), and of federal grants for the fine arts (1899).[14] It was no easy victory, for, as in the United States, the reasons that had delayed and restricted the development of indigenous artistic production continued to make many consider it a secondary or even dubious objective and require a strict subservience of the aesthetic to the ethical and the political.[15] But things changed because the aims of artists and amateurs began to converge with the interests of politicians. There was a will

to express and celebrate the new state with buildings, monuments, and images; to sustain Swiss industry in international competition by bettering the aesthetic quality of its products; and to prevent a further scattering of the country's cultural heritage. And there was more than a material side to it. Art, it was thought, could help hold the country together spiritually in the face of danger. Since the 1870s, with the unification of Italy and of the German Empire, the immoral expansionist politics of the Great Powers had been challenging the right of small countries – Switzerland among them – to maintain an independent existence.[16]

It is worth remembering that, in the American context, the United States acted in much the same way as, and strove to inherit the succession to, the Spanish Empire. This perversion of the republican ideal was denounced among others by Rubén Darío, a cosmopolitan Nicaraguan poet who introduced *modernismo* in Spanish poetry and defended the political and cultural dignity and independence of Hispanic America, notably in his "Ode to Roosevelt." It is therefore revealing to find that when he paid a triumphal visit to his native country in 1909, Darío made a positive allusion to the accomplishment of the Swiss people:

> I desire the youth of my country to become
> imbued with the fundamental idea that, however little
> be the piece of earth on which one happens to be
> born, one can become a Homer if one is in Greece,
> or a Tell if one is in Switzerland; and that
> just as individual persons, nations possess an image
> and a personality that give transcendance to the
> laws of their destiny and to the place where a decision
> of God has situated them in the almost unimaginable
> plan of universal progress.[17]

In *Ten O'Clock*, Whistler had also refuted the idea of progress, at least as far as art was concerned. Whereas he had mocked Tell's killing the tyrant Gessler as having led to nothing but the cuckoo clock, Darío turned to the pro-

totype of the anti-imperialist fight for a political hero – Homer serving as the cultural one – in the wake of the Jacobins' incorporation of the Swiss into their revolutionary pantheon.[18]

The integrating virtues attributed to art both in Switzerland and the United States had to do with the complex cultural character of the two countries. But the imposition in Europe of the concept of the nation-state – the equation of political entity with linguistic or "ethnic" unity – made the existence of multilingual Switzerland still more problematic. Switzerland had to assume this historical heritage and make a virtue of necessity; its political theorists put forward the notions of "nation of the will" (*Willensnation*) and "culture state" (*Kulturstaat*).[19] In this context, art was expected to represent the nation, to strengthen its identity inside the country, and to prove it outside.[20] "National art" was, of course, not a specific preoccupation of the Swiss, but it may have been a more acute and more difficult one than in seemingly more unified countries.

This quest was particularly effective in the field of the applied arts and architecture, where vernacular elements of various origins were stylized into national characteristics. Ironically, but not astonishingly, it has been proved that the celebrated "Swiss chalet style" actually derived from English and German models,[21] just as the cuckoo clock, despite Whistler, Welles, and many others, was invented in Franconia or Bavaria and first popularized by clockmakers of the Black Forest.[22] The task was more difficult in the figurative arts. It influenced primarily iconography (especially in history painting[23] and landscape) and tended to remain a matter of desires, programs, presuppositions, and interpretations. One painter managed for a while to be considered – in his person, his iconography, and his style – an incarnation of the longed-for national art:[24] Ferdinand Hodler, thanks to his combination of a Bernese origin with training and activity in Geneva, an interest in diverse traditions and trends in European art, participation in exhibitions in several European artistic centers, republican and unifying leanings, and a dedication to public art and themes of Swiss history.

Even this relative consensus was a fragile and temporary one. "National art" – rather a concept and object of debate than a fact – had its golden age between 1848 and World War II. It took some substance around the turn of the century, even then provoking much contradiction.[25] In 1897, Hodler's murals for the hall of arms of the Swiss National Museum, representing the Retreat from Marignano (a famous defeat which had stopped the beginning of Swiss imperialism in 1515), roused a nationwide turmoil because of their brutal exposure of the violence of war and their untraditional treatment of form and iconography.[26] The military and ideological clash between France and Germany in World War I had a destructive effect on the relationship between the two main linguistic groups of Switzerland (in 1914 Hodler was excluded from all German art associations for having joined a protest against the bombardment of Reims cathedral). It was only in the 1930s and during World War II that, faced with a new political and military threat, the idea of reinforcing the national cultural identity through artistic and more generally cultural expression gained ground again, culminating in a government-sponsored "spiritual defense of the nation" (*geistige Landesverteidigung*).

After the war – and *The Third Man* – this tendency was increasingly denounced as insular and regressive, and, since the second half of the fifties, the very institution that had been created in the context of the national defense and continued to function as a kind of substitute for a ministry of culture, the Pro Helvetia Foundation, became instrumental in adapting the aims and methods of the support and promotion of Swiss art to the internationalization of the art world, norms, and market.[26] "Swiss art," in this context, could only be modestly defined as the art produced in Switzerland and by Swiss living abroad; apart from providing abstract proof of liberty and modernism – in the wake of the now internationally recognized, government-supported and exported "American art"[28] – no con-

tribution to the morality, spiritual elevation, civic spirit, or cultural cohesion of the nation was expected from it any more. Whistler's conception of *l'art pour l'art* had won, although coupled with a more lucid view of what the state could provide if its intervention was limited to the material and administrative side; this limitation corresponded in effect to the separation that generally occurred between the geography of the artistic field and that of political entities.

As far as the international acknowledgment bestowed upon Swiss artists is concerned, the result of this broad evolution was a success, particularly in the 1980s, when national and regional definitions of art were gaining new currency in Europe. Assumptions about the specificity of this "new Swiss art" were also numerous and – not unexpectedly – diverse, but they led to the paradoxical conclusion that its main national characteristics were its very "un-Swissness" or the doubts concerning the existence of such characteristics.[29] One still finds ambiguities about this question in the texts of authors who begin by declaring the concept obsolete and irrelevant, as if the tranquil and superficial presumptions of unity that can be made in more self-assured national traditions had to remain an object of envy.[30] If Whistler and Welles's deprecatory view is not to be perpetuated, perhaps it will suffice for the image of Switzerland to be linked with the renown of a few artists or architects known to be Swiss, even if the heir to the cuckoo clock, the "Swatch," proclaimed a national product by its very name, still commands priority in this respect.

Notes

1 The text was incorporated in Whistler's *The Gentle Art of Making Enemies* (1891) and can be found in the reprint published by Dover (New York, 1967, with an introduction by Alfred Werner), pp. 131–159.

2 Stanley Weintraub, *Whistler. A Biography* (New York, 1974), pp. 295-296.

3 Ibid., pp. 155–157.

4 Graham Greene and C. Reed, *The Third Man* (London, 1984), p. 100, quoted after William Hauptman, "The Swiss Artist and the European Context: Some Notes on Cross-Cultural Politics," in *From Liotard to Le Corbusier. 200 Years of Swiss Painting*, 1730–1930, cat. (Atlanta) (Zurich, 1988), pp. 35–46. For an opposite interpretation of the Italian Renaissance, linking its creative "clusters" of activities with the republican and urban context, see Helmut G. Koenigsberger, "Republics and Courts in Italian and European Culture," *Past and Present* 83 (May 1979), pp. 32–56.

5 Frank Brady, *Citizen Welles. A Biography of Orson Welles* (New York, London, Toronto, Sydney, and Auckland, 1989), p. 451. Brady adds that "Welles has claimed that the line was not entirely original on his part but stolen from, or based on, a fragment of an old Hungarian play."

6 The difference in the positive paradigms employed is as revealing as the difference in the conclusions. Whereas Welles-Lime makes a crude allusion to the Renaissance and its cultural heroes, Whistler points to the supposedly gratuitous refinement of Far Eastern "decorative" art. The same image had been used by Mallarmé to define his own new aesthetic ideal in the poem "Las de l'amer repos où ma paresse offense" (1864, first published 1866), which Whistler may well have known at the time he wrote *Ten O'Clock*.

7 For aspects of the history and effects of this conception, see James A. Leith, *The Idea of Art as Propaganda in France, 1750–1799. A Study in the History of Ideas* (Toronto, 1965), and Pierre Vaisse, "Salons, expositions et sociétés d'artistes en France 1871–1914," *Atti del XXIV Congresso Internazionale dell'Arte, vol. 7*, ed. Francis Haskell: *Saloni, Gallerie, Musei e loro influenza sullo sviluppo dell'arte dei secoli XIX e XX* (Bologna, 1981), pp.141–151.

8 Brandom Brame Fortune, "Painting in America and Switzerland 1770–1870. Preliminaries for a Comparative Study," in *From Liotard to Le Corbusier* op. cit. (see note 4 above), pp. 23–33, with reference to studies about the search for a "national art" in the United States (p. 24, n. 6).

9 D. Gamboni, *La géographie artistique*, Ars Helvetica I (Disentis, 1987), pp. 140–144 and 203–209, with reference to more specialized studies, and Oskar Bätschmann, *Malerei der Neuzeit*, Ars Helvetica VI (Disentis, 1989), p. 71f.

10 Pierre Chessex, "Documents pour servir à l'histoire des arts sous la République Helvétique," *Etudes de lettres* (Lausanne), series 4, no. 2 (1980), pp. 93–121.

11 On this process, see Lisbeth Marfurt-Elmiger, *Der schweizerische Kunstverein 1806–1981* (Bettingen, 1981); Hans Ulrich Jost, "Künstlergesellschaften in der Zeit der Restauration," *Gesellschaft und Gesellschaften. Festschrift zum 65. Geburtstag von Prof. Ulrich Im Hof* (Bern, 1982), pp. 341–368; Lisbeth Marfurt-Elmiger and Matthias Vogel, *Frank Buchser als Kunstpolitiker* (Solothurn, 1990).

12 *Handbuch der Schweizer Geschichte*, 2nd ed., vol. 2 (Zurich, 1980).

13 Marfurt-Elmiger and Vogel, op. cit.; Johannes Stückelberger, "Die künstlerische Ausstattung des Bundeshauses in Bern," *Zeitschrift für Schweizerische Archäologie und Kunstgeschichte*, vol. 42 (1985), pp. 185–234.

14 On this institutional development, see Hans Christoph von Tavel, *Ein Jahrhundert Schweizer Kunst. Malerei und Plastik von Böcklin bis Alberto Giacometti* (Bern, 1969) (in French: *Un siècle d'art suisse. Peinture et sculpture de Böcklin à Giacometti* [Geneva, 1969]); Paul-André Jaccard, ed., "L'art suisse s'expose," *Zeitschrift für Schweizerische Archäologie und Kunstgeschichte,* vol. 43 (1986) 4; *Der Bund fördert. Der Bund sammelt. 100 Jahre Kunstförderung des Bundes. 100 ans d'encouragement de la Confédération aux beaux-arts. 100 anni d'incoraggiamento della Confederazione alle arti,* cat. (Aarau, 1988).

15 H. U. Jost, "Un juge honnête vaut mieux qu'un Raphaël: le discours esthétique de l'Etat national," *Etudes de lettres* 1 (1984), pp. 49–73.

16 H. U. Jost, "La culture politique du petit Etat dans l'ombre des grandes puissances," *Les "petits Etats" face aux changements culturels, politiques et économiques de 1750 à 1914,* ed. D. Kosary (Lausanne, 1985), pp. 25–32.

17 "Yo deseo que la juventud de mi país se compenetre de la idea fundamental de que, por pequeño que sea el pedazo de tierra en que á uno le toca nacer, él puede dar un Homero, si es en Grecia; un Tell, si es en Suiza; y que, así como las individualidades, tienen las naciones su representación y personalidad que da transcendencia á las leyes de su destino y al punto en que, por decisión de Dios, están colocadas en el plano casi inimaginable del progreso universal." (Rubén Darío, *El viaje á Nicaragua é Intermezzo tropical* [Madrid, 1909], p. 21).

18 On the history of the representation and interpretation of Tell, see Rico Labhardt, *Wilhelm Tell als Patriot und Revolutionär 1700–1800. Wandlungen der Tell-Tradition im Zeitalter des Absolutismus und der Französischen Revolution* (Basel, 1947); Lilly Stunzi et al., *Quel Tell ?* (Lausanne, 1973); Jean-François Bergier, *Guillaume Tell* (Paris, 1988).

19 H. U. Jost, "Un juge honnête vaut mieux qu'un Raphaël," p. 15.

20 See the essays collected in François de Capitani and Georg Germann, eds., *Auf dem Weg zu einer schweizerischen Identität 1848–1914: Probleme – Errungenschaften – Misserfolge,* 1985, Kolloquium der Schweizerischen Akademie der Geisteswissenschaften (Fribourg, 1987).

21 Jacques Gubler, *Nationalisme et internationalisme dans l'architecture moderne de la Suisse* (Lausanne, 1975), pp. 27–28.

22 Berthold Schaaf, *Holzräderuhren* (Munich, 1986), pp. 187–190. My thanks to Georg Germann for this reference.

23 On Swiss history painting and iconography, see in particular Franz Zelger, *Heldenstreit und Heldentod. Schweizerische Historienmalerei im 19. Jahrhundert* (Zurich, 1973); Danielle Buyssens, "Art et patrie: polémique autour d'un concours de peinture d'histoire nationale," *Genava,* vol. 33 (1985); idem, *Les nus de l'Helvétie héroïque. L'atelier de Jean-Léonard Lugardon (1801–1844), peintre genevois de l'histoire suisse* (Geneva, 1991); H. C. von Tavel, *Nationale Bildthemen,* Ars Helvetica X (Disentis, 1992).

24 See the documents collected in Jura Brüschweiler, *Ferdinand Hodler im Spiegel der zeitgenössischen Kritik* (Lausanne, 1970) (in French: *Ferdinand Hodler. Anthologie critique,* 1971).

25 On the question of "Swiss art" and its historiography, see Marcel Baumgartner, "'Schweizer Kunst' und 'deutsche Natur'. Wilhelm Schäfer, der 'Verband der Kunstfreunde in den Ländern am Rhein' und die neue Kunst in der Schweiz zu Beginn des 20. Jahrhunderts," in de Capitani and Germann, eds., op. cit., pp. 291–308; Oskar Bätschmann and M. Baumgartner, "Historiographie der Kunst in der Schweiz," *Unsere Kunstdenkmäler,* vol. 38 (1987), no. 3, pp. 347–366.

26 Lucius Grisebach, "Historienbilder," in *Ferdinand Hodler,* cat. (Zurich, 1983), pp. 257–283; O. Bätschmann, "Förderung in Entfremdung. Zum Widerspruch zwischen Künstler und Öffentlichkeit," *Der Bund fördert* op. cit. (see note 14 above), pp. 41–52.

27 Hans A. Lüthy and Hans-Jörg Heusser, *Kunst in der Schweiz 1890–1980* (Zurich, 1983), p. 97 (in French: *L'art en Suisse 1890–1980* [Lausanne, 1983]); Christoph Eggenberger, "Die Stiftung 'Pro Helvetia' als Vermittlerin schweizerischer Kunst im Ausland," *Zeitschrift für Schweizerische Archäologie und Kunstgeschichte,* vol. 43 (1986), pp. 417–28; Annelise Zwez, "Die Pro Helvetia im Wandel der Zeit," *Kunst-Bulletin* (1987), no. 2, pp. 14–19; no. 3, pp. 6–17; no. 4, pp. 8–13.

28 Serge Guilbaut, *How New York Stole the Idea of Modern Art. Abstract Expressionism, Freedom and the Cold War* (Chicago, 1983).

29 M. Baumgartner, "Anstelle einer Bibliographie. 'Schweizer Kunst' 1980–1987 – und überhaupt. Eine Nach-Lese," in *"Stiller Nachmittag". Aspekte Junger Schweizer Kunst,* cat. (Zurich, 1987), pp. 205–211, with bibliographical references.

30 Beat Wyss, *Kunstszenen heute,* Ars Helvetica XII (Disentis, 1992), pp. 3–69.

Jean-Christophe Ammann

Rémy Zaugg and the Museum Collection of Lucerne

Address at the opening of Rémy Zaugg's Exhibition
Lucerne Kunstmuseum, 12 July 1991

I have the honor of speaking to you today thanks to having been curator of the Lucerne Kunstmuseum from 1969 to 1977 and therefore being familiar not only with the historical substance of the museum collection but also with Rémy Zaugg's oeuvre and theories. The honor shown me has both a pragmatic and a pleasurable side. Many faces are familiar to me, and I shall say now what I had planned to say at the end of this address: I am looking forward with pleasure to the opening and to the gathering afterwards.

In the nine years I spent at the museum, I rehung the collection three times, the most extensively in 1975. Luigi Kurmann, a persevering and loyal comrade-in-arms – today he and Victor Gisler run a gallery of international repute, the Galerie Mai 36 in Lucerne – helped me out, as did the restorer Georges Eckert, who is always full of fun. We proceeded very carefully, removing the ponderous gilt frames from a goodly number of nineteenth-century pictures but leaving those that seemed compatible. The then caretaker of the museum, Mr. Josef Baumgartner, was charged with wrapping the frames for safe storage. Who knows, I said to myself, maybe someone will turn up someday who wants to undo the sacrilege of having removed the frames. I have indulged in these reminiscences not as a veteran but to call to mind the complexity of the problems involved in hanging a collection – quite apart from available funding. (When I left Lucerne, in my last year – 1977 – sixteen thousand Swiss francs had been allotted for acquisitions.)

fig. 1: Robert Zünd,
Haus unter Nussbäumen
(Schellenmatt),
oil on canvas, 77 x 104 cm.
Lucerne Kunstmuseum
(Depository of the Federal
Gottfried Keller Foundation).

The rearrangement of the collection was provoked by an inner need rather than by the desire for change per se. As a result, it required substantial strength to deal with the tension generated by works of art as energetic beings that will not brook arbitrary treatment. It took me days and nights to decide on their neighbors. Sometimes I felt like a marriage counselor, asking myself, "Who wants to be with whom?"

The problem as such has not changed since then, but the times have. Suddenly, so it seems, a collection steps out of art history and into history at large. History can be read by studying art not as a standard of beauty and truth but as a measure of how people felt about themselves and their own present, i.e., as a means of acquiring insight into their present and its conventions.

During the Kandinsky exhibition at the Schirn Kunsthalle in Frankfurt in 1990, I would walk through the rooms, place myself behind the viewers, and listen to their reactions. I can still hear one person's remark, "Hey, look at this; these are pictures he painted in 1912/1913 – they're the same as today." What a revealing and symptomatic dictum on the present.

The invasion of the present by art history as history is a consequence of the end of the avant-garde that has put its indelible mark on this century and, hence, of the end of innovative idioms. This situation has resulted in an unbroken extension of the present into the future, just as the future indefinably shapes the present.

The loud footsteps of swiftly marching time, which rapidly turns art into history, have faded away. History seems to have caught up with the present. There is talk of the "end of history," not because history has come to an end, but because its present is undefined. (The end of ideologies is a mere episode; it is not the reevaluation of their history by collective memory.)

The manner in which Rémy Zaugg and Martin Schwander have chosen to treat the historical collection at the Lucerne Kunstmuseum may be considered exemplary. First, an artist devoted for almost three decades to the subject of perception is invited to "meddle" with a collection; secondly, the director gives him the freedom to do so in such a way that his own work reflects upon this intervention.

Let us talk about that now.

In the room reserved for temporary exhibitions, paintings by Robert Zünd are juxtaposed with Zaugg's works recording his confrontation with Cézanne from 1963 onward. The juxtaposition demonstrates due respect for Zünd, the retiring nineteenth-century artist from Lucerne (1827-1909), by providing a pavilion for his paintings. What does this juxtaposition mean? Is it a gesture of sympathy for the realist, whose work is so moving and so intimately bound up with nature?

I should like to advance the following argument: since history has so forcefully intruded into the present and has even had a positive, dis-enlightening effect, Rémy Zaugg wants to show us, on the basis of his past work – i.e., from a distance – that history has nevertheless irreversibly changed our perception.

For Zünd, nature was the unadulterated experience of nature. The state of nature rendered in his paintings was not prescriptive but descriptive and rooted in convention (fig. 1).

Cézanne abstracted nature by releasing it from convention. Not nature but the *seeing* of nature became his maxim: a process, then, in which continuous control is exercised not by convention but in the practice of seeing applied to the act of painting.

In 1963, when Rémy Zaugg began listing topographically the near endless litany of the colors he observed in Cézanne's painting *House of the Hanged Man*, the then twenty-year-old created a vast linguistic score that has become a paradigm of a new level of perception. From then on it had to be acknowledged that, within the tradition of modern art and the insights it has imparted, the act of perceiving nature could not end in depiction or abstraction. Nature, itself having become culture, had to be perceived via a third plane in order to make the conceptuality and extensive existence of this nature tangible.

Rémy Zaugg has recorded the process of Cézanne's seeing and shifted it to a conceptual plane by developing a vocabulary of colors and designations of objects that allows a comprehensive grasp of nature.

Ladies and Gentlemen, the ozone hole has become a constitutive part of today's experience of nature; it would be absurd to paint it. I call Rémy Zaugg's strategies of perception ecological, not because I want to pin him down to ecology, but because ecology is a constitutive dimension of these strategies.

In 1978 he wrote in his notebook, "And when I eat an unripe apple, the poisonous green would no longer be there?" This gave rise in the past year to a three-part group of works: poisonous green pictures on which that sentence is painted in white lettering in German, French, and English. The anecdotal immediacy of cause and effect indicates an irreversibility, as if spring were going to be deleted from the calendar as of next year.

What I mean to say is that by juxtaposing his works and those of Zünd, Rémy Zaugg frees history from its access to a nearly paralyzed present, gives it breath and distance, declares its cooption unacceptable, and creates room for us to think of the present as a possible form of the future.

We now come to the Rémy Zaugg of today. Let me put it like this: it is possible to misunderstand Rémy Zaugg by taking him for a schoolmaster. It can certainly be exasperating to receive a steady stream of instructions, to be disciplined and regimented.

fig. 2: Lucerne Kunstmuseum, view of the room facing the lake with part of the museum collection rehung by Rémy Zaugg and Martin Schwander in 1991.

fig. 3: Rémy Zaugg, *Tableau aveugle*, 1986/1991, acrylic on canvas, 65 x 52 x 2 cm. Courtesy of the artist.

Were I to view his exhibition totally unprepared, as most visitors will be, I would say, "That guy gets on my nerves. Why the nonsense of accusing me of being blind, of supposing that I'm not here yet, of hunting for something that isn't there? Why should I let myself be ordered to look this way, to imagine that the picture sees me and I don't see it, or to find out how few things I see, etc.? And much of his work neatly painted in variations on one tone, with a smooth primer, in acrylic on canvas. That's supposed to be art?" (fig. 2)

Then how are these pictures to be understood? I have come to a curious conclusion that amazed even Rémy Zaugg. His texts almost literally correspond to the "language-games" formulated by Ludwig Wittgenstein in the mid-forties. In his famous *Tractatus logico-philosophicus*, written in the early twenties, Wittgenstein had tried to come to grips with the world through classification as a reproduction of the world. His late writings signify an about-face. "Language-games," as Wittgenstein calls them, are logical investigations of language itself, of figures of speech, of expression. Hence, language and societal conventions are inseparable and the modes of using language are *eo ipso* societal conventions.

Now when Rémy Zaugg gives orders to viewers or, to put it more gently, invites them to perform certain tasks involving movements of the eye or of the inner eye, i.e., to focus on something, or when he calls their attention to something, he is quite literally engaging in Wittgenstein's language-games. I quote only one example, # 139 in the second volume of *Remarks on the Philosophy of Psychology* (Oxford: Basil Blackwell, 1980, 26e):

139. The sentence "Forming an image is voluntary, seeing isn't", or a sentence like this can be misleading. When we learn as children to use the

357

*words "see", "look", "image", voluntary actions and
orders come into play. But in a different way for
each of the three words. The language-game with the
order "Look!" and that with the order "Form
an image of...!" – how am I ever to compare them? –
If we want to train someone to react to the order
"Look...!" and to understand the order "Form
an image of...!" we must obviously teach him quite
differently. Reactions which belong to the latter
language-game do not belong to the former.
There is of course a close tie-up of these language-
games, but a resemblance? – Bits of one resemble
bits of the other but the resembling bits are not
homologous.* [b:Z 646]

We can obviously take Zaugg's imperatives literally, but
this would mean separating them from the pictorial vehi-
cle. The imperative is to the vehicle as the font and the lay-
out of the lettering are to painting, coloring, and format,
including mount and canvas. The imperative – let us take
this as a given, even though there are pictures that embody
a different type – is one with the picture. The picture as a
totality is the imperative within a context constructed out
of Zaugg's own pictures and those of the collection. The
more I recognize the self-referential imperative as a picture
of my own self-referentiality, the more clearly I recognize
the historical paintings as language-games and societal
conventions of their own respective times.

What are self-referential pictures? They are pictures
that reflect upon themselves and, through this process,
make perception discernible to the viewer. In a picture by
Rémy Zaugg one can read, "Imagine you are not here yet.
/ Look." That may mean: I am already here but am sup-
posed to imagine that I am moving toward the spot where
I am now standing, with the invitation to look (fig. 3). But
since I am in fact already here, the idea of myself moving
there implies the conscious act of perception: I see and rec-
ognize myself as the beholder of a picture by Rémy Zaugg,
and, a moment later, of a work from the Kunstmuseum's

historical collection. It is essential that I regard the latter
as a work of art and not as a visual document, otherwise I
could, for instance, get bogged down in a discussion as to
whether the depiction of Mount Pilatus is too powerful or
not.

So when we think about the sense and purpose of this
exhibition, we come to a simple conclusion: the artist helps
us to perceive history by means of his works, using his own
model of perception as an instrument for recognizing his-
tory. By addressing everyone singly, he consciously ad-
dresses the individual, the visually thinking, hence the per-
ceiving human being. He enables us to see art as a mental
object, to regard, recognize, and understand it as a picto-
rial language-game, and since this language-game is
always an expression of societal conventions, it embodies
both its own history and history in general.

Translated from the German by Catherine Schelbert

Picture credits

fig. 1: Lucerne Kunstmuseum (Robert Baumann, Lucerne)

fig. 2: Josef Riegger, Allschwil

fig. 3: Lucerne Kunstmuseum (Josef Riegger, Allschwil)

Robert Fischer

On the Emergence of a Cybernetic Mass Culture and its Implications for the Making of Art

The Disappearance of the Monument

The monument fulfills a twofold, contradictory function: in a vertical, hierarchic social structure, it is a token of repression; in a horizontal, egalitarian social structure, it is the site and symbol of the assembly of citizens under one and the same banner. This twofold function circumscribes and defines the physical appearance of the monument. It may be a village fountain, a church, an equesrtian statue, a triumphal arch, or even a natural landmark or geographical site, for instance, the Tellsplatte (a boulder jutting out into the Lake of Lucerne, where Switzerland's national hero supposedly climbed out of the boat of oppression), or the Grütli meadow (where the first Swiss swore mutual help and solidarity). The French sociologist Henri Lefèbvre put forward the idea that the monument as the seat of an institution organizes space around it "in order to colonize it." All great monuments are erected in honor of conquerors, in commemoration of the mighty.[1] But the monument is also "the only conceivable sanctuary of collective life." It dominates, but in order to assemble. It embodies a series of social, cultural, and ideological values; it is not only a crystallization of the unity of the people but also projects a world view onto the fabric of society. It embodies beauty, strength, and ideal. And when the world view is long past, staged as a mere ruin, the monument is a link with history.

For several decades now, urban development has been pursuing a course that ignores the monument in its traditional form. This gives rise to several questions: how do societal mechanisms

function in a community without monuments and without places in which shared history is condensed? what has now taken the role once played by the monuments in society? what new forms of monument have emerged? Of relevance in seeking answers to these questions is the transition of Western civilization – of a population that has come to inhabit living spaces without a past and has acquired a mobility that breeds consumerism – to the age of communication and information, and the new culture attendant upon this transition.

The All-American Suburb

The housing development of Levittown, Pennsylvania, was built in the fifties. Within record time, seventeen thousand homes were mass-produced in only four variants for a new type of tenant. Each unit was turned over to its new owner, complete with a fully fitted kitchen in color-coordinated pastels, a standardized fireplace, a uniform two-car garage with integrated workshop, and storage space for gardening equipment. When the new residents moved into their new homes, they were greeted with milk in the fridge and bread behind the door.

Over a period of fifteen years, the United States had built up a vast production base throughout the country, initially to win wars that were not waged on their own territory and later to supply the war-ravaged countries with goods. During the postwar years, industrially produced goods were gradually encompassed in the myth of the United States as a land of milk and honey. New businesses mushroomed and the population buckled down to work. Infrastructures were spread out all over the country and employees followed the call of the workplace. They left their native Brooklyn or Manhattan to move to Nowheresville. In 1956 businesses and companies were paying sixty percent of moving expenses. A new reading was invented for the acronym IBM: I've been moved. People moved away from a relatively young social and communal context, a context in which the structures of their countries of origin were still alive, in order to settle

down in an untried, artificial environment. With this second wave of migration, America's pioneers irrevocably cut all remaining ties to their European "homeland." The all-American suburb was born.

The new settlements were designed primarily to serve the interests of the company. The new "Organization Man" was to have a (small) family that would give him comfort and security – but also tie him down. On the other hand, family life had to be just boring enough to make him spend as much time as possible on the job – so says a memo issued by Sears Company's personnel department. Art and culture were classified as strictly counterproductive.[2] The residents of new settlements all belonged to approximately the same generation. There were no village elders to enrich the community with a lifetime of experience. The mainstay of the Organization Man was his (plucky, determined) wife. The social fabric was defined by the wives and mothers of their children, and instead of village elders, there were "leading wives." The rules of the game were hatched at endless coffee parties – the only social institution that offered anything resembling the bonds of human relationships. Contact with the outside world was embodied by a variation on the (urban) department store, modified to suit the new parameters.[3]

The rurban – rural/urban – department store was laid out horizontally (as opposed to the vertical thrust in crowded cities) because there was room enough – even for parking lots to park the indispensable car. The shopping mall was divided up in a way that resembled a traditional settlement, with stores lined up in a row along an artificial, usually covered, mall or "street." Actually the mall was a horizontal version of the once vertical structure; a hierarchical order transported from the canyons of the city, historically built into the sky, and tipped over sideways, generating an illusion of organic village growth. As we shall see, this transition from the hierarchically condensed vertical structure of cities to the horizontal simulacrum of village structures was to put its indelible mark on the new culture.[4]

The second decisive factor in the rise of American suburban culture was the rampant spread of technological appliances for information and communication. The radio had at that time already reached the heights of commercial socialization, successfully uniting dramaturgical radio arts with commercials, ceaselessly exhorting listeners to perform their consumer duties.[5] The telephone was used extensively – especially by children who were practicing the second-hand communication of the coming media culture in endless conversations in the privacy of their rooms.[6] The fifties also saw the perfection of the "picture radio," and, as we shall see, television would provide the cement for the identity of suburban communities.

Timid forays into culture, mostly modeled after the culture of the original homeland, which marked the first phase of settlement among the pioneering population of America, were blotted out entirely during the second phase, producing a cultural vacuum. The result was an asocial biotope with a cultural zero function that threw the population back upon archaic psychological mechanisms. Significantly, the first reflections on structural theory were advanced in France at about this time, involving the zero function of the structure between a real and an imaginary encounter with the world.[7]

For want of socializing structures in city planning, the media henceforth assumed control of the development, supply, and preservation of community life – against the background of unbridled and regressive psychological forces that reverted to elemental, "archetypal" motifs for the formalization of mental subject matters. The figures suburbia was to identify with proliferated in this cultural compost: anti-heroes of mediocrity in soap operas and mythical heroes of excess issuing from imaginary prehistoric times, from remote planets in space, or from hidden recesses of the unconscious. Their names: Conan the Barbarian, Flash Gordon, Superman, Captain America, the Fantastic Four, the Green Lantern, or Swamp Thing, all products of the flourishing comics industry. Or they are the shapeless, dangerous powers of the unconscious in Stephen King's novels of horror. The film industry appropriated these motifs. There we meet up with the psychopathic chainsaw murderer Leatherface, the savage mercenary and avenger Rambo, the wily teenage killer Freddy Kruger, the resurrected dead – but also all the bizarre intermediaries between the world of the ordinary (suburban) resident and the abysses of the mind, as in the *Exorcist* or *Poltergeist* or – the other side of the coin – *E.T.*, that lovable creature from outer space. In the music industry these motifs are embodied in Heavy Metal, for instance, masked KISS or snake brandishing, blood-spewing Alice "Welcome to my Nightmare" Cooper. We shall see that, more recently, filmmaker David Lynch has given thoroughly premeditated form to precisely these regressive psychic subject matters, both in his films and his TV serial *Twin Peaks*.[8]

Housing on the Battlefields

In 1992 the British "New Town," Milton Keynes, celebrated its twenty-fifth anniversary. The 150,000-strong settlement, situated ninety kilometers northwest of London, is a social and economic success story. It arose out of the postwar need for new living space due to massive destruction through bombardment, the generally run-down condition of residential quarters in major cities, and the influx of demobilized soldiers. The government passed the "New Towns Act" in 1946, modeled after the garden city movement that marked the turn of the century. Milton Keynes, however, was not officially launched until 1967. The needs of postwar England coincided with the requirements of industrial development, and the establishment of New Towns became essential. Dictated by the givens of the burgeoning network of highways, Milton Keynes is strategically located near both London airports and halfway between Cambridge and Oxford. In keeping with the idealistic model of garden cities, no high rise buildings were erected in the new community. Nonetheless, today it looks more like a vast, sprawling factory than a residental community, despite areas of greenery liberally sprinkled

among the housing units and the black-and-white herd of molded concrete cows that rail passengers riding from London to Liverpool see grazing on a pasture. In fact, the futuristic look of the city inspired the producer of *Superman* to use a bird's-eye view of Milton Keynes as a backdrop for his film.[9]

The Structure of the Suburb

Artificial suburban settlements did not make their appearance in Switzerland until the sixties, and when they did, the circumstances of their development were exceptional, since the country was neither ravaged by war nor overwhelmed by the early industrial boom that led in the United States to a redistribution of the population and the attendant rise of new living structures. In a sense, the rise of suburban culture in Switzerland can be considered a pure form of development that coincided with international developments in the economic arena. Its culture and its effect on social life is a model case of developments worldwide that peaked during the eighties, when first-generation born-and-bred suburbans joined the workforce and infiltrated the fabric of society with their idiosyncracies.

But even in Switzerland the rise of artifical suburbs was a far cry from the organic growth of the historical town. At the turn of the century, suburbs emerged out of a steadily expanding historical center and thus remained embedded in the communal life of the town. Moreover, urban areas in Switzerland never really expanded beyond the dimensions of oversized villages. Other European metropolises absorbed outlying villages in the course of their development, forming an urban network of quarters, each with their own social and cultural structures, while Swiss cities remained monocultural, with the population largely oriented toward the historical town centers. The relationship of town and country remained clearly defined until well into the sixties.

The new settlements emerged in an artificial environment. Where cows were still grazing only a few short years ago, blocks of apartments mushroomed along anonymous through roads. No sites were provided to encourage human and social contact. Bedroom communities were organized so that the family breadwinner would be at home only long enough to satisfy basic needs. Social life was incorporated into the workplace – to be enjoyed, however, only by the working member of the family. Family life, cut off from the breadwinner's social life, ended up in an asocial vacuum that was soon filled with a new set of values.

Switzerland's first shopping centers date from this period, and, as elsewhere, these units assumed the role of a social and cultural interface for the residents of the new bedroom communities. The shopping center is not merely a sprawling food store; it not only supplies the new citizen with the necessities of nutrition and hygiene, but also with administrative amenities, such as post offices, banks, and bus terminals.

Gradually all the commodities of a consumer society were integrated into huge shopping malls. Apart from the standard fare – restaurants, coffee shops, clothing stores, florists, video arcades, beauty salons, camera stores, radio and television dealers – they boast such luxury items as bubbling fountains, beer parties, and exhibitions of reptiles or works of art. The residents of suburbia no longer need the city – the historical memory of the population – for they have come to rely on a self-contained, artificial, and anonymous culture that does not stem from their immediate environment, but is instead fed by an international market in consumer goods.

At the same time, technologically perfected electric – and soon electronic – media conquered the market. Television became the navel cord linking the suburbs to the outside world and functioning as a user's manual for the goods on display at shopping centers. Electronic scripts prescribe our dealings with the data of daily life; firsthand discovery and confrontation with existential issues are supplanted by mediatized reflection within the confines of an intricately codified system. Life is choreographed on

the dual level of the encoded, televised message that later has to be reconverted into everyday life. People first learn to read the multileveled content of the media before tackling its existential integration. Confronted from the beginning with a total semiotization of daily life, they must constantly inquire into the mechanics of narration. The content even of the mediatized message is eclipsed by the intrusiveness of its structure. The content is not given by the picture itself but rather by the relationship of each picture with all the others that follow in its wake. Ceaselessly seeking the meta-text of the televisual media demands an operative approach that is interstitially situated between blocks of (visual) text. The continuity of the message is located in the breaks and cuts between sequences of text, and citizens/spectators live their lives like mechanics, endlessly putting parts together to assemble new machines. Instead of the causal, linear thinking that has dominated Western culture for centuries, they must now master a structural, semiotic mode of thinking as the only means of creating order in their lives.

Significantly, the design of the complex scripts of the televisual world resembles not only media technology itself but also the urbanist agenda and the traffic arteries of suburbia. Telephone, radio, and television, like the dwellings of suburbia, sit in a horizontal network of complex units and must first be assembled in order to make sense. Information circulates between the nodes of the media network – similar to the now motorized, mobile population – and it is the path of the information – the path covered to drive to work – that makes a coherent unit out of life. The integrated scripts of the hardware – media technology or road network – are analogous to the narrative strategies of the brainware – the television scripts. The young generation in particular, born in suburbia and confronted with no other cultural parameters in their first years of schooling than the artificial visual world governed by the consumption of goods and information, has built up a relationship with the world that is governed first and foremost by the encounter with a commodified world – while negat-

ing it at the same time, in order to deal with its objecthood through immaterial, semiotically operative systemic thinking.

The Rise of the Global Suburb

Twenty years after the construction of the first suburban communities, the first generation of native inhabitants poured out of their dwellings to join the urban workforce. The members of this generation embody a specific suburban culture, a new social stratum between agrarian and late-industrial culture. Traditional ways of life and thought are antiquated in contrast to this new generation, which has completely assimilated the specifics of an information and communications society. We have analyzed the dual relationship of the suburban population to a commodified world, whose object-like character has been consistently negated in favor of its semiotization; it is this culture that took precedence in the life of the historical city center in the eighties.

On the physical, concrete level, the ordinary units of culture injected into the old city centers by the residents of suburbia include most of the trivial facilities to which they have become accustomed in shopping centers – or in mediatized form on television. A typical example is the fast-food restaurants that have mushroomed in city centers, driving out long-standing local restaurants and also traditional down-home cuisine. Pay-as-you-go standardized menus and self-service are direct replicas of the logistics of supermarket shopping. There has also been a proliferation of cheap clothing, cheap jewelry, cheap perfume, and cheap home electronics, all in imitation of the artificial shopping-mall strategy. Beauty salons with their multi-pack specials (simulated beauty), sporting goods stores with fluorescent T-shirts and home trainers (simulated athletics and physical activity), clusters of studio movie-houses (simulated entertainment), and video arcades with electronic computer games (simulated and perverted working world) also descend directly from the supermarkets. A special category must be reserved for the gift shops,

which offer a range of items useless across-the-board and manufactured for the sole purpose of reinforcing the illusion of buying power. They are related to the souvenir shops in airports – another vital node in the integrated culture of suburbia. Historical town centers have now completely coopted the cheerful, colorful, hyperbolic shopping-center aesthetic, sprinkling it with a dash of noncommital amusement-park ambiance, another of the suburban amenities; and many streets lined with shops nestled in medieval buildings (totally renovated of course) have become indistinguishable likenesses of suburbia's artificial malls or of the backdrops of proliferating amusement parks.

Suburban culture has infiltrated the historical centers of the cities, and we are confronted today with the phenomenon of suburbia's preemption of the city's historical memory, a phenomenon that has also spread to rural areas, which have atrophied into decorative green belts between suburb and workplace. The script written by overdevelopment of the landscape – especially in a small country like Switzerland – is not modeled after a steady expansion of (historical) cities in the sense of a futuristic megalopolis but rather after an inexorably sprawling suburb. The postmodern city is the global suburb. By analyzing the culture of the global suburb as the overarching semiotization of the mediatized world of objects, we shall be able to uncover means toward an understanding of the present-day approach to the making of art.

Codification

An analysis of the socio-political and philosophical implications of suburbia's infiltration of the historical city goes beyond the boundaries of the present text. It would require a definition of the form and function of the city, which is currently in the throes of universal redefinition because of the very influence of suburban culture itself. The "right to the city," which encompasses the principles of human rights, freedom of speech, and democracy, is undergoing fundamental change. The historical city as a polysemous concept is based on its function as an aspect of liberation from medieval subjugation. The transition of the individual to the city meant a transition to an existential field in which the individual can – and must – assert him/herself. The social context and the organization of cities created opportunities to oppose hierarchical omnipotence. The city claimed the legal and administrative autonomy to grant the individual the right to legal protection, the right to rights. Life in the city means situating the individual in a network of compatible relations and social codes that mark the transition from the – hierarchically organized – community ("Gemeinschaft") to an overarching society ("Gesellschaft"), to use Tönnies' phraseology.[10] We are familiar with the vitalistic, neo-romantic philosophy of damning the city for tearing people away from the "warm" community and leaving them to fend for themselves in a concrete jungle. It is an understanding of the city as the terminal phase in a slow process of disintegration that has cut people off from vital roots, from nature. Heidegger, Rousseau, and Nietzsche are united in their opposition to cities. Spengler[11] describes this evolution as a series of cultural stages that runs from vernal birth to wintery death. To him, the modern metropolis is the home of cold, calculating inhabitants who avoid the warmth of contact and isolate themselves from the primeval human condition of the community. Such thoughts reflect vitalistic contempt for the contract and the longing to return to the warm community. This contempt of the city "as a conglomerate of unknown people and unknown things, within which we must credibly seek to assert ourselves through histrionic, codified modes of conduct, indicates the privileged association of city and freedom,"[12] in which freedom depends, among other things, upon restrictions. The city cannot, and must not, spread unchecked. To function as the locus and guarantor of freedom, it must also restrict its own extension in space.

Economic and demographic changes over the past thirty years have generated the need for new urban infrastructures, for a reorientation and reassessment of the

principles of the historical city. The Belgian urbanist and philosopher Pierre Ansay notes that this discourse suffers from a theoretical deficit; the deeds of the social actors and pragmatic, everyday reality have long surpassed theory.[13] One means of access to a redefinition of the city can be found in the concept of public spaces, those spaces where the social context is historically defined. We have seen that public spaces, in which ahistorical, acultural suburban infrastructures have taken root, concentrate on the interface of the production of goods (the supermarket), the road network, and the technological network of communications and information. The static nature of public spaces, which allowed them to be historically charged with a collective memory, has given way to immaterial, mobile, flowing spaces that condition a transient, semioticized mental structure. The art of the global suburb is accordingly manifested in the rejection of the static, object-like condensations of the socio-political environment in favor of a mobile, disembodied model.

A Museum in the Global Suburb

In St. Etienne in central France, a new Musée d'Art Moderne was opened in 1987. Architect Didier Guichard resisted the call of postmodernism's architectural eclecticism and put up a minimalistic right-angled cube that recalls the aesthetics of the large, multipurpose industrial buildings scattered over the French countryside – with one difference: the cladding of square black ceramic tiles, which reflects the fact that this was once a coal mining district.

The museum was erected on an empty lot between the northern and western highway exits on the outskirts of the city, where the landscape has been abandoned by the city and fades into the no-man's-land that borders on the intercity traffic arteries. The size of the parking lot is, of course, substantial. The museum can be reached in less than half an hour from downtown St. Etienne by public transport. The exemplary collection includes all the big names of modern art, from Kandinsky, Léger, Villon to Matisse, Zadkine, Calder, and on to the Nouveaux Réalistes, Pop

Art, and the Minimalists. It is a pilot project for a program of comprehensive cultural animation and museum education, which targets professionals as well as the public at large and, especially, schools. Eighty percent of the cost of building the museum and topping up the collection was defrayed by Casino, one of the most successful supermarket chains in France.

The new art institution embodies a number of features characteristic of planning and development in the global suburb. Although it was only by chance that a supermarket chain took over most of the financing, this fact is indicative of a number of considerations that could never have held sway in the city planning and development of the past. The museum architecture resembles that of the industrial buildings lining the thruways. A thruway exit was selected as the site for the museum. In this form and in this location, the museum forms a node of art reception within a decentralized network of social facilities. It is evidently accessible primarily by car. Art is placed on an ahistorical site in order to fit into the ahistorical context of suburban culture. The site of art is no longer reserved for the condensation of historical development within a free urban culture but has instead become an interface for a culture of communications and information. It acquires a historical dimension through its relation to other sites of social concentration: living spaces, shopping districts, workplace, services, sports stadium, amusement park, vacation spots. At the site of art, the recipient is confronted with a complex unit of information whose function must constantly be interpreted within the semiotic parameters of the fragmented script of suburban life. This is why the St. Etienne museum has chosen to – and indeed must – organize a comprehensive range of museological and educational activities. Within the complex unit of the entire museum, the work of art is an equally complex component that must constantly be subjected to semantic reevaluation. A mode of thought is emerging that is focused on elaborating scripts in which single sequences are constantly being rearranged. Complex units no longer make sense

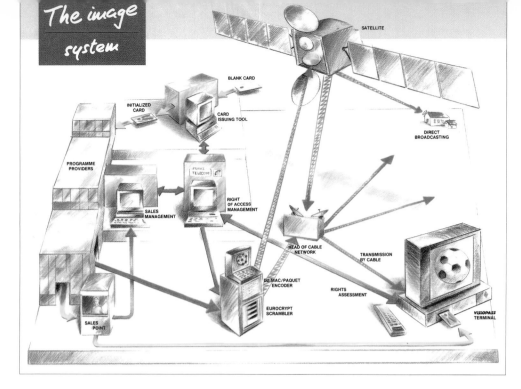

The image system

in isolation and for themselves; they are of significance only in relation to other complex units. Important are the seams, the breaks, the interstices between the sequences.

The Streets of the Global Suburb

In classical antiquity, the street performed a minor function in the organization of the city. It was an extension of the main social facilities of the polis: the forum, the agora, the temple, the stadium. During the Middle Ages, the city street was appropriated by tradesmen; gradually room was made for the passage of customers, and the street became not only a path through the hurdles of the coercion to buy but also a social meeting place, a place to learn and to be informed. There the urbanite is the actor, the spectator, and at times the agent. All the components of the city pour into the street in an existential whirlpool, in a liberating disorder that generates a higher order. The street is the melting pot that quickens city life; without it, all would be separation, intentional and petrified isolation. "On the street and through it, a system is manifested – the city itself."[14]

Cars have deprived the owners of the street – the residents of the city – of their prerogative. People have been ousted by the machine. The street has surrendered its function as a place of encounter to the need for passage, where cars have priority and pedestrians are barely tolerated. For both categories of users, it has become a site governed by dos and don'ts. They are both exposed to the aggressive signals of consumerism and also of endless traffic regulations. While pedestrians – fair game for machines – are constantly seeking to save their skins, drivers wear themselves out looking for parking spaces and chafing in traffic jams. The Boulevards Périphériques around Paris have grown into the city's largest office complex: thanks to their cellular phones, armies of employees do business during endless traffic jams, never losing touch with their head offices, which have long since moved out of the city.

But the street is also the place where the forces of oppression may hinder renewal. The moment revolutionary tendencies surface, the streets are blocked; the interfaces and passages between complex units are thus hardly invulnerable. This applies not only to traffic connections but also to the production of scripts from units of information and communication.[15] Even the artificial shopping mall, in its relatively secure architectural environment, is not without danger, for it is there that users suffer the greatest consumer pressure. The pedestrian on the synthetic street of the simulated city is constantly required to combine the aggressive signals of goods being hawked into an individually compatible script of daily life. Instead of taking place on the level of a subsistence economy, the struggle for survival has been shifted to the level of semiotic plausibility.

Cybernetic Meta-Bricolage

In 1989 the Cologne Kunstverein organized an extensive retrospective of *Video Sculpture*, in which fifty major works were selected to illustrate the most important spatial variations on the use of electronic picture technology to have evolved since the rise of this genre around 1963. The exhibition embraced the work of such pioneers as Nam June Paik (*Zen for TV*, 1963), Bruce Nauman

(*Video-Corridor*, 1969), Peter Campus (*Interface*, 1972), Les Levine (*Iris*, 1968), Dan Graham (*Present continues Past(s)*, 1974), and Bill Viola (*He weeps for you*, 1976), as well as the second U.S. generation from the end of the seventies and the continental European scene of the eighties down to computer-aided pieces by Jeffrey Shaw. Switzerland was represented to great advantage by the installations of Gérald Minkoff, Muriel Olesen, Jean Otth, Alexander Hahn, Anna Winteler, and Rémy Zaugg. Not only did the exhibition embrace the most important video artists, it also demonstrated the fundamental problems involved in the (artistic/creative) exploitation of (visual) information and communications technologies. In addition, it revealed a growing awareness of the aesthetic, socio-political, and also semiological, perceptual, and existential implications of media culture network.

A selection of these video sculptures was on view at the Zurich Kunsthaus that same year, along with a comprehensive Salavador Dali retrospective that drew large crowds. Dali has become an icon in the history of art, a rare occurrence among twentieth-century artists, regardless of the quality of their art. His mastery of myth – the artist as a genius poised between realms of awareness, the artist as an eccentric maestro of the bizarre – has secured him a widespread popularity far beyond the circle of art-loving initiates. Having carved out a place for himself among the greats of mass culture, his name was enough to attract to the exhibition in Zurich many visitors who ordinarily shun the hallowed halls of art.

At the time, the Kunsthaus asked me to conduct a series of tours of the video sculptures. The rather thin showing of art lovers interested in the creative potential of technology was sprinkled with visitors who had strayed in from the Dali retrospective – a unique opportunity to engage in a dialogue with people otherwise indifferent to art. As it turned out, most of these visitors had grown up in the artificial housing developments of the suburbs and were between twenty and twenty-five years of age – certainly a sociologically representative segment of the popu-

Copyright Thomson Digital Image, 1991.

lation. Their most frequent inquiries concerned the operation, the functioning, of the video installations. They were interested in "how it works" and could not have cared less about "why." They wanted to know how many outlets the monitors had, how the closed circuit systems were wired, about the required intensity of the lighting, about delayed signals... Neither isolated elements nor the overall meaning of the system aroused any curiosity. They are too complex to be grasped. The mind can only infiltrate the scheme of the network and check out the instructions. Even suggestions for technical "improvements" were proffered.

The suburban population has become specialized in thinking in terms of the operative procedures that govern the object world. But operative thinking is not judgmental, and it gives itself no priorities. Although it rests on recognition of the system and the production of an overarching script, and has thus become the main axis for grasping the environment, it deals with individual complex units on the same level of experience without exploring interconnective meanings. Thus, the model of the network is not

ess and bricolage as a practical activity, on the one hand, and science, on the other.[17] However, the cybernetic suburban bricoleur produces a total structure by already making use of complex units, which then duplicate the structure of the primary units. This is a quantitative leap inasmuch as he no longer deploys only the (formal) "residue" of events – he avoids the event because it is too complex – instead exploiting (being forced to exploit) its ideological structures as his working material. Assuming that art "is the (precarious) balance between structure and event, between necessity and chance, between interiority and exteriority,"[18] in which the model of the structure duplicates that of the event on the metalevel, we are then confronted with a phenomenon that belongs to the essence of electronic communications and information technology, namely, the displacement of vertical diachrony by a horizontal, flowing, pragmatic, and pluralistic model, where events are nonhierarchically ordered on both the micro- and macrolevel.[19]

Mass Culture/Avant-Garde

Umberto Eco advances an interesting position regarding the mechanisms of mass culture and the production of kitsch.[20] Kitsch claims to impart an artistic message that is revealed to be "aesthetic deception." As ersatz art for instant consumption, it is the ideal nourishment for a lethargic public that wants to espouse and partake of the benefits of beauty without making the effort to understand it.[21] Above all, kitsch tries to suggest that a privileged aesthetic experience is perfected through the enjoyment of these stimuli.[22] Kitsch is therefore not only a question of formal issues but also of psychological mechanisms and modes of conduct. Eco proposes a definition of kitsch as communication that is based on the creation of an effect. Intermediate and popular culture thus no longer offer works of art but only their effect, forcing artists to respond with a "strategic counterproposal" that involves foregrounding the process leading up to the work rather than the work itself.[23] This is the evolution of the avant-garde:

deployed as a cosmology to which primary models are subordinated but instead occupies a position outside the diachronic construction of reality.

Operative suburban thinking is mythical; its "wild" approach to organizing the world yields a cybernetic bricolage. According to Lévi-Strauss, mythical thinking is characterized by the use of events or residual events in order to work out structured totalities, while the sciences – thanks to the structures they indefatigably produce – create their means and findings in the form of events, whereby both paths are, of course, equally viable.[16] Artistic creation lies between mythical thinking as a speculative proc-

artists react to the pressures of an effect-oriented mass culture geared towards instant satisfaction and are forced artistically to emulate (imitative) effects for the sake of perceptual processes and the act of seeing. Mallarmé responded to the spread of popular literature and its promise of instant satisfaction by exploring the poetics of a white piece of paper, and painting had to move outdoors to investigate problems of light because photography was able to furnish the public with satisfactory (and cheap) self-portraits.

The avant-garde may at times respond to the dissemination of kitsch, but, conversely, kitsch is revitalized and flourishes by consistently exploiting the discoveries of the avant-garde.[24] The makers of consumer culture, stimulated by the trajectories of the avant-garde, act as the agents of its promotion, spread, and assimilation. In the capital letters of commerce, they prescribe how we should experience the effect of avant-garde modes of generating form, whose original purpose was to stimulate meditation on sources and causes.

The ambivalent attitude toward the object world in the global suburb supports this interpretation inasmuch as the mechanism – the system of relations and the modes of

behavior – is emphasized in confrontation with its products. Since the social infrastructure of the global suburb follows the exact patterns of such systems, from the road network to the information network, and since these patterns have infiltrated historical city centers, we are currently experiencing the elimination of diachrony between kitsch (mass culture) and the trajectories of the avant-garde. The interdependent, systemic, nonlinear, horizontal thinking of the global suburb has become the overarching paradigm of culture.

Object Art/the Semiotic Art Object

Over the past ten years the European continent has seen a strong presence of objects and three-dimensional presentations in the fine arts, following a revival of painting and a decline in sculpture at the beginning of the eighties. The reasons for this development are manifold. An interpretation in terms of the march of global suburban culture yields revealing insights.

The revival of easel painting at the end of the seventies – Neo-Expressionism in Germany, the Transavanguardia in Italy, and Neo-Geo or illustrative, elementary painting in the United States – followed a period of reflection upon

conceptual issues which resulted in a new positioning of artistic strategy across the board. The explosion of the concerns of modernism during the sixties coincided with the rise of suburbia and mushrooming communications and information technologies. Fluxus, Live Art, Pop Art, Conceptual, Land, and Performance Art, and, of course, experimentation with the technological material itself (from the early stages of video art down to interactive, computer-aided art) are the avant-garde's answers to the invasion of the systemic thinking of a technologically contingent suburban culture. It is art that repudiates the fixation upon the product-as-object and instead puts forward networks, systems, and artistic models.

In the midst of this exploded artistic landscape at the end of the seventies, painting was both a means of processing the formal problems of modernism and also a media conceptualization of the ebbing confrontation. This generation of artists worked with one foot still in modernism and the other already in the global suburb. We shall see that the eighties produced young artists completely rooted in the global suburb, who lent their specific thinking to the creative process.

Systemic, structural, and operative thinking as generated by the infrastructure of the global suburb was not, however, contingent only upon the emergence of faceless suburbs, it was directly associated with the history of communications technologies. *The Meeting of the Umbrella and the Sewing Machine on the Dissecting Table*, described by Lautréamont in 1868 and utilized by the surrealists to define an open-minded aesthetics in constant flux, was a prescient statement on complex, elementary events, whose meaning jelled only much later on, giving it a systemic network reading. The history of the Western mind – indeed, of all the world's cultures – could, in fact, be written in terms of the development of their modes of communication. Reading a wild-game trail or meteorological events is no less contingent upon systemic thinking than the interpretation of a press photograph or a political event in the outgoing twentieth century. The phonetic,

alphabetic codification of language two thousand five hundred years ago marks a decisive turn in the history of Western civilization that acquired the status of a general cultural paradigm upon the Renaissance invention of movable print. The acceleration fostered by the steadily growing mechanization of communication has blurred the distinction between sender and receiver, eliminated temporal distance, and led to an experience of omnipresence, resulting in complete awareness of the pattern of the network.

Wellington reports in his diary that his lifetime as a soldier was spent wondering what lay behind the hill before which he was standing with his troops. Thoreau, on watching the first telegraph lines go up in 1858, commented that the telegraph was a fine invention, but he could not imagine what people would have to say to each other from one city to the next. As it turned out, the telegraph not only changed the conduct of war, it also gave birth to whole new areas of political and economic life. Having conquered time and space, the televisual communication of pictures and their transmission by satellite have created new paradigms of shared social life. The recent development of the technology of virtual reality, which involves the possibility of actively participating in a mathematically devised cybernetic space, replaces symbolically codified signifieds by existential experience that extends the temporal motifs of the network in space.

In the eighties, artists born and bred in the global suburb informed their art with the motifs of network thinking.[25] The brief revival of painting at the end of the seventies was followed by a massive increase in object art, in which the object itself was deployed as a complex element within the network. The artist from the global suburb builds semiotic systems that reflect the cultural patterns of the new living space. Galleries and museums pursued this strategy by mounting complex ensembles of individual works placed within a larger system.[26] Art dealers added fuel to the fire by introducing psychological marketing strategies, thus duplicating the model of fluctuating currencies.

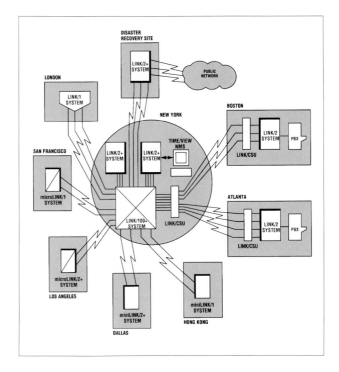

Copyright Timeplex Inc., 1989.

The European continent gradually caught up with the global suburbanization launched in the United States in the fifties, and in the process the main motifs in the making of art gravitated towards equalization. The role of world leader in the arts – a position occupied by New York for some twenty years – lost its raison d'être. The culture of the global suburb had reached intercontinental heights, having spread to the industrialized areas of the Pacific, to Australia, and to a number of places in developing countries (Nairobi, Bombay, Singapore, Seoul, Rio de Janeiro). The march of the global suburb is reflected in the collapse of the Soviet empire, the opening of the borders to Eastern Europe, German reunification, and the forthcoming implementation of the European Community. Within the world network, national boundaries have become impediments to progress. International interfaces are concentrated around airports. Airport art, once confined to extra-European art and handicrafts produced for the tourist trade, has extended to the output of Western civilization.

Object art – the installation, the appropriation, the arrangement – reproduces the models of information and communications media, and we now see the concept of media art – which has made systemic use of technology in its brief twenty-year existence – being applied to works executed in conventional materials. We are confronted with media art that is no longer the exclusive domain of the media (implicitly understood as being technological), for the systemic medial approach has channeled traditional artistic craftsmanship as well. Eighty per cent of the art shown in Aperto (for young artists) at the Venice Biennale

in 1990 was object art that dealt with these issues and applied their strategies. All art is media art. The United States, as the pioneering country of the global suburb, has brought forth a substantial number of young artists – Cady Noland, Robert Gober, Jeff Koons, or Mike Kelly – whose work focuses on the conspicuous properties of suburban culture – fitness gear, teddy bears, salt shakers, and mannequins.

The impact of the media network on artistic strategies in the global suburb is manifest in the growing presence of artists' groups and the production of collective work. Human dynamics serve as a means of exploring systemic schemata. Ten years ago, such groups as Art & Language or General Idea publicized their work largely via printed media; now Présence Panchounette, Art in Ruins, Information Fiction Publicité, Group Material, Stille Helden E.V., Tim Rollins + K.O.S., and Survival Research Laboratories have become veritable production complexes modeled after multinational organization networks. A variation on the artists' group are pairs of artists, many from Switzerland. Fischli/Weiss, Biefer-Zgraggen, ALMA, Sylvie & Chérif Defraoui, Chiarenza-Hauser, and YACH choose to work in a structured human context, seeking to overcome, but also to make a statement about, the isolation of the individual unit. Their themes focus on processes of semiotization, synergy, and the network. Networked strategies to generate networked artistic systems are the subject matter of the network.

Switzerland:
Megalopolis or Global Suburb?

Global suburban culture, bred by all-pervasive communications and information technologies in the ahistorical, acultural housing developments of the sixties, has produced a systemic-semiotic, operative mode of thinking that has permeated all aspects of life. The new generation of artists, born and raised in the global village and thoroughly familiar with its mechanisms, works in a supranational context, outside the paradigms of established,

hierarchical, vertical, and traditional high culture. Common ground is made possible by a virtually identical and uniform context. But this artistic landscape is dotted with identifiable national or local vegetation and idiosyncratic motifs. An ideological, political, and economic heritage cannot be swept away overnight, and artists working in specific geographical locations still incorporate local moments in their work.

The geopolitical organization of Switzerland is marked by an extremely parceled awareness arising from the multicultural structure of the Confederation. Topographically isolated local communities underwent centuries of largely autonomous development and, accordingly, never acquired the dimensions of European metropolises. They form complex units that are surprisingly compatible with the model of the global suburb. Distances in Switzerland allow viable transport facilities within a larger system. It takes an hour or less by car or train from Zurich to reach cities like Basel, Bern, Lucerne, Olten, Winterthur, St. Gallen, or Wil, all of which are furnished with their own art institutions and art galleries. A devotee from Zurich might easily attend a Kunsthalle opening in Bern, a dinner party in Lucerne, and a late night performance in Winterthur, all on the same evening – even more easily if he or she lives in the suburb of Dübendorf, ten kilometers away from the center of Zurich. Decentralized housing developments cover the countryside with a global network of human activity, which has eroded the traditional distinction between town and country. The acultural dimensions of the artificial suburbs have never acquired the ingrained mechanisms of, say, the *banlieue* around Paris, because distances in Switzerland are always manageable. Generalized acceleration and mobility, in combination with the influence of communications and information technologies, has welded Switzerland into one overlapping megalopolis in which separate complex units – historical city centers, rural communities, and artificial suburbs – have been united in a global Swiss urban concept. One source of concern, however, is the interaction between the rurban

megalopolis of Switzerland and the international global suburb – a relationship that cannot be ignored. In this sense Switzerland is presently undergoing a twofold development toward a locally situated megalopolis and an internationally situated global suburb.

Translated from the German by Catherine Schelbert

Notes

1 Henri Lefèbvre, *Die Revolution der Städte* (Frankfurt, 1972/1990), pp. 27–28.

2 Sheila Hayman, "Corporation Street," *The Face*, vol. 2, no. 5 (London, Feb. 1989), pp. 68–69.

3 The social organization defined by women has contributed substantially to the rise of women's consciousness in a traditionally patriarchal society and has nurtured feminist reflection. These developments are incisively fictionalized by Marilyn French in *The Women's Room* (New York, 1977).

4 See also Fredric Jameson, "Postmodernism and Consumer Society," in *Postmodernism and its Discontents*, ed. Ann E. Kaplan (New York, 1988), pp. 13–29. Jameson describes the social mechanisms in the Bonaventure Hotel built by architect John Portman, a horizontal reconstruction in new downtown Los Angeles of the vertical suburban simulacrum of the originally horizontal structure. In *High Rise* (London, 1975), J.G. Ballard dramatically fictionalizes the horizontal dimension of a verticalized village.

5 Cf. Ron Jacobs, ed., *Cruisin' 1955–1963, A History of Rock and Roll Radio* (Los Angeles: Increase Records INCM 2000–2008, 1970). The recording, a mixture of local hits, radio announcements, and commercials, conveys a precise impression of social mechanisms in the new housing developments. The history of commercial radio stations in the United States of the fifties mirrors the development of the all-American suburb.

6 Youthful – and adult – telephonitus belongs to the classical devices of cinematographic narration. A telling example is Wes Craven's *Nightmare on Elm Street* (1984), in which a teenage girl, whose subconscious is plagued by a monstrous killer, talks on the phone to her boyfriend across the street to keep from falling asleep. The kids are within eyesight of each other, which is dramatically emphasized by shot/reverse-shot editing, while the dialogue is dictated by the telephone medium. Helpless, the girl is forced to witness the monster killing her boyfriend.

7 Gilles Deleuze, *Das Leere Feld, in Woran erkennt man den Strukturalismus* (Berlin, 1992), pp. 41–53. Structuralist psychoanalysis, after Lacan, of the all-American suburb could uncover significant motifs in this respect. Mediatized communications networks – telephone, radio, television – would then function as a technological metaphor for the cultural structure of the population.

8 Robert Fischer, "(Why) Is David Lynch Important?" *Parkett* 28 (Zurich, June 1991), p. 155.

9 See Charles Ritterband, "Milton Keynes, das englische Utopia?" *Neue Zürcher Zeitung* 62 (14 March 1992).

10 Quoted in: *Pierre Ansay, Penser la Ville* (Brussels, 1989), p. 90.

11 Ibid., pp. 89–92.

12 Ibid., p. 92.

13 Ibid., p. 38.

14 Henri Lefèbvre, op.cit., p. 25.

15 In David Lynch's TV-serial, *Twin Peaks* (1990/91), few moments of danger have been shot. The narrative is motivated by an event that happened before the series opens – the murder of Laura Palmer. Each episode consists of a number of evidently disconnected sequences, which acquire their intensely disquieting impact only in combination. The director's art lies in his ability to stage the narrative so that the danger is compelling, no matter how the complex units are combined.

16 Claude Lévi-Strauss, *La pensée sauvage* (Paris, 1962; German ed. Frankfurt, 1968), p.35.

17 Ibid., p.45.

18 Ibid., p.44.

19 See also Robert Fischer, "The Flowing Model. The Machine-architecture of Imagecreating Devices as Paradigm of Culture," *Frammenti, Interface, Intervalli* (Genoa, 1992), n.p.

20 Umberto Eco, *Apokalyptiker und Integrierte, Zur kritischen Kritik der Massenkultur: Die Struktur des schlechten Geschmacks* (Frankfurt, 1984), quoted in: *idem, Im Labyrinth der Vernunft* (Leipzig, 1990), pp. 249–255.

21 Ibid.,p. 249.

22 Ibid. p. 251.

23 Ibid., p. 252.

24 Ibid.,p. 255.

25 The systemic thinking underlying Conceptual Art, Land Art, Process Art, Mail Art, etc. logically emerged ten years earlier in the United States, along with the new urban structures and communications technologies.

26 Curator Harry Szeemann organized a thematic show at the Kunsthaus Zurich in 1983, titled "Hang zum Gesamtkunstwerk" – a concept culled from the first phase of acceleration in the evolution of mechanical communications technologies.

Bibliography

Ars Helvetica, Die visuelle Kultur der Schweiz,
a twelve-volume series edited by Florens Deuchler for
the Arts Council of Switzerland Pro Helvetia
and published in the four national languages, offers
the most recent and comprehensive survey of Swiss
art:

Gamboni, Dario. *La géographie artistique*. Ars
Helvetica I. Disentis, 1987.

Deuchler, Florens. *Kunstbetrieb*. Ars Helvetica II.
Disentis, 1987.

Horat, Heinz. *Sakrale Bauten*. Ars Helvetica III.
Disentis, 1988.

Meyer, André. *Profane Bauten*. Ars Helvetica IV.
Disentis, 1989.

Eggenberger, Christoph and Dorothee. *Malerei des
Mittelalters*. Ars Helvetica V. Disentis, 1989.

Bätschmann, Oskar. *Malerei der Neuzeit*. Ars
Helvetica VI. Disentis, 1989.

Jaccard, Paul-André. *La Sculpture*. Ars Helvetica VII.
Disentis, 1992.

Preiswerk-Lösel, Eva-Maria. *Kunsthandwerk*. Ars
Helvetica VIII. Disentis, 1991.

Bouvier, Nicolas. *L'art populaire*. Ars Helvetica IX.
Disentis, 1991.

von Tavel, Hans Christoph. *Nationale Bildthemen*. Ars
Helvetica X. Disentis, 1992.

von Moos, Stanislaus. *Industriekultur*. Ars Helvetica XI.
Disentis, 1992.

Wyss, Beat. *Kunstszenen heute*. Ars Hevetica XII.
Disentis, 1992.